pressPLAY
contemporary artists
in conversation

We would like to thank all the artists and authors of this book for
their kind cooperation. We would also like to thank the following
for their help: Artforum, New York; Alexis Canter, Alexander and
Bonin, New York; Barbara Corti, Hauser & Wirth, Zürich,
London; Lisa Gooding, Serpent's Tail, London; Sophie Greig and
Honey Luard, White Cube Gallery, London; Pernilla Holmes,
Haunch of Venison Gallery, London; Julie Hough, Regen Projects,
Los Angeles; Elisabeth Lebovici, Paris; Markus Lutter, Stadt
Bochum; Thomas Mayfried, Munich; Paula Orrell, London
College of Fashion; David Zwirner, New York.

We would also like to thanks the following for lending
reproductions: Alexander and Bonin, New York; Archiv Franz
West, Vienna; Uta Barth, Los Angeles; Tanya Bonakdar Gallery,
New York; Cai Studio, New York; Cheim & Read, New York;
Stephen Friedman Gallery, London; Galerie Daniel Buchholz,
Cologne; Galerie Lelong, New York; Barbara Gladstone Gallery,
New York; Marian Goodman, New York and Paris; Antony
Gormley Studio, London; Paul Graham Studio, New York;
Solomon R. Guggenheim Museum, New York; Hauser & Wirth,
Zürich, London; Thomas Hirschhorn Studio, Paris; Jenny Holzer
Studio, Hoosick Falls; Roni Horn, New York; Jay Jopling/White
Cube, London; Kelley Studio, Los Angeles; Sean Kelly Gallery,
New York; Lisson Gallery, London; McKee Gallery, New York;
Matthew Marks Gallery, New York; Palais de Tokyo, Paris;
Maureen Paley/Interim Art, London; Presseamt, Stadt Bochum,
Bochum; Richard Prince, New York; Regen Projects, Los Angeles;
Pipilotti Rist, Zürich; Serpent's Tail, London; Jessica Stockholder,
Connecticut; Studio Museum Harlem, New York; Felix Tirry,
Paris; Walker Arts Center, Minneapolis; Jeff Wall Studio,
Vancouver; Zeno X Gallery, Antwerp; David Zwirner Gallery,
New York

Photographers and acknowledgements

John Akehurst; Vivien Bittencourt; Danie Botha 2001, © Dumas,
Botha; Jane Bown; Juan Buena; Bob Braine 2003; Marco Fedele
di Catrano; Renee Conforte; Frédéric Delpech; Niels Dietrichs,
2003; Todd Eberley; Allan Finkelman 1972; Robert Fischer; Jack
Foster; © Abe Frajndlich 2003; Getty Research Institute; Paula
Goodman; © 2003 Timothy Greenfield-Sanders; Steven Gross,
1982; Peter Guenzel; Hejduk/MAK Wien; David Hofstra;
Jean-François Jaussaud; © Gottfried Junker, Nada Film; Emilia
Kabakov; Carina Landau; © Nanda Lanfranco; Salvatore Licitra;
© Armin Linke; Herbert Lotz ; Ulf Lundin; Douglas Martin;
Patricia Martin; © Thomas Mayfried/Haus der Kunst, Munich
2004; John Minh Nguyen; Wilton Montenegro; Pete Moss, 2002;
Flávia Müller Medeiros; Catherine Opie; Rafael Pacheco; Dirk
Pauwels; Robert Pettena; Reporters, Turin; Peter Sandler; ©
Mischa Scherrer, Zurich; Johnnie Shand Kydd; Chloe Sherman;
Ani Simon-Kennedy; © Star Black; Daniel Stier; © Tate
Photography/Mark Heathcoate; © Wolfgang Tillmans; © Paula
Trope, 2004; Michael Tropea; Christian Wachtler; Robert
Wedemeyer; Kirsten Weiner; Edward Woodman.

All works are in private collections unless otherwise stated.

Phaidon Press Limited
Regent's Wharf
All Saints Street
London N1 9PA

Phaidon Press Inc.
180 Varick Street
New York, NY 10014

www.phaidon.com

First published 2005
© 2005 Phaidon Press Limited

ISBN 0714845337

A CIP catalogue record of this book is available from the British
Library.

Designed by Marit Münzberg

Printed in China

Blackburn College Library
01254 292120

Please return this book on or before the last date below

pressPLAY
contemporary artists
in conversation

in conversation

Vito Acconci *Mark C. Taylor*

in conversation
January 2001, New York

Mark C. Taylor *Everything begins with the name or, more precisely, with naming. Vito. Tell me the story of your name, Vito.*

Vito Acconci I was named after my grandfather, who was dying at the time. But he didn't die; and anyway, his name was Carmine. For some reason they called him Vito. So my name was based on habit, convention, not history. As a child I hated my Italian background; I wanted to be an American. Later – at high school dances, for example – I hated introducing myself; it was as if no one could hear me, I had to spell things out: 'No, not Peter – V-I-T-O.' I couldn't present myself in talk; I had to write.

Mark C. Taylor *You have always been fascinated by the play of language. If one listens carefully it is possible to hear multiple echoes in your name:* Vito, vita, vino, *perhaps even* veritas. *Does your name figure in your work?*

Vito Acconci Vito's the name of a pet, a puppet, a child. My name breeds familiarity, even for – maybe especially for – those who have contempt for my work. It might have been my name that allowed me to do performances – I could live up to my name, I could play the fool, I could be a clown. I could throw myself into your hands or at your mercy. My name fits my early work; together, they give people the illusion that they've had a relationship with me. My fear now is that that relationship makes architecture impossible: my person sticks out, and the space recedes into the background. But, thankfully, the silliness of my name is a safeguard against self-importance and over-seriousness.

Mark C. Taylor *Kierkegaard was one of the first to identify the importance of irony as a form of life as well as an aesthetic phenomenon. He always drew a sharp distinction between irony and humour. While irony is the boundary between the aesthetic and ethical forms of life, humour is the form of consciousness that most closely approximates religious awareness. Much so-called postmodern art involves an irony bordering on cynicism. Your work is often quite humorous but is not precisely ironic. How do you understand the difference between irony and humour and how does this difference inform your art?*

Vito Acconci Irony is know-it-all; I prefer slapstick. Irony is laughing at something, or someone, from above; I want laughs from within – laughing at oneself, and laughing *with* someone. My models are Buster Keaton, the Marx Brothers. Let's say there are two views of life, the tragic and the comic. In the tragic view, the protagonist travels along a pathway, a channel, towards a goal; call that goal transcendence, or God. Nothing gets in the way of that trajectory; the viewer's attention is singleminded, the viewer is numbed by the relentlessness of that trajectory. In the comic view, there's the same protagonist, the same pathway, the same goal. Now, halfway along the pathway, the protagonist slips on a banana peel: suddenly the goal doesn't seem so important anymore – the protagonist's mind is on other things, and so is the viewer's. What humour does is allow a second thought, a reconsideration. Humour questions judgement – it riddles holes into the

idea of a Last Judgement – while irony judges. Humour leaves a mess – who cleans up afterward? who cares? – while irony is pointed and clean. Humour is carnival – it's enjoyment from making a fool out of oneself; irony is enjoyment from making a fool out of others.

Mark C. Taylor *You began your artistic career as a poet. As you know, philosophers from the Greeks to the moderns have privileged poetry by placing it at the top of every hierarchy of the arts. While you stopped writing poems many years ago, it is clear that poetry has always influenced your work. Is poetry still directly or indirectly important for your work?*

Vito Acconci I'd put poetry at the bottom of a hierarchy of the arts – not because it's lesser, but because it's the base, the undercurrent, the sub-structure of the arts. But, as a base, it's only a beginning. Poetry has nothing to do with concentration of language, or distillation of language; poetry is an attempt to get through language and arrive at a state of pre-language – it's a cry, a gasp, a screech. Poetry is thinking – or maybe it's only feeling – in opposites; poetry is fluidity between opposites. Then, later, poetry throws the voice into spaces, events; poetry grows up to become a novel, or a movie, or music, or architecture.

But: once a poet always a poet – or, at least, once a language-user always a language-user. I don't know how to think – more exactly, I don't know how to know I'm thinking – except by language. I start a project by naming the conditions and playing with words, punning on those names. Or I start a project by subject-verb-object: I parse a space, I use sentence-structure to plot possible movements through that space.

Mark C. Taylor *In much of your work you shift the focus from the creator of the work of art to what once had been the viewer. In this way, you draw the 'viewer' into the work of art by staging a performance in which he or she can, or sometimes must, participate. From this point of view, the work of art becomes a process rather than an object. This approach differs significantly from the modernist notion of the autotelic or self-referential work of art. What are the artistic and political implications of this understanding of the work of art?*

Vito Acconci Once a viewer is in the middle of things, art becomes architecture. The artistic implication is that, ultimately, art isn't necessary anymore as a field, a profession; art is no longer a noun, it becomes a verb. Art is an activity that you do while having some other career – you do art as a mathematician, as a physicist, as a biologist. Art is nothing but a general attitude of thickening the plot. Once a viewer is a participant, there's no receiver, no contemplator – hence, no viewer. The political implication is that the former viewer becomes an agent, a decision-maker; you're on your way to becoming a political activist, whether or not you choose to take that road to its destination.

Mark C. Taylor *At the time you and some other artists were exploring the complexities of the relationship between artwork and 'viewer', philosophers and critics in the US and Europe were rethinking literary texts by opening their purported closure in*

ways that allowed readers to become, in effect, co-producers. Did these trends in literary criticism influence your understanding of the work of art at this time?

Vito Acconci Yes; but I had been prepared beforehand. In college, in the late 1950s and early 1960s – this was the time of 'New Criticism', with its emphasis on the poem-in-itself – a Jesuit priest, Thomas Grace, introduced me to the opposite, theorists like Kenneth Burke (1897–1993) and Walter Ong (1912–). I loved Burke's titles: *The Grammar of Motives* (1945), *The Rhetoric of Motives* (1950); I loved the notion of writing as intention, of writing as will. Rhetoric assumes an audience, demands an audience; I was re-learning the arts as strategic interaction. And it was not by Jacques Derrida but by Ong that I was taught the difference between writing and orality: orality meant a community of talkers and listeners – orality took the 'thing' out of itself and into the body of the listener.

Later, late 1960s and 1970s, I read the usual suspects. The ones that stick with me – because I couldn't put my finger on just what it was they said – are Maurice Blanchot, and Gilles Deleuze and Felix Guattari when they wrote together. This is writing that demands immersion; it was being inside the mind of a schizophrenic.

Mark C. Taylor *In making the 'viewer' a participant in the work of art, you often create situations that involve or imply a certain danger. What lessons does such danger teach?*

Vito Acconci In some early 1970s pieces, I learned that commitment to an idea, to an abstraction, can be frightening. I could be so concentrated on applying stress to the body that I ignored the ravages that stress was making on my body; I could talk myself into a hypnosis where I probably could have killed somebody. And, gradually, I learned respect for the viewer. Yes, maybe the insertion of real-world everyday fear is a whiff of fresh air into the hothouse of an isolationist art system. But, at the same time, danger only confirms and enhances the victimization of the viewer. Museum-goers are automatically victimized: they're in a building with no windows, as if in a prison – they're ordered 'Do Not Touch'. The art is for the eyes only, and they're in a position of constant desire, hence constant frustration. So, danger to the viewer is unfair; it takes advantage of somebody who's already down. Later, in some of my installations from the late 1970s, where viewers could release a projectile and thereby endanger either themselves or others, I learned that I was cheating. I was depending on, resorting to, the safety mechanism of gallery/museum; I must have known it couldn't happen here, this was a gallery, this wasn't real – I was only making a metaphor, and I thought I hated metaphor.

Mark C. Taylor *The question of the frame figures in much of your work. Perhaps it would be more accurate to say that much of your work puts the frame into question. You often seem to want to step beyond the frame – perhaps even to erase the frame. But can the frame be erased? Can there be art without framing?*

Vito Acconci When I was doing art, when I did installations in the mid 1970s, I depended on the frame of the gallery. I tried to treat that frame as a material condition: if a gallery had an overhang in the middle, then a person had to be under that overhang, so that the overhang could threaten, like a guillotine. If a gallery had columns, then the columns had to be tied together, the columns could be used to support a slingshot, as with *VD Lives/ TV Must Die* (1978). But all I did was become an interior decorator for the gallery; I was camouflaging the gallery's function as a store. That was the real frame for art: the gallery as a store.

No, there can't be art without framing. Art is a simulated category that exists only for the purpose of selling, and self-satisfaction, and self-importance – because art is a belief system that huddles together, as if in a Masque of Red Death, artists and dealers and art writers and collectors. Because art is desperate it needs to separate itself from all other things that are non-art. It can't survive without a frame, or a pedestal, or a vitrine, or a wall, or a floor, or a room, or a label, or a plaque. Architecture is different; architecture survives by breaking the frame – or, more precisely, by melting the frame. Architecture persists when clothing elapses into furniture, and furniture elapses into house, and house elapses into city, and city elapses into landscape …

Mark C. Taylor *Many critics note an important shift from your early performance and conceptual work to your recent architectural project. What is the relationship between these two parts of your oeuvre?*

Vito Acconci Already with *Seedbed* (1972) I was part of the floor; a viewer who entered that room stepped into my power field – they came into my house. But it had happened before that: in the first works like *Following Piece* (1969), I was walking through the city, I was feeling out the terrain, I was using the street as if it were my everyday life-space. Then, as soon as I rubbed my arm (*Rubbing Piece*, 1969), as soon as I bit myself (*Trademarks*, 1970), I turned my body into a place, I made a home for myself. That might have been the beginning of architecture but, in order to prove it, I had to let someone else in. The thing is, all this might be true because the work took the direction it did; if it had gone in a different direction, then that early work, that same early work, wouldn't have been architecture.

Mark C. Taylor *In your early work, you were preoccupied with the complex processes through which subjects are constructed and deconstructed. Your work at this time was influenced by and in conversation with the contemporary debates surrounding structural linguistics. Your transition from poetry to performance art might be understood as an effort to put into practice theories developed by structural anthropologists and psychoanalysts. Are your early performance pieces an alternative version of concrete poetry?*

Vito Acconci I thought my first pieces were doing the opposite: I tied myself into a system that already existed in the world; I became the passive receiver of other

activity. The pieces took me off my writer's desk and out onto the street. But the poems were already performances: the page was a field over which I as writer, and then you as reader, travelled. So the first pieces, conversely, made me travel through a city the way I had travelled across a page. And then the motion changed: instead of attending to a world considered as if it was out there, I came back home. I separated myself into subject and object, 'I' concentrated on 'me.' I treated my body like the page I had been writing on; I inscribed my body – with bite marks, with lipstick (*Applications*, 1970), with wall paint (*Run-Off*, 1970) – the way I had tried to inscribe the page with material objects, the way I had tried to turn words into material objects that could be inscribed on the page.

Mark C. Taylor *What role does transgression play in your art?*

Vito Acconci It's not for me to say. Only another person can apply a term like that to my stuff. I might hope for something, I might will something, I might try out something, and I might keep trying, like a little engine. But only an outsider can verify it.

Mark C. Taylor *From the earliest expressions of aestheticism, art has been associated with an atemporality that seeks to express or embody a certain ideal or perfection. For you, it is important for art to be imperfect. Why?*

Vito Acconci Because I never wanted art, and now I don't want architecture, to present itself as universal. Because 'universal' is a mask; it means only that it's supported by the dominant culture of a time. I want an architecture that's changeable, that can be added to and taken away from. Maybe it means something at this particular time – it will have to change when the time changes.

Mark C. Taylor *In your architectural work, you are fascinated by marginal, residual and interstitial spaces. What makes these sites so powerful?*

Vito Acconci It's not a choice. Because I'm not officially an architect, most of the projects Acconci Studio is asked to do are not 'real architecture' but 'public art': projects around or between buildings that are already designed. We're invited because of 1 per cent laws – 1 per cent of the cost of a public building has to be spent on art; in other words, we're asked to do something that's worth 1 per cent of the architecture. But I'd like to believe that, if we could choose, we'd choose some of those spaces anyway. If you're designing something in the interstices, in the cracks, then you can build a space that bulges out of those cracks, you can build a blob that spills out over and through the official buildings.

Mark C. Taylor *Several of your recent projects involve garbage:* A City that Rides the Garbage Dump *(1999) and* Garbage City (Project for Hiriya Garbage Dump, Tel Aviv) *(1999). What is the artistic importance of garbage or, more generally, waste? Might there be an inextricable relationship between modernism and waste? Is modern art parasitic upon garbage?*

Vito Acconci It's these outlands, these throwaways, these wastelands, that provide the last opportunity for model cities, theoretical cities, future cities. In the city proper, you can't have a master plan anymore, and that's all for the good: a master plan prevents a city from growing on its own, from the bottom up. Or maybe you can still have a master plan, but it wouldn't be allowed to take over an entire region, it could appear only here and there, like growths, like sprouts – or it might wind through existent places, like tentacles. It's only in the outlands, then – only on a garbage dump, say – that you have the luxury to invent a city, test out a city, and rehearse a city.

Mark C. Taylor *It is well known that you listen to music when you work. The writer Edmond Jabes once told me that he went into the desert to 'listen to silence speak'. Would your work change if you listened to silence?*

Vito Acconci In *On the Waterfront* (1954), when Eva Marie Saint says she goes to school in Tarrytown, and Tarrytown is in the country, Marlon Brando responds: 'I don't like the country, the crickets make me nervous.' I need to be in a city – even if I don't use that city, I know other people are using it – in order to design city spaces. If I listened to silence – I would have to be alone, I guess – the places I designed would be all white. I would be making a 2001-world, where the past is eradicated and the future begins from a blank slate, the future is abstract – I couldn't be making a *Blade Runner*-world, where the future is built on top of the past, where the future is a parasite. I'm afraid that, if I listened to silence, I would probably become a writer again; I could write places, but I couldn't design them.

Mark C. Taylor *Looking back over your work during the past forty years, are you more impressed by the continuities or discontinuities?*

Vito Acconci What I have to reconcile myself with is that the career itself – the logic of one phase leading to another, the reconsiderations that force a change from phase to phase, the exhaustions of a method, the back-tracks, the summings-up, the jumps, the false starts – the career itself is more 'impressive' than individual pieces, individual projects. So I've provided only an example, a model, a warning, not an experience.

Mark C. Taylor *What do you most fear?*

Vito Acconci Number 1: dying. Number 2: dying slowly, without being able to work.

Mark C. Taylor *If you had to write your own epitaph, what would it say?*

Vito Acconci There's a legal term for a problem in public space: something that might draw people to an area – say, across train tracks – where they might be caused harm. It's called a 'public nuisance'. I wouldn't mind being called that, for my life's work. But there won't be any epitaph.

Doug Aitken *Amanda Sharp*

in conversation
July 2000, Los Angeles

Amanda Sharp *In your work there are many ambiguities: you're simultaneously attracted to and repulsed by certain subjects. Your perspective on reality and time shifts between opposing positions. The trilogy of works* monsoon *(1995),* diamond sea *(1997) and* eraser *(1998) deals with erosion and time moving slowly, whereas your later works* electric earth *(1999) and* i am in you *(2000) are almost advocating a desire to engage with the incredible speed of the information era, where you need to keep moving fast.*

Doug Aitken I'm interested in organic approaches towards making work, structures which move outward in different trajectories and yet share a connection. If I create a work which is intensely human, then maybe the next work I want to make is as far away from that as possible. It is a constantly evolving process of point and counterpoint. Each work must have its own persona, no matter how quiet or extreme. You mention *monsoon, diamond sea* and *eraser* as a trilogy, but for me each work is very different despite the connections. *eraser*, in which I walked in a straight line across the island of Montserrat, deals with a transformation towards neutrality; in *monsoon*, where I wait for the monsoon to arrive in the Guyana jungle, a negative space and silence create narrative; and in *diamond sea* I just stayed in the diamond mines of the Namib desert for as long as I was allowed, in an attempt to create narrative out of topographical parameters. But there are connections: all three works have at their core the idea of inaction.

Amanda Sharp *They also share a construction of narrative through documentary. They may have different premises, but* monsoon, diamond sea *and* eraser *all follow a similar, documentary-like model.*

Doug Aitken It's funny you say that because I see the notion of documentary as a starting point in reality. For me, these works have been transformed into fiction. They're all very much fiction.

Amanda Sharp *When I was looking at* diamond sea, eraser *and* monsoon, *thinking about your choice of subject matter, I realized that one possible reading concerned information. For example, no one had been back to the site of the Jonestown massacre in Guyana for six or seven years; it was like a black hole. By going there in* monsoon *you gathered information that was suddenly introduced into 'the loop'; it gave people access to that site again. In the same way, I knew that there had been a volcanic eruption in Montserrat, where* eraser *is set, in 1996–97, but I'd never seen or heard of it again. And with the Namib desert, your location for* diamond sea, *no outsider had entered this barren zone in eighty years. I remember you even said it was literally a black spot on the map. But by going in and recording it, suddenly these places return as part of an information database open to everyone.*

Doug Aitken I think that with these three works, which are all quite location-based, the idea of a history – an event or a situation – has drawn me in, but simply as a departure point, an open door. The process begins when you step through the door; what happens thereafter can often create its own pulse. That is

why I see these works as fiction. Each work reaches a point where it functions within its own hermetic, conceptual structure, but after that point the structure is no longer grounded in reality and the work follows its own course. The works are experiments; they are only devices to aid in the transportation of concepts.

With *diamond sea*, *eraser* and *monsoon* it was important to begin with a very specific structure and then let the work evolve in a more experiential, less predetermined way during the working process. I am constantly piecing things together, finding fragments of information, splicing them, collaging them, montaging them to create a network of perceptions. For many months *eraser*, for example, had a very linear structure; it was just superimposing a straight line on the map. But I think the contrast between superimposing an abstract idea on a landscape like that versus actually being there – having the volcanic dust in your lungs, hearing noises out of the corner of your ear coming from an abandoned silo – is really where perception and the process of creating in 'reel time' merge.

Amanda Sharp *In all three of these works you didn't know what you would find at the outset. You don't approach narrative like a conventional cinema director or a novelist, plotting the course of events beforehand. Your films physically embody the narrative as it unfolds in space.*

Doug Aitken In this era of changing perceptions we're responsible for creating new options with which to communicate. Structurally, I'm searching for alternatives. Each work I make is an experiment. I'm not interested in creating projects that illustrate and define; I would rather make departure points, stimuli for questions, provocation. I'm fascinated by the liquidity of time-based media such as sound, motion picture and photography. At times they appear as possibly the most democratic of languages, while at other moments they can slip through your fingers and seem ruled by other forces. I like things that I cannot hold onto.

Amanda Sharp *Director Werner Herzog once explained that his book* On Walking in Ice *(1979) came about when he found out that a friend of his was dying in Paris. Herzog decided that if he walked from wherever he was – I assume Munich – to Paris, his friend lived: he felt he could keep his friend alive by walking. A work like this is about how individuals can attempt to alter – slow down or speed up – time, how they're somehow part of a much bigger system.*

Doug Aitken We all encode our experiences of time at different rates. A single moment from several months ago may consume our thoughts, yet a whole summer five years ago may have completely vanished from our memory. We stretch and condense time until it suits our needs. You could say that time does not move in a linear trajectory, and moreover we're not all following time using the same system.

When I was twenty-one I worked in an editing room for the first time. We were working long hours, day and night, but for me it was a new sensation,

fresh and exciting. When finally I would go home to sleep, my dreams were extremely vivid. As I was moving through a dream, I would look down in the lower right-hand corner of my dream and see numbers: a time code, like the date-time-minute-frame numbers used in editing raw footage. I was surprised that I had never noticed this time code in my dreams before! I also recognized that I no longer needed to watch and witness my dreams passively; I could stop my dream like a freeze frame and look around as if watching a giant frozen photograph. I could pull back and the dream would rewind so that I could re-assemble it in new ways. That night I re-edited my dreams over and over again.

I suppose my working process is very nomadic. I'm not interested in working out of a sterile, traditional, white-cube studio. I'd like to find a methodology that is constantly site specific, constantly in flux. Some works which are very fictional demand to be built and constructed as if part of a new reality, while others require an intense investigation into a specific landscape. I would like the permanence of my process to be as temporary as possible. I like to think of an absence of materialism where at the end of the day, all one needs is a table, a chair, a sheet of paper … possibly less. That would be nice: to be without routine and unnecessary possessions.

Uprooting and removal surrounds us, and at times these can be mirrored in our working process. At times I just let go and am assimilated into my landscapes, other times I feel an active resistance. I think there's something about growing up in America that makes you feel nothing is ever really stationary. Home can be motion at times.

Amanda Sharp *How prescriptive do you ever want to be about how the viewer approaches your work? In* electric earth *you construct a structure of scrims which leads the viewer through the narrative. With* i am in you, *you make a circle of screens around a central screen, where the interplay between them is rigorously resolved. Between internal and external spaces there are points where all the screens come together and points where they diverge; yet if the viewers don't sit on the benches you have placed in the installation, they may not realize the screens are in a circle. With* these restless minds *(1998), which involved recording the monologues of professional auctioneers, you created a simulacrum of an auction environment through the use of the video monitors. Although viewers can elect how to negotiate the installation spaces of these works, they're given guidelines as to how to approach them.*

Doug Aitken The experience of an installation might be different if the viewer moves four or five feet away from where he or she was originally standing. Weighing and unweighing, tension and release all become aspects of the work.

In my installations I don't see the narrative ending with the image on the screen. Narrative can exist on a physical level – as much through the flow of electricity as through an image. Every inch of the work or of the architecture is a component of the narrative. There are very quiet decisions with specific intentions in my work. I don't wish to control an experience, nor do I want to

make something that's merely experiential. I'd rather attempt to set up a system that brings a set of questions to the viewer. I'd like my work to provide nutrients.

Amanda Sharp *Sometimes you work with found footage and at other times you generate your own images.* into the sun *(1999) is unusual from this point of view; it falls into a grey area. You shot thousands of your own photographs of Bollywood, chronicling all aspects of the Indian filmmaking industry, and then used them to make a moving film.*

Doug Aitken In that situation the content revolved around the creation of images, not around any representation of reality. *into the sun* is a landscape of thousands and thousands of images of Bollywood: sets, actors, lighting, film, the processing factories, the unlimited labour force. I was interested in taking what appeared to be a documentary approach while letting the work slowly implode. I was interested in this image machine itself, not the final product. The process of working on *into the sun* led me into a kind of lucid dream of the audience's collective unconscious, one that was tapped, transferred straight onto celluloid, and then reflected back at the audience. There was a perfect connection between the viewers' desires and how they were mirrored with incredible accuracy in these collective dreams on film. I realized before I'd left India that the work had to exist somewhere between the moving and the still image. The work consists entirely of photographs shot in sequence; at times they speed up to twenty-four frames per second. These photographs temporarily come to life, flicker and fall apart again. I did not want the work to flow seamlessly; it had to speed up and slow down, break apart and re-form at its own rate. I wanted *into the sun* to be a flawed illusion, one that eventually collapses in on itself.

Amanda Sharp *Tell me about your use of found footage.*

Doug Aitken What is found footage? We are losing and finding footage all the time. The information which surrounds us is like a mine; it is our responsibility actively to dig it out and use it for our own needs.

The first work I created using appropriated footage was *dawn* (1993). *dawn* was completely constructed from four moralistic films made for teenagers in the 1970s and early 1980s. When I made *dawn* I was interested in the relationship between media image and personal experience. I felt that before I moved forward to make any new work, I had to reclaim the media I had absorbed when I was young. I wanted to reshape it in a new way, take the experience of passively watching television and reshape the narrative. I decided to edit these four very banal, predictable films, splice them together and create one film with a narrative that could move in a new direction, away from any of the films' original intentions. I wanted to gain control of the destiny of the characters and assist them into situations and places they could never have gone in the original films. Through the process of re-editing, *dawn* became an exercise in transforming the dormant energy of the media image.

Amanda Sharp *Surprisingly few artists are dealing with the way the media and technology have become the landscape of our lives, how speed and information are changing everything. When you look at the main character Jiggy moving in electric earth, he could be typing; his movements are almost binary – an either/or option in direction which snaps into place like a synapse. He could be a character out of a William Gibson novel.*

Through travel we often visit areas where we don't plan to stay. They're outside of our usual experience; we're travelling to another experience. We're migrant workers nowadays, people living the facsimile of a jet-set lifestyle without necessarily earning jet-set incomes.

Doug Aitken Yes, maybe; at times our feet become wheels, our arms jet wings. The culture is mobile, but then again there are many, many people who aren't moving much at all. Information moves to them. This is one of the strange situations that I have observed: motion becomes relative after a while. What is moving, us or our surroundings?

I once met George Clinton. He's a funk musician from a band called Funkadelic, a nice guy who mostly speaks in this space-age-like language he has created. He was playing in Las Vegas at a venue on the strip. Clinton arrived in a limousine and I asked him if he was staying at one of those shimmering crystal hotels. He said no, he preferred a cheap Day's Inn in the dilapidated part of the city. For the past twenty years on the road, George Clinton only stays at Day's Inn motels, because throughout America every Day's Inn room is exactly the same: the carpet colour, wallpaper pattern, even the angle of the bed and coffee table. Clinton was searching for a sense of familiarity when he awoke each morning, disoriented from months of touring; he needed to know exactly what the room he was in was like.

In Asian culture you could say that traditionally, through custom and ritual, one slows down deliberately, just for the sake of slowing down. But in Western culture, we speed up to slow down. We seem to be living in an environment that erases its past with a flood of information in the present. Are we attempting to reach a state of nirvana through the over-saturation of information? Is there a point of neutrality, where perception becomes lucid and slow, when one has reached full capacity?

Our blueprints for perception are in constant flux and, as in the design of any construction, there are tests. The test for these blueprints seems inconclusive.

Amanda Sharp *So I suppose my earlier comment, that by accessing the volcanic landscape of Montserrat or the diamond mines of the Namib desert you are returning that data to our collective data bank, isn't true?*

Doug Aitken I don't feel these works necessarily take places as if they were documents, unearthing them and bringing them to the table for examination. If I'm presenting data, it is without resolution … to question and not to conclude.

Amanda Sharp Can I ask you about your work where you swam the Panama Canal asleep?

Doug Aitken In *the longest sleep: pacific ocean – atlantic ocean, swimming the panama canal asleep* (1999) I swam across the canal incrementally. I wanted to experiment with an in-between space. I suppose there's a quiet, unconscious level to that work but also this absurd desire for connection. I often find myself attracted to situations which initially I feel are impossible or improbable; I am drawn to processes that promise no security. At times this puts me in a position where the work must be willed into existence.

Amanda Sharp You have taken a lot of photographs.

Doug Aitken I have a restlessness with the way a photograph captures time. It's fascinating to me, yet I feel I want something more from the formalism of the medium itself. The static quality of the 'frozen' image or 'decisive moment' is not enough. I want non-decisive moments, inactions, what has happened before or what is to come. I would like to smash a photograph, open it and see what's inside. Maybe then this so-called 'frozen' time could expand and contract. In that sense images are like liquids.

Photographs, sound works, installations, film, happenings are all just vessels to be filled. I use a medium only when it's absolutely necessary.

Amanda Sharp How do you approach your soundscapes?

Doug Aitken The area for a conceptual use of sound is so vast. In every project I attempt to approach sound in a different way, creating audio structures that are unique to the concept. I often see the sound in these works as language. Some situations have been attempts to work hermetically with the subject matter; in *eraser*, for example, I wanted to document every sound on-site in Montserrat and create an immense library of field recordings. These sounds were then transformed – stretched out, looped, re-assembled – to create patterns and tempos. The locations and intrinsic sounds became a kind of audio DNA structure.

With *i am in you* the approach to sound was radically different. It was completely reductive. In any given moment, a cacophony of sounds surrounded the viewer. I wanted to slice away the layers of audio to create an organic minimalism: the incredible macro-sound of a beam of wood twisting and knotting to a point of snapping, or the sound of an electrical surge crackling and transforming into the rhythmic sound of clapping hands. In *i am in you* the sounds were like signals or beacons of light.

Amanda Sharp Sound seems to play a key role in the installations; for example in diamond sea there's an enormous score. In a way that's closer in spirit to the working methods of an avant-garde or experimental filmmaker than most gallery-based artists.

Doug Aitken I like to create sound as raw concept. I'm always finding particles of information through listening, whether it's the sound of the wind as it whistles through a crack in my car window, or the white noise of subway chatter. Just close your eyes in a bus station and listen, just listen. Just listen

... someone says, 'What did you do yesterday?' Narratives are being written all around us. They're in the air. I feed off these experiences.

Amanda Sharp *Can you tell me about* blow debris *(2000)?*

Doug Aitken In *blow debris* I was interested in exploring cycles of change as if any given moment could open up onto a multitude of levels. The beginning of the work is open and atmospheric; flares of sunlight shooting into the camera. We are in open, expansive desert-like terrain. Groups of people, naked and unfamiliar with the uses of the broken relics of modern civilization strewn about them, almost merge into their environment. Individuals slowly leave the group and travel alone.

The work follows different progressions and narratives exploring the constant degeneration and regeneration all around us. Individuals find themselves in the isolation of these experiences. As they move through their surroundings, they are caught in a cycle of constant transformation.

Throughout the piece a constant sense of turmoil manifests itself, sometimes quietly and subtly, at other times in a more direct and immediate way. We follow each individual in an entirely separate narrative. Although there is a sense of a connection, it only really emerges in the final scenes, where the progressions tighten and become increasingly ordered. We see an aerial view of suburban housing projects stretching far into the horizon in grid-like symmetry. The individuals we have followed are inside these homes. We sense psychological space narrowing to a finite point. The intense atmosphere earlier in the work is condensed to images of a man flinching his eye, or fingers caressing a kitchen table. We are pulled into a vortex of shifting information, but as this happens in a quiet, almost silent way we begin to notice cracks and inconsistencies. The side of a chair is starting to flake off and turn to dust, filtering through the air into the skin; layers of skin become dust, leaving a DNA trail across a room. In the final scenes, real time seems to accelerate into a process of erosion. The chair disintegrates. The light in a room moves in beams and starts to glow; the room is now a bank of light. The process of deterioration speeds up dramatically. The protagonists begin to dissolve in a cyclone of sand and swirling dust. Everything we see manifests change. All information is caught in a state of flux, graceful and weightless but at the same time violent. It reaches a point where all the components are moving faster and faster, but they begin to fall out of sync. Change occurs on different levels, moving at different rates through time. An object, maybe a lamp or a chair, explodes; meanwhile another object right next to it spins slowly. Relationships with time start to break apart and create faulty connections. Psychological space becomes a flat line.

There is chaos until finally nothing is visible. Everything is white noise. Gradually objects begin to slow down and reverse themselves. Everything slowly returns to its original shape. As the debris falls back as it was, we realize no human presence is left.

In this piece I didn't want to work with traditional actors and actresses. I wanted a direct connection with the individuals with whom I was working. It was a long process to find people who could mould their persona to fit into the trajectory of the work. I needed a kind of community of people for several scenes, and I found a squatter community called Slab City in the Mojave Desert (California). They live in the remote, warm foothills of the Chocolate Mountains, a location falling between government jurisdictions, a kind of legal black spot without taxes or police. You can find between a hundred and two thousand people in Slab City, depending on the season. Some are completely homeless, others live in campers.

For the particular language that I wanted to create in *blow debris* I needed to work at length with some of these individuals. It was a situation in which things could be misread: I was seen suspiciously, as an outsider, someone with film equipment, someone not to be trusted. At times there can be violent resistance, but I had to create a bridge. It took a while before I had their trust; both sides had to offer a level of vulnerability.

Traditionally, film has a degree of distance or safety from its content. I think about this separation sometimes; I am much more interested in either a zero or an infinite distance between the content of my work and myself.

Amanda Sharp *Could you ever imagine working within the stricter parameters of conventional film, like the 90-minute boundary, for a different audience?*

Doug Aitken Cinematic conventions, like 90- or 120-minute films, have become the legacy of the twentieth century. There's always going to be room to work within those parameters, but for now I'm more interested in new and different systems to be created.

Amanda Sharp *In your work, at what point do you start thinking about the way that a film will be installed?*

Doug Aitken With a work such as *i am in you*, I wanted to create and develop these two sides, the film and the installation, simultaneously. While I was writing and executing the concept – that is, while I was filming – I wanted to experiment with architectural aesthetics: the different screens, translucencies and materials. For a while when I was making *i am in you* the processes were co-existing almost one-to-one.

With *eraser* I knew the walk across the island required a strong progression in its installation. I knew it had to be a deconstructed architectural situation where the experience of the work mirrored the walkabout. In *these restless minds* the auctioneers needed to 'step off the floor', the monitors placed above ground level, onto a platform or podium that's almost like the kind you'd find them on at an auction.

I once happened to meet and chat with an auctioneer in a parking lot in Ohio, and that's how *these restless minds* came about. We were talking about reaching a point where the voice becomes unintelligible. Where is that

threshold where voice and language and ideas become just a frequency? How fast can perception move? How fast can you input and output information? This auctioneer I was talking to, Eli Dotweiler, said there's something called a 'chant' that we all have, although we are generally not aware of it. The chant occurs when you talk so rapidly, as an auctioneer does, that language begins to break down and there is only white noise, chaos. When your language continues to accelerate and you listen to this high-speed, post-linguistic sound you begin to hear a certain tempo and rhythm. This is called the 'chant', a rhythm that emerges after language has deteriorated. Every human being has a slightly different rhythm to their chant. We're not all aware of it, but in each of us the chant is as distinct and unique as a fingerprint or DNA imprint. When the chant occurs, it's like unlocking a new door: you discover an internal rhythm and realize that there is a certain unique cycle that we each follow. In *these restless minds* I became very interested in this idea of the chant and also finding where perception goes after it has passed the limits of language, ideas and communication.

Amanda Sharp *It was strange to hear some of those chants, with rogue elements like the description of sunlight entering into the monologue.*

Doug Aitken I wanted to create a connection between the speakers and their surroundings. I'd asked them to step back from their routine and do two unfamiliar things. First, to do numerics, cycles of the numbers 1,000 and zero as fast as humanly possible, or counting from zero to ten over and over, for ever and ever. The numbers were interspersed with their raw perceptions describing their immediate environment. They were situated in very ordinary places which were part of their everyday lives, very banal settings, vast parking lots, revolving escalators or rows of unused pay telephones just before the sunset. I wanted perception to pull information in, like a vortex.

Amanda Sharp *It was interesting when you brought the three sisters, all professional auctioneers, together in that work, because they looked the same but sounded very different, and they played it out as though they were having a normal conversation together, yet they sounded automated.*

Doug Aitken The three sisters were like birds: I didn't take them out into the parking lot where we recorded; they just happened to land there. I happened to meet them while we were shooting, and brought them into the project. When I saw them on film, I realized that I hadn't really met them at all. It was as if they'd just surfaced, for thirty minutes at dusk one day in Ohio, in the parking lot of a Wal-Mart, and started to talk. I hate those terms like 'post-human' which seem so cold and cynical, but I think there's something about those three sisters which is maybe pre- or hyper-human. There's something that I just really loved about them, they were so human, they became almost alien. I had to step back from the camera at one point and watch them. I gradually closed my eyes, let the camera roll, and just listened …

Uta Barth *Matthew Higgs*

in conversation
February 2002, Los Angeles

Matthew Higgs *A biographical entry in your* In Between Places *catalogue[1] states that while you live and work in California, you remain a German citizen. Why?*

Uta Barth The phrasing in the catalogue is probably a good place to start, as I was rather insistent on it. In American museum publications you're often required to state your nationality, and even though I've lived in the United States since I was twelve years old, I do remain a German citizen, and do so intentionally.

I grew up in Berlin. My father's a chemist who came to the United States in 1968 to do a research project at Stanford University. Shortly after he moved my mother and me to the United States. I have never lived in Germany again.

Matthew Higgs *Was that upheaval difficult?*

Uta Barth Well, early adolescence is probably the most difficult age to relocate to a completely different culture.

Matthew Higgs *Did you speak English at the time?*

Uta Barth Not really, but at twelve you're incredibly adept at learning new languages. Within about six months I spoke English fluently, but it probably took me a year to feel comfortable. I moved to the States during junior high school, a period when kids can be pretty inhumane. It's an incredibly unpleasant age no matter what, and being from a different country only added to the sense of not fitting in. It was rather overwhelming and alienating.

Matthew Higgs *Before you moved to California, were you living in West or East Berlin?*

Uta Barth West Berlin. The wall was still up; I haven't been back to Berlin since it came down.

Matthew Higgs *The transition from cold-war West Berlin to 1970s California must have been a culture shock.*

Uta Barth It was very extreme. I was very incapable of identifying with California, or even American culture at large. Yet at the same time my memories of Berlin were pretty dark and austere: post-war Berlin was rather oppressive and dreary. I was very homesick for Europe (and still am) but even at that age, even in the midst of relocating, I knew I never wanted to return to Germany. I'm not sure I particularly liked California either – or at least I did not like the clichéd, carefree California lifestyle of sunny beaches and car culture. All that seemed completely alien to me, and it still does.

Matthew Higgs *Do the Barth family snapshots from that newly American period look radically different from those of your German childhood?*

Uta Barth My family doesn't keep many snapshots, but yes, they are drastically different. Of course this is conveniently exaggerated by the fact that they changed from being in black and white in Germany to colour, once we moved to California. That shift certainly underlines a move from the austere to a … 'California snapshot aesthetic'?

'Austere' is the word that I think I would associate with my memories of Berlin. I've lived in the United States for so long – longer than I ever did in Germany – but I'm acutely aware, when I'm around Americans and particularly those who grew up in California, that I have an entirely different set of cultural references and a different way of seeing the world. This deep difference never ceases to be profoundly apparent to me, even with friends whom I've known for twenty years or more. Growing up in Europe has made me different from my friends here. At the same time, when I go back to Germany, I feel like a tourist.

Matthew Higgs *Your 2000 exhibition was called 'In Between Places' (Henry Art Gallery, Seattle, and tour). Without wishing to play amateur psychologist, it would seem that the sense of displacement or estrangement you experienced as a child, and continue to negotiate as an adult, is a useful position to sustain, especially in relation to the kind of images you produce, which often seem to describe 'non-places' or places situated at the margins or periphery.*

Uta Barth Firstly I should say that I didn't come up with the title for that exhibition and catalogue. My friend Michael Worthington, who designed the book, did.

Matthew Higgs *But you agreed to it.*

Uta Barth Yes, I agreed to it, and I like it very much. However, I've never thought of my work in that way. It's never occurred to me, and it's amusing to think about it in that way. What interested me in the title 'In Between Places' is that it evokes a certain kind of detachment that runs through my thinking and through my work. I am interested in the margins, in everything that is peripheral rather than central. But I've never ascribed it to my childhood or sense of dislocation between cultures.

I guess displacement, estrangement and detachment are all related.

Matthew Higgs *Were your parents culturally inclined?*

Uta Barth I believe my father was interested in history, in cultural and intellectual history, and obviously, as a chemist, in science. He was interested in cultural artifacts, but he was not interested in art. In fact any discipline that values subjectivity in general and visual art in particular is the antithesis of the standards by which I was raised. I know I got my interest in philosophy and my investment in objectivity from my upbringing. Where the idea of art-making as a practice came from eludes me.

Matthew Higgs *Perhaps we could talk about a specific work from your* Ground *series,* Ground #42 *(1994), which includes two images of paintings by Vermeer.*

Uta Barth Obviously they are reproductions. The Vermeer reproductions were the only examples of visual art in the apartment where I grew up in Berlin; I believe they were a wedding present from my father to my mother. When I was four or five years old those images ended up in my bedroom. I spent years and years of my life staring at them, and when my parents eventually separated, I kept them.

I think they've been in every house where I've ever lived, in part as a family heirloom, but mostly because they never cease to fascinate me. As an adult, as an artist, I never thought much about Vermeer as an influence. When I started making the *Ground* series, I found myself looking at one of those *Ground* images, and it seemed perversely reminiscent – formally, compositionally – of something I had seen before but just couldn't place. One day I realized that the composition and the quality of light playing in the room was almost identical to one of the Vermeer reproductions.

The overlap or coincidence made a certain sense to me. What I like about Vermeer's work was the investment in the everyday, in the non-event, its departure from the religious allegory of High Renaissance painting. Also, I have always been interested in the quality of light, and how light really is the primary subject of the work. Light and a certain quietness, slowness, stillness. You can hear a pin drop in those paintings.

The *Ground* series literally have no 'event' or subject other than the light that falls on to an environment, so that's sort of where I saw an interesting connection. *Ground #42* actually includes the Vermeer paintings. It seemed an interesting crossing, or reference, but I never thought of Vermeer as a deliberate point of departure.

Matthew Higgs *Would it be too much to suggest that these images of Vermeer's – with all their autobiographical connotations – that travelled with you from Northern Europe to California, could be understood as a* memento mori *for your childhood in Europe, for your family, for the union of your parents?*

Uta Barth Ummm ... yes! [*laughs*]. I have a tendency not to want to link things up neatly with this type of psychological interpretation or 20/20 hindsight. I have deep doubts about readings of this sort, about narrative inevitably.

But perhaps ... perhaps they are true? I think there's also another, somewhat related aspect to those paintings that I'm attached to, that we can talk about as a 'cultural sensibility', or simply as an art idea. This has to do with attention to the insignificant. They pay attention to the everyday, to the mundane. Time, in the work, is slow. Duration is at play. One does not think of the stereotypical California lifestyle as one that embraces ideas about slowness, or attention to anything other than the spectacle or the event. I can connect with the quietness and attachment to the everyday of Vermeer and see an echo of it in my own work ... one could see that as an echo of Europe?

Matthew Higgs *Could be ... So, tell me about your university studies.*

Uta Barth I went to undergraduate school at the University of California at Davis and then went to graduate school at UCLA.

Matthew Higgs *At Davis, had you already started to think seriously about photography?*

Uta Barth I did photography through most of undergraduate school, but I arrived there in a rather indirect way. I remember being in painting and drawing classes at the

very beginning of my schooling, and always using photographs as source material. I started to take the photographs I needed to work from, and the paintings and drawings quickly became beside the point. There was no need for the translation into painting and I became interested in the photographs themselves. I made a couple of films, some installation work and sculpture, but ultimately I dealt with all different media and the entire required curriculum, working from photographic source material.

At UCLA I studied in the photography department, but I chose that graduate programme because photography wasn't segregated from other media in the way that it was and still is in other art schools. I wanted to be in a programme where those kinds of distinctions seemed insignificant. I do know the history of photography very well, but none of my influences actually come out of that history. I was much more interested in Minimalism, Structuralism and early Conceptual work. I was looking primarily at sculpture and installation work.

If I have to think about the artists whose work is important to me, I end up going back to people like Robert Irwin rather than the most significant photographers. Most photography draws on a drastically different set of ideas, and most photographs are tied up with pointing at things in the world and thereby ascribing significance to them. These works are about the subjects depicted, or about formal ways of depicting a subject. Ideas about perception and seeing as content in and of itself – ideas that let go of subject, subject matter or ways to depict subject matter – are rarely found in photographic practice. So, while I do have great interest in and respect for historical photographic practice, it has never been the point of departure for my own work.

Matthew Higgs *I would imagine being interested in Robert Irwin at that time wasn't highly thought of?*

Uta Barth It was not hip, no [*laughs*].

Matthew Higgs *How prominent was the work of, say, Sherrie Levine or Barbara Kruger?*

Uta Barth That was exactly the sort of work that was around and being discussed when I was at graduate school. I spent a whole lot of time looking at, reading and thinking about that sort of art, and in many ways I am informed by it.

I was very interested in the analysis of how images make meaning in the world, particularly how images make meaning in relation to each other, in context. Ultimately, however, the politics – at least the overt, didactic, surface politics of the 1980s – were not something that I felt any need to rehash in my own work.

Matthew Higgs *How did you situate yourself within the then-dominant process of over-theorizing visual culture?*

Uta Barth Well, ironically, in graduate school I was probably one of the more articulate and informed students, with regard to the theories in vogue at the time. I remember thinking a lot about discussions on the gaze, and ideas about seeing and being

seen, and the power relationships involved in representation. A lot of my early work from graduate school was informed by those discussions.

Matthew Higgs *Were you making your earliest series of multi-panel works,* Untitled *(1988–89), for example, in which a light beam illuminates a subject, at that time?*

Uta Barth Yes. The bodies of work that I started while I was still in graduate school were incredibly self-conscious confrontations with the camera, and were about vision that somehow invades, that is interrogational and confrontational.

The pieces you are referring to, such as *Untitled #1* (1989), dealt with this type of invasive looking and ideas about juxtaposition and malleability of meaning through context. The work later became more and more visceral and more experiential.

With the work from 1988–90 I was primarily interested in the confrontation with the camera, in the physical experience of being looked at, blasted with light, and blinded. I was interested in the physical and psychological discomfort of that. The irony of me being in those images myself is that I am incredibly photo-phobic: ask any of my friends and they will tell you that I am the first to avoid the camera in any social situation. The few snapshots that do exist of me consist of me blocking the camera with my hand. This seems to me either a curiously odd – or a very appropriate? – response for a photographer to have to the camera.

Matthew Higgs *Are* Untitled *(1988–89) important to you now only as a point of departure, or are there still things in those images that resonate to this day?*

Uta Barth *Untitled* (1988–89) was dealing with a lot of things that I'm still interested in, but there was a certain kind of explanatory nature to this work that no longer holds my attention.

Matthew Higgs *How did you feel your work sat within the West Coast sensibility at that time, around the end of the 1980s–early 1990s? If this had become your surrogate home, did you see the work operating within a West Coast trajectory?*

Uta Barth Well, that question sort of assumes the way that we look at West Coast or East Coast identities nowadays. The work that back then was defined as California or West Coast work, from the 1960s, was pretty much ignored when I was a student.

When I was in graduate school, I had very little sense that there was a West Coast aesthetic or sensibility. Los Angeles was not really on the map; everything went through New York, everybody who went to school on the West Coast then went to New York. It was close to impossible for a Los Angeles artist to find gallery representation in town until after they had a gallery in New York. The required validation, to be taken seriously in this town, took place in New York or Europe. In retrospect, we can talk about a group of artists who've all become internationally visible in the last ten or fifteen years, who came out of Los Angeles. We can see how their work differs from what was being made in New York or Europe and how it comes out of a very different set of references, a different type of thinking. Paul Schimmel's 'Helter Skelter: LA Art in the 1990s'

at MOCA[2] attempted to identify and articulate those ideas and to some degree embrace the much disliked notion of regionalism. Of course the exhibition met with a lot of criticism from the local art community, but perhaps, none the less, it was a rather timely idea.

Matthew Higgs *Perhaps you could say something about the relationship between painting and photography in your work. Certainly in an earlier series of works from 1990, where a photographic image was at the centre of an Op art-like stripe motif, there seemed to be a dialogue or tension between the two media.*

Uta Barth The attachment to painting in that period of my work during 1988–94 was really not in terms of 'painting for painting's sake'. I was interested in juxtaposing photographic images, which are always referential to another place and time, with visual information that was just purely optical.

Those pieces such as *Untitled #14* (1990) consist of a field of optical pattern that is so overwhelming that it is virtually impossible for your eyes to focus. And yet you are drawn in to look closer in order to identify the information in the small photographs in the centre of these vibrating fields. The photographs are voyeuristic views, night-time shots, peering into the windows of suburban houses.

Other images that were juxtaposed with optical patterns were scientific magnifications or interrogation and surveillance images. They all pointed to some type of visual scrutiny, to a visual event as the primary content, and they were placed in such a way as to make seeing them almost impossible. So the use of 'painting' was in part just a way to run visual interference.

Matthew Higgs *In this period you also started to make decisions about the 'objectness' of the work. With the multi-panel works from 1989, rather than mounting the images traditionally – like photographs – you started to incorporate stretchers. Were you thinking in terms of trying to go beyond the limitations of the actual physical state of a photographic image?*

Uta Barth Some of those decisions were in part very pragmatic. I was trying to level out the presentation physically: the surface of a painted panel to a photographic image. The decisions were about presenting them in the same way. I was making all of these optical paintings (*1988–94*) which were masked and mechanically done. You can't really talk about them as paintings per se: they're basically painted graphics.

The multi-panel works (*1988–94*) were constructed to make the photographic and the painted images equate and be interchangeable. All of the paintings were made with very matt paint. It seemed that the more matt an image was, the more optically confusing it was. The choice of matt-ness had a lot to do with presenting an image in such a way that the eye had nowhere to rest – no shiny surface on which to stop. The opticality of the image becomes even more exaggerated because you don't see the surface, you don't know where to stop and focus. I spent a lot of time trying to figure out how to produce a photographic surface that was similar to this very matt paint. Photographic papers don't have that quality, so I started using a matt surface laminate. The photographic panels

needed to butt up to the painted ones, so they were flush mounted on the same type of wooden panel used for the paintings. These were really just pragmatic decisions about how to juxtapose two things, how to make all the formal qualities interchangeable, so that there would be a seamless transition from one to the next.

There has been a lot of rather ambitious discussion about why my photographs are mounted on wood in order to embrace some similarity with painting, but I am not sure how truly relevant these are to what I was thinking at the time. I am not very sure about any enterprise of making a photograph that would somehow aspire to the look and conditions of a painting. This implies a curious hierarchy, of painting as 'higher' art than photography, and seems absolutely idiotic to me.

Matthew Higgs *A transitional point appears in the early 1990s, where this idea of juxtaposition becomes less apparent, or less forceful, or just less interesting to you – the beginning of the* Ground *series. Maybe you could say something about how you approached thinking about the* Ground *series – how this binary relationship of photography to painting is initially less obvious, and how the work then begins to embrace other possibilities, which appear right up until the present day.*

Uta Barth People always see the beginning of the *Ground* series as a very drastic shift. Actually the first images for the *Ground* series appeared in the later multi-panel works (yellow *Untitled* series, 1991–94). But yes, there is a big shift in terms of moving away from thinking about juxtaposition and collision between images, and from being interested primarily in context. I lost interest in the potentially explanatory nature of juxtaposition and became interested in the possibilities of the single image.

Matthew Higgs *Your work in the late 1980s was essentially about creating tableaux or situations very much within the framework of the studio, whereas the first series of* Ground *images are exterior places – the outdoors, the beach, the cityscapes, the parks. All of a sudden there's this move away from the dependency on the studio as the frame.*

Uta Barth The images change from being staged or constructed to being made in the world. It seems congruent with a move away from an explanatory mode.

Matthew Higgs *Was the* Ground *series the beginning of this shift away from the photographic work as an object that contained its meaning within itself, towards the idea of experientiality on the part of the viewer? The viewer starts to become much more physically, formally implicated beginning with these works.*

Uta Barth I think all of the multi-panel pieces (1988–94) were trying to elicit a visceral understanding or experience for the viewer through juxtaposition. There is a different type of suspended engagement with the later work. It is not analytical, and somehow embodies an experience of vision in a very different way.

Matthew Higgs *What role does ambiguity play in these works?*

Uta Barth The early work is very exacting, tightly crafted and explanatory. Starting with the *Ground* series, my sense of obligation to explain everything just fell away,

largely because I had enough of a body of work to lay a foundation for understanding, or provide a point of entry.

I value confusion, a certain kind of confusion that resolves visual and spatial ambiguity. Yet there are other kinds of confusions or misreadings that the work is vulnerable to, that I am acutely nervous about. The discussion of these photographs, or anything that lacks focus for that matter, as being 'painterly' or pictorialist, drives me crazy. It assumes that a photograph would secretly – or overtly – aspire to the attributes of painting in order to justify itself as an artwork.

I always try to throw a wrench into those type of interpretations by including hyper-sharp images in a series, or embracing purely photographic phenomena like lens-flare, things like that. But I'm not sure I always get my point across.

Matthew Higgs *In 1994 you made an installation of site-specific photographs at the Los Angeles gallery domestic setting. This work seems to have some bearing on more recent images, either of the interior of your own home or looking out through the windows of your home such as* nowhere near *(1999) and ...* and of time *(2000). How do you see domestic space in relation to public space?*

Uta Barth My choice of returning to the interior environment in about 1999 was not based on an interest in personal space, or the domestic, or the inside versus the outside. But I see it as a very important moment, when I became very clear about my relationship to photography as a medium. Recent projects in which the camera returns to the inside of a house – the inside of *my* house – are *nowhere near* and ... *and of time,* and my most recent series *white blind (bright red)* (2002). There's a very specific set of choices that gets made about location and subject matter, i.e. my own home, in these projects.

Conventionally we think about the camera as a sort of pointing device. It makes a picture of something, for the most part; therefore it is a picture *about* that something. Most of the history of photography is tied up in photographs making meaning in this way. Subject matter, content and meaning are inseparably linked.

The inescapable choice one always has to deal with as a photographer is what to point the camera at, and the meaning that this subject matter might suggest. Well, if you are not interested in this type of meaning, if you are not invested in pointing at things in the world but instead are interested in the act of pointing (or looking) itself, you have a big problem. For many years now I have had this very big problem, in fact have invited this problem and have engaged with it in many ways. For these three most recent projects since 1999 my way of dealing with this problem of choice was to make no choice.

I chose to photograph wherever I happened to be, the environment most familiar to me – and that environment was my home. What interests me the most is that it is so visually familiar that it becomes almost invisible. One moves through one's home without any sense of scrutiny or discovery, almost blindly, navigating it at night, reaching for things without even looking. I am engaged in a different type of looking in this environment. It is truly detached from a focused interest in subject. Instead it provides a sort of ambient visual field.

I have no interest in thinking about those projects in terms of domesticity or the home or anything like that.

Matthew Higgs *That may be, but as a viewer I can't help but think about domesticity when confronted with an image of an interior that's clearly a domestic space. Then I might think about Virginia Woolf's* A Room of One's Own.[3] *I'm sure you're not consciously privileging such things in the work, but there do seem to be signs of internal withdrawal. I can't help thinking about that, especially with images such as* nowhere near, *where you're looking through the window. There's this idea of a longing for what lies beyond.*

Uta Barth People want to read those things into the work, or make those kinds of associations – they make sense to me. And on some level they are accurate or are a subtext of the work. Each series has hundreds of images of the same thing, the same view; so it becomes about time, about duration. And nothing happens, nothing ever changes for days, for months, only the light. It is pretty hard not to interpret this in terms of silence, solitude, contemplation and longing, but that's not what I am thinking.

My friend Michael (who designed the book for the *nowhere near* series) used to tease me relentlessly by saying that the project was terribly 'sad'. He knew this was exactly the kind of sentimental reading I was fighting against, but at the same time perhaps I was protesting too much.

Still, I do not want this type of narrative to take over. I still place much more value on the thing itself than any interpretation of it. I go to great lengths not to be swallowed up by the anecdotal.

Matthew Higgs *Despite your use of seriality and the prolific number of images in any series, it still seems that they resist analysis; they resist that idea of the evidential. One of the things I'm interested in talking to you about regarding the work is boredom; it's in all of the works, especially in the later series, a sense of sort of drifting through the day. The* ... and of time *series, for example, seems to deal not just with the question, 'What do I photograph?' but 'Why?' It's almost existential, about a kind of ennui, and the fact that it's located in the domestic environment seems significant. These later photographs seem to be confronting head-on the idea of an internalized struggle, or trying to reconcile or just embrace boredom.*

Uta Barth That's a really interesting place to go. I wouldn't think about those ideas in terms of boredom – boredom has a certain kind of pejorative quality – but in terms of an interest … in this total investment, emersion, in experiencing the non-event, 'boredom' sounds like something you have to escape. I think that the work invests in ideas about time, stillness, inactivity and non-event, not as something threatening or numbing, but as something actually to be embraced. There is a certain desire to embrace that which is completely incidental, peripheral, atmospheric and totally unhinged.

Matthew Higgs *Have you increasingly allowed yourself a greater degree of licence to embrace the possibility of emotional subjectivity?*

Uta Barth [*laughs*] … Well, I'm not so sure about 'emotional' subjectivity … but, yes. I no longer feel the obligation to answer to an imaginary audience. I have the history of my own work to provide the background information. I mean, I work in the context of my own practice. Previous projects lay the groundwork for how to see my current projects, and that frees up a whole lot of space. I no longer need to address broader ideas; things are getting more and more focused on specific experiences and states of mind.

Matthew Higgs *How did working on the retrospective at the Henry Art Gallery in Seattle in 2001 affect you? Where does it leave you now in terms of moving forward? You've mentioned experiencing a certain kind of 'trauma' with that exhibition.*

Uta Barth [*laughs*] Well, on a pragmatic level, doing a survey show of your own work is incredibly time-consuming and bureaucratic! It's like doing your taxes, you know, sorting your past, your records, your receipts.

 The great part of doing a retrospective is being able physically to see connections between bodies of work that I had not been aware of. Suddenly all these objects, most of which I had not seen in years, were assembled in room after room, and I could find unexpected links – not the obvious ones, but seemingly random choices of imagery that repeat over the years. I saw some quality that is an absolutely irrelevant aspect in one body of work emerge as a main theme in the next, and I had never noticed it before. Suddenly I got to see connections in a very different way than I had remembered them.

 What's difficult is that a retrospective implies some kind of closure. As an artist I'm always working on two or three things at once; they overlap. You come to the end of one project, and there's some kind of quandary as to where to go next, but I am always working on two other things at the same time. Exhibitions want to tie things up in very neat chapters, but this is like closing a book at a random point. I found myself exhausted and at a loose end the morning after.

Matthew Higgs *But even if the sense of closure is artificial, you do work in series. Those series have semi-narrative titles – Ground, Field, nowhere near – and even if the end of one series is the point where another begins, creating ambiguous crossover moments, closure is part of the work. It seems to me that the sense of closure that's ambiguous for you becomes formalized for the audience in terms of how the work is presented. One of the key things that might define theoretical work of the 1980s is suppression of biography: the idea that the biographical, the anecdotal, is somehow incidental to the work, that it's unnecessary – in fact, that it's a hindrance. Inadvertently, what seems to have occurred in your very recent work is that, because those works are located within your domestic environment, the biographical, the anecdotal, becomes a significant factor.*

Uta Barth I think that's true, but I'm still committed to the notion of remaining anonymous. I am uncomfortable with reading the interior in the most recent work as a metaphor. The very notion of looking at work in terms of metaphor runs deeply counter to what I'm interested in. Decoding and metaphors are ways of reading

and interpreting the work, rather than simply looking – detached from narrative, detached from history, detached from identity. I'm interested in detachment and anonymity; I'm interested in eliciting a perceptual experience. Within this process of being interviewed, or doing this book, I keep finding ways of squirming around personal and autobiographical information. I don't think I am doing it out of secrecy, I just don't see how it can be relevant. I am much more interested in pointing towards a perceptual experience, and allowing that experience to be very different for different people. My personal parameters would only interfere.

Matthew Higgs *I was interested in the body of work of 1998 that you've come to call* Untitled *[laughs], which is the first manifestation of that term I'd seen in your work. Was there something inherent in those photographs, for example, because you were photographing in a different way, you were carrying the camera with you everywhere and that made it impossible for them to be given a serial number or title?*

Uta Barth That work was very much about peripheral vision, about visual incidents that one notices when moving through a space while motivated by other interests.

Matthew Higgs *But your titles then changed significantly, like* Field *and* Ground *where there's clearly this allusion to painting – the Greenbergian ideas of painting – to these quasi-poetic titles, such as* nowhere near, *and they're all preceded by three full-stop punctuation marks, which indicate beforeness, or an idea of a continuation or a fragment. It's a gift to an art historian who's been asked to write about your work, because through the titles you've set them the benchmark from which to go forward or backwards.*

Uta Barth I think when I titled the *Ground* series and the *Field* series I wasn't thinking about them so literally, as figure/ground relationship or colour field painting. They were also allusions to phrases like 'field of vision', things like that. They didn't seem quite as solid or literal to me then as I think they do now.

 With the last three or four projects the notion of time becomes really important, and so the titles are fragments of a larger sentence, as if lifted out of the narrative. Just the notion of the titles being fragments seems similar to the images being 'outside the frame'.

 A friend of mine likes to refer to them as 'drifty' titles.

1 *Uta Barth: In Between Places*, cat., Henry Art Gallery, Seattle, 2001
2 'Helter Skelter: LA Art in the 1990s' was shown at the Museum of Contemporary Art, Los Angeles, in 1992. The artists in the exhibition were: Chris Burden, Meg Cranston, Victor Estrada, Llyn Foulkes, Richard Jackson, Mike Kelley, Liz Warner, Paul McCarthy, Manuel Ocampo, Raymond Pettibon, Lari Pittman, Charles Ray, Nancy Rubins, Jim Shaw, Megan Williams and Robert Williams
3 Virginia Woolf, *A Room of One's Own*, Hogarth Press, London, 1929

Christian Boltanski *Tamar Garb*

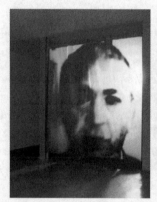 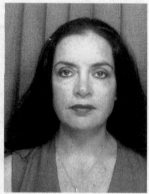

in conversation
October 1996, Paris

Tamar Garb *Your work is about the self, about revealing the self, and about playing tantalizingly with the self. What I would like to know is: who is Christian Boltanski? Where are you in this elaborate ruse, in this series of tricks and artifices which you deploy?*

Christian Boltanski I really think I am nobody. If you work as an artist, you destroy yourself. The more you work, the less you exist; and each time you do an interview a part of yourself disappears. It seems awful, but it can also be a good thing, since it is easier to make art than to live. It's a choice one makes.

Tamar Garb *But there is always an agent involved in the manipulations of self-effacement or display. Is there a puppeteer pulling the strings?*

Christian Boltanski In my early work I pretended to speak about my childhood, yet my real childhood had disappeared. I have lied about it so often that I no longer have a real memory of this time, and my childhood has become, for me, some kind of universal childhood, not a real one. Everything you do is a pretence. My life is about making stories. I travel a lot; I'm like some kind of travelling circus clown.

Tamar Garb *Why then do you choose to tell certain stories rather than others?*

Christian Boltanski At the beginning of all the work there is a kind of trauma: something happened. This might be a psychoanalytic problem. All your life you can be telling the same story, but then you can tell it in different ways – through poetry, through song, etc. For me, then, I feel that there are some very important things that occurred at the beginning and only afterwards could I speak about them. One always first tries to escape a problem rather than talk about it. When I was younger I was very crazy; now I'm very normal. I only do what I do now because I used to be crazy. Art for me is one way of talking about problems and about the past; sometimes, as with psychoanalysis, you are a little better for having done so.

Tamar Garb *Don't you find yourself lapsing into a cliché though, like 'crazy' Van Gogh: the artist who can only act in a state of uncontrolled frenzy?*

Christian Boltanski But it's not totally uncontrolled; you have something in particular to say. Perhaps some artists would say it's better to concentrate on art itself, whereas others would deal with life.

Tamar Garb *Where would you position yourself in relation to this?*

Christian Boltanski Always in between the two. I am an artist of the end of the twentieth century, working with late twentieth-century means; a son of Minimal Art, born at a particular moment in this century. Had I been born ten years earlier, perhaps I might have been an Abstract Expressionist, although I don't like abstract expressionist art very much. This raises the question: why do so many artists make more or less the same kind of art at any one time? There is an individuality, yet there is definitely an aura of the time.

Tamar Garb *You describe yourself as a painter, which is very intriguing. To be a painter, for you, is clearly not about the métier of painting; rather it's about a form of consciousness.*

Christian Boltanski Being a painter means speaking with visual things. But it's also interesting to note the difference between filmmaking and painting. The question of time is the thing here. When you watch a video piece you can stand there for two seconds or two hours – there's no beginning or end and you can move around while you're doing it. When you see a film, on the other hand, you sit there watching it from beginning to end. In films, novels and music there is always this issue of time; when you're looking at a static image, there isn't that progression.

Tamar Garb *There's no catharsis, you don't make that journey in time.*

Christian Boltanski Yes. And I think that one of the reasons we cry when watching a film or a play is because of the suspense. The same goes for music; we might be listening to a work by Bach and suddenly there'll be a moment of suspense. It shocks us; we never know exactly what is going to happen next.

Tamar Garb *Yes, but interestingly, the installation of your work is often very theatrical; it stages itself as an event through which you move in time. I wonder if that's a way for you to create a sense of suspense and drama akin to the effect of cinema while using a still image.*

Christian Boltanski When I create a show I always make the viewer aware that it has a beginning and an end. For a long time there were performances in art where people would just sit and look at something; but in the last five to ten years the spectator has become more of an actor. For example in *The Ordinary Days* (1996), which I did in Dresden with Jean Calman, we created a small dark corridor at the end of which was a very bright, blinding light. The spectator's body was therefore also involved in the 'viewing': looking at something actually became part of the work. I also see this in other artists' work, say in Bruce Nauman's for example: the spectator's body is inside the work. When my work was exhibited at Hamburg, the space was really good and gave the spectator the same feeling. One walked down a long narrow corridor and then arrived in a large room; the space showed the way, it directed the experience of viewing.

Tamar Garb *That almost duplicates a ritual procession, a route by which one travels through the experience.*

Christian Boltanski I am happiest with a show when the whole show is one big piece, when it's not made up of different works. Like the installation *Lessons of Darkness* at the Chapelle de l'hôpital de la Salpêtrière, Paris (1985), and *Advento* at the Iglesia de San Domingos de Bonaval, in Santiago de Compostela, Spain (1995).

Tamar Garb *Yes, I think that's very true, as there is something about the power of seeing a group of works together and their accumulated effect which is indispensable in your work – it completely alters it. Also, because of the lighting and theatricality, your work*

becomes almost religious, and it leads one to think about comparing that kind of space to a space of worship. One engages with the work in a space outside of everyday life, in a contemplative space which is also suggestive of a religious space.

Christian Boltanski I'm not religious, but I do think that the earliest relationship we have with art is when we first go to church. Not because painting is there, but because of the presence of the priest, whose words and actions by some sort of abstraction tell us something very important. You are in the symbolic order and in the realm of the mysterious. The same occurs in painting. In the Middle Ages the town cathedral would keep the relics of its saint – rather like a museum today housing works of art. People would do pilgrimages to the cathedral and the town would earn its wealth from that. The new princes don't build cathedrals anymore; they build museums. Museums have today become the new churches.

Tamar Garb But who is the new God? It's not art, because our culture doesn't really revere art.

Christian Boltanski Yes, but just think of collectors who pay a fortune for a Van Gogh: they want it because it was touched by a holy man – the artist. The artwork comes with so much religious mythology attached to it. People want art for all kinds of 'religious' reasons, thinking that the work will save them, make them better somehow, because the work is precious.

Tamar Garb But do you feel comfortable with that idea of what the artist can be?

Christian Boltanski No. It's true that I am very interested in religion and I also think that my art is very Christian. And if I wanted to be pretentious, I'd say doing the work is rather like being a Zen master, in that my work tells a story and asks questions. At the same time I think that the idea of the relic is completely stupid, especially in art today. In the late twentieth century, more than half of the art produced is not even touched by the artist. If I put my lighter on display at an exhibition, it would be acceptable. It would be on a pedestal and labelled, like a bronze sculpture. But what I have been trying to do for a few years now is to escape this idea of the relic. I remember when the Tate Gallery bought one of my pieces, *Dead Swiss on Shelves with White Cotton*. When I sold it, the curator mentioned that the cotton would go yellow in a few years time, so I told him that he could change it. He also said that the photos would fade, so I told him that's okay, there are always more dead Swiss – I don't care which ones you use. Moreover, even the shelves were not going to fit, as they had been made for a different room! And the curator asked, what did we buy? And I said well, you've bought photos of dead Swiss and shelves with white cotton. But it's not an object, it's an idea.

Tamar Garb But would you expect them in ten years time to show the shadowed remains of that piece, or to renew it with new material?

Christian Boltanski I consider what I do to be like a musical score, and anyone can play it. But each time it's played, it means something different. I remember doing a show

once entitled 'Do It', curated by Hans Ulrich Obrist, which included Mike Kelley, Ilya Kabakov and Bertrand Lavier. Each of us had to describe a piece, then we all had to make these works and exhibit them. We also made a book and sent it to a number of museums and art centres, but the rule was that the artists couldn't actually go to these places themselves. The museums had to interpret our descriptions. Sometimes it would work and sometimes it wouldn't, but we didn't actually control the outcome.

I did a show in New York at Grand Central Station about a year ago in which I showed about 3,000 objects that had been lost on the New York subway. If someone then wanted to do the same piece in Tokyo, it could be done with objects lost on the Tokyo trains. After the show the objects were sold, but the same show could still be done tomorrow. It's the idea that's important. Around half of the work I do is destroyed after each show, but the show can always be done again.

There is this issue of reincarnation. When someone plays a partita, the music is reincarnated, but in painting someone has to sign the piece. Glenn Gould played Bach, but the music was always Bach; with my work, it might be a Boltanski played by Mr Smith. The work is not closed.

I've used a lot of biscuit tins in my work, and at the beginning they were more personal somehow because I peed on them to make them rust. But I was using so many boxes that I couldn't do this any more, so I started using Coca-Cola to rust them. They were easily replaceable and easily rustable. I remember I exhibited them in Hamburg and in Oslo. The piece was sent there, each box wrapped in tissue paper, and when they arrived the curator demanded that all the workers wear white gloves. It was ridiculous because of course the gloves became red in minutes. And the biscuit tins aren't precious.

Tamar Garb *Yes, but because of the way museums commodify their exhibits, these objects become precious within that context. It's like the creation of a relic. It's also about aura, and how the work becomes a magical, totemic object.*

Christian Boltanski It seems to me that Western Christian culture is all about objects. For an African it is not so important to preserve a mask from the sixteenth century. What is important is to have someone now who still has the skill to make a mask. In many other traditions, it's not important to keep the object, but what is of value is knowing the idea or story behind it. In Japan, the Zen temples are so fragile that they have to be rebuilt every ten years. But people there call these buildings monuments precisely because they know their story. So you have cultures of objects and cultures of knowledge.

Tamar Garb *In the West you have this acquisitive mentality, either as wealth or as totem.*

Christian Boltanski Perhaps it's better, though, to know the story.

Tamar Garb *Surely though, at the origins of Christian art, in early medieval times, the object was thought to be the means by which one would tell the story. Now the story seems to have gone and the object has become a thing in itself. When you put your*

objects into glass cabinets to display them, you obviously invoke a number of different registers of the way in which the object is classified and used as evidence in Western culture.

Christian Boltanski At the beginning I was very influenced by the Musée de l'Homme in Paris, which contains huge glass cabinets displaying dead cultures. Nobody really knows what all the different objects on display were actually used for. There are photos showing people of different cultures, but you look at the images knowing that these cultures are all dead. Each cabinet is like a large tomb. I think what I was trying to do in my work was to take strange objects – objects that we know have been used for something although we don't know exactly for what – and show their strangeness. It has to do with individual mythology. The objects I display come from my own mythology; most of these things are now dead and impossible to understand. They might be insignificant things, or just simple or fragile, but people looking at them can imagine that they were once useful for something.

Tamar Garb Often the objects you use invoke lives that have been lived and are now lost, gone. They stand for a death of somebody, maybe a victim.

Christian Boltanski Yes, there is something contradictory in my work, in that it is about relics but at the same time it's very much against relics. Part of my work has been about what I call 'small memory'. Large memory is recorded in books and small memory is all about little things: trivia, jokes. Part of my work then has been about trying to preserve 'small memory', because often when someone dies, that memory disappears. Yet that 'small memory' is what makes people different from one another, unique. These memories are very fragile; I wanted to save them.

Tamar Garb The relationship between objects and cults is interesting too. Like the cult of personality which our society is so obsessed with, and the way in which objects that are residues of a particular person's life become infused with mystery, aura, magic, whatever.

Christian Boltanski For example I often work on pieces that include clothes, and for me there is a direct relationship between a piece of clothing, a photo and a dead body, in that someone once existed but is no longer here. Every time I work on pieces like these there are always people who tell me that they can sympathize somehow with the use of these materials, because when their own mother or grandmother died they never knew what to do with their clothes and things. And especially with shoes, which have a particular link to the person who wore them. What is beautiful about working with used clothes is that these really have come from somebody. Someone has actually chosen them, loved them, but the life in them is now dead. Exhibiting them in a show is like giving the clothes a new life – like resurrecting them. Especially when you think that clothes can belong to such different people: it's like a kind of resurrection.

Tamar Garb *But it need not necessarily invoke loss. In your piece* Reserves: The Purim Holiday, *which of course is related to the Jewish festival of Purim when children wear fancy dress, you invoke the whole fantasy of dressing up. An interest in costume and theatre is suggested here. So the recycled clothes need not only to do with the mournful, melancholic residue of a dead life, but also with the rebirth that fancy dress involves.*

Christian Boltanski I'm glad you've said that, because often people do view my art in a very mournful way, but I feel that there's a lot of humour in it. When I do a large piece with used clothes some people talk about it in relation to the Holocaust and say how sad the piece is. But children find it fun, it makes them happy because they can try on all the clothes. I never speak directly about the Holocaust in my work, but of course my work comes after the Holocaust. You know, at the end of the nineteenth century people believed that science was going to save us. Now we can see that things have got worse: not only the Holocaust but Bosnia, Rwanda, the atom bomb, and then AIDS, pollution, mad cows … So we know that science isn't going to save us, our big hope has been destroyed. The Holocaust taught me that we are no better now than we were in the past. All the hopes of human improvement and progress have been destroyed.

Tamar Garb *People say, however, that you don't have to work directly about the Holocaust, because the Holocaust works through us. The Holocaust shapes the consciousness of most Europeans living in its aftermath. As Lyotard said, 'We are all Jews after the Holocaust.'*

Christian Boltanski Yes, but there have been holocausts after the Holocaust. I'm not working on the issue of being guilty or not guilty. My work is about the fact of dying, but it's not about the Holocaust itself. I made a book four or five years ago called *Sans Souci*. It's a photo album which I bought at a flea market in Berlin. Some of these nice-looking people became Nazis. We see Christmas trees, music, babies: they were just like us. If the monster had been different from us, it would have been easier to deal with. But it was us. I did this book when I was in America, just after the Gulf War. I remember watching television and seeing the pilots returning from the Middle East; they were so young and sweet, kissing their girlfriends and babies, yet only the day before they had been killing women and children! It's a book with no text, but if you 'read' it, it leaves you with a question. Perhaps this is the question about whether one is guilty or not guilty. About being a victim or a criminal – or both. But not necessarily in the context of the Holocaust.

Tamar Garb *So the work involves the Holocaust while not necessarily being about the Holocaust. On the one hand you're not Jewish and on the other hand you are Jewish. And the work is deeply marked by Jewish history, while at the same time it is profoundly Catholic.*

Christian Boltanski I don't think it's about Jewish history. I often get this kind of misunderstanding with my work. Of course it is post-Holocaust art, but that is not the same as

saying that it is Jewish art. I hope my work is general. I'm not a philosopher; I'm an artist. I make paintings.

I know nothing about Jewish culture and religion; I've almost never been to a synagogue. If I had to choose a religion I would choose the Christian religion. I think it would suit me better because it's more universal than Judaism. The Jews never had an Inquisition, for example, in order to convert people to Judaism. What is so beautiful and simultaneously dangerous about Christianity is that Christians want to convert everyone to their faith – so with the beauty of this ideal comes the fact that they've killed so many people. There is nothing more beautiful in Christianity than the fact that Christ was killed for everybody. Also Christ's last words were incredible, they were: 'I'm thirsty; Father, why have you forsaken me?', and 'I'm dying' – which are all so human. It's so amazing that a religion can be built on these words, the words of a man at the moment of such weakness and despair.

Tamar Garb *So when you deploy the lights and the candles and shadows and imagery of death in your work, do you replay that Christian narrative in your mind? To what extent is that narrative being represented?*

Christian Boltanski It's not in the imagery, because the imagery I use could evoke many different religions. I use religion as a vehicle through which to speak, that is true. I think that if my art is Christian it is because I believe that everybody is different – but that is probably equally Jewish. And while everybody looks the same, everybody is unique. Politicians will talk about fatalities in war in large numbers but each person who dies has a mother or a girlfriend and is a unique being. Deaths must be counted in ones. Christianity seems to me to place an emphasis on the individual in a very special way.

Tamar Garb *But at the same time while you suggest individualism in your work, you obliterate it, especially when you use the lights that shine on the faces which become cadavers. You invoke an individual, lived life but at the same time obliterate it by the blinding light. It's different from the mysterious light of the candles; it makes me think of torture.*

Christian Boltanski A good work of art can never be read in one way. My work is full of contradictions. An artwork is open – it is the spectators looking at the work who make the piece, using their own background. A lamp in my work might make you think of a police interrogation, but it's also religious, like a candle. At the same time it alludes to a precious painting, with a single light shining on it. There are many ways of looking at the work. It has to be 'unfocused' somehow so that everyone can recognize something of their own self when viewing it.

Tamar Garb *The candle functioning in that way reminds me on the one hand of the atmosphere of a Catholic church, but it is equally evocative of the menorah and the flickering lights at Hanukkah. It could work in either context.*

Christian Boltanski I always try to use forms that people can recognize. Take the biscuit tins, for example. I use them because they are minimal objects, but also because I know that my generation can recognize them. We have all kept our small treasures in biscuit tins. It also reminds some people of the metal urns where ashes are kept. I suppose I want my art to be more about recognition than discovery.

The big problem in art is being able to tell the story of your own village, while at the same time having your village become everyone's village. I want to be faceless. I hold a mirror to my face so that those who look at me see themselves and therefore I disappear.

Tamar Garb *The part of the body you're most interested in is the face. Your work is obsessively about the face.*

Christian Boltanski The face is so different from person to person. The spirit is revealed in the face. My work is obsessively about people. There are a lot of different people in all my works.

Tamar Garb *Are your works memorials?*

Christian Boltanski Yes, I think so.

Tamar Garb *So they are about lost lives, and the lives that are lost are equally one's own life, one's own childhood …*

Christian Boltanski I'd say that we all have a dead child within us. We don't die once, we have already died several times over.

Tamar Garb *Do you ever photograph an actual person or do you always use found images?*

Christian Boltanski No, I never take photographs myself. I don't feel like a photographer, more like a recycler. When we look at a photo we always believe that it's real; it's not real but it has a close connection with reality. If you paint a portrait, that connection is not so close. With a photo you really feel that the people were 'there'.

Tamar Garb *But not for you, surely, where only the image was there?*

Christian Boltanski I use photos because I'm very interested in the subject-object relationship. A photo is an object, and its relationship with the subject is lost. It also has a relationship with death.

Tamar Garb *What is interesting is that you become positioned in the moment of resurrection rather than in the moment of shooting. If one takes this photographic metaphor, in some ways you are a killer. But if you use already existing images, then you become the life-giver, the person who turns the object into the subject, or at least doesn't have to make the first step in objectification.*

Christian Boltanski Yes, but at the same time they lose identity. I did a big piece in Vienna last year called *Menschlich* in which I used 1,300 photos of people I have used

in my work. They included Nazis, Spanish killers, French victims, Jewish people, etc. I mixed all of them: they no longer had identities. The show was called *Menschlich* (Humanity), because the only thing we can say about these people is that they were human. But we can't judge whether they were good or bad. I believe that the same person can save your life in the morning and yet still be capable of killing you in the afternoon. It's not that people are bad; maybe five percent of the people in any country refuse to act in expected ways. But most people are neither good nor bad. They act within given circumstances. The Serbians are not awful people but they killed the Bosnians. The boss of the café where I have my morning coffee is a nice man. I like him very much, he's a very sweet person, but he might kill me.

There's a story that I really love that I want to tell you. The Vichy regime had passed a law that said Jews could not have cats. My parents had a cat, and one day their neighbours – whom they had known for twenty years – came and told them to kill the cat because it had peed in their flat, and that if my parents didn't kill the cat, they would tell the police. So my parents killed the cat. Just imagine! The neighbours had the power to send my parents to jail if they'd wanted to.

Tamar Garb *The violence in that story is incredible. Here the innocent cat has become a kind of tortured piece of meat. And the potential to transfer that from the cat to the people is very real and very threatening.*

Christian Boltanski Yes. I also did a piece this year called *The Concessions*. The piece is on a wall and consists of very ugly photos of mutilated bodies. The photos are hidden by a black curtain; in the middle there is a screen of white cloth and in it there are the images – half of these images consist of the criminals and the other half of the victims. Nobody knows which is which. In some ways this is a very Christian piece. The pictures on the wall are of the mutilated bodies, suffering bodies, but in the middle you have the spirit – and now the spirits are quiet, and good and bad are identical. There's also a fan which blows the black curtain up, giving you a glimpse of these horrible photographs. The spectators in my work sometimes become kinds of criminals, to the extent that they love these gruesome images even though they refuse them. There is always the temptation to look at them knowing that they're bad or horrible. So if you look behind the curtain you know that you're doing something forbidden. I love to look at awful images; I'm also a criminal. I'm fascinated with the fact of dying. There's a very dark part of my life and my work. It's not only a lamentation; I am a killer.

Tamar Garb *Have you ever made a work about the death of someone you know?*

Christian Boltanski No, I couldn't. There's nothing personal in my work. Ever.

Tamar Garb *What would you say to someone who said that you exploited death and turned it into theatre or pleasure?*

Christian Boltanski Well, I'd say that there are very few subjects in art, and these are looking for God, asking questions about death and love and sex. I'm working around the idea of vanitas, a huge subject in art. You are somebody, but if I kill you, you will become an awful body in a bloody sheet, an object. I find that idea very strange and unclear and it's a question I often think about. I also think that our relationship with death and dying these days is not good at all. Fifty years ago one's grandfather, say, would die at home, and the grandchild would see the grandfather's dead face. The fact of dying was inside the fact of living. Now we've become ashamed of dying, we want to forget that we're going to die. Dying has become an accident. But I think it's important to speak about it as it's the only thing we can really be sure of. We are all going to die. We also have a problem with the fact of killing. For example, I eat meat but I would never dream of killing an animal. But I think if we eat meat, we have to accept that being alive means that we kill things around us. But we forget these basic aspects of our humanity.

Tamar Garb But there's a difference between speaking about death as one of the grand themes of life, and confronting one's own death. Is making art about death yet another defence against the question of your own mortality?

Christian Boltanski I'm sure of it. When I told you at the beginning of the interview that I was 'dead' already, it was to do with avoiding death. If you are already dead then you don't have to die. The idea of not being anybody, or of being a mirror rather, is a way of not dying because I am already dead.

Tamar Garb The way in which you used other dead people's faces in your early work, whilst saying 'these represent Christian Boltanski', was already to construct yourself as dead?

Christian Boltanski Yes, this is to use some sort of magic in order to refuse death. But I also know that I do have a morbid relationship with death. I remember when I was working on the *Dead Swiss*, at the beginning I used to buy the Swiss newspaper and later a friend of mine would send me newspaper photos on a weekly basis of the Swiss who had died. So I would receive about sixty or seventy photos each week. And each week I used to get excited by what I might be seeing, what kind of people would be dead that week. I suppose this relates to some kind of forbidden pleasure, a taboo. I'm not only mourning death, I also take a kind of 'bad pleasure' in the spectacle of death.

Tamar Garb Do you use the same faces over and over again?

Christian Boltanski Yes, and now I don't need any new pictures. I tend to use the same faces in my work. What I can say with certainty is that if you use a life in your art you are always dangerous and a crook. I'm like a bad travelling preacher, preaching doom and destruction and then asking for money. I almost always include photos of the actor Robert Mitchum in my catalogues because sometimes he played a man of God in his films, but he could also be a murderer. I think that's what I am.

Ideally I want to touch people, and I think that my art is for a large public – it's not to be viewed by some exclusive crowd. I try to make my art viewed as if it were life, so that people can speak about my art as if it were something they know. This is why I use photos, since everyone can relate to them, and also why I talk about issues like death, which is important to everyone. It's like people who are really moved when they see the film: they might cry watching the film and then later talk about it and criticize it in a more detached way. That's what I try to do, touch people in a direct way. It's true that sometimes I use very heavy things to do this – and the *Dead Swiss* is a good example. But, then again, it is a way of speaking to people. I chose the Swiss because they have no history. It would be awful and disgusting to make a piece using dead Jews – or dead Germans for that matter. But the Swiss have no reason to die, so they could be anyone and everyone, which is why they're universal.

Last year I did a big show at Santiago de Compostela – the church was actually functioning while the show was on – and a day before the exhibition opened an old lady came into the church and asked us what was going on. I replied that we were memorializing the dead Swiss, and she accepted it and seemed very touched by my work. She understood my work perfectly. Now if I'd told her that I had been sent by the Museum of Contemporary Art and that I'm a post-conceptual artist, she would have said what a shame to put biscuit tins in a church, what does it mean? So I try to touch people on an immediate level. Sometimes in order to do that I have to be very theatrical, even melodramatic.

Tamar Garb *One truly popular art suggested in your work is the Mexican celebration of the dead through visual culture, especially your skeletons and shadows.*

Christian Boltanski The Mexican people have a very special relationship to the fact of dying. And for this reason I am sympathetic with that tradition. But individual symbols like the skeleton have nothing to do with that. I don't find the work I did with skeletons that important in the context of my work as a whole. A skeleton for me is too representative of death; I prefer to work with photos, for example, that show or signify living people but who we know are now dead. I also think that my work has become increasingly tougher and more sad over the years. The *Monuments* or the *Shadows* were made around the same time, and are slightly humorous, playful, sweet almost; the *Monument: The Children of Dijon* (1986) is sad but not disgusting. But now my work has become increasingly sad.

Tamar Garb *But you are working on the level of a generalized meditation on mortality. You are not in the realm of personal grief.*

Christian Boltanski Absolutely not. I did an installation called *Neighbours* last year in a group exhibition called 'Where Is Abel Thy Brother?' about Nazis at the Zacheta Gallery of Contemporary Art in Warsaw. It was a room covered in black

sheets of paper framed in glass which created a mirror effect, and I used lots of names from the local telephone directory. Every five minutes a taped voice would say, 'Are you the next victim?', so everybody could look at their own reflected faces and imagine they would be next. Although the names in the phone book were probably not of people who were already dead, clearly all these people would eventually die.

Tamar Garb *Do you look at death voyeuristically?*

Christian Boltanski We all do that. The spectator becomes a voyeur, and is at the same time ashamed of his voyeurism. And there is a fascination, a specific kind of pleasure, in this. In a way, when you look at violent or morbid imagery you become the criminal.

Tamar Garb *But most of your work is not about the spectacle of death but about relics and traces of lives lived. The photograph is a kind of* nature morte, *a frozen life.*

Christian Boltanski Yes, of course, the photographs are taken of people when they are still alive, even if they are already dead by the time they appear in the work. And when the photograph is taken, the subject is not thinking that this will be his last photo. He doesn't know that he will be remembered by this image.

Tamar Garb *One of the things that you seem uninterested in is the aestheticization of the art, so there is always this tension between how your work reads as a visual object, and the way in which it articulates its meaning.*

Christian Boltanski I think that aesthetics means nothing. There is no such thing as a beautiful or non-beautiful thing. There is art that works and art that doesn't. It's about whether a work can touch people. Six months ago I was at a demonstration in Paris about Bosnia and some students had made huge balloons. The balloons were really ugly (large and figurative), but they made one of the best pieces I have ever seen in my life. It was perfect for this day. Now if I'd seen them in a museum I would have said that they were really ugly, but in the streets against the grey sky and all the people around, they were fantastic. Perhaps there's no such thing as a good or bad piece, rather it's about whether a piece can work at one given moment, about whether it can move us and speak to us. I don't believe in aesthetics, but then I don't think anybody does.

Tamar Garb *What about the titles you give your work? How important are those?*

Christian Boltanski I try to make open titles. The last show I did was called 'Les Concessions', which is the name of a cemetery in France, but it also means to make concessions. My next show in the Netherlands is entitled 'Passion' – both about the passion for life and art but also Christ's passion. So I want titles to be suggestive and emotive.

 I'm sure that the fact that I started working in art during Minimalism is also important. I more or less come from that movement, but the difference is that although I often use minimalist forms, they are more affective.

Christian Boltanski

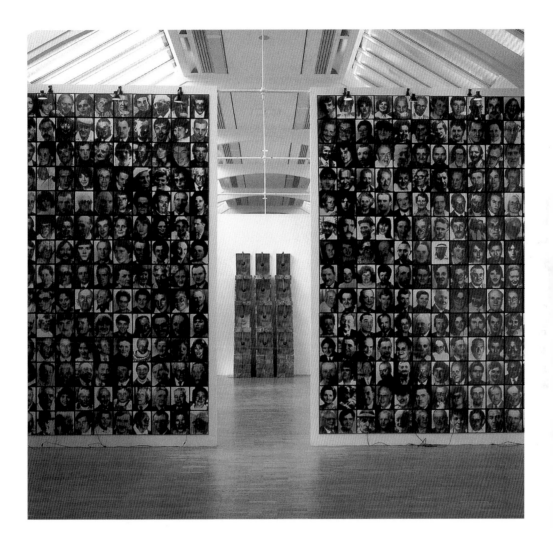

The Dead Swiss 1989
Black and white photographs, metal
frames, metal lamps, wire, tin boxes
Dimensions variable
Installation, Whitechapel Art
Gallery, London

Vito Acconci

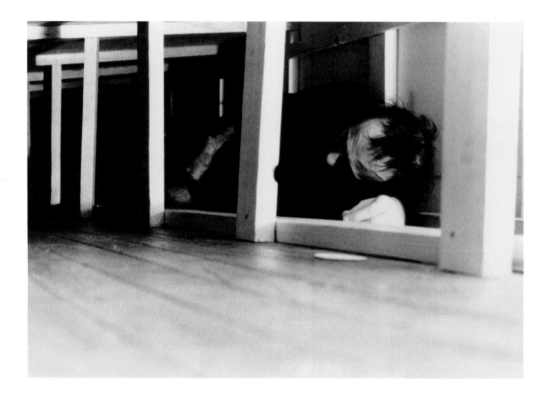

Seedbed 1972
Installation/Performance
Wood ramp, 76 × 671 × 915 cm
9 days, 8 hrs. a day, 3 week exhibition
Sonnabend Gallery, New York
Under the ramp, I'm lying down,
I'm crawling under the floor over
which viewers are walking. I hear
their footsteps on top of me…I'm
building up sexual fantasies on their
footsteps. I'm masturbating from
morning to night…

Vito Acconci

VD Lives / TV Must Die 1978
Rubber, cable, bowling balls, video
with sound
Approx. 305 × 915 × 2.135 cm
Installation, The Kitchen, New York
Collection, Solomon R. Guggenheim
Museum, New York
Each set of three columns is made
to function as the support for a giant
slingshot: a band of rubber wrapped
around the columns and holding in
place a bowling ball. The ball is
hooked through the rubber to a cable
in tension; the ball is directed towards
a television monitor, held by cable to
the columns. Potentially a person can
unhook the ball: the ball would be shot
to the television set. One of the two
slingshots has its plot complicated:
a second rubber band can be released
not towards the TV monitor but
towards the window, and out into
the street.

Doug Aitken

eraser 1998
Colour film transferred to 7 channel
digital video installation, sound and
architectural environment
20 min. cycle
Production stills
Collection, Astrup Fearnley Museum
of Modern Art, Oslo

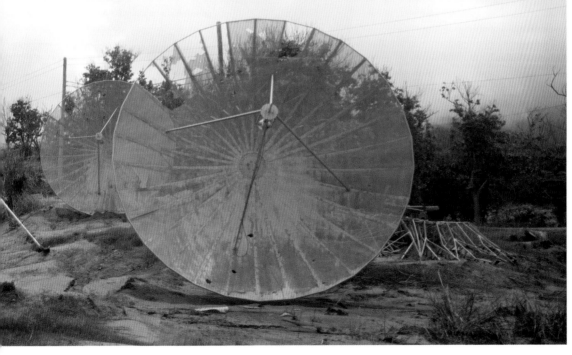

Uta Barth

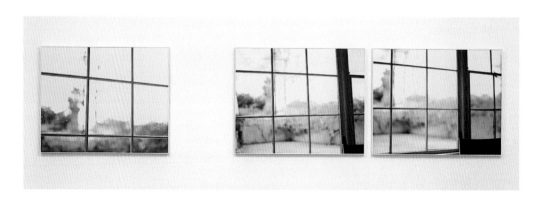

Untitled (98.2) 1998
Colour photographs
2 parts 114.5 × 297 cm
Collection, Metropolitan
Museum of Art, New York

Uta Barth

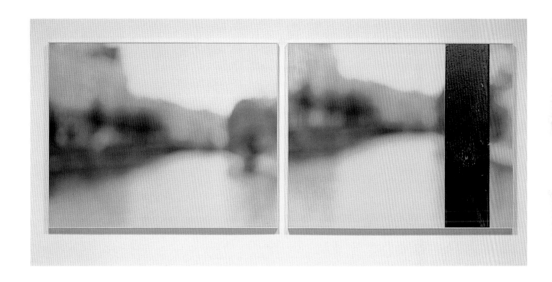

nowhere near (nw 10) 1999
Framed colour photographs
3 parts, 89 × 399 cm overall

Christian Boltanski

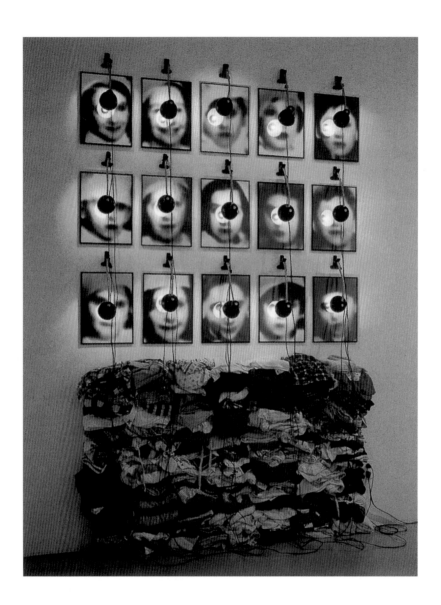

The Purim Holiday 1989
Black and white photographs, metal
lamps, wire, second-hand clothing
Dimensions variable

Tamar Garb *That's what I was thinking of when I asked you earlier about love; what interests me in that is the realm of affect. When I think of your biscuit tins I think of the minimalist cube; but then the fact that you pee on them is also interesting as it's the body fluid that marks the piece. The piece evokes all sorts of responses in the body which the minimalist object doesn't, even though it uses the same kind of cube. So the feeling is very important.*

Christian Boltanski I don't know whether that's love, but to touch people is important. I think that if I were to stop the twentieth century at a moment in time it would be the end of the Communist era and the fall of the Berlin Wall. Before that there was some kind of hope; afterwards there is a complete break. And I think that art also completely changed after that. To take another example, when a Vietcong died, we thought he had died for something. We thought that something would be made better by this. When a Bosnian dies, we know he has died for nothing. Now God is really very far away. We know that all utopias are very, very dangerous. Usually utopian ideals have ended up killing a lot of people in their name. In Cambodia, Pol Pot was a very nice man with utopian ideals, but he killed all his people! Yet on the other hand, if we didn't have utopias, we would be nothing. So we can respond to this in two ways: either by doing nothing, since there's no point in anything anyway, or by trying to create small utopias, by helping our neighbour, by trying to change something near us. If a lot of people were to change something near them, perhaps this would create a big change. Avant-garde art was a large utopia: it was revolutionary, it aimed at universalism. Now we know that this is difficult to do.

Tamar Garb *So does art become a lamentation then?*

Christian Boltanski No, art can now work with people. It's not about creating the big piece, but rather to be active where one is, with no idea of an immortal art work.

Tamar Garb *If we live in the face of the loss of Utopia and the loss of grand beliefs, God and meaning, can art be a space where you can repair that loss?*

Christian Boltanski Art is always a witness, sometimes a witness to events before they actually occur. Like Felix Gonzalez-Torres, who gave things to people, art is to do with our relation to the time in which we live. So if we want to understand society we should look at society's artists.

Tamar Garb *But that's not necessarily going to make you feel better.*

Christian Boltanski Yes, sure, we get pleasure out of seeing an exhibition or a film, but I don't think art has real power. It does, however, have small power. Like I said earlier, I'm like a preacher going from town to town, working with small communities. I think I can communicate with them, touch them, ask them questions. Perhaps they might be different after seeing my art, but if the fascists were to take over France, say, my art's not going to stop them.

I think what's more important for all of us is to be witnesses of what

has happened. In my own art and also in art after the destruction of the Berlin Wall, form has become less important. With the Minimalists, form was hugely important, but that doesn't happen in work of today. Form represents a kind of belief – for example that there is a right way of doing art – but now that isn't the case. Now we're concerned with the right way of speaking to someone; there is no form that is right forever. And that also signifies the end of utopia. Now I find it equally important to work in the newspaper or with posters, say, to do work in the street rather than to make pieces for museum display.

Form has changed a lot over this century, but looking at art hasn't changed, and neither has being an artist. So it will be interesting to see what being an artist in the twenty-first century will mean. Perhaps there can be new ways and contexts of reaching people. You know, I've always been envious of Benetton – not that I like their message, but it's just that they're everywhere, they can touch people all over the world! That's a lot more powerful than doing a show in a museum! In any case I think that now we have to work at different levels: at a universal level like Benetton (which is almost impossible to achieve), and at another level more personally, by touching few or a certain category of people, and really being with them and working for them. I really don't know what it means to be an artist. Is it to produce art objects? In the Renaissance and Baroque periods, when artists were working in churches, they were reaching a lot of people, including the poor. And I'm sure that when people went to church in the Baroque period, it was just like going to see a Hollywood movie today. It could touch people directly.

What I would love is for people to imagine that what I make is not art but something different. For example, I was working at Cologne Station a couple of years ago, and I distributed 20,000 little posters to the train passengers. Doing something like that is so different from exhibiting at a museum. It's what I was just saying – touching people in a different way. Also last year in Vienna I made a piece that was simultaneously in the daily newspaper, on posters and on television. It was a photo under which I had added a message asking the public if they knew the face in the picture to write to me: Again, that's very different from doing something at a museum. Really, it was a way for me to ask, 'What have you done with your Jewish people?'

On another occasion I was working in Halifax in the north of England and one of the pieces I did there was about the carpet workers that were sacked after a factory shut-down. What I did was to create a room for them, and each worker had his own box in which he could put some kind of souvenir of his past at the factory. The piece was not that good, but what was interesting was that someone was prepared to go and speak to them and find out about them. They had all left the factory by then and this was the first time they returned, and it felt like the factory belonged to them. The room is still there. I'm sure that no one knows it's one of my pieces, but that's not of any importance. I saw it about a year ago and around half the boxes were full.

So these kind of pieces are rather different from doing a painting. I'm not saying that they are the only right way to work, but this way of working is a little different. Sometimes, for me, form is very important and I am a formal artist, but in this case the form is not as important as the story and the process. Perhaps this is another way of being an artist. What is important is to do something in the present.

Louise Bourgeois *Paulo Herkenhoff*

in conversation
May–August 2001, New York

Louise Bourgeois Let us get something clear before we begin. In general I don't need an interview to clarify my thoughts. It is absurd, a pain in the neck! Interviews are a process of clarification of other people's thoughts, not mine. In fact I always have to know more about you than you know about me. All the same I like to be crystal clear when I speak. I like to be a glass house. There is no mask in my work. Therefore, as an artist, all I can share with other people is this transparency.

Paulo Herkenhoff You have always kept a diary, ever since you were a child. Moreover, you write on the backs of your drawings and you take notes. All this writing must have a very clear meaning for you.

Louise Bourgeois I use these writings for clarification. I worship transparency. I search for transparency. You see, there is no mask in my work. I am perfectly at ease with language, so much so that when I married somebody who did not speak my own language, it did not make any difference to me. I learn your language, you learn my language. In the end it does not matter, because the language of the eye, the intensity of the gaze and the steadiness of that gaze are more important than what one says. Language is useful but not necessary. You cannot fool me in the visual world, but you can get the better of me in the verbal world.

Jerry Gorovoy [Louise's assistant of twenty years] When Louise is writing it is very spontaneous. Very direct. Her writing flows so tightly, as if in direct contact with the subconscious. I've seen Louise write something on the back of a drawing and when she reads it again she sometimes can't even remember where it came from.

I can tell you the six key events in Louise's early life: the first is the introduction of Sadie, the children's governess, into the family and Sadie's ten-year relationship with Louise's father while living in the house. The second is the death of her mother in 1932. The third, her marriage to Robert Goldwater in 1938; the fourth, their moving to New York. And then there was the adoption of Michel in 1940 followed by the birth of Jean-Louis that same year.

Louise Bourgeois The most important event in my life was the birth of Jean-Louis. He was born on the 4th of July. He was born early; he was supposed to be born on the 14th of July.

Paulo Herkenhoff Your children took the name Bourgeois, not Goldwater. Why? Was this your choice?

Louise Bourgeois No. My father wanted descendents, and since nobody else in the family had any children at the time he thought my children should take the name Bourgeois.

Paulo Herkenhoff What were your biggest losses in life?

Louise Bourgeois The death of my husband and the death of my mother. So, 1932 and 1973 are dates that I cannot forget.

Paulo Herkenhoff So, your mother died before you left for the United States?

Louise Bourgeois Yes; that is why I came to the United States. My father had lovers all
the time. It was a family situation that I could not stand. I come from
a dysfunctional family.

Paulo Herkenhoff *You never really positioned yourself as a foreigner in New York. The role of the*
foreigner, Julia Kristeva has argued, is that of being the revealer of a hidden
significance in a community.[1] Louise, could you give me an indication of that?

Louise Bourgeois I have no desire to express myself in French. I am an American artist.

Paulo Herkenhoff *Do you vote in the United States?*

Louise Bourgeois Certainly. It is a crime not to vote. I am a registered Democrat.

Paulo Herkenhoff *You have spoken at length about the effect of your father's authoritarian role over*
you and your family when you were growing up. Since he was so controlling, how
did you assert yourself in relation to him?

Louise Bourgeois Probably the best answer to that question is to speak of my trip to Russia in
1934, at the suggestion of my instructor at the Sorbonne in Paris, Paul Collin.
Ostensibly I went to Russia to see the Moscow subway. I went as a reporter
for *L'Humanité*, I was going to publish an article on the subject. The trip was
an act of political independence.

Paulo Herkenhoff *Were you a Marxist? Did you belong to the Communist Party?*

Louise Bourgeois I mean political in the sense of rebellion against the father. The trip was
an investigation and an expression of that rebelliousness. My independence
was due to the fact that my father did not have to pay for me. You know,
to be supported by your father is a great responsibility.
 I do not remember feeling anything at the time. I was just moving, moving
on. You know, it is very difficult to remember – even if it is indispensable, to
remember. Memory has become so important to me because it gives me the
feeling of being in control, in control of the past.

Paulo Herkenhoff *It is quite interesting how you tamper with time by retouching photographs. You*
rearticulate what was frozen by photography.

Louise Bourgeois The technique of photo retouching was my first paid job. You are speaking
of the photo of Deauville? I wanted my vision of my brother and myself
undisturbed, so I took the unwelcome presence – Sadie – out. I did it because
it gave me pleasure to suppress her presence. It made me feel omnipotent.
You see, I do not have to be generous but I must be consistent.

Paulo Herkenhoff *Would you say you played God when you took Sadie out of the photograph? Is there*
a relationship between retouching a photograph and mending or reparation?

Louise Bourgeois It is just that I did not want the past exposed in the way it was in that
photograph. I wanted my own vision of the past. In fact I felt very guilty
when I did the re-touching. To exclude or obliterate my own father

reminds me of the death of my dog. It is like when my father buried my dog in the backyard. He did not dig deep enough, so every time I went to the yard I would see that mound where my dog had been buried. My father was just too lazy to bury him correctly. So the dog continued to exist. It is like this with these photographs with Sadie. I must bury them properly or they will not go away. But the truth is I don't need a photograph to remember. Photographs allow you to forget or forgive.

Paulo Herkenhoff *Do you like to be photographed?*

Louise Bourgeois No, I detest it. I am not what I look like. I am my work. I cannot escape being myself all the time. I wish I was a loser. I would be less black and white. Less rigid.

Paulo Herkenhoff *Which photographs of yourself do you like most?*

Louise Bourgeois You know, when I went to have my photograph taken by Robert Mapplethorpe I took the sculpture *Fillette* (1968) as a precaution. In truth I think very little about photographers. Very seldom are they intelligent. When I went to pose for Berenice Abbott I was careful to put on my see-through dress. I put on my very best clothes. I was trying to help the photographer. And I did the same thing for Mapplethorpe.

Paulo Herkenhoff *In your portrait, Berenice Abbott emphasized your head. It is like a monument. It is an architectural portrait of the* femme-maison.

Louise Bourgeois Yes, as if I were looking up, looking for the future. Berenice was interesting. She had clients who asked her to photograph people or furniture but she was really interested in buildings. But you know, I am not really interested in my photo-biography. It may be useful but I have no interest in it.

Paulo Herkenhoff *Why have you never made a realistic self-portrait?*

Louise Bourgeois Because I am not interested in myself. I am interested in the Other. The purpose of the Salons on Sundays was for people to talk about themselves, not about me. 'I, me, myself' horrifies me.

Paulo Herkenhoff *Would you say there is a feminine geometry? What is the importance of geometry in your work?*

Louise Bourgeois Stability. As in life, in my drawings a woman's hair is either well-organized, carefully braided and parted, or dishevelled. There is a message in either case. In the first case, the girl is in control of herself, is self-confident, but in the second, the dishevelled girl is subject to depression. So there is another connection: a dishevelled girl is melancholic. Munch drew a dishevelled woman in the water, her hair was mixed with the water, like Shakespeare's Ophelia. Thus I am saying that there is a feminine geometry. A torsade is something that revolves around an axis. This geometry is founded on poetic freedom and promises security.

Paulo Herkenhoff Is there a job which you think suits your character?

Louise Bourgeois One of my jobs is to wind the clocks in the house.

Paulo Herkenhoff You always pay attention to small details and from there you draw major conclusions, so I would like simply to ask, why is winding the clocks important to you?

Louise Bourgeois Because to rewind is to make a spiral. And the action demonstrates that even though time is unlimited, there is a limit to how much you can put on it. As you are tightening the spiral you must take care. If you tighten too much you risk breaking it. It is the same with sewing. Sewing without a knot at the end of the thread is not sewing. In this sense the spiral is a metaphor of consistency. I am consistent in my spiral. For me there is no break. There is never an interruption in the spiral because I can not stand interruptions.

Paulo Herkenhoff You said that forgetting bothers you, that it is a suffering.

Louise Bourgeois Yes. It is tiresome to look and not to find. It proves the impotence. It is a manifestation of impotence.

Paulo Herkenhoff Before this conversation started you said you had a topic for us.

Louise Bourgeois Here is a subject that interests me today: *l'attente/attendre* [the wait/waiting]. What is going on in your head when you wait?

Paulo Herkenhoff In your work, waiting is a projection of your fears of abandonment, fears of being rejected, fears of being forgotten.

Louise Bourgeois Waiting makes the other too strong. When one waits one is dependent. Waiting for the phone to ring. Waiting when the phone does not ring. Sartre said, '*l'enfer c'est les autres*' [hell is other people]. And for me, *l'enfer d'être sans toi* [the hell of being without you], the absence of the Other. If you have been rejected, you can rebound. You have been rejected, but you don't have to die on the spot.

 Let's focus on the issue of jealousy because it is the most interesting subject. The question is: do you admit it? Jealousy is not humiliating, it is painful! Unconscious jealousy is the topic of Françoise Sagan's book *Bonjour Tristesse* (1954). It is more threatening than conscious jealousy, which is not really dangerous because it is out in the open.

Paulo Herkenhoff What about envy and jealousy? They are not the same thing.

Louise Bourgeois Let's go to the dictionary.

Paulo Herkenhoff From the Oxford English Dictionary: envy, 'mortification and ill–will occasioned by the contemplation of another's superior advantages'; jealousy, 'solicitude or anxiety for the preservation or well-being of something. The state of mind arising from the suspicion, apprehension or knowledge of rivalry.'

Louise Bourgeois You see? Jealousy is the more interesting. It has to do with preserving the well-being of something. My father and my mother were jealous over which

of them I liked most! Jealousy and abandonment are common feelings for young boys and girls.

Paulo Herkenhoff *What about the relationship between jealousy and fear?*

Louise Bourgeois We can answer that with the story of Penelope in Homer's *Odyssey*. Why does she make the tapestry? Because she is afraid Ulysses will not return. It is a question of defeating fear, a question of coming to terms with fear. You convert the menace, the fear, the anxiety, through the redemptive force of art. *[Louise takes Paulo's notebook and writes the following poem in red pencil:]*
Quelle est la couleur de la peur? [What is the colour of fear?]
Quelle est sa chaleur? [What is its heat?]
Quelle est sa valeur? [What is its value?]

Paulo Herkenhoff *What are your reactions when you feel impotent?*

Louise Bourgeois *Quand les chiens ont peur, ils mordent* [When dogs are afraid, they die]. If you make me impotent, I reach for my dagger. There is also the anger of understanding, the anger of travelling, the anger of pardoning.

Paulo Herkenhoff *Your print* What is the size of the problem? *confronts two apparently similar and yet different zones. Is it an unfaithful mirror?*

Louise Bourgeois The print is related to the ambivalence of perception. The printing was done after a drawing and a quotation from the 1940s. Ambivalence is for the emotions. Ambiguity is for the brains.
[Louise reaches for the tiny bottle of Shalimar perfume that she always keeps at her desk and opens it to enjoy the perfume.]
Evanescence and stability are the ground of some of my feelings. The fear of losing – this is very important for me. Evanescence means a come-and-go. The evanescence of memories is very important. You have souvenirs which appear to you and then all of a sudden disappear. Evanescence gives birth to the fear of losing. I want to give my work permanence.

Paulo Herkenhoff *So, Louise, you fight between evanescence and permanence.*

Louise Bourgeois A spiral is also a metaphor for consistency in my drawing. The soul is a continuous entity. I am consistent. You can trust her because she is consistent. If Louise tells you that she loves you she is not likely to change her mind.

Paulo Herkenhoff *Fear is the thing? The result? Your work resists the idea of suffering. Does suffering ever have something to do with sculpture?*

Louise Bourgeois No, because it is too vague. How can art save someone from suffering, from insanity? You have to ask a doctor. I can not answer that because I have never been there. I carry my psychoanalysis within the work. Every day I work out all that bothers me. All my complaints. This way there's always a component of anger in beauty.
Paulo, let me write in your book.

[She writes in red pen:]

I do

I undo

I redo

[Underneath she draws a large circle with the phrase 'the pregnant O'.]

 That is the beauty of the drawing. Drawing opens our eyes and the eyes lead to our soul. What comes out is not at all what one had planned. The only remedy against disorder is work. Work puts an order in disorder and control over chaos. I do, I undo, I redo. I am what I am doing. Art exhausts me. Yet I work every day of my life.

Paulo Herkenhoff *Do you lose the notion of time when you are carving or drawing?*

Louise Bourgeois Of course you lose track of time. You follow the pleasure of the activity of drawing. You do not care what the result is going to be. All the connections are unconscious. You do not know where you are going to end. It is a journey without an aim.

Paulo Herkenhoff *The unconscious brings up Surrealism, a term you reject when applied to your work.*

Louise Bourgeois I was not a Surrealist, I was an existentialist. That is the magic word. I love the literature of Albert Camus. I despise nihilism, however.

Paulo Herkenhoff *You are an existentialist who fights back.*

Louise Bourgeois Perhaps. It is simply that looking is my job. But I am afraid of looking at things that confuse me. To be confused and not know you are confused is the definition of stupidity. Here you see my fear is not fear itself but the fear of being met by confusion. That is why I prefer images. An image never betrays you; if you look hard enough you will make order out of disorder. When I witness mental confusion in another person I fear contamination. Let me live in a world of image and I will never complain.

Paulo Herkenhoff *What do you think about the state of the visual world today? What do you think of the use of new media, such as computers, in the visual arts? You seem scared of computers.*

Louise Bourgeois I don't even know what a computer is. I don't think about it. It does not help me. It does not bother me.

Paulo Herkenhoff *So, what comes to your mind when I say 'the Web'?*

Louise Bourgeois Oh, I think of a spider's web, of course. She weaves her web. You know, *Ode à ma mére* has been a very important subject because it has been at the basis of all my spiders. It relates to industriousness, protection, self-defence and fragility. The spiders I have made over the last decade have been a big success. And I do not object to how such a statement might sound to others, because success is sexy!

Paulo Herkenhoff *Is art not an obsession?*

Louise Bourgeois No. In art one must avoid obsession. Because obsession is a state of being. It is an unfortunate state of being. If you are possessed by an obsession you cannot function. Some artists are unsuccessful, non-pecuniary and yet very good. Some are derivative. Some are original. Ultimately to be an artist is a privilege; it is not a *métier*. You are born an artist. You can't help it. You have no choice.

Paulo Herkenhoff *What is your process of creation?*

Louise Bourgeois Conception and realization of art. There is not one without the other, but the conception comes first. I can be contradictory from one piece to the other. The realization of a work may take place two or three years after the conception.

Paulo Herkenhoff *Is there an emotion one can be possessed by and still make art?*

Louise Bourgeois Yes, compassion. Without compassion there is no work, there is no life, there is nothing. That is it. But at the same time art has nothing to do with love, it is rather the absence of love. To create is an act of liberation and every day this need for liberation comes back to me. In terms of making a statement in art, which do you prefer, to scream or to be silent? It depends on what you want. If you want attention, you scream.

Paulo Herkenhoff *Then what would be the value of silence?*

Louise Bourgeois The gaze is much more important than words. Silence is intimacy. If there is a solid intimacy, the intervention of one and the Other is not necessary. The non-spoken is more important than what is spoken. Sometimes we are not sure that communication exists. Communication is not indispensable. I don't work to communicate and sometimes I wonder if I do.

Paulo Herkenhoff *In terms of body language, you say that the eyes play an important role. How do you relate that to art? Is making art a body language?*

Louise Bourgeois It is the answer to a need. Actually, you don't know what the need is until after the work is done. With words you can lie all day long, but with the language of the body you cannot lie.

Paulo Herkenhoff *Is the body an existential sculpture?*

Louise Bourgeois Oh yes, our body is being influenced by our life. And yet our body is more than the sum of its parts. We are after all more than the sum of our experiences. We are as malleable as wax. Descartes wrote about wax. We are sensitive to the souvenirs of what has happened before and apprehensive to what is going to happen after. Consequently, everything is energy. I experiment with people who are like iron – who are not malleable at all. I have no confidence in my ability to manipulate other people. The Moebius strip is a fascinating topological structure. It stands for the dance of desire.

However, I represent the sexual encounter from the point of view of the woman. She won't let it go.

Paulo Herkenhoff *Tell me about your exhibition with Francis Bacon and Franz Xaver Messerschmidt, at the Cheim & Read Gallery in New York in 1998.*

Louise Bourgeois We three are brothers under the skin. I identify myself with extreme emotions. Messerchmidt could also be the image of the father, or the image of the teacher, of someone superior. That I detest. I am the author of *The Destruction of the Father*. I am not following or referring to great figures of history. I am just doing my work according to the stream of life, the flow of life.

Paulo Herkenhoff *Certain objects incorporate the drives in your sculpture, such as clothing. Louise, is there a basic language of clothing?*

Louise Bourgeois We must talk about the passivity and activity of the coming and going of clothes in one's life. When I come upon a piece of clothing I wonder, who was I trying to seduce by wearing that? Or you open your closet and you are confronted by so many different roles, smells, social situations. For me clothes are always someone else's. That is to say that I have never bought or made my own clothes. Never, never, never. Clothes are a gift, a choice, a test of the presence of a man to a woman. They are a test of taste. Does he see me like a balloon? Does he see me like a sylph?

Paulo Herkenhoff *You enjoy discussing styles and social references in couture, Roland Barthes and the semiology of fashion, or your private memories connected to clothing. Do you think you could have been a fashion designer?*

Louise Bourgeois I could have become a designer of men's clothes, because of my interest in the elegance of men. I am not interested in women. One of my interests in men's clothes is sleepwear. Let's make it very clear – I mean only men's sleepwear, not women's. But in general, for myself, I believe in the uniform, because of the Lycée Fenelon of my youth where all the students wore a uniform. If in one of my installations you find a section called *Les Tabliers d'enfant*, these are my uniforms from when I was young. You cannot be confused if you notice the style of a garment.

Paulo Herkenhoff *Why are you interested in sleepwear?*

Louise Bourgeois Because we spend as much time asleep as awake. In other words, we are wrapped in cloth as we sleep as much as we are wrapped in cloth during the day. Sleepwear for me means all bed wear, that is to say, bed sheets, linens, pillowcases and very special blankets. The clothes I include in my work belong to the artist, the maid and to friends. It is very inclusive. 'Friends' means anybody who has visited the house and who, by inadvertence, left an old book, a scarf, or galoshes, and by doing so enters the 'collection'. For example, Le Corbusier forgot his glasses.

Paulo Herkenhoff *How were you supposed to dress around your family?*

Louise Bourgeois Both my parents dressed me, and competed with one another over it. They were rivals at getting me the best dresses and the latest fashion statement. I was dressed in Chanel, Poiret, lingerie suisse, furs, foxes, boas. Here is an amusing story about my refusal to wear the clothes my father bought me, in the days of the Galerie Lafayette and Au Printemps, the big Parisian department stores. It was a privilege for me to refuse to wear the fox that he had bought me.

Paulo Herkenhoff *You once said that you are constantly learning the experience of time.*

Louise Bourgeois You should never waste your time because time will never come back. Time can be represented by dust. If you don't clean your books the dust will gather and you will have to blow it off. In this sense, to gather dust is to negate time. Otherwise, you can retell your life and remember your life by the shape, the weight, the colour, the smell of the clothes in your closet. Fashion is like the weather, the ocean – it changes all the time.

Paulo Herkenhoff *How is time sculpted in your memory as a lived experience, les temps vécu? Your work implies a very particular phenomenology of time. How do you confront the idea of duration and the passage of time?*

Louise Bourgeois It is water under the bridge, because time never comes back. Time is independent and supersedes my consciousness. For instance, if you say 'time and tide wait for no man' it means that time excludes man, it is not dependent on man. So my consciousness is only a little consciousness within the context of time; time goes on undisturbed, indifferent. What is ultimately most important about *durée* for me is the way it crystallizes into a shape, a form, an image, a metaphor.

Paulo Herkenhoff *Thus, this might be more about the administration and expression of time.*

Louise Bourgeois We use the word itinerary when we travel in space, say from Australia to Russia, all over the world. But there is also an itinerary in time. When people ask me how come I'm not going to an opening it is because I travel in time. I travel in memory.

Paulo Herkenhoff *And what about Marcel Proust's classic* À la Recherche du temps perdu? *What is your madeleine?*

Louise Bourgeois It is really *perdu* because the book is *perdu*. I would not necessarily think of [a taste or a] smell. It is most of all about light. Time is the tributary of the light of the day, of the sunset, of the night, of the dawn. *Le plein jour, ça c'est ma madeleine.* It is necessary to search for the balance between yesterday and tomorrow, since the present escapes me.

Paulo Herkenhoff *You confront the hierarchy between male and female. Thus, in your work hysteria applies to both genders and its psycho-organic arch is made by the contractions of the male body in* Arch of Hysteria *(1993). This disrupts the scientific principles of early psychiatric technology, from Jean-Martin Charcot to Sigmund Freud. What does it mean for you point out the rational, emotional and erotic limits of the male*

and the fragility of men? In your extensive body of sculpture very few works deal with male anatomy: Fillette *(1968),* The Destruction of the Father *(1974),* Confrontation *(1978),* Portrait of Robert *(1969) and* Arch of Hysteria.

Louise Bourgeois My intention is to put down, debunk the abstract male, whose image is constructed by society. In *Banquet / A Fashion Show of Body Parts* (1978) I wanted [to present] an art historian, a critic who was also a man. Therefore I chose G., a specialist in Henry Füseli. He went too far in making fun of himself. There is the ridiculous male. Most of those sculptures deflate the male psyche as a structure of power. *Mamelles* (1991) points out that Don Juan's need to sleep with many women meant an inability to love. Did Don Juan sleep with older women? Isn't 'Don Juan complex' in the dictionary? Or 'Don Juan syndrome'? Syndrome is a very, very good word. It is the concurrence of a set of symptoms, a repetition. That shows a pathology.

Paulo Herkenhoff You aim for the equilibrium between men and women. Fillette *deals with an object of desire. Why does this sculpture, representing a penis of large dimensions, have as its title* Fillette, *meaning 'little girl'?*

Louise Bourgeois The little male has to be taken care of.

Paulo Herkenhoff In Portrait of Robert *you've represented Robert Goldwater, your husband, with many penises.*

Louise Bourgeois It is a sign of his virility and sexual appetite. I wanted to flatter him. I wanted to please him and let him be pleased with himself. This was to make him sexy. A sex symbol.

Paulo Herkenhoff Was Marcel Duchamp sexy?

Louise Bourgeois I always felt he was completely un-sexy. I felt that Marcel Duchamp always played with the truth. Sometimes it is much more interesting to deny the truth. Duchamp was a charmer. He was very sociable. He got along very well with Robert, they shared a sense of irony and a sense of humour. Duchamp liked to tease people.

Paulo Herkenhoff You mean he was a prankster?

Louise Bourgeois No. It wasn't so much that he did things to people, but he tricked people into believing he was a genius.

Paulo Herkenhoff Did he like to play games of seduction with women?

Louise Bourgeois No. I never saw him in that role. Never. I think that Marcel Duchamp became a great man when he reached America. His was a successful exile. The French did not appreciate him.

Paulo Herkenhoff Architecture is a very complex issue in your memories and work; let's focus on one aspect of that. Quite often you mention the maison vide *and the* femme-maison *as referring to the challenges of domesticity.*

Louise Bourgeois I find the duty of running a house almost overwhelming. You have to be so practical, so patient, so energetic and resourceful. Remember that I have done many works representing myself as the *femme-maison*. The *maison* is quite symbolic as architecture, the subject and life. I made a work called *Homage to Bernini* (1967). It was a homage to a sculptor whose work was full of folds. There was no emptiness [in this work], not an inch which was not filled with folds, as if emptiness was Bernini's enemy. The *maisons vides* [empty houses] are a metaphor for myself. The *maisons vides* are houses where I have lived or worked in the past; they are all empty now. Therefore they are the constructions where we exist, the architecture of our life, that is, the different places where we exist. So this is the history of a life. I try to make them come out of the shadows and make them appear under the light of the present.

Life is organized around what is hollow.

1 Julia Kristeva, *Étrangers à nous-mêmes*, Fayard, Paris, 1988. Translated into English by Léon Roudiez as *Strangers to Ourselves*, Harvester Wheatleaf, London, 1991; Columbia University Press, New York, 1991

Cai Guo-Qiang *Octavio Zaya*

in conversation
November 2000, New York

Octavio Zaya *In 1999 you presented* Venice's Rent Collection Courtyard, *an installation that won the Leone d'Oro award at the 48th Venice Biennale. The installation was a reconstruction of an anonymous work from the 1960s, very popular in China during the Cultural Revolution. This propagandistic work, a Social Realist tableau of more than 100 sculptures, depicted the exploitation of feudalism and was meant to contrast with the benefits of life under Mao Zedong. Your re-creation in Venice provoked an intense debate in China about the meaning of art, originality and the avant-garde. Some of the original 1960s sculptors at the Sichuan Fine Arts Academy in Chong Qing have even threatened to bring legal action against you and the Venice Biennale for copyright infringement. An art critic and teacher at the Academy, Dao Zi, called your work 'an example of postcolonial cultural imperialism in which China is demonized as backward and despotic'.*

Cai Guo-Qiang At the time I was thinking about turning 'looking at sculpture' into 'looking at making sculpture', using that very process as a work of art. That was the starting point. *Venice's Rent Collection Courtyard* expresses a number of different things. One of them is the tragedy of time, of people, of artists who were once full of passion and conviction in their beliefs. Reflecting upon the artist's work in particular, we see the discrepancy between ideology and reality, the tragedy of it all. It also reflects on us now; we're so busy working on projects, full of passion and idealism, but what purpose do we serve?

Also, until then the artistic community in China had shied away from reflecting on the artworks from the Cultural Revolution and had resisted taking responsibility for what had happened. Everyone acted as if they were victims of the times, yet these are the same people that made up those times. The heated debate over my work in Venice raised issues such as the role that art and artists played during the Cultural Revolution, and in any strongly political setting in general. It also opened up the discussion of Chinese contemporary art in the context of the global art scene, which had pretty much been viewed as two separate developments that had little to do with each other.

Octavio Zaya *How did you come up with the idea of re-creating the* Rent Collection Courtyard, *and why did you do it?*

Cai Guo-Qiang I'd been interested in the work for many years and had wanted to turn this somehow into a time-based installation. My work has often utilized what I call 'fluid installation' or 'movable installation' – installation based on time. The final physical presence of the sculpture is not that important. The 1999 Venice Biennale seemed like a great opportunity, because in a way it was looking back on the twentieth century. Of course it was also of particular interest to me because I first saw the work as a young person in China and was very moved by it. The work was replicated in every city in China; everyone experienced it and was moved by it. Often people would even cry. At that time I didn't understand the work's cultural strategy, or that

the intention was propagandistic, but now, as a contemporary artist, I notice the techniques that were used to engage with people and make them feel like part of the work.

Octavio Zaya *Some artists in China feel that this and further examples of your work, like that of other Chinese artists who have been successful in the West such as Wenda Gu, Chen Zhen, Xu Bing and Huang Yong Ping, perpetuate stereotypes and misconceptions about China. You, for example, use gunpowder (a Chinese invention), calligraphy, feng shui, Taoism and Zen. But wouldn't it be more true to say that you and these colleagues use this traditional Chinese culture as a reaction against the Western contemporary art that was introduced into Chinese avant-garde culture in the 1980s and soon became predominant?*

Cai Guo-Qiang The influence of Western ideas and trends became a weapon for Chinese artists to use against their own tradition, politically and socially speaking. What influenced me most when we began to learn about Western contemporary art in the 1980s was not a particular work, tendency or idea, but rather the huge amount of information suddenly made available: this vast, hundred-year span of modern and contemporary Western art. The main impression it left me with was: 'Damn, you can do anything you want!' It was like a certain form of Zen enlightenment when the teacher hits you over the head and you 'wake up' with a new realization or vision. That's what Western art did to me when I first saw it in the late 1970s.

Mainstream Chinese art at the time, sanctioned by the authorities, was either a straight extension of traditional Chinese art, or one that served the current political agenda. On the other hand, the unofficial art at the time was using Western art to criticize, comment on and react against official Chinese culture. In other words, in both instances it was socially based. My work, instead, was based on the individual. Throughout recent Chinese history art has been continuously used as a means of deliverance, a tool to bring salvation and awareness, to move society forward. Art has had a collective ideology and purports to serve the people, but in reality it only served the state. My work was not about that. I couldn't please either side, official or unofficial, because my work did not reflect collective thinking but rather a search for the individual.

Octavio Zaya *Have you ever studied traditional Chinese painting?*

Cai Guo-Qiang My father is a calligrapher; he makes traditional paintings and he also studies Chinese history. My home was always full of traditional artists and a love for traditional Chinese art; my family was always talking about the grandeur and accomplishment of Chinese art and civilization. But the huge discrepancy between the greatness of the art and the dissatisfaction in Chinese society created a natural rebelliousness in me. I wanted to follow the Western tradition of oil painting and sculpture, and be influenced by Western thought. Now, looking back, I see I've inherited some of my father's scholarly thinking; Chinese cultural tradition is a part of me.

Octavio Zaya In 1981, when you were twenty-four years old, you went to Shanghai to study and you lived there until 1985. Was it then that you decided to become an artist?

Cai Guo-Qiang I always felt that I was going to be an artist, even as a child; perhaps it was my father's influence. Then as a teenager I filled my time with a lot of other, extracurricular activities, like martial arts. From the end of the 1970s I even acted in martial arts films, such as *The Spring and Fall of a Small Town* (1978). I played the violin, acted, painted and designed stage sets. I did all kinds of different things in an attempt to fill my life, because I was bored and unhappy.

When I arrived in Shanghai I studied at the Shanghai Drama Institute. At that time there were no schools that trained students in contemporary art. Even today, in most Chinese art institutes you study either traditional Chinese painting or traditional oil painting. But theatre school is different because your concerns are more conceptual; you discuss materials, the use of space, time, light and audience reception. You make proposals, develop your ideas and you learn how to work as a team. You're asked to grasp the whole process, from proposal and budget to production and presentation. Theatre is based on time: how your work is revealed in time, how it develops and proceeds, how the audience is engaged. These ideas laid the foundation of my art practice.

Octavio Zaya By the early 1980s, when you were still studying at the Shanghai Drama Institute, contemporary Western art had begun to penetrate China. By 1985 the Chinese avant-garde movement was getting into full swing – yet during the early 1980s you chose not to be involved in this new development but went on a tour of the Chinese countryside. It seems strange to me that in this exciting new situation, when international art was finally arriving in China, you removed yourself to remote country villages. Were you uninterested in the art community? Did you want to study traditional ways of life and art?

Cai Guo-Qiang It was partly a reaction against the 'new art scene'. Everyone was so interested in Western art, particularly Joseph Beuys and Andy Warhol. But when I looked at Warhol's Pop art, for example, I felt there was an immense distance between what he was doing and what I'd seen in my life. The way he looked at materialism and commercialism had nothing to do with us in China, as we stood in line to buy a very few essential things; there was no real dialogue there. Beuys' concern for the environment wasn't really connected with us at the time either. Outside my home I had green mountains, clear water; I could fish and swim in my front yard. I had a huge pond with fish; we had dogs and animals all around us. Of course, materialism and environmental damage have now become concerns in China as well, but at the time I felt, 'what do these issues have to do with us?'

Octavio Zaya What kind of art were you making then, in the early 1980s?

Cai Guo-Qiang Oil paintings – lots and lots of oil paintings. When I toured the countryside, I'd make paintings of the people I met, of their homes or their meals, and I'd give these paintings to them. This always made them very happy.

Octavio Zaya Did you exhibit your work? In your biography, your artistic career begins in the 1990s in Japan; what did you do until then?

Cai Guo-Qiang I was in a few exhibitions in China but I couldn't enter the mainstream; official artists had to make pictures that praised heroism or something, and I couldn't make the cut. I was in things like a national public-safety exhibition, where I made a carving of a policeman and his dog. It was a wooden relief set upon a shield, which I then painted (*Shield*, c. 1984). This work even won an award. I also entered a physical education exhibition, where I made a very big painting of weightlifter with his mother, very small, next to him. In Shanghai I entered another exhibition connected with sports; I painted tiny mountain climbers through the perspective of a pair of binoculars. You could even see their minuscule footsteps in the snow, but if you looked far up the mountain top you'd see the climbers had fallen off: only the empty hook was left. That one didn't make it into the show.

Octavio Zaya So this was the type of work you were making just before you decided to move to Japan, in 1986?

Cai Guo-Qiang I was also already experimenting with gunpowder and trying out other things as well. For example, I used an electric fan on oil paint, fanning it to create 'whirlpools' and other effects. The fundamental idea behind my work has been to borrow power from nature. Sometimes I'd take rubbings of rocks or tree roots on canvas before painting it. Sometimes I'd put gunpowder on the canvas and have some kind of explosion on top of that. The idea was always to derive energy from nature. Out of that came the idea of investigating the accidental, that which cannot be controlled. This was a release from the repression and pressure that I felt around me. It was also an attempt to distance myself from traditional Chinese art, which is very much concerned with controlled form. I wanted to investigate both the destructive and the constructive nature of gunpowder, and to look at how destruction can create something as well.

Octavio Zaya What brought you to Japan? Was it your intention, from the beginning, to stay there for so many years?

Cai Guo-Qiang No, I didn't intend to stay there for such a long time – nearly nine years. It was only after the events in Tiananmen Square in 1989 that I decided to stay for a while. Before then, even though I started to receive exhibiting opportunities there, Japan didn't hold more attraction for me than China. I didn't feel things were much better there than in China. My objective at the time wasn't so much to go to Japan as to leave China; it could have been anywhere. I always say it's not that I chose Japan; Japan chose me.

Octavio Zaya Visiting Japan was an extension of your tour of rural China, in a way.

Cai Guo-Qiang Yes, exactly. It was a kind of spiritual self-exile. While in Japan I began to establish a relationship with an art audience, to assume a more professional

position in society as an artist, and eventually I became very active and achieved some prominence.

Octavio Zaya *By then you were already experimenting with gunpowder, which some critics explain from an autobiographical point of view. In the Fujian province, where you come from, there's an important Chinese army base positioned across the strait from Taiwan. You once told me that as a child you'd seen many fighter planes and that the sound of cannon shots was common. You grew up around explosions: hearing them, seeing their destruction, smelling their power.*

Cai Guo-Qiang Yes, and moreover, in China every significant social occasion of any kind, good or bad – weddings, funerals, the birth of a baby, a new home – is marked by the explosion of fireworks. They even use fireworks when they elect Communist party officials, or after someone delivers a speech. Fireworks are like the town crier, announcing whatever's going on in town.

Octavio Zaya *There was also the violence of the Cultural Revolution, in full swing while you were growing up.*

Cai Guo-Qiang I saw gunpowder used in both good ways and bad, in destruction and reconstruction. Gunpowder was invented in China as a by-product of alchemy. It is still called 'fire medicine' because it was accidentally created during an attempt to produce a medicine.

Octavio Zaya *An explosive force transforms one substance into another through combustion, so we're talking, as you were saying, of alchemy and alchemic experimentation, a metamorphosis of matter and spirit. Reviewing your work in 1994, art critic Yasushi Kurabayashi wrote:* 'An explosion is a magical encounter of two different elements, and a process that encompasses the eternal transformation of matter […] As an explosion is sometimes compared to the Big Bang, the instance of ignition forces us to imagine a moment without time or space, an instant before they come into being.'[1] *There seems to be an extinguishing of time, the explosion taking place both in an instant and in eternity. In your work* Fetus Movement II: Project for Extraterrestrials No. 9 *(Hannover Münden, Germany, 1992), you placed yourself at the centre of a field around which explosives were installed in concentric circles and at radial angles. What did this explosion represent to you, beyond its mere spectacle?*

Cai Guo-Qiang Two machines registered my responses during the explosion; one measured my heart rate, the other measured my brain waves. Eight seismographs were positioned around the radius of the field and another was placed in the audience area. I was interested in comparing the physiological effects before, during and after the explosion. So there's a record of all the vibrations throughout – not just during the explosion but afterwards as well. To ignite the gunpowder fuse I placed slowly burning incense near it, so the moment of the explosion wasn't directly connected with me.

 After the explosion everyone was nervous; people were concerned whether

I was still there, unharmed in the middle of all the smoke, but I was fine. There were Japanese and German scientists there who thought I practised yoga or some kind of meditation, because my heart rate was more or less the same just before and soon after the explosion. During the explosion itself I recited a passage from Lao Zi, and it felt to me like the beginning of time, the birth of the universe.

When I came to Japan my encounters with the theories of twentieth-century astrophysics were very significant to me. The concepts of the Big Bang, black holes, the birth of stars, what is beyond the universe, time tunnels, how to leap over great distances of time and space and dialogue with something infinitely far away – these ideas were still not commonly in circulation in China at the time. They were an eye-opener for me. At the same time, many of these ideas have similarities with traditional Chinese views, with which I was familiar, of metaphysics and the universe. I wanted my explosions to take place in a vast open space, as if designed to be seen from well above the earth.

Octavio Zaya *Do you experience your work mystically, as a spiritual awakening?*

Cai Guo-Qiang No, because I don't separate the physical and the spiritual so distinctly. However, I do think that art can transcend time and space, and achieve something that science cannot. The job of the artist is to create such time/space tunnels.

Octavio Zaya *You have produced other works also intended to be seen as if from a long distance from the Earth.*

Cai Guo-Qiang I made a series of such works around the time of the Tiananmen Square events, in 1989. The first of the series, *Human Abode: Project for Extraterrestrials No. 1* (1989), was done at the Tama river near Tokyo; I built a tent-like home and exploded it. *Human Abode* was about exile, about passing spiritually from this world to another dimension. Later I did a project in Pourrières, France, called *45.5 Meteorite Craters Made by Humans on Their 45.5 Hundred-Million-Year-Old Planet: Project for Extraterrestrials No. 3* (1990). There we dug forty-five and a half meteorite-like craters into the earth, filled them with gunpowder and then linked the craters with gunpowder fuses. But only with the 'Primeval Fireball' exhibition (P3 art and environment, Tokyo) in 1991 did people really begin to take notice of my projects and my ideas.

Octavio Zaya *You returned to China in 1993 to make another work in this series entitled* Project to Extend the Great Wall of China by 10,000 Meters: Project for Extraterrestrials No. 10 *(1993).*

Cai Guo-Qiang Actually we first set up a travel agency at P3 art and environment in Tokyo to fund the project. We invited people to join an expedition to the Gobi Desert, where the project was to take place. The money raised by the agency paid for

the project; the participants travelled to the desert with us and assisted us with the installation. With the help of over 100 such people, we laid 10,000 metres of gunpowder and fuse in the desert, starting from Jiayuguan, where the Great Wall ends in the Gobi Desert. The explosives were ignited at dusk, forming a new wall, of fire and smoke extending from the existing wall.

Octavio Zaya *You've often worked in site-specific situations in Japan using Japanese traditions rather than traditions that relate to your Chinese upbringing.*

Cai Guo-Qiang Yes, for example in the project *Returning Light: The Dragon Bone (Keel)* (1994), which I made in Iwaki, Japan, I persuaded local residents to excavate a ship that had sunk in the ocean about twenty years previously. In this area wooden ships are not in production at all anymore. From the old timbers of the shipwreck we made a pagoda and created an exhibition centred on the old ship. At the time, the Japanese were concerned with 'going global' and creating a Western-style super-economy based on American and European models. In the process they were forgetting their own history and people. I wanted to show how this simple fishing village by the ocean, with its own history, could be universal and international. 'Here' can be just as international and modern; contemporary culture doesn't need to come from far away.

In Mito, for the work *Universal Design: The Feng Shui Project for Mito* (1994), I invited a feng shui master to look at the whole city. We worked with the department of urban planning to identify where the problem areas were, in feng shui terms, like finding the acupuncture point on the body where healing can begin. This project inspired some faith in the local and brought awareness among residents that they could be involved in their own city's destiny.

Octavio Zaya *The Japanese embrace you almost as if you were a Japanese artist yourself; they consider you one of their most important artists from the 1990s. You are even included in surveys of recent Japanese international art, such as 'Art in Japan Today 1985–1995' (Museum of Contemporary Art, Tokyo, 1995) and 'Between Heavens and Earth: Aspects of Contemporary Japanese Art II' (Nagoya City Art Museum, Japan, and Tamayo Museum, Mexico City, 1996).*

Cai Guo-Qiang Japan and China have so many overlaps in cultural traditions, for example the Chinese and Japanese practices of traditional medicine, or the arrangement of objects in the home to emphasize balance and a holistic view of the world. However, unlike Japan, the past fifty years in China have not created the stable conditions necessary for the modern Chinese to develop their own culture; there has been only turmoil. The Chinese have not had the time to reflect upon and preserve our recent Communist and Marxist past. The Japanese have enjoyed a relatively long period of peace and prosperity, enabling them to preserve and study their culture. For example, Zen Buddhism is kept alive in Japan, whereas it is all but lost in China. What the Japanese have achieved is remarkable, whether in contemporary architecture, music, fashion or design. Yet at the same time, as a politically ambitious

cultural giant it has faced many asperities. Reflection on their loss of traditional values has influenced me a great deal.

Octavio Zaya　*We met in 1995, when you were about to leave Japan and move to the United States. Did you have any expectations when you arrived in the States?*

Cai Guo-Qiang　Not really. My biography at that point was of a Chinese person active as an artist for many years in Japan and who had also worked a bit in Europe. It was clear to me that the twentieth century is the American century; I thought it would be a good place to stay and live in for a while. The contemporary art system is so different here in the States; everything is different, from the exhibitions to the institutions, galleries, collectors and media. Art is like an industry over here. It's like the official army, whereas in China, art is like the underground guerilla forces and in Japan it's more like the militia. In Japan I could work with people on the streets who would help with the projects, I could motivate ordinary people to work with me. Here it's different, everything is so professional. If you want to hang something on a wall you have to have a licence; if you want someone to pick up a rock they have to have a licence. Everything has to be done 'professionally', and this has probably caused a shift in my work. There are fewer grass-roots projects. And because of the language barrier and cultural differences, I tend to focus more on visual impact. Besides, as my concern for the universe decreases, the cultural and humanistic concerns in my work have increased. Some critics have noted that I've returned from the heavens back to earth.

Octavio Zaya　*The first work you made when you arrived in the States was a series of photographs,* The Century with Mushroom Clouds: Project for the 20th Century *(1996). Besides the obvious reference to the atomic bomb, this work opened up a new relationship with reality in your work in terms of a larger awareness of political and social issues. I can trace this same concern in the most important works that you produced in the following years, such as* Cry Dragon/Cry Wolf: The Ark of Genghis Khan *(1996) and* Borrowing Your Enemy's Arrows *(1998).*

Cai Guo-Qiang　The *I Ching*, as suggested by its translated title *The Book of Changes*, is about theories of change. The Chinese ideogram for *I* literally means *change*, and this pertains to everything in the universe. I am no different. When I'm in a new situation my methods and concerns change with that environment; the work *The Century with Mushroom Clouds* reflects this shift when I moved to America. I felt that the mushroom cloud was one of the most important symbols of the twentieth century. After the destruction of Hiroshima and Nagasaki, military use of nuclear technology continued in the form of a 'deterrent' or threat. In a sense the mushroom cloud became increasingly conceptual, rather than real, as time went on. It becomes like the Great Wall of China because, practically speaking, the Wall doesn't really keep the enemy out. Once you climb over the wall, no matter how long it is, you've got across.

But strategically and politically it's extremely important to have this thing there. Displaying power, imposing power, is extremely important.

For the first 'mushroom cloud' explosions I made when I came to the States, I used the cardboard tubes inside a roll of fax paper and some gunpowder I bought in Chinatown. These works showed me that it's really not about physical size, but the precision of one's perspective and focus.

Then came *Cry Dragon/Cry Wolf: The Ark of Genghis Khan*, a relatively large-scale work for my first US museum exhibition ('The Hugo Boss Prize 1996', Solomon R. Guggenheim Museum, SoHo, New York). The work retraced backwards the journey of Marco Polo, the first Westerner to visit the East and return with tales of his travels. Here someone from the East came to the West, like Genghis Khan. At the time of the exhibition the Asian economy was very prosperous and China was just emerging as a new world power. There was some concern expressed by the American media that Asia might take over as the leading world power in the twenty-first century, reflected in the front-cover news stories of magazines like *Time* and *Newsweek*. Often the dragon was used as a symbol of China and its assertion of power in relation to the West. Of course the title of this work is taken from the story 'The Boy Who Cried Wolf', using a play on words to suggest it might be a dragon that's coming instead of the wolf, and that it may arrive when you're least prepared. Of course the East thought that its time of world dominance had finally arrived, but I felt this assertion was a bit premature, exaggerated and arrogant.

The work was made of 108 sheepskin bags and three Toyota engines, which formed a dragon that rose up from the ground. The engine motors powered the entire floating dragon from behind, giving a sense of threat and excess. The work referred to the symbolic Chinese dragon, using two elements. The first was a reference to the use by Genghis Khan's soldiers' of vessels made of sheepskin. Normally they would use these to hold drinking water while travelling, but when they came to a river they would fill the vessels with air and use them as flotation devices. When they were faced with a large river they could very quickly assemble rafts using these air-filled floats. This is how they were able to advance rapidly across vast areas, all the way to Europe and the borders of Egypt. The second element is a later, more modern mode of transportation: the Japanese car, for example, the Toyota, which is a very popular, economical and reliable form of transportation. With the manufacture of these cars the Japanese could penetrate economically into many countries – a different kind of 'invasion'.

For the 1997 Venice Biennale I made a work called *The Dragon Has Arrived!* It was a pagoda that looked like a missile taking off. The pagoda was a reincarnation of the 1994 tower I made in Iwaki, Japan, which was first shown in *Returning Light: The Dragon Bone (Keel)* in three separate parts. Later, in 1995, at the Museum of Contemporary Art, Tokyo, it was shown stacked together in one piece. This time, the tower took flight; Chinese flags

were added to the tail and these looked like the fire of a missile at take off. I often recycle earlier work if the opportunity arises, so that it continuously morphs into new lives.

Octavio Zaya *What about* Borrowing Your Enemy's Arrows, *which some critics characterized as a nationalistic piece?*

Cai Guo-Qiang *Borrowing Your Enemy's Arrows* was a work on Chinese philosophy. When I made it in 1998 I had already lived in the West for a few years, so some people thought there was a biographical element in the work. Several people asked me if this work reflected my own history and feelings, but at the time I was thinking mostly of the trauma of cultural conflict and the price you pay for opening up. The other aspect of the work is the idea of using the strength of one's opponents to empower oneself, as in Chinese martial arts in contrast to Western boxing. I'm interested in exploring these opposing dynamics in my work. *Borrowing Your Enemy's Arrows* is a wooden boat suspended in mid-air, struck with 3,000 arrows and with a red Chinese flag at the tail end, blown by a small electric fan. Even though you feel that the arrows symbolize wounding and pain, at the same time the boat is uplifted; the feathers of the arrows enable it, as it were, to take flight. So there's a beautiful contradiction which resembles elements in Chinese martial arts. To describe it in basic terms, in Western boxing if the opponent is hit in the face hard enough he falls, so it's easy to decide who's won. In Chinese martial arts it's much more complex, more internal. The exchanges are more subtle, often using the opponent's own force to defeat him. *Borrowing Your Enemy's Arrows* was perceived by much of the Western media as a very nationalistic work, pitting Chinese against Western culture, but I didn't perceive it this way. I don't believe it's the responsibility of art to make judgements on right and wrong. I'm merely highlighting cultural phenomena during a time of transition and change.

Octavio Zaya *Another work of that time,* Cultural Melting Bath: Project for the 20th Century *(1997), which you presented at the Queens Museum in New York, was more irresolute, less obvious in its implications.*

Cai Guo-Qiang *Cultural Melting Bath: Project for the 20th Century* was another work that aroused varying reactions when it was installed differently in Europe, the United States and Japan. Nine large *taihu* limestone rocks, used in the traditional Chinese art of gardening, were arranged in the gallery as miniature landscapes, creating a space for the free flow of *chi* or vital energy. A jacuzzi was placed in the centre of the space, containing water infused with herbs that are beneficial to the bathers' skin. A large transparent curtain or net separated this work from the rest of the museum. Birds actually lived inside the net, and this resulted in a very strange space for the audience. I first used *taihu* rocks for a show at the Louisiana Museum of Art, Humlebaek, Denmark for the piece *Flying Dragon in the Heavens* (1996). Denmark has

a good social welfare system, with a stable society and relatively little social conflict. So, for the show there I leaned towards using aesthetics, rather than politics, as a topic of discussion. The show was about using what is there to reveal what isn't; in other words, the stones were not the most important element in the work, but rather I highlighted the spaces created by the rocks. The audience is invited to walk amongst the rocks while flying kites. The change in energy flow created by the rocks was perceptible through the way the kites behaved as one walked through the space. This method also related to Chinese traditional painting: when the ink hits the paper with a brushstroke, the dark area doesn't only convey its own darkness but refers to the contrasting white surround that is also 'created'.

When it was to be shown in New York, I felt that the *Cultural Melting Bath* as it was could not establish a dialogue with the vastly different social realities of American life. Without a dialogue, without some friction with reality and the immediate context, the work would lose its power and spirit. So in this version I added an American jacuzzi. It still looked beautiful, like a traditional Chinese painting, complete with the sound of bubbling water. The work really becomes interesting, however, when you're in the water taking a herbal bath with a group of people; that's when the friction occurs and the work has the most resonance. Being in America, bathers had to sign a form to waive the museum of any responsibility, in their health or otherwise, related to the communal bathing. Once in the bath, exhibition visitors found themselves with people of totally different cultures and backgrounds; the work set up a direct relationship with the conditions of living in America. It's the idea of the cultural melting pot of New York.

When the work went to Japan it took on yet another form. The Japanese love taking hot baths together without the fears of contagion that the Americans have, so the conditions were different again. This time I set the piece outside, drawing on Japan's island relationship to the ocean. The rocks were arranged according to feng shui principles; the site has now become a meeting point for museum staff and locals beyond the use of the jacuzzi. This version of the *Cultural Melting Bath* returned the work to aesthetics, about traditional Asian ideas in a contemporary setting.

I often feel that I'm in a state of sway, like a pendulum. On one side of the pendulum is my own cultural history and background, as it faces a new era and new challenges. How do we raise new points of departure from within to advance and extend the East? On the other side is my experience in the West; its concerns have become mine and I can't help but address its dilemmas as well. Sometimes these two sides oppose each other; sometimes they overlap.

Octavio Zaya *Now that you have been living in the States for a few years, how do you see yourself in the context of American art? Many have compared your work – not so much the work you've produced recently in the States but the earlier, large-scale outdoor interventions – to Land art. How do you relate to this movement that was so pervasive especially in the US in the late 1960s and 1970s?*

Cai Guo-Qiang In America I haven't had the opportunity to make many outdoor works; mostly my works have been inside the museum walls. The photographs of *Century with Mushroom Clouds* may look like Land art, but the starting point of this work is grounded in rather different political and social concerns. I actually visited Robert Smithson's *Spiral Jetty* (1970), and made a 'mushroom cloud' there. I was interested in the fact that, at the time Smithson and others were making their large-scale land works, nuclear tests were being conducted relatively nearby. It's easy to make a connection between my work and Land art because of the large scale they both share, but I see the scale in my work as connected mostly to my Chinese background. The Chinese like making things on a grand scale – the Great Wall, for example. It's part of our culture and it reflects the fact that China is such a large land mass. Also, during the Cultural Revolution many things were done on a very large scale, such as the huge portraits of Chairman Mao. Moreover, everyone carried Mao's portrait and hundreds of thousands of people took part in parades, holding the little red book or the portrait, so there was a sea of Mao images. As a child I remember participating in such events, and we certainly weren't referencing the West. During the Cultural Revolution an army stationed near my home town carved an 80-metre-high portrait of Chairman Mao on the side of a mountain; the villagers could see their leader watching them at all times. But the sculpture was stopped because birds and animals would roam across his face and leave their droppings; it was unacceptable to have animal droppings all over your leader's face. But to this day, when I go home I can still see the face of Chairman Mao on the side of the mountain. One day, when I get enough money, I'll buy this mountain and become a collector of Cultural Revolution Land art.

Octavio Zaya *How do you combine being an artist of your generation with the long artistic traditions behind you?*

Cai Guo-Qiang I think the bottom line of being an artist is the passion for art we had when we were very young. I loved looking at works by Cézanne, Picasso or El Greco. I'm envious and moved by their ability to change their times through painting. But I'm even more moved by their continuous life path, following the dream they had as young men. I've been called an installation artist, but I still love painting, and often search for new possibilities of painting, as I did in *Still Life Performance* (2000), at the Sydney Biennale, where painting was turned into performance. On the other hand, for many years I've maintained the practice of drawing on paper, which stems directly from my early childhood passion for working on a two-dimensional surface. The proposal drawings for *Projects for Extraterrestrials* are particularly special since the works themselves cannot be realized. These allow me to treat the drawings as independent works on their own, instead of as a means to an end.

Octavio Zaya *You said earlier that everything is constantly changing; the only thing that doesn't change is change itself. Nevertheless one can't help but try to hold on to something*

that is unchanging. Human beings feel the need for some form of continuity. Your work lacks this; it's in a constant state of change because you're changing, the context is changing: everything is changing, as you say. Sometimes you recycle one work into another, sometimes you contradict one work with another, sometimes you're closely involved in the reality of everyday life, and sometimes you position your work in outer space. There's a kind of pull and push, a coming and going, a yin and yang that pervades your work. What holds it together?

Cai Guo-Qiang My interests don't lie in the continuity of how things appear, whether it is in form, materials, concept or style. Yet unity can be found in my approach and attitude. Eastern philosophy says: 'No law is *the* law, no method is *the* method, and all laws go back into one.' The attempts today to discover the laws governing the universe or society through the concept of chaos are in line with my own thinking. I often think about using this multi-method way to find something that is true, to reveal what is concealed behind appearances. It's similar to what scientists search for in the interrelationship of all things in the universe. This is a very symbiotic way of looking at the world. Whether I use traditional Chinese medicine or feng shui, I always aim to find this symbiotic relationship between things and to bring them together. You cannot use a purely analytical method to understand my working process because it's filled with contradictions. But the holistic and collective approach embodies these contradictions. The process comes out of the work itself, which is constantly in progress. Perhaps we can say that my contradiction-ridden work reflects the contradictory nature of our universe and society.

1 Yasushi Kurabayashi, 'What Is "Open System"? – To Identify It with Artists' Works', *Open System: Mito Annual '94*, Art Tower Mito, Japan, 1994

Maurizio Cattelan *Nancy Spector*

in conversation
April 1999, New York

Nancy Spector *Maurizio, I sense a certain reluctance about being interviewed.*

Maurizio Cattelan My issue is not with the principle of the interview. Rather, I don't think I have anything interesting to say. When I read other interviews, there are always parts that strike me, and I ask myself, 'Why don't I just take this section since it's so interesting? I certainly can't do any better on my own.' The idea then is to reorganize something already there, re-present something that already exists. I'd be happy to do this now. We just have to think about which interviews we like and which ones we can use.

Nancy Spector *I find it strange then that you asked me to interview you for your monograph if it were going to be a cut-and-paste operation. I know that the artist's interview is a fundamental component of this book series so the editors must have discussed this process with you. What were you thinking initially?*

Maurizio Cattelan Well, they reviewed a list of names with me and I selected yours, since your office is close to my apartment. It's a matter of convenience.

Nancy Spector *I'm going to ignore that remark. Does this mean that earlier published interviews with you are borrowed from other sources, pilfered from other artists? For instance, what about the interview conducted by Giacinto Di Pietrantonio in which you discuss your education in Paris?[1] Does this mean that you never studied film theory with Roland Barthes, Michel Foucault, Jean François Lyotard and Gilles Deleuze, as you claimed? I did think your chronology was a bit suspect. If we do decide to proceed with this strategy, I have to admit that I'll be concerned. I'm liable for the truth of my statements as well as yours.*

Maurizio Cattelan But, you see, the truth is not out there. It's just the moment that you claim something as your own. This is my truth; that is yours. Besides, if we use other materials, you will still have the opportunity to observe how I work, and I will have the opportunity to learn more about other people.

Nancy Spector *Are there other artists whose work intrigues you enough that you want to adopt it as your own?*

Maurizio Cattelan The problem with that question is that I am not an artist. I really don't consider myself an artist. I make art, but it's a job. I fell into this by chance. Someone once told me that it was a very profitable profession, that you could travel a lot and meet a lot of girls. But this is all false; there is no money, no travel, no girls. Only work. I don't really mind it, however. In fact, I can't imagine any other option. There is, at least, a certain amount of respect. This is one profession in which I can be a little bit stupid, and people will say, 'Oh, you are so stupid; thank you, thank you for being so stupid.'

Nancy Spector *What you are describing is a classic characteristic of the clown, the court jester who entertains through calculated buffoonery. Your self-derision or exaggerated humility, whether ironic or not, aligns your project with a tradition of clowning which has particular resonance in Italian culture, with its emphasis on the fine*

*line between tragedy and comedy. The curator Laura Hoptman has placed your
work in a trajectory that includes* commedia dell'arte, *Pirandello, Dario Fo and
Roberto Benigni. To that I would add the character of Auguste from Federico
Fellini's film* The Clowns, *the quintessential underachiever and self-styled hack
with a painted smile and real tears.*

Maurizio Cattelan The tears are very real. Sometimes I don't feel comfortable with myself.
I think that maybe I don't know myself very well but then I realize that
I know myself all too well. Problems can seem very dark and the solutions
are very far away. Sometimes I feel that I have to take a break from my life,
a break from being me. That's when I go to the movies, where I don't have
to think about things. It gives me eighty-eight minutes to escape from
myself, whether I'm laughing or crying.

Nancy Spector *Does this stem from your relationship to your art?*

Maurizio Cattelan No, the work sustains me. When I come up with something, the work is
extremely exciting for me for at least two or three months. Such a joy!

Nancy Spector *So what's making you happy now?*

Maurizio Cattelan A fakir and a football team. For Harald Szeemann's Venice Biennale (1999),
I'm planning to show a fakir – a mystic capable of unbelievable acts of
endurance. He will be buried in the ground with only his hands showing in
a gesture of prayer or meditation. And for my show in London at Anthony
d'Offay Gallery (1999), I created a big untitled granite plaque, similar to
the Vietnam War Memorial in Washington, DC. Carved into it are all the
defeats of England's national football team. I guess it's a piece which talks
about pride, missed opportunities and death, in a certain way.

Nancy Spector *The memorial reference could also relate to the fact that there has been so much
violence associated with the game in Britain.*

Maurizio Cattelan And also the violence that will be associated with this show!

Nancy Spector *Are you expecting the audience to be upset by your monument to failure?*

Maurizio Cattelan Generally I try not to expect anything. But I'm afraid some people will get
upset. First, because I'm Italian; second, because football is one of the two
or three subjects that you can't touch; and, last but not least, because they
think it's a stupid idea. People want artists to come up with brilliant ideas,
and the wall is not that brilliant. It's a monument to my failure as well.

Nancy Spector *With both the fakir and the football memorial you are treading
on sacred territory.*

Maurizio Cattelan Not really. It's like pointing a gun at an ambulance or insulting your own
mother. It's considered outrageous, but it seems like everyone does such
things once in a while.

Nancy Spector *Your work is highly context-specific, in that it speaks directly to a particular culture in a particular time and space. Or, to use a militaristic metaphor, it is like a missile aimed at the heart of a specific cultural practice or belief.*

Maurizio Cattelan Not necessarily. I really just take advantage of the exhibition situation. Because I don't have a studio, I use shows as a means to get work produced. Every commitment to exhibit becomes a challenge for me. If I don't have any commitments, I don't do anything. In some ways I'm lazy. I use my head only if I really have to. My creative process, as they say, usually starts with a phone call. I call a gallery, ask for an exhibition date, and only then do I start thinking of a project. I send the description to the gallerist. He or she phones back, we discuss it a bit. After all this, I start looking for people to produce the work. I never touch the work myself; it's out of my hands. Of course, I would prefer to have a kind of unmediated representation, but this is not possible, given my process. The meaning of the work is really out of my control. I prefer to borrow someone else's interpretation. After all, you shouldn't be interviewing me. You could ask different people to come up with an interpretation of my work. They would know better.

Nancy Spector *That would be one approach, but it avoids any culpability for the work on your part. However, it is helpful to think of the objects and actions that you put out into the world as narrative devices, as triggers for stories that might differ from viewer to viewer.*

Maurizio Cattelan Yes, this is more interesting, maybe. I like all the little stories behind the work. They make it more alive. I like faces and legends more than I like artworks. In 1998 I did a project on the campus of the University of Wisconsin, Milwaukee, for its Institute of Visual Arts. The project engendered a long story, almost a novel. When I arrived there, first I wanted to show a series of films. I wanted to steal these films from the cinema at the university. But something went wrong with the equipment so I had to come up with a new idea in a couple of days. I decided to build a sculpture out of rags and old clothes; it was an effigy of a homeless man – *Kenneth* (1998). I left the poor guy near one of the campus buildings. The next morning it turns out that someone had stuck a sign on my sculpture, complaining about the tuition increase at the university. The homeless had become a kind of symbol in a struggle I knew nothing about.

After that, neighbours started to complain about my piece, until eventually someone stole the sculpture, leaving only its shoes. So the police took over the situation; there were officers looking for a missing sculpture. A perfect plot, isn't it? The police found two different sculptures and neither of them were mine. The next day a new sculpture pops up, carrying a sign saying something like, 'We don't need an Italian to teach us what art is.'

Actually when I first made this piece, in Italy – *Andreas e Mattia* (1996) – I received some really different reactions. It was another story but with the same cast of characters: a policeman, some neighbours, a homeless man. Some people were upset and called the police to complain that no one was

taking care of this poor old person on the street. So they went to check on his condition and started shaking him, saying, 'Hey, hey, wake up. It's time to go.' And when he didn't move, they thought, 'My God, he's dead.'

At times I like the idea of taking these stories a step further and creating a sequel. I have actually been thinking about a work I could do in Buenos Aires which would involve installing ten to twenty fake beggars around the city in the early morning and then gathering them at the end of the day in order to collect the money they received.

Nancy Spector *Your work provokes such stories to unfold. While you claim that your art is not necessarily context-specific, I would say that it addresses certain situations by intervening and becoming a deliberately provocative presence, an irritant that refocuses one's perception. How else would you describe the fun-house version of Georgia O'Keeffe (*Georgia on My Mind, *1997) – complete with bulbous head and exaggerated features – which attended the opening of the second SITE Santa Fe, just blocks away from the new museum devoted to her work? Or the masked character of Pablo Picasso (*Untitled, *1998), doyen of high Modernism that he is, greeting visitors to The Museum of Modern Art like a mascot for some theme park or sports arena?*

Maurizio Cattelan Oh my God, no, no. I don't think so. I don't think of the work as intentionally provocative. What other works do you consider provocative?

Nancy Spector *What about the time you had your gallerist Emmanuel Perrotin wear a giant rabbit costume that doubled as an immense, flesh-coloured phallus for the duration of your exhibition in 1995 – a work that you called punningly* Errotin, le vrai lapin, *meaning 'Errotin, a true rabbit'? Tell me you weren't poking fun at the artist/dealer relationship or critiquing the erotic cycle of distribution and consumption that is inherent to the gallery system.*

Maurizio Cattelan Actually, I think that piece lacks any provocation; it has a zero degree of subversiveness. It's just a comment on the private life of this dealer. It was a game played between two people; that's all. It was fantastic because he was willing to go along with it; he laughed with me. It is very well known in Paris that he is a perpetual womanizer. So nobody thought for a second that it was a provocation. It was nice of him to allow himself to be presented in this ironic manner. However, I guess if you saw the performance from the outside, it could seem provocative. The viewer might feel that he or she is being treated like an arsehole or that the gallery is a place where some kind of bizarre theatre takes place. There is always this tension in my work, between my intentions and reality, between what I wanted and what people end up thinking.

In terms of the Picasso piece at MoMA, I felt that there was simply something missing at the museum. I didn't understand why they didn't embrace a more visible means of marketing and promotion. They shouldn't be ashamed. I think it's something that we will be seeing more of in years to come. What does it mean to be a cultural institution? Don't they want

more visitors or do they just want to be boring? In any case, they are already selling coffee mugs, T-shirts, calendars and posters. I don't think it's such a sin. The Picasso figure was very popular; lots of people were taking pictures of themselves with him, as in the photos you take standing next to Disneyland characters like Mickey Mouse. It shows that people always want a different kind of memory of this place, a more personal memory. If the Picasso figure did anything, it was to promote the museum as a friendly place. *Georgia on My Mind* was a much smaller gesture, a rehearsal in a way. I don't usually repeat the same work twice, but the situation called for it. However, this work wasn't perfect. The head was made in the carnival tradition and it was meant to be playful, but in Santa Fe the figure became a ghost.

Nancy Spector *Wasn't your contribution to Sonsbeek 93 in the Netherlands rejected because the work was considered too incendiary?*

Maurizio Cattelan That's true. But again, the intention was not to irritate. For this exhibition, I proposed using the entire city as a chemical experiment about fear. I had gone to Amsterdam on my way to Sonsbeek and while there I had casually eaten some cake, without knowing that it had been laced with some drug. For one day I was completely out of it. The experience was so surreal and intense that I thought afterwards, 'Yes, this is what I want to do for the Sonsbeek exhibition.' I wanted to alter people's perception of the city in this total, all-encompassing way. But at first I didn't know how I could accomplish this without using a drug, without lacing a cake for all to eat. Then I realized I could cover the entire city with a poster campaign and decided to use one that advertised an underground meeting of neo-Nazi skinheads during the week of the opening. I thought this was perfect because the neo-Nazi reference would create a fiction of a fiction, as long as nobody knew that it wasn't for real. I had this kind of experience in Amsterdam and thought it would be interesting to emulate it in some way for a large number of people.

The opening of the show was scheduled to include a visit from the Queen, so there was already a massive police presence, which might have made the whole thing more believable, more hallucinatory. So everything was perfect. But the curator didn't like the idea of neo-Nazis. She thought it was too strong a comment about the Second World War and about the atrocities that they hadn't experienced there directly. She said that I had no right to use those symbols. It was too presumptuous. In a way, she was right. But in another way, it was an overreaction. Nevertheless, they kicked me out.

Nancy Spector *You must have been aware of the political implications of invoking neo-Nazism and, by extension, the Holocaust, in such a context even if you were, as you claim, just trying to create an altered reality. Even the most sincere attempts to mine the Nazi past through humour are met with scepticism and anger. Think of the recent objections to Roberto Benigni's Holocaust film,* La vita è bella *(Life Is Beautiful, 1997) on the grounds that such subject matter cannot be treated lightly. I am*

citing this example in particular because you are often compared to Benigni,
Italian satirist that you are.

Maurizio Cattelan I'm not really sure satire is the key to my work. Comedians manipulate
and make fun of reality, whereas I actually think that reality is far more
provocative than my art. You should walk on the street and see real beggars,
not my fake ones. You should witness a real skinhead rally. I just take it; I'm
always borrowing pieces – crumbs really – of everyday reality. If you think my
work is very provocative, it means that reality is extremely provocative, and
we just don't react to it. Maybe we no longer pay attention to the way we live
in the world. We are increasingly … how do you say, 'don't feel any pain?'
… we are anaesthetized.

Nancy Spector So, to some extent you see yourself as a chronicler of society's ills. Such was the
traditional role of the fool, the town clown or village idiot, who through the
hilarity of his gestures provided an inverted and ironic mirror for contemporary
culture. Is this what you had in mind when you exhibited the rubble from an
explosion in Milan as your artwork?

Maurizio Cattelan This work (*Lullaby*, 1994) was for my exhibition in London at the Laure
Genillard Gallery in 1994; a version was also made for a group show at the
Musée d'Art Moderne de la Ville de Paris (1994). The year before in Italy we
had had a wave of Mafia-related terrorism. The Mafia, or whatever it was,
singled out three characteristic cultural venues to bomb. One was in Rome, at
a historic church, another in Florence, at the Palazzo Uffizi museum, and the
third was in Milan, at the Padiglione d'Arte Contemporanea (Contemporary
Art Pavilion). The bombing in Milan had fatalities; five people were killed
in the explosion. At the time, I was really shocked: it was so well orchestrated.
 It was the first time that I was exhibiting outside of Italy, so I thought,
'Why don't I bring something from my country as a snapshot?' What could
that be? I decided to bring rubble from the explosion as this snapshot of
my country. I packed it in two different ways, like an official shipment. The
rubble for Paris was loaded onto a pallet and wrapped in plastic; the London
shipment was in a big blue industrial bag. It looked like a huge laundry bag.
It was like a laundry grave: it made me think of the kinds of bags hospitals
have to use to transport contaminated laundry. The reaction to this work
was immediate and unpleasant. It received strong attacks from the Italian
press, who claimed I was looking into the garbage bins of our bad history,
or something like that.

Nancy Spector James Joyce described history as a nightmare from which he was trying to awake.
All your work seems like an effort to break away from the burden of history, a
never-ending escape. Just think of your participation in the 1997 Venice Biennale,
organized by Germano Celant. Some of the father figures of Italian contemporary
art – Mario Merz, Giulio Paolini and Gilberto Zorio – were in the main
international exhibition, while Enzo Cucchi, Ettore Spalletti and yourself were

representing the second and third generations in the Italian pavilion. The whole enterprise made me think of Harold Bloom's book The Anxiety of Influence, *in which he filters the literary canon through the Oedipus complex, claiming that each generation of authors must annihilate its fathers.*

Maurizio Cattelan Oh, that's important. We have to kill the father – otherwise we have to lick his feet.

Nancy Spector *Which did you do in Venice?*

Maurizio Cattelan A little of both, it was in-between. I tried to make my fathers laugh, while taking away some of the space devoted to them. Or maybe I was over-reacting because I am afraid of big machinery like the Biennale. Venice was always a nightmare for me, even the first time I went there. There is so much pressure, especially because I'm Italian. In the end, it's just a big fair. It's like a big window where all the people come to stare.

Nancy Spector *The first time was in 1993 when you were in Francesco Bonami's section of the Aperto. You sold your space to a perfume company for their advertisement?*

Maurizio Cattelan Yes, but that wasn't very premeditated, nor was I in it for the money. I just didn't know what to do; like that Beck lyric, ' I'm a loser baby, so why don't you kill me?' It was such a big space and I was so young and inexperienced. Francesco was brave, in a way, to let me do it. Actually, I'm sure he didn't like it. I didn't like the work either. But it saved my arse. In the end, I was probably looking for something more formal and poetic.

Nancy Spector *Were you making a pointed commentary on the commercialization of the art world and the proliferation of these immense international exhibitions with your intervention?*

Maurizio Cattelan No, not at all, but this is what people thought I was doing. I was just thinking about what Venice was for me at the time and I just tried to make this clear. The 1997 Biennale was, for me, very exciting. And I think Germano Celant's idea of mixing generations was the best solution to the Italian problem. Ultimately, the struggle for me was that there always seemed to be another room to do. Everyone thought this would make me happy; every day they would say, 'Here is another 200 square metres for you.' I thought, 'Are you crazy?' What could I do? Instead of feeling empowered in a situation, I felt like all the energy was being drained out of me. It was as if they wanted me to *buy* the space this time. I had got away with it once in 1993, but for the 1997 Biennale they really wanted me to sit down and do something.

Nancy Spector *How did you arrive at your solution for filling the galleries with stuffed pigeons, which seemed at the time to be a very audacious, yet humorous, gesture?*

Maurizio Cattelan I had gone to see the pavilion in Venice about a month before the opening of the exhibition. The inside was a shambles and it was filled, really filled, with pigeons. For me as an Italian, it was like seeing something you're not

supposed to see, like the dressing room of the Pope. But then again that is the situation in Venice, so I thought I should just present it as it is, a normal situation. And of course, where there are pigeons, there is pigeon shit.

In the end, I thought that intervention was almost enough. I would have liked to place the birds all over the international exhibition, but there were limits. I guess if there was anything really provocative about this work it was in its relationship to time. Time doesn't affect this place; basically all the Biennales look the same. If I could, I would love to set up the same show twice in two consecutive Biennales. I think that no one would notice. So I installed the birds and the birdshit to prove that everything stands still in that place, that 'Time goes by so slowly' – that's another song.

Nancy Spector *You have pointed out a few times that you don't like to repeat your work. Each installation, object or action seems to have its own reason for existing. Even so, it is possible to trace certain motifs or strategies that recur throughout the work, such as the use of stuffed animals or your recourse to theft. How do you decide when a work is complete, and that you don't need to revisit it?*

Maurizio Cattelan Well, certain pieces simply can't be repeated. Ideally, when I work on something new it should be really exciting for me. It's like with a new lover: the first time, it's okay, the second time a little better. But after two months, it's … Jesus! So the work is like this. I get struck by an image. It's something that hits my imagination and then the day after it's still in my imagination. It is keeping my imagination hooked. In the end, I can't reduce this image or forget it. So I start working. I begin by thinking of all the possibilities and then I try to clean the idea. I try to find a synthesis of the idea. This is the most difficult thing. It happens though, a few times at least, every ten years or so.

Nancy Spector *What constitutes a successful work for you?*

Maurizio Cattelan I like it when the work becomes an image. I make a distinction between works that function as an idea or a project – like the soccer memorial wall for London – and those which get transformed into a memorable image. These are more readably repeatable, like the tree I made for Manifesta 2 in Luxembourg (*Untitled*, 1998). It started as something I just wanted to see; a huge clump of earth, a real piece of the earth, with a tree growing out of it, as if you could glimpse it from below the ground.

When I first thought of the piece, I imagined a more natural shape than what they constructed in Luxembourg. They made a cube out of the earth, and I found the cube too related to art – after all, I created this piece over the phone. But when I showed it again at the Castello di Rivoli, Turin, with a rounder, less rigid base, it worked much better for me. Since I don't have a studio, I have to work these things out in the public eye. Every time I produce a piece, I show it at the same time. I see the piece for the first time in the exhibition. That's when I assess the failure, if it's a failure.

When I arrived in Luxembourg, it was crazy. There were 2,000 kilos of

earth on the second floor. There were structural problems, technical problems, organizational problems. Then, when it was done I thought, 'Okay, now we'll see what the result is. If I get another chance, I'll want to make it better.' It's as if my exhibitions are my studio. I think that many pieces of mine are public failures. Some things could have been better, presented in a different way. For example, my horse suspended from the ceiling. The first time I showed it, as *The Ballad of Trotsky* in 1996, its legs were normal length. But the second one, *Novecento* (1900) from 1997, has very elongated legs, and I think it works much better. This piece functions very much as an image for me. The first one may have been lighter, but the second has this kind of energy to reach the ground, to participate in the place itself. So it was a necessary change. It was also, let's say, a more poignant, retrospective image (the twentieth century) to give a positive future.

Nancy Spector *Your horse is just one in a string of works involving animals – embalmed animals which are uncanny in their lifelike appearance, comical yet depressing, if not unnerving. I've always thought the animals – from the sleeping dogs to the little squirrel suicide to the mice in beach chairs – might be self-referential, maybe even surrogates for yourself. Is this true?*

Maurizio Cattelan Sure, those references show up in the work – in the animal pieces, in particular. There is the ostrich (*Untitled*) I did for the exhibition 'Fatto in Italia' ('Made in Italy') at the Institute of Contemporary Arts, London in 1997. His head was buried in the floor of the gallery; he was hiding from the exhibition. It was a sort of exercise – I was taking part in a show while trying to keep a distance from it, just like an ostrich, with his head buried in the ground and his arse sticking out. The show was okay, but it opened at the same time as that big 'Sensation' exhibition of young British artists at the Royal Academy. The differences in strategy between the British and Italian artists and curators were very noticeable. I felt as if we were the poor relatives. We were forced into this stereotype of Italian art, and I couldn't really deal with it. So I did the ostrich, but I also spray-painted a new exhibition title on the outside of the building: I wrote 'Bloody Wops' across the wall. I was trying to play with the role of the Italian immigrant; but more importantly I was making a point about curators and the absurdity of these kinds of shows, telling them more or less to wake up.

Nancy Spector *How might* Bidibidobidiboo *(1996), the noir-ish suicide of the little stuffed squirrel in a kitchen, relate to you, if it does indeed relate to you?*

Maurizio Cattelan Well, I really just thought that the squirrel was a nice animal, and as usual I had to make an exhibition. I had to do something I didn't want to do. So I started thinking about putting together two different worlds: the human world and the cartoon world. The squirrel reminded me of Chip and Dale, the two Disney chipmunks who were always playing with Donald Duck. I wanted to put this squirrel into a kitchen, but I didn't know which kind to

use. I thought about something really shabby, and the first image that came to mind was my family's kitchen.

The squirrel's kitchen is my parents' kitchen. I grew up in this kitchen. There is a nice story about it. Once my mother was ironing on the dining table and forgot she had left the iron on. It had been left face down on the Formica counter top. So the Formica had an iron mark burnt into it. My father was upset with her. How were we going to repair the table? He decided to cut off the part of the table with the burn mark, reducing the table by about 15 centimetres. So from that time on our family served all their meals on this shrunken table. That image has stayed with me forever. For the title, I thought about magic words like 'bibeddy bobbedy boo', which could transform something, make something better. That time, however, the magic didn't work.

I showed the piece in London at Laure Genillard's first gallery space, which was small and intimate. I really liked the idea of placing it on the floor in the room. I also liked the idea of seeing the piece while bending or kneeling on the floor. It added a kind of spirituality to the piece. You had to look at it as if you were praying.

Nancy Spector *Do the titles of the stacked animal pieces –* Love Saves Life *(1995) and* Love Lasts Forever *(1997) – have any biographical meaning?*

Maurizio Cattelan Not really. The earlier one with a stuffed rooster, cat, dog and donkey is based on a fairytale by the Brothers Grimm, 'The Bremen Town Musicians', in which the animals each escape an owner who was threatening to kill them because they were getting old and useless. They band together to travel to town and become musicians, but on the way they trick robbers out of their hideaway and take over the house to live out their days in freedom. I thought that this pointed towards a socialist moral about how we can put creativity and friendship together and win every battle.

The second version came about almost three years later, when the curator Kasper König asked me to show the piece at Skulptur Projekte in Münster (1997). I didn't like the idea of exhibiting this piece again so I just thought about how time would have redefined the work. It seemed to me that after three years, the animals would have been reduced to skeletons, so this is what I showed: the same stack of animals – a rooster, a cat, a dog and a donkey, but as bones.

Nancy Spector *I am struck by the morbid quality of the animal pieces. I'm also thinking of your sleeping dogs, which can sometimes be found curled up on the outer edges of your exhibition spaces. For a moment one could think they were real, but then something seems amiss. Before the realization sets in that this is actually an artwork (albeit a rather bleak one), one might think the dog is dead. Of course, you know this well. Why else call the sleeping dog in your Castello di Rivoli exhibition* Morto stecchito *(Stone Dead, 1997)?*

Maurizio Cattelan My work can be divided into different categories. One is my early work, which was really about the impossibility of doing something. This is a threat that still gives shape to many of my actions and works. I guess it was really about my insecurity, about failure. We can have a chapter here called 'Failure'. Let's say that I just transformed something like failure into a work of art. A second category speaks about loss, about absence, about death. Even pieces like *Novecento* relate to this; it represents an energy that you can't utilize. It represents frozen energy. Animals are not so funny. I think they have a dark, morbid side. I'm actually finished with them. At the moment, I'm working on a piece which is a dog's grave (*Piumino*, 1999) and then the series will be over, unless I change my mind again, or I'm called to do another show.

Nancy Spector As I mentioned before, another recurrent motif in your work is theft, from actual larceny, like the time you stole the entire contents of an exhibition at Galerie Bloom in Amsterdam to include in your show at De Appel (in a piece called Another Fucking Readymade, *1996), to a kind of creative borrowing – like 'Moi-même, soi-même', your exact replication of Carsten Höller's exhibition in Paris in 1997, when your own show was happening in an adjacent space at the same time. Your kleptomaniac tendencies have earned you comparisons in the press to fictional characters like Zorro, the Artful Dodger and Robin Hood. Other critics see your blatant appropriation of others' artworks as yet another postmodernist interrogation of valuative concepts like originality and authorship, but with a mock serious twist.*

Maurizio Cattelan Actually, we are stealing right now, here in your office.

Nancy Spector How? What are we stealing?

Maurizio Cattelan Time. Aren't you supposed to be doing your office work?

Nancy Spector Well, I guess I'll have to have this time deducted from my pay.

Maurizio Cattelan Once, a long time ago when I was in Italy, I was working as a cleaning person in a laundry, and they found me washing my own laundry at work. They said, 'What are you doing here?' And I said, 'Washing! Washing my laundry! It's my uniform! Where else am I going to do it?' They fired me. This was one of the first times that I got fired. Another time was when I was working in the church of Saint Anthony in Padua. I was working in the gift shop selling little figurines of Saint Anthony, postcards and so on. I was around thirteen at the time and was with a bunch of friends. So we were taking a break and laughing. I had drawn moustaches on the little statues. And when the priests found them, they came straight to me, they didn't even ask the other twenty kids who were working with me. Basically they knew it had to be Maurizio's fault. So they came up to me and said, 'Maurizio. Why!?' Eventually, I learned to avoid being fired. By my third job, before they fired me, I fired myself.

Nancy Spector And where was this?

Maurizio Cattelan In Italy. I worked in a morgue, and I was fed up with it. I found a doctor who was willing to help me. In Italy we have a system that if you are sick and can't work, your company has to pay your salary anyway. Not bad. I was paying the doctor, and he was giving me days off; it was fantastic. I was so young and the work was horrible. It's not written anywhere that you have to work. It's not written that someone has to pay because you can't work or because you don't want to work. But that's life. I have always found a way to get things done. When I was working, I was also going to school at night so my days were often thirteen hours long. When I turned eighteen, I realized that you need time for friends, for girlfriends, you need to have a normal life. So basically I arrived at this line of work (making art) by escaping from other jobs. Art gave me my time back. And it is not so bad, but now I have to find ways to escape art.

Nancy Spector Didn't you work as a furniture designer early on?

Maurizio Cattelan Well, yes. At that point I had so much time on my hands I started to work for myself. I started to produce things for my apartment. It was something that I had never experienced before. It was a real adventure for me.

Nancy Spector Why did you stop?

Maurizio Cattelan Because I didn't like it. No, because it became too serious. Companies were calling me, asking me to design things. I tried, but it was so difficult. I was making annoying furniture for annoying companies. I found the art world much more alluring. It was like a dream. From the outside, it was really something.

*Nancy Spector I see that your life of crime has deep roots. In many of your pieces you seem to glorify the persona of the burglar, like the time you exhibited actual safes that had been picked open by thieves (−157,000,000, 1992) or when you asked the police to make composite portraits of yourself from various descriptions given to them by friends and relatives (*Super noi *[Super Us], 1992).*

Maurizio Cattelan That piece was really about how people around you perceive you in different ways than how you really are. So I was thinking about visualizing the idea of the self. The drawings really looked like me, but at the same time they were like cartoons. They were terrific. I don't know if it was a fluke.

Nancy Spector Did you learn anything about yourself?

Maurizio Cattelan No, maybe I learned more about other people. You know, the works that you mention in reference to crime have other meanings for me. The piece with the safes was really about my love for certain cops and robbers movies, and, besides, I needed an object for an exhibition. Inside of everyone there is a little thief. So it was a romantic, sentimental piece. The safe is really a magic object. It is really a projection of our inner selves. It was certainly not a comment on the art world. The show of Carsten Höller's work was, from

my point of view, more about parasitical relationships. My version of it was second generation, but at the same time, it was like giving new life to something. Mostly, it was just a comment for fun, but it was a comment without major life lessons. The theft in Amsterdam (*Another Fucking Readymade*) was more of a survival tactic. De Appel had asked me to prepare a project in two weeks. It usually takes me six months to come up with something. I just followed the rule that I told you about before: I took the path of least resistance. It was the quickest and easiest thing to do. Afterwards, I realized that it was much more about switching one reality for another. For me, the idea of stealing was the least interesting part of the project.

Nancy Spector *Your work exists in the interstices between objects and actions. It enters the art institution only to disrupt it, but that is only when you are not ignoring it entirely, working independently, inventing your own structures. Do you have an antagonistic relationship to the museum or the gallery system, or are you lovingly pointing out their contradictions from within?*

Maurizio Cattelan How can I contest the system if I'm totally inside it? I want benefits from this system. So it's like spitting in the hand of someone who pays your salary. I'm not trying to be against institutions or museums. Maybe I'm just saying that we are all corrupted in a way; life itself is corrupted, and that's the way we like it. I'm just trying to get a slice of the pie, like everyone else.

In terms of the choice between actions and objects, this is getting difficult for me as I get more and more tied to galleries. There is always the pressure to produce things, to make objects. I mean I play the game because it is the only way to have a salary, but if they force you too much, you start to do things you shouldn't do.

Let's just say I try to find a balance between objects and actions, otherwise I will lose my mind or kill myself slowly. This is why curator Jens Hoffmann and I have founded the Caribbean Biennale. I'm raising money for it now. It will provide a vacation for all invited artists. It's very simple. It will be a show because you will have your list of artists. It will be a show because there are invitations. It will be a show because there will be advertisements. It will be a show because we will do a press conference. It will be a show because, in the end, it will also take a strong position against the proliferation of all the biennales and triennales. And a vacation is a nice way to make such a comment.

It may seem like a joke, but it is really something quite serious. In a way, we are talking about morality – taking the responsibility for something, taking something that needs to be done into your own hands. Raising $50,000 is very serious. A joke may last for two minutes. This joke will cost me six months of working to raise the funds and organizing the whole thing. It's a huge commitment.

Nancy Spector *You've undertaken such enterprises before, in which you assume the functions of the institution in order to help other artists. Your Caribbean Biennale reminds me of the Oblomov Foundation you formed in 1992 in order to subsidize an artist for*

an entire year, the only requirement being that this artist couldn't exhibit his or her work for the time period of the grant.

Maurizio Cattelan Yes, it's very similar. But on that occasion, I was commenting on how a group of artists had become the 'usual suspects' by showing in every international exhibition. There must have been a photocopied list of artists who had been invited to the last three years of shows. Why bother with advertising? You don't need it. Everyone knows the list already.

This was a very early project for me, maybe too early. At that time, I really liked the idea of involving one hundred people, contacting each of them to raise funds for this grant. So I started to make a list of possible people who might help with this project. It was not so easy. You really have to have balls to make such calls to private people. So I spent four to five hours a day on the phone, saying 'Hi, do you know me?' Nobody knew me at that time. So it was really difficult to introduce myself quickly. I had to get their attention and then say, 'Could you please give me $100 for this project?' So I had to sell my position. It was another really hard job. Eventually I raised $10,000 to give to an artist for not showing any work for one whole year. The artist was selected by the donors; we even had a waiting list. But nobody accepted the grant.

Nancy Spector *What did you do with the prize money?*

Maurizio Cattelan Well, the other part of this story was that all the people were waiting for me to fuck up, to do nothing with the money, to keep it for myself. I had made a plaque with all the donors' names on it – the kind you see in museums – and I placed it outside the Brera Academy of Fine Arts in Milan. I went there early one morning with fake documents, and I fixed the plaque to the wall under some scaffolding. Those responsible for the place came and said, 'What are you doing?' I just claimed that a company had ordered me to post it. The plaque was there for a whole year. So every time I passed it, I would think, 'Hey, that's me.' It was very nice to have this piece on the wall. But the story needed an ending, so the money paid for my move to New York.

Nancy Spector *It was a travel grant!*

Maurizio Cattelan Yes, in the end.

Nancy Spector *How is it that you always seem to get away unscathed from your escapades?*

Maurizio Cattelan I just slide down the surface of things.

1 'Face to Face: Interview with Giacinto Di Pietrantonio', *Flash Art Italia*, No.143, Milan, April – May, 1988

Vija Celmins *Robert Gober*

in conversation
August 2002, New York

Since 1980 Vija Celmins has lived and worked in New York City. About four years ago she purchased a small house on a corner lot in a seaside town on the east end of Long Island. I visited her there on a sultry afternoon in August 2002. She loves her garden and I was introduced to almost every plant, bush and tree. She showed me the grave of her dog, picked beans for lunch and sat me down for our conversation in her living room.

Vija Celmins (*laughing*) So Bob – where's your notebook with questions?

Robert Gober *I don't have any.*

Vija Celmins Oh, you must have some.

Robert Gober *I started writing down questions and they were really stupid, they were so self-conscious. I have a question to start, though, about how you work. Do you work every day?*

Vija Celmins No, I don't work every day. I have always had a very complicated relationship with working – stopping and starting. I can see by your catalogues that you're much more workman-like, maybe that's because you have people working for you whom you have to feel responsible for.

Robert Gober *Yeah, I come in at a certain hour and leave at a certain hour.*

Vija Celmins So in a way, you're engaged in a little community that works with you, where I tend to be always alone in my studio.

Robert Gober *Well, that's why for the last four years I've worked in my garage out on Long Island, so that I could be by myself again. So I could do nothing and get bored all day if I wanted to, or work right out of bed at six in the morning. I needed that kind of freedom.*

Vija Celmins So do I. I am now at a point where I have to re-establish that, because I have been making prints, where there's all those people around all the time, and expectations and deadlines and so forth. And when I do that so much, I lose my sense of self. I have to kind of rebuild myself in the studio again. When I was younger I used to have a lot of problems working. I would spend many days anguishing. Do you ever do that?

Robert Gober *I haven't really worked for the last year and a half.*

Vija Celmins Oh, how could you say that!

Robert Gober *Because it's true. I haven't made a new sculpture in a year and a half.*

Vija Celmins See, now when I don't do something that is real to me – like work, of course – I start feeling incredibly anxious. And then when I fall into finally making the stuff and being in my studio … that's the best. Well, so anyway, you know I'm not that happy with a lot of my work. I tend to beat up my work a lot …

Robert Gober *Mentally?*

Vija Celmins Yes, with a kind of relentless questioning and criticizing of everything. Lately I have been painting a work over and over … sanding it off and painting it again on top of itself. Same image over and over. Actually, I tend to end up with a simple-looking single image that may have six months of work under it. It begins to have this strange quality when you get to a certain point, you can actually … it lets you in for a little bit and you think you may be seeing something that isn't there. The black night sky paintings are especially hard to penetrate … yet I think you get the feeling of a fuller space and some solid structure underneath. I mean one of the things that painting does is … it's quite difficult to react to verbally, even though many try, don't they? They're all out there with their pencils and things.

Robert Gober *I was reading all the essays about you, in which so many talented writers have really seriously taken on the challenge of trying to contribute to an understanding of your work, but after I read them all there was – for me anyway – a threadbare feeling. I think that what's just missing is the experience of the object, and there's no replacing that.*

Vija Celmins Of course. The early work, which had more of a dramatic narrative, like the *Freeway* painting (1966) or the *Burning Man* (1966) or the aeroplanes (i.e., *German Plane*, 1966), they're easier to see in reproduction and to talk about, but the late work isn't. It's more about experience.

Robert Gober *That's why I think that seeing in reproduction images of the later work, the oceans or the galaxies, is deceptive. Because I don't think the paintings themselves are 'images' of the ocean, or 'images' of stars.*

Vija Celmins No. The recognizable image is just one element to consider. The paintings seem more a record of my grappling with how to transform that image into a painting and make it alive. I mean, dead *and* alive, since in the end the paintings (at least lately) have become so restrained and still … the paint and the image packed tightly together. The surface is very closed and flat, but the feeling of the painting (I hope) is full and dense – like a chord of music, maybe. Hard to talk about it; it's sort of difficult to figure out how to make a painting interesting. One of the things I like about painting is that it is so slight a presence … you can't trip over it like any object. You turn away and it disappears immediately, you know?

Robert Gober *People always approach the earlier work through autobiography. I was wondering if the changes in the work might not be some kind of reaction to that, or against that. Of course art comes directly out of who we are, but it's –*

Vija Celmins Well, I believe that the early work was kind of autobiographical. But you can only say that looking back, because when I was doing the work I had a million things I was interested in, like depth and flatness. Somehow I fell in love with that, depth and flatness. Rummaging through memories, trying to find out who I was … My work now seems more abstract.

Robert Gober *But then you stopped painting.*

Vija Celmins Well, I did do some painted objects in the late 1960s, early 1970s; then I switched to drawing only, using a pencil. More clear, I thought at the time. But basically the work stayed flat.

Robert Gober *I get very frustrated when people ask me, 'What does your sculpture mean?' I respond by talking about what it's made of and they get impatient, as though I'm avoiding the question. But I feel that unless you know what it's physically made of, you can't begin to understand it. A lot of times the metaphors are embedded right in the medium and the way that you work.*

Vija Celmins That's true, I'm always talking about 'making' as if that is the only thing there is to it. I think that you, Bob, build more meaning in. You don't think so? I think that your work fits different interests in your life – political, social, personal. My work seems to communicate less about what I think and is more ambiguous. Sometimes I think the meaning is only in the material – I guess you said that already. At any rate, we leave the material there as evidence.

I generally start a painting after obsessing on an image, or the look of a printed image I've found somewhere in a book or remembered from somewhere. I fall for it, carry it around in my head, sort of fall in love with it. I like scientific images, they're so anonymous, and I like the printing quality of certain images. I have collections of many clippings stuffed in drawers. I don't know, do you collect images too?

Robert Gober *I do, but I think maybe you were right in pointing out one of our differences, because what I'll collect is more word- than image-based, like clippings from a newspaper. I feel that that content shouldn't be lost – the way it is, because a new newspaper comes the next day.*

Vija Celmins Yes! See, but that is such a beautiful thought to me, and it never occurred to me to do that. Even though sometimes I cut out a thing and send it to a friend, saying, 'Isn't this outrageous?' or something. But, what I do is I fall for the look. I mean it's so stupid, really. I fall in love with the look. Then the problem is, how to send it through my system, and pack it into this flat thing that I'm going to bring to life in another way.

Robert Gober *That's very familiar to me, because I'll see an image in the world that I also blindly need. I don't know why, necessarily. But then I have the problem of how to make an interesting sculpture out of it, which is a whole other problem.*

Vija Celmins Well, that's your problem. I don't have that problem! (*laughs*)

Robert Gober *Right, you have the problem of painting.*

Vija Celmins I have the painting problem, although I did do a lot of objects too, the comb (*Comb*, 1970), the pencil (*Pencil*, 1967), puzzles (*WWII Puzzle Toy*, 1965) and the houses (*House #1* and *#2*, both 1965). I think they were probably pretty much images of my childhood. See, I think … obviously we're very different

Vija Celmins

Web I 1998
Charcoal on paper
56.6 × 65 cm

Louise Bourgeois

Arch of Hysteria 1993
Bronze, polished patina
83.8 × 101.5 × 58.4 cm

Louise Bourgeois

Spider 1995
Steel, tapestry, wood, glass, fabric,
rubber, silver, gold, bone
444.5 × 665.4 × 518 cm

Cai Guo-Qiang

**Fetus Movement II: Projects for
Extraterrestrials No. 9** 1992
90 kg gunpowder, 1,300 m gunpowder
fuses, 1 seismometer with 9 sensors,
electroencephalograph,
elecrocardiograph 15,000m²; 9 sec.

9:40 p.m., 27 June 1992, Bundeswehr-
Wasserübungsplaz military base,
Hannover Münden, Germany

Maurizio Cattelan

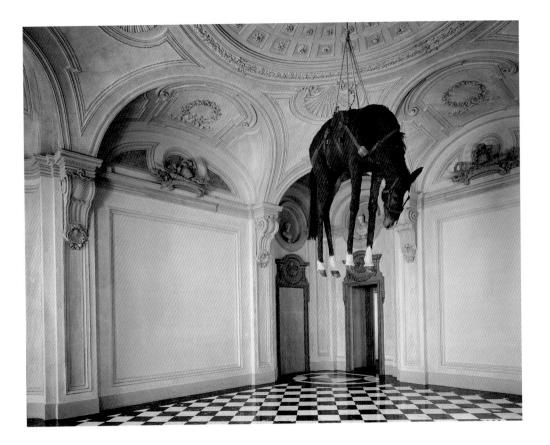

Novecento (1900) 1997
Taxidermized horse, leather saddlery,
rope, pulley
200.5 × 269 × 68.5 cm
Installation, Castello di Rivoli,
Museo d'Arte Contemporanea,
Turin

Maurizio Cattelan

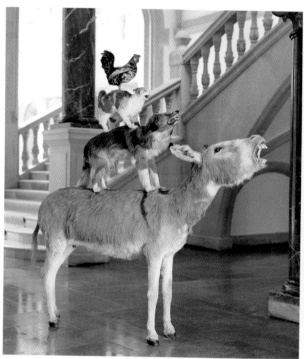 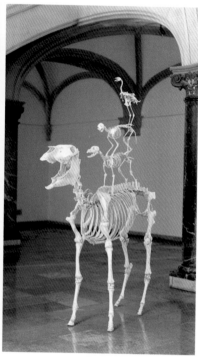

Love Saves Life 1995
Taxidermized animals
190.5 × 120.5 × 59.5 cm
Installation, Skulptur Projekte
in Münster, Westfälisches
Landesmuseum, Münster, Germany

Love Lasts Forever 1997
Animal skeletons
210 × 120 × 60 cm
Installation, Skulptur Projekte
in Münster, Westfälisches
Landesmuseum, Münster, Germany

Vija Celmins

To Fix the Image in Memory I-XI

1977-1982
11 stones and 11 painted bronzes
Dimensions variable

artists, but we have a few things which I think we've both tapped into, and one of them is childhood. And I'm not sure that many artists don't live their whole lives from that childhood.

Robert Gober *Not just artists; most people.*

Vija Celmins Yes, maybe most people. Yeah. I don't know a lot of people, I just know mostly artists. Your work may have been coloured by your religious experience, or whatever, and I think mine was coloured mostly by the chaos of my early childhood in the war. Not that I knew what it was, or that I understood it in any way. Nobody ever talked about it. It was like, this is it, you're born, you're here, you have to deal with it. I was so afraid of being abandoned and lost in it. But later, in the studio, I think I relived all these things, the burning houses, the aeroplanes, the Latvian school in Germany, my eraser, my little pencils. Kind of like sewing this big thing – like the way that you, Robert, put different images together in one piece. I, too, am not bad at picking images, but mine dribble out one by one over a long time. I touch on one thing, and another, done totally like you were saying, in a blind way at the time. Like a kind of desire to see something come up, and then a kind of desire to try to make a painting out of it. Then when the painting got so, you know, tedious, really, I would make a piece that was dimensional. Not uninfluenced by maybe Pop art, except done in a maybe more meticulous manner. Not using Pop's commercial techniques either, but a more tender touch. I developed a touch that you could hardly tell was a touch.

Robert Gober *I think my hands are too big to do that. I can't do such detailed work.*

Vija Celmins What is your problem? You do the most detailed, gorgeous work …

Robert Gober *Maybe it's the physical tininess of some of your gestures which add up to the larger images that I don't think I could do. I was looking at those drypoint marks on your plates; there are so many nearly infinitesimal marks.*

Vija Celmins I know. Can you imagine that the eyes can still do it? I'm in my sixties, you know?

Robert Gober *Do you wear glasses?*

Vija Celmins I have contacts on. And I wear glasses.

Robert Gober *I have a question a little far afield. One of your early sculptures was a huge tortoise shell comb (Comb, 1969-70). And when I was in your bathroom just now, I noticed you use the exact same tortoise shell comb. That was really interesting to me; I, for instance, could never live with a white porcelain sink in my kitchen.*

Vija Celmins Well, you're more perverse than I am!

Robert Gober *Are you aware that that's the comb from your early sculpture? Do you like it because of that? Or don't you even think about it?*

Vija Celmins No, I sort of remember a comb somewhere. Maybe my mother had, maybe my father had, maybe I had, maybe Magritte had. I mean, obviously, nobody could look at that comb that I made and not think of Magritte. You know when you're young … I don't know whether you had influences like this?

Robert Gober *Yes.*

Vija Celmins I had influences that lasted, like, for two months. And I would run through one artist and be seduced by another.

Robert Gober *And did you know you were doing it? Because sometimes I didn't even know I was doing it.*

Vija Celmins No.

Robert Gober *Until later, people would point it out.*

Vija Celmins I'm telling you now all of these memories, and I'm remembering that I once painted a train on one of those little houses I made. Now, where would that train be from? Except, of course, I lived on trains when I was little. A lot of trains, with the smoke coming out. But I think it's probably Magritte's train that got in there. And, of course, Magritte's comb. Not that I was aware of it … I had seen that painting, *Personal Values* (1952), but had I seen it in real life? Or in a book? I think in a book, maybe. I saw the painting later.

Robert Gober *When did you start to see real art?*

Vija Celmins Well, I saw real art, of course, as a youngster in Indiana, but I think my biggest turn-on was when I went to Europe with my boyfriend, in 1962. Quite late.

Robert Gober *Do you remember your first reactions to particular works when you went to your first museum?*

Vija Celmins I remember first seeing the Giotto frescos at the Arena Chapel in Padua. We had to wait to have someone open the door for us and we were the only ones there. What a surprise inside! We were just beside ourselves. So very excited and running back and forth from one panel to another. I had never seen such beauty, such a chalky, glorious blue …

Robert Gober *Did you see art as a teenager?*

Vija Celmins No, not really. But I was always drawing. Were you?

Robert Gober *Yeah, I was always drawing.*

Vija Celmins I was always drawing. But I was very, very jealous about showing. I never wanted anybody to see it. I'm still like that, which makes it very difficult to have people come in the studio, you know.

Robert Gober *I hate having visitors in my studio.*

Vija Celmins Oh, I get so ... I go into another personality.

Robert Gober *I spend the day hiding things, so I don't have to show them to people.*

Vija Celmins Now, why do you think we have that?

Robert Gober *Well, it makes life easier, for one thing.*

Vija Celmins I get so anxious, and then I go into this other personality, which tries to explain things, then I'm always very remorseful afterwards. That's my least favourite part.

Robert Gober *Who comes to your studio? Curators?*

Vija Celmins Well, hardly anybody now. I mean, some dealers I let come, because I make a living from my work. You have to show it. And then when I get over the initial anxiety of showing it, I'm able to accept it, and let go of it pretty much, and see it in a different light. Well, not always. I like to ... I hate to stop working on something. I have this thing – do you have trouble letting go of the work, or not?

Robert Gober *Not so much, no. Sometimes – but I think this is different – I'll finish a piece, but I won't release it into the world. I won't let go of it that way. But I don't have that much trouble knowing when to stop working on a particular piece; those are two different things.*

Vija Celmins Yeah. I'm always trying to make this form that's very tight, that's very, very complete, and I always think, well, a few more spoonfuls of paint in this will make it more, you know, will make the pie better. So I hate to let it go.

Robert Gober *On a very different note, do you enjoy your success in the world as a deeply admired and accomplished painter?*

Vija Celmins Mmm ... I don't know whether I think of myself as that.

Robert Gober *You must, sometimes.*

Vija Celmins I think, yeah, I think I felt a little, I mean, I've been trying to enjoy it. I keep thinking that if I build a studio, and I have another twenty years, maybe I can do some work that seems right to me.

Robert Gober *It's a dumb question.*

Vija Celmins Yeah, why'd you ask it?

Robert Gober *Oh, because it interests me, it interests me in myself. It's a hard thing to talk about, among people, and among friends, and I don't even know you that well. Sometimes I'm just so surprised that I, the person who I am, and who I live with every day, is that other person out in the world.*

Vija Celmins Well, I tell you what surprises me is that so many people can sort of see some of the things that you've done in a totally kind of digging-into-the-self way.

It's sort of hopeful about human beings, I think. You know, I don't really think of it much, but I've had some people say that the work has really moved them. They think they understand some things. And I'm thinking, 'Wow, I didn't even understand it.'

Robert Gober *Do you get letters from people you don't know?*

Vija Celmins Yes, I do. I get letters.

Robert Gober *It's wonderful, isn't it? When they're not hateful crank letters.*

Vija Celmins It scares me a little to get letters from people about all of this. I think that I was always thinking that I was on the outside because I was so foreign. I was a foreigner in Germany. I was a foreigner here in the US. I was sort of a foreigner in California. Because my whole vision … my colour tones were too grey, maybe, for California, or the work was too severe. Maybe this is just clichés, but I had that sort of feeling like I didn't quite belong there, even though I loved the gardens and … I was always fighting. And I was thinking even if nobody gets it, I had a feeling that I could go and I could work. I don't know, it's like building a self through the work. And then the work sort of reflects some aspects of yourself. And I don't mean the brain. I mean like, some aspects of your body and your emotions – and your brain.

Robert Gober *How long can you work in a stretch on painting?*

Vija Celmins Oh, I don't know. I can't … I don't work in stretches. I work, I jump up, you know, I eat cherries, I pace the studio … I work again.

Robert Gober *Do you listen to music?*

Vija Celmins I listen to talk radio. To music, to various things. Sometimes I like silence. Sometimes I like jazz. I tend to listen more to classical music. And then sometimes I get revved up with the public station that I listen to. How about you?

Robert Gober *I go in phases. I tend to work either in complete silence, or I'll find a piece of music that inspires me and I'll just listen to it obsessively while I'm making one work. I'll just replay it and replay it.*

Vija Celmins See, I am able to focus; I have a feeling you're able to focus too. I'm able to focus down and really concentrate. But now that I'm feeling older I'm trying to back away from it, because I don't think that I'm going to have the physical stamina to keep concentrating on the work that much. And I'm trying to figure out … you know, recently I've picked up this spider web image, which is an image that's very, very fragile, and implies something maybe more broken, more old, more tenuous. I was trying to photograph the spider webs out here in the garden, and finding it impossible. You can't find them. I found them in science images and I was drawn to them. I carried it around in my head, like a memory, for maybe about a year or two, and then one day I made

a painting. That was about ten years ago. Probably because I tend to pick images that sort of describe a two-dimensional space. And it's a collection of small things that somehow engage me, almost force me to be engaged in making this very complicated image … it sounds a little depressing, doesn't it? Working on it so long and so tediously, as if hoping that something would be transferred. But I'm not really sure what. Because I tend to want to keep the work kind of mindless in a funny way. Mindless, but mindful building. I think we have some similar things. I mean, the building of it, for me … see I think of it like building, like you build a house.

Robert Gober *My dad built the house I grew up in.*

Vija Celmins Yeah, my dad built the house, too. My dad was a builder.

Robert Gober *I vacuumed the spiders and spider webs out of my house today. And when I was doing it I thought, 'Am I doing this because I am going to see Vija?'*

Vija Celmins Yes, you are, you were. But I've been letting the cobwebs grow and am very delighted that, somehow, from the pictures in books they've come out in the real world. And the fragility of that web … I've always been interested in very impossible images. Things blowing up, things disappearing in a breath. Things like the sky, which doesn't even exist. There is no thing like the sky. It's like a totally … who knows what it is.

Robert Gober *Unfathomable.*

Vija Celmins Right. And then trying to invent it on another surface.

Robert Gober *And impossible things, like the duplication of rocks.*

Vija Celmins Right. And there's no way to talk about that piece either (*To Fix the Image in Memory*, 1977–82). I was thinking of it in various ways. When I first was trying to name it, I mean, look at this pretentious name I gave it. To Fix the Image in Memory. I was reading this story by Borges about Funes the Memorious. Do you ever read Borges?

Robert Gober *I did about a year ago.*

Vija Celmins It's this guy who remembers everything he sees, and his head gets so filled up that he can't function. Because he remembers everything. When I was looking at the rock and painting the bronze, I had to remember what it is I saw even though it was only five inches away. And it was like building a sort of memory. Then I was thinking, well, it's a sort of criticism of realistic art, you know? Like a kind of a 'fuck you'. You point out that art is always invented, and that there's nothing real about it the way nature is real.

Robert Gober *I came across a quote recently, I can't remember who said it. And I guess because I knew I was going to be interviewing you, I remembered it. It said, 'Art is the thing that makes life more interesting than art.'*

Vija Celmins Who said that?

Robert Gober *I can't recall. I'd have to go back and look it up.*

Vija Celmins Well, I was just talking about that, wasn't I? I never paid any attention to cobwebs and now I'm trying to grow them in my studio and in the corners and everywhere.

Robert Gober *How big is your studio in New York?*

Vija Celmins Well, the studio's about 2,000 square feet, but I live in it. So the painting room is only 21 by 26 ft. Then I have a drawing room that's 21 by maybe 13. In between there's tucked some storage, and the bathroom, and then I live in a … you know, it's small. I'm longing to have more space. And I'm now also fed up with the tediousness of my work, and I'm thinking maybe I could do something three-dimensional, which always seems to me like a liberation. I never was a sculptor, you know, I always painted all my sculpture – well, you do, too.

Robert Gober *Yeah, the paint is very important. But I think it's different than the way you painted your sculptures. Like your sculpture with the images of the house painted on the house. If I made a house, I would paint it white because the house was painted white.*

Vija Celmins Right. Going back to *To Fix the Image in Memory*, it was a piece I made when I was very sad. I would go driving around in the New Mexico desert consoling myself by mindlessly picking up rocks and throwing them in my car. Later, unloading them in my studio, I had this moment of inspiration. They seemed so beautiful, I wanted to make them myself. I wanted to see how close I could come; that's how the piece started. There was never any symbolism or any real idea. I just went back to looking, which I guess is a theme that runs through my work. Looking at stuff and sort of regenerating something in me that keeps wanting to live – something that sustains me that I'd forgotten about. Going back to looking in such a thorough way reaffirmed something about the business of 'making'. *To Fix the Image in Memory* was built over five years, mark by mark, in a pointillist sort of way. I could never do that again. I wouldn't want to.

Robert Gober *When you say that you were sad during that time, I can immediately see it in the work, but I never thought it before. I remember when I first saw those rocks I thought they were very funny.*

Vija Celmins Yes, I think other people thought they were funny too. And people said things like, 'How'd you find two rocks the same?'

Robert Gober *Well, part of the humour, I think, is the unexpectedness of it. Because you don't know what they are at first.*

Vija Celmins See, one of the things it points out is that I don't think about how things spin in the art world. I did that piece out of my own head – but I guess that's

how you do it too, isn't it, most of the time? Thinking about it later and trying to talk about it becomes impossible.

Robert Gober *What are things that you would want to talk about that don't get mentioned?*

Vija Celmins You mean things that we've never talked about? Or that I have never talked about?

Robert Gober *Not just those; perhaps also things that are underemphasized in your work, or things people never notice that you feel are consequential.*

Vija Celmins That's a hard question to answer. What don't they notice? See, I hardly ever read anything anybody writes about me.

Robert Gober *You never read it?*

Vija Celmins No.

Robert Gober *Don't they ask you to vet it or proofread it?*

Vija Celmins Well, I mean, I sort of skim it, and then I start feeling my heart fluttering, and then when they say something that seems kind of great, I get flutters. And then when I see something that is totally wrong, which is often the case, then I get the flutters again, and who wants that much fluttering? (*laughter*) I mean, do you? Do you read the things … ?

Robert Gober *I do. I went through a brief but not lasting period when I thought, 'I'm never going to read anything again', but it passed.*

Vija Celmins I can understand that, yeah. I don't really mind criticism. I'm so self-critical myself that I don't mind. One time somebody said to me that they thought my work was too careful. And I thought that was not too bad. I hold an image in my head for like two or three years. I'm sure that none of this is too unusual among artists, or maybe it is. I don't really know. But, I mean, maybe that's part of not finishing the work, not letting anybody really near it, or making it very difficult, then, to take the work apart. Maybe that makes it too careful, I don't know. But that's a good question: what do I think that people don't get about my work? Well I hate it when they keep the drawings in the drawers. I meant for the drawings to be out with the paintings, but I realize that people don't want to ruin the paper.

Robert Gober *Right, but you want the drawing to be given the same importance as the painting.*

Vija Celmins Right. Then I also want to have people think more about the space that the work projects and find their relationship to it. A lot of my drawings really project very far into space, especially the early ones of the ocean and desert. You know, they were concentrated, but they sort of came out like this (*wide gestures with her arms*). You know, they came out on a beam.

Robert Gober *Those woodblocks of the ocean are amazing, technically. Were they hard to do?*

103

Vija Celmins OK now hold on, it just occurred to me that maybe the later work, like the work in the last maybe fifteen years, has not projected out, but sort of invited you to come close. And why is that? There's like a shift, and I think it came about because I was doing black things, the night skies. The black projected the proportion, but the image no longer projected, and you had to physically come up and find it, and then find your relationship to it. Before the work sort of projected out; now you have to get way up to it. Maybe that has to do with the image getting smaller and finer, and that was one of the things that happened in the woodblock.

To answer you question, I loved doing it. I mean, my work has always been so involved in the 'physical' that cutting into the wood with this little knife was very satisfying! I lived for months with my face inches away from that block, cutting this way and that. I never really had a technique ... just trying to build a solid piece that could hold still and move at the same time. When you come very close to the print I think you feel the touch of the knife.

Robert Gober *I wouldn't know how you could direct someone to make your work.*

Vija Celmins Well, I haven't been able to direct them to make the work, dammit! I tend to stay very close to an image right beside me. What do you think you might want to know about my work that hasn't been written about?

Robert Gober *Well, the thing that's missing to me is the future. Because I see it in an arc or a continuum. So I wonder what the next group of works will be, and how it will illuminate the past.*

Vija Celmins But, you see, I have to tell you, the future's missing for me too.

Robert Gober *(laughing) I know that!*

Vija Celmins And, I mean, I think it only comes with the making. I have all kinds of ideas. Certainly I'm not going to tell you my ideas, am I?

Robert Gober *No.*

Vija Celmins No. The way I work is that at first I have all kinds of ideas, but then I tend to reject them one by one and sort of end up in a more intuitive, animal state from which I then begin. And then through the work, some things become evident ... but not too evident ...

Robert Gober *Do you still like living in New York?*

Vija Celmins I like living in New York, but having a little house with a garden outside the city has opened up ... you know how hard it is to get nature in your work! I think art and nature are very separate ... and now I seem to have developed a real friendship with nature – we, I've always had it, I guess, but I used to drive around looking at it from a distance. Now I'm in it, and it's been a pleasure ... almost to the point where it is too much – help! (*laughing*) I've been planting things and pulling them up and seeing things close ... and

who knows? Maybe some of that will get into the work … I mean that I tend to keep images in my mind for a few months, where they get bent a little before appearing in the art. I try to leave the evidence of both thinking and making … like a fingerprint of all I know. Expressive, maybe, but hard to define, and who knows what it means. I've been questioning the meaning of everything. Have you gotten to that point yet? Maybe it's because I'm older. You want a little cold cucumber soup?

Robert Gober *Oh, that'd be wonderful. People always ask me, 'What does it mean, that you make the work yourself? Why don't you just go out and buy it?' I used to try to answer, but now the only logical answer to me is to respond, 'How would I ever find this thing in the world?' You have to make it in order to find the thing that you are imagining. Where would I go to buy a plaster sink?*

Vija Celmins That is a great answer. People used to come up to my things and say, 'God, what a great set of photographs.' I mean, talk about blind! I think one of the things that people tend to look too much for in art is meaning. And they tend to project a meaning much faster than I would like them to. If I was a dictator, an art dictator, I would tie them up and say, 'Here, look at this. And look at it again and look at it again.' And then I might beat them too.

Richard Deacon *Pier Luigi Tazzi*

in conversation
October 1994, Turin and other locations

Pier Luigi Tazzi *I would like to start from the distant past. I have always felt that since the beginning of the modern, there was no place for art. Art was mostly an image in the mind, or a precious object. While it was still in the artist's studio it was as yet unborn, and when it was in a private or museum collection, it was the relic of a practice that took place elsewhere, a sort of unknown non-site that was ideologically akin to the concept of utopia. The work of art began to acquire its own space toward the late 1950s-early 1960s and this ultimately resulted in the gallery space. This was a real space which was increasingly defined over the course of the decade and which in a way contrasted with the museum, which was more abstract, separate from the reality of the outside world. Until at least the end of the 1960s the museum was the principal space for art and where art obtained its status. During that time we had a shift from the closed, sanctified museum space to the living, 'real' space of the gallery.*

At the end of the 1960s-early 1970s, what first emerged in theoretical discourse was the term 'context', particularly in conceptual art. This term was increasingly defined and analysed in its specificity; that is, art does not acquire its meaning in and of itself but in relation to the context in which it is set and brought into action.

When the gallery space came to lose its primacy and at the same time its effectiveness, the term 'context' emerged again but in a different way. Context is no longer intended as it had been in the discourse of Conceptual Art, but now points to a dissolved area where the work of art is placed, although it does not define the context by virtue of its presence. At the same time, there is a demand today for context, a need for context. What I want to ask you then is, when did you start to take the context into consideration not only in the production of the work but in its very constitution? What do you mean by context?

Richard Deacon At the start of the 70s, when I was a student, I was confused about the category of things I wanted to make. I wanted to make something and that involved the manipulation of materials, but the models that were on offer seemed to involve making plans and carrying them out. I felt that this was the wrong procedure. It was also a time when there was a lot of interest in time-based work and performance, so I combined the two interests and started making performance-based work which involved the manipulation of materials over a given period of time. The notion that how you do something had relevance to the thing that you do was a very early part of my work. I used photographs to document it but I became much more interested in description as a means of documentation. It had time in it in a more interesting way than a photograph. At some point in the middle of the decade I abandoned using a performance base with all its connotations of documentation and reproduction, though there are certain elements which carry through from that. These works often extended over a period of time and involved the creation of materials. I found the vehicle cumbersome and thought that it was possible to condense those concerns into a single object. Somehow I changed the way I looked at what I was doing and began to think of my previous work as a training in how to make objects, learning how to

avoid making plans. Also in the context of making performance I found myself uncomfortable with my personal presence. I felt that I didn't need to be there. That describes how I think about sculpture, about making my work ever since. Somehow that 'I don't need to be here' is a good way of describing the kind of autonomy that I think the work should have.

Pier Luigi Tazzi *What startled you most about your physical presence?*

Richard Deacon At the time, I thought that the reason I was there was as an agency to enable the work to be made. I wanted a certain kind of equality between myself as an agency and the material as an actor; I thought that my uncertainties, my doubts and my decision making, that somehow 'me' was the performer in a kind of autobiographical sense which I found uncomfortable. I suppose the honest answer would be that performing that way seemed to say things that I wasn't planning to say. It made the work personal in a private rather than possibly expressive sense. Another possible reason was that I didn't need the audience. I was perfectly happy in a performance situation entirely by myself. If you don't need the audience then you don't need the documentation, so what you have at the end is what you intend to make, that's the full logic of it. I was quite happy with that for a while and then, ten years later, I decided that the sculpture I was making and the gallery which was its location were problematic. Your description of the work being unborn in the studio and already dead when it arrived at the collection was very good. The gallery developed this in between status of 'this is when the work lives'. If that's the case then in some sense the gallery determines the work. The museum legitimizes it and the gallery enables it, or causes it to be. Obviously a lot of the conceptual artists' position was precisely to do with articulating the ways in which the gallery does that. To follow the argument through removes any need to do anything at all, because the gallery causes and the museum justifies.

Pier Luigi Tazzi *This is strange, you stopped performing because at a certain point you recognized that you didn't need an audience. But what the gallery space was offering was a stage without an audience, where the audience was not necessary because the stage in itself, the gallery space, was the place.*

Richard Deacon Yes.

Pier Luigi Tazzi *So in the gallery space you don't need an audience.*

Richard Deacon It's implicit.

Pier Luigi Tazzi *Yes it's implicit, it's already there. The stage, the sacred place is there. I think that your decision, and that of many other artists, was to confirm the primacy of the gallery space.*

Richard Deacon At some point later I began to wonder whether it was a necessary truth and whether the context was not necessarily defined by the gallery; in fact you

could turn it upside down and have the making or the thing that was made define the context. So the gallery was a part but not necessarily the whole. I have often talked about works that I have made on three scales: small, medium size and large works. The small works are domestic, the medium works are gallery size and the large works are public. But there is a continuity between all of them and therefore if you look at context you would look for something that overarched all those three scales. At some point I wanted to make things that didn't fit inside the gallery. I thought there might be other contexts for the work, other places to put things where they could still function as art objects. Obviously there are lots of places where they probably don't function as art objects. I made some things which were placed out in the park. I found that didn't work, it was just taking one thing and putting it somewhere else, which seemed an inadequate solution. In 1985 I did this show at the Serpentine Gallery with the work *Blind, Deaf and Dumb A*, which used a link through the wall of the gallery to a work that was outside. I used the window and the building as a means, and tried to make the architecture be contained by the work, rather than be a container.

Pier Luigi Tazzi *That also occurred with your contribution to the 1985 Biennale of Paris. It had the same aim in a way. The three works,* Other Homes Other Lives, Like a Bird *and* Tell Me No Lies, *were in overt contradiction with the architectural space of the Grande Halle de la Villette. There was a sort of fight between the architecture and your works. The architecture was not the container of the work: there was a sort of dialogue with the architecture itself. Most of the other works in that show were simply contained in a building which falls into the category of industrial archaeology. In your case the contrast was extremely evident.*

Richard Deacon The exhibition in Paris was precisely between having made works which had been placed outside, and my being unsatisfied with that, and doing the work in the Serpentine, where I was more aggressive towards the architecture. Those were intuitive decisions. I removed myself to the outside in Paris, to the exterior of the building; I didn't want to be within the big hall. A part of it was in order to establish a relationship between the work and the building that had some purpose to it, that wasn't temporary.

Pier Luigi Tazzi *In fact one of the feelings I had – it's rather banal, maybe a little simplistic but it might explain something – was that one never knew whether your sculpture came before the building or the building came before your sculpture. There was an overlapping, but at the same time there was no fusion between the building, your sculpture, and the overlapping itself. Also, you were going against one of the most substantial characteristics of architecture: the possibility of opening and closing space at its own discretion. With your work, this possibility is denied. In other words, architecture implies that a given space can be closed. It is not a question of establishing a flexible articulation between aperture and enclosure. The fundamental fact is that enclosure is in any case a possibility. Think of the cave, the first building constructed by humankind, the defence systems brought forth*

during the Renaissance – all things from which modern architecture is derived.
I thought your sculptures were like bars in the door, keeping the door open.

Richard Deacon Well, that's what they should be. Because I was really unhappy about being
given a cubicle in a big space, it was very much a 'fuck you, I don't want to
do this, I'd much rather be outside'. What I was starting to say earlier was
that autonomy becomes a more important term the longer it goes on. The
procedures I had for making work tend to involve a certain kind of wrapping
up of space. They became sort of circular motions. The autonomy has to do
with that decision, that you don't need the audience, you think that somehow
the object should be completely contained, wrapped up in itself.

Pier Luigi Tazzi *Thinking about that show in connection with what we are talking about now,*
I remember other works that had a completely different relationship not only with
the architecture, but with the physical, formal and historical context. Particularly
Luciano Fabro's work, which was outside trying to haul the whole building
in a sort of metaphor of history. Or the work of Ulrich Rückriem, which was
completely detached from the building, like a timeless mark of the presence of art
or of human action.

Richard Deacon The reason I started making performance work at the end of the 60s was
because I wanted to make, but I didn't know what. I suppose in a way it
is still a problem. There is a kind of fixity to Rückriem's work that creates
a problematic for me. This isn't a critique of the work; indeed, there is a
relationship. I wanted to make work that didn't involve gravity in the classical
way that Rückriem's work belongs to gravity, with his simple operations on
the block. The work is always subject to gravity and place in a very definite
way. Material and its manipulation are core areas in what I do. Matter, stuff,
are the words I tend to use. Matter is a ground for the work in relation to its
existence rather than its weight, or its mass. Weight was always a difficult
thing for me. My idea about sculpture was that it was composed of matter but
wasn't subject to gravity. This is metaphorical, obviously, but I thought of
sculpture as being between me and the world, rather than sitting in the world.

Pier Luigi Tazzi *In other terms – not artistic terms – the works of Rückriem have to do with*
erection. It is a phallic work in any case, where the phallus is important as a sign
in its symbolic function as an archaeological point of reference and orientation.
Rückriem reflects quite closely Jacques Lacan's reading of Sigmund Freud in
which the phallus is not a phantom in the sense of being a figure. Nor is it an
object, nor the organ itself. It is a simulacrum, a signifier whose prime meaning
is 'to be or not to be', to be there, to be erect with a specific mass, a specific material,
worked in a specific – and simple – way. On the other hand you consider the
substance of the phallus independently of its function as a signifier, or its erection
and its erectibility.

Richard Deacon Yes I suppose so. I could put it another way: Rückriem's work is clearly made
of material, and the material sits in the world. For me, material, matter, is

much closer to being human, is much less alienated from being human than that opposition of the physical object grounded in the world. Matter is much closer to language and I wanted to make sculpture that showed that aspect of belonging to the human more than belonging to the world. When we speak to each other we use something that is common, that doesn't really belong to any of us. We can extract meaning from it and use it to signify, but what enables us to do that is its commonality, we all agree on it. I wanted to make sculpture that was being more like that than it was to being fixed. The area I was trying to explore has to do with allowing material to have form and at the same time to be able to be formed. There is a certain indefiniteness or ambiguity to a lot of the things that I do in relationship to what they might look like, and at the same time the great specificity of material and of the substance of the work is clear. The form is clear but there's also a desire for a potential plasticity or fluidity which remains latent. In a sense I have been trying to attach sculpture to perception or to experience rather than attaching it to the world. A contemporary analogy is to talk of a virus and the way a virus attacks the host. The problematic is to try and make sculpture that is parasitic upon the perception of the host rather than sculpture that is in and of the world.

Pier Luigi Tazzi *Yes, but when I use the term 'timeless' for the work of Rückriem, I meant just that, to be not against culture but before culture, to go back to a certain archetype, to go back to a certain source. Your work is far more linked to the evolution of language; Rückriem's language is very elementary, whereas your language is much more articulated. What Rückriem is doing is establishing the scan of the language, the primal gap.*

Richard Deacon Yes, possibly. Clearly I don't make work that's primal.

Pier Luigi Tazzi *What I find in common between your works and Rückriem's are at least two things. You share what you called autonomy, and this common base, common ground, even if the articulation is completely different.*

Richard Deacon You mean a material base, a material ground.

Pier Luigi Tazzi *Yes, that was quite important in the early 70s, that had been achieved.*

Richard Deacon Well, it was something that was achieved, and also something that was made available. It was clearly a gain, or an opportunity. If you look at Donald Judd and Anthony Caro as two artists of very similar age, I think surprisingly for such an apparently restricted artist as Judd, the opening he and others made at the time is very clear. The way I put it, Judd doesn't tell you what to do, but he leaves a lot of things to do it with, whereas Caro tells you what to do. The heritage of Caro is stylistic whereas the heritage of Judd is fundamental.

Pier Luigi Tazzi *Caro and even more so Donald Judd have already become part of history, they have already been absorbed in contemporary art, whereas Rückriem remains as yet not digested.*

Richard Deacon Yes, I agree. It's surprising, a good quality. After the Serpentine in '85 there was the show in the park at Sonsbeek in '86 and through the city of Münster in '87. The curator of Sonsbeek, Saskia Bos, had a fairly complex idea about a glass house and a floating pavilion. Partly I suppose that her reason for proposing the pavilions was to underline an aspect of contemporary art practice which was denatured and artificial because of the history of the space as an artificial park. For me it coincided with doing a lot of reading about the picturesque in the eighteenth century and the ways in which the world was seen as expressive and signifying. I was also interested at the time in geological history, very ancient history and the intellectual processes in relationship to the investigation of the earth as an ancient geological item. There was a way in which intellectual operations could picture a world different to the world we inhabit, although it's the same place. In the eighteenth century nature disappeared and was replaced by construction, by a human-centred world.

Pier Luigi Tazzi *The relationship between city and country was completely reversed.*

Richard Deacon And the park at Sonsbeek is a representation. My work was a rigid frame, with an undefined element within it but situated in a place, between the war memorial and the villa. In some sense the physical object and the manifestations of ideology within the various elements of the park – its construction, its buildings, the war memorial, etc. – were all pictures, constructions. What I was trying to make the work do was to be equivalent to the park and to the spectator, so there were three elements: the work, the park and the spectator. They were more or less in balance.

Pier Luigi Tazzi *I found your work at Sonsbeek,* When the Land Masses First Appeared, *extraordinary. It was one of the emblematic works of the exhibition for the relation between the container, the rigid form outside, and the contained shape, the organic free form inside. This relationship was very opposite to the notion of the park, where the natural is the outside world and the design of the park is the inside world. This relationship, in connection to what we were saying before about context, revealed the distance taken from the idea of context as it had been defined by conceptual art. For the first time I could experience through that work something I had not understood before. The context had not been defined by known components and certain elements resisted all definition and categorization and remained unstable. The context had to do with an essence of which you had no knowledge: a sort of first step into outer space, with all its contingent risks. It had the freshness and happiness of a first discovery, like a baby's first word, or like some works from the Italian Renaissance, or in some Impressionist paintings. They have the same kind of dawn, when the day is approaching and everything is pale and bright; the colours are extremely distinct, not attacking your perception, but arriving with the renewal of your perception after a night's sleep and with the morning light. Saskia Bos' project was to create this primeval garden, a kind of Eden. Your work in Münster,* Like a Snail, *was again contextualized in a*

bureaucratic way, the work of art in relation to the urban context and vice versa. The two were well-differentiated, despite the resulting revelation that the chaos of the urban context opposed the positive affirmation of the work of art. This distinction appeared so evidently there for the first time. But the context, likewise, was no longer open but closed in its definition as an urban landscape. Your work stood in relation to architecture as a complement to an established environment.

Richard Deacon That's correct.

Pier Luigi Tazzi My reference to the light of dawn was not merely a poetic digression, it was in reference to the title of an early work of Anthony Caro's, Early One Morning. This seems a characteristic of British art when it reaches a turning point.

Richard Deacon Yes, I know that work. To digress a bit, one of the differences was that I knew what I was doing in Münster but I didn't know what I was doing in Sonsbeek. One of the problems for me as an artist and maybe for artists in general is to be in situations where you don't know what you are doing in a productive way. You can't always do that. I think you are correct to say that the intention was articulated and the context was clearly established. To be brief about it, I said, 'I want to make a work that is the equivalent of a house.'

In practical terms, Blind, Deaf and Dumb A at the Serpentine Gallery, When the Land Masses First Appeared at Sonsbeek and Like a Snail at Münster qualified me in terms of experience to think about and to be offered opportunities to make work in other places. One was in Krefeld, another was in Los Angeles, and there were some commissions that resulted. The work in Krefeld is one of the longest, begun in '88 and finished in '92. Do you know this work?

Pier Luigi Tazzi Yes.

Richard Deacon I didn't really know what to call it. Sometimes it's quite easy for me to title works, in this case the work is titled in relationship to intention. Sometimes work is titled in relationship to image. The work is called Building from the Inside. The place that I found and wanted to use in Krefeld was one of those urban spaces which mean nothing, a kind of open space without any real function, where roads met, that happened to define an area of ground. There are various ways you can think about the work as an entrance. I think you are correct to point out that Like a Snail in Münster was in relationship to a defined context, the elements were clear. In Krefeld it's a more risky operation because the context is undefined. The attempt was really to make a work which defines the context rather than opposing or establishing it. The place has negative qualities; it's not really the city or the country. There are various rebuilding plans for the area. The meaning of the work comes from the inside; its attempt is to generate the place, rather than the other way round, with the place generating the work. There are lots of dimensions to that: political, social, cultural, the idea about public.

Pier Luigi Tazzi *Can* Building from the Inside *in Krefeld be distinguished from what is called public art? You cannot consider the Münster piece public art, it was a component of the overall project, but in Krefeld there were links.*

Richard Deacon It's not the only one; there are other works in public places. I have some problems with the term public art; the other term is art in public spaces, and there is obviously a discourse around that. The problem I have with the term public art is that it implies a degree of social engineering, that it is something that is good for you, like medicine or public housing. But at the same time it has a certain freedom, a free availability, the public domain. When I was making *Building from the Inside* for Krefeld I was doing a number of other projects and talking to various people. It was a time in the late '80s when a confusion between the private and the public space came into being, public space got privatized, particularly in Britain. The plaza became an extension of the commercial space rather than a freely available place. It was characterized for me in the late '80s by a car advertisement which seemed to place a car in that public position. Ideologically I began to wonder whether the sense of openness implied in the notion of the public space was a component in the experience of art, and that in some ways sculpture is in the public domain. The work in Krefeld was an attempt to make an opening in space of a particular sort, to create a potential, and to act as a generator for the space that surrounds it. It's not a sign, it's not a logo, it's not a monument. I've tried to use the interiority of architecture as an element, as an appropriated mode. In Krefeld you could say that I was trying to appropriate publicness to the work, and to put that into the experience of what one has as the spectator. One of the limits of autonomy might not be architecture but publicness. There might be a point in which the social context inhibits or provides a limit to the work. I have wanted to make the connection of the plasticity of material to humanness a feature of the work. Therefore in some senses the human and human experience become a determining context. Another way to put it would be to say that if the work implies that it might belong to the social context then that's OK; if it belongs to the social context then it becomes something else. There might well be a point when the work ceases to be sculpture and becomes architecture. What's interesting is the edge between the two, the extent from which you borrow from one in order to enrich or enlarge the experience of the other.

Pier Luigi Tazzi *There is also another difference between Münster and Krefeld. The context in Münster was connotated by signs and signifiers, whereas in Krefeld the relationship of your work was more with being in an undefined place than with the users of these signs and signifiers.*

Richard Deacon In Münster the context was also established by the fact that this was a temporary exhibition. When you see this or that thing within the city you think, 'Oh, this is part of the Münster exhibition.' That's the first experience, before you explore the particularities of the work. In Krefeld what makes

it particularly interesting is the relationship to other things, to plants, trees, houses, people. So the question of 'what is this', the immediate relationship, is not to an exhibition but to other elements and to other things within the work and to the spectator's own expectations, experiences, history and so on.

Pier Luigi Tazzi *In Münster it is a sign alongside other signs. Of course* Like a Snail *in Münster has a different quality than the other urban signs and this difference is marked by an opposition. In Krefeld the opposition is not so relevant; there is no real opposition, there is a sort of coexistence. In terms of the relationship of art and architecture, your exhibition inside Haus Esters and Haus Lange proposed another series of problems. In that case the relationship was between two disciplines – your work and historically established architecture recognized as being of good quality. It looked more like a laboratory experiment, something done in* vitro.

Richard Deacon I think showing what you do is implicit in the act of making art, and there are models for doing it. The exhibition is currently one of the strongest models around. For artists, to make an exhibition is to a greater or lesser extent a continuation of what happens in the studio. Showing what you do is one of the first consequences or elements of the practice. So the basic model is that you make one thing and you show it to someone else. There are expectations on both sides, and that generates the context and has physical as well as ideological dimensions. The relationship between things is a component in how you understand the particular thing, which is what makes group exhibitions somehow more difficult than individual exhibitions, or more interesting. Haus Esters and Haus Lange are two similar buildings both by Mies van der Rohe next door to each other, but they are separate, and to get from one to the other you have to go outside and then inside. One model would be to assume that the transition from one space to the other is mechanical and there is continuity between the two places, that you are just walking down the corridor. I thought the fact that there were two spaces made it possible to use two models of showing. In Haus Esters the model was conventional as it was understood in late '80s art practice: the work was individually autonomous and contained in the rooms. The scale of the work suggested pressing against the container, but nevertheless it was contained. There was a single work which was repeated in the other house to provide a link between the two spaces, and in the Haus Lange the simplest thing to say would be that I wanted to turn it inside out. There was a work outside the front door and work out the back and on the windows. The major work inside was transparent. At the same time the individual autonomy of the works was respected. The intention in Haus Lange was always to put the viewer in the wrong place in relationship to the work, so that it was either in their way or they were unable to get to it. There was no ideal position for the spectator in relationship to the work, whereas in Haus Esters the spectator was correctly located and physically present in relationship to the work. In Haus Lange the suggestion was that you would experience a desire to be somewhere else in

order to gain the correct view, or in order to understand. That displacement wasn't intended aggressively, it was an inversion in order to shake the model. There is another model which is broadly constructed around the notion of installation where the physical, social or spatial context has a very strong determining influence on the work but disappears outside of the installation. But I did want to press this exhibition model, in part in order to emphasize autonomy and physical continuity within the spectator's view of the work and to make the building less solid.

Pier Luigi Tazzi *This was quite clear, but all that implied a sort of dialogue with the absoluteness and the ideology of form, expressed by the architecture of Mies van der Rohe. It implied a new reading of history, a relationship with history, with something already there and of historical value. A living artist has to deal with that through his work. In this sense, again the relationship is with the 'other', with the unknown.*

Richard Deacon The two houses are canonical spaces; their dimensions are as much in the realm of idea and history as they are physical. I'd like it if they weren't appropriated by history, that they continued to vibrate. One of the problems of showing there is that you can celebrate it, ignore it or try and do something else; I was trying to do something which didn't demean the architecture but wasn't awestruck in relation to it. It was ambitious and egotistical in that I wanted to be on the same level as the architecture. In a way the architecture takes you to the garden. The big windows are intended to idealize the garden. The house is almost closed to the street.

Pier Luigi Tazzi *And the windows always frame the garden outside.*

Richard Deacon By blocking off the windows with screens, a shape was imposed between the house and the garden. From the house you'd see it as in the garden; from the garden you'd see it as in the house. Intellectually I was trying to put something in the way which had to be put aside to be able to see the house. Basically it was an irritant intended to bring forward the house as well as the work.

Pier Luigi Tazzi *There was an opposition: you decided to interrupt the transparency which was one of the principal characteristics in Mies van der Rohe's project.*

Richard Deacon The transparency of the big work made of plastic, *Pack*, was 'removed' from the house.

Pier Luigi Tazzi *The material was, like other works of yours, very evident. Not only the forms were relevant but the material too, especially because of its translucence.*

Richard Deacon I'm quite clumsy; things aren't as pristine as I tend to think they are; I am less capable than I think, but the work gets less interesting when I get too clean. I think it's a quality in my work that has some value, that the material has a sense of the specific to it.

Pier Luigi Tazzi *What was relevant wasn't the transparent quality of the material but the material itself.*

Richard Deacon Yes, it was congealed.

Pier Luigi Tazzi *If the reason to use that material on the work inside was because of its transparent quality, the result was a kind of presence. Again, not the function but the substance.*

Richard Deacon Yes, I agree with that. But substance seems more interesting to me than function, it has more depth. The transparency of the plastic work gets converted to a sense of materiality and substance rather than function. Despite the work being transparent it has a physical appearance.

Pier Luigi Tazzi *Also important to me, considering the peculiarities of the buildings, was that there are no references to the fact that in many of Mies van der Rohe's drawings there are explicit suggestions as to what kind of art – painting and sculpture – his architecture is meant to host. And among the ideal works for his spaces are the sculptures of Henry Moore, which appear quite often. Henry Moore's works are far more dependent on architecture than one would expect. In the ideology of form as confirmed by Mies van der Rohe, the work of art was included as a sort of spiritual element within the rational structure of the architecture. Architecture as a container of spirituality, spirituality represented by the work of art. And Henry Moore followed this guideline.*

Richard Deacon I suppose so.

Pier Luigi Tazzi *I have been considering this relationship between Mies van der Rohe and Henry Moore, because in your work you are refusing this concept.*

Richard Deacon Part of the problem with that has to do with spirituality, doesn't it?

Pier Luigi Tazzi *It has to do with formalization. In a way a work of Henry Moore needs a frame; even if it's sculpture, it needs a frame. What Mies van der Rohe is generally doing through all his work is to build a frame.*

Richard Deacon Well, in the best buildings there is an extraordinary fluidity of space and ambiguity between interior and exterior, particularly true of the German pavilion in Barcelona. Another way is to say that within that fluidity Henry Moore served a purpose of being solid, like lumps … icebergs in the sea. There are points of concretization within the flow.

Pier Luigi Tazzi *In a way the solidity that Mies van der Rohe was searching for had the same character, the same solidity as African sculpture in the eyes of Picasso.*

Richard Deacon Do you mean it was real?

Pier Luigi Tazzi *Yes, and they shared the same kind of approach, solidity and spirituality in the same object at the same time.*

Richard Deacon I accept that. The solidity was also in respect of human presence, so they are not humanless lumps. Lumps is a parody; there is some sense that the flux, the flow within the frame, is one element, and against that you have something static. Both the frame and the lump are humanly determined.

Pier Luigi Tazzi *In your work the solidity is far more a sort of encumbrance that doesn't allow one to go with the space, which blocks the way.*

Richard Deacon Yes, that's what I mean. The body in my work is used as an encumbrance or obstruction, used as flesh and not used as a sign of transcendence or idealization. Antony Gormley uses the body as a metaphor for the transcendent subject, but at the same time the body is that in which you live. One of the ways in which I intend you to experience my work is as if you are in front of another person and in terms of a relationship to particular bodily sensations. When I began making sculptures the procedures that I used were intended to make the act of work create the form and input structure into the material. Structure and material and form were all equally present on the surface; there was no hierarchy between those elements. At the same time the centre was left independent of those elements, so in that sense the ambiguity in the work had to do with the specificities of appearance. I tend to incorporate all those things in relationship to an empty interior.

Pier Luigi Tazzi *The exhibitions we've discussed thus far all implied a relationship with a context, even if the notion of context has changed and has been modified by the evolution of the work of artists, not only personal evolution but in changing ways of presenting art. How is the relationship with context expressed in some exhibitions, like the one in Oslo's Kunstnernes Hus (1990), or at Hanover's Kunstverein (1993)? At first glance they looked – especially the one in Oslo – like canonical gallery shows. And you've told me that both of them have been quite important for you.*

Richard Deacon I've made a lot of things where one work is made for one occasion. I've also done travelling exhibitions which I don't like because there is a balance between place and work which seems necessary to construct. In Hanover and Oslo the work was carefully selected to make a particular ensemble for an occasion. It's normal exhibition making – there is a possibility to cause, permit or prohibit. I make works in many different ways, but obviously there are repetitions, of material, of technique and of form. But individual works also have autonomy.

Pier Luigi Tazzi *I don't want to be over-systematic but I feel there are two strains in your work. One goes from the exhibition in Paris and reaches the work in Middelheim (Never Mind, 1993), in which there is a recognizable tension between the work and its surroundings. The other emerges through exhibitions like the one in Oslo or at Locus Solus in Genoa (1990). In these it's not an integration but a sympathy with the place; place not only as an architectural feature but also in terms of the aura. The exhibitions at Locus Solus, Bikini at Documenta IX (1992) or at Feuerle (1993) where your sculptures were set alongside antique tea pots, all have something in common: the search for an equilibrium between the work of art and its surroundings as something which possesses a peculiar quality – in the same way that the works have a special value for you as the maker.*

Richard Deacon The work on the bridge in Plymouth, *Moor* (1990), would also be within this sympathetic relationship.

Pier Luigi Tazzi *By sympathetic relationship I also mean a certain passive attitude, as opposed to an active one: it attempts to be receptive to the surroundings, to be open to the aura, not to signal difference and impose the mark of the artist or of his/her actions. Sympathy then is more as reception than an effort to mark difference, all the while maintaining the autonomy of the work in that particular environment.*

Richard Deacon The question is, what is the relationship between the two modalities and …

Pier Luigi Tazzi *I don't know whether they should be conceived as two strains or two modalities or just a side effect on the part of the observer.*

Richard Deacon If we accept this distinction then I suppose the experience of looking at art has modalities within it. If you take the line from the Paris shows through, there would seem to be a development in the work towards autonomy, to putting the spectator in the position of being equal but at the same time separate from the work, to separate the elements within a given experience: me, the works, the park etc. I think I do work in two ways. It seems to me an intriguing thing and an extraordinary possibility that under the umbrella of making autonomous objects there are aspects of one's experience in the world that are sometimes separated and sometimes coherent, and it is possible to make objects that characterize those two modalities. This is partly a discussion that is prefigured in the twentieth century with abstraction and empathy. There are works from the beginning of the 80s that attempt to do both things at once, works to which you have an empathetic response. I think that in the work I do there is a sense of connection between those two modalities. In a puritanical sense, for example, the work in Middelheim, *Never Mind*, has many qualities that I regard as highly desirable in a work of art. The way in which the work of art resists appropriation by the spectator or the place seems to me to be a highly desirable feature. I am less sure that the harmonious relationship of the work to the space is of the same value. I like Bernini's sculpture very much, which surprises me because it has degrees of sensuousness which as a puritanical North European I find myself suspicious of, in relation to something like authenticity. If you enjoy it, it can't really be good. So I have to fight against that element within my character, because it's stupid as a reaction and has nothing to do with it. There is nothing wrong with beauty, and what I would really like to do would be to make work which would put those two things together. It may be impossible because you are trying to put dependence and independence into the same thing. But I would like to fuse those two things together.

Pier Luigi Tazzi *The big problem is the condition in which the work of art has to take place. So when I refer to a sympathetic relationship I see an attempt at protecting this modality. In the other modality I see exactly the contrary, the risk of encountering the unknown, the risk of losing control.*

Richard Deacon I think you are right.

Pier Luigi Tazzi *This takes us back to the beginning of the conversation, when we were discussing how the term context has changed. It used to be that context was some sort of structure which hosted a work of art, a conceptual device which established a link between the work of art and the world, which in turn was conceived of as a fixed structure. That structure has to protect and emphasize the value of the work of art in itself. Not the value in absolute terms but in itself; the validity, not the authenticity of the work of art. At the end of this* parcours *we find that the context is exactly the contrary: it doesn't protect the work of art but pushes it out of its traditional protection, into the risks of the world. Its systemic structure not only is no longer effective, but some of its components have yet to be defined and some are completely out of control. In a sense this is also the* parcours *through your work; things are always going from inside to outside and vice versa, meeting the void and encompassing it through a great many procedures, without being afraid and at the same time seeking the security of an established place. Ultimately, again it is the problem of what the place for art is now. Since this notion of context has completely changed over the past twenty years, what can the new structure be, the new possibility for coherent articulation, the new framework in which art can be placed? Where might art find its place?*

Richard Deacon But surely the interesting thing is to keep the framework uncertain; if you make a new framework then you establish a new convention. What interests me is to retain an uncertainty within the framework, because then you are dealing with something you don't know. If the framework is determined then really you have the Academy. What's interesting is that the disruptions in the context that we've been discussing seem to be as much negative as they are positive. In a sense the consequence of the fracture of the monolithic ideas about history is that modalities for perception have alternatives. Authority is broken and values are relative rather than absolute. The very experience of the work of art has a degree of relativity. In some ways I am a very conventional artist and I produce a conventional object. I am attached to an idea about a tradition, but I think that that attachment isn't necessarily one way. It's a means, not a value. So when we were talking about the modalities earlier, to go from one to the other is possibly to say it's all bullshit, to make you feel comfortable with a situation. The problem with relativity is that it's a moving target and enables all things to be made equal and nothing to be determined. That's the stick I have to beat myself with. That question. But it's not necessary if one framework has gone to suggest an alternative, because there may be several alternatives. The difficulty is that if there are several alternatives, that lowers the possibilities in any of them; making judgements becomes more difficult, because there are alternative criteria. You can't make judgements from the same surety because there is always another possible position to take up.

Pier Luigi Tazzi *The problem is not that we are in the absence of context, but that the idea of context has changed. When this notion first came out the context was defined*

through analyses. The instruments had a certain credibility and were considered 'scientific'. They had this kind of aspiration to truth in a way, whereas in the current situation what is lacking is this kind of credibility. The instruments of generalization are no longer effective enough to provide an image of the status of things.

Richard Deacon Yes, but that's a product of relativization. And it seems to me inescapable.

Pier Luigi Tazzi Yes. If we are currently in a moment of mutation then it's time to be very careful about the kind of mutation going on. Not in terms of judgement but in terms of survival. If in 1968, for instance, everybody was talking about how to achieve a better quality of life, today the issue is different: it's life, it's survival. That's completely different.

Richard Deacon One of the dimensions in the political debate in this country at the moment has to do with morality. The sense expressed by Conservative politicians is that the consequence of 1968 has been the degeneration of public morality. And that this is a crisis of value, a crisis of democratic institutions, a crisis of society. The offered solution is regressive; yet at the same time the crisis is a consequence of the pursuit of values promoted by the same political ideology that now fears the situation which it has created. This has some overlap with what you were saying. In the domain of art practice you are left in the situation in which you have had both models taken away from you at the same time. The collapse of social values associated with the left and a collapse of the moral, individualistic values associated with the right. The resolution of the contradiction will be reliant on a reconstruction of the idea of society or not.

Mark Dion *Miwon Kwon*

in conversation
October 1996, New York

Miwon Kwon *Was your move to New York in 1982 a beginning point of sorts?*

Mark Dion This might sound kind of formulaic, but I'd say there were three major stages to my not so sentimental education. The first was attending the Art School of the University of Hartford, which was a giant leap for me considering my working-class background. My folks were intelligent and supportive, but coming from a small coastal town across the river from the industrial seaport of New Bedford, Massachusetts, I grew up with almost no access to fine art. I was eighteen before I saw my first art exhibition – Chardin – in Boston. After two minutes at the Hartford Art School, I realized how ignorant I was about art. So in addition to my classes, I got a job as an assistant in the slide library and asked a lot of questions.

The next stage was moving to New York and attending the School of the Visual Arts and then the Whitney Independent Study Program. There I met many of my best friends and extremely generous teachers like Tom Lawson, Craig Owens, Martha Rosler, Joseph Kosuth, Barbara Kruger and Benjamin Buchloh. They were amazingly smart, tough and fiercely protective of us when we needed it. The third stage took the form of my travels in the forests of Central America. That led to my renewed interest in the biological sciences, which I studied at home and at the City College of New York.

Miwon Kwon *It's one thing to see the art world as a fascinating place of new ideas and another to believe that you have something meaningful to say in that world or engage it in a productive dialogue. When did that shift occur?*

Mark Dion By the time I got out of the Whitney Program in 1985, I sort of knew how to be an artist, because I had been provided with dozens of different models of what artists do and how they do it. But I hadn't figured out where or how I was going to apply the conceptual tools I had acquired. That came much later when I returned to what I was initially interested in long before school: environmentalism, ecology and ideas about nature. In the slick world of Conceptual and media-based art of the early 1980s, no one seemed interested in problems of nature. So it took me some time to get back to it as a viable area for critical and artistic investigation. I had a lot of unlearning to do also.

Miwon Kwon *Can you talk a bit about your early institutional critique projects coming out of the School of Visual Arts and the Independent Study Program?*

Mark Dion During my studies, Gregg Bordowitz and I were very close, and we hashed out a lot of ideas together, especially those concerning art and its possibilities. At the time, we were excited by the debates around documentary – the problematics of telling the 'truth'. We were focused on film: the work of Jean-Luc Godard and Jean-Pierre Gorin in particular, as well as Peter Wollen, Laura Mulvey and Chris Marker, and the photography of Allan Sekula, Martha Rosler and others. These people had an enormous influence on us as we tried to imagine an expanded documentary practice. While the belief in truth as unmediated authenticity had waned, there still remained the task

of describing the world. Some of my early projects like *This Is a Job for FEMA, or Superman at Fifty* (1988), *I'd Like to Give the World a Coke* (1986) and *Toys 'R' U.S.* (1986) were attempts to translate critical strategies from the field of documentary film and photography to an installational or sculptural field.

Miwon Kwon *How did such concerns lead to what you're known for now, which is art that deals with cultural representations of nature?*

Mark Dion It came about as a result of living a dual life. In my 'work' time, I was doing gruelling research to develop various installations like *Relevant Foreign Policy Spectrum (From Farthest Right to Center Right)* (1987) and others. In my 'off' time, I continued to pursue my interest in nature, adding to my personal collections of insects and curiosities, taking trips to the tropics, beaches, salt marshes in Long Island or natural history museums. It wasn't until I began reading a lot of nature writing and scientific journalism that I stumbled onto Stephen Jay Gould, who opened up a huge window for me. Here was someone applying the same critical criterion implicit in the art I aspired to make – which can loosely be described as Foucaultian – to problems in the reception of evolutionary biology. It became very clear to me that nature is one of the most sophisticated arenas for the production of ideology. Once I realized that, the wall between my two worlds dissolved.

Miwon Kwon *So what projects followed that revelatory moment?*

Mark Dion The first works were the *Extinction* series, *Black Rhino, with Head* (1989) and *Concentration* (1989), which explored the problems of environmental disruption in relation to colonial history. It was in these works that I first made use of the shipping crate as a way of addressing the international traffic of material and ideologies and myself. These works were made for shows in Belgium, which has a particularly pernicious relation to Africa as well as a disregard for issues of animal importation and endangered species protection. In both works I was looking at a complex system, trying to examine how the current loss of biological diversity through extinction could be seen as a protracted effect of colonialism, the Cold War and 'Band-Aid' development schemes. Collaborations with Bill Schefferine, like *Under the Verdant Carpet* (1990), also pointed to the impossibility of untangling any single strand from a web of relations; here we literally compacted ideas on top of each other in a way that mirrored that entanglement.

During my travels in the Central American tropics, I became very concerned with the natural and cultural problems around tropical ecology. On my first visit to a tropical rainforest, I was overwhelmed by its complexity and beauty. The alienness of the jungle, its awesome vitality – I was so impressed. I remember taking a shit during a hike in the bush and having titanic dung beetles and a dozen different flying insects descending down on it before I could get my pants up. What a place!

Anyway, even though they make up only 6–7 per cent of the earth's land

mass, tropical rainforests contain well over half of all living species. They are amazing laboratories of evolution, the greenhouses of biological diversity. At the same time, they are enormously affected by postcolonial politics, global economics, sovereignty issues and northern fantasies of paradise and green-hell. In the 1980s, tropical forest debates were like a microcosm of the deepening divide between countries of the northern and southern hemispheres. They were also a map of our assumptions, desires and projections about what constitutes nature.

Miwon Kwon *What did you think an artist or an artwork could do in the face of such conditions?*

Mark Dion What a question! Well, one of the fundamental problems is that even if scientists are good at what they do, they're not necessarily adept in the field of representation. They don't have access to the rich set of tools, like irony, allegory and humour, which are the meat and potatoes of art and literature. So this became an area of exploration for Schefferine and me. Also, the ecological movement has huge blindspots in that it is extremely uncritical of its own discourse. At the time, it was evoking images of Eden and innocence, calling for a back-to-nature ethos. So part of what we did was critique these ideologically suspect, culturally entrenched ideas about nature.

The parade Schefferine and I made for American Fine Arts, Co., in New York called the *Wheelbarrows of Progress* (1990) was largely a response to the shockingly bone-headed ways of thinking which we witnessed around 'green' issues. Each wheelbarrow carried a weighty folly – from the Republican dismantlement of the renewable energy programme, to wildlife conservation groups pandering to the public with pandas.

Tropical Rainforest Preserves (1990) is a good example of a response to a double phenomenon. On the one hand, zoos in North America were creating rainforests inside cities as special exhibits. On the other hand, ecological groups were trying to export notions of a national park – locking up natural resources in order to protect them. Our piece was meant to reflect on such conditions in a humorous way by making an absurdly small reserve that was 'captured' and mobile, comically domesticated and reminiscent of the Victorian mania for ferns, aquariums and dioramas.

Miwon Kwon *What is your assessment of such projects in hindsight? To me, they seemed very didactic.*

Mark Dion I think our projects were more complex than they may have seemed at first glance, less didactic than they appeared. They never spoke monolithically, and often had counter-arguments built into them. For instance, *Selections from the Endangered Species List (the Vertebrata) or Commander McBrag Taxonomist* (1989) tried to visualize two different processes that have a dialectical relationship to one another – the task of naming animals as one 'discovers' them (as in Linnaeus), and naming animals as they die off and disappear (as in the endangered species list). It's like Noah hunting down all

the animals he saved on the ark. We wanted our work to convey the reality of contradictions like that. Moreover, all the works contained massive amounts of detail and layering. Perhaps they were didactic, but at least they weren't boring. Humour was an important factor to the success of these works.

Miwon Kwon *In the early 1990s, the New York art world classified your practice under the banner of 'green' art. But it seems you've moved away from overt references to eco-politics in favour of studies of cultural institutions, specifically the natural history museum, as well as particular modes of display, such as curiosity cabinets.*

Mark Dion I think the politics of representation as it involves the museum has always been part of my practice. As I see it, artists doing institutional critiques of museums tend to fall into two different camps. There are those who see the museum as an irredeemable reservoir of class ideology – the very notion of the museum is corrupt to them. Then there are those who are critical of the museum not because they want to blow it up but because they want to make it a more interesting and effective cultural institution.

Miwon Kwon *You'd be in the latter category, of course, since you're an avid collector yourself.*

Mark Dion Yeah, I love museums. I think the design of museum exhibitions is an art form in and of itself, on par with novels, paintings, sculptures and films. This doesn't mean that I don't acknowledge the ideological aspect of the museum as a site of ruling-class values pretending to be public. Nevertheless, as an institution dedicated to making things, ideas and experiences available to people not based on ownership, I don't think museums are inherently bad, any more than books or films are bad. It is also clear that people enter the museum with their own agendas. Museum visitors are not mindless subjects of ideology. I think many of them have a healthy scepticism of institutional narratives.

Miwon Kwon *In 1990 when you interviewed Michel von Praet, one of the people responsible for the reorganization of the Musée d'Histoire Naturelle in Paris, you commented: 'I'm interested in the tension between the museum's position as an educational forum and an entertainment form.' Can you describe how you explore that tension in your work?*

Mark Dion As sites of learning and knowledge, museums have traditionally been places of extraordinary seriousness that shut out popular culture. But now there are very concrete pressures for museums to appeal to popular taste because of dire funding situations. For example, museums in England and the United States, which once had the benefit of state money, got their funding cut during the Thatcher and Reagan years to the point where they had to cannibalize themselves in order to pull in the admission-paying masses. In many countries, museums are trying to find new ways to remain economically viable as businesses. The explosion of gift shops, restaurants, entertainment programmes and public outreach projects are testimony to the museum's redirection towards becoming more popular.

But a disturbing thing about these shifts is that as the museum has become more 'educational' as part of its popularization efforts, it's also become dumber. The museum seems to conceive of its audience as younger and more childlike now. Rather than a place where one might go to explore some complex questions, the museum now simplifies the questions and gives you reductive answers for them. It does all the work, so the viewer is always passive. A museum should provoke questions, not spoon-feed answers and experiences. Unfortunately, though, that seems to me what museums have become.

When it comes to museums, I'm an ultra-conservative. To me the museum embodies the 'official story' of a particular way of thinking at a particular time for a particular group of people. It is a time capsule. So I think once a museum is opened, it should remain unchanged as a window into the obsessions and prejudices of a period, like the Pitt Rivers in Oxford, the Museum of Comparative Anatomy in Paris and the Teyler Museum in Haarlem. If someone wants to update the museum, they should build a new one. An entire city of museums would be nice, each stuck in its own time.

But to get back to your question, I'm excited by the tension between entertainment and education in the idea of the marvellous, especially in pre-Enlightenment collections like curiosity cabinets and *wunderkammers*. Along with visual games, logic tricks and optical recreations, these collections attempted to rationalize the irrational. They were neither dry didactics nor mindless spectacles. They tested reason the way storerooms, flea markets and dusty old museums challenge cultural categories and generate questions today. This must sound light years away from when we spoke of documentary earlier, but somehow it's related. If an exhibition is a challenge, it is both educational and entertaining.

Miwon Kwon *Do you provoke a sense of the marvellous or generate curiosity in our day and age?*

Mark Dion One thing is to tell the truth, which is by far more astounding than any fiction. (I cringe as the word 'truth' passes my lips, but I always mean it with a lower case 't'.) For example, one of the biggest problems I have with the environmental movement and the museum is that they intentionally mislead people for the benefit of their own pocketbooks, which is unforgivable considering they are organizations devoted to the production of knowledge.

The problem of charismatic megafauna, for instance, which Bill Schefferine and I tried to deal with in *The Survival of the Cutest* (1990), is a case in point. Generally, in order to raise money for the protection of endangered ecosystems, conservation organizations draw isolated attention to extremely attractive and photogenic animals – tigers, whales, pandas. These are not keystone species so the system won't collapse if they are taken out. Of course, all members of an ecosystem are important, but these animals are often the least critical ones, usually peripheral animals at the top of the food chain. They're not like the beaver or corals which produce systems that support other animals. Now, foregrounding charismatic animals is not

so bad if you acknowledge at some point their relationship to other forms of life in the ecosystem. If the conservation effort could highlight the fact that by protecting the jaguar, we can also preserve vast areas of habitat that benefits everything in it, including us, then the focus on the 'cutest' would not be so problematic. But that's not what the conservation groups do. They haven't taken the opportunity to reveal the *real* goals. To me, that shows how much they are working against themselves.

Miwon Kwon *Which parallels the art museum culture in so far as it continues to highlight the 'charismatic' masters to draw people to the museum, to 'save' the institution, perhaps.*

Mark Dion Right. In the case of natural history museums, what you see on display, which represents only 1–10 per cent of the entire collection, is usually remedial pandering equivalent to material in school science textbooks. But there are hundreds of people in the back rooms working with specimens and artefacts, hidden from public view. That's where the museum is really alive and interesting. They directly address questions like: what is the function of a collection? Why is it important to name things in the natural world? The museum needs to be turned inside out – the back rooms put on exhibition and the displays put into storage.

 Art museums also act like butterfly collectors, always repressing context and process. We would understand Manet better, for example, if his paintings were exhibited alongside works from the academy he was reacting against, rather than impressionist paintings from thirty years later. So I say freeze the museum's front rooms as a time capsule and open up the laboratories and storerooms to reveal art and science as the dynamic processes that they are.

Miwon Kwon *My impression is that you're drawn more to natural history museums than art museums. Why is that?*

Mark Dion Natural history museums ask bigger questions about life and history. That's why I'm interested in artists who have expanded the definition of art and enriched the field by looking outside of it. Marcel Broodthaers, Robert Smithson, Joseph Beuys, Joseph Cornell, Gordon Matta-Clark … the dead guys. That's my pantheon. Smithson is of particular interest because he forged a convergence between geology, the science of time, and critical art discourse. There is a side to Smithson that is a bit too Jungian for me, but his practice made art very expansive.

Miwon Kwon *Who else were you looking at as a young artist?*

Mark Dion There were so many: Jack Goldstein, Lothar Baumgarten, Group Material, Hans Haacke, Louise Lawler, Ashley Bickerton, Vito Acconci, Ericson and Ziegler, Yvonne Rainer, Mierle Laderman Ukeles, Chris Burden … I could go on. But my peers were even more influential, like Christian-Philipp Müller, Tom Burr, Claire Pentecost, Gregg Bordowitz, Stephan Dillemuth, Art Oriente Objet, Jason Simon, Fareed Armaly, Andrea Fraser and Renée

Green. Fred Wilson and David Wilson, too, although I don't know them as well personally. I share a lot with all of these artists methodologically. Then there is another group of artists who deal with representations of nature – Bob Braine, Alexis Rockman, Christy Rupp, Rachel Berwick, David Nyzio, Greg Crewdson and Michael Paha – whose methods are far from my own but with whom I feel a strong kinship. Bob, Alexis and I get together and talk like nature nerds about birds and insects. I guess in some ways the division that existed before in my life still exists, although Renée, Claire and Art Oriente Objet overlap into both worlds.

Miwon Kwon *When I interviewed you a few years ago during your preparation for* On Tropical Nature *(1991) in Venezuela, we spoke at length about the mythic figure of the naturalist both in history and in popular culture (exemplified by Indiana Jones at the time). I implied then that rather than being critical of the colonialist underpinnings of such a figure, you were playing out the role as a masculinist fantasy.*

Mark Dion I remember. But adopting that position for a while was perhaps the most efficient way to be critical. Distanced critique is a useful but boring tool. I like the idea of throwing myself into the fray. My role in *On Tropical Nature* was to become a magnet for critical questioning. I wasn't too interested in indicting people who lived more than a hundred years ago for being bad colonialists. There were other things relevant to the work, too, like the quincentennial celebration of Columbus' 'discovery' of America. It was important for me to distinguish between someone who ran a slave plantation and someone who spent years of their lives in extremely dangerous and tedious conditions in pursuit of knowledge. They may both be colonialists but these are hugely different endeavours.

Miwon Kwon *I think the tendency to collapse the two is due to our tendency to describe knowledge in spatial terms, as territories.*

Mark Dion That's why it is doubly important to mark the differences among various types of interactions. Even among a small group of Victorian naturalists, you find vastly disparate attitudes. For example, the English mining engineer Thomas Belt (1832-73) wrote *The Naturalist in Nicaragua* (1874), which is filled with astute field observations but also interventionist logic and horrendous human prejudices. It represents the worst tendencies in the field. But his world-view is very unlike those of eccentric Charles Waterton (1782-1865) or Henry Walter Bates (1825-95) or Alfred Russel Wallace (1823-1913), all of whom spent long periods in the tropical jungles. They were not innocent of the prejudices of their time, but they had robust respect and appreciation for the cultures and individuals who hosted them. Bates spent eleven years in the Amazon Basin and depended greatly on the people of the interior. He owed them his life. And Wallace despised the social Darwinists who judged indigenous peoples as savages, although they had no firsthand knowledge of them.

Miwon Kwon In projects of the past few years, you've referenced several of these naturalists – Bates, Wallace and William Beebe. Why the focus on such figures?

Mark Dion My interest lies in trying to understand their motivations. I want to understand this thing called curiosity – a desire for knowledge that is so strong that it leads one to make incredibly irrational decisions. What is it that leads someone to leave the comforts of home, family, friends and career to go and live in an unfamiliar, unpredictable and physically dangerous environment that can threaten your health and sanity, if not your life? Why choose to be culturally isolated for years in a foreign country surrounded by people from a different world? Why choose years of solitude with guarantees of nothing except maybe estrangement when you return home? These people were not eco-tourists on vacation – they literally risked their lives.

Miwon Kwon Do you think the motivations and desires that drive the naturalist are analogous to those of the artist?

Mark Dion Somewhat. Historically, the pursuit of nature started in the laboratory, the home, the collection. Things that live at a distance were brought into one's own environment to be studied as specimens. Which is to say, what was thought to be observation of life was actually the study of death. Then came the breakthrough when naturalists became field scientists, not only observing nature's operations in its own context, but discovering nature as a system of relationships, an ecology.

Similarly, making art is no longer confined to the institutional spaces that we've created for such activity. It's more in the 'field' now. The focus is on relations and processes – an ecology of art if you will – and not solely on decontextualized objects that are like natural specimens.

Miwon Kwon How has your working method changed with projects like On Tropical Nature *(1991)*, A Meter of Jungle *(1992)*, The Great Munich Bug Hunt *(1993)* and A Meter of Meadow *(1995)*, which involve 'fieldwork'?

Mark Dion To me, seeing a painting is not as rewarding as seeing a painting in production. So I want to build the process into the work, to have the work exist in several stages, and to have the metamorphosis available to the viewers so that they can engage it in different ways. I'm greedy about not wasting any productive moments. That's why I will not abandon the 'fieldwork' model. In works like *A Meter of Jungle, History Trash Dig* (1995) or *A Meter of Meadow*, there is a performative aspect. I take raw materials out of the world and then act upon them in the space of the gallery. This process is visible to visitors during the first ten days or so of the exhibition. I may be going through a pile of leaf litter to sort out the invertebrates, or I may be trying to preserve or identify material. The process is hard to get a grip on because I'm not acting, I'm not a character, I'm not pretending to be someone else. When the collection is complete, when I've run out of space or raw material or time, the work is finished. Later a collection might be re-opened.

For instance, *On Tropical Nature* opened with empty tables, signalling to the viewers that I was working somewhere but not in the exhibition space. I was in the jungle, sending specimens back to the gallery on a weekly basis, with the expectation that, based on my prior instructions, the tables would gradually become filled with the contents of my crates. Essentially, the piece changed with the arrival of each box, which were events in themselves. With works like this and *History Trash Dig* (1995), there are multiple publics that include not only the usual art audience but the people I work with in the field and the partners who put the work together in the institution. In the project for Sculpture Chicago (1992-93), there was an interesting reversal of the role of the audience. The collaborators who helped shape the work were the principal public. In this project, a group of sixteen high school students formed two clubs: The Chicago Tropical Rainforest Study Group and The Chicago Urban Ecology Action Group. For the first few months we looked into the problems of rainforest conservation, culminating with a visit to the Cockscomb Basin Wildlife Sanctuary in Belize. Later we turned our attention to Chicago's ecology. Over the summer Sculpture Chicago convinced the city to give us a clubhouse in Lincoln Park. There we had a sort of resource centre where people could come to discuss ideas about art and ecology but they could also use us as a resource: sixteen strong energetic people available to pick up trash, plant trees, turn vacant lots into gardens … Like all methods, though, this one has its benefits and compromises.

Miwon Kwon *I think the kind of 'field' practice which you, along with other artists you've mentioned, have forged, constitutes an area of artistic activity that is posing the most challenging questions right now. But what are some of its problems?*

Mark Dion One of the biggest problems with this kind of practice, which some call contexte-kunst, is that it is virtually impossible to track the conceptual development of an artist. Normally, each show is a work rather than an exhibition of several works, which makes it difficult to compare and contrast one project with the next. All of us work in relationship to a site, but we don't necessarily work site-specifically. Someone like myself or Renée Green, we try to use each exhibition opportunity to engage our previous projects and to address past mistakes or problems. I like to have a dialogue with other things that I've done. But this kind of conceptual layering is not visible to most people because they encounter isolated events or installations that are in fact part of a continuous development.

Miwon Kwon *How much of that is the structural condition of this type of practice and how much of it is the laziness of the critical community to inform the art audience?*

Mark Dion Let's face it, no one can be expected to see an exhibition in Rome one week, another in Glasgow three weeks later, and then attend a lecture in Los Angeles five days after that. Part of the problem is definitely the condition

of the practice. But because of the problem of distance, there is also very little press attention on this kind of site-oriented art.

Miwon Kwon *Obviously, this kind of practice demands a huge amount of time and commitment from the artist – preparation and execution of the 'fieldwork', production of objects or installations, then dissemination of information about the work. But it is very demanding on the critics, too, because we have patiently to piece together fragments of information from elsewhere, usually, and follow the project over a relatively long period of time – days, months, maybe even years – as it goes through complicated transformations, generating multiple narratives.*

Mark Dion Information about a project is definitely not available all at once. If there has been a reluctance to address this kind of practice seriously, that's one of the reasons. And I concede it is a lot of work to try to examine or interpret such work critically. But remember, the experience I'm most interested in is not the written appraisal but the actual viewing of the work itself. How could words or photographs ever adequately describe *The Library for the Birds of Antwerp* (1993)?

Miwon Kwon *What did you mean earlier when you said you work in relation to the site but not site-specifically?*

Mark Dion Site-specificity today is not that of Bochner, LeWitt, Serra or Buren, defined by the formal constraints of a location. Nor is it that of Asher and Haacke, defined as a social space enmeshed in the art-culture. It can be these things plus historical issues, contemporary political debates, the popular culture climate, developments in technology, the artist's experience of being mistreated by the hosting institution, even the seasonal migration of birds. There are different ways to define a site. And with it comes a newer under-standing and appreciation of the audience. Much of today's art recognizes multiple viewer positions as it attempts to meet the non-art-world viewers halfway. When I make a work, for instance, I don't expect everyone to get everything. People versed in art history will walk away with a different set of references than someone who studied zoology. And I also don't expect everyone to work so hard at analysing the work.

 It is also important to understand the flexible way in which my peers and I think of our practice. We hold dear the belief that our production can have many different forms of expression – making a film, teaching, writing, producing a public project, doing something for a newspaper, curating or presenting a discrete work in a gallery. The differences are noted, but we see each site as one among many at our disposal in terms of cultural work. For me, producing something with a natural history museum, a zoo or a historical society are all viable options. Of course, there is a flip side to this in that it may lead to a kind of dilettantism. And that may be a fair criticism. But for me, the dilettante is a much more interesting character historically than the expert. Some of the greatest contributions in art and science have come from dilettantes rather than professionals.

Miwon Kwon *Has there ever been a problem of being typecast as the artist who does nature pieces? And if so, how do you respond to such prescriptive attitudes?*

Mark Dion On one hand, there is always a desire in the art world to see something familiar – to recognize signature styles. There is a demand that you don't be a dilettante, that you stick with one area and develop it over a long period of time. On the other hand, there is a desire for novelty. So every project has to be new and different. You're accused of being repetitive and boring if you do the same project twice.

Imagine for instance *The Great Munich Bug Hunt* in which I took a tree from the Black Forest and, with a group of entomologists, examined the tree to remove the invertebrates. Now the same procedure could be followed in California and it would become an entirely different project, because it would involve an entirely different tree and reveal an entirely different set of insects, spiders and worms. But if I pursued a California version, someone will inevitably say that I did the project already, that they had seen it before. People's tendency to disregard differences is so automatic that it's exhausting to resist it.

Anyway, I do tend to get pigeonholed as the artist who works on themes of zoology. That's one of the reasons I made *History Trash Dig* and *History Trash Scan (Civitella Ranieri)* (1996), which are works that superficially borrow the methodology of archaeology in order to reframe the fascination that many Americans have with the simultaneity of history that one encounters in older European cities. During my digs into trash dumps of previous centuries I'm not interested in one moment or type of object, but each artefact – be it yesterday's Juicy Fruit wrapper or a sixteenth-century porcelain fragment – is treated the same. Other works, like the *Bureau of Censorship* (1996), *When Dinosaurs Ruled the Earth* (1994) or *Hate Box* (a time capsule of Desert Storm propaganda produced by the private sector), also depart from the focus on issues of ecology. These works are produced out of anger and disgust, they are sort of throwbacks to my earliest projects.

Part of the reason I continue to focus on nature, though, besides the fact that it is a subject I'm most interested in, is because my work involves intensive research and I find that I can build on the things I already know. I've done enough reading now about problems of taxonomy and the history of natural sciences and ecology that my knowledge can function as a resource pool. I also enjoy trying to interpret my own obsessive relationship to nature. My mania for birds, for example – what is that about?

Miwon Kwon *Whereas your earlier work registered a spirited energy about the possibilities of change, your most recent work seems reflective. In* Tar and Feathers *(1996), things feel downright dark and macabre.*

Mark Dion That's an aspect of my work that has become increasingly more defined, perhaps, but not new. If you look at my work through the lens of the grotesque and morbid, you will find them in a lot of the early projects too.

Black Rhino, with Head, which includes a huge severed head of a rhinoceros, *Frankenstein in the Age of Biotechnology* (1991) or the first *Hallway of Extinction*, which I did in collaboration with Bob Braine, are exceedingly dark works. I guess when you dwell a lot on issues like extinction, it's hard not to become a bit macabre. In truth, I'm far more interested in Poe than in Thoreau.

The more optimistic projects like *Project for the Belize Zoo* (1990) or *The Chicago Urban Ecology Action Group* (1993) tend to have a 'real world' practicality, emphasizing productive or generative models of our relationship to nature. But more often than not, the work has tended towards the adverse aspects of our interaction with nature. In fact, I am generally pessimistic about the fact that the environmental movement has shied away from providing a more systematic critique of capitalism. It has become more corporate, divisive and collusive, missing an important opportunity to present a really meaningful challenge to the juggernaut of world market economy. Environmentalism has become eco-chic, another gizmo, another category of commodities. That has led me to a kind of disillusionment.

Flotsam and Jetsam (1994) is perhaps the keystone work for this sense of gloom. It expresses a kind of disbelief in the unwillingness of people to act in their own long-term interest, and was triggered by the collapse of the Atlantic fisheries. For decades biologists told fisherman that they were overharvesting and that this would cause the population to collapse, but there was an outright refusal to control their greed. *Flotsam and Jetsam* articulates a sort of sublime wonderment at the extent of our destruction. The stage is a device to coalesce the tragic and public aspects. I don't anticipate much good news on the environmental front, although it has perhaps the greatest potential to build bridges between progressive social movements.

Miwon Kwon *Do you think your practice has become more private and subjective as a result?*

Mark Dion I think I've been consistent in pursuing my interest in the history of the representations of nature and exploring how concepts like chains of being, evolution, the 'wilderness' and fantasies of growth and utopia have shaped our thinking about nature. These days, the dominant idea guiding what we think of as nature is influenced by environmentalism, especially in relation to conservation, so my work has tried to challenge its effects.

You may be right, though, in that my work has become more hermetic in recent years, or at least more esoteric. In the past couple of years, I've been studying pre-Enlightenment traditions of organizing nature such as curiosity cabinets, which were in many ways the nursery of modern science and certainly the forerunner of the museum. In going back to the seventeenth century, I'm trying to imagine how things could have been different, to follow branches on the tree of knowledge that died of dry rot.

Stan Douglas *Diana Thater*

in conversation
December 1997, Vancouver

Diana Thater *First, could we talk about your interest in Samuel Beckett?*

Stan Douglas Beckett's work represents for me the inverse of what people usually think about it. Instead of being the withering away of action to the point of stasis, I regard it as ground zero, a beginning. The manuscripts of the film *Not I* (1972), were originally written as a more or less naturalistic story. Beckett's editing process was one of reduction and distillation, the focus gradually becomes Mouth's endless task: trying to discover whether or not self-representation or autonomy are possible through a mendacious and corrupt language. This 'linguistic' problem is the starting point of all of my work – not only in the sense of spoken or written language but also in terms of different media and idioms of knowledge.

Diana Thater *The goal then is not to effect the destruction of the subject through language, but instead to find a place for the subject to begin to reconstruct itself, in order to represent itself.*

Stan Douglas A given language always has established tendencies or biases; in order to speak, you have to negotiate what is already embedded within it.

Diana Thater *So Mouth speaks of herself in the third person.*

Stan Douglas Exactly, she refuses to say 'I' because she can't use this language to represent herself.

Diana Thater *And why the lines, 'Scream! Then listen. Scream again! Then listen again'?*

Stan Douglas Just to confirm that she is still there. This happens a lot to Beckett's characters, where every once in a while they stop the exegesis of the play and make sure they're still alive, just in case the drama has gotten the better of them. Like in *Film* (1965), when Buster Keaton checks his pulse now and then.

Diana Thater *Your book and exhibition* Samuel Beckett: Teleplays *(1988) is an important moment in your work. You have also discussed Beckett in relation to masochism.*

Stan Douglas That was in a later essay on the three teleplays collectively titled *Shades* (BBC, 1977). I wrote about the relationship of subjectivity to the law, describing Beckett as a masochist who, like any good humourist, is subjected to the law even though he is well aware of how untrue it can be. The law is either something that presumes to directly (or transcendentally) represent what is good or right, or it is something that represents or promotes the best ethical position possible in an imperfect world.

Diana Thater *So it can represent either the small possibilities or the larger ideal?*

Stan Douglas Yes, but this ideal is impossible in the universe of Beckett. Inevitably he writes from a Eurocentric position, mourning the disintegration of the coherence of that world's values. But what he articulates is not based entirely on the internal disintegration of subjectivity. From our position, fifty years later and an ocean away, we can clearly see how many of the supposedly

ontological problems of existentialism were formed in the numb landscape of Europe after the Second World War, where empires would accept decolonization only because they couldn't afford to do anything about it.

Diana Thater *You're talking about a historical point where this kind of subjectivity was totally decimated but could potentially still be reconstructed, or at least actualized as a representation of the present.*

I'm also interested in the correlation in your work between your use and Beckett's use of popular forms. You pull them from many different moments of twentieth-century history through the type of language you use. One of my biggest interests in Beckett was that he used populist forms to create works that were not populist at all. For Beckett the source is primarily vaudeville; for you there are a number of forms, such as silent films or television commercials. And then there are also specific genres that you use as models, such as horror movies.

Stan Douglas I'm interested in horror movies because there's a bodily response, a physical response, to the image – something that never seems to be present in supposedly 'high' art.

Diana Thater *And that's exactly what Beckett was about: the audience laughs out loud. He was interested in the fact that the audience responds openly.*

The element of shock and fright – in other words, the idea of being scared as a form of entertainment (which I think film perhaps inherited from the nineteenth-century Gothic novel) – is used in your installation Nu•tka• *(1996).*

Stan Douglas In *Nu•tka•* the whole issue of the sublime comes up. And with the extremity of the liminal space to which it is a reaction, we also come back to the notion of the law. Are you able to assume a position transcending the natural world, or are you subject to its influence, as a part of it? The Romantics admit the latter, in as much as the terrified awe they sometimes present comes from the apprehension of the natural world's absolute indifference to human will or presence. The little figures we see from behind in Caspar David Friedrich's paintings are witnesses of sublime events but also underline the fact that the pictures represent something unrepresentable. *In Nu•tka•* the whole question of unrepresentability has been dramatized in the relationship between these two European colonists. They are in a situation they can hardly stand: they have contempt for the landscape around them, they have contempt for the people who live there, the natives, and they have contempt for each other. But that contempt, combined with their faith in the law of their respective kings, gives them their greatest comfort and sense of identity.

Diana Thater *I want to link this back to your use of obsolete systems of representation that no longer function as they once did.*

Stan Douglas When they become obsolete, forms of communication become an index of an understanding of the world lost to us. This is the basic hook in a piece like *Onomatopoeia* (1985–86), an onomatopoeia being a word that makes the

sound of what it represents. In the piece, a player piano plays an episode in Beethoven's *C Minor Sonata, Opus III* that sounds like ragtime. Beethoven had probably written some kind of tarantella, and this dance is certainly not prescient of ragtime, but it sounds like ragtime to us, which means that we are unable to hear what Beethoven heard.

Diana Thater *You usually combine obsolete technology or an obsolete way of seeing the world with the particular moment in history depicted. So the technology is in the story, the actual narrative wrap, as in* Evening, *or at a distance from it, as with* Nu•tka•.

Stan Douglas I'm fond of Modernism in as much as I'm interested in finding forms of representation that have some structural relationship to the subject I'm addressing. *Hors-champs* (1992), for example, presents the spatialization of montage. The screen is this very thin surface through which the montage passes, and what passes through is a series of images that will or will not be censored, so whether you're watching images on the 'official' or the 'censored' side you can only witness the absence of what is being withheld from view.

Diana Thater *So* Hors-champs *is a spatialization of montage … perhaps* Evening *(1994) then is a spatialization of the television system. Would this make* Evening *the political commentary on* Hors-champs?

Stan Douglas I think they're equally political. *Hors-champs* is about exile, a more or less political exile, and this is also embodied in the music. In Albert Ayler's piece for his first concert in Paris in 1965 he tried to redeem the melody of *La Marseillaise*, which is the basis of a violently racialist and nationalistic lyric. He tried to redeem it by finding a place for himself and his history in the music. He indicated its origins in military music, brought in a fanfare, then a call and response, a gospel melody and what George Lewis calls the 'country tune', even though I could never really hear it. But I guess *Evening* is much more explicit: the actual political stories are being told from the perspectives of the three fictitious television stations.

Diana Thater *With* Hors-champs *this information is contained within the music; it is coded and then translated through the viewer's experience of the actual space of the installation. In* Evening, *the elements that link and join and repeat are already part of the space you occupy as audience of the work.*

Stan Douglas This is the way the images work on the two-sided screens; when you walk around the screen you realize that the other side always presents a collection of images that are inaccessible to you. They're '*hors-champs*', they're 'out of field'. It is a very physical thing.

Diana Thater *What is happening on the screen begins to happen for the viewer in the room. What is the relationship between all these things that wrap around one another – the technology, the narrative, the history of the music that's being used? In* Nu•tka•, *for example, which for me is the most difficult of your installations because it's the most plain, that 'wrapping' happens in terms of the sound, in*

terms of the voices that wrap around each other. It begins to be like a circular musical composition; it begins to loop.

Stan Douglas Those two pieces – *Hors-champs* and *Evening* – are my most sculptural in a way, in as much as everything is in the room, like the three zones of sound in *Evening*, and the screen that you need to walk around in *Hors-champs*. Subsequent works have become more like pictures, like old-time screen practice.

Diana Thater *You sculpt space with sound, which is sometimes music, sometimes read text. In the case of texts or monologues, do you attempt to give them a kind of musical form?*

Stan Douglas Sure, absolutely. Peter Cummings and I tried to make the script for *Nu•tka•* as musical as possible, in terms of the repetitions that happen – those parts where they speak in unison, and the parts where there are words or phrases that are echoed by one or the other speaker.

Diana Thater *And the points where they echo one another are where you're quoting from writers like Poe, Cervantes and Swift?*

Stan Douglas There are occasional phrases from the historical characters' diaries that are heard at the same time but, yes, the six segments heard in synchronization are from these other colonial and Gothic texts.

Diana Thater *Which points back to the Gothic. I don't think the idea of the Gothic is obvious at all in* Nu•tka•, *but it starts to become so when you quote Poe.*

Stan Douglas Sure, there are two quotations from Poe, which describe perfectly the landscape out there, such as, 'during the whole of the dull, dark and soundless day ...'

Diana Thater *In* Nu•tka•, *the menacing elements are not present in the image so much as described by the text. We can think about that in terms of Deleuze's discussion of masochism in his essay 'Coldness and Cruelty' (1967), which is also influential on your work. He talks of the writings of Sacher-Masoch and Sade as being, of necessity, verbal, that the events taking place need to be described. Their exposition exists primarily in language. That's what seems to be happening in* Nu•tka•; *what is menacing is not present, but is described as a projection of sorts.*

Stan Douglas Both of the writers discussed by Deleuze are masters of speaking around whatever they're talking about. With Sade you have exhaustive lists and descriptions, and with Sacher-Masoch you have different kinds of descriptions, more loving descriptions, which have more reference to detail – the real object is never really described. The 'big' object is always something that is not there, it's always an absence. And absence is often the focus of my work. Even if I am resurrecting these obsolete forms of representation, I'm always indicating their inability to represent the real subject of the work. It's always something that is outside the system.

The hugest absence in *Nu•tka•* is the natives. They were the trading partners, they were the people who were residing on the land before the Europeans got there, but they are completely out of the discussion that goes

on between the two characters. Except that the Spanish Commandant is paranoid about them coming and playing tricks on him and his crew, and the Englishman fantasizes about becoming one of their mythic characters. This fantasy is actually based on a Kuakutil myth of the Puqmis. If you were shipwrecked and half-drowned, you would be lured into the woods by voices that would transform you into this pale-skinned creature with protruding eyes and an incredibly quick gait.

Diana Thater *So the natives are only present through …*

Stan Douglas An absence.

Diana Thater *And what the piece seeks to speak about can only be articulated through obtuse references.*

Stan Douglas Prior to making *Nu•tka•*, I was surveying the area, finding traces of human presence in the landscape, and out of this came the *Nootka Sound* series of photographs. The typical conception of this kind of terrain is that it's untouched by culture, but anyone who has grown up in the Pacific Northwest knows that all those trees are at least second growth. You see that immediately. In addition to a hundred years of industry, there's the Spanish presence in the well, and in the midden they made as a ceremonial parade ground, or Mowachaht and Muchalaht fish traps, town sites and pictographs which might be as much as three thousand years old.

Diana Thater *The signs of human presence become part of the exegesis in* Pursuit, Fear, Catastrophe: Ruskin, BC *(1993).*

Stan Douglas In terms of the setting, that would be the decrepitude of the British Empire. But the story, too, is about a present absence. The narrative is framed by the three thematic sections of Schoenberg's music – pursuit, fear and catastrophe. The music is present under the sign of a lie spoken by the man in the hospital bed. As soon as he tells this lie, the music starts, and the police constable begins his investigation – pursuit. Fear and catastrophe arrive when the protagonist, Theodore, goes to confront the police about what is going on. He's told that his room-mate has died, which is probably not true. He goes on to find evidence that would discredit the constabulary, but because he's Japanese he can't do anything about it; the end.

All of *Pursuit, Fear, Catastrophe: Ruskin, BC* is concerned with many closed circuits: the turbine in the power plant, the officer's patrol, defining the region, and especially the alarm system in the police station, which Theodore short-circuits so that he can return undetected later, gather the evidence, close the circuit and escape.

Diana Thater *All evidence of his presence is now gone?*

Stan Douglas Exactly. I was also interested in a moment in Bresson's *A Man Escaped*. There's a scene at the very end of the film where the captive does as

advertised, escapes from his cell into the exercise yard, climbs over a wall, then there's another wall he scrambles over. Finally he's outside, and there's a long shot of the prison, with the concentric circles of its walls and a car circling the perimeter. A series of enclosures.

Diana Thater In Pursuit, Fear, Catastrophe: Ruskin, BC *you also create something very claustrophobic out of a vast geographic territory.*

Stan Douglas Yes, in its transitional moment, the catastrophe episode, there are two shots where the power plant's turbine is seen first in daylight, then at night. A big dumb machine spinning round, almost like a sublime force. Once again, here is the theme of the difference between mechanical and human time: the function of machines has always been to do exactly the same thing again and again. Mechanical time is about endless repetition, whereas human time is about transformation and change, with the processes of growth, ageing and death.

Diana Thater *Can you talk about these differing ideas in terms of music?*

Stan Douglas Musicians have invented highly developed and differentiated ways of dealing with time. In a way, every work of polyphonic music is a representation of how a group of people can inhabit time together. Is that relationship to be one of domination or one of equity?

 In my work I have used repetitious structures from certain musical forms, but much of the repetition also derives from Beckett. Almost all of Beckett's plays have this kind of double structure where something happens at the beginning, and the same thing happens at the end – only differently, which I regard as a confrontation with the mechanical world. Something you cannot do with live performance, with humans, is to make them repeat themselves identically.

Diana Thater *So, repetition becomes very much about the difference between what the repeated element was at the outset, and what it has become now that time has passed.*

Stan Douglas Yes. The difference between Albert Ayler and, for example, Stockhausen is that Stockhausen would have assumed that he could control the music and its system of difference, by determining the conceptual frames of performance and reception, whereas Ayler acknowledges that even if the music is repetitious, it is always going to be different, in each recording session or performance. Even when you're seeing the same film loop again and again your perception of it changes, because you have changed even though it has remained the same. It's like listening to recorded polyphonic music: on a second listening, you can hear things that you missed the first time around.

Diana Thater *This seems to be made manifest by the looping devices you use which allow for the actual continuous repetition of the film itself, for example in* Der Sandmann *(1995).*

Stan Douglas In that piece there's a very tiny permutational system that makes it appear as if you've seen a complete presentation of the space when you've only seen half

of what there is to see. The second time around it has changed, even though it's the same sand, the same face, the same architecture, the same story.

Diana Thater *The first time you see the right half of the film and the second time you see its left half?*

Stan Douglas Yes exactly, but the two sides are in a way one side, like a Möbius strip.

Diana Thater *Is the film an actual Möbius strip, or are they two separate loops?*

Stan Douglas My first plan was to be a hard-ass materialist about it and use one piece of film – and I could have done that – only it's safer in long runs to use two identical films in separate loopers. But they are identical.

Diana Thater *Earlier you talked about Modernism as part of your practice. How is it instrumental?*

Stan Douglas It's addressed in my work always, I guess, in terms of failure. *Evening* and *Hors-champs* refer to final moments of the notion of civil society – the idea that you can get together as a group, talk on the street, and change society – before social, political and economic institutions were confirmed as the dominant forms of power. *Nu•tka•*, too, set at the beginning of the modern era (14 July 1789, in fact), addresses this in a fundamental way because the processes of negotiation and transformation that are the basis of modernity have an interesting relationship to the notion of the sublime. The sublime is fundamentally secular. If you're a mystic or if you have direct access to the real through God, no problem; but when the real recedes to that liminal space that the word 'sublime' describes, you become responsible for the world that you've made. However, the first discovery of the modern world was that ethics are impossible without freedom – and this is what makes formalism inherently cynical.

Diana Thater *You're attempting to locate meaning without resorting to formalism or to what previously gave us access to meaning, the notions of God, or the romantic sublime, or even faith in a utopian political system.*

Stan Douglas Sure, but it always comes back to one problem: you cannot devise an ethical world unless you are free; when you are not free whatever restricts you also restricts and determines your choices. Ethics is a form of representation that can never be tautological.

 Being tautological, or self-referential, is a limitation that I, retrospectively, found in the *Television Spots* (1987–88) and *Monodramas* (1991). The idea was simply to play two television genres, dramatic and commercial, against themselves, so that the audience wouldn't be sure if they were seeing something abiding by one or the other of the broadcasting conventions. It was an attempt to disrupt the formal means of television. So when people called the stations, upset about having their expectations confounded, I realized that the anonymity I had insisted upon – that the spots would not be identified as art – was really an act of bad faith. I couldn't tell audiences

I was an artist and that what they were seeing was 'art' because as soon as that happened, they would no longer think that 'television' was speaking. A number of preconceptions would immediately come into play: primary among them the notion that art is about self-expression or formal play. Before they found out it was art, callers talked about the meaning of what they had seen, but once the spots became art they became strangely self-referential. So I figured that if I couldn't take my artistic practice to a public space, I would try and explicitly introduce meanings that were neither 'expressive' nor tautological into the museum.

Diana Thater *Can you describe how you try to reverse the usual preconceptions brought by the viewer to the museum?*

Stan Douglas Well, the television work basically uses the alienation effect, but the museum pieces try to make their density of reference palpable. I hope that all of the work is seductive on an immediate level, but then I try to include that seduction in the network of historical connections. Imagine you're looking at a painting by Agnes Martin. I think that to understand it properly you have to imagine her historical setting, how she's responding to it, and the history of the genre she's decided to work with – it is as it is but it could have been entirely otherwise. If a tradition becomes transparent, works of art will only reinforce convention – becoming merely aesthetic, merely beautiful, and no longer meaningful.

Diana Thater *But by taking forms out of history – and out of everyday life – and placing them in the museum, your work isn't concerned so much with what those media may reveal to us as much as what they're repressing. You've taken them out of history and you're looking back at them, so those cultural forms, instead of performing their intended function, are indicating what they couldn't do, or what they were trying to prevent from being seen. These subtle pieces of information become the keys to the work, and often it's very difficult for people to read. How opaque or transparent are those kinds of meanings being made in the narratives?*

Stan Douglas I'm often asked how I can expect people to know all of the references in a work – I can't – that's why there are supplementary texts, catalogues, etc. The work is seductively simple on one level, and fairly complex on another. But it's usually being shown in a museum, not in a market place or on TV, so I hope that audiences will at least be a little bit interested in figuring it out. An artwork shouldn't necessarily have the same obligations as, say, the advertisement, which has to impress as many people as possible as quickly as possible. We shouldn't be obliged to make work that has to be understood immediately.

Diana Thater *If we wanted to make something that could be understood immediately, then that's what we would do! We wouldn't be playing against all of these forms, in the ways that you are doing, which are complex in terms of the ways the narratives are constructed, but also in terms of the way they are cut, the kind of montage that's being used, and the way that's related to the history of cinema: what's*

allowed, what's forbidden, repressed. In television, what kind of information is repressed? What is repressed is what is on the other side. To see these two things simultaneously is to see what's on the screen and to see what's off-screen.

You play against forms you've extracted from television and cinema history, and your narratives are becoming increasingly complex with each new work. You seem now to be concentrating particularly on the montage, and how that has traditionally functioned in cinema.

Stan Douglas I guess I've become more materialist in how I approach images. In earlier works such as *Deux Devises: Breath and Mime* (1983) or *Onomatopoeia*, the images were more metaphorical in a way; metaphorical about machinery and how the image was generated. But I've slowly been able to learn how certain kinds of images are generated – I've learned to identify the clues in photography that tell you, for example, where the camera was standing, its focal length, the film used. All these things are *in* the image. It takes time to read these clues, but they are always there. That's why I usually hide the gear in my installations – because it's already visible. Lately I've tried to place details of the generation of the image within the image itself, as much as possible.

Diana Thater *Of course many artists rely solely on metaphor as a way to create meaning – this includes the metaphorical use of the equipment, where we read something new in relation to something else which we already know – instead of choosing the harder road wherein they attempt to create meaning which is independent and not referential.*

Stan Douglas I hope to be surprised by the meanings that these works can generate, so that by putting the right materials together, they can do more or result differently from what I expected. This process is opposed to metaphorical constructions, where artists expect to control the meaning of a work by defining how it is to be read symbolically. I want to work with what an image means in a public world. So when people bring their understanding of how images work, and of how things are in the world, they can do something completely different from what I anticipated when I put them together. For a while I was obstinately *anti*-metaphor – but then I realized that language and images are always metaphorical.

Diana Thater *It can define meaning but also confines it.*

Stan Douglas Sure, as with a Joseph Beuys sculpture, where you feel you're not allowed to interpret it until you've been given the key to what these materials mean in his system. This keeps a very tight rein on the work's metaphorical possibility.

Diana Thater *Right; you can control as much as you can control, and then you have to let it go. You spoke earlier of an ethical world which it might be possible to construct. We could locate this idea in reference to various types of utopias, for example Ruskin's concept of an ideal society, or the utopia proposed by free jazz.*

Stan Douglas For me, the Ruskinians made a sort of negative utopia, but the free jazz movement was something else. Maybe those utopias were realized just for a few hours, in a situation where the society was very, very small and briefly capable of working things out.

Diana Thater *But you move back and forth, talking about it in both positive and negative terms. For example, in* Evening *you have commercial television, which in the 1960s was part of a false communication utopia (because it is commercial television), set against this idea about the Black Panthers, which is actually a real and hopeful political moment in history.*

Stan Douglas Sure, and you can look at moments in these communities when the Panthers, with their breakfast programme for example, worked to make themselves autonomous, since the US government was withdrawing its support of its citizens, or that support never existed in the first place. Their utopia did take place, if only for a week or so.

Diana Thater *When you make work for a museum, as opposed to when your pieces are made for television, you talk about increasing the density and wanting to seduce the audience into reading in depth the kind of meaning the work has made possible. Yet you shoot everything with a very neutral vantage point, as the neutral camera, which is not really inviting. We are looking into that space back there, behind that camera, which would seem to be occupied by someone. How is this approach to be read?*

Stan Douglas I guess there is the ideal viewer for each work, somebody who would recognize the idioms that I'm working with, or trying to emulate. I probably learned this economy of reference from old-school hip-hop records, when there was a much smaller repertoire of records being sampled or mixed. I used to have a lot of those records, and so when I'd hear maybe a quarter-second of James Brown, I knew it was James Brown, the song and the record it came from. Records, like photographs, always have a constellation of reference that hangs over them – a place, a period, a cultural setting – which someone familiar with the material can recognize. In a similar way, I hope my work will provoke certain associations in people familiar with the quoted cultural forms. This is very different from the kind of referencing that has developed in, say, television narrative by way of rock video where a series of narrative tropes allow the story to be told very quickly. You don't need character development, because the characters are stereotypes we've seen before, and you don't need to elaborate on a conflict because it is familiar and has been anticipated. So the velocity of story-telling increases, while the possibility of difference being represented decreases.

Diana Thater *Is it possible to say that by stepping away from the camera, by allowing it to maintain what appears to be an objective view, these references can be presented as if independent of you, un-inflected by your presence?*

Stan Douglas The camera is inflected by me but it presents much more than me, even
 though I put this thing together and I take responsibility for it. How
 I might express myself is not very interesting at all. I want to talk about
 the possibilities of meaning that these forms and situations present,
 rather than talking about myself.

Diana Thater *It's a critique of a certain position, of the position of the artist in Modernism,
 and of being able to reduce the work of art to that artist's identity.*

Stan Douglas Yes, and as an example, if you look at the cover of that Beckett book you've
 got there – there he is, wearing a wool sweater, sitting on a fire escape,
 looking morose; it's the cliché of a romantic poet. But for the *Teleplays*
 catalogue I found this picture of him wearing a suit and tie and looking
 like an intellectual in Paris, which is what he was!

Diana Thater *Earlier we were talking about Beckett and populist forms such as silent film:
 what is it that interests you in silent film?*

Stan Douglas One thing I've found particularly interesting about silent films was their
 extremely high narrative density – a quality that is very different from what
 I just described in television. There were few psychological conventions in the
 Hollywood sense, so the stories could be told very quickly. You could establish
 characters in a very brief theatrical way, without resorting to psycho-babble.
 I found this potential quite amazing when I shot *Pursuit, Fear, Catastrophe* ...
 Beckett certainly remembered the cinema before the psychological
 requirements were set in stone – and I think both silent film and vaudeville
 influenced the pantomime episodes in his work. Throughout the 1960s his
 practice became more and more rarefied, as theatre itself became more and
 more rarefied. But in France and England during the post-war period, theatre
 was both a popular and a bourgeois art form. By the 1950s he was doing
 work for BBC radio and work for television, before TV became the most
 conventionalized and controlled public medium. At that time producers
 didn't quite know what to do with it. The shows broadcast on TV and radio
 were a lot more varied than they are now, and Beckett's media work has to
 be seen in that context.

Diana Thater *But again, he was placing something obscure and intellectual (high art in other
 words) in the context of something which was made for the masses (low art), in
 a reversal of the vaudeville to theatre translation that he makes in his plays. You
 also turned around and went in the other direction when you broadcast strange
 little neo-commercials on late-night local television stations in Canada. Can you
 talk about the* Television Spots *and* Monodramas?

Stan Douglas The main difference between the *Television Spots* and *Monodramas* is that
 I wanted the *Television Spots* to be seen repetitiously, so that you can view the
 same spot again and again on the same night, and they're usually depicting
 a repetitious or circuitous situation. Once I got cable I realized that people

watch TV with the remote control in their hand, and I decided to make spots that were more self-contained, so that they could be seen only once and still retain the sense of ruptured convention and interrupted habit that I was interested in establishing.

Diana Thater *So with the* Monodramas *you wanted to interrupt the course of what has become normal television viewing, and to rupture the state of mind necessary to watch television?*

Stan Douglas A word that's used all the time in marketing is 'brand'. PepsiTM is considered a powerful brand because it is widely recognized, and has a relatively consistent meaning world-wide. Television advertisers don't expect you to run out and buy their product right away, but they hope to make it familiar to you even if you've never held it in your hands. The commodity is branded when the brand-name is impressed upon it and therefore supposedly means something – reliability, youth, privilege, whatever – and the audience is branded, too, when it makes the intended association between a thing and a 'feeling'. This is why broadcasters don't talk about how many viewers will see an ad, they talk about how many 'impressions' it will make. My spots were intended to make the wrong impression.

Diana Thater *You believe there is a thinking audience out there?*

Stan Douglas Recognizing the sophistication of audiences who have been looking at moving images with sound all their lives, and who know well enough that media is constructed, has led advertisers to devise more and more ironic and cynical advertisements – like those of Benetton. But however cynical or ironic the ad, its brand is nevertheless impressed on the mind.

Diana Thater *We've discussed the relationship that the* Television Spots *and* Monodramas *construct with the audience as one of discourse. This gets back to your idea about a rupture in the conventions of Modernism, which has taught us how to look at works of art as things that exist in their own world, separate from the social and political borders in which they were made. The rupture that you're attempting to create is a small political rupture that opens things a little, and allows this other kind of conversation back into the work of art.*

Stan Douglas As I mentioned earlier, if you have a secular understanding of the unrepresentability of the real, you take responsibility for what you're making. You can do that either cynically, through formalism, or ethically, through representation. Early influences, or the artists whose projects showed me how this worked, were Robert Venturi, Cindy Sherman and Jenny Holzer. (The *Television Spots* in particular were modelled after the first presentation of Holzer's *Truisms* on anonymous street posters.) And I was also very interested in what was happening in England in the 1970s, where there was this interface between visual artists, theory, film – the writers associated with Screen magazine as well as artists who also wrote, like Mary Kelly,

Yve Lomax, Victor Burgin or Laura Mulvey and Peter Wollen, who politicized the terms of spectatorship.

Diana Thater *You make works that imply different kinds of closed systems, but because of the techniques and systems you use, to quote Deleuze, 'we may conclude that there exists somewhere a whole which is changing, and which is open somewhere'. But they're always open in a different place and that allows that meaning that you were talking about to creep in through the hole. This allows the work to engage with the world, and then to become part of a kind of ethical and social discussion.*

Stan Douglas I appreciate the early work of Deleuze where he was looking at certain writers' and philosophers' work, and asking: what if this body of artistic work were a complete philosophical system? Then he untangles the philosophical logic of this body of work, which I thought was very interesting because it takes something that is very specific and makes it into a complete world. That is, as you say, a closed world that is open to the world: a possible apprehension of the real.

Diana Thater *Then we can think about your work as a history, a narrative and an apparatus that is creating a closed system which, because of the tightness of it, splits open and allows some moment of grace, or of freedom. You talk about each work using a different conception of the medium, or a different genre. But in every instance you talk about a very specific moment, where something is desired, or some idea of utopia is forcing a desire for freedom onto its subject, or its subject is seeking that.*

Stan Douglas I guess in terms of a general technique all the work has this idea of suspension, like taking something that is transient, something temporal, and suspending it in some way. With a film loop, for instance. This was my fundamental interest in re-making the robbery sequence from *Marnie* (Alfred Hitchcock, 1964). It is the crux of Hitchcock's film, the moment where Marnie stops being a professional thief and becomes whatever she is later on – her last free moment as a professional, before she comes under the influence of the Mark Rutland character. I updated the office set and took the moment of the crime, at the interval between working and private life – an in-between, liminal space of a kind that I had been preoccupied with in the *Television Spots* and *Monodramas* – and suspended it with a Möbius strip-like long take. I'm always looking for this nexus point, the middle point of some kind of transformation, like when the English and Spanish arrived at Nootka Sound. I guess this accounts for the embarrassingly consistent binary constructions in my work.

Diana Thater *Yes, there are always systems of two: in* Nu•tka• *it's the two intertwining images and voices which separate and re-connect; in* Der Sandmann *it's the two halves of the screen which merge; in* Evening *it's the two different days presented in the three images; and in* Hors-champs, *the two sides of the screen. Within each of these sets there is a historical space closing up.*

Stan Douglas Almost all of the works, especially the ones that look at specific historical events, address moments when history could have gone one way or another. We live in the residue of such moments, and for better or worse their potential is not yet spent.

Marlene Dumas *Barbara Bloom*

in conversation
July 1998, Amsterdam

Barbara Bloom Let's start with the most clichéd interview question: If you were marooned on a desert island, what would you want to have with you?

Marlene Dumas As a teenager my answer was always: mascara. I was vain, but maybe it was also about putting on a mask or war paint. There's no point in bringing a sketchbook – I could draw in the sand – and to bring a man or a mobile phone would be cheating. I think you'd probably somehow get the yellow pages there – to organize the place better for my arrival.

Barbara Bloom Maybe we should start with the wrong questions, like, 'What is the origin of your relationship to political art?' or, 'Can you say something about how being a woman has affected your art?' These really are the wrong questions! Maybe I should mention another one you asked me many years ago: 'Would you still love me if I stopped making art?' I said, 'Of course', but that was an odd question; I don't think you could stop making art.

Marlene Dumas At art school, I remember, my professor told me, 'You're a born painter'. I replied that I considered painting old-fashioned. All the smart artists were doing other kinds of work, so I wanted to do something else, but he said, 'My poor girl, what else could you do?' In Holland I will never be accepted as a proper Dutch person because I can't ride a bicycle, or swim, and I don't have any hobbies. In that sense I enjoy seeing art as a form of play – you can play, you can lie, you can do all kinds of things.

Barbara Bloom One of the things I love as much as making art is being with plants.
 I've often thought of having a nursery where I'd grow strange hybrid plants or flowers. I could imagine this taking as much of my time, energy and concentration as art. You don't have anything like this that you'd like to do? Maybe you could deal poker in Vegas?

Marlene Dumas Apart from drawing things? I like to read – although I haven't read a book from beginning to end for a very long time, so it's all fragmentary reading. I also like to do nothing. You and I have a whole friendship predicated on loving to lie in bed and talk or watch TV. Some people can make it sound so serious: 'Why do we make art?' They say it can enrich you, but I don't know. Lately I've wondered if, instead of bringing you closer, it makes you withdraw.

Barbara Bloom When I was interviewed by the artist Kiki Smith once, she surprised me by asking, 'What do you do when you watch TV?' I said, 'I don't know, watch TV'. She said she always has something in her hands, she's always making some-thing, and when she looked at my art, she couldn't visualize what I did when I was watching TV. She said, 'Where's the pleasure in making art if it's not in this physical, haptic act of making something?'
 I've thought about this a lot since then, and I think the pleasure for me is the sense that visually, spiritually, intellectually, things are so interconnected.
 That for me is the absolutely pleasurable moment, when someone says

something, or I'll read something in the paper, or I'll be walking down the street, and suddenly I realize this is the connection.

Marlene Dumas That's also why I think we understand one another, that aspect of the connectedness of things. What you describe I always think of as a normal state of being, and assume that everyone has, and takes pleasure in, this way of seeing things, but this doesn't seem to be the case at all.

I am often surprised at how people point out the way I jump around so much, not finishing my sentences. They see it as a chaotic trait, while as you say, there's something wonderful in the way you can see or do something at random, and then something new emerges by chance.

Barbara Bloom *It's almost like a literary structure: Mr A and Miss B have an unresolved conflict in chapter one, but in chapter seven something unrelated happens which indirectly resolves that first conflict.*

In your work, when you make those connections between things, I see that process as keeping the work open, so that it doesn't become didactic or zealous. If your painting connects the colour red with a shape, and that shape with some words, it doesn't seem that you believe this is the only possibility of connectedness. That just happens to be what you noticed at that moment. That's what I like so much: the sense that you don't own it.

Marlene Dumas The San people in South Africa were killed by both white and black people because both wanted to own pieces of their land. Never mind whose it was, all parties wanted ownership of it, except for the San nomadic bushmen themselves who said they didn't want possession, they just wanted access to the land. I like the idea of access rather than possession, but if you work in this way, without a fixed viewpoint, some people feel that therefore you don't believe in anything. However, I think that one can still believe in many things, and since I talk so much …

Barbara Bloom *Maybe because you have something to say! Do you have an idea what it is that people are relating to when they see your work? One of its aspects is colour, the way the paint is applied, the lusciousness of it, the richness of the content. People relate to that, but can you guess what's attractive about the work? Is it the fact that they somehow connect with it?*

Marlene Dumas I think there's a whole set of different perceptions. There's a certain popular aspect of the work based on people feeling that, unlike many other contemporary art forms, they can immediately see or recognize what it is, and from this they feel that they know what is going on in the work.

Barbara Bloom *You mean that the work is narrative?*

Marlene Dumas No, it's suggestive, it suggests all sorts of narratives, but it doesn't really tell you what's going on at all. Someone said that it feels as if something has happened, in the sense of an after-event, or alternatively that something's going to happen but you don't yet know what it is. It's as if I can make people

think they are so close to me that they believe I've addressed the painting directly to them. I give them a false sense of intimacy. I think the work invites you to have a conversation with it.

Barbara Bloom *Do you think that this sense of privacy or accessibility can make the work seem direct and unmediated?*

Marlene Dumas Yes, I think certain people experience it that way.

Barbara Bloom *They think it's direct and naive. That if Marlene Dumas fell down, she'd make a painting about falling down?*

Marlene Dumas Yes, that it's primarily autobiographical. Then there are those who like the titles or the play on words and think it's more complex.

Barbara Bloom *What about the autobiographical content?*

Marlene Dumas People like portraits. Certain works are like portraiture in the sense that you can recognize people, so some viewers see these big groups of faces and think they recognize ex-lovers, or famous people, or …

Barbara Bloom *Like people finding concealed messages in pop songs?*

Marlene Dumas It's almost like that. I don't know if I've succeeded, but I've always wanted my paintings to be more like movies or other art forms, where the work stimulates discussion in all kinds of directions.

Barbara Bloom *Many artists speak a sophisticated jargon peppered with critical theory. Maybe the reason why we take to each other so much is that we don't differentiate in importance between a conversation we have with our lover and what we're doing in our work or our teaching. So there is no private versus public language, no hierarchy denoting how one should use one's energies or abilities.*

Marlene Dumas I like the word hierarchy, or rather, I *don't* like the word hierarchy!

Barbara Bloom *You've said in the past that you'd like to paint love songs, or write lines to rap songs. I began thinking of the titles of your paintings in terms of Country and Western songs, and the line came to me: 'Paintings don't die, they just go to sleep', which of course is about history. Then the next line could be, 'Paintings don't lie, they just …'*

Marlene Dumas Cry wolf!

Barbara Bloom *'Paintings don't lie, they just cry wolf!' It reminds me of listening to Bob Dylan songs as a teenager, those non-sequiturs brimming with meaning.*

Marlene Dumas What's also interesting to me is the mistakes. I would get some of the lines wrong and always sing it that way, and then much later I'd listen to the original again and realize that my version had always been wrong. Some of my better works have been based on mistakes.

Barbara Bloom *There's a short story by Raymond Carver, that Robert Altman adapted for the movie* Short Cuts. *It's about a young boy who gets hit on his bicycle, the day before his birthday. His mother's ordered a birthday cake. The boy's in the hospital in a coma and the baker keeps calling the house to get the cake picked up. It's very dark. I read another version Carver wrote of essentially the same story, but with another title and told quite differently, with much less of a dark ending. It struck me as liberating that he could rewrite the same story, revisit the same material, that there would not be a singular, 'perfect' version.*

Marlene Dumas There was a time when I made a point of only doing something once, and never repeating it, but now I recognize how many things keep on coming back. This reminds me of some cultures in Africa. Here in Europe the uniqueness of a work is so prized. In Africa, if I painted a beautiful painting of you, and someone else liked it and wanted one too, they would pay me to make another one just like the first, and the closer the copy, the more they'd pay for it.

Barbara Bloom *A lousy original and a great copy! If you look at some of the journalism on your work you tend to get these simplistic made-for-TV versions of the Marlene Dumas story: caught between two cultures, South African and European; caught between two languages; the refugee, the woman in exile; the only way she could express herself was through paintings …*

Marlene Dumas I must admit that sometimes it's partially my own fault, for feeding people clichés. My mother always used to say to me, 'Don't talk so much!', because I would talk far too much with people I didn't know, becoming incoherent. When I was at home I would be quiet and just say what was on my mind. She said that if she didn't know me she would think I was extremely superficial. I'm probably more honest in my work.

Barbara Bloom *But you're reacting to what's expected of you as an artist, what's expected of you as a performer. You're giving people what they want. Which brings me to the first question I thought of – about blondes. Not, 'How does it feel to be a blonde?' but, 'What is it about being a blonde?'*

Marlene Dumas Blondes are stereotyped as being so dumb that they don't even know they're having a good time! Fun is wasted on blondes. Youth is wasted on blondes. Womanhood is wasted on blondes. There was a time when I wanted so much to sound intelligent that I wanted to *look* the way that I thought Simone de Beauvoir *sounded*. But then I thought, I like people who can say something serious in a humorous way. To paraphrase Samuel Beckett: 'There's nothing as funny as unhappiness'. I've also realized that this is why I stopped talking about South Africa to most people, because they don't care at all; they just want you to confess and spill your guts out, to entertain them. They don't care about the other things they ask you either, because if the topic is 'in', they ask, and if it's out, they don't ask any more.

I used to be asked about the unconscious. I haven't heard that word for a long time. When I first mentioned being an artificial blonde, it was because I had been asked to write about why I paint, as a woman. The idea was that, apart from the fact that painting is dead, it's also for dead males. I thought, why always be on the defensive, why not turn it around? So I decided that instead of saying that in spite of the fact I'm a woman, I also like to paint, I'd say I paint *because* I'm a woman, I paint *because* I'm a blonde.

Barbara Bloom *Of course blondes have all these different meanings, supposedly: they are dumb, superficial, fake, naughty. Part of the mistake that people can make with you is that, because you're a blonde and moreover a foreigner, they think you're stupid. This makes it easier for them to like your work, like they discovered you have no idea what you're doing and they can* tell *you what you are doing.*
So they can be arrogant, as if you're some kind of idiot savant?

Marlene Dumas Sometimes I think I totally dislike people, while on the other hand, I'm supposed to be the kindly humanist. Is it André Breton who said, 'I paint to be loved'?

Barbara Bloom *Isn't there an expression: Once stupid, always stupid?*

Marlene Dumas There is, 'As stupid as a painter'. Marcel Duchamp said that.

Barbara Bloom *Duchamp: the other MD!*
Show your real colours! Or rather, show your dark roots. Maybe we should edit out all of the smart stuff, and only leave the unfinished sentences?
The titles you give your works are interesting: they inform me of the knowledge you would like me to have about what is being shown.

Marlene Dumas But some people criticize me, saying that quite a few paintings have survived just because they have good titles, although they're actually rather bad paintings.

Barbara Bloom *When I hear something referred to as a bad painting, that always makes me want to come to its defence. It's bad on whose terms?*

Marlene Dumas A good artwork needs humour, distance and a good title. If a work had a different title, it would be seen differently. Certain things, the mixture of the title and the image, sometimes save the work from being pathetic.
Some people say I don't discriminate enough, that I should bring in much more hierarchy in my works, that I should not show everything that I've done. I read an interview with Barbara Kruger describing very well how in the Jackson Pollock era, the major arguments were about who was the best painter, whereas the subsequent generation of women artists were interested in different …

Barbara Bloom *Different voices, different ways of working.*

Marlene Dumas Despite this, people still think I should have stricter selection criteria.

Barbara Bloom *What if your principle is to show everything? You don't want to show junk, but the way you think about the world, so you don't make a hierarchical statement about what might be a better thought or a better image.*

Marlene Dumas I'm interested in seeing what people reject, what they accept, and why. I've made one group of images called *Rejects* (1994–), the ones with their eyes torn or scratched out, and a series of more controlled, smooth works that I call *Models* (1994). The Germans prefer the *Rejects* and the Dutch the *Models*. I always wanted to be a therapist but now I'm pleased that I don't have to sit and listen to people's problems all the time; I get this anyway through the reactions to my work!

Barbara Bloom *Could you talk about the portraits, or group portraits, of friends or people who mentally crossed your path? You've said that you wanted everyone you ever met or saw to be touched by your hand.*

Marlene Dumas I would like that, almost.

Barbara Bloom *I once had this conversation with the artist Allan McCollum about computers. He was talking about being capable of producing as many permutations as there are people in the world. I was just awestruck; I realized that what he really wants to make is a series of objects so extensive that everyone on earth could have one.*
 I was wondering if what motivates you is to touch everyone, for everyone to be touched by you?

Marlene Dumas Yes, and sometimes it's almost like giving homage to everyone that you've been, or felt, related to. Oscar Wilde said that if you are only capable of loving one person then you are quite limited. Mae West, who had so many different lovers, was once asked if she had ever found a man who could make her happy. She replied, 'Yes, many times.' My work is a record of all these people in my life.

Barbara Bloom *Of course, that's what one wants most to do: to have access somehow to someone else's way of seeing the world. All of a sudden you see the world in this other way. You could have an Ed Ruscha moment, or a Marlene Dumas thought …*

Marlene Dumas Whenever I think of Ed Ruscha, seeing as you've mentioned him, I think of his work *Sand in the Vaseline*. I like it so much. Actually, I don't think I ever totally worshipped one type of art, or artist. I suppose the painter I most admire is probably Goya, even though I'm living in Vermeer country.

Barbara Bloom *Marlene, do you prefer pink and fluffy, or dark and gloomy?*

Marlene Dumas The English painter Howard Hodgkin noted that red or black are perceived as dramatic and strong, whereas pink stands for bourgeois babies, softness and weakness. He said this is why people always think that Renoir was such a mediocre painter. Maybe Hodgkin exaggerates the point but I do find it interesting. In daily life, wearing black and brown together, or green and blue, used to be considered bad taste, because of Goethe's theories on colour.

Barbara Bloom *One of my biggest obstacles is my impeccable taste.*

Marlene Dumas Yes, I wanted to ask you about good taste, because my work is said not to be in very good taste!

Barbara Bloom *Of course, it becomes really liberating to embrace things that you don't like. I've always thought orange was such a horrible colour …*

Marlene Dumas I just thought of orange too!

Barbara Bloom *Orange now seems to be* the *colour, as black was in the 1980s.*

Marlene Dumas And in painting, black was traditionally not supposed to be a real colour. Renoir is said to have told Matisse, 'I don't really like your work, but you can use black as if it's a colour, so you must be a good painter'. When I was making art in high school there were these rules against using black, for example, and too many bright colours together were considered vulgar.

Barbara Bloom *That illuminates certain things about the way you go through the world. For instance some people, by nature, defy the rules. And that's important, in terms of their expression of themselves. There are other people who acquiesce to rules.*

It seems to me that what you do is just restate the rules with a question mark: 'Why this rule?' Why not paint in black? Or then you anthropomorphize black and say, 'Poor black!' But you would make a connection between the black of the painting and the black of the people and the black of the night and the black of the eyes, so that black becomes very potent. It's different from defying the rules. You twist and tweak the subject and images so that we can make all kinds of connections.

If you're supposedly blonde and ditsy, and you're just being brainless, you get away with murder in a way. What is the correlation between being a blonde and the lusciousness of the way you paint? What would you look like if you looked like your work? You wouldn't be a blonde.

Marlene Dumas If you saw a certain humour in the work, then you would probably think it fitting, but if you saw the work as very heavy, I would definitely be seen differently. There was a comment-book for one of my exhibitions once; one guy wrote that he didn't find my work at all illuminating – it was drawn badly and the porno wasn't even pornographic. It wasn't hard like the pornography he was used to seeing. All these watery little watercolours, porno in watercolours – that was really weak!

In America, when I did these gallery talks to discuss my work, I had two works, *Porno Blues* (1993) and *Porno as Collage* (1993), which were the only ones with 'porno' in the title. I didn't quite know what I wanted to say about them, so I talked about my other work, and they all waited for me to come to these. When I got to them I said, 'I've talked so much, I don't think I have anything more to say now'. They were so disappointed, and they came to me afterwards to ask all these questions, off the record. Once, in North America, someone was interested in these smaller paintings of a naked young girl, and asked, 'What is the age of the child?' I said, 'It's not a child, it's a painting.'

Barbara Bloom *Has any comment or question made you really rethink what you do?*

Marlene Dumas A long time ago a Dutch painter, Lucassen, was asked about younger Dutch artists. He said he disliked my work because I seemed to have one foot in the tradition of painting and another in the Conceptual court. At the time, although I was struggling with it, I hadn't actually thought of the work in those terms. Then I thought I should make more of a point of this, because he was actually right. I want both worlds. It's like what someone said to me the other day about my *Pin-ups Series* (1996), which I'm adapting for an edition of playing cards. They said that as a woman, in works like this or the *Wolkenkieker Series* (1997) I could be seen as perpetuating sexism. I said that I knew all about that, but that these are all the things that I used to worry about years ago. I don't want to make anti-images; I want to make more desires possible. It's not that the problems have gone away. In South Africa there was a time when I definitely would not have been able to make work about blackness. If you wanted to express things about apartheid, and belonged to the privileged class, how would you deal with someone else's sorrow and your own shame and guilt? Eventually, when I did address it, I felt that even though I was not showing abuse, not saying, 'Look how bad discrimination is', nevertheless somehow I felt okay about making this work.

Barbara Bloom *Okay, so you've been told not to paint black, with all its implications, and then you paint a series of black faces in the* Black Drawings *(1991–92).*

Marlene Dumas I think that of my groups of drawings they are definitely the most intense because they're so very concentrated. They had a moral urgency; it was the first time that I had made a group consciously excluding all so-called white people.

Barbara Bloom *I'm wondering if it would be a mistake to think of your studio as some kind of laboratory where you give yourself permission to look at complicated subjects. You're not frightened that you might be both attracted and repelled. You give yourself permission to work though the complexities, which allows your audience to realize that they too have all these reactions to beauty and ugliness. I find this work in the studio courageous, in a way comparable to the filmmaker Werner Rainer Fassbinder, because he too showed his complicity. His films don't point a finger at someone else. He shows the fascist, amoral, brutal, dark tendencies we all have, by revealing these in himself.*

 For example, I always wondered if it would be possible to make visual pornography that was exciting – there's so little erotic artwork, there are a few erotic works in literature. I somehow expected that you might be the person to do it?

Marlene Dumas It's difficult to know if you achieve what you intended, because often if you take eroticism as your subject matter, then it doesn't have to be an overtly erotic image at all. You could make very boring, dead work using pornographic subject matter. In *Porno Blues*, the subject is looking at herself, she's sitting

there all alone, self-absorbed rather than excited. As for the difference between drawing and painting, I remember what Gerhard Richter said about his Baader-Meinhof series (*11. Oktober 1977*, 1988); how something on a smaller scale is more low key. Intimacy can't be blown up. I have sexual explicitness in my drawings, but I have never made a painting of a copulating couple.

Barbara Bloom *What we can and can't talk about, what we can and can't draw, what we can and can't paint, are all different. Similarly there are things that you can and can't photograph. Or there is the question of painting images which were shot first by a camera (what you refer to as second-hand images and first-hand experience). I imagine you think about what these different media mean in terms of what they do and don't allow?*

Marlene Dumas Think about the woodcut *Young Octopuses – The Dream of Awabi* by Hokusai. The woman has her legs spread and is being kissed or sucked by an octopus. It's one of the most erotic images I know, where the female's feelings in these matters are being expressed. However, I would not know how to paint it myself. I think I would make a disgusting painting if I tried to paint this woman and the octopus, because it would be too much: too much paint, too much weight, too thick, too clumsy. Japanese woodcuts are incredibly explicit sexually, with those enormous sexual organs, but at the same time, because of their technique, they are so delicate and sophisticated. This sets up a wonderful tension.

Barbara Bloom *Or the prints that have the peeping artist, this tiny little image of the artist, who is much smaller than any of the couples with enormous genitals.*
 This tiny artist, who is always lurking around the corner, underneath the table or behind a screen – he's very funny.

Marlene Dumas Or the couples are drinking tea: they're in all these sexual positions while drinking a cup of tea, which I admire. And also the combination of violence with elegance. It's quite difficult, as you know, to keep things erotic.

Barbara Bloom *Could you say that you make your area of work a place where you can explore your own interests and confusions?*

Marlene Dumas Yes, in a sense. You come to terms with your fears or you exorcise them by making the work.

Barbara Bloom *But do you think that part of what you're doing is giving people opportunities to think about just those questions?*

Marlene Dumas I treat all my models equally. I find them all equally strange, and I find all human beings equally scary. To go back to the *Black Drawings*, for example, I don't make work about nostalgia, because even though I did at first use old postcard photographs as the inspirational source for some of the heads, I certainly didn't intend to turn these people's faces back into some kind of ethnic African warrior persona. What interested me was how the subjects

looked at the camera, how the sunlight hit their faces, how the scale of the faces was quite small … and what different people could and would read into them.

Barbara Bloom *You've talked about pornography but there are also other subjects, like belief and trust. Without getting too biographical, there are many theological questions, because of your family background and your rather religious upbringing.*

Marlene Dumas I like the word theology; it's the origin of philosophy, just as photography is the origin of obscene pornography.

Barbara Bloom *Your work so often asks, but not didactically, these questions about how one thinks: What is beautiful? What is ugly? What is moral? How does one act morally? Do you deal with what is and is not ethical?*

Marlene Dumas All choices lead to ethics. Too many alternatives, combined with a lively imagination, lead you into an existential anxiety, where you are in continuous confusion and darkness. Like in the story of Abraham: how did he know that this was God speaking to him?

Barbara Bloom *Because God was looking directly into the camera!*
Whose voice do you listen to?

Marlene Dumas No one's? I can't answer this.

Barbara Bloom *Are you often asked to comment on ethical issues?*

Marlene Dumas What always irritates me is that those questions are so unanswerable, because they put the emphasis in the wrong place.

Barbara Bloom *You've called yourself 'Miss Interpreted', so which question shall we tackle now? How about the future of art? Is painting dead?*

Marlene Dumas The person asking usually has some other reason for asking. He or she is often asking something else which is unspoken. It reminds me of one of my one-liners: 'The only good painter is a dead painter', because everyone always wants to talk – and it's so boring – about 'the death of painting'. And the questions are too broad, vague, unspecific. It's impossible to give nuanced answers to unclear questions. And, as they say, God is in the details.

Barbara Bloom *If you make a painting of a girl (*The Painter, *1994), and she has one red hand and one blue hand, then the wrong questions would be: What does it mean? What does it symbolize? You would have to explain that, actually, the red hand and the blue hand don't have a single meaning. They don't symbolize anything. The red doesn't stand for freedom, or blood, or for menstruation, and the blue doesn't stand for sorrow or loyalty, or whatever. There's a lot of ambiguity, of possible readings, and you're hoping – I'm now speaking for you – that in all of what you do there are not specific, fixed meanings.*

Marlene Dumas I don't hope, I know it to be so; that is the ethical burden. Sometimes people ask me: Why does it all have to be so ambiguous? But it's not that

Marlene Dumas

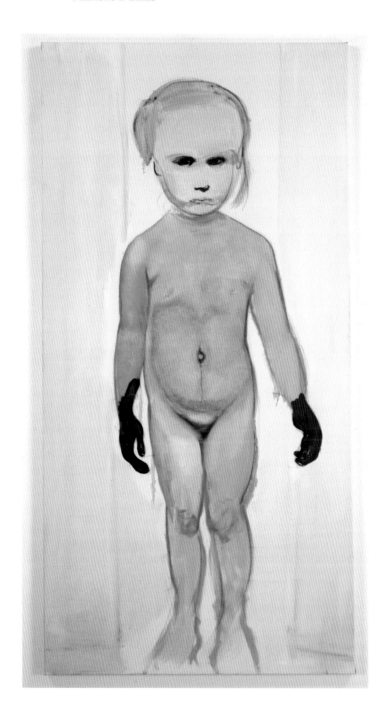

The Painter 1994
Oil on canvas
200 × 100 cm

Richard Deacon

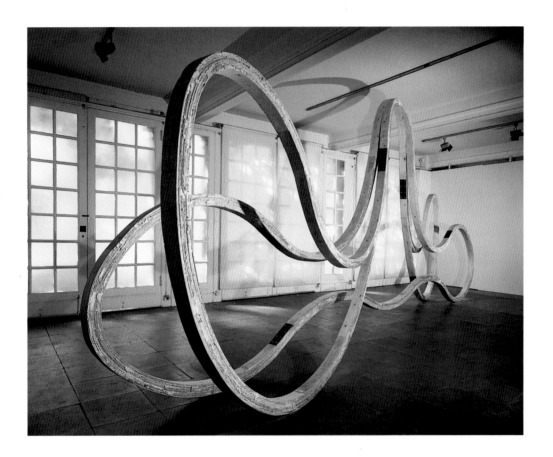

Blind, Deaf and Dumb A 1985
Laminated wood, glue
873.7 × 99 × 312.4 cm
Serpentine Gallery, London
Collection Rijksmuseum Kröller
Müller, Otterlo

Richard Deacon

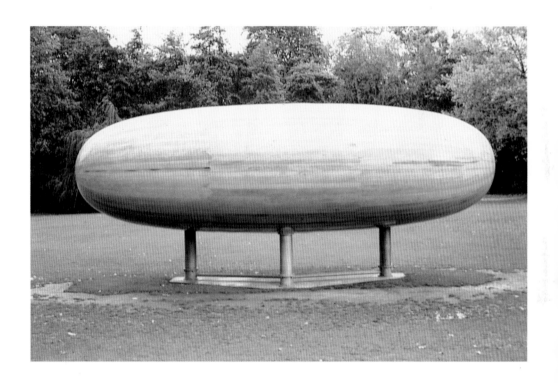

Never Mind 1993
Wood, stainless steel, epoxy
310 × 765 × 300 cm
Middelheim Sculpture Park, Antwerp

Mark Dion

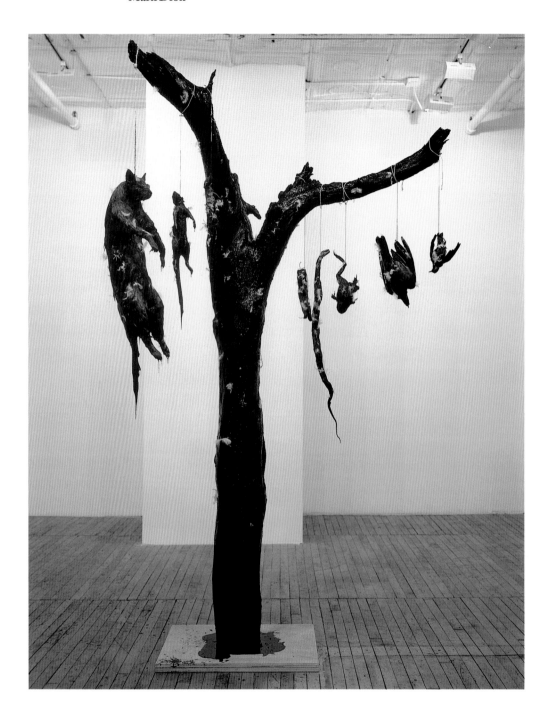

Tar and Feathers 1996
Tree, wooden base, tar, feathers,
various taxidermized animals
259 × Ø101.6 cm

Mark Dion

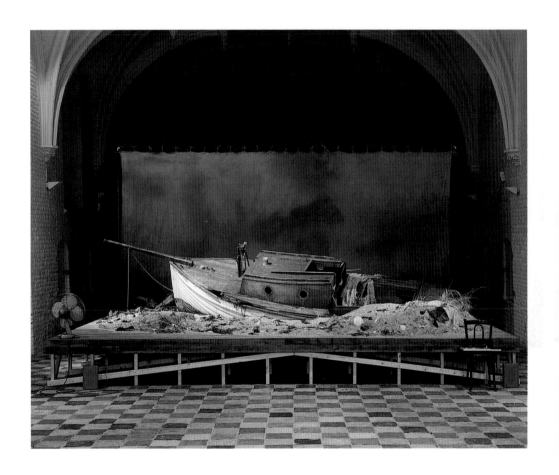

**Flotsam and Jetsam (The End of the
Game)** 1994
Boat, sand, wooden platform, chair,
electric fan, net, assorted beach debris
Installation, De Vleeshal, Middelburg,
The Netherlands

Stan Douglas

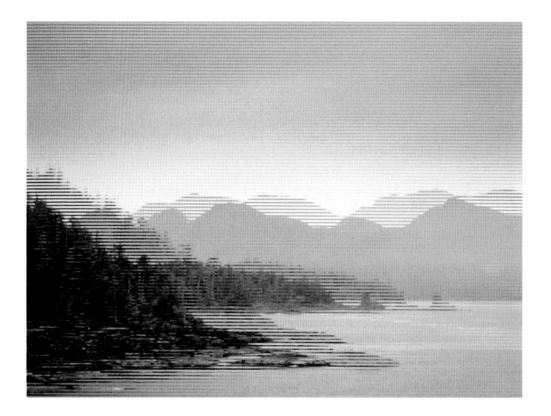

Nu•tka• 1996
Video installation
Continuous video projection
installation, 2-sided CAV
laserdiscs; 4 laserdiscs.
6 mins, 50 secs. each rotation
Dimensions variable
Installation, Solomon R.
Guggenheim Museum, New York
Collection, Solomon R.
Guggenheim Museum, New York

Stan Douglas

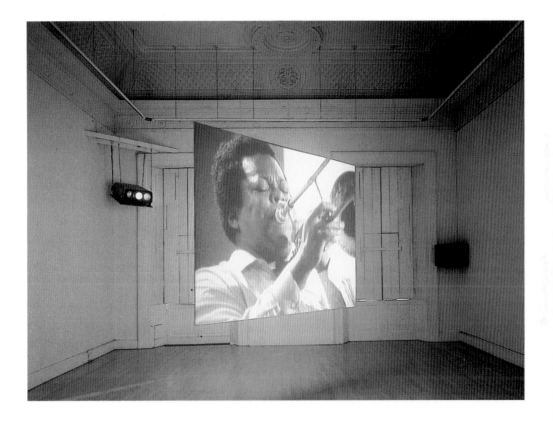

Hors-champs 1992
Video installation
13 mins., 40 secs. each rotation,
black and white, sound
Dimensions variable
Installation, Institute of
Contemporary Arts, London, 1994;
Collections, Musée National d'Art
Moderne, Centre Georges Pompidou,
Paris; San Francisco Museum
of Modern Art

Marlene Dumas

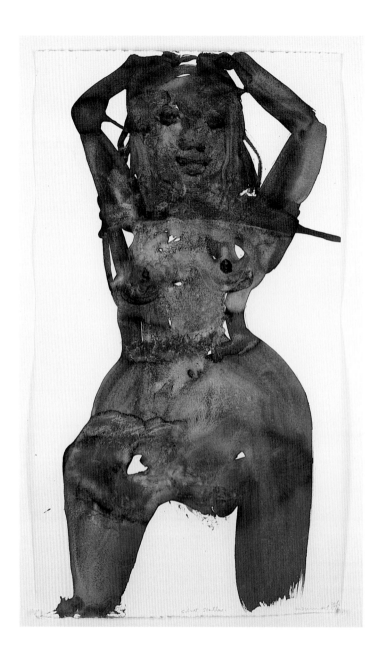

Silver Staller, from the **Wolkenkieker**
Series 1997
Ink wash, watercolour, metallic acrylic
on paper 125 × 70 cm

I deliberately want to confuse anyone; that is how I experience things. There are artists who want to possess their images. Often those who make portrait paintings say they want to *catch* the spirit, or to *possess* the being, *capture* the essence. These are ways of talking about images that I find quite scary; they sound so authoritative. It's not about possession; on the contrary, you have to take distance from the work.

I was thinking of this work of mine called *Tenderness and the Third Person* (1981). It has a texture in the middle, like that of mottled skin, because it was made by frottage, literally rubbing on the surface. At the top of the work are three very small stills from movies, where you have Serge Gainsbourg directing his wife, Jane Birkin, who's with someone else in a love scene in bed, and a scene from *Hiroshima Mon Amour*, and one from *Sunday Bloody Sunday*. The third element is the title, *Tenderness and the Third Person*. I also feel like a third person towards my own work. People always ask me why I write about my work. They think I want to write to protect its territory, or that I want to be the ultimate authority, but it's in writing that I take this distance. I look at my own work in the third person, as somebody else. It's a peculiar human quality to …

Barbara Bloom *To stand outside yourself?*

Marlene Dumas Yes, Simone de Beauvoir said that too. This quality to look at terrible things and to write or think about them; you can't do that if you don't take some distance. Making art is a privilege; people who are in extreme suffering cannot do it, because that's not a situation in which you sit and make art.

You have to be a little bit cruel also, towards yourself and others. Often there is too much emphasis on artists having to be themselves, whereas in fact you have to work *against* yourself. And also there is too much emphasis on the body these days: not *our* bodies but *the* body.

Barbara Bloom *All this talk of the body and none of absence.*

Marlene Dumas Because I make figurative art, people always ask about the figures.

I mentioned earlier this one work in which you see a child from the back; you can't see what he's doing, you can't see anything. And so when someone asked me what the sex of the child was, I said I didn't know. This was of course not only a wrong but an inappropriate question, because it's a painting where you do not have that information. If I were interested in that type of information I would have included it.

Barbara Bloom *As if the subject were on freeze-frame, and I could press fast-forward to find out?*

Marlene Dumas The figure would need to jump out of the painting! Just because you have a figure, that doesn't mean you don't realize it's also an abstraction.

It's also a painting, it's also a thing on a wall.

Barbara Bloom *As you've put it quite beautifully: 'A painting needs a wall to object to.'*

Jimmie Durham *Dirk Snauwaert*

in conversation
December 1994, Brussels

Dirk Snauwaert *You worked as an artist before you decided to become an activist, and then you went back to art again. Art and activism are strangely intertwined in the work of several artists from the late 1970s and '80s. Do you think that your work as an artist gave you a different point of view on activism, and vice versa?* ·

Jimmie Durham Of course it must be true, but I never thought of it. People usually assume that I began as a political activist and then went into art. And if not, people often kind of assume that since I was a political activist, that that must be more legitimate for me, that it's more authentic for me in some way and that art is the same struggle with different weapons. The assumption is that there is a difference in working, but it's not so different, actually. I don't think it comes from something obvious like racism, but if you're looking at a European or a white American or white South African or something, who had a similar history as a political activist and artist, I think the assumption would always be the opposite: that this artist had a political situation confront him or her and had to react, which is the case of Athol Fugard, the South African playwright. He was just a playwright, but he was from South Africa, so he was confronted by a situation he could not deny. Everyone said immediately that his first job was artist, his second job was political activist. With me the assumption is that I began as a political activist and then chose art when the struggle failed. In New York, and certainly in Europe, people have been surprised that I am a serious artist, that my art does not stop at the boundaries of identity struggles.

Dirk Snauwaert *But then in your 'pre-history', let's call it, were you already consciously working as a critical artist? And was this level of consciousness later transposed, transferred to a political activity?*

Jimmie Durham Even now I often have to defend myself from accusations by my own crowd, politically active Indian people, of being an artist first and a political activist second. I have had to defend that and say it's legitimate. When I went to Pine Ridge, to Wounded Knee, I went straight from Geneva and put myself in the American Indian Movement just as a worker, not as a big shot, and stayed completely submerged in the organization for a long, long time. I was in a very privileged position that other Indians didn't have. It was not that I was smarter, it was that I had a privileged position to learn things. So I came back to Pine Ridge, throwing myself into the struggle right there on the reservation but with already a great deal of mental space that was allowed to me by that privilege of having lived in Geneva. Before going to Geneva I was pretty typical in that I wasn't educated. There is always a tendency to be a kind of criminal as a way to get by, as a way to do this, as a way to do that. I was rough, a stupid kid. I was a typical Indian in that sense, but because of meeting different people I was an artist. I was not a good artist, but I wasn't a horrible artist. I was not a completely dishonest artist, I was never an artist with the idea of doing art as a way of representing some Indian-ness for sale. Not once. I had a mixed up idea that it was a way to make some money, but

certainly not very much money; not as much as I could make driving a truck, not as much as I could make as a carpenter. You had more freedom as an artist, more time to yourself, so you could take a cut in pay, that's the way I thought of it. I tried to see what sort of art could work, what art could do, but with no vocabulary, no discourse, no education, so I was groping in the dark, but I wasn't pretending that it was a beautiful twilight. I had my own something as an artist, as an Indian who was an artist. The leadership of the American Indian Movement as a group were like me, rough, uneducated, doing whatever job came along. For many people in the American Indian Movement, the destruction of the movement was the destruction of the person. This is what I have seen over and over in generations of Indians on reservations. The destruction of the plan of that moment is the destruction of the person, you can't see another way, you can't see anything else that could happen. And you make your personhood from that thing. It's not so easy for an artist to make a person, to make personhood, it's not the thing they want.

Dirk Snauwaert *We have this very vague notion that art is like the last 'free space', a podium where you can still do things without having to legitimize yourself continuously, a kind of temporary, autonomous zone. Is there anything like this 'free space' in the Indian community, or does the artist have a different position?*

Jimmie Durham People often ask me a silly version of your question, people say, what do Indians think of your work? And the answer is, Indians love my work, because they don't look at it (*laughs*), they have no use for it. They have use for me being successful, so they can say, 'oh, isn't that pretty or weird', or, 'look, Jimmie's in New York, he's getting a big art show'. But to function as an artist on an Indian reservation is not a possibility at all. There is no art discourse there; what would be my function there?

Dirk Snauwaert *You saw art world things in the 1960s–70s?*

Jimmie Durham Practically not. I think I started doing artwork in '63, I started showing in about 1963, 1964 in Houston, Texas. I didn't really know much in the 60s, even in the 70s. In, maybe it was 1967 or so, I saw a bunch of work in Houston, Texas, by Oldenburg, and I was very excited by it. It was the giant soft fan and those works. But I think that is the only art show that I went to and that was by accident. And I had vaguely seen, in the 60s, photos of Duchamp's work. I had seen some Picasso, I don't know where, it's just there in the world. I was operating from pages filled with misinformation, filled with stupidity, my own defensiveness. When I look back at my history, well, yes, I was part of things, in the way that I was in New York in the 80s. I was part of a Lower East Side art scene, but very much from places like Kenkeleba Gallery, which was for minority artists. When I first met Haim Steinbach we were talking about how we were in New York at the same time in the early 80s and we were both showing on the Lower East Side, and he was trying to figure out where I was and I wasn't anyplace that he

had heard of. It was a completely different world, at the very same time and place, we were just further east and further down on the Lower East Side. And just in Kenkeleba Gallery, for example, David Hammons and I, and Fred Wilson and other people showed maybe every couple of months, but it wasn't really seen as part of the art scene by the critics. Things were more complex, more simplistically complex for me, I think.

I was making things. Some people said, that's art, you should put it in a gallery – that was in 1963. I didn't know where a gallery might be. There was a gallery in the shopping mall, I went there and said, would you take some of my things to sell, and she did and she sold them. And I said, yes, I'm an artist, I like this art business. I can make things and get money. Little pieces of money, $200, $300, for what basically were tchatchkas, little decorative things that would sit around your house to collect dust. But at the same time I was trying to do something, I was trying to make sense of something, I was trying to see if I could investigate certain things with objects, with doing things with materials. And I didn't know that that was an art project, it was just my own personal project. Then I had a solo show at the University of Texas in Austin, maybe it was 1966 or 67. I tried to get people to experience the work differently, so there was one set of objects that I made that were not to be looked at at all, and I would take a small group into a private room and blindfold them and they had to feel the objects instead of looking at them. They never got to see what they looked like. It was the only thing I could think to do at the time, an eccentric little piece of nothing. And I didn't even know why I was trying to think to do it, I didn't have an articulate reason for doing such a thing. But I didn't connect all of that with some project to be an artist. Then, much later, when I went to art school in Geneva, I learned that you could be more serious, that you could try to use art as a serious something in life. That it wasn't about making things to make money and you didn't have to do little tricks like blindfolding people, that it was some serious undertaking worth your while. But there never was a point when I made a decision, unless it was in the 80s; maybe that was when I decided to be an artist, much later.

Dirk Snauwaert *But when you were living in Geneva, what were the influences that affected you, and what did you reject? That was the heyday of post-Minimalist and Conceptual art, the politicization of art. Did the art school you went to follow what was happening in other academies, where disciplines were being merged together, playing around with the art-is-life idea, and considering any part of human life as a part not only of art practice but of political practice? Or the very provocative fluxus actions going on then; were you aware of those things?*

Jimmie Durham I was in Geneva 1968 to 73 and it was as though it was not that time. There was a whole lot of free love, but we hardly knew there was an art world outside of Geneva. I knew some people from Geneva, having met them in Texas; that was my way of choosing Geneva. I wanted to be in Europe,

I wanted to leave the Americas, but I really was not educated and it made me stupidly defensive. I wasn't even very young by that time, I was in my late twenties, early thirties, not young enough that I could excuse myself very well. I kind of vaguely knew that there were art magazines, but I'd never seen one in my life until let's say 1980. So Geneva was isolated, but no matter how much you try, the world creeps in. The art school was in trouble, it had no vision. There were some good teachers, but there was absolutely no idea of what they might be teaching, or why they might be teaching it. I had one teacher and one class for four years. I wrote a very long, long paper which I researched for four years. It was a comparison of Swiss masks and American Indian masks from a socio-political point of view of doing things originally for yourselves and then for tourists. And then it also became a paper about what folk art might be, the idea of folk art and where we get it. In fact it's a very recent invention. I went to all the Alpine villages and I was a real anthropologist. But, aside from doing that paper, my teacher tried to teach me that art is a serious endeavour, but there is no politics. He was Lithuanian, very cynical about any political involvement in the world. He was a classical artist; I go to my studio and I paint my pictures, and the world can go fuck itself. I felt safe with him in a certain way. We started a group, four of us, a French woman, me and two Spanish guys. Our group had the idea of making art and presenting art in ways that were not within the very restrictive little Geneva bounds, which was all we knew: the gallery, the museum and the pretty object. So the world had to have been telling us to do that, especially me. But let me add complexities to it, because it's all so eccentric, that's the problem. In Texas, before having gone to Geneva, I was reading John Berger. I had read what I took to be a beautiful book on the history of the Surrealists by Maurice Nadeau. I was very impressed with the endeavour of the Surrealists, not stupidly. I knew an eccentric art history; I was a Marcel Duchamp fan, I told you I saw by accident a Claes Oldenburg show, I was very impressed with it. I didn't know the current discourse of art; I tried my best to make an eccentric discourse of art. I remember seeing some film, a visual moving image of Jim Dine doing a happening. He was drinking his paint in the frenzy of the happening. I knew that there was this word 'happening' in the 60s, I knew that Jim Dine was drinking his paint, therefore I must have had the typical overload of these kinds of images. Everyone must have, but without a discourse to put it into. We started this group and we tried to do things more seriously. We worked with a gallery, with Jacqueline Vauthier, we worked with whomever we could work with, art centres in and around Geneva, even tried to work with Chase Manhattan Bank because they had bought some of my work and were friendly with me. But if I had gone someplace else, if I had said, Geneva is not big enough for me, Geneva is too provincial, and if I had known there was a place to go, if I had heard of Joseph Beuys – and I didn't even know his name at all in those days – I think I would have gone overboard. I think I would have used all my

stupidity to become successful in a certain vein, maybe similar to Joseph Beuys, similar to somebody, instead of using my intelligence to develop something. I could have escaped into success if I had been less fearful and I think it would have been to my detriment; I would not have developed at all. I might be one of the famous has-been artists of that time by now.

Dirk Snauwaert *Was it an overt choice right from the beginning, to address the complexities of the situation, also aesthetically? It is intriguing that you never chose any of the defensive reactions that exist in art, the hermetic, non-communicative position, like hard-edge abstraction, that must have been popular at the academy in Geneva.*

Jimmie Durham Again there I had a privilege very early on, or I had a potential privilege, of learning an easy lesson, easy because it was so obvious. I could have become a Fritz Scholder, who was the famous Indian artist in the US, who paints pictures of Indians. I can paint, I can do all the things that artists do, I can sculpt, I can do all the arty things. I had the privilege of knowing to refuse that at an early age, because I could see how silly that was, it was so obvious. This Indian art world is so little, it makes everything quite clear. You have to avoid answers at all costs in a certain way, at least I knew that from an early age. The other privilege I had was that of seeing Geneva and its stupidity; that was a privilege because it was something that you had to refuse, you couldn't say yes, I will participate.

Dirk Snauwaert *There was the second part of this transfer, after your activist period. How did you formulate the political discourse that you had before and join it to your previous art practice?*

Jimmie Durham I left the Indian movement and my idea was to write a history of the Indian movement of the 20th century, to put our movement in its proper context. It was all too close and it was all too hard. I had no money; we were shoplifting for food, we were really in bad shape for money so at the same time I was free for the first time after a very intense decade. We were on the job twenty-four hours a day, so in my free time I started doing artwork. But the artwork I started doing was still within where I had just come from, so I did a series of collage assemblage paintings. They were about our political situation, they tried to have nothing to do with aesthetics, which I had already been trying to do in different ways. You would get something from them emotionally and visually, but not at a typical aesthetic level, something much stronger, I thought, in a kind of a romantic way maybe, but the reason for them was a political text. Each one had a text about a situation at the moment, what they're doing on the Rosebud Reservation at that moment which could be stopped and should be stopped. Death and destruction kinds of things, poverty and where we are. And I wasn't making them with any kind of idea in mind, I was just making them. I didn't have an art scheme, I thought my job was to write that book, not to do art. I was just trying to continue a conversation with the world that the world never wanted and still doesn't

want. The way that I normally knew to do it was with the plastic arts instead of with words; it's just a normal way that I work, that I speak. Then the artist Maria Theresa Alves went to apply to Cooper Union, a little art school with a big reputation in New York. This was still in 1980, I think, and she met a guy named Juan Sanchez, a Puerto Rican painter, whose work she had admired. He was doing a show called 'Beyond Aesthetics' of third world artists who were doing strong political work. So he came to our little place in New Jersey where we were living and looked at those collages and said, yes, yes, I want all these in 'Beyond Aesthetics'. Then they were very popular, people liked them very much. I felt very insulted; I saw the weakness of doing that kind of work. It looked like the art crowd of New York was being entertained by the sorrows of my people and I was the agent who allowed them to be entertained. I felt that I had betrayed my own folks and betrayed my own struggle because the work was popular. I had to stop and say, if I'm going to do art once more I have to do a little research about art, once more I have to go back to see what the hell we're talking about with art. So that was the third time I had to do that in a very serious way, and all three of those times, it was a time of success, not a time of failure, a time when I could have gone on to become an angry Indian political artist, which is a beautiful trick the art world likes to play on you. And they played it on Juan Sanchez. He's a good artist; he was doing his marvellous paintings about that time, outstanding, without any idea of what sort of thing painting should be, always about the political situation in Puerto Rico. He was the darling for not even six months, and then they said no, not political painting, and then suddenly Jean Michel Basquiat came along. And I love Basquiat, I love his work, I have no problem with that at all except when I look at the history of New York at that time, the history of the early 80s when things were beginning in New York for the minority syndrome, it's just a disease. What was the discourse in the New York art world that said yes to Basquiat and no to Sanchez? It was, you can't have this blatant political message, we don't like that. It had nothing to do with whether or not this was good in the artwork. But their discourse and watching how that all played out – I suddenly realized I was in the middle of an art discourse. I was in the middle of a heated conversation about art, and that was completely unseparable from politics.

Dirk Snauwaert *Was that when you also started to reflect very strongly about questions like what is political engagement in art, how can it be transmitted and how can it be accurately communicated without losing yourself in the discourse? How can one address different audiences and not just oppositional patterns of dominated/dominating, and can aesthetic engagement also be political engagement? That was also the time when other artists emerged who used agit prop and advertising-like, aggressive media techniques.*

Jimmie Durham It was exactly what you described happened at that time. I said, I can make these people part of another audience, I can change these people's expectations

in some way. I can be part of the discourse by completely disagreeing with it, but I can do it intelligently instead of just making an interruption. I can make this audience itself strange to itself and I can try and expand an audience and make it not so silly. At the same time I was working alongside this artists' organization, the FCA, they did a newspaper and so on. Once I had changed my mind about what the New York art world was, then I started working with them. I started knowing everybody, Basquiat, Haring, Rosenquist, Oldenburg and Sol LeWitt, and thought of them as friends. I didn't know the right critics but I knew some writers. I assumed that they had similar thoughts about me, and I was quite surprised that I was not perceived as a fellow artist exactly, I was perceived as an Indian artist. I was kind of stunned by seeing that at least some people had this perception. No one had a perception of me as a fellow artist because I did not have the proper signs in my work, and that was exactly what my work was trying to do, not having the proper signs. Let's see how we can be postmodern, that's what I wanted, a postmodern situation.

Dirk Snauwaert *And you started to make the animal skulls, not icons of American consumerism. But they're icons in a different way, over-structured symbolically.*

Jimmie Durham I only remember thinking how quickly there came to be a recognizable style, a visual style we could recognize as postmodern. I remember being mad that it only took about six months or so. It was a style that said to you, I am sophisticated, this is the sophisticated style. How naive that seemed, how childish. So I started doing animal skulls and that kind of thing, after going through a short period of doing instructional political work, which is what I first showed in New York. Immediately after that I started doing the fake Indian artefacts from car parts, *Bedia's Muffler* and *Bedia's Stirring Wheel* [1] which were not seen much, even though I was in some group shows away from the minority art set up. I showed those fake artefacts first; people liked them, but they didn't go anywhere. So then I started doing the animal skull things. I did it as postmodern work, animal skulls as part of my tradition, you can't say it's a bad tradition. And I wasn't doing it traditionally, I wasn't making new folk art. I was trying to interrupt what I perceived as a very closed, very satisfied and self-congratulatory discourse on Postmodernism. I felt like New York art in the '80s was not speaking to the times, was not being contemporary, was being nostalgic without admitting that, without knowing that. From the point of really challenging Modernism, I think it was only the feminist artists who actually did so, who actually interrupted.

Dirk Snauwaert *Can you describe the first works?*

Jimmie Durham The first works I did – I've lost the first works, and some I gave away – were automobile parts like *Bedia's Muffler* and *Bedia's Stirring Wheel*. But there were earlier ones than that, there was a muffler before *Bedia's Muffler* and there was a front of a car which Paul Smith has, and other automobile parts,

that were done up to look like stupid Indian artefacts, artefacts from the future I call them. It was a time when art had to have text, so these works had very involved text, but it was also a time when art had to have very specific signs of being postmodern. The visual style of Postmodernism I think must have taken three months or three weeks or three hours to develop. There developed in the Postmodernism style something that looked to me very romantically representational and very naively sophisticated, using cleanness and purity and simplicity as signs of sophistication, using stainless steel as a sign of sophistication, using text as a sign of sophistication. So you knew postmodern work even in those days by those signs of sophistication. And what I wanted Postmodernism to be was not Modernism. I wanted it to be the end of Modernism.

Dirk Snauwaert *The last of the avant-gardist, generational ruptures? After the ruptures the idea of an evolution, or of tradition?*

Jimmie Durham This was the discourse at the moment, but they were not my fathers whom I was trying to destroy. I wasn't trying to be the next generation. They were saying, Postmodernism is this, and I wanted it to be an ongoing discourse and not locked that way. You couldn't be Jimmie Durham in any way because if you make some crazy non-reliance reliance on your background as an American Indian, there are only negative places that the art world can put it, only the most disgusting places, so I said yeah, this can work, I can use that. So I wasn't challenging some other generation, I was saying let's get this discourse going somehow, let's see if we can liven the discussion up a little bit and let me talk also. At the time the only way I could think to do it was say, oh, you mean anything goes, how about a car muffler dressed up as an Indian artefact, does that go? And I'm making it in a political situation that you don't admit. So look at my discourse, in other words.

Dirk Snauwaert *But doesn't that bring us to a basic problem which is very much of interest now, where one sees a lot of reactions of repression, of not wanting to know, unconsciously, in the art world, among its players. You have the challenge of addressing an audience that has blacked out a certain topic, with all the historical and economic implications that go with it …*

Jimmie Durham I can only talk historically because your question makes me think historically, and it's very stupid, recent history. I left New York in about 1986 or 87 or something, and moved to Mexico. Immediately after that I started showing in Europe. I had a show at Matt's Gallery in London and a show at Orchard Gallery in Derry, and they were important shows. In the Matt's Gallery show I tried to make the London art world think about art in ways that it didn't want to, in the way we did the installation, in the way the art was presented and made. There wasn't much art, but there was enough art, I hoped, to do two things. You couldn't refuse the show because there was no art, and you might actually get some encouragement, some energy from the art that was

there. And to talk aesthetically about what kind of energy that might be, well, involves intelligence, not just craft. When I listen to Beethoven's Sixth Symphony, I can get into the pastoral mood – I have no choice, because he did it very well. But at the same time, every time I expect the next note, the next note doesn't happen. He challenges me to be smarter than what I want to be; at every moment I am delightfully surprised when it doesn't go the way I think it should go. I like that kind of aesthetic; I'm imagining doing the Sixth Symphony of Beethoven, as presented by Berthold Brecht where he throws in some Duke Ellington with his own voice explaining why he is doing this. That is what I would like to do in visual art, this kind of thing.

Dirk Snauwaert *So the Brechtian idea of true disjunctions in the normal narration.*

Jimmie Durham Yeah, it's one of the things I like very much. The problem can't be solved. It's more than whether or not you're from some minority, it's how to have a voice these days – not a nationalistic voice, not an ethnic voice, and yet a voice all the same. Jean Fisher said her model was James Joyce, and I agree with that in a certain way. He didn't like Ireland enough to ever live there, all of his work was an attack on Ireland, but at the same time all his work was a new Irish voice. And you can't say he intended to do that, you have to say, well, his project was to attack Ireland directly as an Irish writer, and in that process not be an Irish writer. But I don't see how one might do that in plastic art, in visual art.

Dirk Snauwaert *So you don't see any more possibilities to remain a critical artist, and the idea of art as critique is no longer possible?*

Jimmie Durham Then I wouldn't have a reason to be working.

Dirk Snauwaert *But for instance in your last show at Micheline Szwajcer you were addressing architecture in the nineteenth century and in relation to context. Is it back to a new algebra, back to a new construction system?*

Jimmie Durham Trying to investigate some possibility of new fundamentals. There is a fundamental silliness that I began with that show, which is that the nineteenth century related the plastic arts to architecture, intimately, as if they were organically related instead of historically or politically related. And I see from having done that show that people still agree with that, people still have that 1860s idea of art and architecture being of the same family of endeavours. And I didn't expect it so much, I thought people would appreciate my irony more, but very many people take it at face value that yes, there is this organic relationship between art and architecture. So there I see a new something I can play with for the next year, maybe for the next six months. We only know that we want something that is not the monument, we want something that is not the painting, not the picture. So we've kind of spent this century fumbling about, saying, is it smaller than a bread basket? Asking investigatory questions about what sort of things it might be, but always within a political

situation of the time. Now we can begin, it seems to me, to be more seriously confused, to be more profoundly confused than we were before, especially if we can make a final break within that heroic project of art and architecture. I seem to trust that combination of physical and thinking process more than a strictly conceptual process. The conceptual artist, the minimal artist made so many monuments, and we're still stuck with them. I would like to make art each individual art thing there is, there would not be a time when you had to decide to keep it or to throw it away. And, it seems to me, one can do that sort of non-dictatorial thing by making things which don't have to do with craftwork at all, just intellectually joined to our normal physical world.

Dirk Snauwaert There is this bricolage side to your work …

Jimmie Durham Yes, which I want now to take away, to be rid of, because it's so there.

Dirk Snauwaert That's a very interesting part.

Jimmie Durham Yes exactly. I have to take it away.

Dirk Snauwaert It's what for some people gives it the flavour and the charm.

Jimmie Durham And in some circumstances it's charming to me too. If I can stick things together that are physical histories and they didn't want to go together, but then something intellectual happens when they are together, I'm just very pleased, I'm very charmed by it. And of course I don't trust it and I see now I'm going to have to find a way out of that.

Dirk Snauwaert I was struck by the fact that you read a lot of very advanced, purely scientific books. People expect your work to be the opposite.

Jimmie Durham I actually love science and the Scientific Method, using capital letters. But I don't think it is European and I don't think that it is practised in the science world. I have a great criticism of science because it operates on belief, it doesn't question its basic beliefs. But science as an analytical concept of questioning and experimenting, and saying, let's see, how does this work and what happens here, that's genius, that's what humans are about. If we don't do that, we're not doing a human project, I think. Our project is not to believe, not to find answers, it's to be analytical, to do experiments that should lead us to the next experiment, it shouldn't lead us to a cheap answer. And that's why I love science; it's so scientific. It's not European, it doesn't belong to white people, it's a human thing. I don't want art to be separated from other parts of life, and I also don't want science to be separated from other parts of life.

Dirk Snauwaert I think the hybrid aspect of almost every part of your work is quite interesting, visually and also in terms of context. You don't take advantage of the 'art as a means to an end' maxim but adopt the most interesting part of Postmodernism: the fragmentation and continuous re-constitution of the subject through the reading of signs.

Jimmie Durham It's just the usual problem for me, how to make plastic art which I always relate to the usual problem of how to speak. That makes it a little too universal, but it also allows me to talk about it in a way that I couldn't otherwise. I have it with my own family, this is how universal this problem is. My mother died and my brother had already died, other family members had died and I was sitting with my three sisters, remembering our mother, and each one of us had a different mother. We were strangers at that moment, the four of us, and this is one small, very close family. It made me think once again what everyone has known all these years, that we don't know each other, that we don't communicate with each other, we only hope we do. So if I put the problem of identity into that basic French concept, into the Sartrian concept, we're all strangers, none of us can communicate with each other. There is a place to do some work, an investigative work instead of declarative work. There is a place that I like very much where you define yourself. It's a problem with art in general. We know what art is because we see it in the museum, we see it in the gallery, we see it in the art world and we like that situation because therein we define ourselves, therein we get our identity. If I want art to be a little more free so that our identities are also a little more free, my choices are within the sphere of your already identifying yourself.

Dirk Snauwaert In relation to the current historical moment, there's this 'the dream is gone' feeling. And I think now that artists feel a greater responsibility in intentionally making art. I'm not talking about sociology, I'm talking about art. Maybe aesthetics, even, because it always comes to this point.

Jimmie Durham Except you can't separate these things, you really can't separate sociology and aesthetics.

Dirk Snauwaert No, but there has to be a certain aesthetics in the work, otherwise …

Jimmie Durham There has to be and here is a difference. I will talk again about two artists, both friends of mine, I respect both of them. Mel Edwards, a Black artist my age, my generation, he has a teaching job so he has a life, he makes art that talks about the Black situation. David Hammons doesn't talk about the Black situation, except that that's what he always does. From way over in left field, from a different place, from a place that turns out to be strangely within the art discourse – the discourse we wanted all along. I think in this century there is this art discourse, Duchamp, Joseph Beuys, a certain list of artists that we think tried to take away limits in some way that was not so heavyhanded. This is the art discourse that we find interesting this century, I think, the art discourse that is still not recognized. David Hammons is doing his work completely consciously, he's not doing it innocently in the least bit. He's using the full discourse available to him, but it is in line with this other art discourse. So he is bringing his struggle, the struggle of his people, the absolute horror and hopelessness of Blacks in the US, to that discourse. They still try to refuse him because no one wants Hammons today, but they can't.

He says yeah, all of this, and the American Black experience is part of that, it's not excluded from that. It's a genius thing to say, it's so important to say that, and it's exactly the thing that cannot be said. Don't bring your niggers into our living room, please. And it's at that point that he gets that rejection that he says, see, see, now you can't refuse me, now you have admitted.

Dirk Snauwaert *So does that also mean, and this is perhaps another contradiction, that you have to take up West European discourse?*

Jimmie Durham That is the art discourse. Art is a European phenomenon, it does have a European history. Europe is a human project, it's not a European project, we have all contributed. But because of certain power structures everyone says it's a European project. I then say, there is this marvellous art history in Europe; it's so good I want to be part of it. I want to join that discourse; I don't want to interrupt it or stop it. But I want to join it as me, I want it to be as big as me, which was its original intention.

Dirk Snauwaert *Doesn't one lose one's identity? What does one give in?*

Jimmie Durham You can't lose your own identity. I wish I could lose my own identity. All of my life I wish I could. The problem is you can't.

1 José Bedia, Cuban artist

Olafur Eliasson *Daniel Birnbaum*

in conversation
November 2000, Berlin

Daniel Birnbaum *To start, I'd like to ask you about the position of the viewer in your work. Many of your works can be seen from various perspectives. This is often, or maybe always, the case in art, but it seems that you're very conscious of it in your work. And sometimes the changing perspective is the theme of the piece. The work in your exhibition 'Your intuitive surroundings versus your surrounded intuition' at the Art Institute of Chicago (2000), for example, had two parts, which could be seen from different perspectives.*

Olafur Eliasson 'Your intuitive surroundings versus your surrounded intuition' was very much about the museum building itself. I had the feeling there that when the viewers finally got to the exhibition area, they would have lost their sense of orientation. When you enter the museum from the street level you walk up and down several flights of stairs, and going through the museum is quite labyrinthine. By the time you've gotten to my work you don't even know what floor you're on – you may even be in the basement. Outside the window there's a kind of train depot, which looks like a bridge. Looking out this window you feel as if you're up quite high, but in fact the 'bridge' is on the street level. I wanted to point out that some buildings have the ability to remove the sense of orientation from the viewer, and that alters the way we see whatever we're looking at in the building. For my show at the Kunsthaus Bregenz ('The mediated motion', 2001), it was extremely clear exactly where you were located in the building as you moved around my work, whereas the Art Institute in Chicago had the exact opposite quality. So I was playing with this sensation of being lost, and when you finally find what you're looking for, you've lost your sense of orientation. This is why I made an artificial garden and artificial sky just outside the window (*Succession*, 2000); something to stand on and something to stand beneath, except that these were outside, so you couldn't actually step out and stand there.

Daniel Birnbaum *One way to describe* Succession *would be to say that you lowered the sky, and …*

Olafur Eliasson Raised the floor, yes.

Daniel Birnbaum *And both were equally artificial in a way, although the ground seemed at first glance to be closer to nature – it was outside and it was actually grass. But one could see that it was artificial, that it had some kind of scaffolding.*

In a way it seems that this piece is typical of what you've been doing for some time, in the sense that by changing the perspective you can completely change what you see. When you see the grass through the glass, it becomes almost like an image. It's no longer something that's given directly in any way; it's really a representation.

Olafur Eliasson Yes. Looking out of the window might work in the same way as being inside a museum, where everything is presented as if it's isolated from its time, history and context. Looking at a piece of Chinese pottery in a glass vitrine, you tend to see it as if it were in a frame; it becomes a picture, rather than a piece of porcelain that you can actually use or touch or sense in a more

tactile way. Being in a museum, you have the feeling entering the space that there will be a garden outside, but the real outside conditions – the wind, the temperature, the birds or the sound of the trains in this case – whatever is outside, won't be there. Is the grass outside real or not? Is it a representation (museum piece) or is it reality (non-museum piece)?

Daniel Birnbaum *It seems that your works often make clear that there isn't a sharp line between presentation and representation; that there are many levels – things can be more or less directly presented. You can enter several layers of representation and it becomes more and more unreal.*

Olafur Eliasson Or it becomes more and more real. The question with institutions such as museums is, are we seeing reality or are we just seeing pictures; when we look at a piece of armour or a Buddha, or projects such as mine, are they real? The point is that the museum in particular, and the world in general, try to communicate things as if they were real. And I try to show that there's a much higher level of representation than first anticipated in a museum. So what we actually see isn't real at all but artifice or illusion. And going to the next window in the space you can easily see the scaffolding in the train depot raised to a height of two or three floors, and my garden is indeed an artificial lawn, even though it's real grass.

One can use this as a simple critique of the way in which our surroundings try to convey themselves as reality. For example, in Denmark there's this thing called Legoland, and Legoland is this miniature plastic toy copy of something real. And in Legoland there's something called Lego Skagen. Skagen is the most northern point of Denmark, which is an idyllic fishing village. And the question is, which is more real: the mini-Skagen in Legoland, or the Skagen up in northern Denmark? Of course mini-Skagen in Legoland is more real, because it's not trying to be an illusion. It's not pretending that it's real, like the village up in the north of Denmark where it's all reconstructed in the early twentieth-century language of a remote fishing village where you can visit and have …

Daniel Birnbaum *An authentic experience?*

Olafur Eliasson So-called authentic. So the question is, what is more real? And what is more representational? Of course Legoland is extremely representational, but it's not trying to hide it. And this is what I mean with the museum. It's in fact very representational, but it's also trying to hide it to a certain extent. This is how I saw the grass outside the window, or the lowered sky, in the sense that the windows actually take away our surroundings, or they take them further away than Philip Johnson did with his Crystal Cathedral, or Mies van der Rohe with his Farnsworth House in the north of Chicago, where the surroundings appear to enter the building. I think of it as the isolation of our senses; our surroundings are being taken to a higher level of representation, and therefore taken away.

Daniel Birnbaum *In the piece in the 'Carnegie International 1999/2000' in Pittsburgh (*Your natural denudation inverted, *1999) the same things were negotiated. Here there was also some kind of so-called natural phenomenon that was built on a very obvious construction – the scaffolding again – this water surface and a noisy geyser. Is it a geyser?*

Olafur Eliasson I guess you can see it as a geyser, but it was actually the heating system of the building.

Daniel Birnbaum *So everything was in fact completely technological – everything was part of some sort of machine. But on one level one could also see it as a joke or at least a comment on natural phenomena. And there again the viewer had the same experience of shifting perspectives: once you entered the museum and you saw* Your natural denudation inverted *through the glass, it became a still-life image as it were, or a photograph.*

Olafur Eliasson Exactly, particularly because of the steam. It was a formal garden setting with a big surface covered with water, and in the centre was a steam column sort of rising up through the water. It would be very noisy if you were outside in the courtyard and actually stood face-to-face with the piece; you'd hear the strong sound of the steam, as if it was being pushed through a nozzle. But, when you were inside, it was silent, even though you had the sense that the work was obviously quite loud and aggressive. The wind would blow the steam in various directions, and even though the steam illustrated the wind changing direction you were totally isolated from a physical and sensual engagement with the conditions of the piece. So in this case, also in a museum, it was like looking at a painting through the glass, and you tended to see it as a picture rather than an actual experience.

But it's a little more ambiguous than this, and I think talking about it like this can limit the piece rather than open it up. The point is, if we know we're looking through a window, it's great, it's OK. If we know we're looking at a TV it's OK. But if we think we're looking at the 'real' thing, it's a problem.

Daniel Birnbaum *Could this be compared in some way to Brechtian* Verfremdung, *where you always show the tools? One could say that some of your pieces initially lure the spectator into a romantic position of believing in something, or rather of being part of an overwhelming almost natural experience, only to find a few seconds later that it was part of a machine?*

Olafur Eliasson Yes, I think so. Just as people once walked into a church saw a ceiling painting, and were for a moment tricked by the illusion that the ceiling reached infinitely upwards. Or like *The Truman Show* (1998) when Jim Carey's character sails into the end of his world, and finds that it was in fact a stage set. I think there's a subliminal border where suddenly your representational and your real position merge, and you see where you 'really' are, your own position.

Daniel Birnbaum *Is it also about reminding the viewer that he or she is actively contributing to the experience? In a way you remind the viewer, when you force someone to change perspective and see things in a completely new way, that their experience is unique and that they're not just someone who, in a neutral kind of way, enters into a situation. The meaning of the situation is dependent upon who you are and where you're standing.*

Olafur Eliasson Yes, exactly. I think the situation lies with the viewer. Without the viewer the readings of the the piece could be endless. So with each viewer the readings and the experience are nailed down to one subjective condition; without the viewer there is, in a way, nothing.

Daniel Birnbaum *Is that why so many of your pieces are called, say,* Your sun machine *(1997) or other titles that start with* 'Your'; *who is 'you' here? Is it the viewer? Are you implying that you're somehow handing over responsibility to the viewer?*

Olafur Eliasson Yes, it's from me to everybody, or from me to you. I consider the works as sort of 'phenomena-producers', like machines, or stage sets, producing a certain thing in a more or less illusory way. Then the question becomes, when do you reveal the illusion? If you look closely at *Your natural denudation inverted* (1999) in Pittsburgh you can actually see the heating tube going across the wall in the corner of the courtyard. So there's a certain moment where people go 'Aha!'; the moment they say 'Aha!' they see themselves.

Daniel Birnbaum *We don't always see the machinery as objective; we see ourselves as part of the machine because it's our machine. We see not only the theatre but the machinery behind it. You're reminded of the fact that this is all spectacle. The art critic and curator Charles Esche recently said that he wants to be completely open about how an art project happens; why not keep the space open while you construct the show? And in the development of video art, people were very interested, early on, in the illusionism, but then at some point, Bruce Nauman, say, would show us the projection, the whole construction, how the work had been produced. And someone today like Diana Thater does exactly that: she emphasizes the fact that she's interested not in the illusion itself but rather in the construction of the illusion. One could see your work as related to that of Robert Irwin or James Turrell, who work with light and space; you're interested in those very beautiful and even sensational effects, but you never hide the machinery, and the resulting effects are just as valid.*

Olafur Eliasson A lot of artists work in this way, I think the reason you want to show the machine is to remind people that they're looking. At certain times you can sit in a cinema and become so engaged with the film that you kind of join the level of representation, but then the next moment you flip back out. And I think the ability to go in and out of the work – showing the machinery – is important today. My work is very much about positioning the subject.

Daniel Birnbaum In many of your works there's this idea of the inside and the outside, which could be seen as a comment on the fact that things have a specific meaning when they're inside an institution. This seems connected with the fact that often when you do a project there are several elements to it, and some-times there's a little side-event elsewhere. We could mention The very large icestep experienced *(Musée d'Art Moderne de la Ville de Paris, 1998)*, Corner extension *and* Green river *(IASPIS, Stockholm, 2000) and* Spiral Pavilion *(Venice Biennale, 1999). All these used the same strategy of presenting a piece that was in many ways a rather classical, beautiful sculpture, but there was also something else going on. Those three are, in my view at least, related in the sense that they all somehow deal with the inside and outside.*

Olafur Eliasson Well, in *The very large icestep* … at the Musée d'Art Moderne de la Ville de Paris I had several melting blocks of ice in a box on the floor, and I had the same amount of ice outside in a suburb of Paris – in Nanterre, close to La Défense. It's not only about the limits of institutions; simply by changing the context I was interested in that shifting level of representation.

 The ice inside the institution was obviously an object, and the viewer was in this case very easily defined as the subject; the dialogue between the two is limited or formalized through history. So even though the ice in the museum was undergoing a process of melting, this process was rather neglected compared to the power of the object itself, as an almost static thing. Anyone who spent five minutes in the museum wouldn't really sense the quality of the melting ice, a very minimal change. Whereas outside, in Nanterre, without the museum surrounding it, the ice was not really considered an object in the same way, since it was no more important than its surroundings. And people there, particularly the people who live their everyday life in this area, would see the process of melting more slowly, I guess over three weeks or some-thing, since it was in the winter. And this creates a different layer or lower level of representation. The changing of the ice gives it an almost subjective quality – the process being something with a history, with a past and a future. And the people passing by and looking at it every day on their way to work were the objects. This is how these pieces work, at least for me: as different investigations of the conditions in which an object is an object and a subject is a subject. It's not merely a critique of the institution as being a limited thing; it's just a different set of qualities in terms of experiencing the work.

Daniel Birnbaum Perhaps you could say something about the Venice project *(Spiral pavilion, 1999) –* this pavilion, where the side-event wasn't an event taking place elsewhere, but a little book?

Olafur Eliasson The construction in which my work was shown at the Venice Biennale had a fire-protection system – pumps and water tanks and hoses and so on. I'm sure they'd learnt from the 1996 fire in the famous opera house there, La Fenice. My piece was also a structure using pipes. I tried to turn the pipes and the hoses under the huge tanks into a project, without necessarily turning them

into art objects. And in a geometrical way they illustrated something like a vortex: water as an energy phenomenon. So my sculpture alluded to a natural phenomenon by using a geometrical set-up. The idea of preventing fire is also a question of the conflict between the cultural and the natural, and since Venice had fairly recently experienced this fire at the opera house I thought it would make sense to make a little intervention in the form of a book about the water system. And this small book was called *Suspensione* – 'Suspension' – since it was about the suspension of water in the tanks. I also included a few found or archival photographs of the burning opera house.

Daniel Birnbaum *Often when there are two projects that are related in this way, one is more 'inside', so to speak, while the other describes the context and is in that sense more 'outside'. One would think that the inside project would be visually stronger, and the outside would be more delicate or less visually overwhelming. But in Stockholm I would say it was the other way around: you had a delicate light installation,* Corner extension, *in the museum, which of course was visually interesting, but the work outside,* Green river, *was completely overwhelming visually. So the outside predominated, almost like an atomic bomb. How were these two works linked?*

Olafur Eliasson They're linked in the way that I talked about before: the inside deals with a much higher level of representation, in the sense that it's always a model or it illustrates outside phenomena through a drawing or a photo or installation. I thought about taking it even to the level of a sketch, where it's so representational it's not even really there. But in the end I made a corner light projection, which played with the perspective lines and the way you see a space. It's like an anamorphic principle where you have to be located at a particular point in order to actually see the lines and the space, to find the vanishing point of the perspective, which is an old stage trick. By making lines on the wall you can create the sensation that the space is larger. The other inside piece, *Seeing yourself seeing*, was a mirror which was partly transparent and partly solid, so looking in the mirror you would see the space behind you but your reflection; you'd see yourself seeing through the mirror. The two pieces inside asked, 'How do we see?' and 'How do we see a white cube like this?', which is the Minimalist metaphor for the spatial condition.

The outside piece, which was very physical and organic, was the *Green river* (1998–) project, which I've done in Los Angeles; Bregenz, Germany; and the little town of Moss, in Norway. Every time it turns out differently. In Stockholm we dyed the river green, with an environmentally safe colour, by basically dumping in five or ten kilos of powder, and the turbulence of the water carried the colour rapidly through the central part of Stockholm. When you're in downtown Stockholm, it's so idyllic, it's like being in a museum. It's almost representational, like a postcard. It never changes, and the river – which I consider a dynamic force in the city – was very static. The river in this postcard image was something lively, giving energy to the city. Putting the green colour in the stream for a moment made it hyperreal –

it made it totally real. And everybody, without knowing that it was an art project – and this is very important – looked at the river, and for an instant the power and the turbulence and the volume and speed of the water, and all its histories became extremely visible. For a moment, the city – the downtown area – became real. And therefore the normal condition of the downtown area was seen as being almost representational. The point was not even *Green river*, the point was how it looked before and after. The *Green river* is just a catalyst.

Daniel Birnbaum *Your work triggers off lots of things that activate the whole context and it makes one conscious of what normality is all about, and whether normality is maybe also a construction. And it's of course interesting that it triggered off not only how people saw their own city psychologically, but also the media and the legal system.*

Olafur Eliasson Yes, in fact the next day in the newspaper there was a big image of *Green river* – they took a wonderful picture actually – and then they ran a perfect description of what had happened, claiming that it was the government's heating system, which had sprung a leak or something!

Daniel Birnbaum *They claimed it was a routine, common occurrence! But the people who have lived there for decades knew that this had never happened before. So there was this really strange cover-up. Which worried people a bit, and triggered off conspiracy theories. If this event was explained away as something normal, then what else has been explained away?*

Olafur Eliasson Maybe it's a Swedish thing – they always have an explanation for everything: 'Don't worry; this is safe Sweden, nothing bad happens here!'

Daniel Birnbaum *Why is it important that the* Green rivers *take place without warning anyone?*

Olafur Eliasson Obviously if there was an invitation sent out and a poster hanging on every corner announcing there's an artwork being executed, people wouldn't experience the fear that the river was poisoned. Telling people that it's an artwork makes it more representational – just as the ice blocks in the museum in Paris were more object than the ice blocks outside.

Daniel Birnbaum *It's to do with expectations?*

Olafur Eliasson Yes, and the pre-knowledge that people bring to the piece.

Daniel Birnbaum *There was a* Green river *in Iceland ...*

Olafur Eliasson The one in Iceland, I did with my father, my stepmother and my sister. We were totally alone, but after we coloured the whole river, a group of five cars came driving by. I was up on the mountain, away from any danger, but my father was standing by the water and they all ran to him and asked what he'd done! It was very funny. Every time, there was some kind of interaction with people.

Daniel Birnbaum *And it also took place in California?*

Olafur Eliasson Yes, with only a very few people. In California the concentration wasn't so high, but it was still very green, and nobody cared, nobody stopped, nobody looked. This is weird because Los Angeles is partly in the desert, and water is so important there.

Daniel Birnbaum *Maybe they're just used to special effects. Will there be a limited number of* *Green rivers?*

Olafur Eliasson Yes; eventually, when repeated many times, the work formalizes itself. The content is lost when it's systematized.

Daniel Birnbaum *I'd like to go back to the other works in Stockholm,* Corner extension *(2000) and the first version of what later became* Seeing yourself seeing *(2001), because they seem to deal in a very clear way with the ideas that we've already been talking about. They're absolutely about the position of the viewer. With very subtle means* Corner extension *more or less forces you to think about yourself as you try to find the spot where everything comes into focus. You're reminded of the fact that no experience is just a neutral experience: it always depends upon you. Again, it's about the viewer's position, about the viewer. The other piece –* Seeing yourself seeing *– is perhaps the most subtle piece and so simple. It shows certain paradoxes of what it is to be a subject: you look at this small glass, which is also partly a mirror, and you can either look through it or you see yourself, but you can never do both at once.*

Olafur Eliasson Right, right.

Daniel Birnbaum *You can pretend, with a small syncope, that you see yourself seeing, but it's very hard to be a subject, or rather very hard to be a self-reflecting subject. Either you look through, and then you're a subject looking for something else, or you look at yourself, and you turn yourself into an object, a mirror image.*

Both pieces remind you of the fact that you're an experiencing mind, that you're a subject – you're subject and object …

Olafur Eliasson Both at once. In a sense, our spatial history has given us a language with which we see, and this language dominates our way of seeing. Like you say, the pieces discuss whether it's possible to be a subject, and whether you're being forced to see in a certain way.

Daniel Birnbaum *At a centre point you can almost get the feeling for a moment that it's not you looking at the artwork. Sometimes the works are so subtle that they become an inverted visual experience, and it's the other way round: you're being seen by the situation. You're not only a productive, phenomenologically active subject, you're also produced by the piece. You become that subject-object, that ambiguous space where, as Maurice Merleau-Ponty would say, everything takes place.*

Olafur Eliasson I agree; you could even call it a double perspective. Of course the wall itself doesn't look at you, but the moment you go 'Aha!' – what I was saying before – you see yourself from the point of view of the wall. I did two pieces (*Your blue afterimage exposed* and *Your orange afterimage exposed*, both 2000), where I

projected light on a wall, and the light gradually got stronger and stronger, until after ten or twelve seconds of looking at it, the light would disappear. The after-image, an imprint of the light on the wall, would be stamped on your retina. What happens then is that you actually project a reversed image with your eye, a complementary image, and for a moment you've been turned into a projector. This is how the piece can look back at us, create something in us. I like the idea of us being the light projector, projecting the piece onto the space.

Daniel Birnbaum *Suddenly you also recognize the screen upon which something is projected as both passive and active.*

Olafur Eliasson The reason I think it's important to exercise this double-perspective phenomenon is that our ability to see ourselves seeing – or to see ourselves in the third person, or actually to step out of ourselves and see the whole set-up with the artefact, the subject and the object – that particular quality also gives us the ability to criticize ourselves. I think this is the final aim: giving the subject a critical position, or the ability to criticize one's own position in this perspective.

Daniel Birnbaum *It's not just a sort of game?*

Olafur Eliasson No, it's about structures that pretend or make us believe that we're outside, experiencing the piece, but in fact we're inside, behind the glass, not experiencing anything other than an image.

Daniel Birnbaum *There are two projects that would be interesting to discuss from this perspective. The first is the very early piece* Beauty *(1993), which has been produced in a few different versions; it shows that many of these themes were already present early on in your work. The other is a later piece shown at Marc Foxx Gallery in Los Angeles, called* Your sun machine *(1997). Could you explain* Beauty?

Olafur Eliasson Technically speaking it's a water-curtain of tiny drops and a lamp projecting onto the water at a certain angle. If you're located in the right spot, a spectral phenomenon similar to a rainbow occurs in the water drops. Since the rainbow is obviously dependent on the angle between the water, the light and your eye, if the light doesn't go onto your eyes, there's no rainbow. This piece became important for me because, for the first time, it made it obvious that the spectator is the central issue. The person, the subject looking at the spotlight through the raindrops, is the issue. The water and the light and everything else are just water and light; it's nothing really.

And the same thing, though a little more abstract, is true of *Your sun machine*. I cut a hole in the corrugated metal roof of the Marc Foxx Gallery in Los Angeles, and a round sunspot entered in the morning on the left side of the gallery. During the course of the day this spot would travel diagonally through the space and at the end of the day eventually disappear. People would come into the space and they would turn this sunspot into an object. It's not the same thing as the rainbow, but …

Daniel Birnbaum No, but they both link to this central topic of reminding the viewer that he or she is there, and that he or she is positioned in a certain place. Beauty *does this in a very subtle way: if you step a little bit to the left or the right the piece disappears. The set-up is there, but the phenomenon – that beautiful phenomenon – is gone. That's a very basic way of showing it.*

In Your sun machine *it's about the viewer, but there it's actually very complex and one can trace several stages. First you see the hole, an absence; and then you see something that enters through this absence, and you immediately turn it into an object – it's an image of the sun, or it's the sun itself. And then you might even see it moving, or at least you'll understand that it's moving. And then you're not only displaced on a psychological, geometrical and maybe phenomenological level, you're actually moving cosmologically. At some point, if you start thinking about what that piece is about, your position on a small planet called earth is confirmed.*

Olafur Eliasson This is why I generally say that the spot of light didn't move, which in fact it didn't; the gallery moves.

Daniel Birnbaum *Yes. And you're moving with your own vehicle, namely the earth.*

Olafur Eliasson Exactly.

Daniel Birnbaum *So that piece brings in literally bigger issues, of space and of our travelling with the earth, and the sun actually not moving at all.*

Olafur Eliasson For every experience there's a set of rules or conditions, and these conditions can be set by me or by the spectator, or by other people.

Daniel Birnbaum *With the new, bigger projects, you have the original idea but you work with architects, engineers and scientists. How do these networks and collaborations work?*

Olafur Eliasson Often people ask if I have a scientific background, but in fact I'm less interested in science than in the result of a particular scientific phenomenon. By 'result' I mean the way people experience it. But I need some media, I need some 'stuff' to create a situation. I need a machine to create a phenomenon in order to have an experience. And since I honestly don't know about science – or mathematics or geometry or architecture for that matter – I engage with people who know better than me. By discussion and testing in my studio I try to set out the formal limits of how this particular relationship can be turned into a project of some kind.

I work with some people over and over again, and with others I only work once. At the moment I'm collaborating with a wonderful Icelandic architect, Einar Thorsteinn. He has a lot of experience with tensile architecture, and he's also a trained crystallographer; he is extremely knowledgeable in mathematics and geometry. I use him a lot – or should I say we use each other, I hope.

Daniel Birnbaum *Which of your current projects is Einar Thorsteinn involved with now?*

Olafur Eliasson We're working basically with spatial conditions where the lines of the particular space have been altered away from the Euclidian set-up. The

Venice pavilion, *Spiral pavilion*, was a result of our collaboration.

Thorsteinn then did various drawings of doughnut shapes; we worked on them for a long time until we finally arrived at this doughnut shape combined with a Möbius strip (*Doughnut projection*, 2000). It was great when we finally achieved a shape where it all came together, mathematically speaking. I'm totally unable to draw things like this, whereas he's very good at it.

Daniel Birnbaum *I find these shapes and crystals and geometrical figures everywhere in your studio fascinating. What is it that attracts you to them? Is it their beauty, or their subtleties?*

Olafur Eliasson Maybe it's some old-fashioned utopian belief in the worth of looking at alternative structures – ones that aren't common today. It's a questioning of the dimensions we're surrounded by, and looking into the basics of spatial conditions. I'm not quite sure since it's more or less an intuitive practice.

Daniel Birnbaum *One might get the feeling when we discuss these things that it's almost like a formalistic game, or some sort of completely planned, strategic set-up where one moves into different positions.*

Olafur Eliasson Yes, but it's not. Things become interesting to me without my knowing why. And the things we've been talking about very often occur to me only after I've finished the project. How can you tell exactly what a *Green river* in Stockholm will be like? It has to be unpredictable to a certain extent, even to a very large extent. And it can turn out to be something different from your expectation. If the press had reacted differently it would have been a different piece.

Daniel Birnbaum *Is the context the work?*

Olafur Eliasson I made a piece called *Earthwall* (2000) at the Hamburger Bahnhof; in German I call it *Erdwand*, which means a wall in a house. Obviously a lot of people saw it as the Berlin wall. And since everyone saw it this way – even though I made it particularly low and a different shape and so forth – it has become a work about the Berlin wall. How can I change that? I can't say it's not, since everybody sees it that way. And maybe that's OK. It wasn't my intention and maybe the Berlin wall connection makes it a bad or overly literal or not very interesting work, or maybe it makes it more interesting.

Daniel Birnbaum *You mention that your interest in mathematical structures has to do with the fact that one can find alternative ways of seeing the world, more complex solutions, in a utopian sense. Is there a utopian hope in some of your projects?*

Olafur Eliasson In all of them. But I don't think there's an alternative way in the opportunistic or academic sense. Since the Renaissance there's been a history of generalizing our spatial conception, how we see, from Panofsky to Gideon. But throughout the whole practice, questioning what has most recently been established has always been the issue. And it's not so different today. In this sense it's a process on a larger scale, and I think it was always utopian.

Daniel Birnbaum *So is it a fascination with aesthetics, or is your interest more intellectual than that?*

Olafur Eliasson It's both. Like I said, it's often totally intuitive. I take great pleasure from playing with something I think is beautiful. 'Beauty' is a dangerous word because it's been standardized into something kitsch. So maybe we should talk about 'aesthetics' rather than beauty. Often something very ugly in a particular situation can be unbelievably beautiful in another. So beauty's not just an isolated phenomenon, it's more a question of something valuable. For me these geometric forms are about Op Art or optical phenomena – 'optical' in the sense, for example, of how the eye focuses on the strongest element; how a cube appears invisible in one section, then jumps out in another; how our eyes have been trained in certain ways. And with geometric forms you can actually exercise these perceptual-psychological phenomena.

Daniel Birnbaum *While on one level one might think that these geometrical structures and patterns are about abstract representation – the way that humans have always structured their world – on the other hand they're often taken directly from natural phenomena: they can be found in plants, or in crystals or ice. So it's a question of what abstraction is, and about nature. In very obvious ways your works are about natural phenomena, like the wind for example, but they're also about showing that our way of viewing nature is more complicated; it's never that direct.*

Olafur Eliasson Exactly, and this is the point I'm trying to make. The way we look at nature changes nature the moment we look at it. The way we eventually use geometric shapes in houses or structures or as sculpture is about the way in which the spectator interacts with them, actually changes them, either through time, or their position, or by one's mental play with a particular piece. This is part of the history of how we see nature, which is also where mathematics comes from – from trying to encompass and measure natural conditions, or land and the sun and the planets, from Euclidean geometry to Einstein's relativity. Measuring something can actually change its physical condition. And this is where the subject becomes part of the object.

Daniel Birnbaum *Of course even if you point to a snowflake and say, 'Look, it's not an artificial pattern, it's a natural phenomenon', it's still about your own projections. You, the viewer, the person investigating, will always remain part of it.*

Olafur Eliasson The pointing itself is part of the snowflake. Maybe the snowflake is different when you don't point at it. How can you know? The point is, can we build our world on Euclid, or, as I now think is the question, is seeing the object actually seeing a part of yourself? This is what my projects play with and illustrate a little bit.

Daniel Birnbaum *By bringing in experts and people working in other, non-art fields, it would seem that you're trying to branch out in other directions and reach different audiences, away from those expected of an artist. On the one hand it's about bringing things*

into the art, and on the other it's about bringing yourself and your projects into another reality or another world.

Olafur Eliasson In 2000 I created a smell tunnel for a botanical garden close to Bielefeld, Germany, in a small town called Gütersloh (*Smell tunnel*). I had to engage a blacksmith, a construction draughtsman, and maybe most important of all, a landscape gardener who specializes in the scent of plants, because I don't really know anything about plants. But I had an idea of what I want people to experience when walking through this tunnel. The people working in this garden don't consider it an art project. And the people who eventually visit it don't care whether it's 'art' or not. The experience doesn't change, I hope.

Daniel Birnbaum *Is it important whether you're working with art or whether you're working with experiences in general?*

Olafur Eliasson In general it doesn't matter for the quality of the project whether it's art or not. It's an absurd discussion because saying it's art doesn't add anything; it tends to make it more autonomous, rather than adding something new.

Daniel Birnbaum *But you're not pretending you're something else; you're not trying, let's say, to be a designer or an architect? You work with all these people to somehow design or shape experiences, but it's still, for want of a better word, 'art', rather than, say, design or architecture?*

Olafur Eliasson Maybe it has to do with the fact that by adapting a formal set of rules about how to work with others you begin to question them, and gradually, you create a new set of rules. Discussing whether this is art or not will always be one step backwards, since my immediate concern is, 'How can I set up a practice of having people interact with the work in a way that doesn't formalize the process into telling them how to experience it? How can the piece constantly change with every new visitor? How can the piece be one thing one day and the next day something else?' In order to leave that openness it's very important not to lock it up in a certain frame that determines how people see it.

Daniel Birnbaum *What does it mean to you to work in places such as the Fysik Centrum (Department of Physics) at Stockholm University, where you are currently developing a project?*

Olafur Eliasson It's not different. This project is still a work-in-progress, so I don't know what ultimately it will be – it might not even be art. But whatever it becomes, it'll be on a different level of representation: not on a pedestal behind glass. I do know that it will interact with the architecture, which is considered a 'functional' building. It's very satisfying to work in a 'functional' frame like this, out of the artistic context. Something more artistic can make the work representational, and it would lose its ability to question.

Daniel Birnbaum *You're involved in so many projects all over the world – Asia, South America, the US and Europe. It seems that the issues you're interested in are general enough to be relevant in all of these places. But is it very different when you do something in say, Asia, and when you do it in a European art centre?*

Olafur Eliasson Yes. I've been showing a lot in countries that have had a similar understanding of the object in relation to the subject, so that's why the basic mechanics have been similar. The city structures in various parts of our Western world are very similar. It's only when getting into the fine tuning that you realize that there are differences between America and Europe, and even between Denmark and Sweden. In this way the projects are slightly different in one place or the other, but they always adapt to their surroundings. So the same work in two different countries might be two different projects, like *Green river*, which takes place in different sites and ends up changing. A project in a formal garden in Italy will look like one thing, and the same project in an entrance to a private American home looks totally different. I haven't shown in developing countries, where my work might seem totally absurd. I'm sure it would be very different. So yes,
I think the location matters.

Daniel Birnbaum *When you first started to show internationally – in the mid 1990s, in Germany, where you've been based for some years – people tried to interpret your work as typically Scandinavian. This overly simplistic kind of identity politics can sometimes be a bit annoying. Things are made to make sense in this way, but at the same time the work and the artist's identity is a bit reduced. It's so easy to say: 'Olafur Eliasson is one of those Scandinavian artists who's obsessed with processes of nature and the tradition of melancholy and romantic landscape painting.' Is this still something that happens all the time? Is your work instantly related to some Scandinavian tradition?*

Olafur Eliasson It's definitely a problem, and it still happens, yes. It tends to be art historians, who mostly seek a solution with a single reading. Having been educated in a traditional, analytic track where almost everything has a general objective explanation. The relationship between the work and the spectator has only in recent years gained relevance. Too often the art historians of my and previous generations have this whole romantic tradition of seeking answers in where an artist comes from. I do think it matters where I come from, Iceland, but maybe it's more important that I grew up in Denmark, a sort of pseudo-Protestant Scandinavian country. That probably had a larger impact on my work than so called nature. Of course art historians always think there are autobiographical elements in my works, especially in my photos, but to use this as the reading of the work is, for me at least, a big misunderstanding.

Daniel Birnbaum *Or at least a big limitation, if not a tomb. The final result is that you bring it back to what you knew from the starting point.*

Olafur Eliasson Exactly. And it makes the work extremely representational.

Daniel Birnbaum *Even if one were to try to say that some Scandinavian artists are more interested in nature than artists in other parts of the world, it seems to me that the outcome now would not be some sort of romantic idea about nature, but an interest in the interplay between technology and nature, and the fact that everything takes place within a machine context. On one side there's this old idea that Scandinavia has some sort of romantic obsession with nature and all that. On the other hand everybody knows that Scandinavia is a high-tech part of the world, with Nokia and Ericsson and a lot of Internet companies – a society brimming with digital information. And those different elements are not so easy to reconcile, although Scandinavian society is comfortable with them. This is not to make your art more understandable, but at least one could say that the issues that you deal with relate to those things?*

Olafur Eliasson Yes. I think this is an interesting issue, because I think it's good to demystify some of these background issues. I do think Scandinavians have a special relationship to nature. And while I don't think this is why I do my work like this, of course there's something unique about every single Scandinavian country. But there's something unique about Germany too, so it's not as if that uniqueness doesn't exist elsewhere. Our history of defining the subject in terms of an idea of freedom is quite unique. We have a history of the self – existential or psychological or whatever – while in Japan, and maybe in Asia in general, there's no self whatsoever. We have a history of the self in order to have a community; we have a wonderful humanistic tradition. The Japanese don't have this tradition at all, whereas the Americans have only the self without the community. My work is interested in the subject in relation to its surroundings, which perhaps has to do with the importance in Scandinavia of questioning freedom.

Peter Fischli and David Weiss *Beate Söntgen*

in conversation
January 2004, Zurich

Beate Söntgen *Plötzlich diese Übersicht (Suddenly this Overview, 1981),[1] an installation consisting of approximately 200 sculptures made from unbaked clay, is a work in which subjects from everyday life, from the arts and from film history, biblical and mythological motifs and topoi all combine to form a mixture of banal things and grand sensations. Everything is handled in an egalitarian way within the same medium, using the same material. How did you become interested in this mixture?*

David Weiss The first outline for the project was called *Die Welt in der wir leben* (The World We Live In, 1981). The intention was to accumulate various important and unimportant events in the history of mankind and of the planet – moments in the fields of technology, fairy tales, civilization, film, sports, commerce, education, sex, biblical history, nature and entertainment.

Peter Fischli It's a very subjective encyclopaedia. We were concerned with the simultaneity of the significant and so-called insignificant, minor as well as major events. We then proceeded from this point, working with whatever knowledge we'd retained about each of these topics – our fragmented memories are what flowed into the sculptures themselves. Let's say we were creating a sculpture about, for example, the construction of the pyramids: we wouldn't do any research or consult history books. The sculpture was simply based on what we retained as an internal image or memory of these things. Sometimes, as in the case of the pyramids, mistakes were made.

David Weiss Back then, there were no camels in Egypt. (*laughs*)

Peter Fischli For 'big' events, we also tried to capture moments that wouldn't be viewed as significant within an official historical record – a moment in which things spill over into the private sphere. This was the case with Herr and Frau Einstein shortly after the conception of their son, the genius Albert, for example. We didn't focus on 'Mr Einstein Being Awarded the Nobel Prize'.

David Weiss If the sculpture of the Einsteins were untitled, it would simply be two sleeping people. But one asserts something with the title.

Beate Söntgen *Why did you choose clay?*

David Weiss For the film *Der geringste Widerstand* (The Least Resistance, 1980–81), we made small sculptures out of clay that would act as the figures in the film: a rat and a bear. The experience of working with this good-natured, sluggish and somewhat taboo material brought us to the idea of *Suddenly This Overview* – forming a variety of anecdotes and situations and then placing them next to one another. The uniform, worthless material holds disparate elements together: *The Invention of the Miniskirt* is connected to *Indigenous Forest Floor*, which is the infant of the *Modern Settlement* and everything from *Dr Hoffmann on the Last LSD Trip* to *The Last Dinosaur*. With clay you can work very fast, suggest or quote different styles, spring from one idea to another.

Peter Fischli One concern was to break away from particular styles again and again. There are sculptures that we created quite scrupulously and then there are wildly or hastily made ones. We tried to blur any definite distinguishing style because we had a certain distrust of stylistic consistency, and we wanted to create a kind of confusion on a formal level.

David Weiss Our aim was to incite flooding and confusion in the viewer. We wanted to make a lot of sculptures. Once, we set ourselves the task of creating ten good sculptures per day. We didn't quite get that far!

Peter Fischli The viewer cannot simultaneously take all the sculptures or all the stories into account; one can't maintain a grip on it all. Single sculptures are remembered, but all in all everything blurs together. And there's this failure in *Overview* – the title describes the opposite of what is actually the case: the confusion and the swamp and the simultaneity of these things.

Beate Söntgen *And this mixture of styles, the hasty work, fast tempo and fragmentation are part of an attempt to create a sort of authenticity?*

Peter Fischli I think the intention to create something authentic is the prerequisite for creating something cunning.

David Weiss One sculpture is called *St Francis Preaches to the Animals on the Purity of the Heart*. It's difficult to lay claim to that for oneself.

Beate Söntgen *The much later* Findet mich das Glück? *(Will Happiness Find Me?, 2003) could be seen as a sequel, almost a counterpart to* Overview, *using the medium of language. How did this emphasis on the linguistic aspect of things come about?*

David Weiss Perhaps it just isn't possible to formulate a question with a sculpture.

Peter Fischli Maybe we can answer by going back to the history of this questioning process. The questions and the linguistic approach in our work emerged for the first time in the context of the rat and bear film; it had its roots in writing the dialogue. In the accompanying booklet *Ordnung und Reinlichkeit* (Order and Cleanliness) there was a diagram called 'Big Questions Small Questions', where, for example, we set questions like 'Is the bus still running?' and 'Where is the galaxy going?' against one another. This approach emerged again around 1984 when we made *Grosser Fragentopf* (Big Pot of Questions). There, we placed less value on the friction between 'bigger' and 'smaller' questions. The questions became more egocentric, circling around a fictive 'I' and inclining toward persecution-mania, self-pity and self-aggrandizement. About three or four years ago we revisited this topic, which resulted in the slide show that we showed in Venice, 2003: *Die grosse Fragenprojektion* (The Big Projection with Questions).

Beate Söntgen *Was directly addressing the viewer important for you – 'Hey you! We're asking you a question!'?*

Peter Fischli No, on the contrary. In the beginning, we simply wrote the questions on slips of paper, and then we looked for a suitable form. In the slide show we first attempted to present the questions in a typographically clean format. In this format, they demanded answers, but that wasn't the most important element, so now, with these snaking, handwritten lines, which slowly emerge and then die away again, we take another approach to the questions: they don't demand a response. What we wanted was to create a climate for asking questions. There's a beautiful moment in a book by Boris Groys where he makes the distinction between two types of question. For example, between 'What is the diameter of the Earth?' and 'Why isn't the Earth a cube?' With the first, you say to yourself: 'How many kilometres is it?' With the second, you start to think about the person asking the question, or about his or her condition, and this opens up a much larger field of … I don't know what you'd call this field exactly [*laughs*], but it doesn't just point to the answer of the question. It's not like, 'How long is the Nile?', but rather, 'What sort of state of mind is that? What's the mental state of the person asking the question?'

David Weiss In a certain way, it leads to a dissolution of the self if all of these things simply whirl about unanswered – a feverish, disorientated state that's upsetting because it's unstoppable.

Peter Fischli And because answering the questions is made impossible through the continuous emergence of new questions.

David Weiss On the other hand, the viewer participates by way of this repeatedly asked 'May I? Should I? Must I?'

Beate Söntgen *You decided to include handwriting in* Will Happiness Find Me?. *Did that have anything to do with creating a persona for the questioner, an actual person whom one imagines to be behind it all?*

David Weiss We did in fact imagine a presence at the centre of this multitude of questions, and we made speculations about the person. Most likely it was a man who lets everything run through his head before falling asleep – thus the projection of questions in the dark, and the fact that the book is black.

Peter Fischli We're not responsible for the questions ourselves. It's this secret person. He's also the absent one in *Chamer Raum* (Room in Cham, 1991) and other similar installations such as *Raum unter der Treppe* (Room Under the Stairs, 1993) at the Museum of Modern Art in Frankfurt.

David Weiss The handwriting emphasizes the transience; it refers to the intimate and private, to taking personal notes, especially in cases where the questions are phrased in the first person.

Peter Fischli At the beginning it was necessary for us to maintain a bit of order, so we made index cards for the questions. That was our personal archive. Each question was given a number. Then we worked on the formulation of the

individual questions for quite some time and made corrections on each of the index cards. At some point we realised that we really liked these cards and that it would be possible to present them this way.

Beate Söntgen *And the small pictures, the bird, the car, the milk jug that are also included?*

David Weiss Those are pauses; maybe because birds or cars don't ask questions, or because birds themselves aren't questions, and cars are a reality that simply functions independently of us, out there in the world. One of the questions is: 'Is the freedom of birds overrated?', and another is, 'Should I remove my muffler and drive around the neighbourhood at night?'[2]

Peter Fischli Maybe they're like decorations on a Christmas tree; one doesn't really need them but they somehow spread a good mood anyway.

David Weiss And we've had good experiences with the milk jug over the years!

Beate Söntgen *In another conversation we've had, you said that you'd like to let viewers know exactly how much time they have to spend looking at a work.*

David Weiss We make an offer to our viewers, and they can decide if they want to accept it or not. We also overwhelm people a bit. The videos in the Swiss Pavilion at the Venice Biennale in 1995 lasted for ninety-six hours (eight hours on each of the twelve monitors). It would hardly be possible to see everything, but you could choose whether you wanted to step in briefly or spend a few hours there. We like to flood our viewers with impressions, with information. This approach has proven itself somehow. And the parts that you miss become a space you can fill with your own imagination.

Peter Fischli It's something like a department store where you'd have to spend a week visiting each department.

Beate Söntgen *Does the relentlessness of abundant materials in this work reflect the overwhelming impressions and images offered by the world in general?*

David Weiss The accumulations indicate how much time we ourselves have invested in the work. They're a documentation of our efforts. We stopped making videos after the 1995 Venice work. Maybe we'll do more, but viewing the world in such a passive fashion with the camera, simply watching other people as they work, or looking at how the world is, or how cows stand in a meadow, that's gone now.

Peter Fischli In most of our pieces time is a very important aspect: the time you spend doing something. With the carvings there's also the feeling that they took a long time to make. Among the questions there's one in particular: 'Is the nice thing about work that there's no time left?'

Beate Söntgen *Are you concerned with a particular quality of this lingering or is it more about the fact that one is always lingering in some way, even when one isn't aware of it? Are you concerned with the time aspect, or with exactly recreating the quality of lingering?*

David Weiss I think rather with the quality of lingering. In the case of the Venice videos, to be on the go with the camera and to be recording things during the drive turned the drive into something special. We were more awake, more focused. And everything I saw I could see again on the monitor in the studio. That changes your perception.

Peter Fischli In the equilibrium series *Stiller Nachmittag* (Quiet Afternoon, 1984), there's a work entitled *Die Missbrauchte Zeit* (Time Abused). There's certainly a subversive pleasure in occupying yourself with something for an unreasonable length of time. For the show in Venice we looked around the world for a year. We went on excursions and drove round in the car – or you could say, we 'didn't work' and 'wasted time'. You could also view the carvings that we make as a waste of time.

Beate Söntgen *The predominant question for us is, 'Was it worth it?' – the question is literally imposed upon us, especially in the case of the polyurethane objects.*

Peter Fischli Yes, it was worth it. I get a certain enjoyment from carving; I'm suddenly forced really to contemplate these plastic tubs. The imitation demands patient engagement with the object, an empathy. You could call it 'appropriation of the object'. At best, I'm proud and get pleasure from my replica plastic tubs.

Beate Söntgen *And was it important for you that they were everyday objects? They're just things that are lying around your place. One can imagine objects that would have more appeal than a plastic bucket.*

David Weiss It's reasonable to falsify money and gold. If we imitate something valuable, the intention is always clear. If we falsify something worthless and misuse time, however, then there's a bit of *schadenfreude* involved. On the other hand, these are all objects that we're very familiar with. If we simulate some technical object, there's a feeling of unease, because we don't quite understand the secret of a radio, or other technical devices, and it remains hidden within the object.

Beate Söntgen *What role does sincerity play for you? It's a term that has disappeared from art but that at one point counted for something, didn't it? Your works often seem to want to mislead at first, but this doesn't have to do with trickery. This deception leads to some sort of revelation.*

David Weiss The insincerity lies in the fact that we produce an illusion and then take it back in a cruel way. You suddenly recognize that what you see isn't there at all, but you're quite sure you see it all the same: this tool, this piece of wood – it's quite clear that it's a realistic image, or a partially realistic one, but it isn't actually there. I don't know if that's sincerity or not; it's deception – a sober illusion of conventionality. You produce things and situations that you've never mistrusted before.

Peter Fischli Part of the appeal of this deception lies in the slight deviation, the failure, the incompleteness. A gap appears between reality and reflection. Strangely enough, this space in between can be exactly the point where you're best able to access the work.

Beate Söntgen *There's an intimacy with these objects, an affection. For me, this idea of affection sheds a different light on Duchamp and the readymade. What's your relationship to Duchamp? Is he an important figure for you?*

Peter Fischli Perhaps our carved objects have more of an affinity with painted still lifes. In the case of Duchamp the concept of *objets trouvés*, or 'found objects', is important, whereas we try to create objects. Duchamp's objects could revert back to everyday life at any point in time. Our objects can't do that; they're only there to be contemplated. They're all objects from the world of utility and function, but they've become utterly useless. You can't sit on the chairs we carve. They are, to put it simply, freed from the slavery of their utility. Nothing else is left other than to look at this chair. What else can you do with it?

Beate Söntgen *That's an interesting reversal. The initial undertaking was an act of devotion, wasn't it? To immerse yourself in an object that's at first not especially appealing, and to set about carving it. So it was devotion on your side and then a certain compulsion or pressure on the observer to attend to this object that has arisen from an act of devotion.*

Peter Fischli Yet you could also say it's a spitefulness towards the chair, because I deprive it of its *raison d'être*, its right to exist. If I can't sit on the chair, what good is it?

Beate Söntgen *We've spoken about this spitefulness several times. Why are you interested in this sinister aspect?*

David Weiss You could call it *schadenfreude*. You can't answer the questions posed by the work; you completely lose the 'overview' if you continue to think about it.

Peter Fischli There's also the pleasure of misuse. We performed the concrete misuse of objects in the film *Der Lauf der Dinge* (The Way Things Go, 1987), too, in which chairs and tyres were again used not for their intended purpose but for something else: namely, as components in a chain reaction. Part of the merriment in this film rests on this false use. Here, again, objects are freed from their principal, intended purpose. Perhaps this can be something beautiful. If you identify with these objects, it has a liberating effect. In *Quiet Afternoon*, which preceded the film, we discovered that we could leave all formal decisions to equilibrium itself. There was apparently no way to do it 'better' or 'worse', just 'correctly'.

David Weiss We didn't have to give much thought to the composition of the piece itself. The fact that the objects would continually collapse gave us the idea for the film: to steer the objects in a certain direction during yet another of their inevitable collapses.

Beate Söntgen *How would you describe your relationship to the 'perceptible'? In* Will Happiness Find Me?, *for example, there's the question: 'Does reality really deserve such distrust?'*

Peter Fischli When selecting a title for a work like *Sichtbare Welt* (Visible World, 1987–2001) one also refers to the invisible. We were interested in the uppermost layer of reality, how it offers us only the visible, the surface. It's much like with the carved objects: on the uppermost, discernible surface it's a chair, but immediately beneath is something else: namely, polystyrene.

David Weiss You can view the 3,000 images in *Visible World* in this way. On the jacket of the book there's a hippopotamus whose head is peeking out slightly above the surface of the water, but the rest of this large, beautiful animal is invisible, below the surface.

Peter Fischli That may be a bit clumsy in the figurative sense, but as a sensual image it's beautiful nonetheless.

Beate Söntgen *There is, of course, the sense of the eyes and the water as a mirror.*

Peter Fischli Hidden beneath the surface there's a big, deep, dark space that we can each fill differently.

Beate Söntgen *How did you come to create* Visible World?

David Weiss We began *Visible World*, or rather the series of photos, in 1987 after working on *The Way Things Go* over a period of two years in the studio. We created a world, so to speak, and I think we also needed some fresh air, to get away from this incessant tinkering about, to go out with a camera, looking for interesting things in a passive sense. Using a camera turned out to be interesting. Those were the early stages. We photographed or collected whatever happened to be there – things that simply piqued our interest, even just the slightest bit – a strange car or a horse and carriage, for example – without having any one goal in mind. It was about the world out there as it is: a bird or a horse or a trivial deviation – or no deviation – from normality.

Peter Fischli During our first journey there was an intention to find pictures that already exist as such, that are broadly distributed and enjoy tremendous popularity.

Beate Söntgen *Was it at any point possible to separate the deviations from the norm?*

David Weiss At first, during the short trips we made, we sought out the normalcy of an airport or of gardens because we liked them in all their peaceful plainness. We went from the front of the house to around the house to around Zurich and then into the mountains. That's when you discover that certain places have a title, an ego. They declare: 'We are famous', like the Matterhorn or Stonehenge. And you discover that there are other places that don't have titles but are also world famous: the forest, the sea, the mountains.

Peter Fischli There are pictures that can be clearly classified, but there's also a space in between. At the beginning there were grand things – like Venice, the

pyramids, the Eiffel Tower – the so-called extraordinary things. But we realized that we were taking just as many photographs on the way to these places of interest: the normality of a Cairo suburb, for example. These pictures flowed into the book *Bilder, Ansichten* (Pictures, Images, 1991) from this in-between space. With this perspective, we also photographed our own familiar surroundings, for instance the airports and suburbs of Zurich.

Beate Söntgen *What role does the formal aspect play in these pieces? They have the deliberate appearance of snapshots, and the sheer quantity; they're the opposite of composed photography, and yet they are, at the very least, selected according to formal criteria.*

David Weiss The resistance to releasing the shutter is, as I said, low. We bring innumerable photos into the studio, where we compare and select them. The unspectacular ones have a good chance of being chosen: plainly composed pictures, taken mostly at eye level with normal lenses, imitating the view of a watchful passer-by, free of so-called photographic notions. However, we do particularly like certain light and weather conditions.

Beate Söntgen *You collect and archive the material. Why?*

David Weiss You can't throw it away. It doesn't take up much space and when you throw it away it's gone for ever.

Peter Fischli We've seen that our criteria can shift. It would have been a disaster if we'd thrown something away. In our latest piece called *Eine unerledigte Arbeit* (An Unsettled Work, first unfinished version shown in MACBA, Barcelona, 2000), we dug out lots of these pictures from the dregs of our archives.

Beate Söntgen *There are some artists who work with specific methods of archival classification. How do you compare your work to, say, Gerhard Richter's* Atlas?[3]

Peter Fischli We've already spoken about passivity as opposed to actively producing a world in the studio. *Visible World*, or the entire book, originated from this aspect of passivity: simply to go out into the world without wanting to interpret something, or seeking to make a commentary on what we saw. *Visible World* describes a trip. And that's where our work differs from a project like Richter's *Atlas*. Richter, as far as I can remember, classifies according to motifs: the mountains go together, then come the houses, clouds and so on. I assume he follows an iconographic system of order. They're investigations that he makes for his work. In the case of *Visible World* they're so-called travel photos where the order is more or less chronological, strongly indicating the narrative act of travelling. On a long mountain tour you pass by many mountains, one after another. That isn't ordering by motif but rather a reference to a period during which you had a nice time in a certain place.

Beate Söntgen *You once said that, with these photographs, a marked time-index predominates. Does something melancholy accompany this new temporality? In my eyes, your pictures are astonishingly free of melancholy.*

David Weiss I'm not so sure about that. The melancholy aspect of this work lies in the insight that you can't be in every beautiful place at the same time. That's what's irritating about the table in *Visible World*, displaying the 3,000 slides – that it radiates and glows and offers so much beauty, and is an invitation to dream about each individual picture. In addition, usually the place you're in isn't so beautiful. *Wanderlust* is also a form of melancholy.

Peter Fischli Something that's definitely a bit melancholy is that so many of these pictures are so full and yet so empty at the same time, because they're normally misused and flattened by their context. We tried to retrieve that, to release it. That is, of course, difficult – to be astounded anew by old, used-up images. Their seductiveness can't really succeed for more than a brief moment, despite one's readiness to recreate their innocence. We found the actual encounter with the pyramids or with Monument Valley to be thrilling and overpowering even though we already knew almost all of these sites from pictures.

Beate Söntgen Of course, Siedlungen, Agglomerationen *(Settlements, Agglomerations, 1993) consists of images that aren't so used up.*

David Weiss It's similar to the airports: they lie fallow. These are our surroundings, our city, our everyday here-and-now. You know they're there, and there are few reasons to hold on to or communicate them. They have this special aura; you don't have to take a picture of that. It's a type of architecture that results from a certain economic climate.

Peter Fischli It's the opposite of exotic for us, and I always liked the idea that photos such as these hang in houses, in apartments, just as we created them back then: kittens, or big cities by night, for example.

Beate Söntgen They're very tender pictures. There isn't any sense of evaluation. I don't see any element of reproach in the fact that some places look the way they do. You never photograph interior spaces, why not? Do you find that too indiscreet? Or are the palm beaches a sort of ersatz for the interior shots?

Peter Fischli Perhaps we think that whatever you project onto these pictures, any notion you already have about the design of apartments, is actually sufficient – or almost better.

Beate Söntgen (laughs) That's your exoticism!

Peter Fischli The interior spaces would be quite a different piece of work. We occasionally took photographs in furniture stores. In this roundabout way we show people's interior spaces, but it's about the collective rather than any specific person.

David Weiss With the exterior photography we made sure that the weather was nice, showing the houses in the changing seasons. We didn't want to depict bleakness, but tried to show the houses as beautiful or perhaps simply tidy.

Beate Söntgen When I said 'tender' just now, you made faces at each other (laughs).

Peter Fischli Yes, of course there's a certain hypocrisy in that. We can't deny that. If houses like that are photographed without a functional purpose such as the intention of renting them, they're photographed critically. We did the opposite and attempted, beneath the mask of idealization to …

David Weiss To overcome them.

Peter Fischli … To overcome or to show them. They're represented as they were meant to be, and not as they are. The whole attempt to render them into something beautiful is what we wanted to represent. This stirs up even more mistrust.

David Weiss Some of the works are an attempt to idealize the common, to accept it, or just to see it.

Peter Fischli These photographs partly dispel notions of desire and what we perceive as beautiful. And because of this, a sort of transfiguration emerges.

Beate Söntgen And is this transfiguration there to serve the image or the people who live there?

David Weiss Anyone who wants to understand the full depth of this work should drive around Zurich and see what we didn't photograph. There's quite a bit that's painful – more painful than the pictures and the arrangements of residential blocks we photographed. Our selection of houses corresponded to what we've considered to be modern ever since our youth.

Peter Fischli On the way to school I'd see construction sites like these every day. Many of these buildings are as old as we are.

Beate Söntgen In your most recent slide-show, Eine unerledigte Arbeit *(An Unsettled Work), you completely unfolded a new pictorial world and a new pictorial language. Until that point you'd left the pictures as they were; they were put up and left for consideration without mediation. Now there's an entropy, an implosion of meaningfulness. The pictures are cut together quickly, fading into each other. There are dramatic scenes or bloody scenes that haven't been part of your world of images up until now. What led to this change?*

Peter Fischli We ran *Visible World* through a mixer, cut it up and then put it back together again.

David Weiss On the excursions, we photographed everything that was even of the smallest interest. This is how the remote and uncanny content came together: Holiday on Ice, Ghost Train, Display Window at Christmas Time, Catacombs, whatever had collected in the dark corners of the archive and had been unused until now. With the overlap of meanings we found an appropriate form with this slide show, this flow of images. Here it's related to the non-reality of the early *Fever* sculptures of 1983.

Peter Fischli At the beginning this murky soup was a bit more dismal. But now a kind of weighty sweetness has come along.

Beate Söntgen *Why did you render the dismal into something sweet?*

David Weiss It shouldn't only be macabre and easily discernible, but also a bit seductive. We wanted to lure with beauty so that the viewer stays inside the work.

Peter Fischli The unpleasant and pleasant should inexplicably overlap in a sort of beautiful, feverish madness, in the end imploding under an overwhelming number of interpretive possibilities.

Beate Söntgen *What does beauty mean to you?*

Peter Fischli In the flower pictures (*Blumen*; Flowers, 1998), beauty is important. It's a peculiar, charming companion. That's why we decided to get involved with pleasure. The appeal of the floral images lies in the fact that they depict an unsolved problem.

Beate Söntgen *You speak of 'wanting to seduce' and of 'using beauty'. What do you want to seduce the viewer to do or see by using beauty?*

David Weiss Maybe it's a bit of a surprise attack.

Peter Fischli And it does matter that firstly we ourselves, as the authors of these works, feel captured, that we find them beautiful. This certainly happens with the viewer as well. For a moment, at the beginning, he's a victim …

David Weiss Of himself.

Peter Fischli … of himself or of this reflex. Here the question emerges: 'Can I allow myself to do this?' A question in the book is: 'Do I suffer from good taste?'

David Weiss Jean-Christophe Ammann once said, 'Art begins where good taste ends.'

Peter Fischli Are you sure? Didn't he mean 'Art stops where good taste commences'?

Beate Söntgen *(laughs) I like that. Most of your works are not, despite their subjects, made to be hung in private homes, but are conceived for exhibition situations.*

David Weiss One never thinks about private homes while working.

Beate Söntgen *We've discussed in passing your diverse modes of presentation. One form is the books. Why do you make artists' books instead of catalogues?*

David Weiss Because we think that we have to take part in the design. Otherwise information is included that we don't want. We've noticed that pictures retain a certain aura when we remove or hold back certain information.

Beate Söntgen *I've always sensed a mistrust towards the written word on your part, or towards art history or art criticism.*

Peter Fischli One time we took the reverse route and created a catalogue for an exhibition at an art association in Munich with texts about us but without a single illustration of any of our work.

Beate Söntgen *The first time we met, you said you didn't like interviews. Does this aversion also have something to do with mistrust?*

David Weiss Mistrust of our own statements, which are certainly only as good as the day they were made. One forgets the half of it; one clarifies too much.

Peter Fischli Yes, it's a mistrust towards things that are said over and over again. During interviews you start to repeat yourself, and you think: 'That's not what I really meant to say.' You give explanations that you happened upon at some point, and these explanations are therefore a bit worn out. But once they're in print, they function as if they were permanently valid. The good discussions are those where I end up discovering something for myself, something illuminating, but one already knows that it will lose this illuminating quality and will always remain dull.

Translated from German by Matthew Gaskins

1 The exhibition was held from December 1981 to January 1982. The book with the same title was published in 1982
2 A work in progress, begun in 1962, exhibited several times and published in book form in 1997 by Oktagon, Cologne

Tom Friedman *Dennis Cooper*

in conversation
January 2000, Los Angeles

Dennis Cooper *When did you decide to be an artist?*

Tom Friedman As young as I can remember. I always enjoyed spending a lot of time drawing, focusing my attention on that. I grew up in St. Louis, Missouri, where my exposure to art was limited to the art books my parents had on their bookshelf, on Picasso, Rubens, El Greco, Walt Disney. I looked at them every so often. Art for me kind of began as a skill. But I guess I always knew I wanted to be an artist.

Dennis Cooper *You toyed with the idea of being a graphic artist or an architect, right?*

Tom Friedman Yeah. Where I grew up, I had no concept of what an artist was. I assumed you got a job that could earn money. Initially I looked for creative outlets that were more practical, like architecture, graphic design and illustration. Each change was moving towards doing my own art.

Dennis Cooper *You didn't find those forms satisfactory?*

Tom Friedman I think I had too much of my own stuff to work through, and they weren't ways to work through that. So I decided to go to graduate school and major in studio arts. I went to the University of Illinois in Chicago. I entered this programme doing large charcoal drawings that were like Thomas Hart Benton. At the time, the programme was very conceptually based, and this language being used to talk about art was so foreign to me. I was forced to address why I was doing these drawings, and it paralyzed me.

Dennis Cooper *How did you proceed?*

Tom Friedman Being so confused, I tried to find something incredibly basic and simple. I wanted to gain a grasp of what I was communicating, because the way my work had been read was so far from how I was thinking about it. That was the first year – it's a two-year programme. The next year when I returned, I decided to take everything out of my studio, remove all the stuff that was there. I then boarded up the windows and the closets, painted the entire space white, and made this obscenely white, empty space. There were fluorescent light fixtures on the ceiling that cast a diffuse light, so you really couldn't see the edges of the walls. Did you see the movie *THX 1138*?

Dennis Cooper *Yeah.*

Tom Friedman You know the prison? That's what it was like.

Dennis Cooper *Scary.*

Tom Friedman At this point I sort of dropped the idea of making art; it was more about discovering a beginning. Every day I would bring an object from my apartment and place it somewhere in the space. The first day I placed a metronome on the floor, and it just clicked back and forth. Or I would sit the whole day, on the floor, looking at it and thinking about it, and asking questions about my experience of it. There was something about this space

… I didn't know at this time the significance of the 'white cube'. For me, this was more like a mental space that had been cleared away.

Dennis Cooper *A blank?*

Tom Friedman Right. A way of trying to understand silence, or nothing.

Dennis Cooper *That was a fairly radical shift from Thomas Hart Benton.*

Tom Friedman Well, there were stages towards that simplification. It needed to be radical. I didn't really know what I was doing at the time, but one day I poured honey on the floor, and when I was away from this space someone asked me if I had urinated on the floor. They thought the puddle of honey looked like urine. This incident enabled me to see the potential meaning of this experiment. I started to think of something I could do in the space that related in a way to this activity. I thought about putting together a jigsaw puzzle, as a metaphor for what I was trying to do: to piece something together.

Dennis Cooper *Was this an intentionally pure investigation? I mean, you didn't go comparative idea shopping in Chicago's galleries and museums?*

Tom Friedman No. I went to the store and bought a jigsaw puzzle. I think the faculty was beginning to worry about me. But when I got to a point of almost finishing the puzzle, I thought what I'd do is separate the pieces, like three-quarters of an inch apart from each other (*Untitled*, 1990). So they were in the right order … as if the puzzle was stretched apart. This seemed to redefine the puzzle in a way. You had to look at each piece to construct the total image. That was the beginning, for me, of thinking about using these materials and manipulating them.

Dennis Cooper *Can you define how you knew this piece was a success?*

Tom Friedman I think in the way it was read by people, which was very similar to the way I was thinking about it. There was something irrefutable to me about it. It wasn't about a particular thing, but it seemed to branch off into possibilities of meaning. And these possibilities didn't limit it.

Dennis Cooper *Which de-paralysed you?*

Tom Friedman I had found a clear point of departure. I then started to look for other metaphors to describe my process. At this time I was involved in meditation, so I thought about a process that could somehow describe that. I thought about erasing, so I started to collect eraser shavings. I wasn't familiar with Wolfgang Laib's pollen pieces until people mentioned them to me as I was erasing. But there was something interesting about the romantic aspect of his work versus the mundane, and the meaning of erasure seemed to have a similar significance. And the gesture of erasing … the repetition of it became almost like a mantra. After spending hundreds of hours collecting eraser shavings, I sprinkled them onto the floor of this studio space in a soft-edged

circle (*Untitled*, 1990). And that seemed to take me to the next level of trying to represent something very specific, striving for clarity and focus … finding something objective, in a way.

Dennis Cooper *Clarity in what sense?*

Tom Friedman Through that piece, I identified for myself four basic elements: the material I would choose, the process of altering the material, the form that it would take, and its presentation. I found that there would be an element of logic that would connect them, like the process of erasing with an eraser and achieving this minimal focal point as the idea of erasing.

Dennis Cooper *Was the closed-off, hermetic system interesting to you as well?*

Tom Friedman Yeah, I really wanted the logic kind of to circle around itself in a way, always come back to itself, and be about itself. I thought more about this circular logic, and this led me to the next piece. I made a pendulum out of a string and funnel. I filled it with laundry detergent and then swung the pendulum into a circular path (*Untitled*, 1990). The funnel sprinkled the detergent on the floor in a spiral pattern. After it made the spiral, I removed the pendulum. So there was the laundry detergent in relation to its form, like a spin cycle of a washing machine, and gravity in relation to a galaxy. One thing that was interesting about using the detergent was the idea of cleansing. I started to look for other materials that had to do with cleaning, or personal hygiene. Because I was thinking about ritual and process, I liked the connection these materials made between daily mundane rituals and rituals for spiritual purification.

Dennis Cooper *What about the chemical aspect? Detergent is an artificial construct.*

Tom Friedman This construct for me would flip-flop from a critique to a celebration of itself.
 With the idea of looking for these cleaning materials on my mind, the next work came from being in the shower and noticing that a piece of my pubic hair had got stuck on a bar of soap. I looked at it as being very beautiful.
 It wasn't enough for me to allow it just to be this event that happened. I wanted to ritualize it and incorporate a type of precision that I was investigating and developing in my process. I decided that I would inlay my pubic hair on the soap in a spiral as precisely as I could (*Untitled*, 1990). It was a way to use this circular logic and make something more absolute. I wanted to take this idea further, so I thought about a material that would suggest a process that is as direct as possible, that has a very clear objective. I got a roll of toilet paper and re-rolled it as precisely as I could (*Untitled*, 1990). The ensuing shape was cylindrical like a roll of toilet paper, but without its cardboard tube. And the fact that it was just one roll, the precision, the geometry and the objectivity of the process seemed to make it more absolute.

Dennis Cooper *Were you sufficiently intuitive about what you were doing at that point for people's responses to function as a kind of language-based, correlative explanation for what you were doing?*

Tom Friedman I was discovering a lot through other people's understanding of it.

Dennis Cooper *Were you still in school?*

Tom Friedman I graduated somewhere between the soap with pubic hair and the toilet paper roll. The last piece I did in graduate school was a wall piece where I signed my name on the wall with a felt-tip pen in a spiral (*Untitled*, 1990). I just kept signing it until the pen slowly ran out, so it created this vortex. In a funny way it was a goodbye piece to school. But it's the same type of logic – a type of identity loss in relation to meditation – that was interesting.

Dennis Cooper *You haven't mentioned the work's comedy.*

Tom Friedman That just sort of happened, because of the nature of these irreverent, dumb materials. They became very beautiful.

Dennis Cooper *A comedic tone seems crucial to the work's effect, and that tone's modesty in particular seems key.*

Tom Friedman Right, it's very deadpan, which is one side. The other side is humility or regression.

Dennis Cooper *How so?*

Tom Friedman It depends on where the interpretation comes from. If it comes from the mundane becoming art, it's comedic; if it comes from art as mundane, it's humility, or regression as an acknowledgement of its most base being. I did this piece where I chewed a bunch of bubble gum, about 1,500 pieces (*Untitled*, 1990), then moulded them into a sphere. I was thinking of how to present it. It didn't seem to make sense to just put it on the ground or on a pedestal. So I thought I'd just wedge it in the corner and let the stickiness of the gum hold it up. I wedged it head height into the corner, and that seemed to make sense – like in school, being punished for chewing gum in class and made to stand in the corner. There was also something about 'bubble-head'. In one respect, bubble-head related to someone who just doesn't have any ideas, there's nothing in there, and also this nothingness in reference to a meditative silence.

Dennis Cooper *Were you living in Chicago at this point?*

Tom Friedman Yeah; I had just finished graduate school (1990). I needed to make a living. A lot of artists out of school in Chicago would get jobs with the museums as art-movers, or as exhibition assistants at the Field Museum of Natural History, and that's what I did too. I worked there for about a year. I would work nine-to-five, and then come home and do my artwork. You could turn working at the Field Museum into whatever you wanted. If you really put a lot into it, you could eventually design exhibits. But my mind was constantly on my own artwork. So after about a year, I had worked my way down to changing light bulbs in the museum (*laughter*).

Tom Friedman

Untitled 1992
Pencil shaving
56 × 4 × 4 cm
A pencil completely shaved by
a pencil sharpener into one
long, continuous spiral

Jimmie Durham

Bedia's Stirring Wheel 1985
Aluminium, leather, fur, paint, feathers,
skull, string, cloth, steering wheel
115.2 × 45.6 cm diam.
'from: Site B, quadrant 71 White
Planes, New York Jose Bedia, the
famous Cuban explorer/archaeologist,
discovered this stirring wheel,
sometimes referred to as the "Fifth"
or "Big" wheel, during his second
excavation of the ruins at White
Planes in 3290AD. 'He believes that
the stirring wheel was a symbol of
office for the Great White father,
often called, "The Man behind the
Wheel". Bedia claims that the chief
would stand behind the wheel to
make pronouncements and stirring
speeches.'

Jimmie Durham

La Malinche 1988–91
Wood, cotton, snakeskin,
watercolour, polyester, metal
168 × 56.4 × 84 cm

Olafur Eliasson

Your natural denudation inverted
1999
Steam, water, basin, scaffolding, trees
15 × 25 cm
Installation, 'Carnegie International
1999/2000', Carnegie Museum of Art,
Pittsburgh, Pennsylvania

Olafur Eliasson

Green river 1998–
Green colour, water
Realization, Moss, Norway, 1999

Peter Fischli and David Weiss

Visible World 1986–2001
15 light tables with 3000
small format photographs
2805 × 69 × 83 cm
Installation, Matthew Marks
Gallery, New York, 2002

Peter Fischli and David Weiss

Suddenly This Overview 1981
Unfired clay
Dimensions variable
Installation, Galerie Stähli, Zurich

Tom Friedman

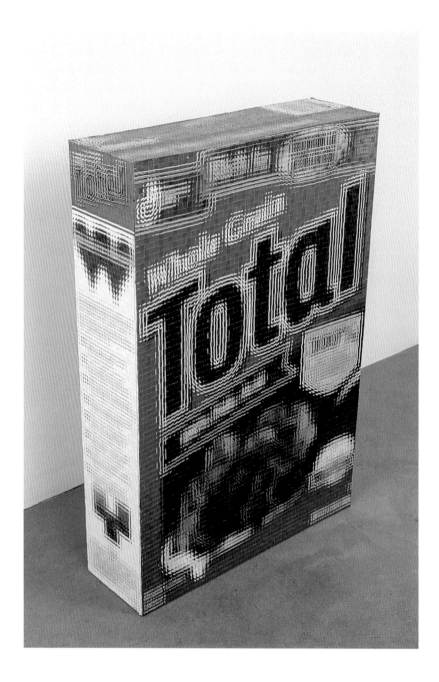

Untitled 1999
Cereal boxes
79.5 × 54 × 17 cm
Nine Total cereal boxes cut into
small squares and combined to
make one large box

Dennis Cooper *Had you already developed a relationship with the gallery Feature Inc.?*

Tom Friedman While I was in graduate school Tony Tasset, one of my teachers, told Hudson – who runs Feature – to look at my work. Hudson did a studio visit and was interested. He put me in several group shows and then gave me a one-person show (1991).

Dennis Cooper *Was that a smooth transition, in terms of how showing affected your working process?*

Tom Friedman It seemed like a natural progression for my work, which was about the experience of being with the work. I was interested in making something, and really investigating how its information unfolded to someone looking at it.

Dennis Cooper *There was quite a community of vital younger artists in Chicago in the early 1990s. Were you part of the gang?*

Tom Friedman I kind of kept to myself in a way. But I knew people who were there, like Jeanne Dunning, Hirsch Perlman, Judy Ledgerwood, Julia Fish and Tony Tasset. But I didn't consider myself in that group.

Dennis Cooper *So you were more interested in the ways in which your work interacted with viewers than in your personal interaction with other artists?*

Tom Friedman Yeah, in fact the next jump with my work in 1990–91 was thinking more specifically about what the viewer brings to an art experience. The idea of expectations stuck in my mind. There was an expectation to have something move you, or tell you something you don't know, or generate a thought process.

Dennis Cooper *Are you talking about generating those things in yourself, or in the viewer?*

Tom Friedman The viewer. You know, no one wants to look at art and have it not do anything. I think this came from the unassuming quality already inherent in my work. I thought about the art of downplay which came from my interest in Andy Kaufman's comedy. I had seen his comedy on TV as I was growing up. He did this one performance where he would start telling really horrible jokes. And you could see the audience was thinking, 'Oh, this is so bad!' He would become aware of the audience's disapproval and become almost paralysed with stage fright. Then he'd start to whimper and cry. The crying would start to slowly take on a rhythm. There were bongos next to him on the stage. And then dancing was added to the rhythm, which led him to the bongos, which he started playing, and then he danced off-stage. It was just unbelievable. After you realized the joke, it just changed your whole perception of what he was doing.

Dennis Cooper *He played with notions of innocence.*

Tom Friedman This innocence seemed to be his point of departure, as if beginning from childhood. But his innocence would always flip-flop and become something else. These ideas sparked my next piece, which was a standard A4 sheet of

paper that I poked with a pin as many times as I could without ripping the paper apart (*Untitled*, 1991). It was displayed on a wall, hung by the pin that poked it. I liked that initially it seemed like this discarded towel, but if you investigated it you would see the pin-holes, and that would change it from this seemingly casual thing to something very laboured. I thought about that type of phenomenon – what happens between the assumption of casualness and the discovery of intensity.

Dennis Cooper *People have often compared your work to magic tricks, gag gifts.*

Tom Friedman Well, I did magic when I was a kid.

Dennis Cooper *Was there something in the formal modesty of the magic trick relative to the grand effect it creates that interested you?*

Tom Friedman Yeah, how the modesty or casualness unfolds into illusion and mystery. The casualness sort of mutated into this idea of fragility, fragility defining a kind of presence. My work was already small and fragile, but I wanted to push this further. I did another piece which was a very thin piece of wire, I think picture-hanging wire, that stood perfectly erect protruding from the floor (*Untitled*, 1992). I made it by initially placing the tip of the wire into a small hole in the middle of the floor. The wire would bend over, so I'd cut it down slightly and straighten it out again. I kept cutting it down and straightening it out to find the exact height at which it could support itself without bending over. It was so sensitive that it would quiver with just the vibrations in the air, and it seemed to be defying gravity. It was almost invisible – you had to be shown where it was. I remember people would come into my studio, and I'd point the piece out to them, and wherever they were, walking around my studio, they'd constantly have to orient themselves in relation to the piece. That's the kind of presence I was thinking about. Because of its fragility, people would have to consider it, hold it in their minds, and be sensitive to it so as not to damage it.

Dennis Cooper *You generally work on the wall or on the floor. What do you see as the differences there?*

Tom Friedman Whether something was on the wall or the floor was part of the basic elements that I was thinking about from the beginning, in terms of presentation. My decision seemed based on being as direct as I could be. Like the laundry detergent; it seemed like it needed to be on the floor because that was the way it fell. Pinning a piece on the wall, I would think about the line or the direction that someone would travel to see the piece. I didn't want any kinks in that line; I wanted it to be fluid. The decisions seemed based on what was most natural.

Dennis Cooper *What about the shit piece, which used a pedestal (*Untitled, 1992*)?*

Tom Friedman I was still thinking about scale and fragility, which led to thinking about the smallest amount of material to present that would have the most significance.

So I thought that I would use my faeces, and rolled some of it into a ball. I wanted it to be spherical, I wanted it to have a shape, not just be the material. It was tiny, about half a millimetre in diameter. I presented it on this pristine white cube/pedestal, because I wanted to draw a relationship between this minimalist icon and the shit. I really wanted the size of the shit almost to create some sort of bridge between the idea of it and its physical presence, to kind of merge the two together. Also I wanted to use the size to draw one's focus towards an idea, a very potent idea. I saw the cube and the shit contrast each other but become similar, both requesting a similar experience.

Dennis Cooper *Making art out of your shit can be read as a transgressive act. That might even be the first reading for some people.*

Tom Friedman That was part of compressing the idea. It was like thinking about shitness through an intense meditative focus.

Dennis Cooper *Still, it's a loaded piece, which must have received a loaded response.*

Tom Friedman I think people talked more about the stories around it than about the ideas. Like at my opening, some guy who I guess was a bit irreverent sat on the cube, thinking it was an empty pedestal. I saw it happen and ran over to him. He stood up, and I told him to just stay there, while I proceeded to look for the shit on his butt. But I couldn't find it! Luckily I had some spare ones.

Dennis Cooper *A multiple! (*laughter*) Was the shit piece shown in Chicago or New York?*

Tom Friedman In New York. It was my second show at Feature. Also in that show was a piece titled *Hot Balls* (1992), which was a collection of toy and game balls I stole from various stores in Chicago. I was working on this piece and had 'collected' about two hundred balls over a six-month period. I didn't know what I was going to do with them. I tried to finish the piece by arranging them. Eventually, I decided to steal a really big ball, which sat on top of the smaller balls and became this kind of prize.

Dennis Cooper *Why steal them?*

Tom Friedman I heard something about how the space shuttle on its next trip into space would take these stamps with it. When the stamps returned to Earth, they would be sold as collector's items. It was interesting that you'd have two of the same stamps, and one would have this history attached to it that made it more valuable than the other one which was visually and even subatomically identical. So I was thinking about presenting information in a piece that wasn't inherent to the physical qualities of the piece, but in what you learned about it, and that would change your perception of it. The fact that the balls were stolen was their attached history. Also the stealing related to the tricks and sleight of hand. It also offset the preciousness of my process.

Dennis Cooper *How would a viewer know they were stolen? I guess the title was a clue.*

Tom Friedman For that particular exhibition there was a hand-out with empirical information written about each piece.

Dennis Cooper *You say that* Hot Balls *involved about six months of stealing and thinking, whereas I assume the shit piece took much less time to realize. How does this time differential distinguish one piece from another, if at all?*

Tom Friedman I think the time element becomes relative to each piece. Even ones that take a minute or a second seem to compress or expand time in a way whereby they become similar to the more laboured pieces. One's idea of an instant or an eternity takes the same amount of time to think about.

Dennis Cooper *You don't speak of your work in relation to other artists' work. Who influenced you? Are there artists with whom you feel a kinship?*

Tom Friedman I think my first art experience was when I was younger; my parents had a lot of Picasso books. They had one book of his etchings. When I would look at them I just saw lines; I didn't really see much more than these interesting lines. Then one time when looking at the etchings, the lines became figures and created these images that seemed housed within the whiteness of the page. It seemed to give the white page this solidity. It was really a profound experience for me to see that happen, that sort of shift in perception.
 When I think about artists who have influenced me recently, I don't distinguish much between one or the other. I think everything I see and consider influences me in some way. It's interesting because art, visual art, doesn't affect me that much for some reason. It could have something to do with the mystery of it, that I feel that I've already gone through it. Music is something that has that mystery for me. It really affects me, and I feel I've been more influenced by music than visual art. It's really odd that I don't get much out of looking at art, because I make objects and I hope people enjoy looking at them.

Dennis Cooper *It makes complete sense to me. As a writer, I learn much more from visual art than I do from other writing, at this point. So what music have you learned from?*

Tom Friedman Recently I've been listening to a lot of electronic music. Like Richie Hawtin is one of my favourites. And Richard James and Thomas Brinkman.

Dennis Cooper *Who's that?*

Tom Friedman I don't really know much about him, but he's collaborated on some things with Richie Hawtin. And Tom Jenkinson, Stereolab. Glitch music, like Oval or Autechre.

Dennis Cooper *How have they influenced you?*

Tom Friedman I've always been interested in the idea of quanta, and the quanta of ideas. I think that electronic music begins to investigate these things, the way sounds and rhythms can be broken down and built up from their smallest part.

Dennis Cooper *Do you think about the way their work diverges from traditional musical structures?*

Tom Friedman I think of it more as pattern and texture, the way different patterns and textures work off each other. I mean once you start dealing with electricity you begin to enter into thinking about synaptic functions, how one constructs thought or thinking based on electrical impulses, and how these impulses affect the body.

Dennis Cooper *Have you consciously tried to translate musical principles into visual principles?*

Tom Friedman For some reason, when I think about an idea I think about it as a physical thing. I think about it as a form that has dimensions, shape, pattern and some sort of structure, or the fluid structure of music. I'm interested in some sort of conceptual aesthetic. It's not so much what the ideas are, but what they look like, and where they are located in relation to each other, similar to the aesthetics of sound.

Dennis Cooper *Is there signage of that thinking in your sense of colour?*

Tom Friedman Yeah. When I work on a body of work, each piece tends to take on a distinct colour identity. Like in my most recent work, the biological colouration of the mutilated figure (*Untitled*, 2000), in contrast to the grey of the robot (*Untitled*, 1999), and then the white of the movie projector (*Untitled, 1999*).

Dennis Cooper *Maybe I'm wrong, but it seems to me that your most recent work involves a more intensive and varied use of colour. I've read that you consider your process to have evolved from a largely intellectual process to a more emotional one. Is there a connection there?*

Tom Friedman Yeah, because I started to think about my work more in the background of my mind. I'd sort of plant an idea in my head and then something would come from that. For me it's a new type of thinking process: not primary thinking, but allowing something to just sort of develop and happen in the background.

Dennis Cooper *Why do you characterize it as emotional?*

Tom Friedman Because it's not an intellectual process, which is more a foreground thought process. Happening in the background, it begins to introduce and be affected by a psychology.

Dennis Cooper *In some way, psychology and poetry are opposites. Psychology seeks meaning in the trajectory of one's past experience, and poetry suggests meaning is impossible, and can only be conjured. How is it that your work seems to have become more psychologically acute and more poetic simultaneously?*

Tom Friedman I think in my latest body of work the idea of cinematography has filtered in. This idea was somewhat the catalyst for my March 2000 show at Feature. When I make a body of work I try to create a piece that represents a

protagonist or a catalyst for things to happen. And the movie projector piece was the catalyst for this exhibition. In a sense, I saw the other pieces in the exhibition to be apparitions created by the projector. Looking at the way my mind works, I was using film as a request or a reference to the cinematographic experience, the layering of different types of represented reality. Because the projector is all made of white paper and the film is paper, it's like a projection of itself. I know that the shape of the film format isn't a square, but I can relate the square to it, and thinking of these as minimalist squares going through this cinematographic type of filter I see as like a shift in consciousness in the way people look at things now.

Dennis Cooper *Because of film, because of the computer, because of…*

Tom Friedman All that stuff. And because of the narratives attached to our consumer landscape. Like one recent piece involves nine cereal boxes that are fused together to make one large cereal box (*Untitled*, 1999). It took me a while to figure out how to do this, but it's based on matrices. It's kind of like if you wished to fuse two material objects together, you'd take the first atom from one object, then connect the first atom from the second object, then the second atom from the first object, and so on. But instead of using atoms I used squares. The squares are combined to construct the total image. I was thinking about the squares like the frames of the projector. In a film, as you move from square to square the image is displaced a bit. And there's a money piece (*Untitled*, 1999) based on the same principle, except it's done with thirty-six dollars. It's a grid of six by six. I was interested in the relationship between the static object and time, and the displacement of your mind continually looping and thinking about the static object. Also, in thinking about fantasy, what obviously comes into play is that separation between real space and mind space, and ideas have this kind of elusive nature to them in mind space. But the idea of a concrete space sort of brought me back to thinking about my white studio space in grad school. It became this clear space in my head where I could put things. So now I'm interested in that edge between the mind space and the real space, which sort of informs these images. They have a solidity inherent in the materials they're made of that grounds them, in a way, like the robot. But they are also like apparitions; they just appear but they are not real.

Dennis Cooper *Are you interested in the paranormal?*

Tom Friedman I love reading conspiracy theories, things like that.

Dennis Cooper *You like* The X-Files?

Tom Friedman Oh yeah, I love that kind of stuff. I think there was a point where I thought about the rules of thinking, all the rules that I've sort of inherited, and I really tried to lay those aside, in a sense. Like I'd give this book on conspiracy theory to someone, and their first comment would be, 'Do you believe this stuff?'

For me that question of believing it or not is not the point. I mean the fact is there is this perception, and there is this amazing fantasy or whatever, someone constructing this theory, and it just makes incredible fiction or science fiction or non-fiction or whatever. It's so interesting because these realities are confused.

Dennis Cooper *So that's the poetic. I mean, that's where the poetic derives from?*

Tom Friedman Yeah.

Dennis Cooper *Did the work you made a few years ago with space station imagery (* Space Station, *1997) begin introducing the poetic into your work?*

Tom Friedman Yeah, the space station was like an outpost connecting the known and the unknown. It's something that, in a similar way to the microscope, extends our perception beyond the capabilities of our immediate senses. I think that work was an attempt at really trying to take these very disparate investigations and solidify or make autonomous each one, and then unite them and bring them together. You can't help but begin constructing narratives when that process happens – just like in a dream, when you're bombarded with impressions, and your mind naturally constructs a narrative to link the impressions together.

Dennis Cooper *So there was a shift happening there?*

Tom Friedman I'm not trying to draw the viewer into a specific place, I'm drawing them into the constellation of ideas, which is probably why I made the spider sculpture (*Untitled*, 1997). I thought about the spider as this thing that spins a web. I see the spider connecting ideas with its web.

Dennis Cooper *Insects keep crawling into your work (laughter).*

Tom Friedman The first insects I made were the fly sculptures (*Untitled*, 1995), which initially began with an incident where the artist Charles Long, who used my shit piece in a show he was curating called 'Critical Mass' (A & A Gallery, Yale University School of Art, New Haven, and tour, 1994–95), had to put a cup over the piece of shit because a fly was buzzing around it. He sent me a photograph of the cup over the shit and the fly on the pedestal. That sparked the fly pieces.

Dennis Cooper *Would the dragonfly (*Untitled, *1997) be some kind of psychedelic mutation of the fly?*

Tom Friedman Yeah, exactly. The dragonfly represented a shift into thinking about fantasy.

Dennis Cooper *But this wasn't a radical shift for you, it was a natural progression?*

Tom Friedman Right. When you think about something over and over again it just sort of vanishes. It diffuses into possibilities and loses its objectivity. I have this fascination with mapping things out, mapping out very complex systems. And being able in a way to map them in my head without being able to

translate them, or not having the ability or the skills to explain them. I'm very torn by that, by that inability. And I think that somehow that's a part of my work, a big part of it.

Dennis Cooper *Are the materials you use a limitation?*

Tom Friedman I have the idea of wanting something to be explanatory, but once I begin to explain, it's not what it's about.

Dennis Cooper *So do you end up simulating the enigma that it has for you?*

Tom Friedman Yeah. The explaining becomes the object, as opposed to the indicator.

Dennis Cooper *I wonder, do your pieces ever fail in process, or do they generally succeed once you've reached the point where you move from concept to construction?*

Tom Friedman There are a lot of pieces I will begin but be unable to resolve. I'll either trash them because I just need to purge myself of them, or I'll put them aside, and come back to them at some other point. I started the toothpick sculpture (*Untitled*, 1995) but had to put it aside for a couple of years.

I couldn't resolve for myself a departure from the clear limits my work was exploring. It wasn't until I made the pill capsule (*Untitled*, 1995) that I could come back to it. The pill allowed me to move from the ideas of containment to invention. I saw the toothpick sculpture as a response to consuming the pill containing Play-Doh as its medicine.

Dennis Cooper *Do you ever look back on pieces you've shown and think, 'Oh, this is a failure'? Or are there pieces you think have been particularly successful? Do you make differentiations like that?*

Tom Friedman Not really. Each piece for me becomes essential to the progression of my investigation.

Dennis Cooper *Have you ever gotten so lost that you've looked back on your older work to remember who you are as an artist?*

Tom Friedman Well, a form that has been recurring in my work is a motif representing diffusion, where there's a dense centre and then it diffuses out, almost like the Big Bang in a way. Even the things that I do now incorporate the idea of clarity and specificity that I was striving for in the beginning. But there are shifts. My thinking started to shift a little around 1995 when I had a show at The Museum of Modern Art, New York, in the Project Space ('Projects 50: Tom Friedman', 1995). I became interested in information and the effects of an inundation of information. As the velocity that information is presented increases, one's ability to process that information shuts down, and just the texture of the information is perceived. I started to work on a piece sparked by these ideas surrounding this flood of information and how it leads to the organization of information into categories. I did this piece where on a piece of paper 36 by 36 inches (91.5 × 91.5 cm), I wrote all the words in a dictionary

(*Everything*, 1992–95). The words were not written in order; I wanted them to be scattered throughout the paper as a way of homogenizing the language. The paper was presented on the floor, and it looked from a distance like a textured blue paper. I was interested in how the information about the piece unfolded. How it began as a seemingly inconspicuous textured paper, the texture becomes words, the words represent a total system, the fullness and the emptiness.

Dennis Cooper *So the creating and unfolding are in perfect balance or mirrored?*

Tom Friedman Right.

Dennis Cooper *Like a film being run forwards then backwards? Two processes that are identical except for their order?*

Tom Friedman It's more my thought process trying to gain an understanding and control of that type of unfolding. Like when you're presented with something unfamiliar you ask yourself a series of basic questions: What is it? Where did it come from? Why is it here? I wanted these objects to begin with this direct line of questions.

Dennis Cooper *While making the piece, is the viewer your fantasy?*

Tom Friedman I developed a somewhat split personality where I could be the artist and also the viewer, in a way. And then the viewer would be in a sense my idea of the ideal viewer.

Dennis Cooper *In other words, you?*

Tom Friedman Right. (*laughter*) I guess my ideal viewer has to be me.

Dennis Cooper *What other works were in that MoMA show?*

Tom Friedman There was a piece titled *Loop* (1993–95) which was made with spaghetti. I used a one-pound (435g) box of spaghetti. I cooked the spaghetti and then let the noodles dry into curls. Then I connected each piece end to end making this meandering configuration until the end connected back to the beginning. At this point I started to think about the idea of complexity, which seemed to be a logical jump from thinking about simplicity. The *Loop* piece, which I somehow saw as a diagram, was a pun on the noodle being the brain, and was directing one through a perpetual convoluted line of thought.

Dennis Cooper *Was that the shift?*

Tom Friedman Yeah. In a way the complexity forced me to think more about the diagram: things that organize information and orient people. I started to use a diagram with every body of work that described my thinking at the time. For my next body of work, which was at the Feature exhibition in 1996, I did this drawing on graph paper where I started with a point, and there was a vector from that point (*Untitled*, 1995). And then that vector would divide at right angles,

and it would be slightly shorter in length than the previous one. It just kept dividing and dividing until it turned in on itself, confusing this basic process. For me that represented a move from the simple to the complex. I think at this point I started to work on each piece within a body of work simultaneously. I wouldn't finish a piece and then move to the next piece. It was almost as if the whole body of work was one piece.

Dennis Cooper *They were more interdependent than before?*

Tom Friedman They related to each other in different ways, ranging from a conceptual relationship to purely a formal relationship. I started to investigate the relationship between ideas that moved apart from each other. I was interested in their increasingly tenuous relationship. There's a word-game you can play where one person mentions two distinctly different words and the other person tries to find a third word that connects the two words. It became almost like that kind of play. I was involved in so many seemingly divergent investigations that I also saw as all part of the same constellation of ideas. I was discovering the elements throughout that constellation of ideas, and finding out how they related or came together as a total thing. The idea of pulling things apart, further and further, was interesting. I did this piece where I chewed a piece of bubble gum, stuck it to the ceiling, then stretched it and stuck it to the floor (*Untitled*, 1995). I used stretching a piece of bubble gum as an analogy for this idea: as you stretch the gum the connecting thread becomes thinner and thinner. I reached a point where the idea of fantasy started to filter in, because when the connection between things becomes so slight, things are not read as a cohesive whole, which is kind of how my work has now evolved.

Dennis Cooper *This might seem like a strange segue, but I wonder about your relationship, if any, to the idea of the 'outsider artist'.*

Tom Friedman I've thought about that, and in fact this recent body of work sort of began with that in a way. I was thinking about the outsider artist as a way of not having to deal with content in the same way; there is this other type of aesthetic that re-situates how one looks at something, not looking from the standpoint of participating, or fulfilling a type of dialogue, but as the personal, bare bones essentials of making something out of nothing.

Dennis Cooper *I mean outsider art has its own problems, there's a condescension towards it. There's a perception of outsider art as a manifestation of insanity that merely resembles art. But, on the other hand, critic Peter Schjeldahl wrote a review of one of your shows where he said something like, 'Tom Friedman would be nowhere without the Minimalism that his work kicks against'. I never think of you as working from Minimalism particularly. But, because you're a 'contemporary artist', the assumption is immediately made that your work self-consciously references art history.*

Tom Friedman I do rely on Minimalism in the same way I rely on the whole art context.

Dennis Cooper *But, if you were an outsider artist, no one would ever say, 'This must be viewed in light of Minimalism.' If you were an outsider artist, no one would refer to your work as obsessive; that would be a given. If there's a chorus in the collected writings on your work, it's the word 'obsessive'.*

Tom Friedman Right. But I think most artists obsess over their work. 'Obsessive' is a convenient word to describe one aspect of my work, but it doesn't take into account the reasons behind the acts that are characterized as obsessive, so it's a failed approach.

Dennis Cooper *Do you feel hemmed in at all by the reality that your work will always be seen either in galleries or museums?*

Tom Friedman No, I really like that context. I think about the ideal viewer, and the ideal viewing situation. The ideal viewing situation is this place that demands that you slow down experience, and bring all of who you are to the experience. I know that, in reality, the gallery and museum don't have that, but I still make work for those ideals. I like keeping that illusion with me.

Dennis Cooper *What about when your work moves from the gallery into a collector's home?*

Tom Friedman I think that after I make it and it goes into the gallery it's in its sort of original context within a body of work. Then it's taken out and it becomes historical, more of an artefact, as opposed to the same conveyor of meaning it was originally. I'm willing to accept that type of conceptual, ephemeral quality; that seems to fit in with my work. I read something about how artist Charles Ray remade some pieces for his retrospective because they had shown age, and he felt their age added a history that got in the way of their immediacy and their presence.

Dennis Cooper *Do you feel the opposite way?*

Tom Friedman Well, I think I'm just more accepting of the inevitable. I have to be. But I am going to remake some pieces that have shown their age and stuff for my survey show organized by the Southeastern Center for Contemporary Art (Winston-Salem, 2000–02). It's not a rigid thing for me.

Dennis Cooper *When you remake a piece, do you simulate the process through which you originally made it?*

Tom Friedman Usually, for the pieces that I remake, the process is very direct. I mean there's really no way of deviating from that process. The process is the process, like putting a pencil in a pencil sharpener.

Dennis Cooper *So you're not going to stare at another piece of paper for a thousand hours (1,000 Hours of Staring, 1992–97)?*

Tom Friedman No, you can do that! (*laughter*) One thing I'm really consumed with is the question of why? What is the purpose of art? How does it serve? What does it do? I can kind of see it as this thing that is not directly necessary – you know, why not spend my time helping people more directly? Why am I spending my time isolated, thinking about and making these things? It's something that keeps me in check in a way: the idea of doing something important or useless.

Dennis Cooper *Ultimately, you believe it's important.*

Tom Friedman I don't know. I think in terms of ideals. If I were to think of what the ideal art would be, that would be art that gives viewers an experience that they take with them and that causes them this incredible revelation which they, as enlightened people, turn towards society. They would do these amazing things that penetrate other people and who then all come together and we live in harmony, and there's peace, and we all are transcendent individuals. It sounds like a comedy. It sort of comes down to something very personal, and that's interesting in terms of any philosophy or art or anything that seems to transcend the individual sitting down thinking about these things where that sort of essential nature comes into play. Like we'll do something, and then that thing we do and the decisions that we make are sparked by our history and stuff. A lot of the decisions that are made now within the social landscape are very business-oriented and business-driven; for example, they are the result of marketing research. What's the end to this process? It seems to be somehow an arbitrary end: that people will fulfil their lives with the product. And then the owners of the company, and the people involved in the company, will have more money, so that they can have the things that make them feel better.

Dennis Cooper *Which has everything to do with you, but nothing to do with your work.*

Tom Friedman You're accepting the enjoyment of it, the personal enjoyment of it, rather than seeing the consequences of being seduced by that enjoyment.

Dennis Cooper *Lastly, has your considerable success as a young artist impacted your work in a positive or negative way? Or does it matter at all?*

Tom Friedman I'm happy that my work can have this type of reaction in people, but it seems to make things more difficult. I'm attempting to create these specific experiences and, as I do more work, there is more and more information and history to look through, that filters one's experience of these objects, like a growing fog.

Isa Genzken *Diedrich Diederichsen*

in conversation
May 2004, Berlin

Diedrich Diederichsen *In the short video by the artist Kai Althoff in which the two of you are shown in conversation, he asks you why you have such an aversion to interviews. You explain that answering questions represents exactly the opposite of artistic work – of making decisions for oneself. It sounds as if, to you, creating art is like being on holiday, without any pressure, while making concrete statements in a conversation is like work. But people send postcards home even when they're on holiday. Perhaps it would be possible to view an interview as a sort of postcard?*

Isa Genzken Actually you only think you're not under any pressure when you make art because there's nobody telling you what you're supposed to do. But you have to find everything within yourself and make each decision on your own. And though there's nobody forcing you to do anything, it can nevertheless turn into a disaster. In the creative process you're very much on your own. You can't simply call someone up and say, 'Have a look at this.'

Diedrich Diederichsen *And do you have imaginary conversations with other artists – people whom you know or don't know? Do you ever ask yourself, 'What would so and so think of that?'*

Isa Genzken No. I don't do that sort of thing. My experience is that the artists I appreciate seldom approve of things made by other artists. I don't often speak with other artists the way I do with Kai in the video, especially since we weren't talking about my art, but rather something we created together – namely this short film. What was interesting was that we didn't plan our conversation.

Diedrich Diederichsen *He asks you what you mean when you say that your work must be 'modern'. You reply that it is precisely this aspect of interviews that you dislike: instead of being able to digress, the questions tie you down.*

Isa Genzken I gave him a completely unrelated answer.

Diedrich Diederichsen *I thought his question was very interesting. The word 'modern' has, of course, two meanings. One pertains to things that are topical and contemporary, the other to the historical movement of Modernism and Modernity, which in a certain way is no longer contemporary. But I suppose that's debatable. In any case, I have the feeling that your work is concerned with both. First, you incorporate contemporary symbols, products, objects, fetishes in your work, but you always make reference to the historical movement as well.*

Isa Genzken Yes, that's true. But I don't want anything to do with traditional elites and their self-awareness. That's too rigid and boring. I focus on completely different sensibilities in my work. 'Topical' is perhaps a better description than 'modern'. But that doesn't mean that I don't want to be modern. My work *is* modern.

Diedrich Diederichsen *There's certainly a sub-movement within historical Modernism to which you make reference in a number of ways: the idea of the 'social' work of art that both incorporates and influences its surroundings. This is something you've referred to often lately, even if in a critical fashion.* Fuck the Bauhaus / New Buildings for New York *(2000) and* New Buildings for Berlin *(2001-2004) come to mind.*

Isa Genzken Yes, although in the last year and a half I've become more interested in a formal language of cheap materials and cheap production. I'm not talking about cheap, hand-made objects, like the self-modelled stuff that's so amateurish you can see it a mile off. When I say 'cheap materials' I mean industrially fabricated sculptures that are very interesting as sculptures in their own right. A year ago I started on the series *Empire/Vampire, who kills death* (2002–2003) using small plastic objects, figures, toy tanks and so forth. At the beginning, the topic of war was uppermost on my mind, because the conflict had just started up in Iraq. But then the objects I'd bought became much more important in themselves, and I started working with them more and more. For example, that hippopotamus figure you see over there and the small iron next to it: I specifically bought things that were cheap, both in terms of how they were manufactured and their retail price. They were things I'd never be able to create with my own hands. If I were to model a hippopotamus it would never look like that – and I wouldn't be capable of doing it anyway. It looks so good, not even Stephan Balkenhol could achieve it. But I think I succeeded in creating something completely different. There's no longer any mediocrity, but it's important that it's based on 'everyday beauty'. Nowadays there are more and more shops that sell these really cheap items. That's where I found all of these figures and objects. I'm not only interested in what they portray, but rather in the formal aspect of how they were made. And they come from all over the world: one component is from Taiwan, the next from Mexico and the third from somewhere completely different. As I said, I'm not speaking of poor quality. You find 'poor' quality in Markus Lüpertz or Balkenhol and in many other areas of sculpture. I combined cheap things with expensive things – for example, very expensive glasses, figures from film modelling workshops, or the costly reflective foil used in architecture. These are all mass-produced, assembly line materials, which I then altered with colour or through their placement in unusual combinations.

Diedrich Diederichsen *A global taste of mass reproduction, yet characterized by exceptional formal qualities.*

Isa Genzken Yes, but I tried to place everything in a different artistic context. What appealed to me was that they could be movie scenes. The works should function as motion pictures rather than sculptures. You see a new picture from every different angle. Nothing is rigid or two-dimensional, but cinematic.

Diedrich Diederichsen *These cheap figures are also often described as emotionally moving. One sees an effort that's futile – towards a totality of form and completeness that's doomed to failure. It's poignant somehow.*

Isa Genzken I disagree – that's not well thought out. The work doesn't fail in any way, and audiences react well; they're perplexed. If you walk around my works and pay attention to the scenery, something different always emerges and

you can always discover something new and sympathize with it. That's the opposite of the tradition that began with the 'Black Square'. This has been abused since the 1960s. Jackson Pollock, Barnett Newman, etc. – I think they're great – Conceptual Art, too. That's more where I fit in, but I didn't want these modernistic, flung-down objects that strive to avoid all content. Benjamin Buchloh criticized my ellipsoids for having too much content. He said to me, 'You haven't even understood Carl Andre yet.' I said, 'Of course I understand him. But I can hardly try to outdo Carl Andre.' Of course, it was exactly this 'content' that I wanted to bring back into the ellipsoids so that people would say, 'It looks like a spear' or a toothpick, or a boat. This associative aspect was there from the very beginning and was also intentional; but from the viewpoint of Minimal Art it was absolutely out of the question and simply not modern. And yet the ellipsoids made reference to Modernism in terms of media and material. I had to go to the University of Cologne, where I knew a physicist who calculated and drew all of the diameters on the computer. After that I had to build it so that it would gain this horizon-like quality – I was influenced by Bruce Nauman. They were tremendously complicated to produce in terms of craftsmanship. I did it all by hand, but I wanted them to look – plop! – right out of the machine. People have always thought they were machine-made, but I wouldn't have been able to afford to get them produced in an aeroplane plant or wherever you can have things like that made. I was also very proud of them because they helped me achieve a level of craftsmanship that many of my American colleagues no longer have. With the exception of my outdoor sculptures I've always done everything by hand anyway. I don't mean to insist that you *have* to do it that way, but it can't hurt. The Modernists might see it differently. László Moholy-Nagy, for example, made pictures by calling up the factory and describing his images over the telephone. That was seen as especially advanced. And it was. But times change, and today everything is out-sourced. And also it's also more interesting to develop things yourself. Many contemporary artists do it. My colleagues in my gallery share this inclination. Whatever 'modern' means, I don't reject the term. On the contrary, for me, 'modern' means progress in social and aesthetic terms, but as a wanderer within diversity.

Diedrich Diederichsen *You said there was this moment at the beginning of your artistic development where you departed from Minimalism and connected it with 'content' – does that also have something to do with the almost involuntary way that Minimalist objects can have 'content'; that they seem to look at you in an uncanny way? They have something like a psychotropic, psychedelic side, and can suddenly appear to have a soul – and this precisely because they aren't supposed to have one. I was just thinking of how you've also given many of your objects proper names.*

Isa Genzken That way I always know exactly which is which. Over the years I've created many objects that, though diverse, look very similar. Because they carry the

names of certain people I thought about during my work – 'Mies' or 'Schindler', names of architects, or 'Schönberg' – I can identify them precisely and know by heart how they look in detail. What else can you do? You could number your pictures like my ex-husband did, but he didn't know by heart which picture went with which number.

Diedrich Diederichsen *Yes. But those are just series when you number them like that. When you assign names, then we're not talking about objects in a series anymore, but rather about a specific type of logic, about something that must have been intended that way.*

Isa Genzken It's always closely related to my feelings at the time. Back then I visited Lawrence Weiner, who had a boat in Amsterdam called *Joma*. I was invited to the boat and had such a nice evening that I used this name as the title for a work of 1981. And now I can always say exactly how that object looks. Later, I named the pillars after friends, but even then, I know exactly which pillar is *Wolfgang* [after Wolfgang Tillmans].

Diedrich Diederichsen *So the sculptures have a sort of physiognomy? They may belong to a genre, a series, but are they nevertheless individual beings that can be differentiated according to their unique physiognomies?*

Isa Genzken There have always been series, such as *30 Ellipsoids* (1976-1982). I'd work on one thing until it became boring. Simply continuing the series would lead to certain ideas, which then provided the foundation for a new kind of work and a new series altogether. This would happen almost automatically. And that's what some people don't understand. People used to accuse me of being indecisive and not knowing what I want, because I was able to change so quickly from one genre to the next: 'First she creates such elegant things and then goes on to make these strange plaster objects.' Honestly, though, I think people have always given me credit for being able to move on. In my life, I've always been concerned with fluidity and opposed to rigidity. That's been automatic – I've never had to think about it.

Diedrich Diederichsen *The elegant hyperbolas and ellipsoids were, of course, the things that put you in the spotlight. It's clear that people wanted to associate you with 'elegance'. It was something new in the late 1970s. I feel that your subsequent works in plaster and cement were, in part, a deliberate attempt to thwart this association.*

Isa Genzken Absolutely. I really wanted a change – and to get away from the drudgery of the early works; they were incredibly difficult to make. So I went to a plaster workshop in Düsseldorf. I'd never been there before. When I arrived, I realized immediately: I really like this. It was something completely different from the places I'd been before, where we were working with wood. Then I played around a bit with the plaster and suddenly had the feeling, 'Hey – this is easier than I thought!' I felt like a real sculptor [*laughs*]. Even so, making my way from plaster to cement was a longer road than I'd imagined.

Diedrich Diederichsen *And now your studio is located next to the city's plaster moulding workshop.*

Isa Genzken I find that almost romantic. And there's the Charlottenburg Palace next door and its lovely park. I've never been to the workshop, but I'll go some time. I wouldn't want to buy the Nefertiti they make there, but I'd gladly go and find out how a Nefertiti sculpture can be made really well.

Diedrich Diederichsen *Or they could make casts of your works.*

Isa Genzken Yes, but I've only made two bronzes in my life. I was at the best bronze foundry in Düsseldorf, and in the process the plaster moulds were ruined. That was terrible for me because I thought the plaster forms were much nicer. The bronze had lost something. I'd never do anything like that again. It would destroy the original. This being said, one thing I believe about my works so far is that I've been able to do justice to whatever material I'm working with. I'm able to make the best of it. For my London exhibit (*Wasserspeier and Angels*, 2004), I worked with this special sort of foil that's very strong and stable. I rounded off the forms with it – and the light shined through. You can incorporate 'inside' and 'outside', and everything appears so colourful and cheerful. But the decisive thing about working with the material was to create something round with it. That's always the most difficult aspect of sculptures, and with this material you can do that.

Diedrich Diederichsen *How did you come up with the idea to create the sculptures you call* Wasserspeier *(Gargoyles) for this London exhibition?*

Isa Genzken Whenever I'm in Cologne I go to the cathedral there several times a day because I find it absolutely magnificent inside. I've even referred to it before as my 'studio'. Wolfgang Tillmans did a photo series there with me. And there's the famous masonry shop there. It's the workshop for the cathedral, a large area that you can look into from above, where they work on the stones. And that's where I discovered the gargoyles, which are normally on the outside of the cathedral. They were being restored. I saw their wide-open mouths, their terrible faces – they're total figments of the imagination. They're meant to protect the building; the rainwater and filth flow from their mouths, away from the church, which is important for the upkeep of the building. I thought to myself that it would be good to take them to London. I tried to convince the cathedral's master builder of the idea, but he wouldn't have any of it. 'Out of the question,' he said. 'They belong to the cathedral here in Cologne and nowhere else.' 'But I just want to borrow them.' 'No, that won't be possible.' I think they would have fit in well in London because there's a certain architecturally similar 'heaviness' – both in London itself, in the architecture of the city, and in the churches. For me, the gargoyles of Cologne were simply 'English'. So I made these photos for the invitation card, which – as someone there told me – was 'very British' in itself. And for the London exhibition I created my own gargoyles.

Diedrich Diederichsen *The* Wasserspeier *are also active sculptures – where the name itself ['water-spewers'*
in German] expresses an activity. The same applies to your works all the way back to
the World Receivers *(1987), where sculptures have a function, an activity. Yet at the*
same time, in that case, the activity is the act of receiving – so you have activity and
passivity all in one. For me, that's a very good description of the art of sculpture:
held as if by magic in a concrete form, but always having something to do with the
possibility of activity and passivity, which reveals itself in titles, contexts, etc.

Isa Genzken Before the *World Receivers* I made the pieces about hi-fi systems – or rather,
the sculptural aspect of hi-fi equipment – which I photographed in 1979.
Then, as usual, I built my own devices and called them 'World Receivers' –
even though you couldn't hear anything. I found that aspect pleasantly
absurd. They were made out of cement, but had small, real antennas. At the
Frankfurter Kunstverein, Nikolaus Schaffhausen had recently put together
an exhibition on Theodore Adorno. He displayed my *World Receivers* along
with similar looking works by Bruce Nauman. Bruce had made casts of
small cassette recorders. My antennas were also meant to be 'feelers' – things
you stretch out in order to feel something, like the sound of the world and
its many tones. But, of all things, some people took offence at the feelers.

Diedrich Diederichsen *Too concrete, too literal?*

Isa Genzken Yes, but people were really disconcerted. And I was upset that they'd taken
offence. But in the end they were pleased with my invention.

Diedrich Diederichsen *It's no surprise that aficionados of 'pure sculpture' thought you were making a*
joke about their artistic beliefs by using these very literal, 'quoted' antennae in
otherwise highly formalistic sculpture. On the other hand, and in contrast to other
artists of the early 1980s, the works don't only strike a humorous note. Their sober,
'pure' aspects are no less important than the more literal, humorous 'quotations'.

Isa Genzken I didn't even want to create such a contrast, or play one aspect off against
the other.

Diedrich Diederichsen *There are many allegories of communication in your works, along with references*
to the outside world: windows, transmitters, receivers.

Isa Genzken Yes. The idea is that you open yourself up and find different ways of looking
at things; that you have more than one frame of reference for the sculpture.
Take for example the sculpture I did in a public space in Munich [*Untitled*,
a project for the award International Kunstpreis der Kulturstiftung der
SSK München, 2004]. It also has something to do with this notion of
communication. It's as big as possible, but still just as delicate as I could
make it. And it takes up as little space as possible. (El Lissitzky was my hero
when I was young.) There's an old cast-iron lantern, very tall, in the square
in front of the Lenbachhaus. I attached a flower to it. Even though it looks
very light, it's very heavy – so heavy, in fact, that you'd normally have to
anchor it to the ground. But instead of putting supports beneath it, like you

would with a tent, I attached cables above the entire square in different directions and to the buildings on the other side: one to the Propyläen, one to the Lenbachhaus and one to a more modern street light. As a result, you get something that's open and communicative. A structural engineer would have attached it firmly to the ground, but this way it's held up securely but still draws in, and engages with, the entire square and the other buildings, and the cars can drive underneath it. Pedestrians can walk under it too.

Diedrich Diederichsen *As we've already discussed, your sculptures have this tendency to become characters, as if they had a soul. Over the course of several years, even decades, you seem to have developed an ensemble of characters. And at some point a story, a plot, began to emerge. But it wasn't there from the beginning. When did you start to narrate?*

Isa Genzken I always have, but not to this extent. At some point – with the New York books (*I Love New York, Crazy City*, 1995-96) – I started doing it more and more. I wanted to move to New York. In the beginning I didn't have a studio and lived in a hotel, so I took pictures. I've often taken photographs when I don't have a studio – for example, the 'Ear' photos (1980), where I took pictures of women on the streets of New York. I didn't have a studio then either. And at one point I put them together and pasted them into books. The idea was to make a guidebook for New York – not a normal one, but something for people who wanted to experience New York differently for a change: a lot crazier, more special, more multifaceted and beautiful.

Diedrich Diederichsen *An atmospheric guidebook? And how did you make the transition from the narration you get from turning the pages of a book to the sculptural narration you practise today? How did you make that step to the 'cinematic' works?*

Isa Genzken I'd already made works in concrete that look like churches, ruins and bombed-out buildings. These have a bit of this feeling to them. If you walk around them, you can discern different stories, find hard-to-reach nooks and crannies, areas that feel more secure. I was also quite explicitly playing with the idea of ruins and a Caspar David Friedrich kind of mood. So these works already had something narrative about them. I also placed small figures in them and, piece by piece, this just continued to develop. When I was in New York I felt this compulsion to make a feature film. That's where the title *Empire/Vampire, who kills death* comes from: a screenplay I wrote at the time; but it was very difficult and I never published it. However, ever since then, the idea of narration has been a latent aspect of my work. I can make relatively small sculptures that go on to attain a large, relative monumentality. That's a rare attribute. It never has a one-to-one effect, but rather the quality of a model. The true size is only realized in the viewer's imagination.

Diedrich Diederichsen *Every narration has a punch line or an otherwise meaningful end. What is it in your story?*

Isa Genzken Humour, Cupid, love and surprise are the future of modern art. How should I close? Many people are unhappy, and I think that sucks.

Antony Gormley *E. H. Gombrich*

in conversation
September 1995, London

Antony Gormley You ought to know that it was reading *The Story of Art* at school that I think inspired my interest in art.

E. H. Gombrich *Really!*

Antony Gormley ... and made the whole possibility not only of studying art but also of becoming an artist a reality for me.

E. H. Gombrich *That's very flattering and very surprising for me.*

Antony Gormley And what I hoped we might do in this conversation was talk about the relationship of contemporary art to art history generally – what is necessary, as it were, to retain and what we can discard from the lessons of that history.

E. H. Gombrich *I would like to start, like everybody else, with* Field for the British Isles *(1992). I'm interested in the psychology of perception; if a face emerges from a shape you are bound to see an expression. The Swiss inventor of the comic strip, Rodolphe Toepffer, says that oddly enough, one can acquire the fundamentals of practical physiognomy without ever actually having studied the face, head or human contours, through scribbling eyes, ears, and nose. Even a recluse, if he's observant and persevering, could soon acquire – alone and with no help except what he gets from thousands of tries – all he needs to know about physiognomy in order to produce expressive faces. Wretched in their execution perhaps but definite and unmistakable in their meaning. He gives examples of doodles all of which have a strong expressive character. Anyone can discover in studying these doodles what makes for expression. I have called this 'Toepffer's law' – the discovery that expressiveness or physiognomy does not depend on observation or skill but on self-observation.*

Antony Gormley For me the extraordinary thing about the genesis of form of the individual figures in *Field* is that it isn't about visual appearances at all. What I've encouraged people to do is to treat the clay almost as an extension of their own bodies. And this takes some time. This repeated act of taking a ball of clay, and using the space between the hands as a kind of matrix, as a kind of mould out of which the form arises.

E. H. Gombrich *Anyone who has ever played with clay has experienced this elemental form. And of course in twentieth-century art, not only in your art, this played a crucial role. Picasso did it from morning to night, didn't he? He just toyed with what would come out when he created these shapes. When we loose the constraints of academic tradition we not only create an expressive physiognomy but an expressive shape or a more independent usage; that's what we admire in children's drawings, though I dare say that children do not intend to do so. We cannot help seeing the creations of primitive art in terms of an expressiveness, which is not always the one intended by the maker. In a certain frame of mind we see everything as expressive. The basis of our whole relationship to the world, as babies or as toddlers, is that we make no distinction between animated and inanimate things. They all speak to us, they all have a kind of character or voice. If you think back to your childhood, not only toys but most things which you encounter have this very strong character*

or physiognomy as Beings of some sort. And I'm sure that this is one of the roots or one of the discoveries of twentieth-century art, to try to recapture this. In my view, it was too exciting to discover how creative and expressive the images made by children, the insane, and the untutored were. It's no wonder that artists longed to become like little children, to throw away the ballast of tradition that cramps their spontaneity and thus thwarts their creativity. But it's no wonder also that new questions arose about the nature of art which were not so easily answered. Deprived of the armature of tradition and skill, art was in danger of collapsing into shapelessness. There were some who welcomed this collapse, the Dadaists and other varieties of anti-artists. But anti-artists only functioned as long as there was an art to rebel against, and this happy situation could hardly last. Whatever art may be, it cannot pursue a line of resistance. If the pursuit of creativity as such proves easy to the point of triviality then there is the need for new difficulties, new restraints. I believe it would be possible to write the history of twentieth-century art not in terms of revolutions and the overthrow of rules and traditions but rather as the continuity of a quest, a quest for problems worthy of the artist's nature. Whether we think of Picasso's restless search for creative novelty, or of Mondrian's impulse to paint, all the Modernists may be described as knights errant in search of a challenge. Would you accept this?

Antony Gormley I think it's true that this idea of a reaction against a kind of orthodoxy is no longer a viable source of energy for art today. But I didn't simply want to continue where Rodin left off, but re-invent the body from the inside, from the point of view of existence. I had to start with my own existence.

E. H. Gombrich I think in your art also, you are trying to find some kind of restraint. You want us to respond to the images of bodies, of your 'standard' body?

Antony Gormley I like that idea of a 'standard' body, but what I hope I've done is to completely remove the problem of the subject. I have a subject, which is life, within my own body. But in working with that I hope that it isn't just a 'standard' body: it is actually a particular one which becomes standardized by the process ...

E. H. Gombrich Because for you, your body is standard. It cannot be otherwise.

Antony Gormley What I'm doing is realizing, materializing perhaps for the first time, the space within the body. It's certainly a very difficult thing to communicate, but it's to do with meditation.

E. H. Gombrich That has to do with breathing, with breath ...

Antony Gormley It has a lot to do with breath.

E. H. Gombrich But you can't create what you breathe.

Antony Gormley No, but you can, I think, try to materialize the sensation of that inner space of the body, and that's what I hope that these large body forms are. They are in some way an attempt to realize embodiment, without really worrying too much about mimesis, about representation in a traditional way.

E. H. Gombrich *About this internal body, this is something that must interest anybody, but the question of whether it can be externalized is still another one, isn't it? It starts from the most trivial fact that when we feel the cavities of our own body, let us say the interior of the mouth, we have an entirely different scale. Any crumb in our teeth feels very large and then when we get it out we are surprised that it is so small, and if the dentist belabours your tooth you have the feeling that the tooth is as large as you are. Then it turns out, if you look in the mirror, that it was an ordinary small tooth. In a sense that is true of all internal sensations: the internal world seems to have a different scale from the external world.*

Antony Gormley I think that's a brilliant, accessible example of what I'm interested in. There was a repeated sensation that I had as a child before sleep, which was that the space behind my eyes was incredibly tight, a tiny, dark matchbox, suffocating in its claustrophobic imprisonment. And slowly the space would expand and expand until it was enormous. In a way I feel that experience is still the basis of my work. This recent piece, *Havmann* (1994-95), a 10-metre high black body mass, will read as a black hole in the sea, but it is made massively of stone. It's put at a distance from the viewer – 46 metres from the shore. Because there's an indeterminacy of scale in relation to the landscape, it is difficult to judge its actual size, which is an attempt to realize exactly the sort of thing you were saying.

E. H. Gombrich *Of course, as you indicate, falling asleep, or even in dreams, this kind of sensation takes over. We are very much governed in our sleep by these body sensations which we project into some kind of outside world and see as things which they aren't. And you say that in Buddhist meditation this is also so, but it's not, because in Buddhist meditation you try to get away from thingness.*

Antony Gormley What I was trying to describe was the first experience of this inner body which was in my childhood. I think then the experience of learning Vipassana with Goenka in India was something very much more disciplined, but had to do with it. The minute you close your eyes in a conscious state you are aware of the darkness. With the Vipassana you explore that space in a very systematic manner. First of all you …

E. H. Gombrich *You have to learn to relax.*

Antony Gormley Well, it is an interesting mixture. Anapana, or mindfulness of breathing, gives you concentration. You then use that concentration to look at the sensation of being in the body, and that is a tool that I have tried to transfer to sculpture.

E. H. Gombrich *Yes, but my problem is how you bridge these very intense experiences which we can call 'subjective', a word which isn't very telling, and what you want the other to feel.*

Antony Gormley That for me is the real challenge of sculpture. How do you make something out there, material, separate from you, an object amongst other objects, somehow carry the feeling of being – for the viewer to somehow make a

connection with it. In a way, where you ended in *Art and Illusion* is where I want to begin. That idea that in some way there are things that cannot be articulated, that are unavailable for discourse, which can be conveyed in a material way, but can never be given a precise word equivalent for.

E. H. Gombrich *Certainly not. Our language isn't made like that. Our language serves a certain purpose, and that purpose is orientation of oneself and others in the three dimensional world. But I cannot describe the feeling I have in my thumb right now, the mixture between tension and relaxation. Sometimes if you go to the doctor you feel this helplessness in describing what your sensations are, there are no words. And that is a very important part of all human existence, that we have these limits. But your problem as far as I see it is to transcend these limits.*

Antony Gormley I want to start where language ends.

E. H. Gombrich *But you want in a sense to make me feel what you feel.*

Antony Gormley But I also want you to feel what you feel. I want the works to be reflexive. So it isn't simply an embodiment of a feeling I once had ...

E. H. Gombrich *It's not the communication.*

Antony Gormley I think it is a communication, but it is a meeting of two lives. It's a meeting of the expressiveness of me, the artist, and the expressiveness of you, the viewer. And for me the charge comes from that confrontation. It can be a confrontation between the movement of the viewer and the stillness of the object, which in some way is an irreconcilable difference, but also an invitation for the viewer to sense his own body through this moment of stillness.

E. H. Gombrich *In other words, what in early textbooks was called 'empathy', a feeling that you share in the character of a building, or a tree, or anything. I am always interested in our reaction to animals, because there we react very strongly. The hippopotamus has a very different character from the weasel, there is no doubt; we also talk to them in different ways. Our response is inevitable when dealing with the world around us.*

Antony Gormley I think you are saying two things there. One is the anthropomorphizing of external stimuli and the other thing, which I am more interested in, is the idea of body size, mass; that a hippopotamus is huge and has rather a simple shape, and a weasel is like a line and sharp. It is also to do with speed; bodies themselves carry feeling which is in itself a kind of information that isn't available so easily to analysis. I want to use that empathy or embodiment in my work, and what I am trying to do is treat the whole body in the same way as perhaps portrait painters in the past have treated the face. I simply use my body as a starting point. I don't want to limit my sculptures autobiographically. On one level it is not dissimilar to choreography and the dancer's body. It is using the body as a medium.

E. H. Gombrich *It is not self-expression.*

Antony Gormley I am interested in discovering principles. In a piece like *Land, Sea and Air II* (1982) there is one standing body case, *Sea*, with the eyes open looking out to the horizon; *Land* is the crouching one which has ears and listens to the ground; and *Air*, the kneeling one, has its nose open. What I was trying to do there was find a bodily equivalent for an element through a perceptual gateway. I think that underlying my return to the human body is an idea of re-linking art with human survival. There isn't just a problem about what we can do next in art terms. In a sense this is where your field and my field mix. You have always been concerned with finding a value in art, the application of rational principles to the understanding of an emerging language, and I think that there has been a sense where art – certainly in the earlier part of the twentieth century – took a view of that history in order to validate its own vision. I think that it is more difficult to do that now. All of us are aware that Western history is one history amongst many histories, and in some way there now has to be a re-appraisal of where value has to come from. Subjective experience exists within a broader frame of reference. When you think about what happens next in art, it is very hard not to ask the question: what happens next in the development of global civilization?

E. H. Gombrich *I agree with you in that the values of our civilization and the values of art are totally linked. One cannot have an art in a civilization which believes in no value whatever, therefore I quite agree with you in the central question. I think that all our response to art depends on the roots of our own culture, that is why it is quite hard to get to the root of Eastern art. I think that sometimes we can't understand the art of our own culture just as we don't understand the letters in Chinese calligraphy. Don't you agree?*

Antony Gormley I think that it is invariably misunderstood, certainly at first experience, but my reply to the Chinese calligraphy question is my reply to anyone who finds it impossible to understand any one artist's work today. I think that if there is some sympathy there, then the invitation is to get more familiar. The idea that in some way value can only come from judging it from its own tradition, from which it may have escaped or never belonged to at all, is going to be less useful than looking at the organic development of an individual language and seeing if that has a universal significance. I would be interested to know whether you feel that it is possible to convey a notion of embodiment without mimesis, without having to describe, for instance, movement, or exact physiognomy.

E. H. Gombrich *I have no doubt that not only is it possible but it happens in our response to mountains, for example, we lend them our bodies. I think that the greater problem is the limit, because in a certain sense it happens all the time: it happens in the nursery, it happens in regressive states of the mind. The problem is not so much whether we can make people respond in this almost elemental form to shapes, but how to distinguish a work of art from a crumpled piece of paper, which also has its physiognomy and its character. I think there is partly still a feeling of a person*

behind it, which adds to the confidence of the viewer, that here is an embodiment and the viewer is interested in engaging in it.

Antony Gormley Yes I think that that idea of purpose is embodied in the way that something is put together, not just in its form. In some way that sense of purposefulness has to do with how clear the workmanship is, how ...

E. H. Gombrich *How manifest ...*

Antony Gormley Yes.

E. H. Gombrich *It is really the 'mental set' in twentieth-century art which is behind all these problems. You have to have a certain feel of what is going on there, otherwise it's just an object like any other.*

Antony Gormley I think that we all are very visually informed these days. Maybe classical education within the visual arts has now been replaced by a multiplicity of visual images that come through computers and advertising and all sorts of sources.

E. H. Gombrich *Then you have the weirdest forms on TV, which I don't possess, and the sometimes amusing shapes created for advertising or whatever else. That is just the problem, the problem of the limits of triviality.*

Antony Gormley Yes exactly. How do you condense from this multiplicity of images, certainly in sculpture, something that is still, silent, maybe rather complete, and therefore rather forbidding because it isn't like a moving image on a screen. It is not telling you to buy something. It's something that has a different relationship to life. And that for me is the challenge of sculpture now, that it may have within it a residue of 5,000 years of the body in art, but it must be approachable to somebody whose main experience of visual images is those things.

E. H. Gombrich *You want them to feel the difference between a superficial response of amusement and mild interest, and something that has a certain gravity.*

Antony Gormley Yes, I think it should be a confrontation (*laughs*).

E. H. Gombrich *Coming to terms with it.*

Antony Gormley And through coming to terms with it, coming to terms with themselves.

E. H. Gombrich *Yes, perhaps that is a different matter.*

Antony Gormley But that question of the difference between subjective response and the object is absolutely the essence of what I'm trying to get at. Whether this is something accessible to discourse is another matter. But for me, the idea that the space that the object embodies is in some way both mine and everyone's is very important, that it is as open to the subjective experience of the person looking at it as it is to me, the possessor of the body that gave that form in the first place.

E. H. Gombrich *You'll agree that everybody's experience is likely to be a little different.*

Antony Gormley Absolutely. We have moved out of the age where you would argue that, yes that is a Madonna, but, well, the drapery isn't quite fully achieved. Today we have moved from signs that have an ascribed meaning and an iconography that we know how to judge, to a notion of signs that have become liberated. Now that has a certain annoyance factor (*laughs*), but it also has a certain invitation for an involvement that was not possible before.

E. H. Gombrich *But it was with architecture.*

Antony Gormley Yes that's true. And it's interesting that you mention architecture because I think of my work, certainly in its first phase, as being a kind of architecture. It's a kind of intimate architecture that is inviting an empathetic inhabitation of the imagination of the viewer.

E. H. Gombrich *But in architecture there was the constraint of the role of the tradition and purpose of a building. This is a church, and this is a railway station, and we approach them with slightly different expectations. The problem I think, which is not of your making, but is for every artist working today, is to establish some kind of framework wherein the response can develop.*

Antony Gormley I'm working on it! I'd like us to talk a bit more about casting.

E. H. Gombrich *Well, did you know that it has turned out that part of Donatello's* Judith *is cast from the body? It's astonishing. I remember Rodin was charged with casting from the body, so it was considered a short cut, seen as very lazy or mean, or cheating.*

Antony Gormley Absolutely, there's a prejudicial negative attitude.

E. H. Gombrich *Of course, quite a number of posthumous busts are based on the cast of the death mask that is usually modified. But this practice is not usually condemned.*

Antony Gormley But it is interesting you see, because the in-built morbidity of the death mask is in some way in keeping with the idea of a memorial portrait…

E. H. Gombrich *It fits into what you call the context.*

Antony Gormley But the interesting thing is that idea of trace. Certainly as a child, probably the most potent portraits which affected me in visits to the National Portrait Gallery were the portraits of Richard Burton, which was a rather dark oil painting, and the head of William Blake, which was a cast from life. What affected me as a child was feeling the presence of someone through the skin, where the contact of the skin with whatever was registering it, the impression, was not really as important as an idea somehow of a pressure behind the skin which was both physical and psychological.

E. H. Gombrich *It was alive in other words.*

Antony Gormley No, it was more than that. There is a sense in which there is this pressure inside the dome of the scalp and then also this pressure behind the eyes which

gives that work a kind of potency. It was as if something was trying to come through the surface of the skin. In a way the casting process in that instance, and I hope also in my work, is a way of getting beyond the minutiae of surface incident and instantly into that idea of presence, without there being something to do with interpretation. One of the bases of my work is that it has to come from real, individual experience. I can't be inside anyone else's body, so it's very important that I use my own. And each piece comes from a unique event in time. The process is simply the vehicle by which that event is captured, but it is very important to me that it's my body. The whole project is to make the work from the inside rather than to manipulate it from the outside and use the whole mind/body mechanism as an instrument, unselfconsciously, in so far as I'm not aware while I'm being cast of what it looks like. I get out of the mould, I re-assemble it and then I re-appraise the thing I have been, or the place that I have been and see how much potency it has. Sometimes it has none; I abandon it and start again.

E. H. Gombrich *What does the potency depend on?*

Antony Gormley The potency depends on the internal pressure being registered.

E. H. Gombrich *And how much of this, in your view, is subjective and how much is inter-subjective?*

Antony Gormley I am interested in something that one could call the collective subjective. I really like the idea that if something is intensely felt by one individual that intensity can be felt even if the precise cause of the intensity is not recognized. I think that is to do with the equation that I am trying to make between an individual, highly personal experience and this very objective thing – a thing in the world, amongst other things. It is even constructed by objective principles; the plate divisions follow horizontal and vertical axes, but then they affect the viewer in a very subjective and particular way. I am not sure if I have any right to prescribe what the viewer should be thinking or feeling at that point. I would like to feel that there is a potential for his or her experience to be as intense as mine was, and equally subjective.

E. H. Gombrich *You work as a guinea pig in a test to find out if it affects you. If the cast doesn't affect you, you discard it.*

Antony Gormley Yes I think that has to be what I am judging when I see the immediate results of the body mould. What I am judging is its relationship to the feeling that I want the work to convey. Once I am out of it, it does become a more objective appraisal. I work very closely with my wife, the painter Vicken Parsons. Once we have defined what the position of the body will be then it is a matter of trying to hold that position with the maximum degree of concentration possible. Sometimes it's a practical thing; the position is so difficult to maintain that the mould goes limp. I lose it, I don't have the necessary muscular control and stamina to maintain it. More often and ore interestingly it isn't those

mechanical things but others that are more to do with intensity, and that can have to do with how much sleep I have had or simply with how in touch I am with what we are doing. The best work comes from a complete moment, which is a realization. I then continue to edit the work. It rarely involves cutting an arm off and replacing it with another but it may involve cutting through the neck and changing the angle two degrees. In terms of the process, we are talking about two stages, the first stage – and this is the most important because it is the foundation of the work – is making the mould. Then I go into the second stage which is making a journey from this very particularized moment to a more universal one, which is a process of adding skins. In the past this has meant I used different colours, to make sure that each layer was exactly the same thickness. Now I just rely on my judgement that I have reached the point at which this notion of a universal body and a particular body is in a state of meaningful equilibrium or meaningful balance.

E. H. Gombrich *What you describe is a little like a painter stepping back from the canvas and judging it, examining it as if it were from the outside.*

Antony Gormley It has to do with making the totality of the work count, as a whole, to deal with the mind/body as one organism, and re-present it as one organism rather than the current orthodoxy of the body in pieces, or the body as a battleground.

E. H. Gombrich *Now I will ask you a shocking question: why don't you take a photograph of your body?*

Antony Gormley This is a photograph; I regard this as a three-dimensional photograph.

E. H. Gombrich *As you say, a three-dimensional photograph, it could be done by holograph, there are methods. Would you accept it?*

Antony Gormley No, that wouldn't interest me particularly. I am a classical sculptor in so far as I am interested in things like mass.

E. H. Gombrich *Tactility.*

Antony Gormley Yes the tactility is very important and the idea of making a virtual reality for me denies the real challenge and the great joy of sculpture which is a kind of body in space.

E. H. Gombrich *And of course it is to scale, while the photograph on the whole needn't be and can hardly be demonstrably to scale.*

Antony Gormley The other problem with a photograph is that it is a picture, and I am not really interested in pictures, as I am not interested in illusion. This idea has in a way informed your book: the history of art as a succession of potential schema by which we are invited to make a picture of the world. As we evolve the visual language, we continually revise the previous schema in order to

find an illusion that works more and more effectively. I feel that I have left that whole issue behind in a sense, as one that has had its story. We have to find a new relationship between art and life. The task of art now is to strip us of illusion. To answer your question, how do we stop art from descending into formlessness/shapelessness? How do we find a challenge worthy of the artist's endeavour? My reply to that is, we have somehow to acknowledge the liberty of creativity in our own time which has to abandon tradition as a principle of validation, to abandon the tradition of mainstream Western art history and open itself up: any piece of work in the late twentieth century has to speak to the whole world.

E. H. Gombrich *It may have to, but it won't.*

Editor *What do you think of the question of your masculinity,* vis à vis *there being an idea about some universally recognizable experience?*

Antony Gormley In some of the work, the sexuality is declared and relevant to the subject of the work and at other times it isn't. I have tried to escape from the male gaze, if we are thinking about the male gaze both in relation to nature as a place of slightly frightening otherness and the male gaze in relation to the female body as the object of desire, or the object of idealization. I think the idealization of my work and its relationship to landscape are very different from historical models. I am aware that the work is of a certain sex.

E. H. Gombrich *Well everybody belongs to a certain gender and a certain age, you can't get out of that and I think it's almost trivial isn't it, if you try to.*

Antony Gormley Yes, but what I am saying is that I think that this is a modified maleness, without trying to be the orthodox new man, a lot of work tests the prescribed nature of maleness in various ways, but I can't deny the fact that it comes from a male body and from a male mind. Part of the reason that so much of the work tries to lay the verticality of the body down, or re-present it by putting it on the wall, is that I am aware that even when a body case is directly on the floor, because I am tall there is this sense of dominance, of a male confrontationality. So a work like *Close* (1992) attempts to relocate the body and relate it to the earth, takes what could have been a heroic stance and puts it into the position of vulnerability. *Close* for me is an image of an adult body put in the position of a child. This could be conceived as being the traditional image of a mother and a child. The mother in this case being the earth, the child being the body that is clinging on.

E. H. Gombrich *You could also say it is a person prostrating himself, which is something different again, because then it is deliberate, humbling.*

Antony Gormley *Close* makes the body into a cross, completely fixes it. The body is almost used as a marker of a place, denying its own mobility in order to pick up on the idea that the earth is spinning at 1,000 km an hour around its own axis, and in order to talk about this illusion that we have of fixedness within the

phenomenal world where in fact nothing is fixed. *Close* for me is a way of mediating the two forces, gravity and centrifuge; the body case becomes an instrument through which those forces are made palpable.

Editor *You mentioned the cross and here is an angel, both historically symbolic forms. What meaning do they have for you?*

Antony Gormley I think that this is a question about religion and religious iconography. Religion tries to deal with big questions, and I hope that my art tries to deal with big questions like, 'who are we?', 'where are we going?'. The fact is that I grew up within a Christian tradition, those things are part of not only my intellectual make-up but images of self that were given to me as a child. But I don't see them as illustrations of those images, they are just part of the mental and emotional territory that I have to explore.

Editor *They are not symbolic?*

Antony Gormley I don't want the work to be symbolic at all, I want the work to be as actual as it can be, which is why my version of an angel is a rather uncomfortable mixture between aeronautics and anatomy.

E. H. Gombrich *Well the problem of how angels managed to fly with these relatively small wings is always present. But then their bodies probably have no weight; the wings are signs.*

Antony Gormley An interesting point, because it is this idea of a mediator between one level of existence and another…

E. H. Gombrich *Of course, the Angelos, the messenger.*

Antony Gormley We need these means of transmission between one state of being and another. We cannot be bound by traditional meaning but at the same time it's important not to reject something simply because it has been done before, because in some senses we have to deal with everything. That is why I am as interested in placing my work in historical contexts, on the end of a pillar or in a church, as I am in the white cube of the gallery. I think that everything has to be accepted as part of the territory and that means accepting what has been necessary in the past for human beings, finding a way in which those needs can be expressed in a contemporary way that is not divisive or prescriptive in its interpretive function. I think that our attitude to history has changed, the idea of layering which also suggests a support structure has been replaced now by a co-existence of temporality. There is a sense in which my work exists within an understanding of historical precedent but also within a matrix of contemporaneity. I do want to ask you this one important question; I feel that you have done a lot for all of us in terms of making apparent the structures of our own visual culture and I get the feeling that you have a faith in the value of that story. I don't know what your faith is in the art of now, or of the future.

E. H. Gombrich *About the future I know nothing. I am not a prophet. About the situation of the arts at present, I think that the framework of art at present is not a very desirable one, the framework of art-dealing, art shows and art criticism. But I don't think that it can be helped, it is part of destiny that art came into the situation and I think it has its own problems. Sensationalism and lack of concentration are not very desirable and not very healthy for art, but I don't despair of the future or at least the present of art. I wouldn't despair of the fact that there will always be artists as long as there are human beings who mind and who think this is an important activity.*

Antony Gormley But do you feel that we are at the end of the story that you wrote?

E. H. Gombrich *No, of course not. I do feel that there is a disturbing element in the story, and in the new edition I am working on the intrusion of fashions in art, which has always existed. Romanticism has created an atmosphere that makes it harder for an artist to be an artist, because there are always seductive cries or traps which may tempt the artist, I wouldn't say art, to this kind of sensationalism, like exhibiting the carcass of a sheep – because they are talking points. The temptation to play at talking points becomes the pivot of what the young then want to do, also to have the same talking point. I think this is a social problem rather than a problem of art.*

Antony Gormley It is very difficult not to start talking about such things without sounding sententious and moralistic, but I do feel that art is one of the last realms of human endeavour left that hasn't been tainted by ideologies that have proved constrictive. In some way art does have this potential to be a focus for life which can be removed from the constraints of moral imperative, but nevertheless can invite people to think about their own actions.

E. H. Gombrich *It has its own moral imperatives.*

Antony Gormley It does for the artist making it. I think it is very, very difficult then to transfer that degree of moral commitment.

E. H. Gombrich *It is not all that difficult. I mean the artist mustn't cheat. It's as simple as that.*

Antony Gormley And he must take responsibility for his own actions.

E. H. Gombrich *And if he feels, as you just said, that something isn't good enough he must discard it. Self-criticism is part of this moral imperative, and has always been. It is the same whether you write a page or whatever you do; if it isn't good enough, you have to start again. It's as simple as that, isn't it? I once said it is a game which has only one rule, and the rule is that as long as you can think you can do better you must do it, even if it means starting again. Of course, from that point of view I don't think the situation has changed very much. I am sure that has always been the case.*

Antony Gormley We keep touching on this problem of subjectivity and I don't think we are ever going to nail it down, but we have to replace the certainties of symbolism, mythology and classical illusion with something that is absolutely

immediate and confronts the individual with his own life. Somehow truth has to be removed from a depicted absolute to a subjective experience, where value transfers from an external system that might be illustrated to one in which individual experience is held and given intensity.

E. H. Gombrich *I think your faith is a very noble one. I don't for a moment want to criticize it. The question with every faith is whether it holds in every circumstance, and that is a very different matter, isn't it?*

Antony Gormley I think the idea of style as something that is inherited and with a kind of historical development now has to be replaced by an idea of an artist responsible to himself, to a language that may or not be conscious of historical precedent.

E. H. Gombrich *Quite, but there is a problem in your faith; would you expect from now on every artist to do what you do? Surely not.*

Antony Gormley No, no.

E. H. Gombrich *Exactly, so it's only one form of solving the problem, isn't it?*

Antony Gormley I think that we can no longer assume that simply because the right subject matter or the right means are being used that there is value in an artist's project. I think that the authority has shifted from an external validation to an internal one and I would regard that as the great joy of being an artist. The liberation of art today is to try to find, in a way, forms of expression that exist almost before language and to make them more apparent. I think that in an information age, in a sense, language is the one thing that we have plenty of, but what we need is a reinforcement of direct experience.

E. H. Gombrich *I fear this is a false trail; people always say if it could be said it wouldn't be painted and things of that kind. It is a triviality. Language serves a very different purpose. Language is an instrument, was created as an instrument. Cavemen said 'come here' or 'run, there are bison about', I mean it's quite clear that language is an instrument. Painting a bison is a very different thing from talking about a bison. Language is in statements, art is not. Language can lie. I would say that the majority of experiences are inaccessible to language, but it is astounding that some are.*

Antony Gormley I agree with your idea that in some way language is an orientation, but the point is that once you have oriented yourself, you then have to leap, you have to go somewhere. And then the question is whether you go into the known or into the unknown.

Dan Graham *Mark Francis*

in conversation
December 1999, London

Mark Francis I want first to ask you about the ideas behind artists' interviews; since the 1960s this has become a widely used genre with a history of its own. The traditional model was that the artist should remain silent and let the work 'speak for itself' or let the critics and the public interpret it as they wished. However, the explosion of artists' interviews seems to have its origins in artists writing about their own and others' work, as you did early on – and as Donald Judd and Robert Smithson did as well. These two now seem key figures of that period, in terms of cutting out the mediator, the curator or critic.

Dan Graham The European way of doing things was to separate critic, curator, artist and writer. In America the reason I got into art was because the artists I knew and with whom I showed at my gallery – the John Daniels Gallery in New York – all wanted to be writers, or they enjoyed reading.

Mark Francis Who was 'John Daniels'?

Dan Graham There were three people. No one wanted to have his full name used. One was called Daniel, one was called John and the other wanted to remain silent.

Mark Francis And you knew artists like Smithson and Sol LeWitt?

Dan Graham We didn't know anyone. We decided, since the gallery opened just before Christmas 1964, to have a Christmas show in which anyone who came into the gallery could exhibit. Sol LeWitt came in and made one of the most interesting pieces (*Floor/Wall Structure*, 1964). He and I were reading the French 'new novel' author and critic Michel Butor, and Sol was also interested in architecture. From conversations with Sol I became interested in the work of other proto-Minimal artists of the time.

Mark Francis There seems to have been an enormous shift at this moment from expressive, almost visionary, painterly work, such as that of early Smithson or Paul Thek, to minimal structures and architectural forms, which the John Daniels Gallery must have registered?

Dan Graham Well, the paradigms were self-reference and also, in the best work, anarchic humour – the idea that things can be banal, stupid, totally reduced, as in Beckett's writing or early Jasper Johns works – and the notion that symbolic space, like Renaissance perspective, should be cut down.

Mark Francis Did this also connect with contemporaneous developments in dance and music, like the work of Yvonne Rainer?

Dan Graham The great person then was the choreographer Simone Forti, who had an enormous influence on Yvonne, on her husband Robert Morris, and maybe on Bruce Nauman as well. Many of the group, including Forti who formed the Judson Dance Theater in New York in 1962, had started in Ann Halprin's dance workshops in San Francisco. However, I think the biggest influences for us were probably the films of Jean-Luc Godard and – from Pop Art – printed matter, particularly in magazines, that could be mass-distributed.

We were interested in a kind of cybernetics, an idea that everything could be information, similar to what interests many artists in computer art today. But the predominant idea was to reduce the gallery to an empty white cube; I thought this was too simplistic. Sol's early sculptures seemed more about grids in the city, so through that I became interested in urbanism.

The first works I made, such as *Schema (March, 1966)* (1966), were in the form of printed matter and were urbanistic.

Mark Francis *What got you into thinking about art even before this period, when you were still a teenager?*

Dan Graham Like Smithson and Dan Flavin, I only went to high school. French new writing and cinema were influential at the time and interested us, as did the Pop art that was being publicized in magazines like *Esquire*. It seemed that art was an area where we could do everything and anything, with no education.

Mark Francis *Did you first think of yourself as a writer?*

Dan Graham When I was a teenager, instead of paying attention in class I would read Margaret Mead's anthropology books such as *Coming of Age in Samoa*, and later Jean-Paul Sartre. In other words, I was a high school student who thought everything was like Sartre's *Nausea*. I wanted to be a writer.

Mark Francis *So once you had found some like-minded associates in New York, did you turn to writing, for* Artforum *and* Esquire *and so on?*

Dan Graham No, I bought an Instamatic, the cheapest fixed-focus camera. At one point the gallery was running into debt and I had to leave and stay with my parents outside of New York. On the way, the train went through a low-income suburban area. It struck me that with no money I could still walk along the railroad and photograph what I saw.

I was always interested in 'upper-' and 'lower-class' housing, because I grew up in a similar situation. My parents were scientists, but because of lack of money after the War we moved to an area in New Jersey for government workers, which looked like barracks. When I was thirteen, my parents moved to upper-middle-class suburbia, so we could go to a better high school. I totally identified with the poorer community, so I was downward identified. Suburbia was discussed a lot in the early 1960s in magazines like *Esquire*. Sociologists like David Reisman talked about the 'lonely crowd', people who were conformist and unhappy in small suburban towns. In music this was reflected in The Kinks' song *Mr Pleasant* and The Beatles' *Nowhere Man*.

To me, Robert Mangold's relief paintings of the early 1960s resembled facades of suburban houses, as did the materials Judd used. And I thought, why do people have to make things for galleries? Wouldn't it be easier just to take photographs or slides?

Mark Francis *You took slides on the Instamatic?*

Dan Graham Yes, the first show I was in was 'Projected Art' (Contemporary Wing, Finch College Museum of Art, New York, 1966). I showed the slides as projections, because I liked the transparency they had, like the Plexiglas in Donald Judd's sculpture, and the fact that they could be thrown away and had no value. *Arts Magazine* asked me to do a piece just about photographs for the December 1966–January 1967 issue. This was *Homes for America* (1966–67). Originally I wanted the pages to read like a suburban plan. I was influenced by an article by Michel Butor which focused on street permutations as a series of designs or arrangements, almost like serial repetition in music. The text replicated the grid and labyrinth of the city, showing how everything was organized in terms of simple permutations.

I had also read an article by Donald Judd on the plan of Kansas City.[1] Along with his work and LeWitt's, I was interested in Dan Flavin; his fluorescents came from the hardware store, and he said they should go back there after they had been shown, thus getting rid of value. Sol was making wood structures, saying that after a show they should be used for firewood. The idea was that you could produce everything yourself, everything was disposable and art should have no value. That was the utopian idea.

Mark Francis *All the same, these artists were still making objects for gallery shows, whereas you were projecting slide images taken with a cheap camera. Your pictures and writing were not so much about objects as urbanism and the suburban experience.*

Dan Graham I think my work has always been about the city plan. My love of printed matter came particularly from Roy Lichtenstein, who took comics and printed sources from magazines and put them in paintings, thus destroying painting. He used to think his work would have no value, but it didn't work out. In works like *Schema*, I was trying to produce something that was simply a magazine page, disposable, available to a mass of people and which was also contingent on the nature of the particular issue of the magazine. In this way it was a little like Daniel Buren's stripes, because it referred to its context – the magazine – as place, as page, as disposable and as information.

Mark Francis Schema *could be seen as a conceptual work, or mental exercise for people to figure out, whereas* Homes for America *combined a work of art, a critique and a parody.*

Dan Graham I just knew the banality of photography. I thought high photography was such a bad area, so stupid and pretentious, but I could work with it as 'anthro-photography', because I believed my work was like a hobby, and I was interested in hobbies. It was a time when everything I liked was parody. Lichtenstein's work was total parody, yet he kept the qualities of the original printed matter. I thought, why not put Pop Art and its sources back into their original context, but also defeat the idea of value by making the work virtually free.

Mark Francis *You were doing that in two principal ways, making works like* Schema, *which could work in a magazine context, and also writing, more or less as a critic, on*

contemporaries such as Dan Flavin and Claes Oldenburg and, for example, on
serial repetition in the photography of Eadweard Muybridge (1830–1904).

Dan Graham Flavin wanted me to write for the catalogue of his show at the Art Institute of Chicago (1976).

Mark Francis *As a print-out, as I understand it?*

Dan Graham The museum director decided to do things that were very modern on a computer. People pushed a button and got a catalogue as a print-out. My article, which was basically comprised of quotes, was almost unreadable because computers at that time couldn't do punctuation. Flavin took an early interest in my writings after reading 'Dean Martin/Entertainment as Theater'.[2]

Mark Francis *So for you and the artists around you, the relationships between popular culture, TV, pop music, urban life, suburban life and the artist's life were all mixed-up?*

Dan Graham Yes, in a way that was like Godard's early films such as *A Married Woman* (1964). We liked all things French, the way people do today, except that to me the French post-structuralists are rather boring. I used to like reading Claude Lévi-Strauss, or the early work of Pierre Bourdieu, where he was more of an anthropologist than a sociologist.

Mark Francis *Was Henri Lefèbvre known to you at that time?*

Dan Graham No, I hated sociology. This is why it's a mistake to see *Homes for America* as a sociological critique. It's actually a parody of the worst sociologists who were writing then in American magazines.

Mark Francis *After* Homes for America, *architecture increasingly became a part of your work. What was your attitude to modernist architecture as represented, for example, by Walter Gropius and Ludwig Mies van der Rohe?*

Dan Graham Because I read Robert Venturi's books at the time, which attacked Mies van der Rohe, it has taken me maybe thirty years to realize I am very close to Mies. In the 1960s I liked architecture because I wanted to make art that was hybrid, on the edge between two different disciplines.

Mark Francis *Marcel Duchamp was also an influential figure in the US in the late 1960s, but you were not sympathetic to his work?*

Dan Graham We had no interest in Duchamp. He influenced Bruce Nauman, Robert Morris, just about everyone on the West Coast, but I don't think the readymade had any influence, for example, on Flavin.

Mark Francis *Were you actively against the attitude that he represented, of the dilettante, the* flâneur?

Dan Graham Duchamp seemed too aristocratic; he didn't have a social conscience. The big influence, for the New York minimal artists and myself, was a show of Constructivism called 'The Russian Experiment in Art 1863–1922' (The

Museum of Modern Art, New York, 1971). We had a lot of utopian ideas, and took Russian revolutionary idealism seriously. I also became disillusioned with Conceptual Art, as it became established through Joseph Kosuth and Art & Language.

Mark Francis *For reasons similar to your disillusionment with Duchamp? Did you feel that it was cynical, still bound up with the market and with high art?*

Dan Graham Yes. As to Conceptual Art, I thought this idea of academic art was a bit boring and lacking in humour.

Mark Francis *What did you decide to do, if you weren't going to participate in this kind of art? Teach? Write?*

Dan Graham I lived in a very inexpensive apartment and gave lectures, because people read my articles, which meant travel – one of the best things about being an artist.

Mark Francis *So you became peripatetic, a lecturer, teacher, writer. Was that also part of the attraction of video and film – that it was not object-bound, nor confined to a studio practice, which you never had?*

Dan Graham I think the attraction was that I discovered Nauman's work. I was realizing the limitations of Minimal Art, that it was totally about the object, whereas the artists Judd had written about at the start of the 1960s, such as Yayoi Kusama and Lee Bontecou, had been involved with process. It seemed that the subjectivity of the spectator, which both Nauman and Michael Snow were getting involved in, was my position. So I did a critique of Conceptual and Minimal Art in an article titled 'Subject Matter' (1969).[3] I thought the perceptual process – and the optics – of the artist and the spectator should be what the art was about. And I was very interested in the drug culture, hippies and rock music, like Neil Young's first album, *Neil Young* (1969) and Bob Dylan's *Nashville Skyline* (1969), about going back to the country. I wrote a lot of rock criticism.

Mark Francis *By the early 1970s, were you beginning to make architectural models, or were you making video works?*

Dan Graham David Askevold was teaching a course at Nova Scotia College of Art and Design called 'Projects', where Conceptual artists were invited to submit projects for the students to fulfill. When I heard about this I thought it was a great idea for a course, and maybe, since I had no money at all, I could invite myself there to help realize one of the many video and film projects. I began teaching at Nova Scotia, and also invited artists who had never taught before, such as Michael Asher, Dara Birnbaum, Martha Rosler and Jeff Wall.

Mark Francis *Can you describe the video projects you were making in the early 1970s?*

Dan Graham A lot of the video was time-delay, which you could do with the standard video recorder by making a loop between the two analogue-based machines.

With digital video you can no longer do this and it could only be done in black and white. So the work that both Nauman and I had been doing with time delays, which was parallel to the time-delays that Terry Riley and then, later, Steve Reich were doing in music, couldn't be done any more.

My interest in video installation was in using, for example, a mirror, a window and instant time, everything having a fixed point of view. I was interested in the just-past rather than the instantaneous; in frozen time, where the subjective, perceptual process would be part of the way the work functions. Spectators can see themselves seeing and being seen by other people, maybe in a different location. For example, in *Video Piece for Two Glass Buildings* (1976) you could see spectators looking at themselves as seen in a mirror, being looked at by other people on adjacent glass office buildings.

Mark Francis *To me, that is the beginning of your fully realized work, where the spectator is so implicated, either as part of an ongoing video or mirror installation/performance, or part of a piece of architecture. What was the earliest piece like this?*

Dan Graham *Two Consciousness Projection(s)* (1972), which was both a performance and a self-contained video feedback loop. A woman focuses consciousness only on a television monitor image of herself and must immediately verbalize the content of her consciousness. A man focuses consciousness only outside himself on the woman, observing her objectively through the camera connected to the monitor. He also verbalizes his perceptions. The audience sees both simultaneously and witnesses an overlapping of consciousness. The piece drew analogies with various ideas in psychology, social anthropology and cybernetics, from R.D. Laing to Gregory Bateson.

Mark Francis *So in the first pieces of that kind, the spectator is the performer and in a way stands in for the artist. It is as if you transformed the lecture situation into a performance. You, the artist, were also a spectator and commentator.*

Dan Graham But I was also contrasting American behaviourism and European phenomenology. When I made a description of the audience or myself, I would talk about myself or them behaviouristically, somewhat like an American sports announcer. However, since the piece was also concerned with a changing past time, I also used the kind of European phenomeno-logical description that was becoming popular in the 1970s art world.

Mark Francis *You would be, as I recall, standing in front of an audience, with a structured narrative in mind, that would then be improvised (*Performer/Audience/Mirror, *1977). In that sense it was like music; you would describe yourself looking at the audience, then you would turn around, look at the mirror behind you, and describe yourself and the audience through the mirror, then you would describe the audience, and so on.*

Dan Graham It began more simply, as a way to show intentionality. In the first piece I talked about my intentions, while also describing myself in my intentionality

– what I was seeing phenomenologically. But I had no idea what the work would be. This developed into *Intention/Intentionality* (1976) – without a mirror – where I would first look at the audience and describe them, then describe myself as they would see me. I couldn't see myself, so there was always a slight time delay, because I would make an action and then describe it a little later. Putting a mirror at the back implicated the audience more, because I could describe the audience, where they would be seeing themselves in a kind of instantaneous time but my description would be phenomenological. It would also influence how they saw themselves. When I turned and described myself or the audience looking at the mirror, rather than looking at or having the mirror at the back of me, I could move around, which the audience couldn't do. So I would get different perspectival views of myself and the audience that they couldn't have, as they were fixed in space. In that sense it was about the audience being implicated in their own perceptual situation, and also about the limitations of Renaissance perspective.

Mark Francis *Would you have been historically interested for instance in a painting like Manet's* Bar at the Folies-Bergère *(1881–82), which depicts that kind of interaction: the mirror behind, spatial distortion and the figure of the spectator implicated in a compromising situation?*

Dan Graham No, I hadn't considered the Manet. I think what you describe emerged later in *Public Space/Two Audiences* (1976). I was only interested in philosophical, psychological models, which Sartre described in his existential form of phenomenology, where you would only have identity as an ego through being reflected by the ego and perceptual process of another person. I wanted to make a separation between subjectivity and objectivity.

Mark Francis *By 1976, you were beginning to write about architecture, you were making models – some of which could only be realized on the scale of a house – and you were beginning to make pavilions, or pavilion-like structures.* Two Adjacent Pavilions *was realized as a full-scale work at Documenta 7 in 1982, but began to be conceived in 1978. How did the pavilion works evolve?*

Dan Graham They developed out of my exhibition at the Museum of Modern Art, Oxford, in 1978. After I had done *Public Space/Two Audiences* ('Arte Ambiente', Venice Biennale, 1976) I realized the piece was too perfect. It worked because there was a white wall, and opposite it, a mirrored wall. I wondered what would happen if I took out the white wall. It would becomearchitecture; it would no longer be part of a gallery. I conceived of a series of models that were similar to *Public Space/Two Audiences*, where there would be rooms divided either by mirror or other forms of screen. I made about ten models; some, like *Alteration to a Suburban House* (1978) or even *Video Projection outside Home* (1978) were for suburban situations, a bit utopian, like a filmic fantasy.

Mark Francis Since that time you've made a whole range of pavilions of different kinds, playing
variations on a certain basic formula, and on a consistent human scale. Many are
outdoor structures, so they involve walls; transparent, reflective mirrors; cages;
sometimes landscape elements, and so on. They are often fairly minimal structures,
but they have become increasingly complicated technically, with, for instance,
curved walls that create distortions. Can you discuss where the idea of the
pavilion comes from historically?

Dan Graham The origin of my pavilions dates to the time when I first saw Minimal Art
installed as outdoor public sculpture. It looked so stupid. I wondered how you
could deal with putting a quasi-minimal object outside, and also wondered
how these things could be entered and seen from both inside and outside.
So I thought of the pleasure pavilions of the Baroque and post-Baroque
period. A good example is the Amalienburg Pavilion designed by François de
Cuvilliés as a royal hunting lodge in the grounds of the Nymphenburg Palace,
Munich. In the pavilion, each of the four windows faces one of the cardinal
directions; between each window there are two mirrors, with silver-embossed
ornamentation of foliage, which relates to the rococo gardens outside. When
the windows are open, a spectator standing in any one cardinal direction and
looking through a window can see the views from two of the other windows
reflected from the mirrors on the left and right side. So there's a relationship
between inside and outside, and also a power relationship. The king was
symbolized as the sun. When he was present the windows would be opened,
and the sun would transform the silver interior, as if by alchemy, into gold.

I was interested in the two-way mirror because it's usually used in a one-
way mirror fashion; for example, in psychology laboratories, where student
psychologists can watch consultations by looking through a transparent
two-way mirror from the side that is not lit, whereas the patients see only
a mirror-wall. It's a kind of surveillance system, and when it was first used
in glass office buildings, the Bauhaus idea of transparency was replaced by
surveillance. But this was also a time of ecology problems, of corporations
having problems with polluting the environment, so they wanted to use two-
way mirror glass with sun-reflective mirrors on the outside to cut down the
costs of energy-consuming air conditioning. It also creates an identification
of the building with the skyscape, so it becomes ecological symbolically. It's
also interesting that when two-way mirror office buildings came in, the glass
was often gold-tinted; at that time everyone was interested in going to the
gold standard. But now these buildings refer more to the sky and to God. It
has a lot to do with surveillance. My indoor video installations generally used
time-delays but brought in issues of surveillance.

Mark Francis When you talk about inside and outside, you don't just mean in a physical sense,
but also public and private. For instance, your early work brought what was
normally private behaviour into a gallery space; and you have reversed public

and private spheres, playing on those modernist ideas about transparency, both physically and symbolically.

Dan Graham When two-way mirror glass is used in office buildings it's always a mirror for the people on the outside, and transparent for the people on the inside. That's the surveillance aspect, whereas in the glasstower 'show rooms' designed by Mies, people saw only the parts on the ground floor, which didn't show production, because the idea was not to show production. At the very top, from the executive suites and boardroom, you could look down and survey the city. I'm trying to reverse that. My pavilions are always a kind of two-way mirror, which is both transparent and reflective simultaneously, and it changes as the sunlight changes. This relates to the changing landscape, but it also means that people on the inside and on the outside have views of each other superimposed, as each gazes at the other and at the material. It's intersubjective.

Mark Francis *Generally, your pavilions have been made for manufactured landscape situations, urban parks or city parks, rather than for a gallery. Would you say that these works are a response to the issues of the museum as an institution that many artists have been struggling with?*

Dan Graham Art that tries to be against the museum as a totalitarian architectural structure doesn't interest me. What interests me is that perhaps the first museums were in the parks of the Renaissance period, which were in one sense like Disneyland, with water-tricks, educational puzzles and allegories, and they were always literary in their references, like the English garden later. Of course, this was a private, aristocratic area. Where I use a two-way mirror situation, as in *Two-way Mirror Hedge Labyrinth* (1989–93) the two-way mirror is emblematic of the city's centre, and the pavilion, or let's say the labyrinth situation, is emblematic of the labyrinth of the city.

The idea of the primitive hut as a kind of pavilion in a natural or woodland setting contradicts, in a utopian way, the despoliation of bourgeois society in the city. There's also a tradition of pavilions in the nineteenth century as fun-house situations – gazebos, music pavilions – or in German they're called '*lust*' or 'pleasure' pavilions. But this was a democratic idea; the folly was probably still aristocratic. I see them as photo opportunities for parents and children, inside and outside, a little bit psychedelic, and with the anamorphic situation very much related to the body, the 360-degree radius of the body and your visual field; the sky, and your relation to the rectilinear plan of the city.

I guess in this century we had Mies' Barcelona Pavilion (1928–29), where the structure was emblematic of the new products and utopian ideals of the Weimar Republic. There was very much a mirror situation, a little bit allegorical – something of the English garden in an urban setting. My later work becomes more emblematic; for example, the *Star of David Pavilion for Schloß Buchberg* (1991–96).

But I also think museums have some very good areas. The empty lobbies, the gift shop, coffee shop, sometimes the elevators. In other words, they're great places to look at people, who look at other people, who look at other people.

The pavilion I did for the Carnegie International, the *Heart Pavilion, Version II* (1992), was intended as a romantic meeting place in the empty lobby.

Mark Francis *So you're interested in the interstitial spaces between what is identified as an exhibiting space and spaces with other functions or uses?*

Dan Graham Well, there are also non-places related to bus shelters and telephone booths, where people are anonymous, surrounded by the city. These spaces are kind of blank, and thus a bit meditative, like the Californian light spaces of James Turrell, but I contradict the idea of the isolated, meditative subject or artist by making my work very social.

Mark Francis *Your early pavilions seem not to have been referential except to minimal and modernist architectural forms, but later, as you say, you made a number of pieces that have a consciously symbolic form, like the* Heart Pavilion, *the* Star of David Pavilion *and* Double Cylinder (The Kiss) *(1994), which makes a romantic reference to Brancusi's* Kiss *(1907).*

Dan Graham The *Star of David Pavilion* came about because I was invited by an art collector who owned a castle, Schloß Buchberg, in Vienna. When I went there I was offended that the Austrians, unlike the Germans, didn't show much evidence of guilt about their role in anti-Semitism. Many ex-Nazis were still in the government; many Austrian artists made work that included the cross and blood. However, I thought that being Jewish, I could do a Jewish star, and as an ironic parody of most Austrian art, something on water (the site was the former moat area of the castle). The structure was designed so that you would walk on water, like Jesus. (Actually, you walk on a grating just below water level.) Also, water became another way to make a reflection, relating to the two-way mirror reflections.

Mark Francis *You've used water in other ways such as in* Two-way Mirror Triangle One Side Curved *(1996), where the waters of a Norwegian fjord, and the surrounding landscape, are reflected in a parabolic curved panel. The reflection becomes like an enormous panoramic landscape painting, reminiscent of the work of the American sublime painter Frederic Edwin Church (1826–1900).*

Dan Graham It's definitely like Frederic Church, but of course, he was influenced by Caspar David Friedrich (1774–1840). I'd like to think that I work as a combination of two Hamburg artists, Friedrich and Philipp Otto Runge (1777–1810).

Mark Francis *Runge in terms of the paranoid representation of the family?*

Dan Graham The child. My work is for children and parents on weekends. Some would call it Lacanian, but I don't know that much about Lacan.

Mark Francis *The* Children's Pavilion *(1989–91) that you made in collaboration with Jeff Wall has picture-windows with images of children …*

Dan Graham They're actually tondos.

Mark Francis *The children appear as if they're looking through the windows in an aquarium.*

Dan Graham Well, originally Jeff had seen the video tape of my smaller-scale *Children's Pavilion* at the 'Chambres d'Amis' show in Ghent (1986). The video was filmed live from a child's viewpoint. Making the pavilion small was actually a pragmatic decision because it was between two buildings belonging to an architect, his old house and the studio in the backyard. So the idea was to build something that would go through the garage and the yard beyond, and be like a small conservatory. I realized that the structure I had originally planned was very large and would dwarf his two architectural buildings, which would damage his family business. So I decided to make it small and orient it towards the children who used to play in the muddy backyard. When Jeff saw the plans he said, why don't we do something with children? So I started thinking about it.

 I was influenced by the architect Emilio Ambasz, and wanted to do something underground. Having made curved anamorphic structures, I wanted to construct something that had concave and convex two-way mirror-coated lenses. So the structure is underground, a little like a grotto, and it's modelled on the kind of mountain that children have in playgrounds, where they can see who's king of the 'mountain'. I got the idea for a site from Parc de la Villette, Paris, where there is a science museum and attached to it a mirror-surfaced dome, La Géode, designed by Adrien Fainsilber. Inside it, 360-degree Cinemax films are shown. Nearby was a children's 'mountain', so I thought of putting it on that site. This was in France before Jean Nouvel and Bernard Tschumi; modern French architecture was like a pitiful re-doing of Le Corbusier with a lot of cement – *béton*. It was still the bunker period.

Mark Francis *Wasn't it then that I.M. Pei's glass pyramid for the Louvre was being commissioned?*

Dan Graham The original idea dates back to before that time, around *1987*–88. I wanted to make a kind of grotto, with an entrance from the side, which would make it similar to caves like Lascaux, where there are prehistoric paintings. Also, with its dome, the *Children's Pavilion* becomes like a planetarium and observatory, like the insides of the French Enlightenment theatres or temples to Reason and Nature planned by Étienne-Louis Boullée and Claude-Nicolas Ledoux, except that at the very top, the tondos feature children. Jeff decided it would be children of all countries and all colours, a little like the Benetton ads, against different skies which would be the horizons for each individual child.

Mark Francis *Where were the children photographed?*

Dan Graham In Vancouver, because Jeff said it was like the whole of America in that it had people of all races. Psychologists said that these giant images might frighten

children. So I realized this was a pavilion for adults, and Jeff had emphasized the adult position. I think it's for adults wanting to be children, and I also realized that with the Benetton ads you have the beginning of that 1990s idea that we should all be childlike, in buying things for our children and ourselves – a kind of corporate sentimentality based around children, which I think is also a focus in Jeff Koons' work.

Jeff Wall and I were asked by the French Minister of Culture and Mayor of Blois, Jack Lang, to build another children's pavilion for the millennium year. I cut down the size; it's not built of concrete and it's easier to deal with. Whereas Jeff's architect, in the illustrations, made it into a very complex spiral, like the New York Guggenheim Museum, I made it into one ramp with wheelchair access, so that people could also sit on it. The optics are very important; at the top of the dome there's a convex two-way mirror fish-eye lens, which shows everyone, and in the centre there's a small reflecting pool of water, so it's like a grotto. Both reflections show the pavilion's entire interior, the people in its interior, and also the nine tondos. At the very top – and I hope this can work so that they don't fall into it – children can look through the concave two-way mirror and see the real sky as well as (from the back) the depicted skies in Jeff's tondos. They also see a view of themselves, each as an anamorphically enlarged as a giant in relation to the adults and the other children inside, who are looking up. So both gazes face each other, and because it's a coated two-way mirror, it becomes more or less transparent or reflective as the sunlight changes. Very idealistic, like Boullée.

Mark Francis *You made another great collaboration with the artist James Coleman at a ruined castle in Galway, Ireland (Guaire, 1986). Can you describe this piece?*

Dan Graham I've never actually seen it. James wanted to do a piece in this castle, where they normally have tourists sitting at the old wooden tables, drinking mead, as if they were medieval people. Apparently the king who owned the castle was overthrown by his subjects because he wasn't authoritarian enough.

James constructed a play around this, where at one point the king holds a shield, and this serves as an optical situation where the tourists, who have the role of his subjects, see images of themselves that are more powerful than the king's image. So the shield acts as a mirror, and I decided to make it into a concave two-way mirror, onto which the image of the audience is video-projected. It's also like a ghostly skull.

Mark Francis *So it prefigures the mortality of the audience.*

Dan Graham And the king. The king is losing his grip. What I liked about the first pieces James made when he moved back to Ireland was how they dealt with the real culture of Ireland – tourism, cliché, political dreams, history.

Mark Francis *And mythology. Do you think that your work has dealt with these aspects in terms of American history? Cliché especially.*

Dan Graham I was very influenced by Leslie Fiedler, who wrote about American history, and by many of the writers on rock music like Richard Melzer. Also when I was trying Conceptual Art, and when the minimal artists were doing their first pieces, the paradigm was present time, moments, middle history, middle representation. In the 1960s we believed in instant moments, in 'no-time', getting rid of historical and metaphorical time. Moments after moments, with no memory. I got involved in the idea of the just-past, probably through reading Gregory Bateson and also through music that used a short memory-time and time-delay. Also, of course, there was drug-space; I remember thinking about the pop group The Byrds – they were yelling a kind of mythology of the past and a projection of the future. So there was no now, but just these different projections. I also read a lot of science fiction novelists like Brian Aldiss and Michael Moorcock, who were influenced by drugs.

Mark Francis *You've also said that you were interested in The Kinks' use of cliché and hence of mythic, suburban ideas that had a kind of nostalgia for the past.*

Dan Graham Well, I think it's the just-past that we suppress. So the idea – and I got this later from reading Walter Benjamin – was that every time we have a new-now, we're suppressing the just-past. Or, as in the Rolling Stones' song *Yesterday's Papers*, I thought that the just-past was the most interesting area.

Mark Francis *When you're making pavilions now for different situations, do you think they perform the same kind of function as they did when you began doing them?*

Dan Graham I think what has changed is that I started doing things that were half-utilitarian, so that by 1986, because I couldn't use the new digital recording and play-back units, instead of continuing to make video installations I designed a maze-like structure with two-way mirror screens (*Three Linked Cubes/Interior Design for Space Showing Videos*, 1986). It was designed for showing six videos, one in each cubicle, so the viewers would see themselves watching.

Mark Francis *Were the videos shown in a fixed sequence?*

Dan Graham They were shown simultaneously. There would be six different images and six different play-backs in small booths, so people could sit in groups of three or four in each of the booths, and they'd be seeing a different video.

Mark Francis *In each of the booths?*

Dan Graham Yes, it was a bit like a drive-in cinema where you can see other people looking at the images. The reflectiveness, as against transparency, of your own view would change because the images would change in light. So there's a kind of self-consciousness that I built into pieces like my first video installation, *Present Continuous Past(s)* (1974), where you'd be aware of yourself as an individual in the audience looking and being looked at. But here what you were looking at was normal video tapes.

Mark Francis *When you say 'normal' video tapes what do you mean? Video tapes made by artists, or daytime TV, or cable? I guess the question is really, how important is the content of the videos to you?*

Dan Graham They should be by different people who have different audiences. The installation should be very comfortable so you can lie down. Too much art is seen instantaneously, and there's too much video art that consists of giant, overwhelming images. This should be small, home-like, an area that I think should be a romantic, comfortable kind of place. More and more I want to situate people on the floor or on the grass. But *Two Adjacent Pavilions* was designed so that each pavilion would have about four or five people inside and two people lying down on the diagonal.

Mark Francis *How is that reflected in your current work? You're making pavilions in certain situations, you're writing periodically.*

Dan Graham My best recent projects haven't yet been realized. One is a landscape pavilion, *Double Exposure* (1995–96), which was intended to be installed near the Fulda river, at the very end of the sequence of works shown at Documenta X in 1997. It is in the form of a triangle, two sides of which are made of two-way mirror, one side of which can be entered. On the other side is a photograph of a landscape, roughly 50 metres long. It's a transparent Cibachrome print which you would be able to see through on a sunny day. People think it can't be done permanently, but there's now an American company that can coat Cibachromes so the sun doesn't fade them.

When you're on the inside, you see landscape on both sides of the two-way mirror. You also both see and look through the photograph. When you look through it you see the moving, real transparent image and the real environment from your viewpoint. In other words, it's like putting aspects of the *Children's Pavilion* outdoors into a landscape situation. It could only have been done for a large exhibition like Documenta, and enough funding wasn't raised to make it.

Another piece I wanted to do was a version of the *Yin/Yang Pavilion* (1996) for the World's Fair in Hanover in 2000. The idea for this pavilion came from seeing a Bill Viola video where the figure of a man emerges out of a pool, like John the Baptist (*The Reflecting Pool*, 1977–79). I remember watching it in Viola's New York gallery and turning to artist Paul McCarthy who was there. I said, 'This is religious but it's not my religion.' I also thought that the strongest interest in religion in the West now is in Eastern thought, so I decided to do something referring to the yin/yang principle. I'm using a two-way mirror that makes a curve, and every reflection is a curve. So one side is a water basin – I guess the yin side – and the other is raked white gravel, like a zen garden. You enter the gravel section from the outside, and there's a two-way mirror making a half-circle around the gravel area; then between the water and the gravel area is an S-curve. So you have an incredible space – they're all two-way mirrors reflecting the water and reflecting each

other, anamorphically. I wanted to make this into a pavilion that you could go underneath, as a café. You'd go under the water; the water would be up on the roof, so you could see the sky through the water. Many different possibilities, but I don't think it'll ever be built.

Mark Francis *What do you think about the work of younger artists who are using and referring to design, like Jorge Pardo.*

Dan Graham I think Pardo is looking for a fantasy of the 1960s and 1970s, but his work is luxurious in a very 1990s way. You can see that it comes from a generation that only has vague information about the recent past, which barely even knows Alvar Aalto. I always want things to be utilitarian, and I think this generation want things to be anti-utilitarian, a little fantasy world of art.

Mark Francis *So the younger generation has a nostalgia for the period when your work first emerged?*

Dan Graham I think they want to eliminate hard greediness and the return to painting and sculpture of the 1980s and 1990s. So they're looking back for a utopia. They somehow found it so quickly and it's become so popular that they haven't developed their research or ideas any more; their work seems easy. Dealing with the relationship between art and architecture has become a cliché now.

What I do notice, and this is very important, is that I'm often in very bad shows, in the middle of nowhere, and see the work of younger artists. For example, I remember being in a terrible show sited in a small British town where there was a great piece by Tacita Dean. So the further away I get, into the most out-of-the-way places, the better the art that I find there, often better than in the main centres.

1 Donald Judd, 'Month in Review', *Arts Magazine*, New York, October, 1964
2 'Dean Martin/Entertainment as Theater', first published in *Fusion*, Boston, 1969; reprinted in *Rock My Religion: Writings and Art Projects 1965–1990*, ed. Brian Wallis, MIT Press, Cambridge, Massachusetts, 1993
3 First published in Dan Graham, *End Moments*, New York (self-published), 1969

Paul Graham *Gillian Wearing*

in conversation
February–April 1996, London

Gillian Wearing Is there a place to begin?

Paul Graham I suppose so. I remember 'discovering' photography. I remember clearly, for want of a better term, the light going on. I was 19, and I walked into a magazine store and found *Creative Camera*, at that time a very good magazine. I remember the shock of seeing serious photography, it was just a revelation. That was 1976 I think, around there. It's very strange when you feel an immediate empathy for something. You just feel you've utterly understood it, that it resonates inside you. I still get that feeling today when I see really good work.

Gillian Wearing What issues were you hoping to see with photography?

Paul Graham If I'm honest, I guess the biggest issue at that point was finding my own voice. Trying to express this profound empathy that I felt for the medium, seeing, if you like, that as well as going into me, that it could come out of me.

Gillian Wearing It was slightly different for me when I chose photography, that's why I asked that question. I had an idea, and photography was the way of working out that idea.

Paul Graham I suppose you could say that I had a hunger for an expressive outlet, and photography was a way of answering that hunger.

Gillian Wearing How did that relationship develop?

Paul Graham It developed through seeing good work. A friend sent me a catalogue for a body of colour photographs called *Election Eve*, by William Eggleston. It was a really thin pamphlet with just four photos, and it blew me away. He is often-cited for his show at the Museum of Modern Art, New York, but to be truthful, I didn't like that so much. The book, *William Eggleston's Guide*, was not as powerful for me as this smaller catalogue. It wasn't only the photographs, you see, it was the structure of the project – to travel from his home town to Jimmy Carter's home town over the month leading up to the presidential election, and photograph the state of the nation. It was so elliptical, so tangential to traditional photographic practice that that approach probably moved me more than any specific image.

Gillian Wearing I can see that; I can draw parallels.

Paul Graham Yeah, and it's good to be honest about it. It was quite influential for a while but then I reacted against it, drawing upon the work of people like Walker Evans, August Sander and the 'New Topographics' work. I went to the opposite extreme and made the *House Portraits*, which were just the fronts or sides of houses. They were incredibly austere. I used to get up at three a.m. to go and catch dawn in these modern housing estates when the light was really strong . I got completely immersed in that, probably because I was brought up in a new-town and it struck a particular chord. I did that for over a year, then thought, right, now I'm free. It's quite strange, I felt like I'd learnt something fundamental.

Gillian Wearing *You'd gotten your own voice?*

Paul Graham I'm not sure if I would go so far as to claim that at that point, but I certainly felt a clear change. You know, when you look back and somehow see everything in perspective, catching yourself in the rearview mirror as it were? Recently I realized that the work I'd made in my twenties – that's *A1, Beyond Caring* and *Troubled Land* – were different and distinct from that made in my thirties – *New Europe, In Umbra Res* and *Empty Heaven*. The earlier work was produced with the consciousness of the outside world being there, waiting to be photographed, and me positioning myself against that. Later the world was more useful as a source for reflecting essentially invisible concerns.

Gillian Wearing *I understand, especially in the beginning where you position yourself in your surroundings. I can relate to that because that's how I felt when I started out in my relationship to other people.*

Paul Graham Do you think that's always necessary? Do you think that artists have to orientate themselves to the outside world first?

Gillian Wearing *I don't think it's necessary, no one ever told me to do that. I was particularly interested in documentaries, not accepting any handed-down truths, finding out what my relationship is to things, my own truths. I think those areas are quite important because then you can see there are actually other ways of dealing with it. Photography still talks about the world, the truth comes into it somewhere along the line.*

Paul Graham You know how at certain ages you're fighting angry about certain issues? *Beyond Caring* was fighting talk, in a way, confronting the economic violence being done to a large section of the population by early 1980s Thatcherism. It wasn't some theoretical principle, it was my personal situation. I was unemployed, so giros, UB40s, waiting rooms and endless interviews were a part of my life. What is interesting about these places is that they are where political policy and people collide, where economic decisions and human lives meet head on. This was the primary concern of the work . The other factor, and remember this was 1984, was that people were shocked to see work like this made in colour; 'serious' photographers used black and white and that was that. Colour was seen as trivial, and it's hard now to imagine the flack it received, people thought I was taking a serious subject and trivializing it, as if colour film removed any social context.

Gillian Wearing *Whose noses was it getting up?*

Paul Graham I guess we're talking about the photographic establishment. Some people embraced it and saw it as something positive, but other people – Magnum photographers, photojournalists – would pick on this photograph for example, the baby in a waiting room in Birmingham, and say that any social interpretation is undermined by the fact that the child is wearing pink, and that's a happy colour, so surely it would be better in black and white ...

Gillian Wearing But colour work did have a context of its own at that time.

Paul Graham True, and again these images worked a bit outside of that colour genre, as it was then. They were non-colour images, with fluorescent light casts, dull institutional colour schemes, grey corridors. The few bright colours are those of forcefully optimistic orange seats or yellow walls.

Gillian Wearing Do you ever feel that you were coming from the photojournalism angle, or did you always consider yourself separate from that?

Paul Graham I never considered myself a photojournalist. I considered myself a photographer, I suppose, but labels only confused the issue.

Gillian Wearing Right, but you can see that there's a barrier between yourself and that trade. I wondered if that extends into the work you did in Northern Ireland, Troubled Land.

Paul Graham I suppose it did, because that work transgressed two genres, mixing up landscape and war photography, and remember that war photography is the hallowed, high ground of photojournalism. To many people that was plainly perverse, to go to a war zone and make landscape photography, but I think that it was in part a reflection of my distance, and a way of approaching something big and beyond ordinary rational comprehension, starting at arm's length, as it were.

Gillian Wearing Yeah, and it has a British reserve.

Paul Graham Sure, it's strange how work always ends up having a degree of self-reflection in it no matter what you do. A key image that helped me locate the work was *Roundabout, Andersonstown, Belfast*, 1984, where you simply see a scruffy suburban fringe of Belfast, with everything looking quite banal, at least to anyone familiar with the topology of the British Isles, but then you realize all the lights have been smashed off the stands, the posters are placed very high so that nobody can interfere with them, the roundabout's all ripped up, there's nationalist graffiti on the railings. And then finally you see the soldiers, one running over the roundabout, others walking away on the extreme right, secreted into this everyday scene. So the inventory isn't actually correct, what appears to be ordinary is quite extraordinary, and perhaps more interestingly the opposite is also true, the adoption of the extraordinary into the ordinary fabric of the place.

Gillian Wearing What problems would this cause for photojournalists?

Paul Graham These images are the reverse of press photographs. Photojournalists always use Robert Capa's famous dictum, 'If your pictures weren't good enough you weren't close enough.' You are supposed to be there, running with the soldier on the front line. Through these images I realized that you can reverse that; instead of running with the soldier you can pull back to show the surroundings. Instead of isolating a detail, like the soldier, you can

reverse out of that to embrace the housing estate, people going shopping, graffiti, the gardens, paint flecks and so forth.

Gillian Wearing *The first time I ever saw that the houses were painted in Northern Ireland was when someone went on holiday there and brought back photos. What were your own thoughts on Northern Ireland, what was going through your mind when you were there?*

Paul Graham I guess, without trying to be slippery, that was the question for me as well. That's probably why I was there. It's part of our country, rightly or wrongly, and I wanted to find out what was happening in our name and how it differed from what the newspapers told you.

Gillian Wearing *Did you reach any conclusions?*

Paul Graham Art isn't about providing answers, is it? It's more about questions – asking thought-provoking, unexpected, unarticulated questions.

Gillian Wearing *Did it change your mind in any way, because, I mean, war's always about land, isn't it? It's funny how we often see images of people when we know it's actually about soil. We are told about human suffering in isolation, even though it's a consequence of disputed territory.*

Paul Graham For sure, the land is an issue at the heart of this dispute: who has the rights to it, whose history is contained in that soil. What I overlooked at first, but which became extremely important to me later, was how the reality out there completely changes according to one's polarized perspective of it. There's this territory in Northern Ireland, and some people were seeing it as Irish and claiming it as theirs, and trying to alter it to match their reality, painting kerbs, putting up flags, graffiti, and yet other people were seeing it completely from another perspective, another reality, according to where they came from. It's such a simple thing, but you just have to have it driven into yourself, that the world out there alters completely according to the way you look at it. It's the same bit of land, but people have their own versions of it in their minds, and were trying to impose that over and above others. That was a hard, useful lesson, and it made a big change possible in my work – recognizing that you had to consider the fractured nature of reality, the invisible, personal nature of it. That made me reconsider my approach to photography – how much of our world you can see and photograph.

Gillian Wearing *It's interesting how, when you find a structure to explore, you go there with certain notions but enter a state where you forget that knowledge and see beyond it to something further, unexpected.*

Paul Graham Sure, that's why we do it isn't it? Forget the popular, clichéd misunderstandings of artists' motivations. One real reason is to go beyond your knowledge, to transcend that foreground and be seduced by your own actions into unpacking something unexpected yet insightful and fulfilling.

Gillian Wearing *How do you enter that state?*

Paul Graham I guess I just work my way through my limited knowledge and out the other side. I photographed in Northern Ireland for many weeks, but all the early images were rubbish, and I was lost till I found the roundabout image. I took that photograph without much thought, so you could call it an accident, but then I subscribe to that school of thought which says that you should look at your mistakes and accidents as your subconscious strategies.

Gillian Wearing *When I go back to some of my sign photographs, the ones that I've never shown, I think, God, they're actually quite amazing, but I just ignored them at the time. You have to keep on going back to realize that there are other nuances there that may be more relevant to what's going on in society. That's one of the wonderful things about photography, that you can keep on going back to what you're showing and find new readings.*

Paul Graham Sure, as your perspective changes, what was opaque at the time becomes clearer. The medium has this amazing consultability that extends far beyond the surface of the image.

Gillian Wearing *But surely when you combine photographs in diptychs and triptychs, as you do, you close some of those avenues.*

Paul Graham That's always the problem of putting work together, which photographs you combine. Whether it's just in the sequence of a book or exhibition, or locked into the diptychs and triptychs, you're trying to tease out certain readings yet not deny other positions, not trap and kill the work. It's a fine balance. Gombrich, writing about Picasso, talks about how if you explore his symbols and metaphors of sexuality, life, fertility, etc, although these are all there, to actually give every symbol a name, to declare it, is to deny it its secret integrity, and destroy it.

Gillian Wearing *Which brings me to the first photograph in* New Europe, *the guy with the war wound. It looks like he's mourning some kind of a loss; when I first saw it I was thinking maybe that area might have been bombed and replaced by new housing.*

Paul Graham Well, yes, it's a photograph of a man with an amputated arm, looking across the new developments on the outskirts of Madrid, although it could be almost any modern city.

Gillian Wearing *But I know there's more to the image than that.*

Paul Graham Indeed, it's a gay cruising area, and he's out offering himself, his body, for what it is – the seductiveness of the wounded flesh. That's why it's the opening photograph in the book, it lays between past and present, with damaged lives connecting them. I put that with an image of a very barren barber's shop, also in Spain, with these sparkling chandeliers reflected in its windows. They're probably just paste, an illusion of wealth, floating there out of reach. I use the two as a diptych on the wall or sequentially in the

book, and, this is difficult, because I'm close to doing what I was referring to with Gombrich just now. I guess it's largely subliminal, that connection where both touch upon something that's not there anymore – the wealth in the window is illusory, and they say that you still get feelings from a lost limb. So it's about sensations from an amputated past. There you are, I've killed it now, explained it away. I've pinned the butterfly down!

Gillian Wearing *But that is an interesting area, what we want to hear, what we want explained. It's a bit like that in the cinema when there's a narrative that's not giving the full picture. We're always looking for the story aren't we?*

Paul Graham Yes, looking to understand, for answers that make sense. Like we said before, I'm happy to have found interesting questions, perhaps unanswerable ones. Photography is well-suited to this, to pinning fleeting moments down, piercing the opaque membrane that surrounds us. The problem is how to select that sliver, that thousandth of a second that is meaningful, out of the whole. Which stones will keep their colour once they've been pulled from the river? Sometimes they're just made on a hint of a feeling, an intuitive whim, and one can't rationalize it till later.

Gillian Wearing *The photographs in* New Europe *from Northern Ireland are quite different from the earlier ones.*

Paul Graham Sure, physically they're a lot closer, more direct and visceral. The photograph taken in an unemployment centre in Belfast shows just a scrappy corner of the phone table, where people ring up after jobs, and looks across the tabletop full of graffiti to touch on the word 'religion' which someone has scribbled there. This is obviously because they were asked, or were worried that they'd be asked, are you Protestant or Catholic? The wire on the post image was something I'd seen and went back to photograph at night because I wanted it surrounded by blackness. I mean, it's just this house post on the one hand, quite ordinary, but then again, with its crown of thorns, its wounded side, it is much more about the pressure of being there, the crucifying psychological burden.

Gillian Wearing *You're putting these disparate elements together, but they all have a relationship, in some way, if you start looking closely.*

Paul Graham When I was making this body of work it was one of the most traumatic, intense periods for Northern Ireland. They were burying the people that were killed by the SAS in Gibraltar, and then a gunman attacked that funeral and killed some of the mourners. Then at the funeral for those mourners they caught two soldiers in a car, and they were lynched on the spot. It was an endless black spiral. Looking back I would say that you enter this state of numb hypersensitivity. It's hard to name it but, for example, even late at night, when you're eating your take-out dinner at the side of the road, you look at this skip behind you and realize that someone's shoved three bricks

under the corner, and they're completely crumbling, disintegrating from the weight of the load, because they're being asked to bear too much. It's some sort of transcendent frame of mind you enter, quite impossible to describe.

Gillian Wearing *Was it an intense time, going around Europe when you did all the photographs for* New Europe?

Paul Graham Going and coming. I had to get the tourist out of my system; you have to get the sightseeing out of the way, then get angry and frustrated with yourself. Photographs are everywhere and nowhere. You can go around the city all day fruitlessly, then you might be sitting at the bar late at night, only to find yourself opposite this guy who had come from East Germany, and he's sitting in a disco, surrounded by colourful lights, the appealing glow of entrancing promises ...

Gillian Wearing *That one's out of focus. I don't know if that's deliberate ...*

Paul Graham Oh is it? I've never noticed that! But surely a photograph can never really be out of focus, if that is how you experienced it? It took me some time to relax about those sort of things. I am very jealous of people who come from an art background and don't give a toss about technique. I remember when you exhibited your photographs at Interim Art, you had rather badly-made big prints on the wall, from Snappy Snaps or somewhere, and I offered to print them better for you, sharper prints and so forth, only for you to say, 'Mm, thanks', pretty non-committal. So I walked around and thought, why was she so uninterested? Then I suddenly realized that you wanted them like that, you were happy with the feeling of them, and it didn't matter if the edges fell off out of focus or whatever ... The light went on, and I thought, why not? It's liberating when you realize that you don't have to have high production values, as long as the feeling you want is in there.

Gillian Wearing *And also you can evoke memories of the way people take photos anyway.*

Paul Graham Sure, break down those barriers.

Gillian Wearing *Actually our relationship with photographs in everyday situations is a physical one, when we get our holiday snaps we hold them. Sometimes framing can get in the way of what we feel, we can't get near it. Glass can distort when you want to look at it directly.*

Paul Graham I tried hard to get the photographs out of frames or out of that whole acid-free archival mounts business, but you're still left with an image on a gallery wall, which is slightly unnatural. That's one reason why books are important to me, that intimacy.

Gillian Wearing *Sure, and you could never hold a big photograph anyway! But whilst we've talked about individual pieces, we've been skating over the issues of the work as a whole. Obviously history's very important to you; it seems to be an undercurrent in a lot of the recent work.*

Paul Graham When I started that work it was just on the feeling that this was a significant time for Western Europe. Only after I had gone some way down the road did all this stuff about 1992 come up. Prior to that nobody was talking about the single market, European unity, economic and legal bonds, etc. Then suddenly there were all these promises of a new beginning, facing the future hand in hand, free from the shackles of the past … and I'm sorry, but one should always be sceptical of promises of new utopias. Spain's not going to forget about Franco, his shadow is stained into the place for a long time yet. You realize this history is not something dead and buried, it pursues people in every country.

Gillian Wearing *It seems to be becoming more apparent now since Bosnia. Nationalism is hitting back quite hard when we didn't expect it.*

Paul Graham There's a village in Bosnia where people live together in a mixed, intermarried community, and when the war started they regarded it as something far away, on the other side of the country. A few months passed by and it was only 20 miles away; a few weeks later and it was in the next valley. Then suddenly one morning a car drew up in the centre of their town, out got some young men who went to a particular house, knocked on a certain door, and shot the boy who answered dead. Then they got back in their car and drove away. All the younger people were devastated by what they saw as a senseless attack, but the older people understood, they knew that the dead boy's father's father had killed someone 50 years ago, just after the Second World War, and that this very specific murder was the settling of a score that had been simmering for 50 years.

Gillian Wearing *That's very dramatic. It's not as obvious in Britain, it's more nebulous than that isn't it?*

Paul Graham Sure, but we're continually living in our past. I remember this taxi driver saying how when he drives through the East End of London he feels like shouting out to people on the streets: 'The war's over … you can eat good food now! Buy fresh vegetables, there's no more rationing, enjoy life!' You do almost have to shout at people to get them out of this historical torpor.

Gillian Wearing *I'm quite interested in how we address all this. It's a very ambitious thing, isn't it, to address that 'new Europe' …*

Paul Graham It's an ironic title, obviously.

Gillian Wearing *Yeah, sure, but it's still ambitious, on whatever level you look at it.*

Paul Graham Of course it's ridiculous if you try to address everything, but you can narrow it down to a couple of main concerns, like how the past pursues each nation state, Germany, Spain, Ireland, Italy and so on. The other interesting question for me was what are we heading towards, what is this united common goal? Is the prospect simply a capitalist consumer heaven that they'd have us accept?

If you're too poor to take part, or your lifestyle's too different, are you to be marginalized? I wanted to make pictures about the banality of this promise, of people caught in a modernist nightmare, trapped in this web of consumerism with all its promises. Didn't you feel that personally? I spent all my Saturdays going to shops; that's what you did when you were younger, and you finally realize that it amounts to nothing. You realize how hollow it all is.

Gillian Wearing *I've been trying to escape Sundays most of my life! But mostly I've been trying to escape boredom.*

Paul Graham It's this dead avenue of existence, that's why I put the shoppers' photograph next to the image of a false wall. I don't know if this will sound pompous, but *New Europe* was quite different from the previous works. As a book it did strive for something denser, layered, requiring multiple readings, to work as photographic 'literature', if you can call it that.

Gillian Wearing *I think I prefer images which start having intimate associations on the wall or page.*

Paul Graham At the beginning I never realized that you could do that. You're brought up to believe photography works on the surface.

Gillian Wearing *It's hard to break away from conventions, isn't it? And once you've been in it for a while, you have to keep on trying to question yourself.*

Paul Graham I could have had a very successful career making more *Troubled Land*-style photographs, but can you imagine a fate worse than being trapped into repeating your own successes?

Gillian Wearing *People remember what you were doing when you were first discovered.*

Paul Graham Keeping that excitement takes real determination. So much baggage accumulates around your imagination that you can become leaden, grey. Without the energy to interrogate yourself you're dead. For example, going back to this question of history, I began asking myself, what was at the heart of this? Somewhere in there is the question of what kind of pressure a society, and ultimately individuals, hold within them, bottle up inside their heads. What containments do we live with?

Gillian Wearing *Whether we share identities or not.*

Paul Graham Everyone has these burdens within them, and I guess that's really what interested me, the balance between living a normal life and these unspoken weights that have to be carried, sometimes passed down through generations, often unwanted, on the shoulders of people across a nation or continent, concealed, hidden. I realized that concealment is something important that has run through a lot of my work, from the landscape of Northern Ireland, and the unemployed tucked away in backstreet offices, to the burdens of history swept under the carpet in Europe or Japan. Concealment of our turmoil from others, from ourselves even.

Gillian Wearing *How do you feel you can gain insight into that?*

Paul Graham It's difficult for me to answer that. I don't know if I want to talk about this really, but I had a bad past when I was younger. I went to a tough school in a new town, and there was a lot of pressure – physical, psychological, intimidatory, some real, some in the mind. I had to take tranquillizers for a time, and I think that experience made me very aware of the stress and turmoil that people can hold within them, under the surface. It was a very formative thing, understanding what people can conceal within themselves – and from themselves, when it becomes too painful – yet maintain outwardly normal appearances.

Gillian Wearing *People modify, they try to fit in. This obviously connects to the Japanese work.*

Paul Graham Sure; what is the burden of being Japanese? It's an interesting question, as they've dealt with the past quite differently, and, for the majority of the population, quite effectively. The work centred on that gap between the past and the blanket of willed happiness, pink-out culture, that smothers everything; the masks of happiness and benevolence that cover history and power structures, invisible yet all-embracing.

Gillian Wearing *Japan is still very isolated as far as cultural gaps are concerned. I did a piece with a camcorder where I went round and asked Japanese people why they liked London so much ...*

Paul Graham I didn't know that. What did they say?

Gillian Wearing *They tried to be polite on the whole, and said they liked it because of the shops – they go to Scotch House and buy labels that are very British – Burberry, Aquascutum, etc. I kind of touched on it very lightly, but you still feel the same kind of distance; I felt that I hadn't got any closer. You actually told me before that you think there's a lot of similarities there.*

Paul Graham Human beings aren't so very different.

Gillian Wearing *I don't mean alien, but culturally there are gaps.*

Paul Graham Yeah, sure. But you have to resolve it down from that to how the social structures affect people.

Gillian Wearing *The close-ups of the men you did are very much like some of the images that I did do with the camcorder.*

Paul Graham Oh really? So did you ask men as well as women?

Gillian Wearing *Most of them were women, but I did ask men. With the men for some reason I just went quite close up to their faces, and I don't know what the connection is there.*

Paul Graham You'll have to show me this!

Gillian Wearing *I've wiped a lot of it off, because I wanted to use the hi-8 tape for something else.*

Paul Graham It's a great pity you can't wipe some photographic films out again. In *Empty Heaven* I found myself sometimes re-photographing a photograph, because if you're trying to seek out sources of experience, then sometimes key images become icons of that event: the atomic fireball, or the moment of surrender. The actual photograph becomes a source of experience in its own right, a touchstone. That validated them as subject matter for the work. I'm explaining this because normally I had a problem with such ways of working – I guess it's part of the baggage I carry.

Gillian Wearing *I think you can't escape a sort of baggage, personal and artistic.*

Paul Graham I also used to be sceptical of artists who travelled to make their work, and I'm very conscious that my work could look like that, but it wasn't. I didn't plan to go to Japan, I just stumbled into it. That's kind of why I did the *Television Portraits*; they were the antithesis of working in foreign lands: taking photographs in your own home.

Gillian Wearing *Is that how you thought of it? You sound so self-deprecating.*

Paul Graham Perhaps you're right, that's too neat. No, I was with my flatmate watching television, and just took this picture, *Cathy*, and realized how beautiful it was.

Gillian Wearing *How many are in that series?*

Paul Graham It's open-ended. I keep doing it. Funny thing is I can't set them up. I'd like to have about twenty of these, and I've got twelve now, but it never works when I say, can I come round to your house and do one of you? I tried it, and it just doesn't work.

Gillian Wearing *Strange, because there are some times where I have to be careful with the timing, and in that kind of situation there's this kind of intuitive quality when you know it's going to be right.*

Paul Graham But you must set up such situations, when you were doing *Dancing in Peckham*, for example.

Gillian Wearing *I had to, but I knew that would be easier because I was relying on myself. It's when I rely on other people that it's very difficult, because I'm depending on their collusion.*

Paul Graham But then I have the collusion of the world to my ideas. I come along with a set of ideas about Japan, for example, and then see how much the world colludes with those ideas and thoughts. You start out with a structure, and as long as it's not dogmatic, when ideology overrules the subject, then you discover more than your ideas could ever hold. That's the great thing about photography – it's so close to life. Have you ever rejected people's collusion only to come back around to them later?

Gillian Wearing *The problem for people seeing photography as art is that it's one single mechanical action, rather than something constructed over a great space of time, as in painting or sculpture. Perhaps an exception is when people digitize their images,*

composing and manipulating in the computer and studio, but the majority
of work falls outside that, and that's where the problems lie.

Paul Graham That's right. By all the traditional measures with which one judges the craftsmanship of the artist, photography fails to deliver because of its mechanical nature. I remember reading the first photography review in the *Independent*, and the opening line was, 'Photography is a fundamentally repellent medium.' I was amazed at this, but I guess I shouldn't have been, because it reflects the prevailing misunderstanding about artistic practice residing in craftsmanship. The mechanical quality of photography, considered a limitation, is precisely its strength. Most contemporary art strives to move towards some kind of quasi-mechanical mode of production, and photography is already there.

Gillian Wearing *You could argue that it was the first modern art movement; it certainly changed the way painters looked at the world.*

Paul Graham Oh sure, it liberated painting, but going on from that mechanical aspect, there is a difficulty of attribution, because when you take a photograph you basically buy everything in a job lot, don't you? I could take a photograph of you now, but I'm also getting the bowl behind you, the mirror, and the scene out the window.

Gillian Wearing *It seems you only control a tiny bit of it.*

Paul Graham Yes, so how can you tell what was intended? Work like Jeff Wall's is obviously less problematic, because it's completely controlled and then digitally re-engineered afterwards. People have proof that every square millimetre of the image has been planned, even though the end product is exactly the same: a big colour photograph on the wall. When you go out there, look at something and say 'this is right', these hoary old problems of attribution, mechanization and artistic control emerge. When I first showed *Troubled Land* in France in 1987, I had some guy asking me how long it had taken to paint the kerbstones, and what a good climber I must be to get that flag high in the tree! He thought I was a landscape intervention artist, and this was the documentation of my works. He was disappointed to realize that I 'just' take the pictures.

Gillian Wearing *Do you think it's changing? Is it becoming acceptable? Do younger artists have an easier time than you had?*

Paul Graham Of course, and I had an easier time than photo-artists before me, and I acknowledge all the groundwork those people – the artists, publishers, the people at The Photographers' Gallery – have done. If it weren't for them fighting their corner at that time, not as much would have been possible now. But the demarcations are coming down even now, which are all for the better.

Gillian Wearing *What about the demarcation between photography and video? I was going to carry on using photography, but I pursued video in the end. Although video's got*

its limitations, it loses something photography has, which is so beautiful, about a moment, the way it fixes everything as all-important.

Paul Graham Against that there's what Wittgenstein called the 'fascism of the snap decision', clicking your fingers, summing up the world in an instant. It's so arrogant. That's why so many photographers work in extended series of thirty, fifty or more photographs, to deflate that quality.

Gillian Wearing Are there any younger photographers around whom you're interested in?

Paul Graham Of course! But to be honest I'm more interested in the contemporary art world right now, which includes photographic work. Probably what I'm looking for, selfishly, is to broaden my own horizons, escaping from the shackles of the photographic ghetto. I may have broken the chains, but they're still sort of rattling around my ankles!

Gillian Wearing But the work has changed over the years, you're isolating people and objects more. Before the photographs were broader, all-inclusive.

Paul Graham My gallerist asked me why I always put things in the centre of the photograph, which sounds like an embarrassing or critical question, but then if this is what you want to photograph – this person, this object – then why not put them in the centre? You really don't need to play clever games, or resort to any of that graphic design artistry. If that's what is interesting, let it sit there, right in the middle of the picture, be it the cancelled Star of David, the bloodstain remover or the Japanese boy. Show it plainly and clearly; no clever lighting, avoid all that stuff of being a great photographer. That's enough if something profound lays beneath the surface of what's being photographed; you only confuse it by adding decorative flourishes on top. That's not creativity, that's stylization.

Gillian Wearing No, but beyond the photographic, there have been points of constancy and points of change in your work.

Paul Graham If there's any kind of thread that runs across them, it's what we touched on about dealing with historical pressures, social pressures, and how that affects individuals, human beings, us. It's hard to know your threads because you're so close, and while history is a link between later works, it goes beyond that to a question of what societies and individuals conceal within themselves, consciously or not. Looking for those fissures that give it away, be it in a choice of wrapping paper or a hand gesture. Hopefully they extend into questions of individuality and identity, finding the right balance between individual freedom and social order, what price we must pay in society and the psyche to survive. These issues extend far beyond Japan, for example.

Gillian Wearing Japan is useful because it's a society that hasn't been so fragmented.

Paul Graham Yes, it's strange, it seems by turns transparent and opaque, but it is self-contained, and that's why there's that picture of the bottle plant roots at

Paul Graham

Roundabout, Andersonstown, Belfast
1984
Colour photograph
68 × 87.5 cm
Collections, British Council, London;
Det Kongelige Bibliotek, Copenhagen;
Wolverhampton Museum and Art
Gallery; Victoria and Albert Museum,
London

Isa Genzken

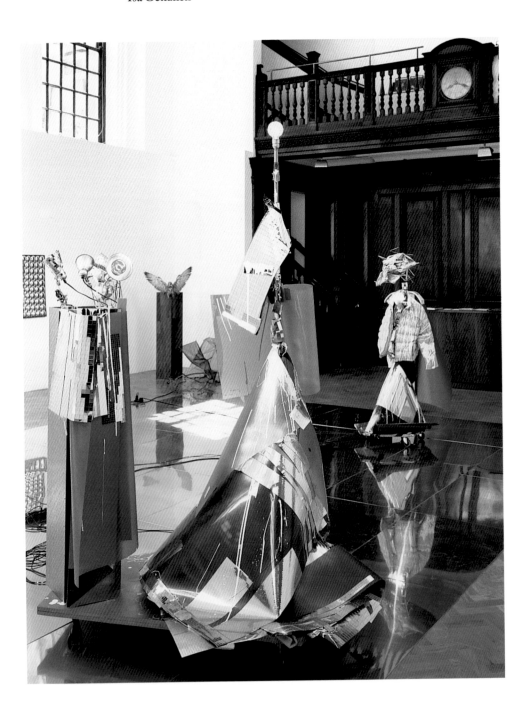

Wasserspeier and Angels 2004
18 parts and 42 aluminium panels
Various materials, dimensions variable
Installation view, Hauser & Wirth,
London 2004

Isa Genzken

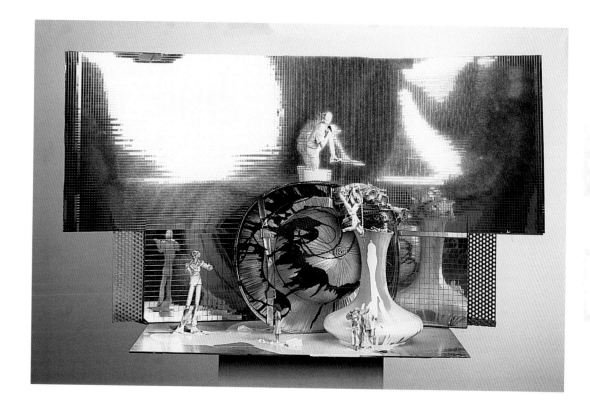

Empire / Vampire, who kills death
2003
1 of 22 parts, various materials
98 × 62 × 45 cm

Antony Gormley

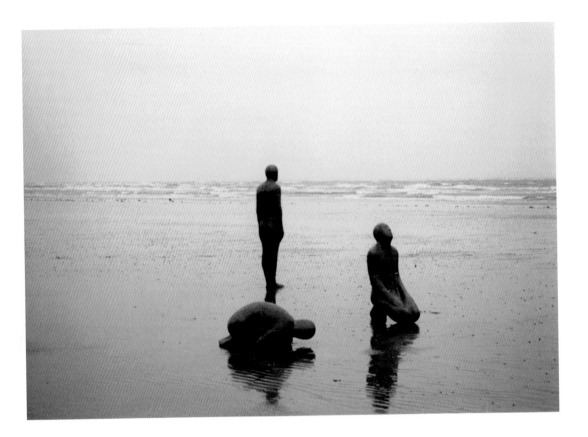

Land, Sea and Air II 1982
Lead, fibreglass
Land (crouching) 45 × 103 × 53 cm
Sea (standing) 191 × 50 × 32 cm
Air (kneeling) 118 × 69 × 52 cm

Antony Gormley

Field for the British Isles (detail) 1992
Terracotta, approx. 35,000 figures
Variable size, 8-26 cm each
Collection, the Arts Council of
Great Britain, London

Dan Graham

**Star of David Pavilion for Schloß
Buchberg, Austria** 1991–96
Two-way mirror, aluminium, Plexiglas
261 × 420 × 238 cm
Permanent installation,
Schloß Buchberg, Vienna

Homes for America 1966–67
1 of 2 panels, colour and black and white
photographs, texts
101.5 × 84.5 cm each
Revised version produced in 1970 of
the artist's original paste-up for *Arts
Magazine*, New York. The version
published in the magazine's December,
1966–January, 1967, issue substituted
a photograph by Walker Evans for the
artist's images

Paul Graham

Television Portrait, Cathy, London
1989
Colour photograph
110 × 90 cm
Collection, Tate Gallery, London

the end of the *Empty Heaven* book, beautifully nurtured, yet trapped, unable to escape. Perhaps that's a cliché?

Gillian Wearing　*It's like some unnatural growth as well. I like the idea that images use clichés, although that has such a horrible sound to it. But actually, though it's there all along, someone's discovering it. Pinpointing it is always the hardest thing to do.*

Paul Graham　Oh sure, piercing through the opacity of what it is now is very hard. But once it's done you immediately see it for what it is, and that's one of the tasks of artists. There's a line in *The Life and Opinions of Tristram Shandy*, by Sterne, where he says, more or less, 'Are we doomed to become like monks, forever parading the relics of our religion without ever performing one miracle with them?' And that's what happens. One forgets that that is the whole point, to say something, to work miracles ...

Hans Haacke *Molly Nesbit*

in conversation
February 2003, New York

Molly Nesbit *All conversations pick up where others have left off, so I thought it would be good to acknowledge right away one of the best you've ever had in print, and which gives any later interviewer real pause. I'm speaking of your dialogue with the great sociologist Pierre Bourdieu. There he said that your work represented an avant-garde for what intellectual work could become. What the two of you began in 1991 (during the same period that Bourdieu was writing* The Rules of Art[1] *and you were invited to represent Germany at the Venice Biennale) achieved written form two years later in your book* Free Exchange.[2] *But your own exchange with his work had begun much earlier than this, hadn't it?*

Hans Haacke Discovering Bourdieu's writings in the early 1970s, and then, some fifteen years later, meeting him in Paris, ranks among the fortunate events in my life. (I've always thought of myself as lucky.) The two volumes of his texts that I read then, in a German translation, had been published by Suhrkamp Verlag, one of the venerable publishing houses in Frankfurt that brought out most of the theory that mattered at that time. They were difficult to read, because they were written in a rather academic style – very different from Bourdieu's later writings. Or is it just that I'm more attuned to it now?

Molly Nesbit *Academic, yes, because he was concerned to prove his points using the very best sociological protocols. I should think, however, that his intensely rational tone would have had a special appeal for you.*

Hans Haacke Yes, absolutely. He explained in terms of sociological analysis a good deal of what I'd experienced in the art world, in galleries, museums, art talk, etc. The titles of these two books, translated into English, were *Foundations for a Theory of Symbolic Violence*[3] and *On the Sociology of Symbolic Forms*.[4] I read them after I'd been censored by the Guggenheim Museum, around the time I had also been kicked out of the Wallraf-Richartz-Museum in Cologne for my work on the provenance of Édouard Manet's *Bunch of Asparagus* (*Manet-PROJEKT '74*, 1974). Bourdieu's writing seemed to confirm some of what I'd learned from that marvellous sociological trickster Marcel Duchamp. In the other Marcel – I mean Broodthaers – I'd already found a kindred spirit. Bourdieu's texts helped me to understand things in the larger context of the sociology of culture. Then, at the end of a talk I gave at the Centre Georges Pompidou in Paris, when I had a solo show there in 1989, a woman in the audience asked me whether I knew Bourdieu and, if not, whether I'd like to meet him. She'd been working with him and, eventually, arranged for our first encounter.

Molly Nesbit *And this was Inès Champey?*

Hans Haacke Yes. I got the impression that Bourdieu knew some of the stuff I'd done over the years. He may have been particularly intrigued by my polls of the art world from the early 1970s.

Molly Nesbit *Behaving like a sociologist.*

Hans Haacke An amateur sociologist. So there was a certain affinity, as there had been some fifteen years earlier with the American sociologist Howard Becker. Bourdieu and I liked each other, and a little later, we taped a conversation. It took us quite a while to edit it, sending updated versions back and forth, until *Free Exchange* was ready for publication.

Molly Nesbit *At what point during this free exchange did you learn that you'd been chosen to represent Germany in Venice?*

Hans Haacke I was invited about a year and a half before the opening in 1993. I showed Bourdieu slides of what I'd done in the German Pavilion, and he'd read the text I'd written for my Biennale catalogue. He then wrote an addendum to our joint venture, in which he contrasted my *GERMANIA* with Ernst Jünger's nationalism. What triggered this juxtaposition was that Achille Bonito Oliva, the Italian Artistic Director of the 1993 Biennale, had seen to it that the official Venice Biennale catalogue carried a turgid prologue by Ernst Jünger. In Germany, in France, in Italy and in Spain this German writer is admired for his prose, his esoteric rejection of the Enlightenment, and his lifelong, dandyish disdain for democracy. In the 1920s Jünger had made a name for himself with a celebration of war – where a man shows his mettle (he'd been in the trenches of the First World War). He allied himself with the right-wing enemies of the new democratic Republic and distinguished himself with nationalist and anti-Semitic tracts. It was his habit to send his books, with personal dedications, to Hitler. In 1982, he had Arno Breker, Hitler's favourite sculptor, model a bust of him – as did the collectors Mr and Mrs Ludwig. Oliva managed to make Jünger the recipient of a Golden Lion Prize. I was outraged. To my great delight, a year after the Biennale, choreographer Johann Kresnik asked me to design a stage set for his dance-theatre production about Jünger at the Volksbühne in Berlin. It was not appreciated by the Jünger fan club. I had a facsimile of the golden lion trophy from Venice play a prominent role – as a toy for the warrior to ride.

Molly Nesbit *When chains of associations intertwine and extend like this they can take on a life of their own. These chains appear all the time when you talk about your work. Sometimes they come along by coincidence (your luck?) and sometimes because you yourself have returned to an old link, not necessarily to revise some associations but rather because it centred on a good point that bears repeating. These links and chains, however, have a place, and* Free Exchange *describes that place well.*

You and Bourdieu speak a great deal about what you call the 'battleground' of public opinion, its nature and its importance. 'Battleground', of course, makes plain the existence of structural adversarial conflicts in the public sphere. It also implies weapons – means for challenging one's opponents, one's adversaries, be they institutional or ideological (those two things now being exactly the same). Bourdieu was fascinated by the way in which you've used the techniques of mainstream publicity to produce your critique of its business (and big business in general). The provocation, then, is produced both by the means and the ends – a double challenge.

The particular provocations being discussed by the two of you are now part of the history of the early 1990s. But as we speak, ten years have passed. Would you see your challenges in the public sphere to be differently defined now? Are different means of provocation, different formal weapons and rhetorics required? Is the rhetoric of the advertising image still useful to you?

Hans Haacke When Bourdieu and I were talking about cultural politics in the US and how they're connected to 'big-time' politics, things were far from settled. What we saw as a threat then, has since gained incredible force. More and more, every day, the coalition of Christian fundamentalists and neo-conservatives is undermining the public welfare and the American Constitution. Practically all institutions have accepted the domination of the public sphere by corporate interests, many of them without offering much resistance and without embarrassment.

Until the year 2000 the New York art world had reason to believe that assaults on the freedom of expression were foreign to their city. The 'culture wars' were fought elsewhere, not in New York. We seemed to be secure. And the art market was humming. New York's Republican Mayor Rudolph Giuliani taught us not to be so smug. In 1999 he cut the Brooklyn Museum's monthly subsidy of about half a million dollars (a third of its budget); he threatened to replace the Museum's Board of Trustees with people of his choice; and he announced he would evict the Museum from its city-owned premises. All this to punish the Brooklyn Museum for including Chris Ofili's painting *The Holy Virgin Mary* (1996) in its show of the Saatchi collection, 'Sensation' (1999). The subtext was that Catholic voters were to be rallied to prevent the election of Democrat Hillary Clinton to the US Senate! When the New York Mayor's 'sensibilities' are offended, the separation of Church and State, and the right to free speech, as protected in the First Amendment of the Bill of Rights, were no longer considered binding by this former Federal prosecutor! Giuliani believes – like some of his peers in Washington – that he can impose his private or politically expedient views on the country through his hold on public money, i.e., the taxes paid by us. The Brooklyn Museum went to court. Eventually, a Federal judge ruled that His Honour had indeed violated the Constitution. Judge Nina Gershon didn't mince words. Let me read to you what she wrote in her decision: 'There is no federal constitutional issue more grave than the effort by governmental officials to censor works of expression and to threaten the vitality of a major cultural institution as punishment for failing to abide by government demands for orthodoxy.'

In the early 1990s, the Los Angeles County Museum of Art had put together a show commemorating an exhibition that the Nazis had organized in 1937 under the title 'Degenerate Art'. Stephanie Barron, the curator of the show, reported in her catalogue that there was 'an uncomfortable parallel between' the issues raised by the assault on the NEA and those 'raised by the 1937 exhibition, between the enemies of artistic freedom today and those responsible for organizing the "Degenerate Art" exhibition'. Perhaps because

I was born in the country with this infamous past, and because I was myself twice the victim of censorship by a museum, I've become allergic to the sort of parallels that Barron saw. In today's media fog, it's easily overlooked that there's something at stake here for all of us. Worrying about freedom of speech is not cool – it doesn't sell.

Molly Nesbit *But certainly the revelation of corporate wrong-doing is daily news right now.*

Hans Haacke Sure, corporate scandals, Enron, WorldCom, etc. are our daily fare. But we get used to them and merely become cynical. And then a war comes along and we get enthralled by a new spectacle. Rarely can we pay attention to more than one big item at a time. That may indeed be what the current Bush administration is banking on. They're endowed with an incredible combination of ruthless cunning and arrogant naivety. It's an advanced case of hubris. Except for a few, we're all going to foot the bill.

It boggles the mind that within eighteen months of the attack on the World Trade Center, George W. Bush has squandered the outpouring of sympathy for the US around the world. Instead of sitting on the budget surplus that he had when he took over, with frenetic tax cuts for his wealthy cronies he's piled up an ever-larger mountain of national debt. In 1992 I called a work about his father's version of the redistribution of wealth *Trickle Up*. The son has turned it into a flood. The readers of this exchange between the two of us will know more by the time it's published. I hope that then things will be a bit brighter.

Molly Nesbit *So the challenges are still the same. What about the critical weapons you use in your art? Mostly you still use elements found at the site in which you happen to be working.*

Hans Haacke I often work with the specific context of the place for which I produce a piece – both the physical as well as the social and political context. They're part of the materials I work with; they're like bronze or paint on canvas. In the place for which a project was conceived, the work has a charge, a performative quality, so to speak. When a work of this nature is shown outside its original context, background information needs to be provided so that the viewers can understand the references and the impact it might have had. Many people think this isn't necessary for other kinds of art. Of course that's a fallacy. We know this from personal experience.

In the 1960s, when minimalist and conceptual artists first emerged – Pop Art had already gained a certain market share – their work was hotly contested. Many people dismissed it as utter nonsense. Do you remember that Abstract Expressionism was once suspected of being a Communist conspiracy while, at the same time, the CIA employed it in the Cold War? It's hard to believe today that a Jackson Pollock painting could have played a role as a cultural weapon. People who didn't live through that period cannot have a sense of the significance these works had, what was at stake for those

who made them and for those who supported or dismissed them. It's for historians to expose the many meanings and often conflicting roles that artworks have played over the years of their existence. But historians can only offer the views that are compatible with their own time.

Molly Nesbit *We know that the way we think at any given time doesn't, and shouldn't, frame a work forever. But this allows us to enlarge upon the matter of communication in the public sphere. Let's look at the different strategies you've used over the years in your work. Let's compare* GERMANIA *in the German Pavilion in Venice with* MetroMobiltan *(1985) in terms of the way in which your provocation or exposé is set into motion formally and physically. In Venice, it's rather like looking at a cubist picture. You've put various symbolic forms together and asked us to read them against and through the ripped-up floor. One sees the violence of the ideological battle physically present in the disruption, giving us a way to hold it in the mind as a memory. The adversary becomes a wreck.* MetroMobiltan *is very different. It's more like looking at the blocks of a well-designed advertisement from the mid-1980s. You've re-arranged the elements from the display culture of New York's Metropolitan Museum of Art – its banners, its facade – in order to expose the financial interests supporting the museum. The museum reveals its own moral weakness once we examine the parts, but we have to work to pry the elements apart. There's no actual formal violence, just the compression of two opposites into the same facade. The explosion happens conceptually. But in this case you work in the present on the present. In Venice you worked in the present on the past. Is this shift due to a different public being present there? Or is your sense of the work of art's place in time changing?*

Hans Haacke I don't believe that the public of the Biennale and that of the Metropolitan Museum are so different. The Museum is an institution with a very rich past – 'rich' in the multiple meanings of the word. My mock rendition of its facade speaks of that. On its entablature I quote from a leaflet by the Museum with the cute title: *The Business Behind Art Knows the Art of Good Business.* In a nutshell, it explains the rationale behind the involvement of corporations in sponsoring culture. Corporations don't have aesthetic desires. They're set up to promote the financial interests of their shareholders. And that includes not only promoting the company's image but, as the current crop of executives sees it, making sure institutions that receive their support do not engage in activities that could cast doubt on their 'responsible citizenship'. A Mobil PR-man once said: 'These programmes build enough acceptance to allow us to get tough on substantive issues'; Mobil and Philip Morris have both tried to interfere with shows of mine. Institutions usually don't let it get that far. Self-censorship is a given. *MetroMobiltan* is a collage of disparate elements, put together like the Surrealist's 'exquisite corpse', without smooth transitions. It's the viewers' task to understand the conflicts between these elements and to draw conclusions. It's a technique similar to that of Bertolt Brecht.

Molly Nesbit *But the disruption becomes much more physical in the German Pavilion.*

Hans Haacke Yes. There's a fundamental difference between how we react to physical reality – in this case the breaking of marble slabs – and mere representations of violence through a photograph. Neither approach is possible or appropriate in every situation.

Molly Nesbit *Viewing Matters: Upstairs (1996) at the Museum Boijmans Van Beuningen, Rotterdam, was again very different in approach. Here, you found a way to work with others in a museum setting. It's no surprise to find you working at the Boijmans. Over the years you've often worked on the site of the museum, unmasking what Bourdieu would call its 'invisible structures'.* MetroMobiltan *would also be a good example of that or* Manet-PROJEKT '74 *in Cologne in 1974. But the Rotterdam project didn't get you into trouble.*

Hans Haacke Interestingly, some curators and museum directors in The Netherlands were outraged!

Molly Nesbit *Why?*

Hans Haacke I believe they thought I didn't treat the works with the proper respect.

Molly Nesbit *What did they mean by 'proper'?*

Hans Haacke I think they were offended by my bringing the storage racks from the basement upstairs to the *bel étage* and presenting the collection as it is housed downstairs: according to how best to save space, irrespective of medium, period, monetary value and historical or aesthetic significance.

Molly Nesbit *Literally revealing the invisible structure.*

Hans Haacke Yes. Presenting the works they cherish in this seemingly disrespectful fashion they considered insulting both to them and to the works. I meant to demonstrate that every presentation of works from the collection is inevitably a highly selective choice, driven by an ideologically inflected agenda – as was mine. It's often assumed that what we get to see on the walls of museums is a disinterested display of the best works, and represents a reliable account of history. This, of course, is never the case. The canon is an agreement by people with cultural power at a certain time. It has no universal validity.

Molly Nesbit *They've cleaned it up, as André Malraux told us at great length in his text on the museum without walls, the* Musée imaginaire *(1947). But your Rotterdam project had other elements to it, didn't it?*

Hans Haacke There were a number of other significant components to this show. I called it *Viewing Matters*, both in the sense that it matters to look, and that there are things, or matters, to examine and choose from – like in a department store. For the walls, around the central complex of the storage racks with the indiscriminate display of unrelated works, I selected specific paintings, sculptures, photographs and objects of all sorts, according to five themes: Artists, Reception, Power/Work, Alone/Together/Against Each Other, and

Seeing. Throughout the show I provided no explanations. Had I done so, I would have undermined the technique of causing creative friction that has been attributed to the Comte de Lautréamont: juxtaposing normally unrelated objects, such as an umbrella and a sewing machine on an operating table. This was his prescription for producing new and unexpected meanings, adopted by the Surrealists with a similar intent in the parlour game 'the exquisite corpse'.

Molly Nesbit *Then you made a book to accompany and survive the show. Often your books are an important part of the work: they provide another ground with which you, the artist, can communicate with the public.*

Hans Haacke With the book, I tried to do something similar to the exhibition. I emphasized the peculiar nature of a book's physical properties and design: layout, page-sequencing, printing techniques, the qualities and flaws of photographic representation. I was lucky to be able to work on this with Paul Carlos, a very gifted designer in New York who has a rare sense for creative collaboration. The book is not meant to be a documentation of the show. However, like in the exhibition, I positioned images in relation to each other as a motor to create meanings that they wouldn't have had in isolation. We played with varying degrees of photographic resolutions and digital techniques. This highlighted the technically contingent quality of reproductions. We accepted reflections on the surface of paintings and protective glass as they appeared in the photos, and we accepted angled views of planar works. In short, we violated standard design rules. It was a lot of fun.

Molly Nesbit *Were you thinking about turning the book into a* musée imaginaire, *or making use of another of Malraux's ideas – that works of art exist in the museum as a confrontation of metamorphoser? The works undergo yet another change of state when photographed. And there the metamorphosis becomes even more dramatic because of the way in which photographs flatten form and distort colour. Was the museum–book as an engine of metamorphosis (and alienation) one of your working concepts?*

Hans Haacke The museum as an institution that shapes our sense of history was certainly on my mind. I have only a vague memory of Malraux's *musée imaginaire*. I believe he spoke about the homogenization to which works are subjected in books, due to the standard size of the printed page and their reproduction in black and white.

Molly Nesbit *Yes, and the strangeness of the close–up also worried him.*

Hans Haacke In many instances in the book, I retained the size of the works relative to each other. Small works were reproduced small next to big works that were reproduced large. But I also played with close-ups and excerpts and collage.

Molly Nesbit *And there's the shifting between black and white, and colour.*

Hans Haacke Yes. There are colour pages, pages with black and white, and pages with both – or a monochrome colour.

Molly Nesbit Your book calls to mind another compendium too, in part because you included so much of his work here, and that's the Boîte-en-valise *(1935–41) of Marcel Duchamp. Duchamp's* Boîte-en-valise *became a portable museum of his own work, which no museum in the world at that time would have shown. It's very personal. How does the* Boîte *function in the context of your Rotterdam project?*

Hans Haacke Duchamp was, of course, the first artist to think about the aura that surrounds art and artefacts, and the power of context. As we know, they fundamentally affect the way in which we look at objects. The paintings on the storage racks didn't look like much (maybe that was behind the disapproval I encountered). In 1972, Marcel Broodthaers continued Duchamp's project with his fantastic exhibition 'Musée d'art moderne, départment des aigles, section des figures' (Kunsthalle, Düsseldorf). I was glad the Boijmans had a good number of works by both of these iconoclastic artists. They allowed me to introduce notions of the contingency of meaning and to undermine universalizing assumptions.

Molly Nesbit *Perhaps there's something else involved as well. While Duchamp was an ardent explorer of what he would call the 'non-retinal dimensions', he was also interested in the ways in which retinal matters can be extended. For him these two preoccupations went together. The non-retinal dimension of your own work is probably the one that has been most emphasized over the years, in part because you've asked us to think. Your earlier work using Duchamp's example – I'm thinking of* Broken R.M. … *(1986) and* Baudrichard's Ecstasy *(1988) – involves more knowing than seeing. Duchamp is there as symbolic form first and foremost. Yet at the same time a retinal dimension is quite evident. In the Rotterdam project it dominates. There you give us more something to look at than something to read.*

Hans Haacke In the section of *Viewing Matters* I called 'Seeing', I included a walk-in camera obscura. Once your eyes had adjusted to the darkness, you could see the street with cars passing by and the church across from the museum. Of course, they all appeared upside down. During the opening of the exhibition, the head of the installation crew told me with great excitement that he and his kids had just seen lightning in the camera obscura.

Molly Nesbit *It's very interesting conceptually to think about this work together with* DER BEVÖLKERUNG *(TO THE POPULATION, 1999), in which you brought soil from various different sources into the Reichstag. The seeds and plants that inevitably arrived with it will be allowed to grow there forever. But the historical ground from which museum curators choose their exhibitions is just as charged as the soil that came to the Reichstag. You could even say that it's spiked. It has its toxins and its late bloomers.*

This project, like GERMANIA, *did not spring from museum conditions. At the Reichstag, another kind of communication has been attempted, and another kind of disorder is produced. This time it stems not from violence but from the*

eruption of natural growth, natural processes, from mother earth. You have a different kind of frame, a different kind of ground. As an American looking at this I say, 'My god, it's incredible! Hans Haacke has the ground of the state on which to make art – and the state itself has given it to him!' Such a thing wouldn't be possible in the United States. As you've spent many decades living in America, what does it mean to you for the German state to give you a space like this for your work? Do you find it extraordinary? Because, you know, you're not exactly a state artist in most people's minds.

Hans Haacke Some do now think of me as a state artist. As you say, it is indeed uncommon for a parliament or the commissioner of a pavilion at a Biennale to allow national showcases of such symbolic significance to be used as a forum for the discussion of public issues. I give great credit to Klaus Bussman, the German Commissioner in 1993, for inviting Nam June Paik and me to represent Germany at the Venice Biennale. Even though Paik had lived and worked in Germany, he's a resident of New York. He's not a German citizen. And I'd been living outside of Germany for almost three decades and hadn't particularly ingratiated myself with the powers that be.

Molly Nesbit Did that in any way come into play when the commission for the Reichstag was being decided?

Hans Haacke It may have played a role. I was the last of nineteen artists to be invited, and, as we know, my proposal did, in fact, cause problems.

Molly Nesbit And as an artist of conscience working for the state, what changed when you found yourself speaking both for the state and to the state in these different commissions? The Venice Pavilion was a temporary installation, a temporary conversation between you and the state and your audience. But the Reichstag is something else again. It has created a conversation that could and should be heard for centuries. As a stage for contemporary art this is extremely unusual. Most contemporary artists couldn't imagine a situation where their work would be shown in a public place for more than six months, much less decades, much less centuries. But when you work for a state that sees itself as having an eternal life, conceivably your work can have an eternal life too.

Hans Haacke Attitudes towards the state in a liberal society are complex and differ between countries, especially between the US and Europe. Traditionally, Americans – particularly the more conservative ones – are hesitant to cede powers and responsibilities to the Federal Government. In the wake of the French Revolution, Europeans, on the other hand, have put the state in charge of practically all matters of public welfare. Public money – which always means taxpayers' money – is used to underwrite the *res publica*, the public cause (Republic). As part of this understanding, culture has been unquestioningly subsidized by the state in Germany and other European countries on a scale that's simply unimaginable in the US. It's a relatively new custom that the organizers of costly exhibitions are emulating the American model and

making appeals for corporate sponsorship, even though they know full well that it limits their curatorial independence.

Every artist who exhibits in a public institution is, in a way, a state artist. By accepting the commission from the Bundestag, I allied myself with an institution that constitutes one of the major pillars of German democracy. My work in Berlin obviously wasn't meant to endorse this or that political party. And it wasn't perceived as such. The opposition to it crossed all party lines. The Bundestag Art Committee charged the invited artists to address the history and the political significance of the site. I think I did that. I alluded to the troubled German past and to the present debate over German citizenship, and the responsibility of the Bundestag to all who live on German territory. I wanted the project to be an ongoing participatory process. Taking politicians at their word turned out to be provocative.

Molly Nesbit And there was one word in particular that you picked up on. The controversial component of the piece was to present an alternative to the Reichstag's inscription 'DEM DEUTSCHEN VOLKE' ('TO THE GERMAN PEOPLE') with 'DER BEVÖLKERUNG' ('TO THE POPULATION'), written in neon light.

Hans Haacke The third article of the German constitution of 1949 speaks about equality: nobody should be discriminated against or favoured because of their gender, origin, race, language, birthplace, their religion, beliefs or political opinions. Obviously, this is based on the Declaration of Human Rights of the French Revolution. Politicians usually claim to have everybody's interests at heart. They invoke the *Bevölkerung* (population) in every speech. But if that inclusive word is played back to them and related to the historically burdened word *Volk* (people), as it was with this project, attitudes change. All of a sudden the population becomes suspect, particularly to conservatives. For non-Germans, 'people' is an innocuous word. However, because Germany became a unified nation only late in the nineteenth century, in the myriad principalities and kingdoms the word *Volk* implied ethnic unity and a common culture. It was this exclusive tradition that the Nazis tapped into. Blood lineage became an issue of life and death.

Molly Nesbit It does still have a currency, doesn't it? It still has political force behind it of some kind. It's not a dead word.

Hans Haacke Yes. The revolutionaries of the failed uprising against the German princes and kings in the mid-nineteenth century were inspired by the French Revolution and its emancipatory goals. And in this context it meant, and still means, 'everybody'. Unfortunately, the understanding of *Volk* in the tribal, *völkisch* sense is not yet a thing of the past. As in other countries there are nativists in Germany. Neo-Nazis beat up people who don't look sufficiently German to them. And conservative politicians don't shy away from making veiled appeals to an undercurrent of suspicion regarding people of other ethnic and national backgrounds – not unlike the racist code words with

which politicians in other countries try to win elections. The Christian Democrat MP who led the campaign against my project – like so many in his party – is a fervent opponent of the liberalization of the German citizenship laws. He and his supporters want to hold on to the *jus sanguinis*, according to which citizenship depends on parentage rather than place of birth.

Molly Nesbit *You might say that we're not speaking so much now about an artistic strategy of provocation or contradiction as about the promotion of a concept of a people. The weapons we talked about earlier should maybe at this point be called 'tools'.*

Hans Haacke Yes, I'd rather use the word 'tool' than 'weapon'!

Molly Nesbit *Swords will turn into gardening tools at this point in our interview. With DER BEVÖLKERUNG you allowed other people to choose where the soil comes from. Did you do this so it would change form in a way that you couldn't have imagined?*

Hans Haacke It's unpredictable. It's a communal project. Many opponents in the Bundestag accused me of laziness, claiming that I didn't even do my own work. But now, more than 200 Members of the Bundestag have participated, and the project has gained a degree of popularity. Looking back, it's hard to believe that it caused such a bitter national debate and that the Bundestag spent more than an hour, in full session, arguing over it. Eventually, its realization was approved by the slimmest of margins, by a vote of 260 in favour and 258 against. As I imagined, many MPs involved people from their election district in choosing where the soil should be collected from. And so it became a participatory process even at the district level. Wolfgang Thierse, the President of the Bundestag, inaugurated the project with earth from the Jewish cemetery in his district in Berlin. Several Members brought soil from the grounds of former concentration camps. There's earth from a house that had been burned down because Turks had lived there, and from other places that are relevant to the ongoing debate over residents who don't have German citizenship (currently more than nine per cent of the population). Some MPs spiked the soil with seeds. It's fantastic. Nobody knows how it will develop.

Molly Nesbit *Are you going to leave instructions for the kind of garden it will become in the future? Will it ever be trimmed or cut down?*

Hans Haacke No, no gardening whatsoever. No watering, no weeding, no cleaning, no nothing. It's to be left alone. The coming together of earth and plants from all over Germany in a building with the highest security provisions makes this is a unique ecosystem. With the soil, a host of insects, worms and snails arrived. The pigeons in Berlin have also contributed their share.

1 Pierre Bourdieu, *The Rules of Art: Genesis and Structure of the Literary Field*, Polity Press, Cambridge, 1996
2 Hans Haacke, Pierre Bourdieu, *Libre-Échange*, Le Seuil/les presses du réel, Paris, 1994. German translation: Freier Austausch, S. Fischer Verlag GmbH, Frankfurt am Main, 1995; Portuguese translation: Livre-Troca, Editora Bertrand Brasil S.A. Rio de Janeiro, 1995; English translation (American edition): *Free Exchange*, Stanford University Press, 1995; English translation (British edition): *Free Exchange*, Polity Press, London,

1995; Japanese translation: Fujiwara-Shoten, Tokyo, 1996; Chinese translation: San Lian Shu Dian, 1996; Finnish translation: Ajatusten vapaakauppaa, Kustannusosakeyktiö Taide, Helsinki, 1997

3 Pierre Bourdieu, *Foundations for a Theory of Symbolic Violence*, Les Editions de Minuit, Paris, 1970; Suhrkamp Verlag, Frankfurt, 1973

4 Pierre Bourdieu, *On the Sociology of Symbolic Forms*, Suhrkamp Verlag, Frankfurt, 1970

Mona Hatoum *Michael Archer*

in conversation
November 1996, London

Michael Archer *The basic facts of your early biography are well documented. You were born in Beirut and came to this country in 1975. Intending only to stay briefly, you had to remain because the war broke out in the Lebanon. There are a couple of things that I'd like to explore to expand that set of very simple facts. First, the way in which you have described ending up going to art college at the Slade. You've said that, finding that you had to stay, you thought you may as well go to art school. There must have been some awareness that you wanted to do that before that time.*

Mona Hatoum I have always, ever since I can remember, wanted to be an artist, and I always assumed that once I finished school I would go to university and study art. But my father couldn't support me through art school; he wanted me to study something that would get me a career and a job right away. I ended up doing a two-year graphic design course at the university in Beirut and then worked in an advertising agency for two years, where I was very unhappy. I was taking evening courses in anything available just to keep me going: drawing, ceramics, photography – quite a bit of photography. Eventually I decided to go back to the university for another two years, for a BA. It was at that point that I came to London for a break. All along I had been thinking that I would eventually come to England for a postgraduate course, in part because I had a British passport and thought it would make things easier. When I found myself stranded here I decided that I could do something with my stay and enrolled on the Foundation course at the Byam Shaw School of Art. At the time I thought that I may stay here for a year and then go back, but the war got worse. Anyway, I very soon realized that being able to visit the Tate and the National Gallery and seeing all these artworks 'in the flesh' would be an education in itself.

Michael Archer *In discussing your work, particularly your performance and videos from the early 1980s, you have pointed to the Western European way of relating body to mind and how that contrasted with the attitude in the Lebanon, where there is no straightforward split between mind and body.*

Mona Hatoum The first thing I noticed when I came here was how divorced people were from their bodies, although recently the art world has become far more preoccupied with the body. I am convinced that this is a direct result of the AIDS epidemic which has forced everyone to become aware of the body's vulnerability. Since my early performances, the body has been central to my work. Even before that I was making small works on paper using bodily fluids and body rejects as materials. I have always been dissatisfied with work that just appeals to your intellect and does not actually involve you in a physical way. For me, the embodiment of an artwork is within the physical realm; the body is the axis of our perceptions, so how can art afford not to take that as a starting point? We relate to the world through our senses. You first experience an artwork physically. I like the work to operate on both sensual and intellectual levels. Meanings, connotations and associations come after the initial physical experience as your imagination, intellect, psyche are fired off by what you've seen.

Michael Archer *Did you very quickly recognize the relevance of performance to the way you were thinking at college?*

Mona Hatoum Coming to performance was quite a gradual process which resulted from a number of coincidences. When I was at the Slade, after the Byam Shaw, the experimentation I was doing was quite dangerous. I was using 240 volts of electricity passing through a 'circuit' of metal household objects; or an electric current going through water to connect electrodes that intermittently lit up a light bulb. I could not put up these works without getting permission from security and fire officers, and very quickly got tired of all the bureaucracy. As a way out, I would put something up for a very short time – half an hour, an hour – to an invited audience. These works became like a kind of performance or demonstration. This also coincided with my new political awareness at the time. The Slade politicized me. I got involved with feminist groups, I became aware of class issues, I started examining power structures and trying to understand why I felt so 'out of place'.

Michael Archer *This sense of displacement was something you had to deal with?*

Mona Hatoum I had both to understand it intellectually and integrate it emotionally into my life. It was a time of tremendous personal struggle, turmoil and confusion. Performance was very attractive to me because I saw it as a revolutionary medium, setting itself apart from the gallery system and the art establishment. It fitted exactly the kind of issue-based work I was beginning to make.

Michael Archer *Were there examples that you followed: Stuart Brisley, say, who was teaching at the Slade then, or others such as Marina Abramovic or the Viennese Actionists?*

Mona Hatoum Of course Stuart Brisley and others, but mostly I was hanging around with a group of students who were involved in performance. In fact my first performance at the Slade was a collaboration with two other students whom I had overheard talking about an idea for a work. They were planning to perform two independent actions in the same space without prior knowledge of what the other would do. I started suggesting other things to them, like somehow intervening in the audience's space. They invited me to participate with them, and this was when I used a live video camera for the first time, to scan and annoy members of the audience while they were trying to watch the performance.

Michael Archer *You talk about becoming politicized in terms of class and gender, which were issues dealt with in a lot of people's work in this country at the time. What about the politicizing of your sense of cultural difference, something that would later become an important aspect of your work? In the late 1970s I would think someone like Rasheed Araeen was an important example. He had made the performance* Paki Bastard, *and published the first issue of his journal* Black Phoenix, *which later became* Third Text.

Mona Hatoum I wasn't aware of all that until much later. When I met Rasheed Araeen in the mid 1980s, it was a revelation. He was someone who had rationalized and theorized issues of Otherness. But long before that, for several years after leaving art college, I was involved with activist groups outside the art world which I saw as a separate activity from my work as an artist. While I was at the Byam Shaw I saw art school as a sort of haven from social and political upheaval. It was a time of formal experimentation for me, and I enjoyed every minute of it. I had a very long relationship with Minimalism at the time before starting to make work that was more conceptual. The Byam Shaw was a small and friendly place, like a big family with lots of foreign students, so I did not feel like the odd one out. The Slade was my first encounter with a large institution, and the impersonal, bureaucratic machinery that constitutes the 'institution' was totally foreign to me. I was so much at odds with that environment that I started to examine the reasons why. Getting involved, however briefly, with feminist groups started me on my enquiry about power structures. Before then, I had this very naive idea that as an artist you are part of a community of people with shared interests which somehow cut across social differences.

Michael Archer *Your dealing with the body, with the personal both as theoretically enlarged through feminism and in the physical sense you described, is evident in your work right from the beginning, even as far back as the 1981 performance* Look No Body!, *which you made while still a student at the Slade.*

Mona Hatoum With *Look No Body!* (1981) I was considering the body in terms of its orifices, and how some of the orifices and the activities associated with them are considered socially acceptable and some not. I was trying to unite the activity of, say, drinking and pissing. I should have called it *United Orifices* or something like that; it was quite humorous. I had a video monitor in the space which was connected to a live camera in the toilet. I drank cups of water and offered every other cup to the audience, hoping to incite them to use the toilet. I used it myself two or three times. Throughout the performance you could hear my voice on a soundtrack reading out a detailed scientific account of the act of pissing, or 'micturition', to use the scientific term. It was like looking inside the body while keeping the 'correct' distance from it. My accent was much more pronounced then, so trying to read all these scientific words made the whole thing quite funny.

Michael Archer *That performance also asks fundamental questions about identity. The scientific viewpoint of the soundtrack offers a certain perception of the world; one that conflicts with a very physical understanding of what, where and who one is. This concern with identity is a thread that runs through your work. In* Don't Smile, You're on Camera *(1980) you trained a video camera on your audience, relaying the image to a monitor which they could see. Out of their sight, however, you had someone mix into the signal other images of unclad body parts, both male and female. It appeared that you were seeing through their clothing and shifting their gender.*

Mona Hatoum Yes, I was doing some gender bending there, but there was also a desire to look behind the surface or beyond social constructs. In both these performances, I was also interested in the issue of surveillance and the penetrating gaze. Around the same period I made a proposal for the 'New Contemporaries' exhibition at the Institute of Contemporary Arts in London. In those days the toilets were on either side of the bookshop. I wanted to place a small monitor above each door and connect it to a live video camera trained on a cubicle in each of the two toilets. I wanted to look into the taboos around certain bodily functions, and how the body's orifices have been organized in a hierarchical structure.

Michael Archer *Did you find that there was a certain critical resistance to some of the things that you were doing, in so far as they could be construed as objectifying the body in a very negative way? In the end, for instance, your ICA proposal was rejected.*

Mona Hatoum The ICA wouldn't allow me to put it on, although it had been selected by the 'New Contemporaries' committee. I was told that the toilets are in a public space, where people have not made a conscious decision to be confronted by art – can you imagine this kind of response now? I then tried to do the same work for my postgraduate show at the Slade, but it was turned down again. So I put up a statement in my space documenting the history of the piece and how it had been censored. Because I was not allowed to use the toilets, I constructed a male and a female toilet in the main studio space, but of course there it became something else. In *Don't Smile, You're on Camera*, where I focused my live video camera on members of the audience, I was criticized for being aggressive and invasive. I was trying to make people aware of the fact that we are constantly subjected to some mechanism of surveillance – the invasive look. It was making people aware by showing an exaggerated form of surveillance. Of course, I *was* invading people's boundaries.

Michael Archer *If you do something by example you're involved in the whole process yourself: you are as gazed upon as anybody else. You are complicit and not in a position of power. Was it, however, seen as manipulative rather than as having to do with shared responsibility?*

Mona Hatoum People got up and walked out of that performance, asking me why I was doing this to them. I remember a review that described one of my works as 'another macho performance by Mona Hatoum'. At the time people were talking about the gaze being a male thing and I was insisting that it was not necessarily so. I suppose I was trying to challenge prescribed male/female roles. I have always resisted those stereotypes, and I was criticized, even by feminists at one point. I collaborated with my friend Brenda Martin in a performance which was basically about competition between women. We were both quite critical of this blanket concept of 'sisterhood', and wanted to question whether competition is an inherently male trait. We were accused by women of being publically critical of feminism.

Michael Archer These issues and preoccupations are still in a lot of what you do. I don't see a split between your early performance period and a subsequent phase in which you went on to do other things. A sense of the body, the way in which you see relationships of power, questions of gender, considerations of cultural background and placement – those things are persistently there.

Mona Hatoum Very much so, but now I'm not using a clear narrative. I'm not pointing a finger directly at one issue or another. Things are implied and not directly stated.

Michael Archer How much do you think that was just to do with the times? There was a lot of work like that in the late 1970s and early 1980s; it was the fashion.

Mona Hatoum Yes of course. In the 1980s it was possible to make didactic political statements. I think we have gone beyond obvious statements into something perhaps a bit more sophisticated and subtle. Some work of artists I admired in the 1980s – for instance, Barbara Kruger – can look quite dated now. I don't think art is the best place to be didactic; I don't think the language of visual art is the most suitable for presenting clear arguments, let alone for trying to convince, convert or teach.

Michael Archer Visual art's not didactic.

Mona Hatoum In 1988 I was invited to do an installation for an exhibition called 'Nationalisms: Women and the State' in Toronto. It was one of those times I felt I had been given an assignment because I was known as a political artist. At the time the Intifada was happening in the West Bank and Gaza, which was the biggest spontaneous demonstration of social protest or resistance that had ever taken place in that part of the world. The work had to have something to do with women and it had to deal with stone-throwing. That's what the Intifada was about: kids throwing stones at the army and getting bullets back in return, hundreds of bullets. The title was something like *A Thousand Bullets for a Stone*. I found a newspaper image of a woman confronting a soldier holding a big gun, and in the background there were these kids throwing stones at the soldier. It was perfect. I projected the image quite large on two walls and had stones scattered all over the floor. Each stone was labelled and numbered, like weapons when they are seized and displayed by the police. At least there was a bit of humour in the work, but overall I felt really unconvinced by it because the Intifada was such a strong expression of dissent or protest, and had manifested itself in so many different ways. I felt almost opportunistic using that material. For me that was really the beginning of the end of working in an overtly political way. When you present someone with a statement in an artwork, once they get it, they either agree with you or dismiss your argument and move on to the next thing – no need to look again. It was the same with black issues.

Michael Archer Even when there was much more of a sense of narrative to what you were doing, you rarely did work that was specifically directed at where you came from. You did

the performance Under Siege *(1982), which referred to the Lebanon, and later you did the video piece* Measures of Distance *(1988), which was about conversations and correspondence with your mother.*

Mona Hatoum *Under Siege* happened a week before the Israeli invasion and the siege of Beirut; it was almost like a premonition. But in general in my work at that time, I was trying to remind people that wars were still raging in many parts of the world. I say 'still' because at that time most people's energy was going into the the the anti-nuclear movement and 'keeping the peace'. They were saying, 'We've had peace for forty years and we want to keep it that way.' But that only concerned Europe. I was trying to remind people of conventional wars happening outside the West. For instance the billboard work *Over My Dead Body* (1988) touched on that, though there was also a humorous reversal of power relationships. *Measures of Distance* was really the only work where I consciously used autobiography as the text of the work.

Michael Archer You mentioned black issues just now. How useful and how restrictive was it to think about a lot of these issues of cultural difference in terms of blackness? There has been a totalizing use of that word, which can erase all kinds of differences within its scope.

Mona Hatoum At the beginning it was important to think about the black struggle as a total political struggle. There are common political forces and attitudes that discriminate against people. In the same way as feminism started off with this totalizing concept of 'sisterhood', and then we ended up with many feminisms, if you like. The black struggle became more diversified once the basic issues were established. And blackness here is not to do with the colour of your skin but a political stance. In the early 1980s I don't think I saw my practice as part of the black struggle, I was doing my own thing. I have always worked in an intuitive way and couldn't see my work as serving any group, political or otherwise. I was basically trying to deal with an environment that I had experienced as hostile and intolerant and eventually those feelings began to pervade the work – and still do. For instance, they are evident in a piece I've just made for the current exhibition at De Appel: a little doormat made of pins with the word 'Welcome' in it. It's related to a series of works made last year which had to do with carpets. Visually I find it quite beautiful, because the word 'Welcome' is made with shorter pins, so it's like a little recess within the surface of the mat. From a distance you see the word clearly, but when you get close and you look down at it, the word almost disappears.

Michael Archer The first work with that dual characteristic of being both welcoming and potentially harmful was The Light at the End, *the installation you did at the Showroom in London in 1989. The glow from vertical electric elements at the rear of an otherwise darkened space drew you towards them, until you were hit by the intense heat they gave off and realized the immense danger of the situation. Is it also true that the title – 'the light at the end' (of the tunnel) – was important for you? Was there something revelatory about doing that piece?*

Mona Hatoum *The Light at the End* was the beginning of a whole new way of working. In a sense with this work I was going back to a minimal aesthetic and working with certain material properties which amplify the concept. The associations with imprisonment, torture and pain were suggested by the physical aspect of the work and the phenomenology of the materials used. It was not so much a representation of something else but the real thing in itself. I felt satisfied for the first time that the balance between the issues, the materials and the space was just right for me. It also had this paradoxical aspect of being both attractive and repulsive. It was obscene. The space at the back of the Showroom is this strange funnel shape which made me think of a trompe l'oeil perspective of a tunnel. The expression 'the light at the end of the tunnel' came to mind and I used it in the title to set up the expectation of something positive which is then disrupted when you realize that the light was actually red hot bars that could burn you to the bone.

Michael Archer *I'm interested that you mention Minimalism, because it also seems to me that your more recent work clearly pulls that back in. I'm thinking, to mention a few, of the very spare white installation at the South London Art Gallery in 1993, with the glass swings hung very close together; or the form of a piece like* Socle du Monde *(1992–93); or the mats you just mentioned; or the glass bead floor piece.*

Mona Hatoum I like to explore the sensuousness of materials and use them to create an emotional charge, if you like. In *A Couple (of Swings)* (1993) I feel that the elegance and coolness of the swings makes the tension of an impending disaster – they could swing towards each other and smash to pieces – even greater. *Socle du Monde* is a very good example because it was specifically a reference to the archetypal form favoured by Minimalism, the cube. But instead of it having a machined, clean surface, untouched by human hands, I wanted to turn this upside down and make it very organic. The strange furry texture on the surface gives you a moment of anxiety because when you first see it you don't immediately recognize the material.

Michael Archer *The turning upside down, which refers to Manzoni's gesture in his original 1961* Socle du Monde, *is allied to turning inside out. In your* Socle, *the way in which the iron filings cluster on the cube's magnetic surface make it look visceral: like intestines, or the brain.*

Mona Hatoum I was commissioned to do that piece for an exhibition in Montréal called 'Pour la Suite du Monde'. First I thought, 'Here we go again, they want me to make a political statement about the state of the world.' I was resisting doing something very obviously political, but in fact they seemed to have a very open-minded attitude about what constitutes a political statement. They had invited artists like Hans Haacke, Alfredo Jaar and Adrian Piper, but also less political artists like Giuseppe Penone, for example. So I decided to make this piece which referred to the world put on a pedestal, but a pedestal that might have been eroded by some kind of disease and so had lost its stability. At the

same time it was an excuse to play with this intriguing and beautiful material. When I made *Socle du Monde* and saw those meandering shapes that looked like intestines, I decided to make a carpet with the same pattern of 'entrails', which I called *Entrails Carpet* (1995). I thought it would look quite repulsive and I wanted to contradict that by using a seductive material. While researching another piece a year or so later, I had a lot of rubber samples sent to me. One was this translucent, almost opalescent silicone rubber, and I knew that would do it.

Michael Archer *Does it sometimes happen that you light upon material and say simply, 'I'd like to work with this stuff'?*

Mona Hatoum Yes. But it is more that I recognize certain properties in a material I come across, that I feel would work for certain ideas I've had in the back of my mind for a while. Sometimes it is the space that triggers certain associations, or sometimes the possibility of using certain local materials and crafts inspires the work.

Michael Archer *Like those glass beads you used in the installation in Rome?*

Mona Hatoum Oh yes. I was in Rome trying to work out ideas for a piece, and I kept coming across marble everywhere. It made me wonder whether the marbles kids play with were called that because they were originally made of marble. Also, the gallery space at the British School at Rome had a very busy herringbone-patterned floor, which I did not like very much. I started thinking of covering the entire floor with marbles made out of Carrera marble, like a carpet, but that turned out to be very expensive. A few weeks later, I came across these transparent ones which had the additional quality of reflecting the light beautifully. So they looked very seductive but at the same time they created an unstable surface on which you could slip and fall.

Michael Archer *You have been collecting your hair for a long time.*

Mona Hatoum A very long time. Sometimes an idea develops over a long period of time before it finds a 'home', so to speak. The hair balls that ended up in *Recollection* (1995) were collected over a period of six years. I made one accidentally when I was staying at a friend's place in Cardiff in 1989. I had just started my job there. It was the hair that came off my head in the bath. I didn't want to leave it behind, so I picked it up and was playing with it absentmindedly, rolling it in my hands. It was a perfect ball, very cocoon-like. It was beautiful. I decided to collect them without any specific idea of what I would do with them. I made a hair ball every time I washed my hair and they ended up in shoe boxes under my bed. When I saw the space in Kortrijk I felt that this was the time to use the hair balls, partly because the space had been occupied by women. I visualized the hair balls as dust balls that gather in the corners of rooms. Similarly, I had been looking for an excuse to use heat for about three or four years before I made *The Light at the End*. I had seen the work by Calzolari which used ice in 'The Knot', a fantastic Arte Povera

exhibition at P.S.1 in New York in 1985. I still think that is the most brilliant exhibition I have ever seen. It was a major experience for me. When I saw that work, I thought, it would be nice to make a work using heat. I find it difficult to build pieces for no specific reason. You know this little idea for the doormat? I had this idea before I made the big pin carpet or the prayer mat, but I had no specific reason for making it until I saw the space at De Appel. They have a room that looks like a living room with a narrow doorway, and I thought it would look good just inside that doorway. That was the incentive to make it.

Michael Archer Visual welcoming and the contrasting physical danger recur in your work, like in your installation at Mario Flecha Gallery in London in 1992. The wires strung tautly across the space guided the viewer in a very helpful way, yet if you strayed slightly off the path you would cut your ankles, groin or neck. This sense of danger comes up again in the visually provocative baby cot, Incommunicado, *where the mattress base is made from cheese-slicer wire.*

Mona Hatoum The Mario Flecha installation was an instance where I felt that the balance between beauty and danger was taken to an extreme. It looked like an effortless drawing in space, almost ethereal but also quite lethal. Every aspect of life is full of contradictions: some people think that aesthetics and politics don't mix, but that's ridiculous. When I moved into the studio in Cardiff I had this vast space with nothing in it. The first thing I did was to stretch these wires across the space. The Mario Flecha Gallery gave me the perfect opportunity to use this idea two or three years later. I see furniture as being very much about the body. It is usually about giving it support and comfort. I made a series of furniture pieces which are more hostile than comforting. *Incommunicado* (1993) is almost like an imprisoning structure, with its cold metal bars. I replaced the solid platform that would have supported the mattress with taut cheese wires.

Michael Archer There was also a chair, Alive and Well (1990), *which used electric elements.*

Mona Hatoum Don't remind me of that! For a couple of years after I made *The Light at the End* (1989) no one wanted to show anything else. It was made as a site-specific piece for the space at the Showroom and I never, ever thought of it going anywhere else. The curators of 'The British Art Show' insisted that I reproduce it for the tour rather than make new work. But then it became something else, because putting it into the museum it had to have all the security devices to make it childproof, foolproof, everything proof. I was working on elements of *Light Sentence* and *Short Space* (both 1992) in my studio in Cardiff, but no one was interested. I made *Alive and Well* as a sequel to *The Light at the End*, but I didn't think it worked. I think it was a bit too obvious.

Michael Archer The piece with the two chairs is intriguing, the big chair with the little chair butted up against it. Why is it untitled?

Mona Hatoum I didn't give it a title because I wanted to keep it open. That was actually one of my first furniture pieces. I had made the two very large installation works, *Light Sentence* and *Short Space*, for an exhibition at Chapter in Cardiff. I saw the large-scale pieces as referring to some kind of institutional violence. I wanted to place another piece in the space between them which dealt with the same ideas but on a more personal, domestic level. It was referred to as *Mother and Child*. The two chairs have an unequal but inescapable relationship. They are very angular, cold and cage-like, but at the same time there's a symbiotic relationship between them because they are so similar.

Michael Archer Light Sentence *seems to be a grand refusal of any possibility of fixing a particular meaning, of saying 'This is about this.' The whole thing is so utterly mobile: the scale changes, the relationship between the viewer and the elements of the work – the light source and the walls of cages between which one can stand – constantly shifts. The manner in which the shadows of these cages are thrown onto the walls by the slowly moving light bulb makes them both hugely threatening and insubstantial. The work goes through all the things we have talked about so far and beyond.*

Mona Hatoum I'm happy to hear you say this, because most people look for a very specific meaning, mostly wanting to explain it specifically in relation to my background. I find it more exciting when a work reverberates with several meanings and paradoxes and contradictions. Explaining it as meaning this or that inevitably turns it into something fixed rather than something in a state of flux. Years after making this work, I still discover interesting associations, sometimes pointed out to me by viewers.

Michael Archer *Following* Short Space *and* Light Sentence *at Chapter (1992), and* Socle du Monde *in Montréal, you did* Corps étranger *for the Centre Pompidou in Paris (1994). This endoscopic exploration of the body brought forward concerns explored in the performances we talked about at the beginning.* Look No Body! *included the sound of the heartbeat and the noises of the body; the gaze of* Don't Smile, You're on Camera *is here sharpened so that it can penetrate not only clothes but also skin and flesh. Was the Pompidou show an opportunity to realize an idea that you actually had had that far back?*

Mona Hatoum Yes, it was exactly that: a piece that I had shelved because nobody would take me seriously. As a student at the Slade, I thought I was entitled to hassle the doctors at the University College Hospital across the road. They wouldn't do the endoscopy on me, but I managed to get a sound-recording of my heartbeat and stomach rumbles, which I used in *Look No Body!* and eventually in *Corps étranger*. It only became possible to make this work when the Centre Pompidou commissioned me to produce it. Without their influence and financial support I would never have been able to make it. So *Corps étranger* was a very old idea, but there are a lot of old ideas that keep coming up in different ways. There are different strands in my work that develop over a long period of time and keep coming in and out of focus. For

example, I've recently made a piece related to *Light Sentence*, because that work is 'still there' in my mind. Certain works I made as a student were about the dispersal of the body, and this is now coming up in works like *Recollection*. I used to collect all my nail parings, pubic hair, bits of skin and mix them with pulp and bodily fluids to make paper: a kind of recollecting of the body's dispersals, if you like. Pubic hair I had collected all these years ago ended up in a much later work, *Jardin Public* (1993). There is a triangle of pubic hair that looks like it is growing out of the holes in the seat. Incidentally, this work was the result of discovering that the words 'public' and 'pubic' come from the same etymological source. Some of my current work represents the maturing of ideas from many years ago; ones that I could not articulate at that time without relating them directly to their sources – a news item, or even a childhood memory – like a kind of illustration.

Michael Archer *Tell me about working in Jerusalem.*

Mona Hatoum Going to Jerusalem was a very significant journey for me, because I had never been there. My parents are Palestinian. They come from Haifa, but have never been able to go back since they left in 1948. Jack Persekian, who has this little gallery in East Jerusalem, and I had been discussing the possibility of doing the exhibition there for over two years. I kept postponing it because emotionally it's a very heavy thing, and I wanted to be able to spend a whole month out there, producing the work.

Michael Archer *What work did you do when you were there?*

Mona Hatoum I ended up making about ten works. I made three installations and a number of photographic works and small objects. The ideas I had proposed beforehand seemed to be about turning the gallery into a hostile environment, but the environment outside was so hostile that people hardly needed reminding. On my first day in Jerusalem I came across a map divided into a lot of little areas circled in red, like little islands with no continuity or connection between them. It was the map showing the territorial divisions arrived at under the Oslo Agreement, and it represented the first phase of returning land to the Palestinian authorities. But really it was a map about dividing and controlling the area. At the first sign of trouble Israel practises the policy of 'closure'; they close all the passages between the areas so the Arabs are completely isolated and paralysed.

When I first came across it, I had no intention of using it, but a week later I decided that I would like to do something with this local soap made from pure olive oil, and the work came together. Originally I was going to draw the outline of the map by pushing nails into the soap, but it looked quite aggressive and sad. I ended up using little glass beads which I pressed into the soap. The piece is called *Present Tense* (1996); it's about the situation as it was then. Now, with the change in government, some of those areas are not being returned to the Arabs. The Palestinians who came to the gallery recognized

the smell and the material immediately. I saw that particular soap as a symbol of resistance. It is one of those traditional Palestinian productions that have carried on despite drastic changes in the area. If you go to one of the factories in Nablus, the city north of Jerusalem which specializes in its production, you feel you have stepped into the last century. Every part of the process is still done by hand, from mixing the solution in a large stone vat, to pouring it on the floor, to cutting and packing it. I also used it because of its transient nature. In fact, one visitor asked, 'Did you draw the map on soap because when it dissolves we won't have any of these stupid borders?'

When the exhibition opened and Israeli people came from Tel Aviv, they started reading a reference in the soap to concentration camps. This couldn't have been further from my thoughts. Those two readings of the work give you an idea of the very different backgrounds and histories of the two cultures trying to co-exist.

For another piece I brought into the gallery a metal bed which I'd found in the street. I attached castors to the legs and then proceeded to immobilize it by tying it down to the floor with fishing wire. The wires were invisible, you almost tripped on them before you saw them. I called it *Lili (Stay) Put* (1996). I was having fun with the titles. One visitor said it felt just like their situation, that everything is trying to push them out but invisible threads tie them down. I was impressed that he'd made the connection between an inanimate object and his situation.

Michael Archer *So someone who knows nothing about Conceptualism or Minimalism won't necessarily see some of the formal resources you are employing. You've said similar things about the performance you did in Brixton, where you walked around with Doc Martens boots tied to your feet. There was a directness of perception amongst the passers-by which suggested that people knew exactly what was happening.*

Mona Hatoum Yes, because that was another instance where I was performing for an uninitiated audience – passers-by – and addressing issues that they experienced in their everyday life: police presence and surveillance.

Anyway, the saddest thing in Jerusalem was the policy of 'closure' that restricted movement for the Arabs. I gave a piece the title *No Way* (1996) as a response to that. It was a large spoon I'd found full of holes, and I decided to block all of them with nuts and bolts. At the same time it became an uncanny and threatening object, like a weapon. I have since made another version of it.

Michael Archer *The colander.*

Mona Hatoum Yes, *No Way II* (1996). I did another residency this year which was extremely inspiring. I spent a month at a Shaker community in Maine, the last remaining Shaker community. It is a small community of only eight members. There was this wonderful, settled feeling of warm domesticity in the place, so household objects became my focus. I did some rubbings of colanders which the community had made by hand in the 1830s. I had fun

knitting and weaving with spaghetti and pasta and making miniature baskets. I like turning up at a place and letting myself be inspired by the situation. After being with the Shakers and making very discrete little objects, I then went to San Francisco for another residency at the Capp Street Project, where I had to deal with a very large space that required a bold statement – not quite what I felt like doing at that time.

Michael Archer *Big things?*

Mona Hatoum Yes. These days I feel drawn towards making works like *Recollection* with the hair, or even those little objects I made at the Shaker community. I feel it is more appropriate for our times. People have become more aware of the body's fragility, and the work has become more humble in a sense.

Michael Archer *They occupy space by giving a sense of the activities of people living in and using it, rather than by physically imposing themselves.*

Mona Hatoum The redeeming factor in the Capp Street installation was its simplicity. In a sense it is similar to *Light Sentence*, which is quite spectacular but very simple. Neither of these works are about the glorification of power structures, but rather a critique of those dehumanizing institutions and their effect on our existence.

Michael Archer *It's a square enclosure of wooden 'cages' which is empty in the middle.*

Mona Hatoum There were four very imposing wooden columns interrupting the space. I had somehow to integrate them into the work, so I constructed an enclosure of wooden cages between them. Every cage had a light bulb lying at the bottom, and I used a computerized device which dimmed the light bulbs on and off in a quick, random sequence. I amplified the buzzing sound of the sixty-cycle current going through the light bulbs. There was something unsettling about it because there was such chaotic and mad activity within the regimented structure of the cages. It felt as though it was about to self-destruct. It's called *Current Disturbance* (1996).

Michael Archer *Do you think the humbleness you speak of is something particular to you or do you sense that it's more widespread?*

Mona Hatoum It is a feeling I have been picking up for a while.

Michael Archer *Do you want to say anything else?*

Mona Hatoum It is refreshing to be interviewed without once being asked to explain my work in relation to where I come from. Most people who interview me seem to have this journalistic attitude that wants to explain or validate my work specifically in relation to my background.

Thomas Hirschhorn *Alison M. Gingeras*

in conversation
October 2002, Paris

Alison M. Gingeras You first trained as a graphic designer, and later decided to abandon design to become an artist. How did that choice relate to your vision of artistic practice, which is very much engaged with notions of political commitment, and which questions the role of the artist–activist?

Thomas Hirschhorn It was a difficult choice for me. I studied at the Schule für Gestaltung (School of Design) in Zurich. There was no proper art department, nor was it a school of applied arts like the École des Arts Décoratifs in Paris. The educational philosophy at the school was inspired by the principles of the Bauhaus, but in a degenerate and rather deviant version. Of course, it was neither the Bauhaus, nor the Ulm School, yet it adopted the precepts of both. As theorist Thierry de Duve pointed out in his book *Nominalisme Picturale* (1984), the very name Schule für Gestaltung implies these two affiliations, both practical and theoretical. It's important for me to stress this point, because the teaching at the school was generalized: the vague and the unsaid dominated the official discourse. Our training positioned us against the advertising industry, yet our teachers were great Swiss-German graphic designers who had worked in advertising. None of my fellow students wanted to work in advertising, but everybody knew that 95 per cent of job opportunities were in this field. We learned a great deal about the legacy of the Bauhaus, and we were taught about the history of graphic designers, fashion designers, architects and artists. I was fascinated by Russian revolutionary artists – Malevich, Rodchenko, Tatlin, Klutsis, El Lissitzky, Popova and Stepanova – who are still very important for me. So this was my foundation at that school, with all its intellectual vagueness, the things it left unsaid, its equivocations and institutionalized ambiguities.

Alison M. Gingeras But I would imagine that the school's hybridity was an important early lesson for you. I'm thinking specifically of an education about art that also included a philosophy of its use-value.

Thomas Hirschhorn In the midst of all that ambiguity, I always really wanted to be a graphic designer. My goal was clear. I was attracted to the use-value of the graphic designer's work. My friends wanted to become artists: they painted, they drew, they sculpted, and some actually did become artists. I didn't share their vision at this time, so I refused to take certain art classes, particularly those devoted to drawing and painting. Despite the school's philosophy, I wouldn't take those courses because I thought that as a graphic designer you didn't need to know how to draw or how to make a sculpture. An old Bauhaus principle stated that everyone had to know how to draw a pack of cigarettes. I figured there was no need to draw a pack of cigarettes – you could take a photograph.

Alison M. Gingeras When you left school, did you intend to give a political dimension to the profession of graphic designer?

Thomas Hirschhorn I really wanted to work with existing images, with photographs, with texts, with forms. I wanted to find a way to confront an audience directly with my

work. I wanted to work for a cause or an idea that I agreed with, to which I had a commitment. It was then that I started to claim that I was a 'graphic designer for myself' – that is to say a graphic designer who doesn't work on commission, but creates for himself, independently, but also for others. To me this wasn't a contradiction. When I attended a lecture in Zurich given by Grapus, a collective of politically engaged graphic designers from Paris, I was impressed by their posters for the Communist Party, the CGT (Confédération Générale du Travail, or Workers' Union) and cultural events in Paris. I wanted to go to Paris to work with Grapus and make posters, prospectuses, brochures. I wanted to make images with an immediate impact, to address a street public. But I thought I didn't need anyone to commission them; I wanted to create on my own.

Alison M. Gingeras *You thought you didn't need clients?*

Thomas Hirschhorn Yes. That's where this notion of 'graphic designer for myself' came from. Of course, I was completely out of touch with reality, and that's why I spent only half a day with Grapus in their studio, in spite of all the admiration that I had and continue to have for them. I realized that they too were executing the wishes of clients, even when these wishes came from the Communist Party or the Workers' Union. It was an ordinary creative graphic-design studio with its own hierarchies and clients.

Alison M. Gingeras *They were working with the commercial model of the capitalist system. Was that the start of your disenchantment with being a graphic designer?*

Thomas Hirschhorn I started to question what to do, how best to use my forces and strengths. I was interested in working with two-dimensional forms, and thinking of how to put together existing pictures, how to design forms, cut text, crop photographs. But I dropped the idea of a being a graphic designer, living in Paris and working for myself, because I realized that graphic designers are the servants of someone else.

Alison M. Gingeras *As a graphic designer, you are essentially someone who provides a service?*

Thomas Hirschhorn To be a graphic designer means not to be totally free and absolutely responsible for what you do. I wanted to be a graphic designer for political reasons. I wanted to be free, and responsible for my work. I wanted to be the sole author of my work. I needed a lot of time to figure that out; it was the beginning of my quarrel with graphic design. I felt I was at a dead end.

Alison M. Gingeras *So you were trying to create visual form that had use-value, not some sort of aesthetic value?*

Thomas Hirschhorn Yes, but no one was commissioning it, no one was interested in it and I didn't have any audience to communicate with.

Alison M. Gingeras *What happens to a graphic designer with no clients? Perhaps the ambiguity that this dilemma posed made you start thinking about making art.*

Thomas Hirschhorn I couldn't resolve this dilemma by talking with other graphic designers. They were no help to me, because as far as they were concerned art was defined by painting and sculpture. I had to find a way out of this cul-de-sac for myself. At this time I became more familiar with the work of Hans Haacke as well as that of Barbara Kruger – both of whom I found interesting. Their approaches were close to those of graphic design.

Alison M. Gingeras *Yet their work was in a different context.*

Thomas Hirschhorn I realized that I was almost the only person in my circle of peers familiar with this kind of art. I particularly remember an exhibition by Hans Haacke at the Centre Georges Pompidou in Paris. His exhibition was running simultaneously with a conference on graphic design there; the graphic designers in attendance hadn't even gone to see the exhibition. I was shocked! I was the only one who had seen it. There I was, in the milieu of Parisian graphic designers, isolated. I had support from my friends at Grapus who did appreciate my way of thinking, but ultimately I was on my own because they weren't interested in Haacke's work or other works of art.

Alison M. Gingeras *Was it then that you began to question a political commitment based only on negation and denunciation? I recall you telling me on another occasion that there was a climate of suspicion about art in your circle. There was a consensus that art was reactionary and mainstream.*

Thomas Hirschhorn Yes.

Alison M. Gingeras *At the same time, it seems you maintained a certain pragmatism in this early period of questioning. Perhaps this pragmatism came from your training, imbued as it was with the ideas of the Bauhaus. While you were eager to question the commercial models specific to graphic design, you were simultaneously trying to find a different political or critical model, one that wasn't based in Marxist ideology, in negative dialectics.*

Thomas Hirschhorn I realized I had to make a decision. I went on seeing exhibitions and reading about art. I had no quarrel with the world of art – I was just outside of it. I'd seen the work of Joseph Beuys and Andy Warhol, who had both impressed me a lot, but I was still stuck in my dilemma.

Alison M. Gingeras *So it sounds like this was the turning point in your work. When did you shift roles, and begin to feel comfortable with the notion of being an 'artist'?*

Thomas Hirschhorn Basically my transition to 'artist' took place over several years. First of all I had some important encounters – not with artists, not with graphic designers, but with intellectuals. However brief these encounters were, they put me in contact with people who helped me to take my trajectory seriously. They helped me to understand that my choice was political, not artistic, that I was refusing to become an artist for confused reasons. I was denying art on the grounds that I found it too navel-gazing or too technical. The fact

was that I simply found art too formalistic. I realized that I had to make the choice to be an artist because only as an artist could I be totally responsible for what I did. The decision to be an artist is the decision to be free. Freedom is the condition of responsibility. I realized that to be an artist is not a question of form or of content, it's a question of responsibility. The decision to be an artist is a decision for the absolute and for eternity. That has nothing to do with romanticism or idealism, it's a question of courage.

During times of crisis, people often need to look for role models. In my time of crisis, I read about artists – Joseph Beuys and Andy Warhol in particular. I also read about Otto Freundlich and Piet Mondrian. These were artists who had spent their lives being true to an initial idea. Their work wasn't just to do with formal concerns. The best example for me was Warhol. I'd seen the exhibition at the Fondation Cartier, Jouy-en-Josas, 'Andy Warhol System: Pub, Pop, Rock' (1990). It was at that point that I understood that throughout his whole life Warhol remained true to what he had been at the outset. He never deviated from this initial approach. This said a lot to me. He understood that he didn't have to be either a painter or a sculptor; he understood that commercial graphic design fell under the heading of 'illustration'. Having grasped that, he just developed, repeated, industrialized. It was that understanding that gave his work all its formal strength, and introduced a critical dimension.

Alison M. Gingeras *Warhol's work also revealed a sense of humour. He had a conflated view of the notion of high and low culture, such as you developed in your own work later on.*

Thomas Hirschhorn That's why Warhol is important to me. He stayed true to that little drawing of shoes that he had coloured in gold. His approach helped me when I was questioning myself. When I made the decision to become an artist, and to break with the world of graphic design, I understood that from that moment onwards I had to stay true to what I was looking for. I chose to be liberated from the constraints of format, material and support.

Alison M. Gingeras *From your very first works up to now, you've questioned the categories of 'sculpture' and 'installation'. You often use the term 'display' to describe your first artworks. It seems this was a bridging term between your work as a designer and that as an artist. Works such as* Fifty-Fifty *(1993) or* Très Grand Buffet *(1995) fall into this category: they're essentially two-dimensional pieces that combine text, image and flat objects. Is that a kind of continuity with your earlier principles, now displaced into another context?*

Thomas Hirschhorn From the moment I worked on a sheet of paper, on cardboard, or on other easily available materials, I wanted to do it with a two-dimensional spirit. This implies that I can look at it from all directions, that it can be turned any way up, that there's no directed reading. I wanted to do a three-dimensional work in a two-dimensional spirit – not to think about the volumes. I was never interested in volumes, weights or the dynamics of forms.

Alison M. Gingeras *But it also acquires the status of an object?*

Thomas Hirschhorn It becomes something else, like a map. All of a sudden another dimension appeared – not a dimension that I had created, but a dimension that made a vision possible. That's why my earliest works, such as the 'displays', were conceived as though they were being perceived by a pilot in a plane, who can make out shapes from above the earth. In fact, it was a post-post-supremacist vision. As my ruminations on the question of how to show my work became urgent, I understood that I was abandoning the format of the A4 page, books and other elements of graphic design to which I had at first limited myself, while also making a clear choice not to make drawings or paintings. I still had to come up with an alternative to these. This is where the idea of the 'display' or 'lay-out' presented itself: how to present my work, not like a product or as an object, but something in process. I borrowed these terms from graphic design so as not to refer to the history of painting or drawing. The term is supposed to indicate something other than a finished product. When I say 'display', it's something banal, unspectacular, like something in a shop window that's just put there. At the same time, you can also look at a shop window from behind, from all sides.

Alison M. Gingeras *If I've understood correctly, this early work could be read as a partial critique of the autonomy of sculpture, as well as the term 'installation' – which has dominated recent art practice, often replacing the category of sculpture. But this critique was born out of a genuine pragmatic drive: your desire to be faithful to your beginnings as well as to a certain aesthetic that was part of both your graphic and artistic practice.*

Thomas Hirschhorn I was visiting galleries and museums, and already had a critical attitude towards the 'white cube' and towards glorified, mystified artworks and the means of displaying them. I always hated a certain way of presenting artworks that aims to intimidate the spectator. Often I felt myself excluded from an artwork by the way it was presented. I hate the suggested importance of context in the presentation of artworks. From the outset I wanted my works to fight for their own existence, so I wanted to put them in a difficult situation. My early works were intended to be a critique of what I was seeing; I didn't want to imitate what I was criticizing, I wanted to try another way.

Alison M. Gingeras *This brings me to the question of the materials you consistently use in your work. From the very beginning through to your most current works, you've used banal and ephemeral materials such as cardboard, packing tape, aluminium foil, Plexiglas. Looking at your vocabulary of materials, it's tempting to project the notion of 'precariousness' on your works. These materials are all very cheap; they share a functional role in our society as 'wrappings' for commercial merchandise that ultimately becomes the refuse of consumer society. Was the choice of these materials essentially pragmatic? Was it part of the struggle that you wanted to set up in relation to the status quo of the art world?*

Thomas Hirschhorn The issue of the choice of material is political but it's also pragmatic. Joseph Beuys said, 'I work with what I've got, what I find around me.' In my case, I don't have fat or felt, I don't have sandblasted glass around me; nor am I surrounded by gold and marble. I haven't got a big light box. What I've got around me is some packing tape; there's some aluminium foil in the kitchen and there are cardboard boxes and wood panels downstairs on the street. That makes sense to me: I use the materials around me. These materials have no energetic or spiritual power. They're materials that everyone in the world is familiar with; they're ordinary materials. You don't define their use in advance; they aren't loaded. There's no doubt, no mystery, no surplus-value. I have to like the material I work with, and I have to be patient with it. I have to like it in order not to give it any importance. And I have to be patient with it in order not to give myself importance either.

Alison M. Gingeras *You can't project a mythology on to them, unlike with Beuys' use of fat?*

Thomas Hirschhorn These are materials that don't require any explanation of what they are. I wanted to make 'poor' art, but not Arte Povera. My work has nothing to do with Arte Povera. Because it's poor art, the materials must be poor too: quite simply, materials that make you think of poverty. To make poor art means to work against a certain idea of richness. To make rich art means to work with established values; it means to work with a definition of quality that other people have made. I want to provide my own definition of quality, of value and richness. I refuse to deal with established definitions. I'm trying to destabilize them. I'm trying to contaminate them with a certain non-valuable aspect of reality. The value system is a security system. It's a system for subjects without courage. You need values to ensure yourself, to enclose yourself in your passivity and anxiety. You need the idea of quality to neutralize your proper freedom: the fact that it's you who decides what's valuable or of worth. People need quality as a kind of ghost who helps you escape the real. To make poor art is a way to fight against this principle. Quality, no! Energy, yes!

Alison M. Gingeras *So the reference to 'poverty' in your work operates on many levels. The association, for example, with the homeless person on the street corner who builds a little cardboard shelter – is that a deliberate and direct reference in your work too?*

Thomas Hirschhorn All of the materials I use have some local or vernacular usage: the aluminium foil you see in rural discos; the photocopies you see stuck up on university noticeboards; the packing tape you see everywhere; the wood and cardboard I can find on the street; the cheap reusable paper is very common. All those possible associations – from drugs bagged up in plastic and tape, to the cheap suitcase that bursts at the airport and which you quickly tape up – all those local or vernacular references are deliberate. It's a political choice.

Alison M. Gingeras *In this context, I've always thought that an exclusively political reading of your work neglects an important part of your practice. Despite the absence of mythology*

in the materials you use, they nonetheless help to underscore the self-effacing, humorous perspective that you have with regards to your role as an artist. An example of this is one of your earliest works, the performance entitled Jemand kümmert sich um meine Arbeit *(1992; Someone Takes Care of My Work). You placed a number of your sculptural objects on the sidewalk, and then documented the sanitation workers throwing them in the bin. By placing these works in an awkward position – where it was very hard to differentiate them from the general garbage – was a laconic way of positioning yourself as an artist.*

Thomas Hirschhorn I said to myself, 'If my works are like canvases by Picasso abandoned on the street, perhaps the passer-by won't throw them away. He might say, "That's beautiful, I'll take it home and hang it up, it's like a Picasso and it's valuable." He might say that – or not.' At that time my works had no market value – in fact, these works come from a series that I still own. But what I'd put on the street wasn't exactly rubbish either. My aim wasn't to put the person who came across the work to the test. Instead my idea was to hold an exhibition with active spectators, hence the title. Filming the action was like documenting an exhibition. Even if everything ended up in the bin, it was the same as exhibiting in a gallery or a museum to me.

Alison M. Gingeras Just as humour is an agent that activates the political meaning of your work, I wonder if the recurrent use of collage is also intended to emphasize a political will? Your collages articulate very clear political commentaries, without being devoid of humour. They also seem to refer to the politicized tradition of collage in art history, in artists such as John Heartfield and Aleksander Rodchenko, whom you doubtless studied in art school.

Thomas Hirschhorn Collages, from those of Heartfield to those of Kurt Schwitters and others, made a big impression on me, mainly because those artists worked only with what they had within reach. I always liked making collages. I liked bringing together what shouldn't be brought together. The stronger the contrast, the better it was. I liked that material constraint and I liked the easiness of making collages. I liked their 'stupidity'. I tried to ensure that the message was immediately apparent. As students we were always encouraged to go beyond the Rolls Royce juxtaposed with the hungry Third World child. It took me a long time to understand that the really important thing was the Rolls Royce juxtaposed with the hungry Third World child! The action of putting together two things that have nothing to do with each other is the principle of collage – that's where the politics lies. In today's society meaning is diluted by an overload of information as well as the tendency to over-explain everything. We're getting further away from the Rolls Royce and the hungry Third World child. There are examples in Heartfield's work that showed the same direct, brutal juxtaposition process. Heartfield said, 'Use photography as a weapon.' But if it is a weapon, you can blow your own head off with it – it's just as dangerous for you. You can define philosophy and art as the search for your weapon. It's a question of how to arm yourself while

fighting against the established power. Philosophy and art are *machines de guerre*. I like this. A war machine is a tool with which to struggle for freedom, to territorialize yourself, to get out of the whole shifty art, culture, power system. There's nothing new, no creation, no action without this *machine de guerre*. Art and thinking result in permanent self-mutation, self-deconstruction and self-mutilation. You have to overtax yourself again and again.

Alison M. Gingeras *Can you talk about the moment you decided to exhibit your works in a public space?*

Thomas Hirschhorn At that time I was having discussions with friends who were very critical of the 'system', of museums and of galleries.

Alison M. Gingeras *I can imagine that the assumption was that the art shown in those places were corrupt a priori.*

Thomas Hirschhorn They were preoccupied with the fact that art in galleries and museums had become institutionalized. From the moment I decided to be an artist it was clear that, along with my choice of materials, how and where I presented my work would be important. I realized that, as an artist, I'd have to show my work in museums and galleries. But I also tried to show it in public spaces or in alternative galleries or in squats, in apartments, in the street. I wanted to be responsible for every side of my work. That's what I call 'working politically', as opposed to 'making political work'. I wanted to work at the height of capital and the height of the economic system I'm in. I wanted to confront the height of the art market with my work. I work *with* it but not *for* it. Overall I confront people with my work both in the museum and on the street. From the very beginning I've tried to head in these different directions simultaneously. The work comes first; where to exhibit is secondary. This is my guideline. Of course, early in my career I wasn't given the opportunity to show in a museum or a gallery anyway, but I did exhibit in public spaces. I've made more than forty projects in public spaces, so my work hasn't moved from the public space to the museum, nor from the museum to the public space, but towards all these places at the same time.

Alison M. Gingeras *So you have no sense of a hierarchy in terms of exhibition spaces and opportunities?*

Thomas Hirschhorn I do hate hierarchy, every hierarchy. In discussions with other artists, I've always felt quite alone with this position. In the alternative venue called Zonmééé, in Montreuil, where I worked for a while, there were many discussions about hierarchies, strategies and about fighting against the museum, the system, the market, the institution. I never really understood the critique of the institution. It's important to stress that I've never based my work on institutional critique or the critique of commerce. I don't want to fight *against*; I want to fight *for*. I want to fight for my work. And through my work I want to confront the audience, criticism, the market, the institution, the system, the history, but it isn't an end in itself.

Alison M. Gingeras	This brings us to a notion that recurs in all your works. It seems that you systematically integrate a certain form of struggle in your art. But there must be a difference between the way struggle is integrated in a work conceived for public space and a work conceived for a closed space, a commercial space or a museum context. Can you talk about strategic and formal changes in the conception of your work in relation to context?
Thomas Hirschhorn	There is no change. There are basically things that work better in a museum or in a gallery or on the street. For example, in public space the 'precariousness' you mentioned is more intense because the project is subject to weather and vandalism. But for me it's only about scale; inside the museum is almost equally as precarious as outside on the street. After all, the Egyptian pyramids are precariously out in the open! I like this term 'precariousness' – my work isn't ephemeral, it's precarious. It's humans who decide and determine how long the work lasts. The term 'ephemeral' comes from nature, but nature doesn't make decisions.
Alison M. Gingeras	We're not talking about Process art.
Thomas Hirschhorn	No. That's another reason why I don't use different materials in the public space and the museum. The public doesn't change. For me, the context doesn't change the work, because I want to work for a non-selected audience. What changes is the opening hours. In public space, the exhibition is open twenty-four hours a day.
Alison M. Gingeras	Yet I've noticed a sort of evolution or shift in the works you make for public space. For example, earlier works such as Skulptur-Sortier-Station in 1997 at the Skulptur Projekte Münster, or VDP – Very Derivated Products at the Guggenheim SoHo (New York, 1998), or the work in Bordeaux, Lascaux III (1997), all took the form of closed structures, or 'vitrines', that the public could look into but not physically enter. Some of your more recent works, such as the Bataille Monument for Documenta 11 (2002), or the project in Aubervilliers, the Musée précaire albinet (2004), are structures that the public can use, enter, occupy and animate.
Thomas Hirschhorn	In my two last public-space works, the Deleuze Monument (2000) and the Bataille Monument, there is certainly a development. Clearly there's a difference between a piece like Travaux abandonnés on La Plaine-Saint-Denis (1992) and the Bataille Monument in Kassel. The difference is the scale on the one hand and the possibilities of implication for spectators on the other. But I'm not an animator and I'm not a social worker. Rather than triggering the participation of the audience, I want to implicate them. I want to force the audience to be confronted with my work. This is the exchange I propose. The artworks don't need participation; it's not an interactive work. It doesn't need to be completed by the audience; it needs to be an active, autonomous work with the possibility of implication. With projects such as the Deleuze Monument and the Bataille Monument I wanted to multiply the possibilities of implication. Before, when I made larger-scale works – I'm

thinking of the work that I made in Langenhagen, the *Kunsthalle Prekär* (1996), the *M2-Social* in Borny (1996) and later the *Skulptur-Sortier-Station* in Münster and Paris (1997) – I was creating closed structures. There was no possible implication for the spectator other than thinking – which is of course the most important activity an artwork can provoke, the activity of thinking.

Alison M. Gingeras *So the issue was confrontation rather than some sort of participation or supposed 'community' activity, as suggested in the relational theory of Nicolas Bourriaud, which emerged as a model about the same time as your early public work and had some claim to political meaning.*

Thomas Hirschhorn Confrontation is key. You get that again in the altars (1997–98), in the earlier projects such as *Travaux abandonnés*, and even in *Jemand kümmert sich um meine Arbeit*, in which there was already the will to confront. I've always thought that the work of art exists even if no one looks at it. It doesn't exist only in relation to someone. Because if a work of art only exists because someone uses it or employs it in some way, there's a *non-will* that I reject. The artist has to take the responsibility for the artwork, including responsibility for its failure.

This criterion was applied to *Skulptur-Sortier-Station* when I installed it under the Stalingrad Métro station in Paris (2001). The critics said it didn't work because it had no use-value. This reproach never bothered me. With an artwork in a public space it's important to provide the choice not to see the work or not to use it. It's important to provide the possibility of ignoring the artwork. Because just as an artwork in public space is never a total success, it's never a total failure either. Anyway, it doesn't need this criterion of 'success' and 'failure' in order to function. What I'm criticizing about participatory and interactive installations is the fact that the artwork is judged as being a 'success' or 'failure' according to whether or not there's participation. I now see this kind of work as totally delusional, although I did make a work in this participatory vein, *Souvenirs du XXème Siècle*, at the Pantin street market in 1997.

Alison M. Gingeras *This work took the form of a sort of market stall where you sold different things you'd made such as T-shirts, mugs, banners and football scarves with the names of artists on them.*

Thomas Hirschhorn Yes. That project was deemed a 'success' because we sold the lot. But let's be honest, about 90 per cent of the objects were bought by people I knew, collectors who knew that this was an art project by me. Then there were about 5 to 8 per cent of people who were passing through, who might have known Deleuze or liked Mondrian and bought a mug for that reason, without knowing it was my work of art. Only 1 or 2 per cent just bought them for no reason other than because they needed them and they were cheap. I was certainly aware of the unreality of my project, but this 1 or 2 per cent is still important. The danger with these types of projects is to think that it's a success when it's actually a failure. So I'm suspicious of the interactive side

of art projects. It's important not to fall into the trap of 'success'. What I'm criticizing is the idea that failure isn't accepted, that it's hidden. I wanted to stop hiding failure, stop hiding the fact that I might be wrong.

Alison M. Gingeras *So there's never any preconception of what the spectator's participation will be, even if your work has developed away from closed sculptures towards more open sites? Your recent series of monuments in Avignon or Kassel – where inhabitants of the community where the works were installed were directly invited to participate – created a social environment that involved the participants maintaining or animating the work. It seems as if you cannot avoid creating some sort of social contract in these works.*

Thomas Hirschhorn With the monuments, the only social relationship I wanted to take responsibility for was the relationship between me, as the artist, and the inhabitants. The artwork didn't create any social relationship in itself; the artwork was just the artwork – autonomous and open to developing activities. An active artwork requires that first the artist give of himself. The visitors and the inhabitants can decide whether or not to create a social relationship beyond the artwork. This is the important point. But it's the same in the museum. The idea of success and failure is also present in the museum: a lot of visitors pass in front of the artwork, but what is the visitor's implication? Yet people want me to subscribe to this shabby 'contract' with my projects in public space. The *Deleuze Monument* and the *Bataille Monument* were much more: they were experiences.

Alison M. Gingeras *So there's no ambiguity when you create a social contract, because there's no fiction behind it. You're not creating a predetermined, fictional political act?*

Thomas Hirschhorn There is no fiction. There's reality and my will to confront reality with my work. Art exists as the absolute opposite of the reality of its time. But art isn't anachronistic; it's diachronic. It confronts reality. As an artist, I ask myself, am I able to create an event? Am I able to make encounters? With the last monument project I understood more and more clearly that it's important to assert the complete autonomy of the artwork.

Alison M. Gingeras *So it's a matter of suggesting things to the inhabitants of the place in which the installation is made without having any preconceptions about them?*

Thomas Hirschhorn The *Spinoza Monument* (Amsterdam, 1999) – the first monument I made – already had all the elements I used in the later monuments: the sculpture, the photocopies of selected texts, flowers, a video I'd made, books that you could consult. It was small, compact and concentrated. It was lit day and night thanks to a cable plugged into the sex shop opposite, which supplied me with electricity. It was located in Amsterdam's red-light district. I thought it was pertinent for it to be placed there. It provided a kind of nexus of meanings. But I thought that some elements could be more active, more exaggerated, more intrusive, more offensive, more present, more overtaxing to myself, and I wanted

to be more involved in order to increase confrontation. I wanted to develop these aspects with the subsequent *Deleuze Monument* and *Bataille Monument*.

Alison M. Gingeras *So this desire for more intrusiveness gave rise to the works' potential to be 'inhabited' by people? This habitation wasn't necessary for their existence; they didn't really need to be activated by the public, it was just part of taking it to another level?*

Thomas Hirschhorn The work only provides the possibility of activation. It wasn't necessary that it should be activated – neither for the work nor for the spectator. Yet there was this possibility. The confrontations in the *Deleuze Monument* and the *Bataille Monument* were dense. They were pertinent experiences that raised many questions for my future works regarding the presence of the artist, paying the inhabitant for their work, the creation of libraries. Such projects have an aesthetic that goes beyond art towards service; it loses its strength as an object.

Alison M. Gingeras *The autonomy of the object is sacrificed in favour of activism?*

Thomas Hirschhorn The *Bataille Monument* develops other strengths through the fact that it can be 'used'. There's no 'sacrifice in favour' of anything. The will to confrontation and the assertion of its autonomy works!

Alison M. Gingeras *The monuments have no use-value or didactic mission, even if they often have libraries, videos, television studios? I think people are likely to read this element of these works as some form of artist-activism, as your desire to spread the word of these philosophers.*

Thomas Hirschhorn There is no 'use-value', it's about absolute value. It's too vulgar and too easy to communicate the work of philosophers; there's nothing to communicate about artists, writers or philosophers.

Alison M. Gingeras *So you just give a clue by providing a library?*

Thomas Hirschhorn The entire monument was one form with different elements; the library was one element of the monument. I didn't 'provide' the library; I'm not a politician and I don't represent anything, but I did give form to the library. I want to give form – I don't want to make form. I give a form, my own form, and I only want to represent myself. I wanted to assert my love for Gilles Deleuze or Georges Bataille. I want to give form to this love. And I do think love can be infectious.

Alison M. Gingeras *There's a parallel between the monuments and the altars. In both you use proper names in the titles: Mondrian, Deleuze, Bataille and Spinoza, to list a few that are recurrent in these works. Why these names? You've mentioned in the past that these are people whom you appreciate, but you're clear about them not being heroes for you. Aside from being figures who've taught you something, I also wonder if you aren't seeking to allude to the exchange value of those names: the way they signify intellectual capital in our culture. You play a lot with those notions, and the kind of 'devotion' that they provoke.*

Thomas Hirschhorn That's very perceptive of you. Obviously what interests me about Deleuze and Spinoza is the value of their work, but not as an 'added value' that I integrate into my work. If I love Deleuze or Spinoza it's because of the absolute value of their work, because they give me strength – I need them as a human being!

Alison M. Gingeras And what about Ingeborg Bachmann?

Thomas Hirschhorn I chose her for her writings, for her magnificent poetry and for her beauty. Her work manifests itself as an exchange value in the sense that I assert that I'm a fan. I am a fan of Ingeborg Bachmann. I give something, I uncover myself, I assert. The fan decides on his attachment for personal reasons. These reasons could be geographical in nature, or have something to do with age or occupation. I like that idea. You've perceived this aspect of what I'm saying when you use the term 'exchange value'. I made the monument series about people I'm a fan of. Someone else would have made a Michael Jackson Monument.

Alison M. Gingeras The fan isn't obliged to have a professor's knowledge. This is an important distinction. I've heard people making critical comments about your work along the lines of, 'Thomas Hirschhorn has not read all the works of Deleuze or Bataille.'

Thomas Hirschhorn Of course I haven't! I've only read a few books by Georges Bataille. But I read, for example, what he wrote about an 'acephalous society', one that's headless, stupid or silly, in German: *kopflos*. I really like that 'headless' idea. I made the *Bataille Monument* because of Bataille's book *La part maudite* (1967) and his text *La notion de dépense* (1933). It's not about being a historian. It's not up to me to be a scientist. This isn't scientific work, it's an artwork in relation to the world, which confronts reality, which confronts the times I live in. I've never claimed to be a specialist, or even a 'connoisseur'. I'm a fan of Georges Bataille in the same way that I could be a fan of the football club Paris Saint-Germain. I'm not obliged to go and see all the matches. I'm not obliged to know the whole history of Paris Saint-Germain football club. You can even be a very fickle fan: when a fan goes to live in Marseille he can become a fan of Marseille's football club; he's still a fan. That's why I like the term 'fan'. The fan can seem *kopflos*, but at the same time he can resist because he's committed to something without arguments; it's a personal commitment. It's a commitment that doesn't require justification. The fan doesn't have to explain himself. He's a fan. It's like a work of art that resists, and preserves, its autonomy. It's important and complex. When I made the *Artists' Scarves* (1996), it didn't depend on people in Limerick knowing Marcel Duchamp, never mind Rudolf Schwarzkogler or David Stuart. It didn't matter. This project was about the desire for non-exclusion. In the same way, the *Bataille Monument* enabled me to have a better understanding of what a fan really is.

Alison M. Gingeras Can you talk about the reception of Bataille Monument at Documenta 11? There was some confusion in the German and international press regarding your

intentions – be they political, social or intellectual. There was particular attention paid to the fact that you lived in Kassel for the duration of Documenta – as if to guide or control the reception of your work.

Thomas Hirschhorn I wrote forty-nine pages about that experience and its reception. I went through a process of self-criticism as well as public criticism. For four days straight I wrote everything down, so I can talk about it now. The most important decision was to be on the site during the entire exhibition period. I realized this after my experience in Avignon, when my *Deleuze Monument* had to be dismantled before the end of the exhibition due to vandalism. Since there was a strong possibility that the work wouldn't last until the end of the exhibition, I was eager not to repeat the same error.

Alison M. Gingeras How did you reconcile yourself to the fact that the work was physically destroyed in Avignon?

Thomas Hirschhorn I accepted its early dismantling because it was my error. It was neither a success nor a failure, it was just what it was. If I'd been in Avignon the whole time, I could have seen the *Deleuze Monument* through to the end of the exhibition. This became my primary preoccupation with the *Bataille Monument*. As is often the case with artists' projects installed in public space, the artist is present during the installation period, on the evening of the opening, and sometimes for another day or two afterwards, then he goes away. I've understood that this is dishonest to some extent. This kind of project needs a total investment from the artist. I've realized how much that costs in terms of energy, investment and money. In the case of the *Bataille Monument* for Documenta 11, I did everything I could to confront it while it was in existence, bringing my own presence to it, not as an artist, not because I'm the vehicle of the idea, but as a 'housekeeper', the person who tends to it. So in the end the reception of the *Bataille Monument* was enormously positive. It was a complex work, a work that was problematic, that was difficult, but which was also beautiful and strong. I'm convinced that the gamble of getting to the end, of having held on, set new limits for me.

Alison M. Gingeras That places big demands on the kind of work you do next. You're developing more spontaneous projects in which you initiate the situation rather than responding to the invitation of someone commissioning an exhibition, so that you don't become 'Thomas Hirschhorn, professional maker of public art'.

Thomas Hirschhorn That's right. The only demand I have to make on myself is to go on producing non-commissioned artwork. And to stay alert, stay attentive and to keep conquering.

Translated from French by Shaun Whiteside

Jenny Holzer *Joan Simon*

in conversation
June 1997, New York

Joan Simon Why don't we start right in the middle of the public life of your work so far, if not quite at the chronological mid-point: the 1990 Venice Biennale?

Jenny Holzer OK, so we're starting at the end.

Joan Simon The end of what?

Jenny Holzer I'm not sure yet. Certainly some chapter.

Joan Simon You were, in 1990, the first woman to represent the US in a solo show in the then almost 100-year history of the Biennale. Your show won the prestigious Leone d'Oro award – grand prize for best pavilion – and it highlighted dramatic changes in your work. Some of the texts on paper posters that you left anonymously on New York streets in 1977, for example, turned up etched in marble fit for a palace, specifically, the palace of the Venetian Doges. Here your 'one-liners' were presented underfoot, carved in stone; they were also on electronic signs in a complex retrospective barrage of your writings, which one witness characterized as 'firestorms'. And while the show incorporated the anonymous, genderless speakers of your earliest Truisms (1977–79), it also emphatically presented the anguished, distinctly female and personal voice of the Mother and Child (1990) texts. What did all this mean to you?

Jenny Holzer Because I was the official representative, I was extremely self-conscious. I didn't want to be the first woman to bungle it. I was in a personal pickle because my baby was mad at me for being distracted and my husband was distraught. I was exhausted. Venice followed the Dia and Guggenheim shows in New York. Eventually, I was glad to have written about how it is to have a child, and I was privileged to walk Venice so often. I was happy to be able to complete the work.

Joan Simon How did you construct the show?

Jenny Holzer There were public pieces, electronic signs, and there certainly was more stone than there had ever been before.

Joan Simon You're referring, I think, to the texts cut into the Italian marble of the floor and benches.

Jenny Holzer The stone was prominent because I was trying to make the piece Venetian, rather than trying to go over the top with materials.

Joan Simon How so?

Jenny Holzer The beautiful red and white stone is asphalt there. I saw that red and white everywhere. I put polished marble floors in the pavilion so the signs would be reflected in them. The lagoon does the same for Venice.
　　I made marble benches in two of the pavilion's rooms, so that people could sit and await fate, as practised in the Doge's antechambers.

Joan Simon You've often called yourself a 'public artist', and Venice is among the most public of art-world events.

Jenny Holzer I thought the anonymous public pieces for Venice – the TV spots, the posters, the signs in the Mestre taxis and Venice's *vaporetti* – would take care of themselves, but I was terrified by the prospect of the American pavilion. I was interested to watch the pavilion's audience. I put everything in the world into the 'toaster oven' room – the horizontal sign room – because I wanted it to be too much for the viewers. I also wanted to see the reactions to the *Mother and Child* work. There were strong responses. People stood very still. Some would cry and others would turn and walk out quickly. Many would tell me stories about children they had lost.

Joan Simon Did people move easily between the two sections – the church-like sobriety of the vertical signs in the Mother and Child *room and the delirious, disorienting, cacophony of messages on the horizontal signs in the other?*

Jenny Holzer I can't give you an accurate answer, but my hunch is that the work tended to sort people into groups, the contemplative group in one room and then another gang. The thrill-seekers went to the 'toaster' room.

Joan Simon Let's go back to the beginning. Where were you born, when and to whom?

Jenny Holzer Gallipolis, Ohio, 1950. In Holzer Hospital, to Richard and Virginia Holzer.

Joan Simon Holzer Hospital?

Jenny Holzer My grandfather and grandmother founded it. He was a doctor and she a nurse. There were no hospitals in that area so they made one.

Joan Simon How long were they in Ohio?

Jenny Holzer They were both born in Ohio. They met, and instead of wandering off, lived and died in Ohio.

Joan Simon When did the family originally come to America?

Jenny Holzer I believe they came in the middle of the nineteenth century, with one of those waves of German folk.

Joan Simon Wasn't your dad a Ford dealer?

Jenny Holzer And my grandfather, my mother's father.

Joan Simon Why is the Midwest called the 'heartland'?

Jenny Holzer I've never been sure. What seems credible is something about true and solid values.

Joan Simon Did you go to the public library when you were a little kid?

Jenny Holzer A lot. My mother was determined to have that happen. Unlike some things she was set on, I liked to go to the library.

Joan Simon Were you a writer as well as a reader?

Jenny Holzer More a reader, but I wanted to write ecstatic, fantastic things. I tried to imagine what it would be like to write on drugs. I'd heard of Coleridge.

Joan Simon *What did you write?*

Jenny Holzer Anything; I wrote about light bulbs and insects. I tried to write as if I were mad, in some exalted state.

Joan Simon *Did you read newspapers?*

Jenny Holzer I liked newspapers a lot. And novels. Probably Emily Brontë's *Wuthering Heights* scared me the most. There's a scene in which a lost child's ghost appears and frightens the sleeper. The child's arm is fearfully cut.

Joan Simon *Even if the child is a vision, it's a terrifying image, not unlike those in your* Under a Rock *(1986) and* Lustmord *(1993–94) series.*

Jenny Holzer There is horror in those works.

Joan Simon *When you were a child, what was Ohio like?*

Jenny Holzer I thought it was pretty grand. We lived in a new development on the edge of a town of 30,000 people. It had been an apple orchard, a wild abandoned apple orchard. I stayed until I was sixteen, and then went to Fort Lauderdale, Florida, to improve my image. I wanted to see if I could be less of a nerd.

Joan Simon *Why did you think you were a nerd?*

Jenny Holzer Inner conviction. Tall. Too skinny. Approximately intelligent. Things like that.

Joan Simon *Did you do any art when you were a kid?*

Jenny Holzer I did most of my art when I was a kid. I wish I still had the same rhythm and frequency. I drew.

Joan Simon *Which you don't do any more?*

Jenny Holzer No. It went away. And I'm sorry.

Joan Simon *What did you draw?*

Jenny Holzer Epics. No single-sheet stuff after I was five or six. Shelf-paper scrolls. Everything from Noah's ark up to the development of the automobile. I tried to get it all down.

Joan Simon *Was anyone in the family an artist?*

Jenny Holzer My grandmother's sister, Audrey Donaldson Ruston, who did Grandma Moses-type paintings. Even better than an artist, she was a psychic. She could predict events and could find water with willow switches. The art and water-witching were a great combination.

Joan Simon *Did you go to museums as a youngster?*

Jenny Holzer I went to the Metropolitan in New York once, for an hour.

Joan Simon *Do you remember anything in particular from that visit?*

Jenny Holzer Rembrandt behind a rope. They had just bought one, and had it out. I think they even had the price by it. About a million dollars. It was something like what my father used to do to sell Fords.

Joan Simon *Your work is so much about 'public voice', I'm curious to know if you remember any influential ministers, teachers, lawyers, politicians, newscasters? American newscasters and radio announcers often come from the Midwest.*

Jenny Holzer This probably sounds fake, but I did like that Times Square sign that had war news on it, that I'd seen in old news reels rebroadcast on TV in Ohio. It had reports from the front.

Joan Simon *The one I remember from my childhood had only words. Was there another sign with moving pictures?*

Jenny Holzer My 'dream sign' of childhood was the text-only Times Square 'zipper'.

Joan Simon *That news 'zipper' has been in operation since 1928. In fact, it is on the same Times Square building where you, in 1982, first worked with electronic signs on its Spectacolor board.*
Were the Holzers church-goers, Bible-readers?

Jenny Holzer My father refused to go to church. Refused to have anything to do with it. My mother tried to have me attend for a while and then gave up. I had a religious spell. I was interested in rapturous writing.

Joan Simon *What did you intend to study in college?*

Jenny Holzer I was trying to be normal, so I thought maybe I should be a lawyer. I wound up at Duke University in North Carolina on the suggestion of an alcoholic guidance counsellor. I was too timid to go where I wanted. That was Radcliffe. I had the notion there were interesting women there. I wanted to see what smart women did. At Duke the women were bright, but they didn't always let on.

Joan Simon *After studying liberal arts at Duke from 1968 to 1970, you changed schools a couple of times. Why did you transfer to the University of Chicago?*

Jenny Holzer I was in love. He was going to graduate from Duke and I wasn't all that happy there. I felt becalmed but not enchanted. I wanted to go to a new place, a city. I was getting closer to admitting that I was, well, two things: useless for regular life and less ashamed about wanting to be an artist. I thought I could do art in Chicago.

Chicago was the best place I'd ever been. I loved the university and the city. It was very hard to leave. I would have stayed, but as a transfer student I would have had to study still more liberal arts. If I wanted to do studio,

Roni Horn

Piece for Two Rooms from **Things That Happen Again** 1986–91
(Room 1)
A suite of four sets of paired, solid copper forms, each forged and machined to duplicate mechanical identity
L. 89 cm each
⌀ 43-31cm each
Installation, Galerie Lelong, New York
Collections, The Detroit Institute of Arts; Donald Judd Foundation, Marfa, Texas;
Städtisches Museum Abteiberg, Mönchengladbach

(Room 2)
A suite of four sets of paired, solid copper forms, each forged and machined to duplicate mechanical identity
L. 89 cm each
⌀ 43-31 cm each
Installation, Galerie Lelong, New York
Collections, The Detroit Institute of Arts; Donald Judd Foundation, Marfa, Texas; Städtisches Museum Abteiberg, Mönchengladbach

Mona Hatoum

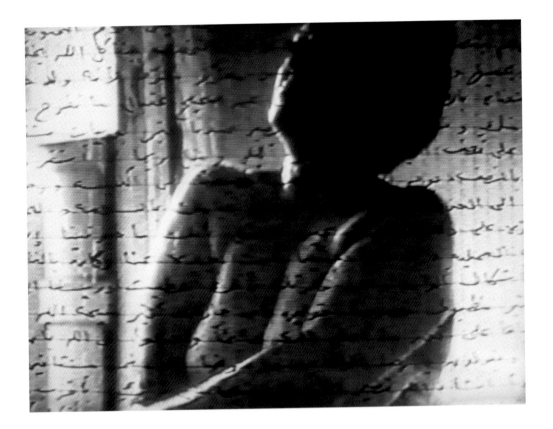

Measures of Distance 1988
15-min. video
A Western Front Video Production,
Vancouver
Collection, Art Gallery of Ontario,
Toronto; Musée national d'art moderne,
Paris; Museum of Contemporary Art,
Chicago; Museum of Modern Art,
Toyama; National Gallery of Canada,
Ottawa

Mona Hatoum

The Light at the End 1989
Angle iron frame, six electric
heating elements
116 × 162.5 × 5 cm
Installation, the Showroom, London
Collection, British Council, London

Thomas Hirschhorn

Deleuze Monument 2000
'La Beauté', Avignon
Collection Fonds Régional d'Art
Contemporain Provence-Aples-Côte
d'Azur, Marseille, France

Thomas Hirschhorn

VDP – Very Derivated Products 1998
Wood, cardboard, prints, photocopies,
marker pen, aluminium foil, gold
foil, transparent plastic foil, adhesive
tape, stickers, Plexiglas, umbrellas,
toys, gadgets, books, plastic cover,
neon lights, electrical fans, integrated
video. Installation, 'Premises',
Guggenheim SoHo, New York

Jenny Holzer

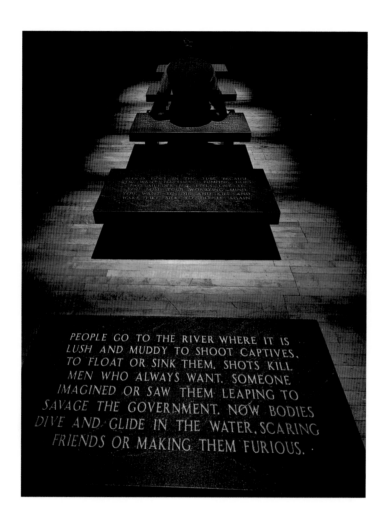

PEOPLE GO TO THE RIVER WHERE IT IS
LUSH AND MUDDY TO SHOOT CAPTIVES,
TO FLOAT OR SINK THEM. SHOTS KILL
MEN WHO ALWAYS WANT. SOMEONE
IMAGINED OR SAW THEM LEAPING TO
SAVAGE THE GOVERNMENT. NOW BODIES
DIVE AND GLIDE IN THE WATER, SCARING
FRIENDS OR MAKING THEM FURIOUS.

Under a Rock 1986
5 misty black granite benches,
LED signs
Benches, 44 × 122 × 53.5 cm each
Signs, 25.5 × 286 × 115 cm each
Installation, Rhona Hoffman
Gallery, Chicago, 1987
Collections, Art Gallery of Ontario;
The Museum of Modern Art,
New York; Museum of
Contemporary Art, Chicago

Jenny Holzer

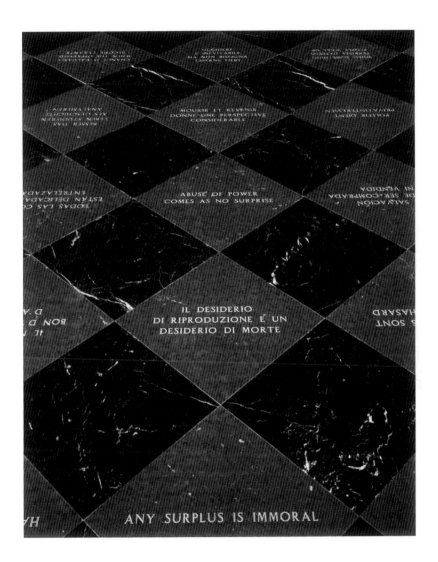

from **Truisms, Inflammatory Essays, Living, Survival, Under a Rock, Laments, Mother and Child**
Floor, Rosso Magnaboschi marble tile in diamond pattern with Biancone marble border
Right wall, five 3-colour LED signs
14 × 609 × 10 cm each

Left wall, five 3-colour LED signs
14 × 609 × 10 cm each
Far wall, eleven 3-colour LED signs
24 × 447 × 11 cm each
Installation, Gallery E, United States
Pavilion, 44th Venice Biennale, 1990
(detail)

Roni Horn

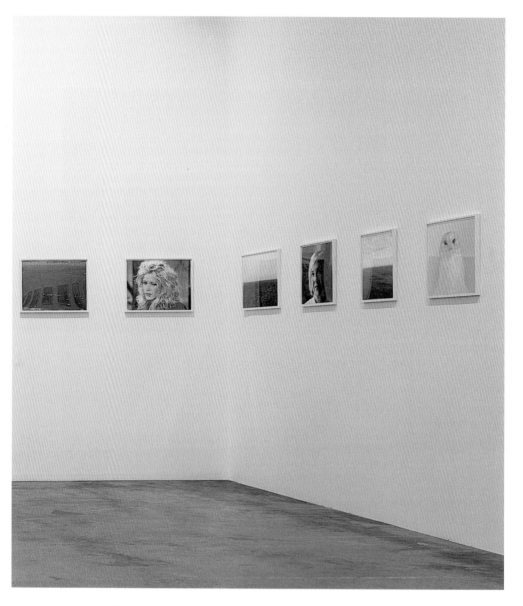

Pi 1998
Photo installation, 45 Iris printed
colour and black and white
photographs installed on 4 walls
Various dimensions 51.5 × 69 cm;
51.5 × 51.5 cm; 51.5 × 46 cm
Collection, Staatsgalerie Moderner
Kunst, Munich

I couldn't remain. While there, I did manage a fair amount of print-making and a lot of drawing. I was happy to use my hands.

Joan Simon *Why did you choose Ohio University in Athens?*

Jenny Holzer It was the time of the Vietnam War. My boyfriend, a conscientious objector, found a job at Holzer Hospital. See how we circle back? I wanted to concentrate on studio, and, from my summer school experiences, I knew there were a number of good people teaching at Ohio University. That was sufficient encouragement.

Joan Simon *When you graduated from Ohio University in 1972 with a degree in fine arts, did you want to keep doing art?*

Jenny Holzer I wanted to, but I couldn't figure out how. In my childhood, the artist I knew most about was Picasso. I saw him in a magazine article with photos in which he was on the beach ogling a mistress. I knew I wasn't Picasso. I didn't know how to be an artist.

Joan Simon *What was your work like at this point?*

Jenny Holzer Things that were found. Data. I had worked at Holzer Hospital in the claims department. I typed cards with information about what patients were suffering. For my artwork, I used all the cards ruined by my typos. I pasted the cards on a panel, in rows. I put them in lines, just had to organize them in tight, neat rows. I didn't show the piece to anybody.

Joan Simon *What did you do after graduation?*

Jenny Holzer I went to Europe: Germany, France, Spain, Denmark; to Frankfurt, to Paris, to Madrid, to Barcelona. I saw many major museums for the first time. I looked at medieval and Renaissance art. The Goyas in the Prado sent me – his darkness and determination to look and show perfectly.

Joan Simon *And after the European stay?*

Jenny Holzer I went home for a while. I tried to go back into the horse business. I made a run at it a couple of times. I gave riding lessons, worked at farms, galloped youngsters and walked hots. Not my talent.

Joan Simon *The horse business was your mother's work.*

Jenny Holzer She was a riding teacher. I was no good at it. I gave up horses, went to Arlington, Virginia, got a job at People's Drugstore, and wasn't discovered. I started making some paintings, and I decided to go to Rhode Island School of Design for summer classes.

Joan Simon *You actually went to Rhode Island School of Design two different times. Was this the 1974 summer session when you took the 'painting alternatives' class?*

Jenny Holzer Yes, that's the summer class.

Joan Simon *Some of the works you made that summer were the first of your public pieces.*

Jenny Holzer I did paintings I didn't like. I was cutting them to ribbons and ripping them. After I had done that to a huge painting, I had all these painting shreds. I thought maybe I'd tie them up, tie them together. I started doing that and made a half-mile-long painting. It was a really big bad painting, enormously labour-intensive, painted on both sides. I left it at the beach. I watched people walk by it and on it. Be around it and ignore it.

Joan Simon *What was the bread piece,* Pigeon Lines *(1975)?*

Jenny Holzer Longing for order, I put bread out in geometric patterns. The pigeons had to eat in squares and triangles – sometimes they had to eat lines.

Joan Simon *And the indoor environment, the* Blue Room *(1975)?*

Jenny Holzer That was one of the first pieces I did that felt right. Everything in the room was painted. The walls, floors and ceiling, the glass in the window, the door, were all done white. Then I went back and put a Thalo blue wash over the whole room. Where the paint would dry, all of the surface would have an irregular edge. The space was disorienting. The paint was rather lovely, especially that colour.

 I did the room instead of easel painting and presented it to the faculty and the students. I worked outside for the general public but didn't have the idea of inviting them inside. I was also working on plain painting then.

Joan Simon *What were those paintings?*

Jenny Holzer I made abstract paintings that were fairly traditional. The only somewhat unusual thing I did was to paint pieces of canvas and then superimpose them. The result was traditional abstract painting with literally overlapped fields. Then there were long, rectangular, found fabrics on which I began to write.

Joan Simon *What did you write?*

Jenny Holzer This is a bit embarrassing, but one dark to light green material made me think of the depths of the ocean, so I wrote oceanographic information. That was lame, and it sent me to the Brown Library to find more subject matter: a return to the library. Next I did a blue fabric piece with text about time and space, and I began to draw the diagrams.

 Maybe this started with seeing the old boyfriend's physics diagrams. I thought they were great. I loved drawings of time. I also saw that trying to represent time was kind of absurd, kind of grand.

Joan Simon *You re-drew the diagrams you found in the library?*

Jenny Holzer Very carefully, and painfully, on paper. Hundreds of drawings. I would only try once. I had to draw perfectly the first time, and if I couldn't, I'd stop and start a new one. It was a horrible test. I tried to draw the diagrams freehand just as they were in the books. Ridiculous. Straight lines. Hatch marks.

Joan Simon *How were these discrete pieces of information organized?*

Jenny Holzer I made books and I stacked the drawings in boxes. Sometimes they were grouped by subject.

Joan Simon *What did making an extremely precise copy of someone else's original (even one already mechanically reproduced in a book) mean for you? Contemporaries of yours, such as Sherrie Levine, made this a critical practice.*

Jenny Holzer It was a trial for me, a salute to the subjects and a study of representation. Eventually it was a fascination with the captions.

Joan Simon *After summer school you stayed in Rhode Island.*

Jenny Holzer I met Mike (Glier) in the RISD 'painting alternatives' class, and after summer school, I found a studio in Providence. I decided, OK, I'm going to be an artist. A year later I went to graduate school there (1975–77). Before I went to graduate school, I worked as a model for RISD drawing and sculpture classes. Then I entered the painting programme.

Joan Simon *Put your clothes back on.*

Jenny Holzer Put my clothes on as a graduate student and taught some of the same kids for whom I'd modelled. That was a manoeuvre.
 In the studio I was working hard. Some of the faculty rejected what I did. They hated my blue room and my videos.

Joan Simon *What were the videos like?*

Jenny Holzer Not great and somewhat autobiographical. Once, I went to my grand-parents' house and shot all around their farm. That's as close to autobiography as I ever came. I couldn't manage it.

Joan Simon *What other art were you connecting with at this point?*

Jenny Holzer When I was working in summer school, Bruce Helander said the pieces looked like Nancy Graves'. By the time I got to graduate school, I ran into John Miller, who was interested in the art journal *The Fox*. He educated me.

Joan Simon *How did you get from RISD, where you got your Masters of Fine Arts degree in painting in 1977, to the next stop, New York?*

Jenny Holzer Mike had been accepted into the Whitney Independent Study programme, and I was desperate not to get tossed from RISD even though I didn't want to be there. Actually, it was better than that. I wanted to go to New York City to be an artist. I was in trouble with the RISD painting faculty. One of my videos was about alcoholism, which was in my family, and in the faculty. Someone asked me, 'You would expose your alcoholic aunt?', and a painting professor said, 'You would do anything. That is what is wrong with the twentieth century.' I considered suicide.

Joan Simon *The alternative became New York.*

Jenny Holzer I applied to the Whitney programme, and was accepted.

Joan Simon *That was in 1977. What's discussed most often regarding your time at the Whitney programme is the reading list which, you've often said, was a prompt to your writing the* Truisms. *Who assigned the list, and what import did it carry in the programme?*

Jenny Holzer It was Ron Clark's list, and it was important.

Joan Simon *Did the programme focus more on theory than studio issues?*

Jenny Holzer There was a dose of theory, and they were quite willing and able to discuss studio. I thought the programme was nicely balanced. They were hands-on when needed, hands-off when it was crucial. I liked that.

Joan Simon *What artists were important to you at the time?*

Jenny Holzer Yvonne Rainer fascinated me. I thought about the things she had done with the body and with words. They scared me to death but I wanted to find a way to her subjects. I couldn't see how. The way became clearer, and it had to do with language.

Joan Simon *What was Rainer like as a teacher?*

Jenny Holzer A bit remote. Reserved, in a dignified, elegant sort of way. I appreciated her even if I mostly observed her. I didn't talk to many people in those days.

Joan Simon *The first work of Rainer's you had seen in person was the film* Kristina Talking Pictures *(1976).*

Jenny Holzer The first things of Rainer's that struck me were the pictures of her performing at Judson. I was amazed that she could be in motion with clothes off, being expressive that way. I didn't fully understand *Kristina Talking Pictures*, but what was clear – and I really can't explain this – is that the piece was hers. That she made it. It was the story of a woman.

Joan Simon The Story of a Woman Who …, *as another of her titles put it.*

Jenny Holzer Exactly. A woman working. Going back to the Picasso problem. Here was a woman's life, and she was deadly serious.

Joan Simon *Any other artists?*

Jenny Holzer By the time I was part-way through undergraduate school, my art history went to Rauschenberg. I had a whiff of Joseph Kosuth by the time I was out of RISD. By the Whitney I was, maybe not up to speed, but something approaching that. Vito Acconci, Dan Graham and Alice Neel all talked at the Whitney.

Joan Simon *When did you begin to write your texts down?*

Jenny Holzer Sometime in the first session of the Whitney programme I tossed the painting with captions and started writing. Then I had to decide what to do with the writing.

Joan Simon *For the first writings, what were your tools?*

Jenny Holzer Lined paper, and a Bic pen.

Joan Simon *Why did you write the first* Truisms?

Jenny Holzer It's too neat to say it was just the Whitney reading list, but it was influential. I was intimidated by the list but wanted to address the subjects. I did the best I could with a number of one-liners.

Joan Simon *Did everyone in the class address the list?*

Jenny Holzer Some people even read it (*laughter*). I read Sontag, and it was the first time I understood something of the difference between the critic and the artist. The distinction between writing about something and just plain writing. I didn't read much of the French stuff. Couldn't appreciate it. I read some of the Marxist offerings.

Joan Simon *You worked on only the* Truisms *from 1977 to 1979?*

Jenny Holzer That was it, pretty much. I did one last painted gasp at P.S. 1 (1978). I painted the walls of a Project Room in different colours.

Joan Simon *How did you decide what form the* Truisms *should take?*

Jenny Holzer I was still at the Whitney when I did the first poster. I hate to give Mike all this credit, but he had the idea of doing a street poster. I was jealous immediately. The fact that he was going to do a poster was enough to make me print one.

Joan Simon *What was to be printed on Mike's poster-to-be?*

Jenny Holzer A man falling through space.

Joan Simon *What was your first poster?*

Jenny Holzer Thirty or forty of the best *Truisms*. I didn't alphabetize them – that change happened later. I typed, offset and pasted them on walls around town.

Joan Simon *Then what?*

Jenny Holzer I just kept going. I didn't dare think of the reaction to them, but I hoped they would mean something to someone. At that stage I wanted to stay in motion, like tying the knots of the painting of a thousand cuts. I had to work and write a lot.

Joan Simon *You finally did.*

Jenny Holzer A couple of hundred.

Joan Simon *Not long after writing the* Truisms *you had three shows at three alternative spaces that were somewhat related: Franklin Furnace and Printed Matter in Lower Manhattan and Fashion Moda in the Bronx. These installations included audiotapes. Why, and at what point, did you jettison the live voice? Also, whose voice was on the tape?*

Jenny Holzer I didn't quite throw the voice away, but took a rest. Voices came back in the virtual reality *World II* (1994). I used other people's trained voices. I never had any interest in performing, even on tape. I used sound because it involves different body parts, plus you could hear the *Truisms* a block away.

Joan Simon *It was that loud?*

Jenny Holzer In some places. I did one piece that was all audio: the *Truisms* in an elevator. It was in our loft at 515 Broadway. Sort of elevator music.

Joan Simon *You've written eleven series in the past twenty years:* Truisms *(1977–79);* Inflammatory Essays *(1979–82);* Living *(1980–82);* Survival *(1983–85);* Under a Rock *(1986);* Laments *(1988–89);* Mother and Child *(1990);* War *(1992);* Lustmord *(1993–94);* Erlauf *(1995); and most recently* Arno *(1996–97). Since each set of writings flows into and sometimes integrates with the next, and as they are at times presented on the same kinds of signs or in assemblages, it would be good to hear about each series specifically. I'm curious to know how, in what forms and in what contexts, they were first made public.*

Jenny Holzer The *Truisms* are numberless one-liners written from multiple points of view. First they were on cheap offset street posters in Lower Manhattan, and they have been in many forms and places since.

Joan Simon *On baseball caps, condoms, T-shirts, pencils, cash-register receipts, in a dance performance, on electronic signs and on the Web, to name a few.*

Jenny Holzer The *Inflammatory Essays* were also street posters. Each poster was a different colour – a change of colour would announce the appearance of a new text. The essays had exactly 100 words in twenty lines; the inspirational literature was the writing of Emma Goldman, Rosa Luxemburg, Mao, Lenin, et al. *Living* was shown on cast bronze plaques and hand-lettered metal signs. The bronze stood in contrast to the underground posters. The subject matter is everyday life with a twist. The tone of the writing is matter-of-fact. *Survival* was the first series written for electronic signs. It appeared on Unex signs, made by the same company that created the Spectacolor board at One Times Square. *Survival* is more urgent than *Living*.

Joan Simon *Working on the Spectacolor board in Times Square in 1982 was the first time you used any of these electronic signs – what did it offer you?*

Jenny Holzer Memory. It let me show the material I had in Times Square for a good stretch of time. It let me programme. That was interesting – to decide where to place emphasis, when to make something fly, and how to stop.

Joan Simon *This was different from typesetting, which was a paying job for you in the late 1970s and early 1980s.*

Jenny Holzer The fingers were on the keyboard again, but this time I was setting words in motion.

Joan Simon *What working materials do you use preliminary to making an electronic sign? You say you don't draw anymore. But what are those things that look like drawings or mock-ups for panels on the UNEX, for example, and how do they relate to some of the photos you took for the same images?*

Jenny Holzer There are only images on the UNEX signs and the UNEX are no more. Those weren't drawings – those were aberrations! I did shoot photos to make the aberrations. The diagrams were the last drawings.

Joan Simon *Your words appear in stone for the first time in* Under a Rock.

Jenny Holzer *Under a Rock* was written after I moved to the country. The texts are somewhat desperate. The work appeared as a number of inscribed granite benches and electronic signs. People could occupy the benches and read the signs. *Under a Rock* was the first complete interior installation. I worked with Paul Miller at Sunrise Systems for this show. He has helped me realize all the major exhibitions that have electronic signage, including the hair-raising Guggenheim show.

Joan Simon *By the time it was installed in 1989, the mechanical feat appeared seamless. At the Guggenheim, a retrospective of your writings was seen on a 163 metre-long sign, forming a continuous spiral up the museum's conical interior parapet wall. The grandness of the architectural intervention, as well as the combination of conical and spiral forms, and the spectacle itself, made me link your project with Tatlin's* Monument to the III International *(1919–20).*

But back to Under a Rock. *When it was first installed as a complete room in 1986, a single electronic sign was on the gallery's front wall; viewers, seated on the benches, faced the sign. The gathering place was likened to a chapel; you call it 'a Greyhound bus terminal'. And while the* Under a Rock *writings were extended meditations on what you once called 'unpleasant topics – things that crawled out from under a rock',¹ they were still reportorial in tone. What followed were the* Laments, *no less gruelling but now elegiac, even lyrical.*

Jenny Holzer *Laments* came during the AIDS epidemic. I had been writing about unnecessary death of any sort, for example, from bad government or accident. The *Laments* were shown at the Dia Art Foundation on thirteen stone sarcophagi and in thirteen vertical synchronized LED signs. I was pregnant when I was working on this series; Lili was crawling during the installation. The *Mother and Child* writing was done for Venice. It outlined fear. The work was programmed on twelve vertical LED signs and cut in the floor of the American pavilion. The text was reflected in the stone floor.

Joan Simon War, *the next series, still brutal, begins to look outward again.*

Jenny Holzer The *War* series (1992) began during the Gulf conflict. I watched hours of coverage on CNN. Vertical signs with *War* made the stairs of the Kunsthalle Basel impassable (1992). The signs went to Saint Peter's Church in Cologne (1993). The Nordhorn *Black Garden* (1994) has *War* on five red sandstone benches.

Joan Simon Lustmord *was published as a project in a newspaper's weekly magazine – a format similar to that of the Sunday magazine of the London* Sunday Times, *or the* New York Times.

Jenny Holzer The editors asked me to do a piece for the *Süddeutsche Zeitung Magazin*, and I didn't have anything. I waited a year for the writing. I had been working on the *War* series when *Lustmord* came. I thought it appropriate for the magazine.

Joan Simon *There is no translation in English for the word* Lustmord *that is as specific, or as horrifically evocative.*

Jenny Holzer Nothing like the word in German, which means 'rape-slaying', 'sex-murder', 'lust-killing'.

Joan Simon *You returned to writing in multiple voices.*

Jenny Holzer *Lustmord* was written from the vantage points of the perpetrator, the victim and the observer. Within each category there were a number of individuals. I didn't think the writing could be complete if written solely from the perspective of the raped woman. I wanted to be able to explain the act to myself and then to other people.

Joan Simon *The observer?*

Jenny Holzer That could be a family member who comes afterwards and does something or nothing, or someone with official standing, such as a United Nations observer.

Joan Simon *While* Lustmord *is in good part about the Bosnian war, it is also about family violence.*

Jenny Holzer It was prompted by the war in Bosnia, but it's about what happens in other wars, and in peace time, in love and hate.

Joan Simon *You've also said before that it had much to do with the loss of your mother at this time.*

Jenny Holzer My mother died when I was writing and this influenced every part of the work.

Joan Simon *This particular project – almost thirty pages in the magazine – differed from your other work in that you used a human body. The texts were handwritten on the bodies of women and a man, then photographed in close-up so that hairs, pores, skin are magnified as well as the words.*

Jenny Holzer I went to Tibor Kalman, a friend and designer (M & Co., Benetton's *Colors* magazine), because I wasn't sure what to do on pages. I had used so many

electronic signs that by then I was afraid of paper. He and I decided to write on skin, and to print in blood, so that words would be on and from bodies.

Joan Simon *The card printed in blood was a small, very proper-looking folded white card, the kind you might use to write a thank-you note. It was printed separately and glued to the cover. The blood, donated by women volunteers, was treated with intense heat to kill any contaminants, and then mixed with printing ink.*

Jenny Holzer German and Yugoslavian women donated blood so we could write in it. We had a cover card that could be opened to show all three voices.

Joan Simon *This cover caused a scandal far beyond what you anticipated.*

Jenny Holzer I wanted people to feel rather than simply to know. I thought they must touch the blood.
We didn't imagine the way it turned out. We had everything from tears to outrage – the outrage almost exclusively from men.

Joan Simon *It also triggered other reactions and taboos, some spoken, some not. A fear of blood in general, of women's blood in particular, the notion of impure blood, whether racial or viral.*

Jenny Holzer There was a bloodbank scandal and so I think everyone was hyper-aware.

Joan Simon *For me, more frightening than the almost dainty notecard on the cover were the photographs of bodies inscribed with texts, triggering thoughts of branding, tattoos, concentration camp numbers. Was there a violent reaction to that part of the project as well?*

Jenny Holzer People mostly spoke of the blood, but I suspect that everything, from the history of tattoos in Germany to the fact that it was women's blood, created the uproar. People were appalled by a small amount of donated blood used to highlight *Lustmord*.

Joan Simon *Related to the next series of writings, the* Erlauf *texts, it should be noted that in recent years you have been commissioned to do several memorials, including a blacklist memorial for Los Angeles, to be built in 1998.*

Jenny Holzer Before *Erlauf*, I did an anti-memorial memorial in Nordhorn, Germany, the *Black Garden*. It has a number of very dark, or black, flowers, foliage plants and trees in an uncanny, deathly space. There is a small, white, fragrant garden in front of a plaque commemorating the political opposition and the Jewish families who were murdered.

Joan Simon *The de-emphasizing of words, not to mention the use of plants, is new to you.*

Jenny Holzer Much of the content of the piece is carried by the black and white flowers. The black flowers are something like one of my rooms when the signs are off. The white flowers are light.

Joan Simon *Stone benches are used but take a modest place in the overall garden plan.*

Jenny Holzer There are benches, but part of the piece is that the garden has to be kept alive; it requires attention and work and revision. A garden is an obligation.

There's a work in Erlauf, Austria, that commemorates the signing of the peace in that theatre of war. The Russian and American generals met in the town to accept the German surrender. The peace components are the white flowers and searchlight, visible for miles at night. The war part is the text that is on the paving stones.

Joan Simon *The most recent text series is* Arno.

Jenny Holzer The *Arno* writing started as text for a video directed by Mark Pellington for 'Red Hot and Dance', an AIDS fund-raiser. I rewrote it for the 'Biennale di Firenze: il Tempo e la Moda' show in Florence. The text rose on signs in the pavilion I shared with Helmut Lang. In the middle of the night it was shown on the Arno River; this was my first Xenon projection. A variation of the text is at the Guggenheim, Bilbao.

Joan Simon *For Florence, you and Lang collaborated in another medium, odd even for you.*

Jenny Holzer Helmut and I made a perfume that smelled of alcohol, tobacco, starch, sweat and sperm, a love of some sort.

Joan Simon *The equivalent of your* Arno *line I SMELL YOU ON MY CLOTHES. What's ahead?*

Jenny Holzer Trying to write something again. I haven't locked myself up recently. As soon as I finish the next round of public pieces – in Europe and the US – I have to go to writing jail.

Joan Simon *The artists that have fed into your thinking are an extremely diverse lot. Among the earliest is writer, artist and printer William Blake.*

Jenny Holzer When I read *Songs of Innocence* (1789–c.1800), for the first time I was entirely convinced that there was good in the world, including people.

Joan Simon *And his illustrations?*

Jenny Holzer I liked the fact that Blake was able to have the text and images inhabit the same space.

Joan Simon *Was there any one poem in particular?*

Jenny Holzer There is a lamb poem with just one little sinister turn that mentions a neck.

Joan Simon *'Little Lamb*
Here I am,
Come and lick
My white neck.' [2]

Jenny Holzer That's the one. Then from *Songs of Experience*:

> 'If thought is life
> And strength and breath
> And the want
> Of thought is death.'

Joan Simon *You have spoken to me before of Malevich and Tatlin. The forms and functions of Tatlin's* Monument to the III International, *in particular. His tower was to be built of glass and steel geometries: a glass cylinder, cone and cube. It was to be a disorienting environment; each element was going to revolve on its axis. The cube at the top was to revolve once a day and was to be an information centre, with 'an open-air screen, lit up at night, which would constantly relay the latest news; a special projection was to be installed which in cloudy weather would throw words on the sky, announcing the motto for the day ...'³*

Jenny Holzer I was fascinated by the tower, but didn't know much about it. In art history it was only covered in passing – flipped on the screen once. I loved how it looked and thought the way it was meant to function critically important. It makes the blimp in *Bladerunner* unidimensional.

Joan Simon *The fact that it could not be built at the time ...*

Jenny Holzer That seemed perfect in some way, too. The whole concept was grand and tragic, hopeful, cruel, necessary.

Joan Simon *So much of its programme makes me think of your hopes and also what technology has only recently allowed you to accomplish – that new kind of Xenon projection, for example, used to 'throw' writings onto water and buildings.*

Jenny Holzer It is a great luxury for me to have the laser and Xenon projections.

Joan Simon *Your pieces share the palette of Russian constructivist work. I know you mentioned specifically Malevich's* Black Square and Red Square *(1914–16).*

Jenny Holzer All the colours required. Not coincidentally, they are the early LED sign colours.

Joan Simon *What aspects of Duchamp have been key for you?*

Jenny Holzer I was encouraged by the fact that he used a sign-painter when necessary. I liked the fact that language came in and out of the work as required. It was much discussed that his work was responsive to the tension in the air before World War I. I think he was alive to whatever it was that culminated in war.

Joan Simon *You were talking to me earlier about what you called his 'swirly optical' things: words and lines spiralling on the spinning disks filmed in* Anemic Cinema *(1925–26) and his emphatically colouristic swirls on the disks of his* Roto-Reliefs *(1935). From the artist of the 'non-retinal', these works are dazzlingly optical.*

Jenny Holzer For all his detachment, I've always thought his work looks perfectly right. The disks are eye candy, have content, and do move.

Joan Simon *You mentioned also what you called Duchamp's 'female fig leaf' (Feuille de Vigne Femelle, 1950) and the 'crotch for Teeny' (Coin de Chasteté, 'Wedge of Chastity', 1954).*

Jenny Holzer You don't see too many crotches in art; I have to take my hat off to him. I recall thinking how important an object and subject this piece of anatomy was. I remember that the work was nicely puny, seemingly made with a minimum of effort and material. I saw *Fountain* and thought it represented artistic freedom. The fig leaf and the urinal are also good for contemplating form and function.

Joan Simon *You threw many other artists' names at me the other day, among them Louise Nevelson and her black constructions.*

Jenny Holzer The relentless black spoke to me along with her compulsiveness in getting more and more material inside the frame. Then ordering was critical.

Joan Simon *Mark Rothko and Ad Reinhardt were critical even when you abandoned painting.*

Jenny Holzer I thought I would have to leave everything like rapture or the sublime when I began the *Truisms* posters. When I was invited to do the indoor installations, I could practise something akin to what happens in a Reinhardt. This is too literal, but an example is the installation at Dia, when I made the room black for a moment before the signs could begin. There was nothing but the apprehension of a presence.

 The language would rise on the signs and with it a glow. I am uneasy claiming that my work functions as Rothko's does, but I can say I wanted to offer light like that at the edges of his forms.

Joan Simon *When you finally began to put your words on something other than single, rectangular paper sheets, your structures and references are minimalist. You talk about being fascinated by the detail of LeWitt's pencilled wall drawings and his large, white, open-cube, lattice-like constructions. You also cite Donald Judd as extremely important.*

Jenny Holzer LeWitt, like Nevelson, displayed clarity, order and innumerable possibilities for structure. That was the great appeal, plus the fact that he did it so beautifully and economically. With Judd, much of the aforementioned applies, plus I liked his repetitions and the space made by his boxes. I also appreciated that everything of his lined up.

Joan Simon *When you first began to show your work you were identified with the Colab collective.*

Jenny Holzer Shortly after the Whitney programme I met Colen Fitzgibbon when I staggered into the 'Doctor and Dentist' show at Robin Winters' loft. With Colen I conspired to make the 'Manifesto Show' (1979). This Colab show

had everything from the Futurist Manifesto and the Communist Manifesto to proclamations by any number of artists and individuals. People said what they desperately wanted to happen or what they didn't ever want to transpire. These pronouncements were writings, images or performances.

Joan Simon *How long did Colab hang together?*

Jenny Holzer I don't know. I guess I intersected with the gang for four or five years.

Joan Simon *Curators and critics have also linked you with Louise Lawler, Cindy Sherman and Barbara Kruger. You seem to share theoretical concerns, an ease with pop culture, an implicit politics, and you have come to know one another.*

Jenny Holzer I am very interested by all the artists you mention. I only have a passing acquaintance with the theoretical, but I always felt Louise's work was great. I found what she did both fabulously opaque and absolutely transparent and solid. Sometimes when I'd see Michael Asher's work, I'd appreciate it because I couldn't get it. With Louise's, I could love that aspect, but I also knew what she was about. I knew her subjects, and I thought that the subjects were important.

Joan Simon *You mentioned in particular the racehorse piece of Lawler's:*
————,Louise Lawler, Adrian Piper and Cindy Sherman Have Agreed to Participate in an Exhibition Organized by Janelle Reiring at Artists Space, September 23 through October 28, 1978 (1978).

Jenny Holzer It had to do with wealth, privilege and illumination. It was blinding light and the gorgeous body of a race horse. I got it, and she did not pander.

Joan Simon *You also speak of particular pieces by Sherman and Kruger.*

Jenny Holzer The Kruger is *Your Manias Become Science* (1981). I thought it important because getting blown off the face of the earth is relevant.
 That early work of Sherman's in which she looks like a young female Mao Tse-tung was extremely good. It made me review what he did.

Joan Simon *You have collaborated in many ways and in different media since the beginning of your career: with the members of Colab on various projects; with Peter Nadin on artists' books; with Mike Glier for drawings with texts; with graffiti artist Lady Pink on paintings with texts; with Keith Haring on billboards; with Helmut Lang on an installation and a perfume. Why do you think you're such an avid and good collaborator?*

Jenny Holzer I want to learn something.

Joan Simon *I recently learned about two collaborations of yours that re-form the* Truisms *in radically different ways. One is on a Web page, begun in 1995, which is about as disembodied as a transmitter, vehicle, voice and receiver as can be. The potential size of the audience using the Internet makes this one of your most far-reaching public projects. The other is a dance work choreographed by Bill T. Jones,* Holzer

Duet … Truisms *(1985), where your* Truisms *are literally bodied forth by Bill T. Jones and Larry Goldhuber. The* Truisms, *spoken aloud, structure the dance.*

Jenny Holzer The äda'web project has something like 10,000 new *Truisms*.

Joan Simon People are adding their own Truisms *to yours?*

Jenny Holzer That's the idea. It's not so much to put my stuff there. My things are prompts for people's rewrites. Once written, the new and improved *Truisms* are automatically alphabetized and added to the list.

Joan Simon What's the address of the äda'web site?

Jenny Holzer http://adaweb.com/cgi-bin/jfsjr/truism [4]

Joan Simon The Bill T. Jones work is a stunning visual correlative to your text. The precise, strong movements that the pair of dancers hold as your words are heard have the clarity of each of your phrases. The 'different voices' in your texts are embodied by two very different-looking men. One is black, one is white; one is taut, sculpted, athletic; he is bare-chested and barefoot, costumed in black shorts. The other has what would have been called a 'non-dancer's' silhouette. Big and pear-shaped, he wears a suit and tie, though he is sometimes seen without his jacket, as if at work at the office, and dances in shirtsleeves, braces revealed. His voice sounds New York City nasal. Another voice (from off-stage) has 'no' accent, not unlike the broad sounds of upstate New York or the Midwesterner's heartland speech.

Jenny Holzer I was so thankful that Bill and Larry did it because I'm timid about flesh. It was of great interest to me to have the *Truisms* said, touched, flopped and rubbed by two people.

Joan Simon Each performer is correct to the spoken language and to the language of form in movement. Duet *is a great piece of dance formally, and it is powerful emotionally.*

Jenny Holzer It was something I couldn't do and I'm relieved they could. I am encouraged by it.

Joan Simon I saw excerpts of Holzer Duet … Truisms *in a film where Jones is interviewed.* [5] *He said something that, to me, is on target about the intentions of your work and also summarizes what a viewer feels in its presence; and he characterizes the 'duet' between his work and yours, the politics and poetics, the visual, formal and temporal essence of what you both offer your audience:*
 'I'm laden with expressions. I'm laden with anger, and discontent and social commentary. (For) the piece I made recently with Larry Goldhuber, I purposely chose Jenny Holzer's writings because Holzer is dealing with something I have felt. She would like to voice points of view that are left, centre and right, and they all exist in some sort of disembodied presentation so that we the observer(s) must decide where we fit. I don't take a particular stand. I'm presenting political work without committing my own particular point of view. Trying to balance

abstraction, trying to give the audience the time, the breath, to make their own decisions, and entertain their minds and eyes as they are going through this process.'

Jenny Holzer I am glad he said 'disembodied'; I am so happy he has the body.

1 Quoted in Michael Auping, *Jenny Holzer*, Universe, New York, 1996, p. 38
2 William Blake, 'Spring', *Songs of Innocence and Songs of Experience*, Dover Publications, Inc., New York, 1992, p. 23
3 Camilla Gray, *The Russian Experiment in Art: 1863–1922*, Harry N. Abrams, New York, 1971, p. 226
4 'Please Change Beliefs', on-line project, launched May 23, 1995
5 Sally Barnes, *Retracing Steps: American Dance Since Postmodernism*, Michael Blackwood Productions, New York, 1988. My thanks to Kellie Jones for bringing to my attention this film and Bill T. Jones' *Holzer Duet ... Truisms*, 1985

Roni Horn *Lynne Cooke*

in conversation
April 1999, New York

Lynne Cooke *Your most recent piece,* Pi *(1998), establishes a new relationship in your work between the photographic image and architectural space.*

Roni Horn It started as a book in the ongoing series of volumes, *To Place. Arctic Circles* (1998) was the title of the book, and in that context, it was overtly located in Iceland. When I pulled this other work, *Pi*, out of the *To Place* series, by implication it was pulled out of Iceland. When you're looking at this piece there's no necessary relation to Iceland, although it derives from there. The title evolved into a broader relation to the circle: *Pi* being a reference to the mathematical constant π which is the ratio of the diameter to the circumference of a circle. The Arctic Circle doesn't exist except as a mapping device. It's a bit of civil infrastructure; it functions, in a sense, as a means to relate humanity to the scale of event that the planet exists in. *Pi* too presents a means of relation to something that exceeds us. In this installation it refers to a collection of circular and cyclical events, which, together, form an idea of constancy. The passage of time; life-death rounds; mundane daily existence; dramatized stylized life; the harvest … all form these cycles. The installation of *Pi* also involves an architectural aspect that extends the circular reference to the idea of a surround or a horizon. The work surrounds the viewer spatially. It is hung above eye-level so that you literally come in onto a horizon.

Lynne Cooke *It's installed about six feet off the ground, so the horizon line is over the average viewer's head. Since you look up at an angle, you are forced to stand back; as you move towards the middle of the room to look at it, no-one is ever in your way. You can always see the work as a whole.*

Roni Horn I wanted to prevent the viewer from focusing on each image singly, isolating and interacting with individual images out of the context of the whole. If that happened the work would not, in a crucial sense, be readable.

Lynne Cooke *In the presentation of* Pi *at Matthew Marks Gallery, New York, in particular, it was evident that there was no hierarchy: all four walls of the room were virtually the same length and there were three entrances. There seemed to be no starting point, no point of closure, and no focal point. Moreover, several images which were repeated, or reversed, were so situated from each other across the room that a dialogue developed or an echo formed. Consequently, the viewer was always looking across, round and back:* Pi *is a non-directional, non-directive piece.*

Roni Horn There is no prescribed beginning or end, and, among the images, no single motif dominates. The potential for narrative, which is implied in the nature of the imagery, never actually evolves. Thwarting the narrative is an important way to engage people's interest.

Lynne Cooke *Tidal and seasonal change are cyclical rather than linear. Such cycles suggest an eternal return. Then there are the cycles of the birds' lives and, of course, the lives of the elderly couple Hildur and Björn, who are towards the end of their life cycle.*

One feels a conscious layering and overlapping of different histories, different temporalities and durations.

Roni Horn There's also the cycle of the harvest. And then there's a cycle, at least in my mind, which is the relationship of human nature to nature, this mirror-like relationship in which humanity is trying to remake nature in its own image. That's the role of the stuffed examples of indigenous animals, which have an extraordinarily human look to them. Mainly they're odd or goofy looking. Maybe the taxidermist just never got them right. They seem closer to human beings than to familiar animals ... I see the seal and Hildur, or the mink and Cassie – a fictional character from the American soap opera *Guiding Light* – as being like twins.

Lynne Cooke *The sea is uninflected. There are no rocky outcrops or boats interrupting it: it's a quintessential expanse of water, like a slate. It's both a place and placeless, both very particular and universal. Given that there's nothing to identify out there, the singular and the generic are conflated.*

Roni Horn The television stars are generic types so they, too, operate in the realm of the collective. The daily drama of the soap opera, *Guiding Light*, is another cycle that is important to the work. Whatever kind of artificial, mundane drama it might contain is reflected in the mundane drama of the birds, dead, alive, on the cliffs, over the water: a local and universal expression of drama. *Guiding Light* was part of the daily routine for Hildur and Björn and most of rural Iceland.

Lynne Cooke *The eider down is collected and stored in a very spare, austere room. Beyond that, there is no further access to Hildur and Björn's home, to their living-quarters or anything that would domesticate or localize them. They reveal their individuality through the way that time has marked itself on their faces, rather than via objects or surroundings. These two people are recognized in their singularity but they're not explored in their anecdotal particularity. They're locked into very large cycles related to space and time.*

Roni Horn Were I to have gone too specifically into them I would have wound up with a narrative or a more descriptive relationship to the subject, which I didn't want. I wasn't so concerned with the fact that they were old, but with the intricate qualities of their physiognomies which you don't get with younger people, for the obvious reason that aging is a dimension which becomes more apparent in the face with time. It operates as a metaphor for landscape: when I look at those faces there's a level of complexity which doesn't come from their expression; it comes from their physical reality ... I originally placed some of the dead animals and Hildur and Björn opposite from one another so that gaze met gaze. I liked this intersection in architectural space, this use of image to engage physical space. There are images which I cut in half and which occur in different parts of the room, and there are images which were taken seconds apart from each other. One series of images was photographed

at three in the morning, and then again at three in the afternoon. The light was oddly similar, yet you felt the difference when you were there; it was more a tactile or palpable experience than it was a visual one. So in *Pi* there's a delicate relation to the passage of time: minuscule differences in physical terms may prove great in visual terms. I also used these manipulations in the book *Arctic Circles*. *Pi* has half as many images as *Arctic Circles*: every motif had to occur at least twice, preferably three times, in order to create a circular experience for the viewer. That limited the way it was structured.

Lynne Cooke *What are your feelings about the inversion or reversal of an image? To me, it operates like a flashback; it reminds you to look back, literally, or to look a second time, metaphorically. It also brings the photographic medium to the fore, making it self-reflexive. There's one motif which, exceptionally, is not repeated yet which also, in a very subtle way, ties things together. This is the image of the wallpaper, which is like a map or a net. It introduces a larger infrastructure into the piece, a skein of things overlaid, interwoven and entwined together.*

Roni Horn Yes, it is the only image that doesn't recur. I thought I could use that image alone because it communicated 'cycle' in itself. I thought about the way the formal structure might allow me to relate images together which are so disparate. All the shots of the Arctic Circle, the horizon shots of the ocean, are cut in half. Given the nature of the horizon, a person looking at them will understand that they're only seeing half of something. Either they'll look for the other half or they'll carry it in their head. This was the element that really allowed me to draw together all this seemingly unrelated imagery. The half horizons sew the work together. The inner logic needs to be extremely intelligible to the viewer in order to have this wide range among the images and still keep the work cohesive. Each visual motif is woven in or drawn together, so that everything seems to have a certain quality. The wallpaper has the passage of time in it, in the way that it's faded. It also has a visual relationship to the feeling of oceanic expanse, to the static field of the television set, and from that to the down, the soft down material; that then goes into the nest. Or Cassie with her TV nest and the close-up shots of the down, and then the crowd shot of the birds on the rocks. One of the reasons I chose Cassie was because she has this big hair. I like the idea of moving from human to landscape via big hair, which became an extension of place. There's another woman I wanted to use, named Dinah, who was a Warholian type with close-cropped black hair and red lipstick. She was very photogenic. She would have been an interesting presence, but she was completely separate from the setting – too graphic, perhaps – whereas Cassie was half place and half object. So I worked with her.

Once you recognize and step into the logic of this piece, it becomes evident how everything matters. The more clear the thing becomes to you, the more defined the critical edge becomes. This work is complex, not just in terms of its content, but in terms of how the viewer relates to it and, ultimately, puts it

together. A work always comes together twice: first, for the artist, and, second, for the viewer. For me that second coming together is really an essential part of the experience.

Lynne Cooke One is very conscious of one's movement in the space of the gallery, which is quite different from the kind of experience one has with the book to which it is closely related.

Roni Horn This is a subject that I come back to again and again. I'll go into a work thinking that it's going to be a book, and find that it then develops into another work which is parallel and separate, sometimes in very subtle ways and sometimes in really big ways. In the latter, they become completely different works. For example, in *You Are the Weather* (1994–95), a hundred images of the same woman stare at you from a hundred different points in space. This sets up a completely different experience from that which anyone could possibly have flipping through those images in the book *Haraldsdóttir*, to which it is related, where no more than two are visible at any time. The differences between these works are much bigger than the quantitative description of either one of those two forms allows.

Lynne Cooke One aspect of Pi *that is quite different from* You Are the Weather *is that when experiencing* Pi *one is conscious of being in a social space. Being present with one or two people, which is normally the case in a gallery setting, is, for me, the optimum experience: it reinforces the social identity of the two protagonists, Hildur and Björn. With* You Are the Weather *the movement is incremental, you go from one image to the next, just you and the woman in the image (Margrét Haraldsdóttir Blöndal), whereas with* Pi, *by contrast, there is a more fluid, unstructured movement across and around the room.*

Roni Horn Pi *is more fragmented and the fragments add up eventually, whereas in* You Are the Weather *there is a constancy and extension to the gaze, either because of the voyeuristic element or because of the fantasy element. I'm interested in that relationship to the image: in the way an image breaks down and becomes less an image.*

Lynne Cooke *Given that Margrét's face is not expressionless but is very contained, one watches subtle, incremental shifts which one might think are physiognomic changes, or the product of changes in the light, rather than changes in her moods. That is, we're very conscious of reading the face as a physical surface. In the faces of Hildur and Björn there's a condensation of what we've been discussing – time and its imprint on the surface – whereas, because Margrét is so much younger, and because there are so many more images that are subtly different in the work, one finds oneself moving literally across textured surfaces - not internally and, therefore, not psychologically – but nonetheless in a one-on-one relationship, an individuated engagement.*

Roni Horn When I was editing the images for *You Are the Weather* and now, again, with *Still Water* and the book in progress, *Another Water*, the editing process

became the principal aspect in the development of the form: images were either taken away or sometimes later added back in. It's a slow process of learning to see what you're looking at, paying attention, with something that is not exactly ignorance but a kind of intuitive intelligence. In *You Are the Weather*, I edited out all the images where Margrét was smiling or really miserable, all the extremes, which I learned to do with *Pi*, too, because they broke the continuity and cohesiveness of the work. I also cut images that became too descriptive or seemed too novel, and so functioned differently from the others, taking away from what was going on around it. Although *Pi* is not an intimate experience in terms of physical proximity, it is in terms of where you go in your head. It's half you and half what's out there, because it keeps you in the space in such a way that the room becomes a landscape.

Lynne Cooke *It becomes a place?*

 Roni Horn Exactly, it becomes a place. That doesn't happen in *You Are the Weather*. It's you and this woman, and where you go with that.

Lynne Cooke *In this,* Pi *recalls your pair objects, sculpture suites such as* Things That Happen Again *(1986–91), or* Pair Field *(1990–91), which engage circumstantial reality. When, for example, you are looking at one of two forms that are apparently identical, you realize that they cannot, by definition, be identical because you can't have the same experience twice. In addition, you inevitably see each one from a different angle, approach it differently, and thus always see one in relation to another. So though these works utilize space differently from* Pi, *it seems to me that the vividness, the sense of presence and immediacy they engender in the actual space, has been carried through into* Pi.

 Roni Horn I'm working on a pair object now that happens to take a photographic form. It's so integrated into that series that the photographic aspect is nominal. I suppose I haven't really used photography in any way but nominally. Usually the subject matter of the image is not the subject matter of the work. A thing can generate so many different appearances as an image. If only through its use in mass media, photography has become increasingly vital to our knowledge of ourselves. My work rides on that familiarity, and uses photographic images in order to get into architectural or psychological spaces that have very little to do with the image *per se*. In *Still Water (The River Thames, for Example)* (1999), photographs of the water in the River Thames that are then footnoted extensively, there is something interesting in the quality of the images because, photographically, they capture aspects of the water that are not visible to the naked eye, such as when the water is moving a touch too fast to be seen. When water is translated into a photographic image it has so many different personas. I was not expecting that. I know that most of what's out there in the world is occurring too quickly or too slowly for me to see. But somehow I didn't expect that when water was converted into this graphic form it would be so surprising. In these images you see how

unfamiliar water really is. Perhaps because it's so complex, one of the qualities of water is to sustain this unfamiliarity.

Lynne Cooke *The photographs in* Still Water *are intended to be shown in different spaces, so that it won't be possible to see more than one at any time. One's ability to hold in memory an image that is intrinsically evasive is stretched to the fullest. The subject is highly elusive. To recall each image as one moves from one space to another brings into play a very different sense of time and vision from that found in either of the two projects we've been talking about.*

Roni Horn That depends not only on the evasiveness of the images and the way they seem to haunt your memory. The footnotes, which form a band at the bottom of each image, sustain a third element in the work. The image is one part of the form, the viewer is the second, and the voice in the footnotes is the third. This voice is mainly characterized by an endless flow of consciousness. In parts of the text it anticipates the viewer. It is also my voice. I am there with you as you look at these images. I'm talking to you. The idea of installing the images throughout a building – using the service and transition areas as well as the exhibition spaces – is a way of redirecting the flow through a space.

I'm working on another piece called *This Is Me, This Is You* (2000) – something that my niece often says to me. For example, when looking at a photograph with two elements, she will say 'This is me', and 'Roni, this is you.' I've reached the point where I see this as a paired form. It's not comparative: it's an identification of relation, a simple relation. The form of this work is evolving into a collection of twenty or thirty images that are related to another collection of twenty or thirty images. The only difference between the two groups is that within each pair, each image was taken a few seconds apart. The thirty pairs of images are composed into two separate groups and hung in two different places. One of the things I'm interested in here is the way that this integrates photography. The photograph almost disappears because difference is being measured in seconds. You're recording or identifying difference as a measure of change. In a few seconds you can have extreme changes or imperceptible ones.

Lynne Cooke *As viewers, we'll literally act out what conceptually we comprehend as the subject of the work ...*

Roni Horn Yes. Narrative has no interest for me except in terms of how an experience unfolds for the viewer. That is the narrative of the experience of the work itself. To take another example: in *Piece for Two Rooms* (1986–91) you go into a space and see a simple disk. It doesn't look like much: it isn't, until you walk in and see that it is a three-dimensional cone-shaped object which is familiar but has certain subtle formal qualities which make it different, which take away from it being familiar. It becomes memorable. Then you go into the next room and enact exactly the same experience, but of course it's unexpected and it's so many minutes later; it's a slightly younger experience in your life.

Whereas when you walked into the first room, you had the experience of something unique, you can't have that a second time. That's it. It's a one-shot deal: it's not a reversible thing. When the viewer is going through this experience, that becomes the narrative: it's literally a piece of your life and it's the narrative of the work.

Lynne Cooke *Your exhibitions are made in the 'here and now'. Whatever allusions or recollections one might have from other pieces or previous shows don't seem particularly relevant. It's an unusual way of working. But you not only make exhibitions that are highly self-contained; almost every work in your oeuvre seems hermetic vis-à-vis your practice as a whole.*

Roni Horn That goes to the heart of it. I have this idea that each work should be unto itself. You walk in, you engage the experience, you leave: that's it. There shouldn't necessarily have to be a history of like works or future works, or variations on them. I've never felt tied to that way of working. If you say that the viewer's experience is a big part of the realization of the work, then you have to tune in to that individual possibility.

Lynne Cooke *One of the consequences of the way that you've made shows up until now is that an informed viewer is not in a better position than a viewer who has no previous experience of your work. If each were actively prepared to engage, each could apprehend the art equally well. That's very unusual. It's generous to the viewer. It doesn't distinguish between different types of audience.*

Roni Horn If you present someone with a credible physical reality they have to deal with it, and to do it whether they have a lot of information about what is in front of them or not. Preferably not. Knowledge is a funny thing: it often precludes experience. Usually no knowledge is better than some, or too much.

Lynne Cooke *Because with too much knowledge one reaches automatically to the previously experienced, to the known?*

Roni Horn Yes, you don't really have an experience. There's a discovery process involved in every experience, and I want that discovery process, that starting from zero, again, and again, and again. I feel I'm always starting from zero. Obviously I have more experience than I did ten years ago, but somehow that experience has not dedicated my future towards a certain outcome, in terms of style, medium or even idiom. I don't think I'm going to run off tomorrow and make a film, or write a book of poetry. But I do feel that within a limited range I can utilize a number of different forms with ease. I don't think of myself as a writer, but I conceive works, such as *Another Water*, which require a significant amount of writing. In these texts, it's not just what is being said that matters, but how it is being said.

 When developing three-dimensional work, I've always thought in terms of language as opposed to thinking visually. So even in the case of the sculpture *Piece for Two Rooms*, the initial idea came when I was reading a

book and started to think about how you could take an episode and repeat it a hundred pages later. I thought of this originally as a publishing defect; then it became the same thing in two different places; then it became two different things … I think in terms of syntax if not quite of grammar; of phrasing, leitmotif, chorus – the tools of language structures – which then take a visual form in the work.

Lynne Cooke *You haven't yet embarked upon a film, but the way you speak brings structural film to mind.*

Roni Horn Most popular films have a narrative. You step into an abstraction of time, which is not at all like the time one lives. But occasionally you have a film that does use time in a manner that is very similar to the way one lives time. In Robert Bresson's *A Man Escaped*, for instance (or, in a very different way, in Rainer Werner Fassbinder's *Why Does Herr R. Run Amok?*) the narrative goes on in real time. I would argue that my work, similarly, is not abstract: the acquiring of an actual experience is also the content of the work. That's all there is, and that's what it is, whether it's *Pi* or *Piece for Two Rooms*.

Lynne Cooke *Another parallel with film might be that during the encounter a sense of the actual place is obliterated, instantly; it's very rare to remember the form or character of the cinema as architectural space. There's been a lot of theorizing around the fact that the cinematic experience is quintessentially an experience of being in no place, and yet, at the same time, being in the absolutely here and now. Ultimately, it doesn't matter which auditorium one is in, or how the architecture is configured, the experience of the 'here and now' overrides all such considerations. Similarly, in the* Pair Objects, *it doesn't matter finally what the gallery is like physically, more important is the sense of an active relationship with the spatial envelope.*

Roni Horn If you imagine a cinema, it necessitates the disembodiment of the world. Yet in some ways it's the exact opposite of what I'm doing. When a work is installed, the experience of the setting becomes more prominent. The circumstantial aspects – that is, the specific architectural setting, the proportions of the space, the quality of the light, the location of the entrance and exit, the materials, all the things that make a space a particular place – become more prominent.

Lynne Cooke *A viewer develops a heightened acuity to that context and yet, at the same time, the work wasn't made for that unique space or for any one particular gallery or museum. It's attentive to a sense of place, it's embodied in the space but not in the way that a truly site-specific work is, for such a work cannot by definition be transferred elsewhere. There seems to be a sliding scale between certain of your works which heighten one's awareness of the spatial context, like the* Pair Objects, *and others which draw more directly on it and are more governed by it, like* Pi, *and others which are commissioned for unique locations.*

Roni Horn Site-specific remains an elusive term for me. There's a further distinction between these works and a commission. What happens when a work is commissioned is that the form of the piece evolves out of a dialogue with that site. It becomes indigenous to it. In site-specific works it's the entwining of the work with the circumstantial aspects of a place that makes it inextricable from it. The 'how' of that concept would be articulated very differently in a different building or site. But the 'what' of it would still be similar, if not the same, from one site to another. I don't think the concept itself is ever really site-specific.

I'm working on a semi-public installation in Basel (*Yous in You*, 1997–2000) that involves a rubber-tiled walkway. The surface form is taken from a rock face in Iceland. The experience is primarily a tactile one, that is, one that will be felt via differences in density which, visually, will be imperceptible. On one level there is a purely conceptual element, which is the idea of taking the impression of a landscape from one place and shifting it to another place – a geological and a geographical shift. Sections of the walkway are cast in very soft rubber, others are in a harder rubber. Since there is no visible clue to those differences, you become the reference for the experience. There is no visual confirmation of what you feel. It remains within the subjective realm: you're really on your own.

I think of the path as a reflection of the human condition: its scale is always that of an individual person. Crucial to the idea of the path is that it's an irreversible form with a very delicate and truly complex relationship to the place it's in – every path is a site-specific event – in contradistinction to civic events like roads and highways, things that are built out of social need, out of massive collective effort. This path in Basel goes through an architectural setting which is fairly classic, a structure of platonic geometry. It introduces not simply an organic form – landscape – into an urban context, a public space, but also a psychological presence, a kind of mirror for the unseen. It introduces the idea of another place in order to form a complex with it and re-form the place you're standing in. Proximity is a very powerful basis for relation, for human and circumstantial relations. Proximity can compound meaning or, conversely, it can fragment it.

Lynne Cooke Over the years, certain of your abiding concerns have been differently parsed; as, for example, when the Pair Object *series took on the medium of photography in one of its variants. What is the basis for a related process: returning to a specific form, or revising a particular image?*

Roni Horn Around 1980 I made *Pair Object I*, which was prescient, because I didn't do anything like it for another five years. Then there were *Pair Object II* and *III*, with the same theme. The idea of pairing then occurred in the drawings in a very odd way, with this distant-double thing, where you have different but very similar drawings in different rooms. I'm unsure which occurred to me first, the *Double* and *Distant Double* drawings (1986–90) or *Piece for Two*

Rooms and related works, but they informed each other. There was no question that they were parallel developments that helped me to grasp the possibilities of proximity and distance and, from that, difference and identity. I guess we're really talking about what happens when I go from one form to another, whether in a book, or a three-dimensional work, or a two-dimensional work, or an installation. I can take the same material in these different forms and arrive at different experiences. For me, that's the basis for the re-use of certain images. An important instance of this is the owl image. It occurred first as *Dead Owl* (1997) where it offered an experience of infinity or at least the beginning of infinity. Then the same image, again paired, was used as a spread towards the end of *Arctic Circles*. A form of punctuation, it was a full stop. And then, in *Pi*, I used a cropped version of it, a head shot. There it was one element among forty-four others.

Lynne Cooke *Closely related to this is the way that in certain of your titles the words themselves mediate between your experience and the viewer's: they categorize or classify one in relation to the other. Many of the terms you choose, like 'me' and 'you', 'here' and 'there', 'this and that', are shifters, which makes for very complex, fluctuating relationships. If I say 'you' and 'me', and you say 'you' and 'me', we mean the same thing but in reverse, from opposite sides, so to speak. This plays crucially into the active role you consistently assign the viewer.*

Roni Horn I love the way language compounds identity. I don't know who 'I' would be, or what the meaning of the relationship would be without specific instances. But I'm attached to all the shifters, especially to 'you'. It is ungendered and entirely dependent on point of view. It is all inclusive. But a work can be especially meaningful and effective in how it questions one's relationship to oneself. Through that it can be quite profound in how it affects the world.

Ilya Kabakov *David A. Ross*

in conversation
December 1997, New York

David A. Ross *I was thinking of bringing a guitar – you could sing some Russian songs and maybe I'd sing Bob Dylan. The first time I was in Moscow in 1979, I was taken to a dinner party the likes of which I'd never seen before: one chicken for around fifteen people, and of course a great deal of vodka. I remember passing a guitar around the table, and everyone singing Russian and Jewish folk songs. It's slightly embarrassing to recall, but when my turn came I sang Dylan's 'Blowin' in the Wind'. I remember thinking: was this really an adequate rejoinder? Was there a way that an American Jew, from a generation that took for granted so many aspects of identity, independence and freedom, had anything to say to these young Soviet Jewish artists?*

Ilya, when you were growing up in the Soviet Union, did you have a particular sense of your own Jewish identity?

Ilya Kabakov Because this question has been asked so often, it is now easy for me to answer. I never had, and still don't have, a clearly defined sense of racial belonging. I see myself a little like a stray dog. My mentality is Soviet; my birth place is the Ukraine; my parents are Jewish; my school education and my language are Russian. My dream was to belong to European culture, a dream that was practically unattainable during most of my life.

Looking back on my childhood, my school and the Surikov Art Institute in Moscow, I cannot say that we were differentiated by racial or religious identity. In our circle there were people from Azerbaijan, there were Tartars, Russians, Ukrainians, Jews, but who belonged to which religion was relatively unimportant. We all belonged to the Soviet religion. We all shared a similar unhappiness, because we were all Soviet. One of the qualities I saw in the Soviet people was the feeling of their own inadequacy, the feeling that somewhere beyond the border, there existed a real, more authentic, life. It's like a child who doesn't love his parents: the neighbour's soup always tastes better.

David A. Ross *The grass always seemed greener … But isn't this feeling what was always decried as 'cosmopolitanism'? Didn't the paranoiac nature of the Stalinist Soviet state discourage the desire to engage the notion of the modern multicultural city, sensing that it was inherently anti-national, the carrier of the hybridizing influences of modern European urban society?*

Ilya Kabakov Yes, in official life, cosmopolitanism was strictly forbidden. But, as you know, thirty years of my life were spent in the circle of Moscow's unofficial culture, which was isolated to a certain extent from Soviet society. It was possible to remain safely cosmopolitan inside this circle. But this is a general theoretical position; personally, I did feel that I was Soviet.

David A. Ross *Can you describe your family life, what your parents did, how they encouraged or discouraged your interest in art?*

Ilya Kabakov Neither of my parents had any connection with the arts. I discovered my 'real family' at my school in Samarkand and later at the Art Institute, which represented the standard model of Soviet society in all of its aspects. I was

eight years old when the Second World War started. My father was drafted and my mother and I were evacuated in 1943 to Samarkand, in Uzbekistan. It so happened that the Leningrad Art School, the dormitory school for 'artistic' children, had also been evacuated there. They saw some of my drawings and I was accepted into the school.

David A. Ross *So, very early on, people recognized your ability to draw.*

Ilya Kabakov Maybe they recognized my talent for drawing, but at the same time they thought I was quite talentless at painting.

David A. Ross *Would you say your talent was nourished by the State?*

Ilya Kabakov Looking back, after having lived by now for ten years in the West, I can say that the State gave me a lot, in a material sense. My education both at school and at the Art Institute was free, and at the Institute I even received a small stipend.

David A. Ross *By the end of your formal education you must have been deeply imbued with the idea – which presumably was so pervasive that it was like the proverbial forest where you can no longer see the trees – that art was in the service of the people. What did you feel was your role as an artist? To follow some inner desire to express yourself, or to follow orders, stay on course and make art that served the State?*

Ilya Kabakov Like everything in the Soviet Union, outside appearances did not represent what was inside. From the outside, the school looked highly professional. We lived in the school; they fed us, and gave us clothes and materials to work with. From the inside it looked completely different. It was just the shadow of the art system that had existed before the Revolution.

 Maybe it was inevitable that the academic system, like everything else during the Soviet years, had deteriorated so much. But there was also a personal psychological phenomenon that I would like to describe: from early childhood I demonstrated a complete distrust of everything they were trying to teach me, no matter who my teacher was. Nevertheless, during my early years as a student and later as an illustrator at a children's publishing house, I did everything that was expected of me. In the same way, I accepted the Soviet reality – like the weather, it was a given entity. If you live in a country where it always rains you can't expect to fight the rain by organizing a demonstration.

David A. Ross *The problem within the meritocracy of the Soviet art system must have been, how do you reward something better or of more value while remaining true to a notion of complete equality and non-hierarchy?*

 This kind of idealism is particularly ironic when you think of the eventual influence of Zen and John Cage's thought on the development of Soviet Conceptualism in the 1970s, wherein a levelling or emptying of Western hierarchies of experience, the notion that no experience is better than another kind, was imposed on this system in its last moments of decline. This was in some ways a wonderful mockery of the impossible idealism of Soviet Socialist art. The absorption by the Collective Action group of this Westernized–Eastern

approach subtly criticized the Soviet system's inability to impose pure Communist egalitarianism into the aesthetic system.

To return to your early experience of Soviet society, I'm interested in how you became aware of these social and psychological contradictions, of the lie that you were living.

Ilya Kabakov This is a central question. This awareness began in my early childhood: a feeling that the outside is not co-ordinated with, or is not adequate to, what's taking place inside.

I didn't want to see this social reality as a given. My problem was how to learn to have a double mind, a double life, in order to survive, so that the reality wouldn't destroy me. At school I was amicable, but inside was a small scared person watching the other person behaving in a socially acceptable way. This little person was incredibly scared, all tied together inside.

David A. Ross *What you're describing sounds like a kind of schizophrenia.*

Ilya Kabakov Yes, that makes it easier to understand how I was working as an artist. I very quickly learned everything that my teacher instructed me in order to go by the rules, but the person inside never understood what was going on. I was like a trained monkey or dog. The person inside me didn't have any contact with my hands, with what was produced by these hands. So what was natural for others, in order to become a Soviet artist, for me was a learned ability.

David A. Ross *What did it mean to become a Soviet artist, to employ your talents in the service of the people, of the State? What was expected of you?*

Ilya Kabakov The Soviet art system was strictly and formidably divided into themes, subjects and formal styles. The programme was already set – there had to be happy, festive paintings, works celebrating the structure of social life. Each artist would receive a list of the same themes, which he or she had to follow in order to exhibit or sell to the State.

David A. Ross *So if Matisse said that art was like an armchair for the weary businessman – the bourgeois owner, or viewer, of a painting could just relax in its presence and take pleasure from it – in the Soviet Union this Matissian formula became a prop for the State. Art became a function of communal happiness, with conditions that everyone understood. Your job was to help people feel better about the reality of their lives.*

Ilya Kabakov As I recall, the structure of Soviet art production, by the end of the 1950s, was strictly hierarchical. Paintings depicting the history of the Soviet State were considered the most important and prestigious. Then, in descending order, were portraits of Party leaders, metal workers, *kolchosniks* (collective farms); then landscape, still life and, at the lower end, genre painting. Incidentally, this was reminiscent of the hierarchy used by the Bologna School in the sixteenth century.

David A. Ross *So what had happened to the revolutionary idea of pure, non-objective painting and sculpture, via Malevich, Kandinsky, Tatlin and their contemporaries? How did this early modernist legacy disappear?*

Ilya Kabakov These ideas were channelled into the propaganda structure.

David A. Ross *So, during the period of Productivism, these ideas were only acceptable when mediated through industrial and graphic design? In a sense, the avant-garde was being taken at its own word, because its impetus was 'art into life' and the slogan of Productivism was, 'Not the new, not the old, but the necessary!' The State absorbed the avant-garde and then dismantled it by embedding it into everyday life; artists no longer made art but made everyday objects. Rather than being dismissed as anti- or counter-revolutionary, or cosmopolitan, was this artistic tradition just invisible, forgotten?*

Ilya Kabakov What I describe is the situation in the 1950s, the artistic climate in which I and my friends were formed as artists. I didn't see the works of Malevich, Tatlin and others, because their works weren't exhibited and publications didn't exist. But no, I'm wrong – in the Pushkin Museum during the 1960s Kandinsky's paintings appeared in the section of Western art with the label: 'Wassily Kandinsky. French Painter'.

David A. Ross *But surely you saw their influence in your environment? There were posters, there still is the great architecture, there were examples in your day-to-day life, at least in Moscow, of revolutionary artistic thinking.*

Ilya Kabakov The things you are talking about were visible to all the civilized world, but my friends and I saw Maria Ivanovna in the communal kitchen frying *pozarski kotletas* – meat patties.

David A. Ross *So none of your art teachers said privately, or whispered to you, 'I'm going to tell you about something … '?*

Ilya Kabakov Private conversations and whispering would have been politically incorrect.

David A. Ross *So how old were you when you first encountered these avant-garde traditions in your own culture that had been hidden from you?*

Ilya Kabakov I found out about them when I was almost forty, and by that time they were dead for me. The majority of us didn't know about any traditions at all. We all started from scratch.

David A. Ross *Almost forty years old – that's 1973!*

Ilya Kabakov In the Soviet Union time passed at a different pace from the rest of the world. Many of the older artists were working at home, in the tradition known as 'Cézannism'.

David A. Ross *Because that was the last radical movement before the 1917 Revolution?*

Ilya Kabakov In the 1950s and 1960s the 'Cézannists' didn't exhibit, that is true, but they did live in Moscow and the tradition of this kind of art was still alive. They were called formalists and they were 'underground', a term synonymous with modernist. When we visited Robert Falk's studio, for us his abstract style of painting, which was known as 'Cézannism-Cubism', represented a grand art form in opposition to Soviet art.

David A. Ross *Yet when you walked past buildings in Moscow designed by architects such as Konstantin Melnikov, surely you couldn't look at them without realizing that there was an entire aesthetic world attached to this architecture that was different from anything you knew. These buildings were as radical as any painting – did they not lead you to the same notions of non-objective space and abstraction that you would glean from a Malevich painting?*

Ilya Kabakov I didn't see them. The problem was that I didn't have any contact with this vanished civilization. My perception of these buildings was like that of a dog running about the ruins of the Parthenon. I was on another level. For me it was the past; maybe it was beautiful, but it had nothing to do with me.

David A. Ross *Why did you become an illustrator of children's books rather than an artist who represented and glorified the State? Where are the illustrators in that hierarchy you were just describing? Were they below the landscape painters?*

Ilya Kabakov My view as an outsider to this person, to myself, was that this artist, educated in Soviet institutions, was always aware that he couldn't escape the system. He had to do exactly as the Soviet institutions asked him. Yet the person inside, who didn't understand why he was supposed to do all this, who was always trying to express what he was really feeling, didn't understand that everything of artistic importance was in the art of the outside, the art of others. This small person could only see the boring or scary or banal aspects of everyday life. He saw dirty bottles, a lot of garbage, tickets to the subway, advertising. This little person felt a unity with everyday life. There wasn't a desire to disappear, to run away from the everyday, to do something romantically high; there was rather a desire to express this unity with banal everyday life. That's how he created two ways to live in order to survive in this society. To survive, he started making illustrations and, in order to be paid, he completely followed the rules.

I was always aware that I was making children's book illustrations for only one reason: to make a living. It left me with free time in which I could do what I really wanted. I learned how to produce children's books so fast that for twenty-eight years of my life I could spend only two and a half months a year doing this job.

David A. Ross *So it was your decision not to seek entry into the official Soviet art academy and become an official artist? Would that have been denied you?*

Ilya Kabakov If I had continued only making children's illustrations I would have made a great deal of money and risen up the official hierarchy.

David A. Ross *So, in your role as an artist, as opposed to your official job as an illustrator, you had to be invisible?*

Ilya Kabakov I was making enough money to build my own studio and I was a legalized artist, which was incredibly important. An artist who wasn't a member of the artists' union had problems working at home, because it was against Soviet laws.

David A. Ross *But couldn't art be your 'hobby'?*

Ilya Kabakov Yes, but you would have to work and then have it as a hobby in your free time off work, even if that meant sweeping the streets.

David A. Ross *So if you wanted to be a painter, you could take a job as a street-sweeper and work eight hours a day and then paint at night, no problem.*

Ilya Kabakov I had the right to make drawings for myself because I was officially an illustrator.

David A. Ross *In one sense there isn't a totalitarian overtone to the kind of decisions you had to make. You made the same kind of decision as any young artist whose work is not in favour with the prevailing system. For example, Edward Hopper had to survive by working as a magazine illustrator until eventually people became interested in his paintings, when he was in his forties.*

Ilya Kabakov Except for one difference. In the Soviet Union you wouldn't have a background activity that was the same as your official activity. That's why official people couldn't understand what it meant to be an unofficial artist, to have an unofficial art world. Especially if you were an artist with official education and recognition. That's why there were such wild explanations: they were spies, they wanted to sell their paintings in order to discredit the Soviet Union.

David A. Ross *Who created that notion?*

Ilya Kabakov The Soviet government officials. They couldn't understand. If you were an accepted artist, why would you produce this garbage? To discredit the Soviet Union?

David A. Ross *How did you answer those questions? Can you describe the first formal incident where you were confronted by an authority about your unofficial work?*

Ilya Kabakov It was when my drawings were first shown outside the Soviet Union, in a group exhibition, 'Contemporary Alternatives II' at Castello Spagnolo, L'Aquila, Italy, in 1965. Antonelli Trombadori, a member of the Italian Communist party, attended Communist meetings in the Soviet Union and wanted to demonstrate that we had another art apart from official art.

David A. Ross *Why would an Italian Communist want to do that?*

Ilya Kabakov The Italian Communist Party had a broader understanding of Communism at that time. Trombadori was also a well-known poet; he would visit the studios of unofficial artists, who gave him a generous amount of drawings, so eventually he exhibited them. He showed a series of my drawings entitled *Shower* (1965/78). They depicted a man standing under a shower but with no water. This series, which I continued over a number of years, developed a number of metaphors, one of which related to the person who is always waiting for something but never receives anything. In Italy, however, the drawing was interpreted as a metaphor for Soviet society: people are always waiting for a material reward that never arrives.

David A. Ross *What exactly happened – was an export licence requested, or were you visited by a member of the union, or by a local commissar?*

Ilya Kabakov No, it's a long story. For almost twenty-eight years there was a feeling of danger. One sensed that at any moment somebody could come and take your work away or destroy it. Because of this exhibition, for four years I couldn't get a job in any Soviet publishing house and was forced to make my illustrations under someone else's name.

David A. Ross *Was there ever any actual confrontation where someone came to you, or was it more like blacklisting in America in the 1950s?*

Ilya Kabakov There were articles in the newspapers stating that these artists were making fun of the Soviet Union. During the Stalin era, after appearing in this kind of article you would be completely destroyed. Contact with foreigners was forbidden. The 1960s were different times; the KGB knew everything but didn't grab you. If they thought that there would be no reaction in the West, they would make an arrest and throw you either out of Moscow or into a mental institution. But they were reluctant to touch people who had received more attention in the West.

David A. Ross *So what happened to a literary figure like Alexander Solzhenitsyn was different from what could happen to a visual artist?*

Ilya Kabakov The foreigners who visited us were rather like a protective shield.

David A. Ross *Yet, the officials could still act upon you by denying you a living? Were you ever formally confronted by a colleague or by a former employer, by someone who said, 'Ilya, you're making a mistake. Don't do this, you're going to hurt yourself'?*

Ilya Kabakov Yes, many times. All artists were controlled by someone on the side of the government, who would patronize them and give them 'advice'. I had a few conversations with the chief artist of Detgize where I was working. He said, 'You participate in exhibitions with anti-Soviet artists like Rabin and others. You are not supposed to participate in these exhibitions. I would recommend that you write a letter to the newspaper stating that you have nothing to do

with all this. In your place I would do that.' I refused to follow his advice and immediately lost my job.

David A. Ross *Did any of the people in your circle of artists turn out to be working for the KGB?*

Ilya Kabakov I don't know. For me it was an ideal circle, very intimate, friendly, with very decent people, and strongly tied together. But the KGB knew very well what was going on in the studios. I imagined that whenever a foreigner arrived, there was always an agent in a car outside listening to what was going on upstairs in the studio. All the telephones were bugged and the KGB knew exactly who came to the studios and what they talked about.

David A. Ross *In 1979 I was making a video performance work with Roschal, Donskoi and Skersis in Moscow, which referred to Chris Burden's work. They buried themselves in a mass grave while painting and talking about their experiences as Soviet artists. When I got back to Berkeley I discovered that I had been followed the whole time in Russia. Even when I thought I'd freed myself and went out in a taxicab into the countryside, they knew exactly what I was doing. So that's a life that I wasn't used to as an American, even as a paranoid anti-war activist. We were all paranoid about being followed, but none of us actually were. In Russia everyone was.*

Ilya Kabakov In Russia it was everyday reality. It was the normal climate.

David A. Ross *At a certain point, even though you could continue working in Moscow and your reputation was growing, you still decided that you had to leave.*

Ilya Kabakov I applied to leave three times, because I knew that the climate was not going to change. But something inexplicable prevented me from leaving.

David A. Ross *Were you officially prevented from leaving?*

Ilya Kabakov Maybe something in my character stopped me from leaving. I couldn't make a serious decision and radically change my life. I could live a double life but I couldn't change my reality. Probably I would have stayed there forever if Perestroika hadn't come. I was offered a grant by the Kunstverein in Salzburg in 1986 and received permission to leave. It was the first time that someone was granted such permission, an artist by himself, alone, for three months. So I left not because I was a heroic person, not because I decided to change, but because the situation had changed. I have to say that today I have a comfortable psychological feeling that I didn't emigrate, I didn't leave my country. I simply work. I receive many invitations and I am constantly working around the world. This has a long tradition, for example Chagall worked outside of Russia, and Kandinsky left and worked in Paris. In any case, I know for sure that I will never return.

David A. Ross *Earlier you talked about a kind of a Europeanism that was your ideal in terms of your identity.*

Ilya Kabakov I wanted to be accepted and to participate in a family that I know, which for me is a 'family' of European contemporary artists.

David A. Ross *One of the things that I noticed, in my brief exposure to a Russia in a period of rapid change, is that in my early visits there was this enormous sense of community, particularly among the unofficial artists. There was an unbelievable sense of compassionate criticism and mutual empathy. Everyone was equally respected internally. People would stay up all night talking about art, not complaining that their work didn't sell or that they didn't get the right show, or any of the realities of the Western art world.*

I remember seeing a show of Conceptual art in Moscow that wouldn't draw fifteen people in New York. People were lined up around the block to see it because it was unofficial. It represented freedom and independence. I wonder if everyone sensed the loss of that sense of community as rapidly as an outside observer, like myself, observed it?

Ilya Kabakov The unofficial world has many levels. A new kind of artist came after Perestroika, but the general core of artists that existed before Perestroika kept working in the same way as before. The changes were on a different level. During the Soviet period it was as if everybody was living in a bomb shelter – there was a war going on outside, but they were all together. Like a friendly circle, they were very close to each other, they exchanged news. Everybody respected each other even if they weren't close, artistically speaking. Perestroika was the moment when the war ended, the sirens stopped sounding, the doors opened and you could come out. At that point the connection that held everybody together for thirty years stopped working. That was the price of peace, and from an ethical point of view this was the real tragedy for many. Today the feeling within this circle is one of great bitterness.

David A. Ross *For artists whose content was based on an analysis or critique of that oppression, the content was pulled away, there was no longer the frisson needed to construct their work. Your work, which is about a certain kind of internalized duality and the irony of modern life, could in fact be anywhere. It is not ideologically specific – although it was generated within a specific ideological and social context – because it addresses a broader philosophical and spiritual set of concerns. It must have been important for you to recognize that your work could be independent of the Soviet system, as an artist living in the late twentieth century, experiencing the reality of modernity.*

Ilya Kabakov For me it's important to exist in the perception of others. In fact, the opinions of others are more significant to me than my own. The mind of the other, for me, is not relative but completely idealized.

David A. Ross *An idealized and imagined space.*

Ilya Kabakov It was only in my imagination, but the image I used to have in my mind was so clear that I could see worlds that I never saw in reality. I saw images of

curators, the art world, who could understand my work. When they came from the West to my studio, I recognized them as if they were long-lost relatives. I projected my internal state of mind onto them, so their language was my language and I felt that I was finally understood. This is how it was, and it's interesting psychoanalytically, even if it sounds sentimental.

For me the art world is like a huge river, which began somewhere in the past and keeps flowing towards the future. Speaking metaphorically, I was always dreaming about coming to this river and being able to swim in it. For me the two scary possibilities were either of being too far away to dive in or of sitting on its banks, only watching the others swim.

David A. Ross *Ironically, the years you spent as an illustrator, developing the ability to tell simple stories to children, became an operating condition for your art, a language you could bring to the production of very sophisticated art. Your art still tells very simple stories and speaks in a very direct way to people. It's very accessible to audiences who aren't very knowledgable about art. I remember spending some time observing people walking around one of your installations, people who'd mostly never seen your work before and who would have had no understanding of Soviet Conceptual art made in that era. They walked into the space and seemed to understand it completely, viscerally, without being able to read the conventions of Modernity or Postmodernity or Conceptualism.*

How do you see yourself now in relationship to artists of your generation, Russian or otherwise? What traditions do you sense that you're part of?

Ilya Kabakov For almost eight years I felt like an airplane that was fuelled up with gasoline. It took time to burn this gasoline, these endless stories about Soviet civilization. Now I feel that the gasoline tanks are empty, as though the Soviet theme is almost over for me.

I think that in every culture, in every country, there is a person who is very unhappy inside himself, very closed inside, out of contact with real life. Someone who creates projects that nobody needs. On the other hand, of enormous importance for me is the paradox that I've noticed since I came to live in the West. I became far more aware that in Eastern consciousness, the culture of the nineteenth century still plays a major role. I noticed that all these issues connected with sentimental life, with the life of the soul, which are enormously important for the Eastern world, are taboo in the West. For me it was extraordinary to discover this huge attention in the West to the body. So many issues are explored in terms of sexuality and the body, yet there is the impression that in the contemporary art world there exists some kind of taboo on everything soulful, metaphysical or transcendent.

David A. Ross *I think that's true. I noticed, in the response to the Bill Viola show that I curated in 1997, that many younger artists were very uncomfortable to see an artist like Viola become so involved in issues like spirit and transcendence. There's no language to talk about it, it seems taboo. It seems like, how could you fall for that? Those issues are not real issues, the real issues are social ones. The complete*

rejection, by so many, of art's ability to address transcendence is a remarkable backlash from a period when so much social struggle was about creating a space where that was possible.

Ilya Kabakov It may sound reactionary, but I think that in the future it will be important to look back to the nineteenth century.

David A. Ross How would you define, at this moment in your life, the purpose of art?

Ilya Kabakov I don't see any special goals, but I think there will be a sharp and fast turn to the viewer. Today, the level of contact between the viewer and the work that exists, for example, in theatre and other forms of performance, does not exist in visual art. Perhaps this difference will disappear.

Alex Katz *Robert Storr*

in conversation
April 2003, Philadelphia / New York

This interview began as a public discussion between Alex Katz and Robert Storr on 2 April 2003 at the University of Pennsylvania and continued as a private conversation a year later at Alex Katz's studio.

The original public discussion was the first installment of the Locks Foundation Distinguished Artists Series, organized by the University of Pennsylvania Department of Fine Arts, School of Design, and held at the Harold Prince Theatre. The lecture was introduced by John Moore, the department's Chair and Gutman Professor of Fine Arts. With thanks to Gerald Zeigerman, Jane Irish and the University of Pennsylvania.

Robert Storr *What was your relationship to the kind of painting that was being done when you entered the scene in the 1950s – to use Greenberg's term, 'American-type painting', by which he meant a certain kind of reach, a certain scale? How much of what you were doing was a reply to that?*

Alex Katz It was knocking out the bouncer, that's what it was!

Robert Storr *Knocking out what?*

Alex Katz The bouncer! There's a guy I know who used to go dancing at the Palladium. When he'd had a bad night, he'd say, 'Well, I tried to take out the bouncer.' (*laughs*)

Robert Storr *You once said that a jerk is somebody who competes with the wrong guy. (*laughs*)*

Alex Katz Well, yes. Those Klines and de Koonings had so much big energy; I wanted to make something that knocked them off the wall. Just like that – more muscle, more energy. They set the standard. It wasn't the style I wanted to follow, but I wanted to paint up to their standards. So I took a figurative work and I said, 'Well, I want a figurative painting on the scale of the Abstract Expressionists', you know, on a big scale. No one had been there, so it was really exciting. I had a painting in my first show at Marlborough in 1973, which was a group exhibition with Franz Kline and Clifford Still and others.¹ I put a flower painting in from the late 1960s and I was really scared that it was going to look like a piece of crap there. But it didn't. It held up.

Robert Storr *Earlier you also saw that Beauford Delaney (who made high-impact paintings) was someone to compete with, even though he wasn't particularly well-known.*

Alex Katz Just out of art school, someone asked me to put a painting in a show, a cityscape of 1948/9. I got a nice review in the *Times* for it, and I said, 'Well, the real world's going to be as easy as art school!' The next time – a couple of years later – that I put a painting in a show, it was a small, delicate still life (*Ivy*, 1950). We got to the gallery and there was a Beauford Delaney. He was sort of primitive, a little primitive guy, but he just wiped that gallery out! My painting looked like an old dishrag. I laughed. I thought it was really funny, because I had this painting I thought was real good and it looked

like a dishrag! I decided this was never going to happen again. And that was the start of it. That was the beginning of my lesson. I said, no one's going to knock me off the wall. Period. You're competing with everybody else in a way – guys like Rothko, who's a terrific painter. I like to make a painting that you can stick anywhere; that is the idea. The Times Square thing was where I did it. Finally I stuck a work in the middle of Times Square and it held up. It doesn't make it a better painting necessarily than a Rothko. It's a different idea.

Robert Storr *You're talking about* Billboard Project, *the set of heads on billboards that was on the corner of 42nd Street and 7th Avenue in 1977.*

Alex Katz Yes, and it went around the corner, like a marquee. It was amazing. It was 250 feet long and 60 feet high. One day I saw a Guston next to a Rothko and the Guston chewed the Rothko up – and Rothko is the better painter. I thought, 'I'd like to make a painting they could put up in Times Square and would hold up next to billboards.' Then I was offered this opportunity to do it. No one was using the billboard, so when one of these city groups came around and offered it to me, I tried to act cool: 'Oh, yes, that sounds interesting …' (*laughs*) We got it up there and some guy came in from an airplane from Texas, and said, 'I saw this billboard from the plane. I wondered what my ex-wife was doing in Times Square.' (*laughs*)

Robert Storr *So, it carried?*

Alex Katz It knocked out the billboards, and I felt great. The fact that it was there gave me more pleasure than if it were in some museum someplace. Anyway, it was one of the big kicks of my life.

Robert Storr *Do you see your art as a bid for a certain dominance?*

Alex Katz Yes, yes, that's what it's about. I'm trying to fight with the movies! (*laughs*) Movies in the 1930s and 1940s took the place of the church in their powerful influence on the way people dressed, the way they stuck their hands in their pockets. Everything came out of the movies – the good and the bad. You just start seeing things that way. That, to me, is where the marbles are: not in invention, but in visual dominance. The dominance is in the vision.

Robert Storr *They've upped the ante. Now, it's neon and TV in Times Square. That's also what's happened in museums. A lot of what you see now in contemporary art is, in fact, alternative media of one kind or another.*

Alex Katz It's an expanded field. In the 1950s they used to say there are a hundred interesting artists. It changes a little bit every year. Now, it's about the same number of painters, except most of them are not in New York. But there are a lot more artists. You can become an artist at art school in video or more conceptual things; it's mostly to do with ideas – you don't have to fool around with craft. It expanded the field. There are a lot of artists around, real

artists, but with painters it generally takes about six or seven years before they get the craft down.

Robert Storr *What do you think painting needs to do in order to hold its own, both spatially and institutionally, with video installations?*

Alex Katz I think painting ought to be shown separately from photography and video, in a contemplative space. I think showing it in a food show ...

Robert Storr *A food show?*

Alex Katz You know, a food show – you just walk by taking samples. I think that's a bad atmosphere for painting. Paintings are a different thing, perceived in a different time and space, and I think they should be separate.

Robert Storr *And the museums of modern art should be structured so that there's a place where painting can live by its own rules?*

Alex Katz By itself. You can have video living by its own rules too. And photography should live by its own rules. I don't think they should be mixed. I mean, I live in the world of photos and movies. They're part of our culture. I just think they're different, that's all.

Robert Storr *When you came onto the scene in New York in the 1950s, there was considerable emphasis on the performance aspects of painting. There was the whole myth that Pollock was a catharsis-driven Action Painter, which was in part propagated by Hans Namuth's movies of him at work. In your work a great deal happens on the surface, but you're not interested in 'venting on the canvas'.*

Alex Katz No.

Robert Storr *How do you relate your work to the culture of painting when you first started?*

Alex Katz At art school I started painting 'modern art'. The techniques were dry. It was a lot of drawing, and then you put a drawing on the canvas and you put paint on that and you worked on the paint. Braque was considered the best painter of that type; then there was Pollock at the other extreme. After art school I dived into the Whitney and The Museum of Modern Art right away, like the last hot student from that school. When I saw Pollock's work, I dumped the old style and I started *plein air* painting. I just said, 'Well, that was art school and I'm not doing it anymore.' With the *plein air* paintings I found that I was painting from the back of my head – things were coming out much faster. That was the first stage; it was also the beginning of learning how to paint directly, without using a model or making studies. I kept doing these over and over again, and eventually, in four or five years, I developed a fairly good painting technique. But when I wanted to go larger, I just couldn't do it in the same open way. I started to paint more indirectly in the mid 1960s. The way in which I'd been working the canvas out was like de Kooning or Picasso or Cézanne. You build it and you tear it down and you build it again. But I'm not

suited temperamentally to that. The other type of painting is arrangement, like Barney Newman or Monet. Those seem to be the two poles. When I wanted to do the figure compositions like *Paul Taylor Dance Company*, 1963–64, they had to be predetermined. It's an entirely different way of painting. I was taking the open painting, which I got from painting outdoors 'with no brain', so to speak, and working it into a way of doing more complicated paintings. Basically, I've always been going for places where no one's been before. You want to go there and see whether it's possible, and adjust the technique to your ideas.

Robert Storr *With Pollock and others the speed of execution seemed to be visible on the surface, though in Namuth's film Pollock doesn't move all that fast. Then there was Pop Art, which was about speed of apprehension. You seem to be in neither camp. You must have thought about your distance from both, given that those things were going on around you.*

Alex Katz I felt very uncomfortable with Action Painting – its broad, philosophic generalities.

Robert Storr *How so, particularly?*

Alex Katz The idea of truth. I was very sceptical about 'truth' even when I was young – of it being a constant. I was also sceptical about utopian vision.

Robert Storr *Which is classic Modernism.*

Alex Katz Yes, Modernism and 'progress'. For me, everything has more to do with instinct than intellect. If things didn't feel right, I couldn't do it. It was like lying, so I went another way. With Pop Art, it was simple. I was in it early. Then these guys come and they're making it into signs, while I'm interested in symbols and perceptual information.

Robert Storr *What do you mean by 'symbols'?*

Alex Katz A sign is like a stop sign, a sign that says 'Stop' and nothing else. When you see a head, like in *Red Coat*, 1982, it refers to many different things, a particular person, a beautiful woman, a stylish woman. Your mind keeps wandering on it. When I painted myself with a hat on and a suit and a tie in the early 1960s (*Passing*, 1962–63), I was thinking about the Dutch guy. I used to look at those Rembrandts and say, 'Gee, those were some weird outfits; they're so awful looking!' I finally realized that the man in the grey flannel suit with the hat in my work is within the same bourgeois society that Rembrandt was painting and it was up-to-date, but it referred back to other things. That's a symbol. A symbol moves. Symbols are much more variable than signs. Signs are just 'blue sky', 'green grass' – and Pop Art was a little like that. I was interested in a more complicated kind of thing. I was also interested in fancy painting. (*laughs*)

Robert Storr *By which you mean?*

Alex Katz The painting performance is something I got interested in. Pollock was pretty good, but when I really got how well Picasso could paint once he got to *Girl Before a Mirror* (1932) … Actually you don't get a big technique until you're around thirty-five or forty, usually, if you're any good. Picasso's early paintings were technically, for me, pretty wobbly. Even his great Cubist paintings don't have a big technique. When he gets into his thirties – when he does *Girl Before a Mirror* – that's a big technique. For me, it was just awesome, and that's what I wanted to do. Matisse has a big technique. It took me three or four years to learn how to appreciate paintings. I was in art school, and the teacher said, 'Take a look at Matisse.' Well, I fainted; I couldn't believe anyone could paint that well! That was a big technique. So, that's what my mind was set on – that and the small technique things. They function in terms of invention and they function in terms of fashion and style. There are some terrific Pop paintings, but I had my eye set on something else.

Robert Storr *And that was?*

Alex Katz Big technique painting.

Robert Storr *What does that mean?*

Alex Katz What I said. A real big technique!

Robert Storr *Basically, you're talking about taking full possession of the style and pushing it right out in front, saying, 'Here it is'?*

Alex Katz Yes, a really big style painting. As far as I was concerned, I like the style to be the content. The style is cut in with the painting. Painting without style is just a craft.

Robert Storr *De Kooning famously remarked in the 1950s that he didn't want to 'sit in style'.*

Alex Katz That's total baloney! I mean, it's embarrassing! He said, 'I don't want to paint any style' and all his paintings look alike! That's the dumbest thing this brilliant man ever said.

Robert Storr *OK, granted. But it expresses a certain wish to …*

Alex Katz I know what he meant. He didn't want to paint a *stylized* picture, where the artist changes subject matter and keeps the same style. 'Stylized' is what he really meant. And stylized is a total failure. A stylized painting is in a coffin, really. It's in bad taste. It's bad art.

Robert Storr *A lot is made of the Americanness of painting on this vast scale. Did you see this as a cultural or national issue at all?*

Alex Katz No. I thought it was like going back to the Venetians, like going back to European painting. That's what I was looking at. When I saw the scale of the Abstract Expressionists, I thought it was a continuation of that large-scale European painting. They call my work very American, but I can't see it. I'm

just trying to see the world I live in, not the world that someone else lived in, to get into the present tense and see where I am.

Robert Storr *Most big paintings of that time were of gods and goddesses, or religious themes, or battle scenes or whatever. You're painting on what would have been called a 'heroic scale', but the subject matter is not heroic.*

Alex Katz As I've said before, I don't do crucifixions! I have a very jaundiced view of subject-matter artists – whether the painting is good is all predicated on the acceptance of the subject matter. My work is quite the opposite: the subject matter is just about nothing. You have to see it as a painting or an image. And the heroic thing I've always thought of as a big joke. I never could take that part seriously.

Robert Storr *When you look at Old Master paintings – where the gesture is a big gesture, where the scale is a big scale – do you just see it without its subject matter, and look only at it as a painted object?*

Alex Katz Yes, for me it's a painted object. I get an emotional response from the way it's painted. I just can't take subject matter seriously.

Robert Storr *But what if you look at Titian or Tintoretto or Veronese?*

Alex Katz I don't even see the subject matter; I just look at the painting. There was a Masaccio painting that knocked me out when I first saw it. I remember some fantastic greys, blues and reds and flesh colour. Thirty years later someone told me it was an upside-down crucifixion. I didn't even see that. It's a very good painting; it just knocked me dead. It was mostly the colour. I don't usually respond to narrative paintings very well.

Robert Storr *So what's the subject matter of your paintings? I mean, your landscapes, your people?*

Alex Katz It's an optical thing. The late landscapes were all trying to make an optical sensation from something you see. I'm working on something that painters have never done before. I'm trying to see something and make other people see what I saw. That's it. And the portraits go into a social thing, too, because I'm painting the society in which I live. So it has that social identification, but it's also pretty optical. I'm just trying to paint what I'm looking at.

Robert Storr *Well, it's partly the social thing I want to get at. In the so-called postmodern age, the tendency is to read pictures as much as to look at them. People nowadays look at your pictures and scrutinize them very closely for the texts or subtexts they contain.*

Alex Katz I know.

Robert Storr *How do you think people perceive your work? For example, if I say to you, 'These are pictures of extraordinary well-being, pictures of a middle-class life and the apogee of American power and prosperity', that's not to reduce them to that, but is it something you think about while you're painting?*

Alex Katz No, not when I'm painting. I'm just trying to think about getting the paint on the canvas. That's enough for me to think about: whether the paint's going on right or not. Or just trying to get it to look right. I don't think about anything else. Painters construct layers. To me, if the subject matter's on top, it's a very uninteresting picture. With a complicated picture you have layers, and my pictures are fairly complicated. So when you look at *Edwin and Rudy* (1968), all of a sudden you see that one of the men is older than the other. Then if you keep looking, you find out everything about the person. It's all there. But it's not the first thing you see in the painting. There is a lot of human content in the pictures, and I do think that all my paintings are done from a certain social standpoint. Some people are poor, some are rich, some are old, some are young – but that's not the prime issue. That's what I don't like about Rembrandts: they tell you too much *about* the person, rather than showing you the person.

Robert Storr *I read an interview where you come down pretty hard on Rembrandt.*

Alex Katz The thing about Rembrandt is, he puts the message in front of the painting sometimes. The tragic man is hard for me to take. The technique is fantastic, but the narrative line, on a lot of his things, seems a little gross. Think of Giotto: Giotto can do a crucifixion and show people with intimate feelings; it's never gross. It's dynamite, right on the money. He's a great narrative artist. I don't think Rembrandt is a great narrative artist.

Robert Storr *But there's more to Dutch painting than Rembrandt. If Hals paints a ruffle or a cuff or the pleats in a jacket, there's a series of marks, but within that, an amazing amount of invention takes place.*

Alex Katz Yes. Hals' big paintings in Holland are fantastic. But Rembrandt does skin better than Hals, hair better than Hals, velvet better. He can do all the local surfaces and get a nice look of light better than Hals. Hals' brushwork is terrific; I like those big paintings of his better than Rembrandt's big paintings, but, all in all, he was just technically out of Rembrandt's league. I like Goya's portraits of men. I think they're fantastic. They reveal themselves much more slowly than official portraits that give you the guy's social position and everything.

Robert Storr *The obvious connection here is Baudelaire's idea of the 'painter of modern life'.*

Alex Katz That's right.

Robert Storr *Manet was one of the first painters to put all the technique on the surface and to push the subject matter back. He painted for the sake of the opportunity to paint those things. But you look at Manet's paintings now and they give you the best view of a certain nineteenth-century reality that we have now. In a sense you are in the same territory. How open are you to people analysing the paintings in those terms?*

Alex Katz I think a painting is up for grabs once you paint it. Anyone has a right to say whatever they do. In a sense they explain the painting to me. People say things that I never thought about. I just paint, and I'm thinking about things, but I don't know what the painting's going to communicate. When you work on a painting you can't possibly know what the hell you're doing, right? When you finish it, people tell you.

Robert Storr *And then when you start again, how much of what they told you carries over?*

Alex Katz A lot, definitely. People give you points of stability, because it's really unstable when you're out there, floating away on a twenty-three-foot painting, just splashing. When someone says something, you listen very carefully and that gives you a fixed point to which you can anchor, and then you move on to other points that are equally insecure.

Robert Storr *If you have a little painting, where your hands are moving quickly and the surface is contained within your field of vision, that's one thing. But when you're dealing with a big surface, you're up close to it, and you lose that sense of relative distance. How does that affect the way you work?*

Alex Katz I've always been able to paint from 'behind me'. I found out in art school that I could paint close to the work and the focus would be twenty feet behind me. I was really shocked when I first found that I was able to do that. I have a fairly good feeling about the way things focus. It feels right when I'm doing it; I know it's going to focus. It's all very instinctive when you're painting. It's just like floating and hoping that it'll come out OK.

Robert Storr *How do you set up a session like that? It must be like playing a piece of music.*

Alex Katz It's actually a performance. And you can work up to it for a week, like a performance. There's often a smaller version of the painting in front of me when I'm working on the big one. I know every brush for every stroke, the colours are all mixed in big pots and there's an indication of the armature. So then it's a matter of a technical performance. And I've been painting long enough to get it right – although you never know what the paint's going to do when it hits the canvas. But you have the energy all built up. That's the big thing – to have the energy.

Robert Storr *Are you like an actor who has to have a quiet day before the performance?*

Alex Katz Yes. I'm not going to paint two portraits the day before I do one of those.

Robert Storr *You just sort of let the energies pool?*

Alex Katz I pool them for a whole week or so.

Robert Storr *And the actual performance of a picture like that, a very large one, is a matter of what, one or two sessions?*

Alex Katz No, that big painting, *Edwin and Rudy*, was done in a five-hour period.

Robert Storr *Really?*

Alex Katz Yes. I can paint!

Robert Storr *Well, I know! (laughs)*

Alex Katz Putting the yellow on took about half an hour or so, and the painting was finished in five hours. I said, 'It's got to be inside six hours.' I knew that before I started. It's like a piano performance that's supposed to be twenty-three minutes; if it goes to thirty-five, it isn't so good. That painting was the perfect performance. And when Ada came in and said it looked good, I knew she wasn't kidding. So if it looked good to her, it meant it must be a pretty good painting. Everyone who saw it seemed to like it. But I had trouble reconciling myself to the painting because it was so different from anything that I've done before.

Robert Storr *Can you characterize the kind of energy that you experience when you're making this sort of work? The myths surrounding certain kinds of energized painting are all about frenzy, cathartic energy. What kind of energy is this?*

Alex Katz It's kind of a control, but it's open at the same time. If you take a brush and try to do the top of a mouth or the inside of an eye or something like that, you have to really focus on it; you have to have a rhythm in your strokes. But it's more open than that. And sometimes I'll say, 'We need ten per cent more.'

Robert Storr *Ten per cent more what?*

Alex Katz Ten per cent more colour, or ten per cent more definition. I was painting sort of in planes, giving it some meat at the end, getting it away from being too illusionistic. I wanted it a little more concrete. Some paintings, you just feel your way through, and some you think your way through.

Robert Storr *In this process that's developed, is it essentially putting layer upon layer upon layer?*

Alex Katz Yes, it's layered painting.

Robert Storr *Do you use cancellations of any kind, or bury anything?*

Alex Katz Not much, no. It's built up. If it botches, I just wipe it and build it up again.

Robert Storr *So you don't come in with a colour and crop something that's already there?*

Alex Katz No, not much. The colours are on top of colours, but you sort of build it up until it's finished. Well, it's supposed to be finished, but I've gone back into pictures from twenty years ago and sometimes there's an area that I keep wondering about. There was *The Ryan Sisters* (1981). Twenty years later, the sky was green and I made it blue.

Robert Storr *And you were right?*

Alex Katz I don't know. I think it's a little better.

Robert Storr *What about more complicated things, like general body language. I mean, to take* Edwin and Rudy: *where they touch and where they don't touch, how they don't quite make eye contact – all of this becomes a remarkably complicated relationship done in a very understated way.*

Alex Katz Yes, well, all I did was set up the situation for it. It's their gestures; I just let them sit and they sat and I painted. But they made it. Anything they do is much better than a contrived thing that I do. Generally when you paint people they should be moving, and they usually go into gestures that suit them.

Robert Storr *What about the 'black paintings' like* Ada's Garden *(2001), in which you have many figures with congested spaces between them? Do you see scenarios developing? Does the body language turn into some kind of narrative? Or is that more of a formal arrangement for you?*

Alex Katz It's a formal arrangement. I was doing something in the 'black paintings' that I hadn't done before, with that much space between the people. It seemed more appropriate to the time we're living in than before, in works like *Cocktail Party* (1965), where people were closer together. The gestures came from the people, but I chose them and pushed them around a little bit.

Robert Storr *What I have flashing at the back of my mind is somebody like Pierre Puvis de Chavannes, for example, who painted very large figure compositions in frieze formats with muted colours and flat areas. Most of those pictures are incredibly stagey.*

Alex Katz They are very stagey, yes.

Robert Storr *And your pictures sort of hover in a very interesting space between something totally controlled – a tableau – and casual gestures, details of gestures, little intimations of what goes on between people.*

Alex Katz Chavannes' gestures come out of what he knows, and my gestures come out of what I find. I set up the situation but people make the gestures, and then I have to deal with them, whereas Chavannes', I think, is more of a contrived situation.

Robert Storr *Do you think like a stage director, blocking action but letting the actors improvise the details?*

Alex Katz Yes … yes, that's exactly what it is. Because I know what I want. For example, in *Ada's Garden* I wanted a night painting and I did a couple of Ada with windows and then I took out the window and it got interesting, with the all black. I was just scaling in the colour. And I kept doing four by six foot paintings until I got some colours I liked. I finally got the colour and the light right, and I did a lot of shooting with the camera and I had the people pose differently. It's a very indirect way of getting at it.

Robert Storr *How much do you actually use photography? Mostly what I've seen of your preparatory studies are drawings.*

Alex Katz I used photography in that one for the gestures. For the last three or four summers I've been doing these beach paintings; the gestures come from photography, but then I have to make the paintings *en plein air* to get the colours right. You can't get any colours from photography, but I can get gestures that I couldn't get at any other way. I want to go into areas where no one's been in terms of time: at twilight, you get ten or fifteen minutes. *Dawn* (1995) was done in no time. The time frame I had to do that painting with the snow (*Winter Scene*, 2004) was just a blink. It's really quick stuff. Otherwise you're painting from memory and I've never trusted my memory.

Robert Storr *To my eye in the early paintings there's a lot of movement of the paint on the surface and there's a lot of give where edges and colours meet. The drawing aspect is very intensely considered all the way through. Do you think there's been a change in that relationship, at least in the recent landscapes?*

Alex Katz The small, early landscapes of the 1950s were all open. I just threw drawing out of the window. My training is drawing. For three years I was drawing antiques and cats. And I drew sketchbook stuff for two years intensively. So I come from a drawing background, but to get it to something live, I just discounted my whole background and painted openly.

Robert Storr *This enormous painting you're working on in the other room, with the yellow ground (*Song, 2003*): the drawing is almost completely dissolved into marking. To what extent is a painting like that really plotted out in the way the earlier ones were? Or is something changing in the way you work now?*

Alex Katz I wanted to make a painting that didn't have any structural patterns and was really 'all over'. There is a frame or structure underneath it, but it's very minimal. The paintings I did about four or five years ago, such as *Autumn* (1999), had real armatures, but this one I wanted to make open. I needed to lock the paint into the yellow ground. The problem was between the specific leaves and the generalized shapes of the marks. If it had too many leaves it would just look awful, like something from 1950.

Robert Storr *What do you mean by that?*

Alex Katz Well, like a generalized, semi-abstract painting. Something vaguely …

Robert Storr *Generic?*

Alex Katz Generic, yes.

Robert Storr *But, for example, in* Blue and Yellow *(2001) and in some of your other recent paintings, the amount of openness with the brushwork of the small details like leaves and so forth seems to have really changed qualitatively in some way. There's no silhouette, there's no edge, necessarily, that conceptually or actually pre-exists.*

Alex Katz I think the early landscapes were all more gestural, and I seem to want to go that way again. It's a different way of painting. I'm relying much more on instinct, and basically the idea was to take the little paintings such as *Winter Scene* (1951–52), which were all done that way, and put them on a large scale.

Robert Storr *What's the importance of virtuosity in your work?*

Alex Katz For me the image is the most important thing. I'm an image-maker, and I think my paintings are visionary images: you can see things through the image. The technique of painting makes it more palatable, or more acceptable. And a good technique holds it all together, makes it more fluid and more believable. But it doesn't get in your way. A good technique is supposed to support a painting; it isn't supposed to be in front of it, right? Also, my big audience is painters, basically. And one of the things I enjoy is 'Eat your heart out! Check this out and eat your heart out!'

Robert Storr *In that regard, who do you see as the peers who matter to you?*

Alex Katz I think Sigmar Polke is a really good painter. He has strong technique. Polke is about the best around, but I don't think anyone is in my league technically.

Robert Storr *And if you step back from just the technical issue, as an image-maker, who do you think is out there now making indelible images?*

Alex Katz Every so often Francesco Clemente can make an image that's really big time. I like Jasper Johns for trying, you know? I think David Salle has done stuff that's interesting. I don't even know whether I like his paintings, but they are arresting for me to look at and they have lots of energy. I think Enzo Cucchi is a pretty good painter too. I don't know what he's doing now but I thought he handled a big surface well; he's technically very good. He paints very well and he makes pretty strong images; he's a very intelligent artist.

Robert Storr *I wonder if you could talk a little bit about your relationship with other generations of artists, younger than you, and older than you, when you were young? You were very good friends with Franz Kline, as I understand it?*

Alex Katz No, we spoke together; I wouldn't call it 'good friends'. He was real open and very generous. But I was always too conceited. I liked Bill de Kooning who was very friendly to me, an absolutely great human being. And Philip Guston was really nice to me. He was just really great. We could talk like social equals about this and that. In my own time, I had a lot in common with Jane Frielicher and Fairfield Porter, but also with Al Held and Philip Pearlstein. We were very argumentative for years. I related better socially to Clemente and Salle than to anyone of my own generation.

Robert Storr *What was the point of contact?*

Alex Katz With David it's always about theatre. We have a thing about theatre. I think David's space is interesting. He took the flat painting and made it into a

plastic painting quite successfully. The subject matter got in the way of the painting and all that, but basically David was visionary. Francesco asked me about American poets so we had that in common.

Robert Storr *There are basically two other art forms that have had your attention all the way along: dance and poetry. In the 1960s you painted ensemble dancers, the Paul Taylor Company and so on.*

Alex Katz A lot of it belongs to the tradition of gestures. I get a lot from looking at dance.

Robert Storr *One of the things about American dance is that it brought in a lot of the postures and gestures of everyday life – somewhat in the way that American poetry did with language. There's a kind of common speech in American poetry and there's a common deportment in American dance. Is that something you picked up on?*

Alex Katz That's part of it. The vernacular interests me: speaking with your own voice and not trying to speak with that kind of Henry James voice that seems like another time, another place. I think I can feel something is right when it belongs to me, when I'm painting or when I'm writing, and if it's not I can feel its affectedness.

Robert Storr *You read and re-read a lot of poetry. Could you talk a bit about your relation both to poetry and to individual poets? You've painted poets a lot.*

Alex Katz Yes. The poets were more interesting to me in the 1960s than the painters; they were dealing with their life as they were living it. It's marvellous to see something fresh that belongs to the time you live in. And I felt empathy with the poets regarding the idea of an art form that wasn't institutionalized.

Robert Storr *What's your relation to the institutions of art, to museums, to the academy?*

Alex Katz It hasn't been so hot, for the most part.

Robert Storr *Did you keep a distance from them?*

Alex Katz No – they kept a distance from me! I was never really heavily embraced. The Whitney paid attention, but overall I think institutions were not enthralled.

Robert Storr *Why do you think that is?*

Alex Katz I think the work was too new. I mean, when I showed those little paintings from the 1950s like *Winter Scene* (1951–52), no one looked twice at them. And when I showed them at the Robert Miller Gallery in the 1980s, Hilton Kramer came out and said, 'Well, we didn't understand them then.' That's a lot for a guy to say. I think the paintings were really misunderstood. They look different now to people.

Robert Storr *One of the things that strikes me is that your work isn't something that you can extend into a theory about how somebody should make the next painting, or how these paintings inevitably came from work preceding them.*

Alex Katz I think the big thing is that they don't give anyone any stability. You can't rely on the subject matter. They move around a lot. They're basically a little unstable for an institution.

Robert Storr *What about the pleasure factor, that people underestimate them because they provide pleasure, without stinginess?*

Alex Katz That's the thing about subject matter. How can you possibly be serious about painting a flower?

Robert Storr *Do you think this is part of the cultural moment? The twentieth century has been a very rough ride, and when you started making your work mid-century, things were pretty grim in many respects – although they were also becoming prosperous in others. That was the moment where pain, angst, anguish, struggle, anger, the whole mythology of the artist as exemplary sufferer or exemplary worker – someone outside of society – came about. And that's the moment when Picasso eclipsed Matisse as a model, for example.*

Alex Katz Yes. In the 1950s there was a feeling of a community and it was an open place for ideas and things. It was really fabulous in the sense that you could learn a lot. There was so much art. But I don't think I could have gone on being in the 1950s; I think I would have cracked up. Living was pretty rough if you didn't want to sell out, if you wanted to be a full-time, serious painter – 'serious' is to paint seven days a week and to take the consequences of your decision. I didn't want to paint soft pictures that people liked. And I also wanted to make realistic paintings, which people didn't think you could do then.

Robert Storr *You've managed to slip through the nets of one movement after another. You were sort of Pop in some people's eyes, but not Pop enough. You were gestural realist in some people's eyes, but were not a member of a movement.*

Alex Katz It actually started in the 1950s. I was doing realistic painting and all of a sudden there was Larry Rivers, and I went concrete and all of a sudden there was Richard Diebenkorn. And I went into popular images and all of a sudden there was Roy Lichtenstein and Andy Warhol. And then there was the figurative stuff later on. I just didn't fit. My style always had this or that in it. I was doing hard-edge painting in the mid 1950s; anything that was in the air I was getting. I think I have a sensitivity towards fashion and that's what helped me. Fashion is dealing with the present tense and currents. Fashion is a no-no to people for whom the artist 'creates in beauty forever'– beauty is a constant factor and will always be there. It's unstable when you get to fashion, because it changes. Nothing is stable.

Robert Storr *That might in part explain why there's so much attention paid now to your work among younger people. Certain kinds of modernism put themselves forward as the definitive statement, the be all and end all, and you didn't.*

Alex Katz Absolutely.

Robert Storr *And they thought that they were the culmination of history, that they'd got to the essence of things and after that everybody could go home. The discovery – or rediscovery – was a shift away from that kind of certainty. To show as you do in your paintings that things move and change, that styles change, to depict very specific moments of light, of gesture: all of those things militate against an idea of the big historical wheel turning. You said earlier on that in the 1950s you felt at odds with the idea that modern art, modernism, was to do with progress.*

Alex Katz Yes, I don't believe in progress in art. It's an idea that a lot of abstract painters had and to me it's obsolete. It's a Hegelian idea. Art doesn't progress, it just changes. There're some caveman paintings that are as good as anything I've seen. They're real art. I do think you have to make it new though; as an artist, what you're trying to do is make something new, that you didn't see before. Malevich thought he was making progress. He's a fantastic artist, but he isn't involved in progress.

Robert Storr *Let me flip it over. There're a lot of artists I know, particularly younger artists, who gravitate to figurative painting, but who actually take the opposite view. What they want to do is to conserve or hold on to a given tradition.*

Alex Katz I know, I know. I don't feel that. It's like past-tense painting. I want it to be new, and I'd like to be able to have it be as fashionable as anything else.

Robert Storr *Did you ever believe you had to work out a tradition in that way?*

Alex Katz No. I had this teacher when I was in art school and he said that art always returns to old values. I wondered about that.

Robert Storr *Is there something to be said for the art in the 1980s that looked self-consciously over its shoulder – sometimes sarcastically, sometimes enviously – at the past?*

Alex Katz It had to do with nostalgia in the 1980s.

Robert Storr *And now?*

Alex Katz Painting seems far removed from the old modernist idealism. And in some sense, because of that, it's a little reduced in its ambitions. But it does seem stylistically aggressive.

Robert Storr *Certainly, nowadays, lots of younger artists working in installation, performance, or video – people coming through the schools or just starting out – still have a sense that they have the wind of history at their back, even though some of these 'new media' are forty, fifty, sixty or more years old.*

Alex Katz One winter I started to read St Augustine. It was kind of great. He says, anything past is past and it doesn't make any difference whether it's a half hour ago or two thousand years. And the future doesn't exist; what exists is

the present. When you start talking about installation, and those things, they become traditional forms very quickly. In two years, those artists are out of it; they're way off the bubble line as far as fashion and style go, and the majority of art done off the bubble is behind. I'm trying to fight for the top of the bubble. So, if you have twenty million guys working two years off, it doesn't seem so threatening. (*laughs*)

Robert Storr *What you've got now is a series of simultaneous traditions. You've got a tradition of Duchampian art-making; you've got a tradition of …*

Alex Katz Duchampian art-making is obsolete – period. My definition of the avant-garde is something that happened in France a long, long time ago. The prime thing the avant-garde was built on was invention. It's connected to Surrealism and Dada, which had invention at their core. But the reason my audience has got much larger has to do with the death of the avant-garde. It just passed away about seven or eight years ago. (*laughs*)

Robert Storr *That's a very American usage: 'just passed away'.*

Alex Katz Yes.

Robert Storr *It's not dead, it 'just passed away' … Some artists – Giacometti is one of them – kind of used up all the oxygen in the room they occupied. There's very little you can take out of Giacometti that doesn't attach itself to his style. Other artists leave some pieces that can be picked up and used by somebody else. I wondered if you see yourself as having left a vocabulary or an attitude that others can push off from; not a style that can be appropriated, but a way of solving problems or thinking about painting?*

Alex Katz It's gone more that way. It definitely seems to have gone that way, because people have come over to me and said, 'Thank you.' Some of them are making movies and all kinds of different things. They've chosen very different forms. When people try to paint like me, it's usually pretty embarrassing, because of the technical demands. They can't come up with the technique. A lot of the visual things in my work have been appropriated by all kinds of people – in advertising, movies – outside of the art world. I think it's my gain; it makes me feel good that the work can be used. I feel great about that. The thing about Giacometti is very interesting; it's an out-of-fashion idea and yet it's real big-time sculpture. I don't know whether it's used up, as you say, because it's out of fashion or because there isn't anything there.

Robert Storr *You've been in style and in fashion for a very, very long time. Is there a way in which you see this moment as different from others? For example, you were very much part of the painterly realist scene in the 1950s and 1960s …*

Alex Katz I was a little off it.

Robert Storr *A little off, yes, but very much in play. And these days, for instance, you're in 'Dear Painter' in Paris in the company of Elizabeth Peyton and Kurt Kauper*

and a whole series of European artists. Let me throw out a possibility: it's not so much a matter of cool – which is a hyper style in its way – that gives you this fashionableness, but, rather, of decorum, which is a very old value in classical art, where things are, in a sense, proportionate and balanced. The classical styles of decorum have come back in a lot of work that's otherwise very hip on its surface.

Alex Katz Do you think it's the classicism?

Robert Storr Yes, maybe.

Alex Katz Oh.

Robert Storr That's not so bad.

Alex Katz It's an interesting idea.

Robert Storr Let's talk a little bit about New York and of being a New York painter now. What do you think your relationship to this city is? How do you feel New York is as a city for art now?

Alex Katz You have a lot of stuff coming here still. It's a fairly high-energy place, which really helps young artists. They have commercial possibilities here that we didn't have. I think the commercial thing in painting hasn't been understood – how important it is. There's a whole world out there that exists without *October* magazine.

Robert Storr Yes, you bet!

Alex Katz There's a big influence of institutions and academia, but I think the other side is the big influence of the commercial. There are two kinds of horrors. If you go to an art fair, it's a commercial enterprise. The paintings are there to sell. If you go to the Whitney Biennial it's supposed to be academic art. It's a terrible, competitive situation. One's institutional and one's commercial. And they're in slightly different places, and I belong to both. But I believe I have more connection to the commercial world than to the institutional.

Robert Storr New York was, for many years, a centre. The centre, some people thought. What's your sense of New York's situation and the effect that it has on being a painter?

Alex Katz I had the luck to come out of school and be right next to where it was all happening. But Germany and England are turning out really good painters, so I think painting now is really international. New York has sort of disintegrated as the centre. It's a bigger playing field, but I don't think there are more players. They're just spread out more.

Robert Storr Why do you think there's more painting outside New York now?

Alex Katz They have some really good art schools in Germany and England. I think that's it. The economies of the countries in Europe have improved a lot, so they can support artists, too. Artists have more of a chance if you have an economy where the cost of living is low than if it's very high. In Paris,

it was low; then it became high, and you have fewer artists coming out of there. New York has changed from low cost to higher cost, and it makes it more difficult.

Robert Storr *Around the early 1980s, you broke through to a European audience that you hadn't previously had. A lot of your work is circulating in Europe, and in a way this book represents a change in perception: previously your audience was primarily American, now it's truly international. You've been seen in Britain, in Russia, in Germany, in France and so on a lot in the last decade and a half. You're present in these burgeoning art scenes. What's your sense of why this has happened?*

Alex Katz It's kind of weird because the paintings were once considered like bad Pop Art or bad photo-realism in Europe.

Robert Storr *Do you think you're seen as a particularly American artist in Europe?*

Alex Katz Yes, they see me as American. It used to be 'too American'. Now, they like it *because* it's American. It's like how we enjoy German movies.

Robert Storr *And what's that American quality?*

Alex Katz I want to paint what I see; I don't want to paint what someone else painted. I live in New York and I go up to Maine, and that's what I paint. I don't want to paint other people's pictures in my studio. That makes it American, don't you think? When you're working with the tradition of art, you're usually painting like the paintings you've seen; your vision is other people's vision. You see things through the culture in which you live, and the culture in which you live is always past tense. Some people are always seeing things in another time period. To see things in the present time period, you have to break through, and that's what I've been trying to do.

Robert Storr *Bice Curiger – who edited the original issue of* Parkett, *a magazine that focused on your work and broke things open in Europe for you – also curated a show called 'Birth of the Cool'. She associated you and a number of other artists with a particular kind of American sensibility, a jazz aesthetic.*

Alex Katz I grew up in a cool world. It was Queens. In high school, we were involved in half-tempo Lindy Hops. It was really cool stuff; whereas it's very hot in the Bronx and other places. You danced with people from Queens and some people from Manhattan. That was the start of the sensibility. I never responded emotionally to things. It was always, like, *not* responding. My father takes me to the circus, and I'm supposed to be very happy that I'm at a circus and everyone's laughing and screaming and I'm saying, 'What the hell am I doing here?' I had to laugh to make my father feel good. I took psychological tests when I went to Cooper Union, and I was on the bottom of the chart. There was no response to anything much. (*laughs*)

So it's two things. One is personal – where my reaction level is really on the bottom. The other was the cultural thing, with jazz, which came at about the

same time. I couldn't believe it when I heard it – it was terrific stuff. You really related. So, these cultural things come in waves. You get on it or you miss it. Like the breakdown of linear form in Faulkner and in de Kooning – they say it has to do with Existentialism, but it had as much to do with jazz and bebop. Bebop and de Kooning and Faulkner were all doing the same thing at the same time. These intellectuals tied it to a European past tense: they tied it into the Existentialist movement – the heroic man alone and stuff like that. The artists lived swell because they were getting great promotion. But I thought it was baloney – just something in the air. By the end of the 1950s they were working out a new type of linear idea and styling in music. Sonny Rollins did 'Wagon Wheels', and it was dynamite. It was all linear again. These cultural waves are things that no one can predetermine, no one can really explain – they just happen. It has to do with fashion. Style and fashion go together.

Robert Storr *Something you've talked about a little bit, both directly and indirectly, is about choosing to be a painter who works from the outside rather than the inside, from the exterior or surface of people and things. I wondered if you could speak about that as a general attitude towards what painting is and towards what you do, since so much of the way we're educated to think about art hinges on the inner life of the painter or of form. The Van Gogh story, the Pollock story, is about why it comes 'from the inside out'.*

Alex Katz I hate those sentimental art books; I really despise them. You know, 'Poor Vincent' and the 'soul of the artist' and 'inner vision' and all that. A lot of times it's like trying to put the content in front of the picture. For me, there's nothing more mysterious than appearances. I want to see this thing fresh, and I don't want anything to get in the way. Appearances, for me, are a real mystery. Sometimes, I'll paint something, a sketch, and then I'll do it over (and I can do some of them six times over), to get what I thought I saw, or to make me see something. To see something is not a given; it's something you really have to be aggressive about. If you're involved in that, telling some silly story about someone suffering seems of much less value. You have to deal with your own temperament. Everyone's temperament is a little different. Mine's very quick and electric. I was taught to paint slowly, but when I got into this quick, outdoor painting, I really connected. It's malleable, painting; you try to take that medium and fit it to your temperament.

Robert Storr *You can see that in the film* Alex Katz Five Hours *(Vivien Bittencourt/Vincent Katz, 1996) of you working. When you start painting branches and leaves, the whole movement of your body, the whole rhythm, takes off in an entirely different direction. It's interesting because until then, it's all been anticipatory, spreading and blending. And then 'Bam!' Were you listening to music while you were working in the studio?*

Alex Katz I usually use music to blot out the outside world.

Robert Storr *What are you working on now?*

Alex Katz The winter started with using photographs and gestures of people on a
beach. I've been using gestures that I never used before, because this is the
first time I've taken my own photos. I can get these quick-motion things
that you couldn't get any other way. Then I work perceptually to get the
colour, the light, painting the landscape in *plein air* or sometimes getting
a model to reproduce a gesture from a photo. I've been working on them
a good part of the winter. I don't have the control, so I decided to do some
control painting. I'm doing attractive women with hats and coats in front
of one of those beach scenes from the summer – a really artificial thing, but
I have great control over them. The pictures are coming out terrific and
I'm very happy. One day, I'm going to get bored, but I'm not bored yet.

Mike Kelley *Isabelle Graw*

in conversation
September 1998, Vienna

Isabelle Graw You are one of those artists who claim responsibility for analysing and talking about their own work. The advantages are pretty clear; such exposition opposes mystification of the work, makes it more accessible, and negates the traditional idea of artists as incapable of speaking about their own practice. The possible disadvantage is that you narrow the possibilities of reception. Critics or others might respond to your work by simply repeating what you have said, potentially as the final conclusion about the work. Since your explanations are always very dense, allusive and witty, one likes to quote them. It makes me wonder what there is left for the critic to do?

Mike Kelley When I was younger, I was so unhappy with what critics wrote about my work that I was forced into a position of writing about it myself. It wasn't something I wanted to do, but I found that all these erroneous things critics wrote about me were then passed on from article to article, quoted as if I'd said them myself, as if they were my intentions. I think it's just the opposite: me saying something about my work puts the critic in the position of having to openly disagree with me. Often critics write as if they're speaking for the artist, and that's not true.

Isabelle Graw Your texts are not always art critical texts; they can be wild manifestos, such as 'Goin' Home, Goin' Home,' the text printed in the catalogue for 'The Thirteen Seasons …' exhibition at Jablonka Galerie, Cologne, in 1995.

Mike Kelley As opposed to a catalogue essay, that text was intended to mirror the aesthetics of the installation.

Isabelle Graw It was somewhat like poetry, yet it also operated as another figure in a visual proposition. You often use text in the same way as your drawings: they function as an occasion to say something.

Mike Kelley My language usage in artworks is not just babble. Often there are jokes on certain critical or historical issues – and that can be seen if one reads closely.

Isabelle Graw So text is not there to state 'this is the meaning of the work', but to offer another layer of propositions?

Mike Kelley Right, issues are raised. Sometimes one has to distinguish between true issues and red herrings, and this calls for close scrutiny. I expect the reader to spend a little time with the work. I'm not interested in quick surface readings. This is especially important in relation to my works that have a socialized veneer, that seem to be a reiteration of mass cultural tropes.

Isabelle Graw You also oversee closely what is written about you in catalogues, through discussion with the authors. Have you ever thought that you would like the reception and interpretation to be more unpredictable, to be distant from how you think about the work?

Mike Kelley No. When I don't say anything about my practice I have found that its interpretations become even narrower, because they most often simply

subscribe to contemporary intellectual fashion. I don't think stating my intentions prevents people from expanding upon the work. I believe my work definitely allows for an openness of readings.

Isabelle Graw *I think it is legitimate to relate your work to that of other artists and art-fashions, in so far as your work is 'debate specific' – a term the artist Mary Kelly has used to describe her practice. Your work takes up debates centred on, for example, commodification, as contexts which allow one to understand the craft-related works, or a neo-minimalist use of plywood; very specific aesthetic conventions inform your work.*

Mike Kelley In relation to commodification, my work would never have been discussed in those terms without me raising the issue. My work has been most often discussed in terms of its having a populist rather than a critical impulse. I myself had to contradict that. I had to say how my work operated in relation to various discourses, because no-one else would have done so. I've said this many times before: if you don't write your own history, someone else will, and this 'history' will suit their purposes.

Readers may project whatever meaning they want upon my work, but if they attribute their projections to me, I have a problem with that. They must take responsibility for their own reading. For example, one could say that *Sod and Sodie Sock Comp. O.S.O.* (with Paul McCarthy, 1998), with its fetishization of military aesthetics, could be read as pro-military, but many things in the installation work against such a reading.

Isabelle Graw *When I first saw this installation I was amused by the instances of aestheticized arrangements, like the stacked mattresses, reminiscent of a minimalist aesthetic. It's simultaneously ordered and totally excessive. It has a formal concern running through it, in its obsessively consistent use of colour, for example. The emphasis on the colour green reminded me of your earlier performance and installation work,* Confusion *(1982), where there is a similar, systematic concern with aesthetic conventions, overlaid with diverse themes, and the stubborn insistence on a certain modernist look. I could see a formal relationship between* Sod and Sodie Sock … *and* Confusion.

Mike Kelley I use various strategies to give a sense of cohesion to the viewer. An image or colour might reappear again and again; a given theme might be constantly referenced, and I might use comfortable formal placements or traditional decorative approaches to achieve this. These elements are just visual communication devices so that the viewer doesn't perceive the work as a random accumulation. In *Confusion* it's simple: everything is green, or black and white. Presented through those restrictions are thematic lineages that sometimes make reference to them, sometimes not. *Sod and Sodie Sock …* can be described simply as a military camp; it's not a bunch of abstract blocks, but it definitely has a very clear sense of order that could push one to see the piece as very formal in its intentions. This order is not surprising, given the

work's military theme. This duality of formal and political references produces a work that is inherently contradictory.

Isabelle Graw *The possibility of a literal reading is immediately disturbed or interrupted by abstractions, complications and layers of deterioration. You have spoken of how, in the 1980s and early 1990s, your projects grew out of notes and writings; now, increasingly, you do something just for the visual kick, whereas before you felt that another legitimation was necessary.*

This corresponds to a shift in art-critical debates. There has been a tendency recently to acknowledge the importance of what is called the materiality of the work, or the visual specificity of art production.

Mike Kelley My interest in increased visuality started in the mid 1980s when I began working with craft materials. Before that my work was very much influenced by my conceptualist training at Cal Arts. Even though my early work was a strange sort of conceptualism, I still gave myself a lot of restrictions in terms of material usage.

Isabelle Graw *How would you describe these restrictions? What was forbidden?*

Mike Kelley I'd rarely use colour, and if I did it was only in the most codified way, as I described in relation to the *Confusion* project. For years almost all of my paintings were black and white. And I would rarely use materials that I thought had too much cultural or associative presence. I wanted to make sure that the work was not perceived as being primarily formal in its intentions. I knew when I started using craft materials and found objects that there was the possibility that my work could be seen within the tradition of Arte Povera, for example, and I felt that was a problem. I thought that those artists often used materials because they were 'exotic' relative to their primarily formal usage. In contrast to this, I wanted to present these 'poor' materials as texts themselves, to try and broaden my notion of textuality.

There was still a kind of fictive subject, or flow of thinking, underlying my work at this point. But it became increasingly impossible for me to maintain these flows as coherent entities. The projects all started running into each other; I couldn't keep them separate as I had before, even though such orderings in my early work were always provisional.

Isabelle Graw *So, research, as the term 'project' implies, was no longer as dominant?*

Mike Kelley It broke down. I started to organize the work more around visual than language flows. After I quit doing the performances, I felt there was a problem because people didn't have access to the language flows or my notes for background information. I didn't want the work to become Duchampian, to be reliant on hidden material that the viewer did not have access to for its meaning. I was worried that without background material, the work would have no meaning unless the viewer projected upon it. I'm against that: it's not art to me, it's the condition of nature. I think that the relationship between

the viewer and the artist is 'conversational'; even though I allow for an openness of reading, it's not completely open.

Isabelle Graw *You set the parameters.*

Mike Kelley I set some parameters, right. This is why I've distanced myself from the neo-Pop Art currently in vogue. I see a lot of art now that mimics popular culture, the look of advertising or fashion photography, modernist design, and so on. It strikes me that much of this work is concerned with a mastery of those visual tropes, that there is some investment in mass culture on the level of desire. I'm of another generation. I have a more critical relationship to mass culture. I'm not solely interested in arresting visuals; I'm more interested in questioning the conventions of reading within a given genre. I'm constantly giving clues that there's some kind of rhetorical or critical interest operating in my work. That's what becomes fuzzy; and that's where you find the poetics – which include the critical. I'm not an anti-critical artist, as some would propose.

Isabelle Graw *There seems to be a methodological change from the craft-related works to your recent, more spatial installations. How would you describe this shift?*

Mike Kelley My early work – in part under the influence of the Conceptual Art generation of the late 1960s and 1970s – refused to acknowledge that there was a historical 'I' in the work. There was only the voice of the social, so the autobiographical was not allowed. Meaning would flow in a kind of mythical third person, as if I, as producer, were absent and the historically grounded reader were also absent. Then I realized that this was a lie, a reiteration of the voice of dominant culture. So I tried to deal more with the specific aesthetics of my own lower-middle-class background. Before that my work adopted the general look of common black-and-white line illustration as a sign of its socialized condition. But it didn't work – the art world at that time was still so caught up in high/low distinctions that this widespread mode of illustration was not perceived as being 'generic'; it was perceived as being 'low', and somehow confrontational. I could never understand why people would always talk about my black-and-white paintings in relation to the 'low', because that form of visual communication isn't limited to popular culture. The mode of illustration utilized in comic books is the same as that used in dictionaries or technical manuals. I was not attempting to elevate a 'low' form of communication to the status of fine art as with Pop Art; I was simply trying to use a generic mode of illustration and work against its conventional, transparent reading.

Isabelle Graw *Early works like the birdhouse sculptures belong to that phase. These sculptures have a generic, laconic look, hinting at their own narratives.*

Mike Kelley Yes, I thought of birdhouse building as a very generic type of production. The first ones I made were literally copied from craft manuals. Later, when I started working with other crafts, especially sewn materials, I knew that a

lot of people would immediately see that as a critical act, as some kind of play with feminist art tropes, for example, although that was not my intention. Those materials were more loaded because they were not 'natural' to me as a male artist, and I wanted to try to deal with that, to work against such essentialist notions.

Through making that work I became even more aware of this lie of the anonymous producer. I found that people would constantly read into that work a psychology of its maker, even though it seemed fairly obvious to me that these were found objects and not made by me at all. Despite my focus on these materials as social signifiers, most viewers wanted to read them through the personal. I began to realize that I had to work overtly with my personal life as a kind of fiction. In my last couple of shows, especially 'Toward a Utopian Arts Complex' at Metro Pictures, New York, in 1995, I have increasingly dealt with biographical material. Yet much of it is blatant lies.

Isabelle Graw *In* The Trajectory of Light in Plato's Cave *(1985/97), there is a preoccupation with the personal, a construction of an intimate situation. In the references to monochrome painting in that work, I see three levels operating. First, an acknowledgement of Modernism and the overdetermined formal aesthetics of post-painterly abstraction, with which one could have a form of emotional relationship. Secondly, there is a kind of sexual moment – the work suggests something hidden: a private space that has been created. Thirdly, the installation seems to create a stage.*

Mike Kelley *The Trajectory of Light in Plato's Cave* was one of my first major works in which I used colour. I was consciously rebelling against my own restriction to a black-and-white pallette. The main focus of the piece is on these large multi-panelled monochrome paintings. It was a kind of joke on colour field painting. It was part of the larger project called *Plato's Cave, Rothko's Chapel, Lincoln's Profile* (1985), so there was some play with the equation of religiosity and abstraction. Of course, the paintings fail as true abstraction because they've been given titles. The titles make the monochromes 'illustrative' and thus worldly.

I'm surprised you see that work as personal. It was very game-like in its construction. A lot of the relationships were produced through random methods. The very title of the project *Plato's Cave, Rothko's Chapel, Lincoln's Profile* is a random grouping, linked only because they are all in the possessive. All of the metaphorical connections in the piece grew out of that loose pairing of possessives. I was trying to produce something that seemed mysterious and arcane, but was just facade; it is a pseudo-mystical artwork. In the early 1980s I was interested in mysticism as an 'alternative' form (yet akin to more dominant forms) of knowledge, that could be treated as a given and played with. At that time in the art world, usage of such material was fairly uncommon so some people took it as a serious, if failed, attempt at a mystical artwork. I suppose you could say the piece represents the construction of

a personal mythology, but it would be one made up of elements that are social givens. The personal was not much of a concern to me at that time.

Not long ago I made a series of photoworks titled *Timeless/Authorless* (1995), for which I used self-help books to determine what my 'pathological' psychology is. I just plugged my own background details into the standardized dysfunctional schema. I wanted to respond to a general interest in the psychology of the victim. I felt that that this was how people tended to understand my work anyway, so I might as well make work that appealed to the interests of those viewers – but fuck with it. In past works, especially the ones utilizing stuffed toys, many viewers had projected scenarios of a disturbed childhood upon them. That had not been my intention, yet I found that the works could not escape this reading. I had to quit making works using those materials, but I thought I should deal with the issues these works raised. That's when I started making work about my 'abuse'.

Isabelle Graw *When making works about your 'abuse', even though this occurs in the artistic realm and is fictitious, does it relate to a psychic real?*

Mike Kelley I thought I should address my 'abuse' through the art-education system instead of the more common examples, such as the home, because it made it more obvious that this was an aesthetic exercise. That is why I constructed the *Educational Complex* (1995), a large architectural model made up of every school I have ever attended, with the sections I cannot remember left blank. The blank sections are supposedly the result of some 'trauma' that occurred in those spots, which has caused me to repress them. However, it's obvious that there are formal considerations at play in the organization of these blank areas – these point towards my formalist art education itself as the possible 'trauma'.

Isabelle Graw *It is interesting to realize how much you acknowledge that your work is about its reception. I think of Martin Kippenberger, who often also responded aggressively to certain readings of his work, either by pushing them to an extreme or otherwise disrupting them. In your installation* Sublevel *(1998) the personal again comes into play. You choose carriers which secure the work's status as sovereign art, like the model tunnel based on remembered floor plans of your schools, or magazine covers presented with corresponding, decorative coloured panels, or the shaped canvases in the side gallery with the little clusters of paint pots. There's always an abundance of formal propositions, of suggestions as to what this could be about. Your work is getting denser and more multilayered.*

Mike Kelley This is the result of not being able to come to terms with the complexity of my themes. For example, once I started working on this abuse work I became interested in the various arenas in which victimization occurs. I discovered three main areas: first, child abuse, which is of the family; second, satanic cult abuse, which positions abuse more within a broad social conspiracy theory; and third, alien abduction and abuse, which is more hooked to religion and the supernatural. I was intrigued by the differing visual aesthetics of these

three arenas and tried to analyse why a particular visual aesthetic was appropriate to a particular abuse bracket.

In my work I'm constantly mixing up the various aesthetic categories. I'm unable to make much sense out of these differences because in many senses they are the by-products of chance occurrences. To my knowledge, little research has been done to trace the genesis of these visual tropes. I can point towards how these various aesthetics meet or split, but I can't fully explain them on any base level of symbology. Because these terms are so ill-defined my usage of them tends to be very open. I'm sure that in the future when these phenomena have been more carefully researched and are presented in terms that are more defined, my work will make no sense at all relative to these issues. At this point these issues are still outside the interests of the critical community. And because these things are currently so ill-defined I can get away with being sloppy.

Isabelle Graw *Returning to* Sublevel, *this installation seems to counter the art-historical notion of participation, in that the viewer is asked to humiliate him or herself by crawling through a dark tunnel. It's optional, but there's the possibility of this literal participation. I have always had doubts about the notion of participation, for example in the context of Minimal Art, as if this had really been the intention of artists like Robert Morris. What is your attitude to the viewer's potential submission, in this aspect of your work?*

Mike Kelley *The Trajectory of Light in Plato's Cave* was partially a comment on participatory art. You had to get down and crawl into the artwork, submitting yourself to its faux-grandiosity. I didn't think about *Sublevel* in that way. I wanted to present the opportunity to explore a work on different levels. The act of crawling through a tunnel is not necessarily degrading. It's just part of a set of metaphors operating within the work. You have a sublevel and you have a 'below-sublevel' – a 'sub-sublevel'; how can that differentiation be produced without a strong psychological shift? Without such an experience, the two planes would remain too similar. I'm not saying that the work is not completed until the viewer performs the task of crawling through the tunnel, because I'm against such demand-oriented artworks; they strike me as authoritarian. I needed to produce a psychological shift, and the easiest way to accomplish that was through a kinetic shift. A forced shift in orientation of the viewing body announces that different areas exist in the sculpture. I don't think it's absolutely necessary to enter the tunnel. Simply looking at the tunnel already performs its function, but crawling through it to the metal examination chamber definitely expands the experience of the piece.

It's the same with *Sod and Sodie Sock* … , which also has a long tunnel. Here, it leads to a crawl space with a peep hole looking into a shower room. But instead of crawling down the tunnel, one can just go into the shower room and peep into the crawl space. There are no big surprises. The point of crawling down the tunnel lies in the pleasure of doing so. The fact that

the tunnel is linked to a shower room sexualizes the activity to a minor degree. I happen to enjoy crawling in tunnels myself.

Isabelle Graw *Crawling is not necessarily a degrading activity, but it is somewhat regressive. If you are claustrophobic it might involve fear. It's more extreme than just walking into an installation, but then again it is not connected with notions of extreme action or experience in the work, say, of Chris Burden. Nor is it similar to walking through Bruce Nauman's* Performance Corridor *(1968–70).*

Mike Kelley You can see how long Nauman's corridor is and you know you can get through it easily. Maybe people are scared that they're going to crawl into my tunnel and end up in a meat-grinder or something! I suppose the unknown aspects of the work can be scary, but in *Sublevel* I believe this is necessary.

 I wanted to get across a subterranean feel of two kinds of depth, something akin to the relationship between the subconscious and the unconscious: a below-meaning and an even further, inaccessible zone. Smallness, closeness and darkness in architecture always evoke this kind of psychological effect. That's what I was working with.

Isabelle Graw *I'm interested in the relation between colour and sexuality in your work. You use colour both as a formal device and as an element coded with sexual meaning. It is hard to determine what, specifically, in your recent installations causes their sexualization, especially in* Sod and Sodie Sock … , *in which a military green is the predominant colour. There are obvious ways of pointing to sex; here, it is difficult to define why sexuality seems at issue in the work.*

Mike Kelley It is complicated. I do think my works are becoming more and more sexual. Earlier, I kept away from the sexual, or it was very buried. Now its 'buriedness' is obvious, so that you know you're looking at sublimated objects. They reek of sex, yet nothing is openly erotic. I've always been interested in the signs of repressed sex.

Isabelle Graw *There are moments of caricature, of exaggeration, like the* Sex to Sexty *adult humour magazines in the* Missing Time Color Exercise *series (1998). The covers of these magazines are too obvious to be really sexual.*

Mike Kelley What kind of sex is represented in those magazines? It's the equation of the sexual with the dirty, the dysfunctional and the 'other' of a lower order: the country bumpkin.

 In the paintings that utilize those magazine covers there is a sophisticated game with colour arrangements, so that all these 'dirty' images become luscious, pretty, compositional and harmonious. With the *Missing Time Color Exercise* paintings I tried to make seemingly over-simplified paintings. They are composed in a grid, one of the most over-used devices in Modernism. Yet I took the colour relationships very seriously. I tried to produce an overall colour balance between the magazine covers and the same-sized panels that stand for the missing issues – which can be seen as analogous to the missing

'repressed' sections of architecture in the *Educational Complex*. Each panel colour is meant to function as an intermediary among all the magazine covers around it, whereas the colour relationships in the other set of paintings in the same exhibition, such as *Free Gesture Frozen Yet Refusing to Submit to Personification* (1998), are very simple. The colours were left-overs from the complex colour-mixing episode I just described. I simply grouped them by spectrum. There is a reddish group, a greenish group, and so on. The pigments were applied to a support which is shaped not only in contour but also in profile. The panels are very baroque in contrast to the gridded series. They are finger-paintings that took about an hour to produce at maximum.

Isabelle Graw *These shaped panels are so exaggerated and funnily shaped; they're reminiscent of some of Carroll Dunham's paintings.*

Mike Kelley Dunham plays a lot with elements that call to mind doodles or children's drawings, elements one might think of as anti-compositional; but the final paintings are very elegantly composed. I wouldn't compare my finger paintings to Dunham, but there is one similarity, in terms of imagery, particularly in the modernist trajectory of art history, which is the idea that florid forms are 'low'. *Jugendstil*, for example, is very looked-down upon, and psychedelia is not even included in art history. I've used these goopy kinds of forms so many times now, however, that I can no longer see them as non-compositional. A while back I used them as some kind of play with the abject – the unformed. Now I just see them as complex forms.

Isabelle Graw *Across your work one can find a shift from obvious to more subtle sexualization. For example, in the video piece* The Banana Man *(1982), you wear a funny bright yellow suit and have an exaggeratedly long 'penis' made of a piece of white cloth. You become a personified joke. Later,* Nostalgic Depiction of the Innocence of Childhood *(1990) references Yves Klein's* Anthropometry *(1960), as well as coprophilia. These are obvious references to sexuality.*

Mike Kelley Those images are obvious, nevertheless the play in *Nostalgic Depiction of the Innocence of Childhood* and *Manipulating Mass Produced Idealized Objects* (1990) was with colour references. The whole point of the piece was to present two nearly identical photos whose meaning was changed by virtue of their colouration. One was black and white, and the other was sepia toned. One was supposed to be documentarist and 'Marxist', the other sweet and nostalgic. The action was a prototypical depiction of infantilism, although there's a sexual component because a man and a woman are pictured together, which is almost never done in infantalist erotica. Still, those works were not really meant to function erotically. It's the aesthetics of repressed sexuality.

Isabelle Graw *I am also reminded of works like* Orgone Shed *(1992), exhibited at Documenta IX. On one hand, this installation alludes to a minimalist aesthetic; on the other, it makes heavy-handed reference to the theories of Wilhelm Reich and the use of an 'orgone energy accumulator' for sexual healing.*

Mike Kelley That sculpture was meant to be somewhat juvenile. I installed a paper towel dispenser inside the *Orgone Shed* as if it were a public toilet. I was pushing that sexual/dirty connection. Many of my sculptures in Documenta IX were conflations of various objects. The *Orgone Shed*, for example, is an 'orgone energy accumulator' made out of a pre-fab metal tool shed. I wanted to play with these mixed references: the 'sex energy' aspect of the 'accumulator' mixed with the common association of the tool shed as a place where you might have been taken as a child to get a spanking. I was also interested in the theatrical nature of those sculptures; there is a tendency to project a fictional maker upon them. They are so varied in conception that it doesn't seem possible that one person could have made them all.

Isabelle Graw *You seem to feed aesthetic sensibilities and expectations as well.*

Mike Kelley It's always been very important to me that my work has a socialized veneer. I've never wanted my work to be associated with the Dada sensibility – to be perceived as simply negational. I want the initial perception of it to elicit comfort, which then starts to break down. You come to recognize that it's not what you thought it was. Works that are too negational on the surface repel viewers before they can become involved. I want the viewer to spend enough time with the work to discover all the jokes and perversities at play. If the work immediately insults viewers, they will just ignore it.

Isabelle Graw *I understood this aspect of the work for the first time when I saw your 'hanging sculptures' (1991) installed at Jablonka Galerie, Cologne. Clusters of soft toy animals suspended by pulleys, they were surrounded by slick, shiny, identically formed relief objects on the gallery walls, each a different colour.*

Mike Kelley That was at the tail end of my usage of craft materials. I was sick of being associated with stuffed toys; I was attempting to get people away from their empathetic relationship with the stuffed toys through various strategies. In the *Craft Morphology Flow Chart* (also made in 1991) I exhibited handmade craft items in a simple and uninflected way – the way tools would be shown at a fair. In the 'hanging sculptures', the toys were treated as pure colour, almost like daubs of paint in an abstract painting.

Isabelle Graw *Did* Craft Morphology Flow Chart *mock some types of classification?*

Mike Kelley Yes, the toys were laid out on tables organized according to material usage and construction technique. They were accompanied by a series of photographs of each toy with a ruler alongside it, as if they were archaeological finds. The 'hanging sculptures' were more formally organized: one quantity of colour balanced another. The painterly notion of colour balance was thus literalized. The clumps of animals were on pulleys, so they literally balanced each other by weight, not colour. Despite these tactics, I knew full well that the audience could not escape feeling empathy for the stuffed animals, so I turned them all inwards, so that their faces didn't show. It made people feel quite

comfortable to see the stuffed animals treated just as wads of dirty fabric. To push that effect further, I paired the stuffed animal clumps with very clean, pristine fibreglass wall units that looked like futurist automobile designs, each a different bright colour. Furthermore, these objects actually sprayed room deodorizer. They made the stuffed animals look even more decrepit. You could read the whole installation as a play on personification and the abject, dirtiness and cleanliness, and how that applies to design. People project moral conclusions onto artworks by virtue of
the social codes associated with various abstract motifs – clean lines next to fuzzy broken lines will be read as forms in conflict. I treat those moral interpretations as an intrinsic aspect of composition. There are conventions within modernist art history that have come to signify the abject, the confrontational, the pure. These conventions are now so naturalized that they seem random. I play games with them and invert them.

Isabelle Graw *Where do you get this impulse to challenge the dominant understanding of how art should function?*

Mike Kelley I think that the practice of art is an examination of visual communication. People have to recognize visual culture as a constructed language, a language that acquires meanings through its construction. The art viewer should not simply be a patsy who performs a set of knee-jerk responses in reaction to a set of visual conventions. Art should be more complex than that.

Isabelle Graw *Your work can equally be seen as disruptive of the 'anti-aesthetic' mode prevalent in American art during the 1980s.*

Mike Kelley For many artists of my generation there was a tendency to think of art as a visual analogue to the written word – but it's not that simple. Written, spoken or read language operates in one manner and visual language operates in another. It has to do with tactility, materiality, presence – all the other carriers of meaning. Often there's a great discrepancy between surface symbolic meaning and the associative qualities of the material carrier of that meaning. In Conceptual Art, and ever since, there has been a strong anti-optical impulse.

Isabelle Graw *An attack that was well founded, directed against the New York School's idea of immediacy, authenticity and a privileged gaze.*

Mike Kelley But since the decline of the New York School, there has been a useless perpetuation of the idea of visual opulence as negative. This idea still persists, and strikes me as very puritanical. It also oversimplifies the reception of art by constantly reinforcing the idea that the visual carrier has no language itself; and that's wrong. There is a very complex relationship between visual and verbal language. It's the resonance between these two elements that makes a complex artwork.

Isabelle Graw *There's one instance in your work where the specificity of visual language overlaps the specificity of linguistic discourse: your drawings.*

Mike Kelley It's easier with drawings, because both writing and drawing are thought of as primarily linguistic forms. They aren't perceived as having materiality. My early paintings were never discussed as paintings because they were black and white and they were on paper. They were seen as illustrative, but they didn't really illustrate anything. They played with the equivalence of the letter form and the pictograph as carriers of meaning; their meaning was produced in the space between those two functions. I'm more interested in sculpture now; it's more complex in its referentiality since it is made up of 'real' materials. Painting is difficult. At this point, my painting practice is much more geared to historical questions than to any material considerations. *The Thirteen Seasons* ... paintings, the *Timeless* (1995) and *Missing Time* (1974–76) series, all point towards my scholastic training in painting.

Isabelle Graw *The* Educational Complex *allows the biographical – your schools and your memory of them – to enter the work.* The Thirteen Seasons ... *paintings engage with Hans Hoffman's 'push-pull' theories which were prevalent in your art school education. It is easier to identify the construction of biography in your work than the sexual energies that run through it like a leitmotif.*

Mike Kelley In *Sublevel* people automatically associate the erotic components with the sexual, due to its closed spaces and flesh tones. I've merged them and created a reduced architecture that's lined with pink. It's automatically bodily, though I try not to be so obvious by making the pink lining crystalline. So there's a contradiction there: you approach it not as the lusciousness of the body, but as the lusciousness of a non-fleshy form. A lot of this came out of my exploration of the aesthetics of ufology, in which there is often this conflation of the cold, the hard and the metallic with the runny and sticky, and with luminous colouration.

Isabelle Graw *It's easier to determine the moments of sexualization in* Sod and Sodie Sock ... , *due to the relics of soldiers' removal of their clothes, or showering. I like the staircase that leads to nowhere, where anything could happen.*

Mike Kelley It's a place where your imagination can run wild. There are elements that are obviously either sexual or medical, or which are indicative of group activities, perhaps sexual, perhaps abusive. The installation has the feeling of an abandoned site; it promotes narrative speculation. Paul McCarthy and I are now working on a videotape which we shot using the camp as a set. The tape reveals the actual activities that took place there. The scenarios are a mix of scripted scenes and group improvisation. There are military hazing rituals, an alien abduction, a transsexual shower scene; I'm not sure how all of this is going to come together. This tape will probably not be shown with the installation, so that the installation will maintain its sculptural identity and not be seen simply as an elaborate film set.

For me, critical interaction has always been about sexual interaction. It is typical of the bookworm to confuse intellectual interest with sexual desire.

That's obvious in the sublimated aesthetics of adolescents. When one talks about sexuality in art it generally means anti-art – like Otto Muehl's work, where the art process seemed to function as a stepping stone to get to the sexual. That's not what I do. My work is still invested in its status as art, in its sublimated nature. I'm interested in the ways sexuality is caught up in language games, whether they be visual or linguistic. What is sexuality outside of that?

Isabelle Graw *You don't seem to belong with the current generation of artists who either essentialize sexuality, or hold onto the notion that you can just exhibit the sexual as a statement in itself, as a radical or political activity.*

Mike Kelley There has already been a whole generation of feminist artists who really tried to examine the rituals of daily life and of culture, followed by another group who tried to address identity politics – whether racial, sexual, or class-based – in relation to art production. Despite my reaction to some of the individual work that emerged from those movements, I feel a great affinity with their aims. At this point, I see a lot of art that seems more than willing simply to ape the mass media. It is a non-critical reiteration of that desire-producing industry. It completely bores the shit out of me.

Isabelle Graw *But in relation to your own work, you said before that biography is increasingly important. You acknowledge the highly mediated, highly constructed idea of your biography.*

Mike Kelley I felt I was forced to go to the biographical at the point when I became disgusted with the general ahistoricity of the art world. Despite the fact that my biography might be fabricated, it's not ahistorical. All the terms for understanding my work come from specific historical lineages. I did my recent paintings specifically in response to a very particular history of painting. They mimic the way I was trained to paint, they reiterate an institutionalization. My only control of this, perhaps fatalistic, world view is through the overt construction of it as fiction; that's my only power.

Isabelle Graw *Identifying yourself as a working-class guy or …*

Mike Kelley … being abused by my father, or finding myself in a bad school, or any common scenario that could 'explain' my artistic motivations narratively. The work then takes this fabrication as its ostensible subject, yet its true meaning comes from how things don't add up. Its manner of construction is much more telling than the narratives, because they are simply a pack of conventions.

Isabelle Graw *How would you describe the defence mechanisms you build in order to prevent this 'pathological' reading?*

Mike Kelley There are a number of strategies that I use to prevent people from buying completely into these common narratives. One is discontinuity; another is exaggeration. These could be seen as defence mechanisms relative to the

general pathological references in the work, but they also function to make the viewer aware that these references are suspect.

Isabelle Graw *When you describe this procedure it sounds very systematic. But I can imagine that it begins simply with, say, a preference for a certain shape?*

Mike Kelley Part of my methodology is to stop at a certain point and change direction. Part of my sublimatory aesthetic is to shift the focus away from something once it starts to reveal itself. Yes, I might have a fondness for pink crystal, but the question is, what do I do with it? How do I make art out of it? I can tell you a biographical story that explains my interest in pink crystal, but that closes the reading down and makes it too biographically specific.

 I prefer to play games of deferral, prolonging the eroticism of the viewing experience. Hopefully, then, the erotics are experiential and not definitional.

Isabelle Graw *Your titles were a vehicle, in the late 1980s and early 1990s, to add another layer. You have never used 'untitled' extensively. I always associate 'untitled' with a lack of courage or fear of being overly explicit. As if the artist doesn't want to take any responsibility for meaning.*

Mike Kelley I think it implies that the artwork is a thing in itself, which I don't believe. I like to think of the art viewing experience as a series of unfoldings, and of the title as the first moment. When I have used 'untitled' as a title, it is usually to point towards this fiction of material self-sufficiency.

Isabelle Graw *Are your own texts still an integral part of your practice?*

Mike Kelley The use of text in my work has changed a number of times. My early work was very text-driven; later it became less so. In the late 1980s I wrote more art-critical texts, so there was less of a relationship between what I was making and what I was writing. They were designed for the general art world reader. But now that I don't have time to do the research for those kinds of texts, I've found that I've started to think of my notes themselves as my writing practice. Often they are just lists of statements. I take those and rework them. I have done performances where I simply read these notes, often accompanied by sound. Several times I have presented them in essay-like form. I'm thinking now of using them as lyrics. I've done mostly instrumental music in recent years. Maybe this is a way for me to pair text with sound that's not as labour-intensive as my performances, which took months and months to write. I miss that pairing of sound and text that I had in the performance works.

Isabelle Graw *Your text 'Goin' Home, Goin' Home' (1995) was a bit like a song, I thought. Less discursive.*

Mike Kelley Yes, more condensed – unlike the performance scripts where duration is really important, where you follow an idea as it changes through time. Now I think it's okay just to present a compression of ideas. In the past I would have felt that this wasn't well-crafted enough, but now I think it's fine.

1 *'Looking backwards, ass backwards/ This is your life/ Peephole history/ The Wayback Machine/ Porthole to the soul/ Your lemon sheets, hung out the bedroom window to dry/ Lonesome yellowing scrapbook in the sun/ Gilded hair gone white/ Silver mirror/ Golden Boy/ White Trash/ Upscale cracker, with caviar on it/ Tommy Roe, Cum Gum, Bun Boy, Love Gun/ This is the oval reflector, solar-framed, exuding light/ The mirror has been painted on, outlining the self.'* Extract from Mike Kelley, 'Goin' Home, Goin' Home', *The Thirteen Seasons* (Heavy on the Winter), (cat.) Jablonka Galerie, Cologne, 1995

Mary Kelly *Douglas Crimp*

in conversation
October 1996, New York

Douglas Crimp *I want to talk initially about the reception of your work in the American context, which is how I came to know it. Because my interest in Postmodernism and the critique of art institutions did not include, as it might have, the feminist critique of vision, my involvement with feminist art practices and with your work was somewhat delayed. Probably this has to do with how long it took me to take my own subjectivity, my sexuality, into account in my work, something that didn't begin until 1986, when, in the first of the 'Dia Conversations on Contemporary Art', I spoke about art and AIDS. My talk concerned what seemed to me a hierarchical division of political art in two simultaneous shows at the New Museum: the Hans Haacke exhibition and a small, ancillary show called 'Homo Video' organized by Bill Olander. The year before, the New Museum had organized the 'Difference' show, which included your work along with other British and American artists engaged with questions of sexual difference. But your work had been shown in the U.S. before that. When did you come to New York?*

Mary Kelly It was in 1983 when Jo Anna Isaak organized 'The Revolutionary Power of Women's Laughter', for the Protetch McNeil Gallery. Then the entire *Post-Partum Document* was shown at the Yale Center for British Art in 1984, and part of it was included in the 'Difference' show, curated by Kate Linker, at the New Museum of Contemporary Art, in that same year.

I think that's how my work became contextualized with what has been described by Benjamin Buchloh as a second group of conceptual artists, mainly women, even though I began working at an earlier period that has another history in Europe. Coming to the U.S. at a later stage in the 1980s meant that my work was historicized within a context that placed emphasis on institutional critique, on photographic work, and what was termed 'appropriation'. It was also a moment when so-called essentialist feminism was being questioned by what is now called social constructionism – not my term, but it's become a label that's applied to me as well as artists like Jenny Holzer and Barbara Kruger. In the 1970s, though, that division between essentialism and constructionism wasn't so apparent.

If you go back to the founding period of the women's movement in Europe, in 1968, it was about not only changing our conditions – legally, practically, politically – but also trying to find a theoretical apparatus that recognized the subjective dimension of that process. And this led us to look at Freud and later Lacan, who hadn't even been translated yet. The work of that period was not really about establishing our difference from other kinds of feminisms …

Douglas Crimp *But surely cultural feminism was known in Europe. In fact Juliet Mitchell engages with writers such as Kate Millett in* Psychoanalysis and Feminism.

Mary Kelly I'm not sure she would have called Kate Millett a cultural feminist. Radical feminists and socialist feminists – that's how it broke down in England. Those feminisms were already inscribed in larger movements, except that radical feminism was separatist and socialist feminism used the slogan 'separate but not autonomous', meaning part of a broader movement for

social change. What I think of as cultural feminism in the U.S. was perhaps best exemplified in projects such as Judy Chicago's *The Dinner Party* and not necessarily in the broader women's movement represented by organizations like NOW.

Douglas Crimp *But when you began working on the* Post-Partum Document, *were you not aware of the feminist art being made in the U.S., work like that at Woman House?*

Mary Kelly No, because it hadn't been made. It was happening simultaneously on two fronts. I was aware that Judy Chicago was doing something, but it wasn't formed enough for it to be contentious. We were working in different ways on what we thought was the same project. 'Women of the World Unite' was the slogan that prevailed. There was a different political atmosphere in the 1970s, which didn't apply to the moment when you and I met in the 1980s. By then, there was a cultural movement developing in Europe and the U.S. that …

Douglas Crimp *… was reacting to essentialist feminism?*

Mary Kelly Well, what I'm trying to say is that my work cannot be a reaction because it was part of a founding moment. What happened in the 1980s was the reaction of a second generation against the first generation of cultural feminism, and even though I was a part of the first generation I was identified with the second.

Douglas Crimp *It's true that much of the work which you came to be aligned with was in fact made in relation to your already existing work, and to the context in which your work had developed, knowledge of which came to this country largely through* Screen *magazine and feminist film theory.*

Mary Kelly But for me the story doesn't begin there. First of all, I was an artist making systems work without any political content, if you like. When the great upheavals of 1968 opened up areas of activism, none of us immediately responded at the level of our artwork. As Hans Haacke has said, for an interim period people just kept their art and their politics separate. For example, I did a performance in 1970 called *An Earthwork Performed* which involved shovelling coal. There was an obscure allusion in it to the miners' strike, but for the most part, it was just a systematic series of actions.

 Then I started to move to film and photographic media, which were assumed to be inherently more progressive, as a way of addressing political issues. In 1970 I became part of the Berwick Street Film Collective as an artist and as someone involved in the movement. I was drawn to what was becoming the dominant aesthetic of the Left in Europe – coming from Benjamin, Brecht and Godard, trying to make a film which would be about its own processes as well as the issue of unionization and the historicization of the women's movement in that context. We shot hours and hours of film because of the emphasis on real time, getting rid of direct address, using blank spacing and no voice over – it's the sort of materiality of film that's also in the work of Straub and Huillet or Mulvey and Wollen. That was extremely formative.

From 1968 to 1970 I was at St. Martin's School of Art in London because I was interested in the work there – people like Gilbert and George, Richard Long, Charles Harrison and Art and Language. But from the moment that this imposition of social issues occurred, there was also something very inadequate about the systemic approach to art, something wrong with the formula 'art interrogating the conditions of the existence of the object' and then going on to the second stage and interrogating the conditions of the interrogation itself, but refusing to include subjectivity or sexual difference in that interrogation.

The people who *were* interested in doing that kind of theoretical work happened to be in film and *not* in the St. Martin's post-Caro conceptual group. Also, formally, when I saw Straub and Huillet's *Othon*, the long take going into Rome – you know they run the whole reel, it's ten minutes – I was knocked out, it just took my breath away, and I thought: why should all the interesting work be in film? Why can't you do that in an exhibition? Why couldn't I think about drawing the spectator into a *diagetic* space: the idea of real time or what you might call the *picture* in the expanded field. And that's what I eventually got back to in *Post-Partum Document*.

Douglas Crimp *I'm not familiar with your work prior to the* Post-Partum Document. *The film* Nightcleaners *was done before the* Women and Work *project?*

Mary Kelly The film project started first, in 1970, but wasn't finished until 1975; the *Women and Work* project was begun in 1973 and ended in 1975. *Post-Partum Document* also started in 1973, and was shown in 1976, so there was an overlap. There are elements from all of this activity that condense in the *Post-Partum Document*.

Douglas Crimp *You have said that, at that time, many thought of photography and film as being inherently more progressive, which is a position that I came to later in a different context, through reading Walter Benjamin and Roland Barthes in relation to new photographic work produced by younger artists. But when you were working on those three projects, there was something else happening in the U.S. in the context of Conceptual Art and of post-Minimal Art more generally: many artists began to turn to a range of mediums, especially film. So, for example, a number of sculptors made films – Robert Morris, Richard Serra, Robert Smithson – and Yvonne Rainer moved from dance to performance art to film. I don't think this was done because of a sense that film was more progressive; rather, the specificity of modernist mediums was being broken down. It was no longer considered the task of art to investigate the terms and conditions of one's chosen medium. Whatever medium seemed useful for a particular investigation would be used. So it's interesting to me that you moved in the opposite direction. That is to say, you had worked on a film, but wanted to take what you had learned from that medium and apply it to the artwork. Even if the* Post-Partum Document *is related to Conceptual Art or to installation work, it also takes its concerns from other mediums.*

Mary Kelly You can see that the *Women and Work* project looks a lot like Haacke's
'Shapolsky piece' (*Shapolsky et al. Manhattan Real Estate Holdings, A Real-Time Social System, as of May 1*, 1971): in the display of documents, the time
that we took to investigate the conditions in the factory, and the way that
we used all the forms of information and visual display that would give the
viewer a way of weaving through and understanding the problem of that
factory and its means of implementing equal pay.

But something wasn't working in the strategy. For instance, when we were
in the factory trying to record the conditions of work, we interviewed the
men and they told us everything that happened on the job, but the women
wouldn't even talk about what they did at work. They just said, 'Went to
work, came back', and then they talked about what they did at home, about
their children and about work in the home.

Because there was a question about domestic labour emerging in the
women's movement at that time, as well as my own experience of being
pregnant, I thought: well, I'm going to see what really is going on in the
home. What kind of labour is this? At first I looked at it very sociologically,
but it became more and more obvious that you couldn't get rid of the
irrationality of this event, the question of desire and questions of the social
and psychic constructions of maternal femininity. But in the installation
itself, regarding the impossibility of conforming to what might be the limits
of a site-specific project, we weren't even getting information at the centre
of it that referred us back to that site. The site shifted to the domestic space,
and once again, when we got there, we found that it was even more radically
dispersed at a psychic level. It was the specificity of *debate*, or discursive sites,
that became increasingly important for me.

Douglas Crimp *There is a visual similarity to the 'Shapolsky piece' in the first part of the* Post-Partum Document, *in the use of text for example, but there are also some very
obvious differences.*

Regarding the representational strategies of the Post-Partum Document, *both
its refusal to image the woman and the deliberate use of fetish objects, you introduced
the necessity to counter the fetishistic nature of representation in visualizing the
woman's body, which also arose in the theoretical work of that period.*

Mary Kelly In the mid 1970s, a number of women used their own bodies or images to
raise questions about gender, but it was not that effective, in part because this
was what women in art were expected to do. Men were artists; women were
performers. Yvonne Rainer says that she and Simone Forti were called 'the
dancing girls'. The field was absolutely divided according to heterosexual
imperatives. I wanted to question those essential places. But when I started
the *Document*, it was much more intuitive than it appears now. For instance
I decided to use the vests in the *Introduction* because I couldn't really 'figure'
the woman in a way that would get across what was going on, the level of
fantasy that was involved, in an iconic way. I needed something that was more

Mary Kelly

**Post-Partum Document:
Documentation I, Analysed faecal
stains and feeding charts (prototype)**
1974
Perspex units, white card, diaper
lining, plastic sheeting, paper, ink
1 of the 7 units, 28 × 35.5 cm
Collection Generali Foundation,
Vienna

Ilya Kabakov

The Red Pavilion, with musical
arrangement by Vladimir Tarasov 1993
Wood, board, paint construction,
pavilion, wood fences, flags, builders'
materials, loudspeakers, sound
installation
Dimensions variable
Installation, Russian Pavilion,
45th Venice Biennale,
Collection, Museum Ludwig, Cologne

Ilya Kabakov

School No. 6 1993
Constructed and found school objects
Dimensions variable
Installed, disused barracks building,
Chinati Foundation, Marfa, Texas

Alex Katz

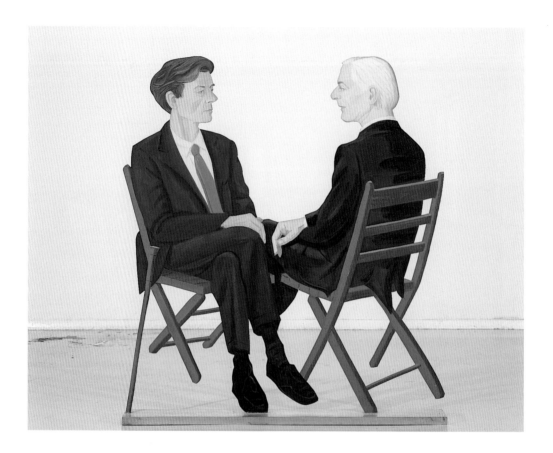

Edwin and Rudy 1968
Oil on aluminium
122 × 110 cm

Alex Katz

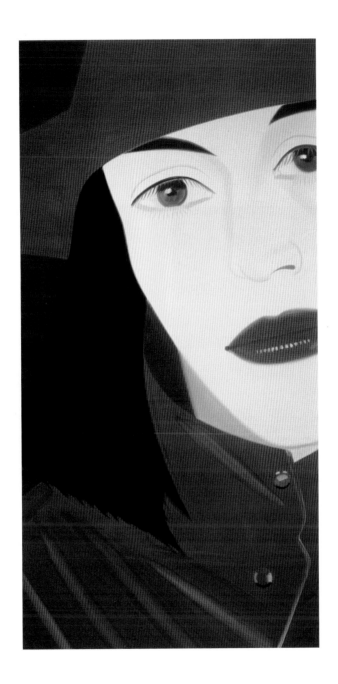

Red Coat 1982
Oil on canvas
244 × 122 cm
Collection Whitney Museum
of American Art, New York

Mike Kelley

**The Trajectory of Light in Plato's
Cave** 1985/1997
Acrylic and acrylic latex on canvas,
cotton, wood, electric lights,
fake fireplaces, paint chips, felt
Dimensions variable
Installation, Rooseum, Malmö,
Sweden, 1997

Mike Kelley

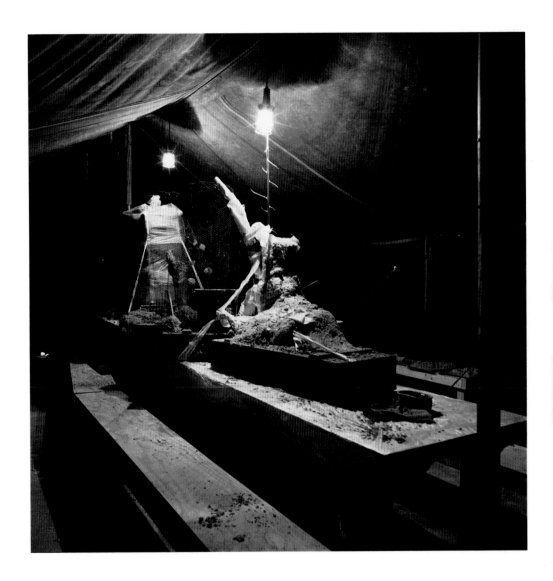

Sod and Sodie Sock Camp O.S.O. in
collaboration with Paul McCarthy
1998
Mixed media
Dimensions variable
Installation view

Mary Kelly

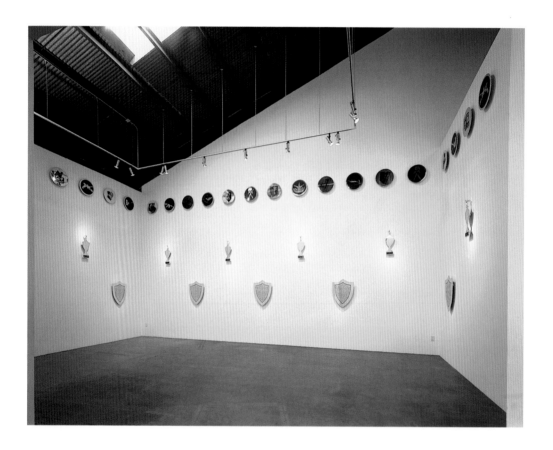

Gloria Patri (detail) 1992
Etched and polished aluminium
1 of the 5 shields
73.5 × 61 × 6 cm each
Installation view, Rosamund Felsen
Gallery, Santa Monica, 2001

indexical, more like a trace. Then, because of my collaboration with Laura Mulvey, and the theoretical understanding that we began to develop through psychoanalysis about voyeurism and fetishism, it made a lot of sense to displace that element of iconicity, to take the woman's body and estrange it somehow, in order to create an effect of critical distance.

Douglas Crimp *Most Conceptual Art consists largely of text. For that matter, there was even indexical work in Conceptual Art. There was a general avoidance of iconicity. But you don't usually speak about this in relation to your work of this period. When you refer, for example, to Norman Bryson's term 'aniconic', it's in relation to avoiding or reconfiguring the fetishistic nature of representation and the problem of representing Woman. On the one hand,* Post-Partum Document *looks like Conceptual Art; on the other hand, it's parodic of Conceptual Art. But surely no one else involved with Conceptual Art at that time would have spoken of the necessity to avoid iconic representation, or the necessity of using a multiplicity of sign types – the symbolic, the indexical, along with the icon – in the same way and for the same reasons that you do now.*

Mary Kelly The text of *Post-Partum Document* is still quite conceptual, diaristic. There's no attempt to correct the spelling mistakes or anything; it's just another found object. But there is a process in the *Document* that's beyond rationality, too, and something that I see looking back is that in distancing myself from the child, the work becomes more premeditated. By the time you get to *Documentation VI*, the work becomes more constructed and also becomes more heavily narrational, and then I had to end it because there was a moment when there were two very autonomous subjects and it terrified me. The last proposition, which appeared in the form of the algorithm, was: 'What will I do?' – from the mother's point of view, but also as an artist. It's the debate or the question – both aesthetic and political – that propels me into the next work.

Later, I became more concerned with the question of pleasure: how a woman – I mean a spectator in the position of the woman, not the biological woman – finds a place not just in front of the picture but behind it too, a space where a certain parody of the feminine masquerade is possible, or perhaps a gap that evokes the pleasure of the joke.

Interim is much more self-conscious in this regard, of course. I use unabashed stories with endings which are probably as seductive as the iconic image, but I think unexpected in that context. The subject of ageing, too, got me much more interested in the idea of a community of women than I had been in the previous work; the erotic pleasure that women share, what they do together, how they dress for each other, all the things that the narratives in *Corpus* take up. So the problem of the sign was linked to redefining visual pleasure. That's when I introduced the strategy of shifting from looking to listening and formulated more clearly for myself the issue of the spectatorial gaze.

Douglas Crimp It's not entirely clear to me what you mean when you say listening. Why not from looking to reading?

Mary Kelly I'm referring to Freud, and what he said about his hysterical patients, what is seen as the founding moment of psychoanalysis, that is, the therapeutic practice of listening rather than looking, which is aligned with Charcot and his theatre of hysterics. This concept of listening was interesting to me as an artist because Freud dismissed Charcot as a *visuel*. In turn, I thought: 'Could an artwork mime analysis?' What's more, hysteria no longer seemed relevant for clinical practice. Yet, in feminist debate, it has become a way of staging the protest against the fathers, as it were – hysteria as the discourse that cuts across or transgresses the mastery of analysis or indicates a refusal to take up the position assigned to the woman – the question of the hysteric is, after all: am I a man or am I a woman?

So I started *Corpus* with a little theatre of passionate attitudes. The clothes, presented as photo laminates, verge on the iconic, but they're dark, shadowy, and induce a certain kind of paranoia, a fear of being seen to be looking or in this case reading. But, although there's a literal reading involved, I really thought of it more as a texture of writing, as evidence of the body. The use of first person indicative feels as if you're listening to someone speaking. It's about that experience of the voice.

Douglas Crimp Why do you use Latin?

Mary Kelly I wanted a language that represented language rather than a language that was spoken. My initial thoughts were that it would provoke reflection on a certain moment of Western civilization and the instigation of patriarchal social relations. For example, in *Potestas*: to use *populus*, *labor* or *bonus*, instead of, say, 'population', 'labour' and 'wealth' – they don't translate exactly – suggests that it's not a literalization of content, but a reflection on linguistic construction. In *Pecunia* I use *mater*, *conjunx*, *soror*, *filia*, instead of 'mother', 'wife', 'sister' and 'daughter', because they're not tied to a particular historical-cultural moment. This is not to say they're outside of it, but I wanted to take it away from the familiar in order to say something about the way a category is constructed which produces the woman as agent, rather than the biologically determined and experiential subject.

Douglas Crimp In your work there is a very strong relation between feminism as a movement, feminist discourse, and artistic production, which I don't see so clearly in queer work. This is particularly clear to me with Interim because of my own interest in ageing as a gay man, for which there is little or no discourse at all. The older gay man doesn't exist in gay culture, except as a couple of horrible stereotypes – the dirty old man, the sad old queen. The founding moment of psychoanalysis in the shift away from the visibility of the hysteric has its parallel in relation to homosexuality. The third-sex theories of homosexuality with which Freud was grappling in his Three Essays are also about what can be seen, the physiognomy

of the homosexual, an anatomical hermaphroditism. And Freud's reply was to deny that the homosexual existed at all as a special sort of person. However, that insight was not taken up in gay work until much later, until the insights of psychoanalytic feminism were imported into queer theory.

Mary Kelly There being no place for the older gay man perhaps is not unlike the older woman who disappears from Freud's discourse. The analysand is always a young woman. Dora's mother doesn't interest him. Culturally, the gay man is pulled into the same representational space as the woman, I think, because what's represented as masculine in the psychic sense is going to be aligned in a number of ways – whether it be science vs. art, or technology vs. the handmade, all kinds of binarisms … with a certain display of power, which is not about the visible or the vulnerable, while the feminine turns, as we know, either towards the erotic or the abject.

Douglas Crimp *But it seems to me that gay men occupy shifting positions regarding masquerade and display, femininity and masculinity. In reading what you've written in relation to* Gloria Patri, *I couldn't help thinking that many gay men participate in the masculine display. One of the things the older gay man does in order to maintain any sort of position in gay culture is to don a uniform. There's a stereotype about the leather scene, that it's where we end up when we get older. In order to maintain sexual desirability, we dress in leather uniforms.*

Mary Kelly But once the uniform is made prominent in that way, I think it's parodic. It reminds me of what Genet says about the policeman's badge – 'an object in which the quality of males is violently concentrated'. To be fetishized is once again to be in the space of the vulnerable, the visible, the psychically feminine. What's so intractable about the display and its implications for a certain psychic masculinity is exactly that it's *not* about being seen. A uniform is about a certain kind of obliteration. The uniform is like what you have on now, where you can *be* in the world, the art world in this case, and have a voice. The use of leather is certainly not about this, of course there's power in seduction, but it's not the same thing as authentication.

Douglas Crimp *What about the so-called gay clone, who wears the traditional uniforms associated with masculinity and makes himself indistinguishable from the other gay men around him?*

Mary Kelly I actually think the guys who don't get involved in that are the ones occupying this masculine space, because they allow the others to be Other, and their shield as it were, their protection, is their normalized masculinity, not a sensational, gorgeous or masqueraded, muscle-bound parody of it.

The way I first started to think about this was in relation to women. The last part of *Interim, Potestas,* is about women's relation to power. Even though I figured it in a didactic way with the bar graphs, across those graphs are stories. One of them in particular might remind you of the Joan Rivière case about the woman who, after her lecture, felt that she had to ingratiate herself

to everyone, use 'womanliness as a mask'. But then I became more interested in the historical shifts that have caused another kind of identification for the woman with the masculine ideal. That's the question *Gloria Patri* took up, and the Gulf War simply became a convenient way to frame or discuss it.

Douglas Crimp *Your work has consistently taken the form of installation, a form that hasn't been much interrogated or theorized. It's now become a genre or medium more or less equivalent to traditional media. You come out of the moment in Conceptual Art when installation was being invented as a means of questioning the autonomy of the art object and investigating the context and site of the artwork's exhibition. But that initial impetus for installation seems to have been lost. The ease with which installation has been naturalized as just another mode of working is disturbing.*

Mary Kelly That's an interesting point, but I don't see why it should be disturbing to say that the installation can be discussed as a genre or discipline. You could say that until recently the field of fine art was dominated by the paradigm of painting and everything that didn't conform to it was called sculpture. The refinement of our understanding of the implications of a brushstroke, the degree of impasto, *scriffito* or whatever, has never been applied as rigorously to sculpture, much less to the 'expanded field' or to the installation. If you were going to discuss it with the same kind of precision, you might take up the frame or its absence for painting as a secondary level of non-mimetic signification. With the installation, framing infers such a complex spatial and even temporal structure, that you could say it supersedes a work's mimetic or internal system of meaning.

 What's characteristic of all forms of installation is that the spectator is in varying degrees an element within the frame, so obviously it would be imperative to consider not only your phenomenological presence, but also your subjective positioning, as effects of that signifying order (or disorder).

Douglas Crimp *I'm curious about the current disposition of your works. I know that some of your work is owned by museums; if the parts of* Post-Partum Document *are dispersed in different institutions, how do they come together for an installation? What is its meaning when dispersed? As a work conceptualized as a single installation, what happens to it when it no longer takes that form in its current locations? Do your works come with installation instructions? Could* Gloria Patri *be installed differently?*

Mary Kelly Let's go back to *Post-Partum Document* and what I called debate-specific work. The site wasn't so important in terms of installing it as the different discursive contexts in which it was made. I still try to insist on a linear presentation of the work because that has temporal and diagetic implications, and ideally the entire work should be shown together. I refused to split up individual sections, and because they're in public collections you can always get the parts together again. With *Interim*, each section was done over such a long period that for me it feels like it has the autonomy of an individual

work. If you bring together *Corpus*, which is thirty panels, it's practically an installation in itself, and I have shown it that way.

Gloria Patri, though, can't be split up. It was done as one complete installation. I became more self-conscious about using that phenomenological dimension of installation which involves the positioning of the spectator. When I install *Gloria Patri*, although I have placed it all on one wall, usually it's on three walls in three registers surrounding the spectator. Even so, it maintains a pictorial stance, something that's like a facade, but there's no position from which you can actually see everything at once. It sets up an expectation of spectacle, a fetishistic pleasure, but as you enter into it you're sort of out of control. To see the trophies or the logos you have to look up or over; the view is always partial. I was interested in peripheral vision and how it fragments the viewing space. You could say for installations in general that texture and surface don't immediately appear to be tied to a specific field, but are the effects of dispersal or repetition – the fanatical repetition and horrific shininess of polished aluminium in *Gloria Patri*, for example, is a kind of framing device.

Douglas Crimp *I know that for you, what gets left out in the development of one work often suggests material for the next. But I'm curious about what happens in between. What sort of research takes place in the period between the completion of one work and the beginning of another? Perhaps you can say, for example, what your plans are now that* Gloria Patri *is completed.*

Mary Kelly From the very beginning of *Gloria Patri* there was what I thought of as the other side or 'beside', as Homi Bhabha has suggested, of the shield, something about death and victimization, which was not about parody and masculinity but what I call the anamorphic image, the thing you didn't see on the TV screen, or if you did it was just a flash, the charred body, the screaming witness. I felt the only spaces of identification that were allowed were either hysterical over-identification with the victim or projection of the Other into the realm of the abject. So, in between those I wanted to reconsider another position. I think of this visually in terms of the way the spectator will negotiate his or her position in the installation. I was also interested in the notion of hysterical blindness, particularly during wars – not necessarily the Gulf War. In Cambodia there are many reports of women who were declared hysterically blind after witnessing atrocities. And then there's the question of Bosnia and the Bosnian War Crimes trial, which I have followed.

If you look at the *Interim* notebooks, you'll find in all of the sections themes developing at the same time. Also, a project that has to do with our very old age, with death and abjection, and has been running parallel to my current works is *Mea Culpa*. They're brought together by a photograph taken of me that looks like a shroud, the dead body of the woman – need I say any more? I was fascinated not just with the question of death and ageing but the link it had to the other questions I was raising about war trauma and victimization

and identification: vicarious identification with a traumatic event which you did not witness except as filtered through the media. I think that has as much impact as the so-called 'real' event. If we consider Freud's theory of seduction – that the problem is not whether the trauma was real or fantasized, but its implications in the formation of the symptom – then we need to think more about not just those who were victims, but those for which the subjective moment of the trauma is the inscription of this *history of victimization*. I would say the gestures of the mother perhaps more than words are implicated in that founding moment. I'm thinking about certain things like a Jewish child saying, 'There were these books that we weren't allowed to read, but we knew what was in them even before they were opened.'

Douglas Crimp *After I published the AIDS issue of* October *in 1997, I was accused of privileging AIDS activist art over any other aesthetic response to the epidemic. The assumption was that I was claiming that only work directly connected to movement politics had any real political force or meaning and was therefore the only work that should be supported. In fact, at that time, my argument was, rather, that activist work, agit prop, was being overlooked by art world institutions because they tenaciously held onto idealist notions of the work of art. This forced me to clarify my position, to demonstrate my commitments to other work on AIDS and to argue for other work also to be understood in political terms. Because you always stress your relation to the feminist movement, especially at the beginning of your work as an artist, I would be curious to know how you negotiate the charge that difficult, theoretically informed art practices are somehow not political. For example, I think it's easy enough for most people to accept a slogan like 'the personal is political', but when you translate that in a particular way, as paying attention to the 'subjective moment', and paying that attention by taking a detour through psychoanalytic theory, it is often read entirely differently, as* theoretical *instead of* political. *I think much of the current work informed by queer theory confronts these same charges.*

Mary Kelly My work is not about positive images or local issues. It is, as I said, about continuing the legacy of institutional critique by expanding the notion of site to discourse, and discourses continually problematize themselves. So, my only aim is to keep pace with them. As far as feminism is concerned, that process is both theoretical *and* political. As far as 'detours' are concerned, they're *always* more interesting than the main road.

William Kentridge *Carolyn Christov-Bakargiev*

in conversation
autumn 1998

C. Christov-Bakargiev *You've often said that everything you do is drawing, and that you see drawing as a model for knowledge.*

William Kentridge What does it mean to say that something is a drawing – as opposed to a fundamentally different form, such as a photograph? First of all, arriving at the image is a process, not a frozen instant. Drawing for me is about fluidity. There may be a vague sense of what you're going to draw but things occur during the process that may modify, consolidate or shed doubts on what you know. So drawing is a testing of ideas; a slow-motion version of thought. It does not arrive instantly like a photograph. The uncertain and imprecise way of constructing a drawing is sometimes a model of how to construct meaning. What ends in clarity does not begin that way.

C. Christov-Bakargiev *Your charcoal drawings and prints since the late 1970s; the animated films and videos which began a decade later; as well as your theatre and opera productions as actor, set designer and director, have been informed by your growing up in South Africa under apartheid. They have dealt with subjugation and emancipation, guilt and confession, trauma and healing through memory.*
 How has belonging to a family of prominent lawyers' committed to the defence of the abused affected your work?

William Kentridge There are three separate things: themes or subject matter in my work; my South African background; my family background. The themes in my work do not really constitute its starting point, which is always the desire to draw. It can become a self-centred reflection of whatever is around that interests me rather than great issues that have to be answered objectively. Rather than saying, like Lenin, 'What is to be done?', my engagement is politically concerned but distanced. One contradiction in the South African situation is the oscillating space between a violent, abnormal world outside and a parallel, comfortable world from which it is viewed.

C. Christov-Bakargiev *You have spoken of the modernist houses in the suburbs of Johannesburg which were the basis, in the animated film* WEIGHING ... and WANTING *(1998), of your depiction of the house of Soho Eckstein, the pinstripe-suited businessman who is one of the principal characters in your films. You also told me that this image in the film relates to a modernist house in Sergei Eisenstein's film* The General Line *(1929). Your work seems to convey both nostalgia for Modernism and a sense of relief that it is over.*

William Kentridge You once described this as a temporal space which becomes a metaphor for geographic space. These images don't suggest my wish to live in a different time and place, closer to the centre, although there is an element of this. The nostalgia in the work is connected with moments of childhood that one tries to reclaim as a touchstone for authentic experience. When I draw a telephone, the automatic assumption is that I'm going to draw an old Bakelite phone from the 1950s, not a 1990s cellphone. However, the lines of communication from the phones in the recent films, like *Stereoscope* (1998–99), are contemporary even though the instruments are old.

C. Christov-Bakargiev *On one hand your style of drawing is reminiscent of the early twentieth-century German Expressionism of Max Beckmann, Otto Dix and others. On the other hand, you freely explore new media and techniques, from video installation to chalk drawing (on the landscape or onto walls) to projections onto buildings and drawings made with fire, as in your collaboration with Doris Bloom for the first Johannesburg Biennale,* Memory and Geography *(1995). A similar juxtaposition of traditional technique and playful experimentation occurs when you bring a finished drawing to an exhibition space and 'extend' it directly onto the wall, 'dirtying' and smudging the white cube of the European or North American museum. One of the most hilarious examples of this almost anarchic attitude is (*Ubu Procession, *1999) a large white chalk drawing on a black background, reminiscent of a roll of film scratched to make a primitive form of animation, depicting a monstrous figure based on the French playwright Alfred Jarry's character Ubu (*Ubu Roi, *1869), that you placed irreverently along the horizontal axis of Richard Meier's new – pristine white – Museu d'Art Contemporani, Barcelona, in 1999.*

Could your origins on the so-called 'cultural periphery' explain this mix of traditional and contemporary, of Eurocentric art history and a different, non-linear history?

William Kentridge Much of what was contemporary in Europe and America during the 1960s and 1970s seemed distant and incomprehensible to me. Images became familiar from exhibitions and publications but the impulses behind the work did not make the transcontinental jump to South Africa. The art that seemed most immediate and local dated from the early twentieth century, when there still seemed to be hope for political struggle rather than a world exhausted by war and failure. I remember thinking that one had to look backwards – even if quaintness was the price one paid.

C. Christov-Bakargiev *Ever since your early films, such as* Johannesburg, 2nd Greatest City After Paris *(1989), your work has addressed the nature of human emotion. Your films often evoke pathos through their imagery techniques (such as imperfect erasure), and classical or jazz soundtracks. They refer to the public sphere as well as to the intimately private. As Okwui Enwezor*[2] *has noted, they could be considered post-Holocaust works. The Frankfurt School theorist Theodor Adorno stated in 1949 that after Auschwitz there could be no more lyric poetry. You have stated, 'Alas, there is lyric poetry', because of the dulling of memory, which is both a failure and a blessing. What is this relationship between forgetting and remembering? Is there a connection between this retrieval from memory and the retrieval of a possibility for figurative art, after the non-figurative Conceptual and Minimal art of the 1960s and 1970s?*

William Kentridge Adorno's much-quoted proclamation[3] of the end of lyric poetry was directly followed by his assertion that literature must resist this verdict; that it was now in art alone that suffering could still find its voice, without immediately being betrayed by it. My statement meant something slightly different:

409

I referred to time's dulling of memory and intense passion. This allows other, less bleak, more lyrical moments to surface.

C. Christov-Bakargiev *Conceptual Art remained aloof to the human suffering related to the post-colonial era.*

William Kentridge An early nineteenth-century depiction of a foreign war seemed far more immediate and local in the South African context than contemporary Conceptual Art. Mid twentieth-century art, such as the work of the Abstract Expressionists, which tried to define a new language for a post-Holocaust world, seemed to me to be stuck in an abstractionist silence. Now I can understand its eloquence but it first appeared almost catatonic to me – an admission that the world is too hard to describe. I felt that description or evocation might be flawed, but its attempt was to be relished.

C. Christov-Bakargiev *By insisting that the language of the artwork was its content, conceptualist Joseph Kosuth could be said to have focused on the glass of the window rather than the view through it – if we were to use the classical description of painting as a 'window on the world'.*

William Kentridge I think the glass itself *is* interesting, but only for a few minutes. What is seen through the window is interesting for much longer. You can't have a *fin de siècle* introversion, closing out the world in the hope that what's outside the window will go away. There's a knowledge of the 'glass' through which you perceive the work, even if it's the projection screen. But it doesn't negate what is represented, nor that representation is possible.

C. Christov-Bakargiev *Do you feel there is also a relationship between your South African isolation from contemporary European and American art in your formative years and your adoption of a traditionally 'minor' art form, drawing, as your principal medium?*

William Kentridge Yes. I started off as a painter and continued for sixteen years, but I was in neither of the local art schools that taught traditional techniques of oil painting in a way that made you comfortable with the material. Nor was I in an intellectual space which could provide me with an understanding of what was really happening with painting in Europe or America.

C. Christov-Bakargiev *The avant-garde art in Europe and America during the 1960s and 1970s was rarely painting; it was installation, performance, body art.*

William Kentridge That's true, although I was completely unaware of this. I was familiar with Clement Greenberg's heroes: Larry Poons, Jules Olitski, Helen Frankenthaler; the New York School. Their non-figurative work looked so apolitical to me that painting seemed an impossible activity. When Robert Motherwell painted the series *Elegy to the Spanish Republic* (1953–54), I felt this was pure ideology. If you want a statement about the Spanish Civil War, look at Picasso's *Guernica* (1937). The Conceptual artists were even more removed; at the time I thought they were nuts. I preferred the theatrical madness of the Dada movement.

C. Christov-Bakargiev *Yet you were reading Adorno's work and other political and aesthetic writings of the Frankfurt School which influenced Conceptual Art.*

William Kentridge At the time I could not begin to connect these writings with contemporary art. I was intrigued by Joseph Beuys because my art teacher used to go to Documenta every five years and come back with reports of what he'd seen. But even Beuys' work seemed an indulgence from the vantage point of South Africa, where the political struggles were so serious.

C. Christov-Bakargiev *During the Soweto riots in 1976 over 700 people were killed. In the aftermath South Africa became progressively isolated from the international arena. Sanctions imposed by other states meant that artists could not participate in international exhibitions. A vivid art of denunciation developed in the country which came to be known as 'Resistance Art'. The 1980s were violent years; the first State of Emergency was proclaimed in 1985.*
What was your attitude towards politically engaged art? Is your love for Goya, Hogarth, Beckmann and Eisenstein an attempt to reinvigorate the socially critical tradition in Western art with new possibilities?

William Kentridge During the 1970s and 1980s I made some posters and drawings as well as theatre pieces, all of which I saw as acts of political opposition. More importantly, there were times when my own real anger formed the impetus behind particular works – and so became part of the process, without any expectation that the work itself would be an act of resistance. Since then the work has become more a reflection on the political world, in terms of the way it affects us personally, than an attempt to become part of it. A reference to Eisenstein does not convey a nostalgic yearning to be in Russia in 1924, but rather attempts to chart the connection between Eisenstein's imagery and the failure of his project.

C. Christov-Bakargiev *What kind of theatre were you involved with?*

William Kentridge It was simple agitprop theatre. I was neither an activist nor a politician. I was working with two theatre groups: one that consisted of students performing in ordinary theatres, and another that worked with trade unions, using plays to raise consciousness.
We would stage a play which showed domestic workers how badly they were being treated, implying that they should strike for equal rights. This would be presented in a hall with four thousand domestic workers. I remember standing at the back of the hall while a play was being performed. I had told the actors that if I couldn't hear them, I'd wave a shirt at the back as a cue for them to speak louder. I remember standing at the back waving the shirt frantically, hopelessly, while the play carried on regardless. I understood then that this work was about the actors' needs rather than its meaning for the audience. There was a false assumption about the public, in that we 'knew' what 'the people' needed, so I stopped my involvement with these groups. The early twentieth-century German Expressionists, such as Otto Dix and

Max Beckmann, as well as the early Soviet filmmakers and designers of propaganda posters, had a way of using their anger, drawing it quite directly; this corresponded to what I was feeling at the time.

In my work the vocabulary and the dramatis personae haven't changed so much, but there is no longer the triumphant ending that you see in the cinema of Eisenstein, for example. It's important that the endings of my films are less coherent, less definitive.

C. Christov-Bakargiev *You studied mime and theatre at the Ecole Jacques Lecoc in Paris from 1981 to 1982. This was followed by several years during which you stopped drawing and exhibiting, and became interested in filmmaking. How does this experience inform your later work as a visual artist? Your drawings are post-cinematic in a way; you often draw cinematic effects – such as close-ups or long-shots. First there was drawing, then filmmaking; then you began making drawings as they were part of the process of film itself.*

William Kentridge In the late 1970s I made a series of drawings in which the mise-en-scène was a three-walled pit, like a stage. The space had a single vanishing point. Then I tried to get away from this by having a single horizon line in the set of monoprints that followed (*Pit*, 1979). I understood that I was stuck in these two kinds of representation of space. In the early 1980s, for about four years, I had a block; I felt that I no longer knew what I was drawing or even how to draw. During that time I worked in the film industry as a kind of props designer. This showed me how it was possible to construct space and lighting at will, not trapped by Renaissance perspective and natural lighting. You can bring a lamp to light any section of the scene; you can pull a wall out, you can make a corridor that widens at one end, to get a greater sense of depth.

I'm more competent now at understanding how I can edit, with a close-up here or a linking scene there, but I sometimes wish I could reconstruct the absence of that knowledge. I suddenly wonder if I am just drawing a film, rather than constructing something out of drawing. Recent research claims that the eye sees as if through two simultaneous lenses: one part of our vision is like the wide-angle lens of a camera, while the centre of our field of vision is like a zoom lens. There's no cinematic lens that can do that. In film, you have physically to cut from a wide shot to a close-up to approximate how we see naturally.

C. Christov-Bakargiev *There is a strange inversion in your work. You represent landscape as a cultural construct and that distances it; you represent the body in a way that also shows it as a construct; you represent the story and distance it by making drawings based on film techniques, so that they themselves become objects of representation. What does it mean to use a pre-film technique to draw the way in which a film 'represents'?*

William Kentridge Photography has changed the way we represent the world, in art, from Degas onwards. There is a similar effect on representation after a century of film, and this relates to my interest in a less synchronic, more time-based art

practice. This also relates to the larger question of whether drawing can act as a metaphor for the way we think.

C. Christov-Bakargiev *You have collaborated with the Handspring Puppet Company since 1992, presenting both the puppets and their manipulators on the stage, alongside your animations. What led you to juxtapose your drawing and film with actors and puppets?*

William Kentridge Both the traces left on the drawings in the animated films and the double performance of manipulator and puppet in the theatre works were borne of unsolvable problems. When I began drawing, I tried very hard to make perfect erasures. I later understood that the traces left on the paper were integral to the drawing's meaning. In theatre, we first tried a number of ways of hiding the manipulators, behind screens or in shadow; it appeared to us as a failure that we couldn't hide them. It was only halfway through rehearsing the first of these collaborations, *Woyzeck on the Highveld* (1992), that we realized the visible manipulators were an asset. Their presence was central to the meaning of the work. It's like another way of drawing a character. Instead of a two-dimensional charcoal drawing working through time in a film, it's like a three-dimensional 'drawing' working through time in a play. The principle is that there's a double performance: you watch the actor and the puppet together. The process recalls Brechtian theatre: the actors focus on the puppets and the audience has a circular trajectory of vision from the puppets to the actors and back to itself. It's about the *unwilling* suspension of disbelief. In spite of knowing that the puppet is a piece of wood operated by an actor, you find yourself ascribing agency to it.

C. Christov-Bakargiev *Do you think this process has influenced your later method of layering in the drawings for films?*

William Kentridge In *Woyzeck on the Highveld* or *Faustus in Africa!* (1995), a different kind of drawing became both possible and necessary. There is a moment in *Faustus in Africa!* when everyone in the underworld goes through the old files of the dead. On the screen behind, you first see close-ups of names and then gradually the camera pulls back and you see an unending list of names. The only way to achieve this was to make a huge drawing consisting only of a list of names. I would never have made that drawing without the play, but as a drawing it's intriguing. Also, in theatre, I sometimes drew the thoughts of the characters and presented them as imagery on the screen backdrop. In later animated films, a whole world of people's thoughts came in.

C. Christov-Bakargiev *There's a constant and almost obsessive thematic reference in your works to the landscape in relation to the human body. For example, from* Johannesburg, 2nd Greatest City After Paris *to* Felix in Exile *(1994) your films deal with events in the urban public sphere, set in a confused and multi-perspectival wasteland of ecological and human disaster. Is there a relationship between exploring the landscape through drawing and retrieving the history through this process, a history that the landscape hides?*

William Kentridge First, the drawing doesn't begin as a moral project; it starts from the pleasure of putting charcoal marks on paper. You immediately see two things: a sheet of paper with charcoal dust across its surface, and the evocation of a landscape with a dark sky. There's a simple alchemy in the transformation of the paper into something else, just as there is in filmmaking or any mimetic work.

 This brings in its train a series of other connections to the outside world. You have a simple, schematic drawing which has three distinct levels of comprehension. The first level is the sensual pleasure of the charcoal, the blackness of its gleam. The second level is the evocation of a landscape, and the third level is the charcoal mark that can be read ambiguously – for example, a mark that could be read, say, as a monolith in the landscape. Built into the very immediacy of the drawing is both an evocation and a reflection or comment. Then, at the film stage, these drawings get rubbed out and altered. You have a sense of a process occurring on the paper.

 Very early on in the drawing there is a sense of the passage of time. The ethical or moral questions which are already in our heads seem to rise to the surface as a consequence of this process. Initially I just wanted to draw landscapes, then I realized that the drawings, in themselves, evoked these larger questions.

C. Christov-Bakargiev *You once mentioned to me a book of European landscape paintings that your grandfather gave you as a child.*

William Kentridge Yes. I felt that the landscape around me was a lie, as if I had been cheated. Rather than growing up thinking that these green hills in that book were a fiction, I believed they were real. The South African landscape wasn't less real; it was more like a disaster zone. When I first started drawing I depicted the local landscapes I knew, rather than those utopian, lush landscapes far away.

C. Christov-Bakargiev *Later, in your* Colonial Landscapes *(1995–96), you do use that kind of lush, foreign imagery. These drawings of yours refer to early colonial illustrations which catered to European audiences who wanted scenic paintings of distant, exotic lands.*

William Kentridge Yes, but these were nostalgic visions of how people wished a new world could be made; my drawings suggest how this was not possible.

C. Christov-Bakargiev *The red pastel surveyors' marks on your black charcoal drawings indicate how the colonial images were like projections onto the land. By observing the landscape itself you discover things you wouldn't normally notice: for example that a hill is really an artificial mound left over from a mining dump.*

William Kentridge Compared with drawing a mountain created over time by movements of the earth's surface, there's something more direct about drawing a culvert or ditch that wasn't there a hundred years ago, the trace of some activity that has passed. I had to become aware of the cultural, social constructions of European man before I could draw the South African landscape.

C. Christov-Bakargiev *Pathos and pathology seem linked in your work: medical and psychoanalytic metaphors abound. There is a relationship between studying the body as an object and reconstructing the psychological history of a patient's illnesses. The anatomy theatres of the early sixteenth century have been seen as an emblem of the birth of modernity. The stage set for your opera* Il Ritorno d'Ulisse *(1998) is based on an anatomy theatre. How does the observation of the body enter into your imaginary?*

William Kentridge I am generally more interested in representations of anatomy than in anatomy itself. Our greatest knowledge of the body is not through the body itself but through its representation. You can understand more from an MRI scan of the brain than from looking at the brain itself. There's an irreducibility of our mind's otherness, and drawings of the body allude to this.

C. Christov-Bakargiev *In your recent work intimacy takes precedence over the 'external' events.*

William Kentridge All my work is part of a single project; I don't see a great shift. In *Il Ritorno d'Ulisse* I was looking at the body as a metaphor for our relationship to memory and the unconscious, acknowledging that there are things happening under the surface, which we hope will be well contained by our skin. We hope that our skin will not erupt, that parts of us will not collapse inside. The body in this sense is other to us; we shepherd it along like an ox, hoping it will come quietly to market and not run away. In recent works such as *Stereoscope* I'm interested in the co-existence of all those contradictory strands, and what it means to synthesize them into one subjectivity.

C. Christov-Bakargiev *There's a great sense of pain on the individual level: the loss of the self as it tries to bring these strands together.*

William Kentridge Yes, *Stereoscope* is about the cost of trying to bring these disparate parts of oneself together.

C. Christov-Bakargiev *How does one synthesize many contradictory selves into one subjectivity, in an age when the exploration of borderline situations, uncertainty and fragmentation, has become the dominant model, for example in post-feminist and post-colonial theory?* Stereoscope *marks a feeling of doubt about the positive value of dispersed, multiple identities. The other side of the coin is an increasingly dislocated, diasporic world culture, with countless uprooted and suffering people.*

William Kentridge *WEIGHING … and WANTING* and *Stereoscope* ask how to maintain a sense of both contradictory and complementary parallel parts of oneself. Since James Joyce there has always been in modernist writing the notion of a stream of consciousness – floating connections rather than a programmed, clear progression. What I'm interested in is a kind of multi-layered highway of consciousness, where one lane has one thought but driving up behind and overtaking it is a completely different thought.

It's a particularly South African phenomenon of the late 1980s and 1990s to have contradictory thoughts running in tandem. You had people rebuilding

their homes while simultaneously planning to emigrate. These contradictions work at an internal level in terms of the different views one has of oneself from one moment to the next. I was interested in mapping out that process, to see what would arise. In *Stereoscope* the central character, Soho Eckstein, is split into two, like the two images you have in nineteenth-century stereoscopic photographs. The two Sohos combine to make one stereoscopic image. They seem identical but sometimes get out of sync.

While I'm making my work, the larger questions about cultural paradigms are not in my mind. Mine is a desperate sort of naturalism. I question the cost and pain engendered by self-multiplicity. Pieces are not just dispersed all over the landscape.

When I draw the character Soho in his two rooms, it's not to say that this is how the world is constructed, and for others to be made wiser by this revelation. For me it's to understand the double vision represented by these two rooms. There's a kind of madness that arises from living in two worlds. Life becomes a collection of contradictory elements. Somehow this state is not so terrible or strange when it's named, fixed through its representation.

C. Christov-Bakargiev *Early in 1996 the Truth and Reconciliation Commission began as a series of public hearings broadcast on national television. Agents and victims of human rights violations perpetrated under apartheid testified before a national forum. Perpetrators of abuse were offered possible amnesty in exchange for testimony. The main objective was to create a context through which national healing was made possible. The video projection* Ubu Tells the Truth *(1997) and the play* Ubu and the Truth Commission *(1997) layer South African realities with Alfred Jarry's grotesque portrayal, in his* Ubu *plays of the 1890s, of the way in which arbitrary power engenders madness. The installation seems more open-ended: less clear who the 'bad guys' and 'good guys' are.*

William Kentridge When I made the series of eight etchings *Ubu Tells the Truth* (1996–97), which initiated the play and installation in the following year, I wanted to draw a version of the character Ubu which was different from Jarry's. I first had the idea of a schematic drawing of Ubu, in Jarry's style, with a moustache and a pointed head, wearing a robe with a huge spiral on it, but I didn't want a pastiche. I had the idea of someone in front of this figure drawn in a different style. I would draw this other figure as a naked man. Then I wondered whether to base this figure on the naked figures in Eadweard Muybridge's *Animal Locomotion* (1887), who were often in ridiculous, bombastic poses. Finally I decided I might as well enact those poses myself. I placed the camera, with a self-timer, on one side of the studio, and I performed Ubu in front of the blackboard. I was not thinking of those images as myself at all; they were the poses that Ubu needed.

When I made the video installation I assumed that people who had seen the play would have no interest in the installation because there's no new material. In the play he shows a different kind of anarchy, madness and

illogicality to the installation, but it needs the hour and a half of the play's duration for that to be extricated. The installation demonstrates that anarchy through the very impossibility of connecting the fragments of the piece. What is the significance of a cat that suddenly becomes a radio? In the play it's easier to understand: you see it as the drunken thoughts of Ubu. Here you almost have to become Ubu yourself to understand that this is a world where successive waves of violence or craziness follow each other. If you're watching something that's eight minutes long, as you do in the video installation, this kind of extreme open-endedness is fine. If you're watching for an hour and a half, you keep on wanting a structure that makes sense.

C. Christov-Bakargiev *How do all the machines of communication depicted in your work fit into this?*

William Kentridge They often indicate what needs to be heard or seen, outside of oneself. I draw megaphones because they're so beautifully painted in Beckmann, or because they appear, for example, in photographs of Italian Futurist concertos for factory workers. I feel I'm part of earlier heroic attempts at connecting the world with art.

C. Christov-Bakargiev *There is also the image of the camera in your drawings, which transforms into a police helicopter or a surveillance eye.*

William Kentridge There's a range of associations around the camera as an instrument of control, scrutiny, recording and memory. It's a rich emblem. But I couldn't tell you if, in the film *Ubu Tells the Truth*, when Ubu turns into a camera, he is photographing himself. Is it some god-like body or conscience photographing him to judge him? All I can say is that during a Truth and Reconciliation Commission hearing of one of the South African police, part of the evidence presented was home movies of murders, which the police had filmed themselves. Were those policemen filming this out of a crazed sadism? Were they doing it thinking that, if they were charged they could prove that others were also involved? Were they perversely acting as documentary photographers? That ambiguity is echoed in what the image might be doing in the film. The story of how those police came to have those home movies somehow confirms the figure of Ubu turning into a camera.

C. Christov-Bakargiev *Although stemming from the Truth and Reconciliation Commission, guilt does not seem to enter the Ubu works. On the other hand, the character Soho Eckstein in* History of the Main Complaint *(1996) explores his personal responsibility in horrific events. Lying in a coma in hospital he relives two incidents: first he is driving and witnesses a man being beaten in the middle of the road; next he is driving when a man suddenly runs in front of his car and is killed.*
 Is recognition of one's indirect guilt enough?

William Kentridge I don't know; that's a moral or ethical question. The film asks how you map the effects of guilt. For me the film was about trying to be as accurate as possible.

C. Christov-Bakargiev *In some ways ethics is the object of your art – or maybe its subject.*

William Kentridge I hate the idea that my work has a clear, moral high ground from which it judges and surveys. To put it blandly, my work is about a process of drawing that tries to find a way through the space between what we know and what we see.

 The drawings attempt to map things which normally one just talks about. For example, if you have a notion of two rooms, one room full of secrets, the other an empty room of truths – how can you draw these two spaces? We have a certain sense of ourselves that derives from our surface, our skin. So much of the history of Western art consists of representations of the surface, yet there's the whole other side of us, our interior. We hope that the engineering inside us will work, day after day, year after year.

C. Christov-Bakargiev *Your work explores the borders between these states: between memory and amnesia, drawing and erasure. The process of re-drawing and erasure means that each drawing is poised in a state of uncertainty. Each stage of the drawing carries with it the visual memory of its recent past. This suggests a view of knowledge as constantly negotiated between the present and memory, as if forgetting and remembering were not distinct moments, but overlapping. Does that have a political implication?*

William Kentridge I think it has more to do with the personal, psychological structure of my way of working in the world. It's a position I would defend as a polemic for a kind of uncertainty.

C. Christov-Bakargiev *What are the political implications of the cultural and moral relativism you seem to be describing?*

William Kentridge I don't think it's relativism. To say that one needs art, or politics, that incorporate ambiguity and contradiction is not to say that one then stops recognizing and condemning things as evil. However, it might stop one being so utterly convinced of the certainty of one's own solutions. There needs to be a strong understanding of fallibility and how the very act of certainty or authoritativeness can bring disasters.

C. Christov-Bakargiev *The international recognition your art has received in the mid 1990s has run parallel to an emerging consciousness of multiculturalism and debate around the issues of 'otherness': local and global; centre and periphery. The roots of today's debate are the post-war narratives of national liberation that emerged at the close of colonialism as well as feminist discourse in the 1970s and 1980s.*

 Your cultural formation, like that of most white South Africans, was centred on the validity of European culture. Yet the process-oriented and narrative quality of your work recalls some forms of African story-telling. Is your work a cultural hybrid? In what sense is it international? This meant something specific at the beginning of the twentieth century, as a reaction to nineteenth-century nationalism; then it meant something else in the 1960s: a utopian ideal of multidimensional, universal creativity. What might it mean to you now, as you exhibit on the circuit of international group exhibitions and biennials?

William Kentridge Many international shows, such as the Venice Biennale, are really about nationalism. I like, however, the fact that someone, say, from Romania can see one of our South African-based plays at a theatre in Germany and feel that the play could almost be about Romania. This is something I understood most clearly in the work of Goya. The specificity of what he drew gave his work its authority, for example in the *Disasters of War* etchings (c.1810–15). In my work, to take an example, the idiosyncracies of the witnesses' evidence in *Ubu and the Truth Commission* are what make people connect to its narratives. The more general it becomes, the less it works.

C. Christov-Bakargiev *Our initial discussion about representation and language, and the notion that the language of the art can be both the object and the subject of the work, in a way was founded on a notion that we must be international, as if there were a kind of Ur-language or way of thinking.*

William Kentridge But if you don't know the local references you don't get them. In the animation for *Ubu and the Truth Commission* there's an image of a pig's head wearing a Walkman that suddenly explodes. Many viewers don't know that this is based on South African police photographs of experiments testing a Walkman booby trap on a pig's head, which were used as evidence in the Truth and Reconciliation Commission. There is also an image of a body exploding and turning into a constellation. This comes from another action by the police that was called 'Buddha' for some reason. They would take people whom they had killed and blow up the corpses. They would collect the pieces and blow them up again, and again, until no recognizable fragments remained. You may not know these facts, but nevertheless would be able to sense in these images the background of horrific violence. If you stick closely enough to specifics – which are usually stranger than fiction – somehow that authenticity will convince an audience, bring them along with you.

C. Christov-Bakargiev *Nineteenth-century realist painting was based on similar convictions.*

William Kentridge My conviction in realism stems from an awareness of the limits of my visual imagination.

C. Christov-Bakargiev *So although you said at the beginning of this interview that for you drawing can become a self-centred process, drawing does not justify itself per se.*

William Kentridge No, but I believe that in the indeterminacy of drawing, the contingent way that images arrive in the work, lies some kind of model of how we live our lives. The activity of drawing is a way of trying to understand who we are or how we operate in the world. It is in the strangeness of the activity itself that can be detected judgement, ethics and morality. Trains of thought that seem to be going somewhere but can't quite be brought to a conclusion. If there were to be a very clear ethical or moral summing-up in my work, it would have a false authority.

C. Christov-Bakargiev Is there anything you'd like to add?

William Kentridge Before I'm shot? No.

1 William Kentridge is the grandson of three prominent attorneys and son of one of South Africa's most
 distinguished anti-apartheid lawyers, Sydney Kentridge
2 Okwui Enwezor was Artistic Director of the Johannesburg Biennial, 1997
3 Theodor Adorno, 'Cultural Criticism and Society' (1949), *Prisms*, MIT Press, Cambridge, Massachusetts, 1981, p. 34

Yayoi Kusama *Akira Tatehata*

in conversation
July 1999, Tokyo

Akira Tatehata Ms Kusama, after many years of being viewed as a kind of heretic, you are finally gaining a central status in the history of postwar art. You are a magnificent outsider yet you played a crucial, pioneering role at a time when vital changes and innovations were taking place in the field of art.

During 1998–99 a major retrospective exhibition of your early work ('Love Forever: Yayoi Kusama, 1958–1968') toured major museums in the United States and Japan. How did you feel when you looked at your past works again?

Yayoi Kusama Well … if I were not Kusama, I would say she is a good artist. I'd think she is outstanding.

Akira Tatehata However, you had to fight one difficult battle after another before you came to this point.

Yayoi Kusama Yes, it was hard. But I kept at it and I am now at an age that I never imagined I would reach. I think my time, that is the time remaining before I pass away, won't be long. Then, what shall I leave to posterity? I have to do my very best, because I made many detours at various junctures.

Akira Tatehata Detours? You may have experienced hardships, but I don't think you wasted your time. You have never stopped working.

Yayoi Kusama I have never thought of that.

Akira Tatehata And each one of your battles that you fought at each stage of your life was inevitable. In fact, you yourself jumped into them.

Yayoi Kusama Yes, like the Happenings I staged in New York.

Akira Tatehata First of all, I would like to ask you about the period when you were in Japan before going to the US. You went to New York at twenty-seven. By then, you must have already developed your own world as a painter.

Yayoi Kusama Yes.

Akira Tatehata Your self-formation was grounded in Japan. Still, you did not flaunt your identity as a Japanese artist.

Yayoi Kusama I was never conscious of it. The art world in Japan ostracized me for my mental illness. That is why I decided to leave Japan and fight in New York.

Akira Tatehata In any case, while in Japan you had already produced numerous works, most of which were drawings. It is true that in your encounter with New York's atmosphere your work flourished, beginning with the spectacular large-scale canvases such as your Infinity Net paintings of the late 1950s and early 1960s. Still, the nets and dots that dominate your early New York works are clearly prefigured in the small drawings you made before your move to America. These nets and dots are predicated on a technique of simple, mechanical repetition; yet, in a sense, they also epitomize hallucinatory visions. At that time, were you interested in Surrealism?

Yayoi Kusama I had nothing to do with Surrealism. I painted only as I wished.

Akira Tatehata *I once wrote that Kusama was an 'autonomous' Surrealist; which is to say that without you having had any direct knowledge of the Surrealist movement, the outbursts from your singular, fantastic world characteristically appeared to converge with the world of the Surrealists. To put it another way, André Breton and his colleagues began this movement by methodologically legitimizing the world of those who possessed unusual visions such as yours.*

Yayoi Kusama Nowadays, some people in New York call me a 'Surrealist-Pop' artist. I do not care for this kind of labelling. At one time, I was considered to share the sensibility of the monochrome painters of the early 1960s; at another time I was regarded as a Surrealist. People are confused and don't know how to understand me. Regardless, some want to call me a Surrealist, trying to pull me to their side, others want me in the camp of Minimal Art, pushing me in the other direction. For example, Henk Peeters, an ex-member of the European Zero group, came to the opening reception of my exhibition at The Museum of Modern Art, New York in 1998. He phoned his former Zero Group colleagues all over the world and told them to come and see my show; but I had no special relationship with Zero. All I did was do what I liked.

Akira Tatehata *You haven't thought much about 'isms', have you?*

Yayoi Kusama Nil.

Akira Tatehata *Yet people try to attach these labels to you.*

Yayoi Kusama Since I rely on my own interior imagination, I am not concerned with whatever they want to say about me.

Akira Tatehata *Another question I have is: why did you go to America in 1958, particularly after you had gained admission to the Académie de la Grande Chaumière in Paris?*

Yayoi Kusama I chose America because of my connections. Besides, I believed the future lay in New York. However, I had a hard time due to the restrictions imposed on foreign exchange by the Japanese government. I even sold my *furisode* [long-sleeved kimonos with sumptuous designs]. Georgia O'Keeffe, with whom I had corresponded since before my arrival in the US, was so worried that she invited me to come to her place, offering to take care of me. But I remained in New York, in a studio with broken windows at the junction of Broadway and 12th Street.

Akira Tatehata *Did the various art scenes in New York excite you?*

Yayoi Kusama The first thing I did in New York was to climb up the Empire State Building and survey the city. I aspired to grab everything that went on in the city and become a star.

At the time, New York was inhabited by some 3,000 adherents of action painting. I paid no attention to them, because it was no use doing the same thing. As you said, I am in my heart an outsider.

Akira Tatehata Are you self-conscious at being an outsider?

Yayoi Kusama Yes, I am.

Akira Tatehata To you, 'outsider' must be a word of pride; to me, you are no mere outsider. It feels odd
to say this in front of the artist herself, but Kusama can be considered as an artist
who, seriously engaged with the art of her time, has been situated at the centre of
the unfolding of art history, like Van Gogh. Mere outsiders could not change history.

Yayoi Kusama I had no time to dwell on which school or group I belonged to. Van Gogh
would have thought little of schools when he was painting. I cannot imagine
how I will be classified after my death. It feels good to be an outsider.

Akira Tatehata Still, you had certain exchanges with other artists.

Yayoi Kusama Yes. Lucio Fontana, for example, in Europe. I made some of my works at
his place and he helped me with my exhibitions. Our contact lasted until his
death in 1968. I borrowed $600 from him to have the mirror balls (*Narcissus
Garden*) fabricated for the Venice Biennale in 1966. He died before I could
pay him back. He spoke highly of my work; he was very kind to me. He was
like that, encouraging the development of younger artists. His work is also
wonderful, both his painting and sculpture.

Akira Tatehata And in New York?

Yayoi Kusama I was close to Joseph Cornell for ten years. He developed an obsession for me.
When I first visited him he was dressed in a ripped sweater. I was very scared,
I thought I was seeing a ghost. He had such an extraordinary appearance, and
he lived like a hermit. He was unusual as an artist. He, too, was an outsider.

Akira Tatehata How about Donald Judd?

Yayoi Kusama My first boyfriend. I met him in the early 1960s, when he was very poor. He
was studying at Columbia University and had just begun writing criticism
for *Art News* and *Arts Magazine*.

Akira Tatehata He made a very accurate observation of your work. As a formalist, he keenly
discerned the spatial essence of your Infinity Net *paintings – their stratified
structure and oscillating sensation.*

Yayoi Kusama Judd was a theorist. Simply put, he could not make an ordinary kind of work.
In a sense, half of his work at that time was my making. He once griped,
'What shall I do now? I am at a loss.' I responded, 'This, this is it,' kicking
a square box that we had picked up somewhere and turned into our table.
That gave him a hint for his box pieces. We were both extremely poor. As
I recall, an armchair that became one of my *Accumulation* pieces was also
scavenged from somewhere by him. He helped me make the stuffed phalluses
from bed linen.

 Later I moved to a larger studio, separated from Judd. Larry Rivers and
John Chamberlain lived upstairs; On Kawara was across the hall from

Chamberlain. One day I was struck by fear while I was standing in the building. I cried out: 'I'm scared. Somebody, please come.' There came Mr Kawara: 'Don't worry. No need to be scared, I am with you.' He lay down with me. There was no sex but we held each other naked. He helped calm down my attack. My attacks became so severe that an ambulance came every night. At the hospital they recommended I see a psychoanalyst.

Akira Tatehata *What was your problem?*

Yayoi Kusama Depersonalization. Everything I looked at became utterly remote.

Akira Tatehata *Did you have the same problem while in Japan?*

Yayoi Kusama Yes. When I was a child, my mother did not know I was sick. So she hit me, smacked me, for she thought I was saying crazy things. She abused me so badly – nowadays, she would be put in jail. She would lock me in a storehouse, without any meals, for as long as half a day. She had no knowledge of children's mental illness.

Akira Tatehata *How long did your hallucinations persist?*

Yayoi Kusama I still have them.

Akira Tatehata *Is your work a kind of art therapy?*

Yayoi Kusama It's a self-therapy.

Akira Tatehata *Is it fair to say that you make your work in order to gain spiritual stability and release yourself from psychosomatic anxiety?*

Yayoi Kusama Yes. That is why I am not concerned with Surrealism, Pop Art, Minimal Art, or whatever. I am so absorbed in living my life.

Akira Tatehata *I interpret your dot motifs as representing a hallucinatory vision. In your experience, just as attacks of depersonalization bring you a vision of fear, so do these dots. Proliferating dots append themselves to scenes around you. You attempt to flee from psychic obsession by choosing to paint the very vision of fear, from which one would ordinarily avert one's eyes …*

Yayoi Kusama I paint them in quantity; in doing so, I try to escape.

Akira Tatehata *You have also described this process as a 'self-obliteration' into a world suffused with dots. Salvation through self-obliteration.*

Yayoi Kusama I was so desperate that I made my art during hallucinations. When I was studying *Nihonga* ('Japanese-style painting' that employs traditional glue-based mineral pigments) in Kyoto, I would go out in the rain to practise Zen, wearing only a T-shirt. I would meditate in the mud in a heavy downpour, go home when the sun came out, and pour icy water over my head. I could not work otherwise.

In some ways, my New York years were no different.

Akira Tatehata Is the imagery of phallus-covered furniture related to your hallucinations?

Yayoi Kusama It is not my hallucinations but my will.

Akira Tatehata Your will to cover the space of your life with phalluses?

Yayoi Kusama Yes, because I am afraid of them. It's a 'sex obsession'.

Akira Tatehata Still, these works motivated by your interior necessity are considered to be precursors of Minimal and Pop Art. Although what people say may be of no concern to you, it is a fact in terms of chronology. Art historically, your work of the late 1950s and early 1960s was contemporary with that of the Zero and Nul Groups and what became known as the New Tendency in Europe, with its emphasis on monochrome works.

Yayoi Kusama In 1960 one of my *Infinity Net* paintings, *Composition* (1959), was included in Udo Kultermann's exhibition 'Monochrome Malerei' at the Städtisches Museum in Leverkusen, Germany. Mark Rothko and myself were the only two artists from America invited to participate. I made an inquiry as to why and how I was chosen and learned that the curator saw an article in *Arts Magazine* that discussed my work as black-and-white painting. It was on this basis that Kultermann initially contacted me.

Akira Tatehata You yourself did not think that you were making monochrome works?

Yayoi Kusama No. People made it up after the fact. My *Infinity Net* paintings and *Accumulation* works had different origins from the European monochrome works. They were about an obsession: infinite repetition. In the 1960s, I said: 'I feel as if I were driving on the highways or carried on a conveyor belt without ending until my death. This is like continuing to drink thousands of cups of coffee or eating thousands of feet of macaroni … I am deeply terrified by the obsessions crawling over my body, whether they come from within me or from outside. I fluctuate between feelings of reality and unreality.'[1]

Akira Tatehata Your obsession with repetition signals both desire and the need to escape. However, you also added: 'In the gap between people and the strange jungle of civilized society lie many psychosomatic problems. I am deeply interested in the background of problems involved in the relationship of people and society. My artistic expressions always grow from the aggregation of these.'[2]

Yayoi Kusama Yes.

Akira Tatehata When I say you are no mere outsider, this is not an unfounded opinion that I made up. All the more because you are an actual person who breathes the same air as we do, you were able to exert a tremendous influence.

Yayoi Kusama …

Akira Tatehata For example, you challenged the authorities of the time, as in your guerrilla event at the Venice Biennale in 1963.

Yayoi Kusama Yes, what was most important about *Narcissus Garden* at Venice was my action of selling the mirror balls on the site, as if I were selling hot dogs or ice cream cones. I sold the balls from *Narcissus Garden* at $2 each. This action was done in the same spirit as my nude Happenings.

Akira Tatehata *So, in an explicit challenge to the authorities, you not only exhibited but also put your work on sale outside the Italian Pavilion – until the organizers of the Biennale stopped you. I have to confess, however, that I was mesmerized by the installation itself of* Narcissus Garden, *which was re-created for your retrospective in 1998–99, especially when it was displayed outdoors at the Los Angeles County Museum of Art. It radiated a beautiful, almost sanctuary-like, light.*

* The Rockefeller Garden at The Museum of Modern Art in New York, where you staged one of your later guerrilla nude Happenings (*Grand Orgy to Awaken the Dead, *1969), was at the very centre of all the American art institutions. You chose your sites very pointedly.*

Yayoi Kusama In the Rockefeller Garden I did body painting while my models fucked a bronze sculpture by Maillol.

Akira Tatehata *Although many of your Happenings bore social messages, people tended to see them as scandals. Sacred scandals, I would say in retrospect. Did you from the beginning plan to incite a scandal or was it an unexpected result?*

Yayoi Kusama It was not intentional. Whatever I did tended to become a scandal or a piece of gossip.

Akira Tatehata *When we think about it, these scandalous Happenings differ a great deal from your lonely toil in the studio. Whereas in your Happenings you were the leader of many participating people, in your studio you spent endless time alone, painting the* Infinity Net *works. It was a monotonous, solitary act.*

* What inspired you to change your* modus operandi, *from the interiorized self-salvation of your early New York days to an anti-establishment, anti-institutional provocation that directly engaged society?*

Yayoi Kusama Since people in New York were so conservative, so narrow-minded about sex, I wanted to overturn the conventions through my demonstrations. I organized several political Happenings involving national flags. One Happening was staged in front of the United Nations building in 1968 when the Soviet troops invaded Czechoslovakia. I washed a Soviet flag with soap, because the Soviet Union was dirty.

Akira Tatehata *Among your oeuvre, politically and socially oriented works were concentrated in the brief period of the late 1960s. You did little work of this kind before or after this period.*

Yayoi Kusama At the end of the 1960s I did think of continuing, somehow, in this direction. I was planning a Broadway musical entitled *Tokyo Lee Story*. The protagonist,

Tokyo Lee, was me. Rocky Aoki and I attempted to set up a fund-raising company. We lined up the actors and stagehands, but then, in late 1969, I became sick again. So I saw a doctor, who said that it was nothing. The psychiatrists I saw were in my opinion a mess, with their heads muddied and brainwashed by Freud. For me, they were useless clinically. I frequented them, but my illness remained as debilitating as ever. It was a waste of time. They were antiquated Freudians. All I needed from them was a piece of information about how to cure myself, which they never gave me. As they asked, I recounted to them, 'My mother did this to me, did that to me.' The more I talked, the more haunting the original impression became.

Akira Tatehata *They didn't save you but prompted your memory to recover?*

Yayoi Kusama My memory became clearer and clearer, larger and larger, and I felt worse and worse.

Akira Tatehata *Towards the end of the 1960s you also founded a fashion company, which marketed radically avant-garde clothes. It was a part of your art project.*

Yayoi Kusama Walking on the streets, I noticed many people who wore clothes which were very similar to my designs. After some investigation I identified a company called Marcstrate Fashions, Inc., which manufactured them. I met with the company's President, showed him a trunkful of my designs, and told him that his products were all imitations of my ideas. He said, 'Oh, you are ahead of me, I didn't realize.' Then he and I decided to make a company that specialized in my line. It was an officially incorporated company. He was Vice President and I was President.

Akira Tatehata *What was it called?*

Yayoi Kusama Yayoi Kusama Fashion Company. The mass media reported about us big time. We did fashion shows and had a Kusama corner at department stores. Buyers from big department stores came and selected 100 of this, 200 of that, although they only bought the more conservative styles. The radical vanguard items that I poured my energy into sold little in the end.

Akira Tatehata *In the 1970s you returned, or rather moved your activities, to Japan.*

Yayoi Kusama I came back to Japan to have surgery. I had a foot problem. A doctor in New York didn't even give me a blood test, didn't know what was wrong.

Akira Tatehata *The first time I saw your work was at Nishimura Gallery in Tokyo, where you showed your collages in 1975, soon after your return. I was much moved by the mysteriousness of your singular, fantastic world. The commonly held opinion in Japan was that Kusama had returned a loser from New York. That was completely blown away when I saw your work. It was then that I made it my curator's mission to have society rediscover this genius. It is humbling how long it has taken to realize this goal.*
 By the way, I wonder why your works made in New York and in Tokyo are

so different? I don't mean to suggest that one is better or worse than the other. The same can be said of your early Japanese work before you went to America.

Yayoi Kusama Originally, I didn't have enough space in Japan to make large works.

Akira Tatehata In addition to the issue of scale, your New York work feels drier and more inorganic, whereas your Japanese work is – though I am concerned that my expression may be misleading – more literary. That is the kind of difference I have in my mind.

Yayoi Kusama I could not survive in New York otherwise. You cannot live there with a lyrical frame of mind.

Akira Tatehata When you came back to Japan the fantastic and lyrical aspect of your work that characterized the pre-New York works re-emerged. It is interesting that your work after New York grew increasingly younger. Your fantastic vision is beautiful yet macabre. Your New York works exude an awe-inspiring sense of scale, with literary qualities eradicated. Presenting an intensified vision marked by materiality, they have their virtue. However, when you came back to Japan, another aspect of your work emerged.

Yayoi Kusama A reverse side, so to speak.
 It is as if another person surfaces, to complement my personality. If New York is the front side, Japan is the back.

Akira Tatehata If so, even works by an outsider artist like yourself are differently affected by their surrounding environments: New York versus Tokyo and Japan.

Yayoi Kusama It's true. In Japan, I write poetry. In New York, there was no mood for poetry; every day was a struggle with the outside world. It's hell for a woman to live alone there. For example, one day when I returned to my studio I found all my belongings had been stolen; I saw my paintings suddenly appear in junk shops.

Akira Tatehata You produced no literary or poetic work in New York. Certainly New York is a theme in your works of literature but these were all written in Japan. You have published fifteen volumes of novels since your return to Japan.

Yayoi Kusama I also wrote and composed songs.

Akira Tatehata Composition as well?

Yayoi Kusama Yes. I bought a piano.

Akira Tatehata Did you sing them?

Yayoi Kusama Not in public, but I sing them at home. One is called 'Song of a Manhattan Suicide Addict' (1974). It goes like this:

> *Swallow antidepressants and it will be gone*
> *Tear down the gate of hallucinations*
> *Amidst the agony of flowers, the present never ends*

At the stairs to heaven, my heart expires in their tenderness
Calling from the sky, doubtless, transparent in its shade of blue
Embraced with the shadow of illusion
Cumulonimbi arise
Sounds of tears, shed upon eating the colour of cotton rose
I become a stone
Not in time eternal
But in the present that transpires

Akira Tatehata *This is included in your anthology of poetry,* Kakunaru urei *(Such a Sorrow, 1989). Your word images are piercing. Your novels received high praise from the reputable novelist Kenji Nakagami and one of them won you a literary award for emerging writers.*

Yayoi Kusama He was very supportive. It is truly a great loss that he died young.

Akira Tatehata *For you, what is the relationship between art and literature? Do they share anything or are they totally different?*

Yayoi Kusama Different.

Akira Tatehata *Do you consider writing as a means of self-salvation?*

Yayoi Kusama No, poetry is not about self-salvation.

Akira Tatehata *You mean poetry is differently motivated than art?*

Yayoi Kusama That is correct. When I was writing poetry in the 1970s, I was very
depressed. I was on the verge of committing suicide, constantly.
I consulted with a doctor in Tokyo and was advised that hospitalization
was necessary.

Akira Tatehata *I have one more question that will probably bore you.*
In recent art criticism and scholarship, there is a distinct tendency to honour
you as a great forerunner of feminist art, to interpret your work within the history
of feminist struggles.

Yayoi Kusama I am too busy with myself to worry about a man-woman problem. Since
I find a refuge in my work, I cannot be bullied by men.

Akira Tatehata *However, would you say that those who wish are free to render a feminist*
interpretation of you?

Yayoi Kusama Yes. Although I have never thought of feminism. In my childhood, I
experienced so much hardship, all thanks to 'feminism'. My mother wielded
a tremendous amount of authority and my father was always dispirited.

Akira Tatehata *Your family was a matriarchy, with your mother at the centre.*

Yayoi Kusama She turned the entire household into her own castle. Her children had no
meaning other than as existences subordinate to hers. She was smart and very

strong. She was also good at painting and calligraphy. She was a valedictorian at her school. My father was dominated by her, which he disliked. He customarily went out, he was absent at home. Yet he was a very kind father.

Akira Tatehata *Psychoanalysts would have a lot to say on the subject – citing the Electra complex among other things. However, feminist discussion of your work has produced certain interpretations that cannot be ignored. Indeed your phallus-covered high-heeled shoes, handbags and dresses are potent fetishes.*

Your work also merits a formalist analysis, as articulated by Donald Judd, for example, and furthermore it has the impact, which we have discussed, of art that comes from an outsider. You are at once part of the New York scene and closely connected to the European trends of the 1960s. You are regarded as a progenitor of feminist and issue-oriented art. Your work allows all these inherently contradictory discourses, yet departs from them all. You are an artist outside the given boundaries. It may take a little more time to comprehend the whole body of your work.

Yayoi Kusama I have had so many hardships, with people saying various things about me. Time is finally turning a kind eye on me. But it barely matters, for I am dashing into the future.

Translated from Japanese by Reiko Tomii

1 Interview prepared for WABC radio, New York by Gordon Brown, executive editor of *Art Voices*; first published in *De nieuwe stijl/The New Style: Werk van de internationale avant-garde*, Vol. 1, De Bezige Bij, Amsterdam, 1965, pp. 163–64
2 Ibid., p. 164

Robert Mangold *Sylvia Plimack Mangold*

in conversation
October 1997, New York

Sylvia Plimack Mangold *I would like to start by discussing how your experience with New York School abstraction affected your work. My education began in New York City, and this kind of painting was the prevailing atmosphere there, but your education began in Cleveland …*

Robert Mangold I am sure our experiences were quite different. When I first saw Abstract Expressionism in 1958–59, I was dumbfounded. It was not abstracted nature or designed abstraction, it was not playful. I felt I was in the presence of a different kind of picture-making, and I did not understand it. It was very powerful emotionally to me; it wasn't a picture in the way I knew a picture to be.

Sylvia Plimack Mangold *What was it about Abstract Expressionism that affected you? And which of the Abstract Expressionist artists did you feel most connected to?*

Robert Mangold The work was liberating because it suddenly presented to me the idea that abstraction could make this very direct statement to your emotions, to your sensibility, to your mind. I did not respond to the artists equally or simultaneously, but I felt I had to paint like them in order to process their work. Mark Rothko and Adolph Gottlieb became early influences, Clyfford Still and Barnett Newman followed.

I remember my first contact with a Rothko at the Albright-Knox Art Gallery in Buffalo (New York). I was studying at the Cleveland Institute of Art and would visit the Albright-Knox on my trips home. The Albright-Knox at this time, the late 1950s, was acquiring a great collection of Abstract Expressionism.

I saw a Rothko painting, *Orange and Yellow* (1956), big enough to blanket you physically when you were close to it. You could bathe in the light-colour. Viewing this work was like a spiritual moment; I was stunned by this painting, and yet the paint was so thinly applied – barely there. For me these experiences made me realize what painting's unique reality was: neither object nor window. It existed in the space in between.

The other artist from this generation whose work has affected me profoundly and continuously is Barnett Newman. My initial experience with Newman's work, when I felt this grand sense of union with his work, was in 1961, while we were students at Yale. You remember, we went to the Guggenheim Museum to see an exhibition called 'American Abstract Expressionists and Imagists' and in the large room just at the top of the first ramp, facing out as you approached, was *Onement VI* (1953). It was extraordinary, an immense blue field with a single vertical band in the centre.

I could not get enough of that painting; I barely remember anything else there.

Sylvia Plimack Mangold *What art has had a strong influence on your thinking since Abstract Expressionism?*

Robert Mangold You know, all of it influences your thinking somehow. But, of the many movements in the 1960s – aside from Minimal Art – Pop Art had an

influence on me, as did Conceptual Art. They both helped me shape my work, but I soon distanced myself from them.

I think that in many ways I learned by testing things out: you only find out if a coat fits by trying it on. I did not know where I was headed in my work; in testing things out I could at least sense what I did not want to do, and narrow my focus.

The work of many of my friends and contemporaries has been a source of inspiration and measurement. Some of these artists fall under the loose heading of Minimal Art; others, like yourself, do not. In watching the unfolding of their work I see that the decisions they made have been remarkable.

Sylvia Plimack Mangold *Do you think an experience of painting can be likened to a spiritual experience? Do you want your work to impart a contemplative mood?*

Robert Mangold There are many kinds of 'painting experiences', and we encounter all of them on various levels. The kind of experience I described with a particular Rothko or Newman, or for that matter a particular Piero della Francesca or mosaic, seems to take things to a higher level. I am not sure 'spiritual' is such a good word because of its associations with religious experience. I am referring instead to the very personal, intense relationship you can have with a work.

I am not sure I want the work to provide a contemplative mood either; rather I want the work to cause me to drop everything and then slowly pick up the pieces and enter into a dialogue with it.

I am not very involved in the process of painting. I know many artists are, and it is this process, this involvement in the making, that is most powerful to them. The work is the reminder, the result of this activity. For me the 'painting' is the only element, not as an object but as a work whose 'thingness' is secondary to the seeing-viewing-experiencing – which takes time.

Sylvia Plimack Mangold *When you were younger, your interest was intensely focused on the contemporary art scene. In recent years you have been more inspired by images or objects from the past, like Greek vase painting or Egyptian bas-relief, or fifteenth-century Italian fresco painting. How do you regard this shift of interest and appreciation?*

Robert Mangold As a young artist I was engaged in a particular moment in history. It was a germinal moment, and I was shaped by its forces and the particular situation of 1960s New York. Prior movements and artists had set that situation; my task as an artist was to find a way to make relevant work in their aftermath. I could either deal with what had been already brought to the table, or I could clear everything off and redefine what painting could be for me. I tried to work with a clear table.

Besides this external situation, an artist has internal needs and the work must fortify these. Perhaps the internal becomes clearer over time. In my case, as time goes by there is a looser connection between myself and any new historical moments – or lack of them. The work simply progresses, moves on

and finds curious linkages with the past and other cultural situations which hopefully enrich the work. I see this as the benefit of 'letting go of the moment'.

The Yale Museum has a great collection of early Italian panel paintings. When I was a student there I must have seen them regularly, but they had no effect on me; I had no use for them. In later years when I rediscovered them I felt an immediate connection and I could not believe that I had ignored them initially.

It was many years before I found ways of connecting to all art of the past, or art before Cézanne. I did not feel in the painting of the nineteenth century and earlier the direct connection I felt with contemporary painting.

Sylvia Plimack Mangold *Seventeenth- and eighteenth-century painting too? Velázquez, Goya, Rembrandt, Titian …*

Robert Mangold It's not that I cannot respond to the great works by these painters, but the kind of direct connection that I felt for some contemporary painting was not there.

Now, when we went to Italy in the mid 1970s, and I saw the frescoes of Giotto, Piero and others, as well as pre-Renaissance panel painting, I felt a sudden closeness to this work that I had not felt with other historic painting. My connection to past art was there; I just had not gone back in history far enough. My interest in painting diminishes with the rise of oil paint and frames.

Sylvia Plimack Mangold *When I see fresco painting, I concentrate on how the forms are painted, while you look at the shape.*

Robert Mangold Yes, it is very interesting to me that up until the Renaissance, shape played a strong, even symbolic, role in painting. As painting gradually became more of a window onto some other reality, shape tended to defeat or contradict the illusion. Shape is the first element in my work; I would not say that it is the most important, but everything starts there.

When I am in one of the great, fresco-covered churches, I have a harder time dealing with the frescoes themselves. It is very difficult to get close enough to have a one-to-one relationship: they are so connected to the whole environment. The shape of the work is welded to the structure of the building.

I like being able to stand in front of a painting and have this direct experience of looking and responding. You know the three versions Matisse did for *La Danse*? These works are very important to me, but I have only ever seen them separated from their real, very particular architectural situations. Maybe if I went to see the final mural in its true architectural site it would be disappointing for me.

I am not so interested in the story a painting might be telling but the fact that the idea of a painting can be a carrier of something else. It can communicate directly to me, the viewer – not a particular emotion, although the emotions are involved – and I can be part of this dialogue. This is the mysterious, wonderful thing about painting.

Sylvia Plimack Mangold *It's a different feeling than what you have watching a sad movie. It's about a transformation of some kind; it's suggesting that you see something differently than how you've seen it before. It doesn't have to be provocative, but it affects your vision.*

Robert Mangold It affects your state of mind.

Sylvia Plimack Mangold *It has an impact …*

Robert Mangold It has an impact that stays with you. I think I am very selective in what I enjoy and really feel excited about. When these experiences happen they are treasured. I recognize value and I am interested in many kinds of work, but there is that special pleasure that I get from certain artworks.

Sylvia Plimack Mangold *I think an artist has to be narrow and stubborn enough to say, I only want to deal with this, and I don't want to deal with that. Even if everyone likes it, it just isn't useful for me.*

Robert Mangold I agree.

Sylvia Plimack Mangold *I would like to discuss the relationship of serial work to editing and the use of a system for conceiving of a work of art. Do you think of your work in groups or in series? What sort of system do you have for arriving at the differences between works produced at roughly the same time?*

Robert Mangold I have probably muddied the group-series idea myself by using the words loosely. I rarely conceive of a single work; I usually approach an idea again and again, and what came out of this is a group of related works.

From roughly 1968 to 1970 I worked with a more rigid serial intent, in that I conceived ideas – the *W, V, X Series* (1968–69), for instance – that attempted to work out all the possibilities of a given idea. The entire series could be visualized from the outset, but working this way became an uncomfortable fit.

In 1971 I went back to the idea of making works that were part of a family of similar works, which is to say I made variations on an idea, and I am still working this way. For me it is a more natural way to work; the group of works end when I feel that further variations are unnecessary, or when the particular idea is complete enough for me – not because a particular system or series has been exhausted.

In 1990 I started what I sensed would be a group of paintings. After completing five or six of them, I became aware of a relationship between these works and Greek (Attic) vase painting, and I called the group of works I was working on the *Attic Series* (1990–91). In the end I completed eighteen large-sized works.

I called them a series not because they explored all the possible permutations of the given idea, but because in my mind the idea developed as I progressed. The order in which they were done was particularly important.

For every group of works a set of rules emerges that I maintain throughout,

for instance a group of paintings I did in 1972, all titled *Distorted Circles within a Polygon*. From the titles – and I most often use descriptive titles for this reason – we know the shape will be a polygon and inside will be a distorted circle. Aside from this, there is an additional constant – the curved form inside will touch at the centre of each side edge of the polygon.

I make these rules that govern a group of works; I want these constants around which variations can occur. You might ask, 'What if you came up with an idea that violated your rules, but one that you liked very much?' In that case there would likely be a new group of works with amended or new rules.

I think that the work itself generates more work; the work itself suggests possibilities. It's funny that I often talk about the work as though it were something someone else did, separate from me. And in a way it seems that way to me.

Sylvia Plimack Mangold How can the work be separate from you?

Robert Mangold It can't, in fact, because I make it. And how can you have a dialogue with yourself – maybe this is, in truth, what it is. The point is, I have an idea for a work, and the completion of that work sets into rhythm possibilities for several other works. The fact that the work exists allows me to study it, and allows other works to be suggested. New work comes from the earlier work, and my exchanges with it.

Sylvia Plimack Mangold Do you think that your kind of abstraction is a construction of the mind and reflects internal considerations which are essentially emotional?

Robert Mangold I am stuck on your phrase, 'your kind of abstraction'. What is my kind of abstraction? I do not automatically feel closer to an abstract painting than I do to a figurative one. It has more to do with how the painting is built, the structure.

Sylvia Plimack Mangold How is it if I say 'your kind of painting'?

Robert Mangold Yes, well I am not trying to be difficult, but I don't have a clear idea in my mind when someone says that. So, as you say, the work is a 'construction of the mind', with an emotional, internal source: I guess I would agree with that. However, even though my work does not have this direct dialogue with observable nature, this does not mean that the work is totally self-contained. I feel that in each work another kind of dialogue exists, a dialogue with the history of art, a dialogue with the present moment, a dialogue with my earlier work. For me these visual and mental connections become part of the work. Perhaps this is not unlike the way a filmmaker will make a subtle homage to an earlier film within a new film.

Sylvia Plimack Mangold In my view there is a distinction between painting that relies on the physical world for its imagery and work that doesn't. Your physical world, 'your kind of painting', consists of your materials and the surface on which you paint. These have a reality and a presence, and this presence is not disguised as something else.

Robert Mangold I think this is correct. I want the work to be directly in front of you, something that is blocking your mental and physical path. You can size it up and walk away, but you can't see it as a recording or a translation of what is already in the world. On the other hand, there are similarities. I have an idea, reinforced by drawings and studies, that I am trying to realize.

Sylvia Plimack Mangold *You say that your work is not essentially emotional, although its reason for existence is probably emotional. Is it essentially interactive? That is, interactive between the elements of line, colour, shape/edge, and interactive between your work and the work of the past and present. Would you say that your work probably has an emotional reason for its existence?*

Robert Mangold I think that is a good way to describe it. I always use the word 'dialogue' in relation to the work, but 'interactive' is perhaps a clearer way to describe it.

Let me go back to emotions. I am not trying to deny the role of emotion when I am planning the painting and then working on it, or when I or someone else is viewing it. However, I do not think of the final work as essentially emotional; I also see it as logical and reasoned.

Sylvia Plimack Mangold *There are certain colours that repeat themselves in your work year after year. The sort of reddish burnt sienna colour in this painting right here,* Red-Orange/Gray Zone Painting A *(1998), is a little bit like the colour in* Red Wall *(1965). You've done certain green paintings, you've done that certain kind of red painting. You often use red and green together, and orange.*

Robert Mangold I tend to return to similar colours. They are mostly mixtures, as I seldom use colour full strength and straight from the bottle. They are modified in one way or another so that they have a slightly muted feel. One of the elements that I work with in the painting is line, and for the line to be seen and to have equal strength in the work there is a kind of balance that you have to have between the colour and the line. And then there are certain colours that I seem to prefer. We have often joked about doing an all-red show, covering years of work.

Sylvia Plimack Mangold *How do you decide whether colour is 'tasteful' or not? Sometimes the work is aggressive in choice of colour, sometimes it is very subtle. Do you want to have that range?*

Robert Mangold Colour plays a functional role in the work. Most often I am thinking about how it will work in a specific situation. When a canvas's shape is more dramatic, a stronger colour might be called for. Also, because one work follows another, one colour follows another; a new choice is affected by the previous choices.

I try not to think about tasteful or not tasteful. I remember when I was working on the *W, V, X Series* I lifted colours – a kind of pumpkin orange, a forest green and a blue – from a fabric store window display on the Lower East Side of New York, near where we lived. I thought they were OK, but

when they were exhibited people talked about their extraordinary beauty, and in truth they were beautiful. But so much for taste! I am always asked about 'Mangold colour'; maybe it's a reality, I really don't know. It seems to me that I use a full range of colours, not a small palette.

Sylvia Plimack Mangold *I think you have a certain way of using colour that is distinctive. It's not Matisse colour, it's not like any of your contemporaries whom I can think of. Actually, if anything, it's your perverseness, your avoidance of looking like anyone else. If you found yourself using a colour that would be associated with someone else, you would change it.*

Robert Mangold Not necessarily. Sometimes I'll be working on a painting and it will remind me of someone. I'll think, didn't Newman do a painting with a green and grey similar to this? I doubt that I would change it, because I have this strong connection to Newman's work. But if the colour connects to work that I don't like, it would bother me and I would change it.

In the late 1960s and 1970s, I used denser pigment, but also lighter ones, more greyed down, so that it was more of an opaque surface. The earlier spray paintings from the early 1960s tended to be a little bit thin, but there were transitions in the colour. Later, when I started using acrylic paint, and putting it on with a roller – which must have been 1968 or 1969 – I tended to use it (and sometimes still do) in a couple of coats. It was pretty opaque. Later, and particularly in the last few years, I liked using much more transparent colour so that you kind of see through it. It isn't as opaque a surface.

Sylvia Plimack Mangold *One of the interesting things in your work is this subtlety of yours. You create these very interesting yet almost imperceptible relationships in the painting.*

Robert Mangold I like the idea of something happening in a painting that you don't see right away. A lot of the distorted paintings that I did in the early 1970s were based on something that looked like a perfect circle even when it was a distorted circle. If someone looks at the painting and sees that the square and the circle don't fit, then he or she has to think about it and figure out what is off. They'd have to spend time and look to see it. I think that often people look too quickly.

Sylvia Plimack Mangold *There are certain artists whose audience is educated towards the subtle qualities.*

Robert Mangold In other words, the audience is looking for them. But I think it's better if you don't tell people what to look for; I think it's better if they discover it. I don't give them, as you might say, little entry areas. I don't give the viewer a lot of help.

Christian Marclay *Kim Gordon*

in conversation
December 2003, New York

Kim Gordon *When you were young, did you have a relationship with records?*

Christian Marclay No, not much actually.

Kim Gordon *I only ask because when I was little I was obsessed with my dad's record collection. He had jazz records. I'd pick them out and lay them in a row and make a story out of the covers.*

Christian Marclay Did you listen to them?

Kim Gordon *Yes, I listened to them too.*

Christian Marclay My family wasn't very musical. My parents had this great-looking Braun turntable, and a bunch of Christmas records and a few show tunes that my mother brought back from the States. My father never really listened to music, so I didn't grow up listening to it much. Maybe that explains the freedom I have with records. I didn't collect and obsess over vinyl when I was a teenager. I was shocked when I first saw thrift stores filled with records. Thrift stores were a big deal for me when I first came to the States. I bought everything from thrift stores, and it was an incredible source for really cheap vinyl. Before that, the record was something I was taught to respect and preserve. But in the States everything was about consumption and I was reacting to that as well. I was also attracted to all the album covers – such an amazing variety. Now this is an obsolete art form, but there was so much creativity in the design of those 12-inch squares.

Kim Gordon *I know, I'm sort of sad that my daughter's not going to have that record experience.*

Christian Marclay She's probably disgusted because Thurston [Moore, husband and fellow member of Sonic Youth] is such a collector.

Kim Gordon *We joke that when she's a teenager she's going to be selling his records.*

Christian Marclay At least she knows what they are. Some kids don't even know what records are.

Kim Gordon *That's true. Did you see that show I curated, the 'Record Cover Show'?*

Christian Marclay I don't think so.

Kim Gordon *I asked artists to do record covers.*

Christian Marclay When was that?

Kim Gordon *In 1983 or 1984, at White Columns on Spring Street.*

Christian Marclay I don't remember the show. You asked artists to design covers?

Kim Gordon *Yes, just any cover. It was very open. I thought the record cover was such a good format. It didn't even have to be a square.*

Christian Marclay I wish I'd seen it.

Kim Gordon *Your work manifests itself through music and sound and it's all about that, but to me, you're such a consummate visual artist. You have so many more influences than those of a visual artist; influences that are more than just post-Conceptual ideas. I'd never think of myself as a musician, because of my training as an artist. In some of your interviews you say the same thing. And because you can go and look at The Who or Sid Vicious and make an analogy to something in the art world, you're also a visual thinker.*

Christian Marclay It's my background. I went to art school, not to music school. I don't think like a musician.

Kim Gordon *Someone like Thurston, who grew up listening to every lyric on every record, has studied rock and roll in the same way you studied visual art. I've realized that I'll never relate to music or write music or lyrics with the same intensity that makes me angry or passionate or excited about visual art. But I see it in Thurston and other people like Jim [O'Rourke, fellow member of Sonic Youth], who grew up thinking about music in that way.*

Christian Marclay Thurston looks at pop music through a literary interest, through poetry and writing, from the point of view of the words. For me, lyrics have always been a totally abstract thing, because when I listened to pop music while growing up in Switzerland my English wasn't good enough. So I've never listened to pop music with a focus on the words.

Kim Gordon *Was it more the attitude and the intonation?*

Christian Marclay And the sound. There are many people in Europe who grew up listening to British or American pop songs and never understood the lyrics well. But it didn't matter: the music had meaning, even though I know the words are so important. Rap is even harder to understand because it contains a lot of slang that I'm not familiar with, or different accents. I tend to listen to the textures, the samples used, the more unusual the better. Very often, there's this language barrier. For example, I listen to a lot of Brazilian music and don't understand the words. Listening to lyrics in French is more natural for me.

It's interesting that you have the same kind of relationship to lyrics as I do, that they're not always so crucial. I'm surprised, especially because you sing. Which dominates in your mind when you create a song, the music or the lyrics?

Kim Gordon *The lyric ideas come from the music, or the mood of the music, but sometimes I'll just try and write conversationally. Or I have a bunch of lines, and then when I actually do a vocal take, I just try different stuff; sometimes meaning comes out when you juxtapose words or lines. It's more what goes with the voice. I've learned what works best for me because I'm not a natural singer or a trained singer.*

Christian Marclay With my first band, 'The Bachelors, even', I wrote the lyrics first. I was a terrible singer. When my mother heard that I was singing in a band she said, 'That's not possible! He never even whistled in the shower.' So it wasn't something that came naturally. I was watching this documentary that Yoko

Ono did on John Lennon's recording sessions for the album *Imagine*. They're in this house with the famous white room and white piano, and the camera follows him around. He was such a ham; he loved the camera. He was constantly clowning around and I was amazed by how it just seemed so natural for him to sing and write music. Some people are born performers, born with that talent. I don't have it; I never had, although I've always had a secret desire to play music.

Kim Gordon *But that's a different kind of music. I mean look at Yoko Ono – how ineffective she is in the pop music realm, and yet she's a really interesting artist.*

Christian Marclay She is a trained musician though. In the film, she gives her input during the recording.

Kim Gordon *She's a trained opera singer, but not as a pop artist – even though some of her lyrics, her feminist lyrics, were definitely ahead of their time.*

Christian Marclay I love her hardcore vocalizations.

Kim Gordon *Yes, and her films.*

Christian Marclay She is a great artist, but people don't talk enough about her work in terms of this crossover between art and music. She's really an under-recognized precursor, an early Conceptual artist. I'm sure she had a great influence on John Lennon and The Beatles in the way they presented themselves. Their visual style was certainly influenced by her ideas. I don't think the *White Album*, for example, could have existed without her art interest.

Kim Gordon *I think she had the distinct disadvantage of having come out of Fluxus, one of the most obscure art movements ever.*

Christian Marclay It didn't help her reputation. In fact, when you think of it, the *White Album* is a perfect crossover object, a mix of pop music, Pop Art and Fluxus: a cross between a Richard Hamilton and a Fluxus edition.

Kim Gordon *To go back to the point I was making earlier about people like Pete Townsend and Sid Vicious – the whole notion of the physical/visceral aspect that so enhanced rock and roll, which clearly influenced not only you but other young composers like Glenn [Branca] and Rhys [Chatham] – there was something going on that they wanted to inject into new music. A lot of it has to do with sexuality, which is the one element that in art you're not really supposed to see in a direct way.*

Christian Marclay While pop music always had sex.

Kim Gordon *But not composer music. And art is never about that. It's about ideas, it's all intellectual. It's all in your head. Have you thought about that as a challenge, or an interest?*

Christian Marclay I've never identified with serious music – contemporary classical music or whatever – because it's a language I can't express myself in. I can't read or

write music. The first thing that had a creative impact on me was not this kind of music, though Cage and Fluxus were influential. It was the Sex Pistols and DNA – the really raw energy of punk. It was more than just music; it was very physical. It's not music that translates well on recordings, because being there, the loudness, being part of the event and the performance was really important. I was more interested in the process.

Kim Gordon *Were you ever interested in Jack Goldstein?*

Christian Marclay Yes, I knew the records and the films.

Kim Gordon *He's the first person I saw coming out of Conceptual Art who bridged the generation of the 1960s and 1970s – people like Dan Graham, Michael Asher and Vito Acconci – and the younger 1980s artists who started to bring in elements of pop culture and also Expressionism. Jack's work took a more structuralist approach, and injected pop forms in – things that were not associated with Minimalism.*

Christian Marclay Yes, that was in the air, and had a huge influence on the whole group of artists associated with Artists Space and Metro Pictures in the early 1980s: Cindy Sherman, Robert Longo, Sherrie Levine and Richard Prince. These artists reworked pop culture. For me it was like taking the Conceptual Art motto of Douglas Huebler, 'The world is full of objects, more or less interesting; I do not wish to add any more', and using it towards a different end – like a Pop artist gone Conceptual.

Kim Gordon *Right, it wasn't so pure.*

Christian Marclay And music was the perfect antidote to making objects.

Kim Gordon *There was room for sexuality and attitude.*

Christian Marclay It seemed like there were so many things happening in the 1980s that revolved around the body. Performance art was really important at the time, if you remember. Artists were always looking for places to do performances, and those places were not the museums because they weren't quite ready for it. They'd take place in music clubs, in abandoned buildings, wherever. The punks were piercing their bodies, abusing them with drugs. At the same time the gay culture became really visible and the male body became more sexualized. And then there was the AIDS crisis. The body was very present in that context. It wasn't just about concepts.

Kim Gordon *There was the humour of it too, people like John Baldessari and the influence of Marcel Duchamp.*

Christian Marclay Yes, Duchamp was someone I was interested in. I was always more into Conceptual Art and ideas. I discovered Baldessari much later, and again, he had a Pop quality. I also always liked the Nouveau Realistes, the French Pop artists like Martial Raysse, Jacques Villeglé, Nikki de Saint-Phalle.

When I was much younger I loved Pop Art. This idea that anything can be art, I first learned not directly from Duchamp but from the Pop artists. And then the whole movement of performance art opened the right doors. When I was first in New York I saw a lot of performances. You and I first met in 1980 during the Eventworks festival, which I organized in Boston; I wanted to show the relationship between punk and performance art. I invited Dan Graham and he did this performance with a girl band, with you, and Miranda Stanton and …

Kim Gordon Christine [Hahn]. She was with The Static.

Christian Marclay I invited Dan after seeing him perform at the Mudd Club. He was walking around on stage with a mike, asking people to relax (*laughs*), talking to the audience in a monotone voice. It was a strange contrast to this punk audience on speed. Most of the bands that I invited had some background in art schools, you know, like DNA, Z'ev …

Kim Gordon And filmmakers like Eric Mitchell.

Christian Marclay Yes, and Vivienne Dick, Beth and Scott B. There were all these films being made, low-budget productions, a lot of people making Super-8 films. There was also an interesting kind of crossover going on between film and rock music – and this was before MTV existed. I curated the festival because I wanted to show all the different manifestations of this crossover, to show the influence that music had on the arts.

I was a student at the Massachusetts College of Art in Boston, and in 1977 I came to New York on an exchange programme to The Cooper Union. I was there for one semester, but I found this cheap apartment, so I stayed in New York for the whole year. Then I went back to finish my BA at Mass Art and I had this idea for the festival, to show what I'd discovered in New York. It was the first time that DNA played in Boston, and the first time that Boyd Rice played on the East Coast, as well as Johanna Went. I wanted Vito Acconci to do something, because for me Vito is a key figure in this crossover. He's not an obvious crossover artist, but I felt his work and attitude were very connected to rock and roll. I asked him if he wanted to come and do a lecture on the subject of his relation to rock music. He said 'yes', and then cancelled at the last minute; I was really disappointed. I still think he should do it one day. His word pieces were written like rock songs. He liked rock music, and I'd seen him in clubs.

Kim Gordon I don't remember ever seeing Vito at clubs. Dan Graham was always there.

Christian Marclay I remember seeing Vito at Tier .

Kim Gordon Dan had one of the first stereo cassette players, and he recorded all these shows. It was an insanely large machine! But I remember I always heard of Vito as this rock and roller, in terms of his work.

Christian Marclay The ranting on some of his early tapes, and his use of the body, made me link him to punk rock. There was a natural connection.

Kim Gordon *Well, he definitely had the fearless bravado, especially compared with someone like Dan, who's more cerebral, conceptual. But Vito – like Chris Burden and Bruce Nauman – had more obvious emotional manipulations going on.*

Christian Marclay But Dan is dealing with the relationship between audience and performer.

Kim Gordon *Yes, the time delay between the camera and the mirrors. It's very psychological, but in a different way. Aesthetically, it looks like Minimal Art, which is the difference. It's loaded with other things.*

Christian Marclay His performances were a cross between a lecture and a performance. It wasn't always clear what he was doing – sculpture, performance and lecture all in one. New York was a really fertile environment; I got so much out of being there at the time. To be exposed firsthand to it was exciting. You could go out and see so many kinds of activities that didn't take place in museums and galleries, but in clubs.

Kim Gordon *I don't know how many conversations I had with Rhys [Chatham] about the difference between playing in clubs and art spaces. It was an ongoing conversation. Rock spaces are expressly made for music, but they aren't really … you know, they're made for the performer and the audience. The situation is always unclear. That definitely adds an exciting element to the work, and the context is going to change the perception of whatever you do. That was always interesting.*

Christian Marclay What do you think of what's going on now in terms of the relationship between art and music?

Kim Gordon *I think it's a really great time for music, especially underground music, experimental music. People talk a lot about the revival of New York music with these well-known bands like the Yeah Yeah Yeahs and Interpol and Liars. But there's this whole other sub-genre of experimental noise music going on that's so interesting, like the Double Leopards. It's really all about the small events and little gestures. Everything's so commercial now in New York, but for some reason music is still very uncommercial. It's still very pervasive, and it's never quite gone away.*

Christian Marclay I don't think it's just happening in New York.

Kim Gordon *Absolutely; it's everywhere right now.*

Christian Marclay It's so easy to make music today. The tools are more accessible. Everybody has access to equipment. It was rare that anybody had equipment in the 1980s, but now everything is much easier. Computer technology facilitates things a lot and everything is very portable. I'm sure there's a lot of stuff that we're not even aware of being made in people's bedrooms.

Kim Gordon *You seem to do two different kinds of work. The* Guitar Drag *(2000) piece is probably the most extreme, creating this whole other sound from the destroying of a guitar. And also, it alludes to the killing of James Byrd. Was there something about the guitar that stood for white male rock?*

Christian Marclay The piece is charged with so many layers. At first I was ambivalent about responding directly to a race crime. There was something almost indecent about recreating this kind of violence, especially for a white artist. But because the video is also about so many other things, I felt I could do it. I never stress the connection with James Byrd, Jr. over other links, such as the rock-and-roll tradition of guitar smashing, or the destruction of instruments in Fluxus. It's as much about all these things as it was about a desire to create a new type of sound. The variety of interpretations is what makes the piece successful. I'm always interested in the different reactions to the piece.

Kim Gordon *Will it be available to buy as a DVD?*

Christian Marclay No, it's an installation. To make a DVD would take something away from the piece. It has to be a projection, it has to be loud, it has to be experienced in a black box where you can lose track of time and space, lose your balance. The image is jerky and you may get dizzy. It has to be a physical experience; you need to feel it through your body. It's not a pleasant experience, though some people are exhilarated by the sound, its rock quality. If you could watch it at home on your little monitor with a bad sound system, then you'd be missing a lot. It needs a certain scale. But I have agreed to release the soundtrack on vinyl. At first I was reluctant to put it out on a record because of this reduction aspect, but being on a record will allow the piece to be more musical and also to reach a different audience, a music audience. There'll be a picture on the cover. I hope it'll make people think about the process. The guitar is the icon of rock and roll, it epitomizes this music, and there's something so American about it. It's an American invention. But now rock and roll is becoming nostalgia for the baby boomers.

Kim Gordon *To me, your most interesting work is the most simple, like* Record Without a Cover *(1985). That's so brilliant and it's such a simple gesture, yet it works on so many different levels. You've done lots of pieces like that. Often, an artist will have only one idea and base a whole career on it. You're one of the few I know who can go between the music world and the visual art world and be equally respected. There aren't really many others, possibly Michael Snow. There's a certain tradition, but it seems to be much more visually oriented. A true crossover is very rare.*

Christian Marclay I don't like repeating myself. I'm lucky that I have more than one interest. I can make some music when I'm not inspired to make sculpture; I can shift worlds. It's refreshing. Right now, I'd like to make more music, but in a different way, without necessarily using records. I try to find new methods to challenge myself musically, like *Graffiti Composition* (1996), or *Guitar Drag* and *Video Quartet* (2002). Video allows me to work with sound and

image simultaneously. Working with video and doing a live performance are two very different things; video is more like recording. Performing is great, because it's all about the moment, and that's what I like.

Kim Gordon *Have you ever thought about working with a record lathe? I know you use a lot of found objects, but working with a lathe would introduce another aspect.*

Christian Marclay Yes, actually, I did this gig in Geneva last September at the Festival de la Bâtie. I collaborated with Flo Kaufmann, a technician who's been collecting old lathe-cutting machines. In the 1990s many record companies got rid of their record-making equipment, but as the demand for vinyl came back with the alternative dance music, there was a need for someone who could repair this obsolete technology. Flo, who lives in Switzerland, is now an expert, and he goes around the world to repair these amazing machines. They're massive and very heavy. So for this gig, he brought his lathe on a truck. I came with three turntables and no records, a very light set-up for me. He joined me on stage with his lathe. I created a collection of sounds on the spot with the turntables, using no records. I started with loud feedback, swinging a turntable with the volume cranked up in front of the monitor, and making all kinds of sounds, tapping and rubbing the tone arm, and banging the casing. Simultaneously, Flo was cutting these sounds on an acetate. Then he handed me the first disc and I started manipulating it, playing it at different speeds, scratching, and that was cut on a second acetate. So for an hour it went on like this, back and forth, creating new sounds and new discs, composing a piece out of nothing.

Kim Gordon *I can see how it would add a whole other element of physicality to the performance.*

Christian Marclay It was a lot of fun. We're doing it again in Bern this summer. It was so liberating to come to a gig with no records, just creating the records on the spot, and reworking the sounds again, like a loop constantly evolving, being recycled.

Christian Marclay

Record Without a Cover 1985
Vinyl record
⌀ 30.5 cm

William Kentridge

Drawing for **Johannesburg, 2nd Greatest City after Paris** 1989
16mm animated film, transferred to video and laser disc, 8 mins., 2 secs., colour
Soundtrack: Duke Ellington; choral music

Collections, Chicago Institute of Art; Johannesburg Art Gallery; Tate Gallery, London; Art Gallery of Western Australia, Perth; Carnegie Art Museum, Pittsburgh; National Museum of African Art, Smithsonian Institution, Washington DC

William Kentridge

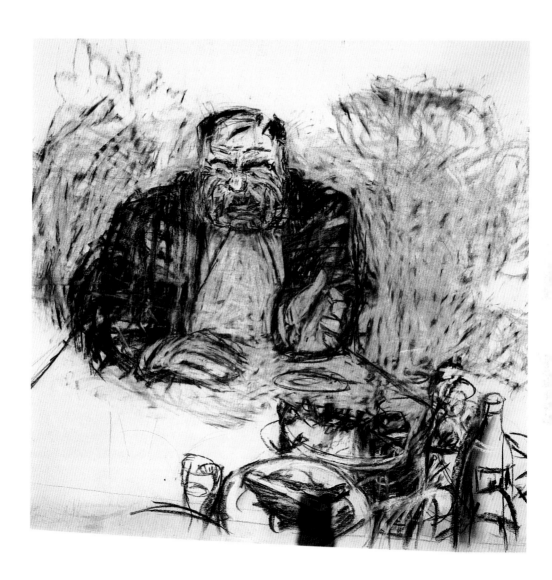

Stereoscope 1999
35mm animated film, transferred to
video and laser disc, 8 mins., 22 secs.,
colour
Soundtrack: Score, Philip Miller;
sound design, Wilbert Schübel

Yayoi Kusama

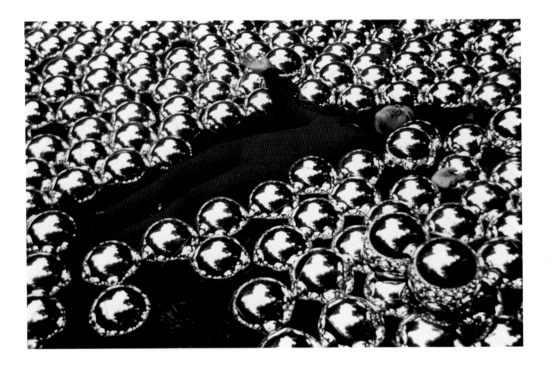

Narcissus Garden 1966
1,500 balls, ⌀ 20cm each
Installation, 33rd Venice Biennale

Yayoi Kusama

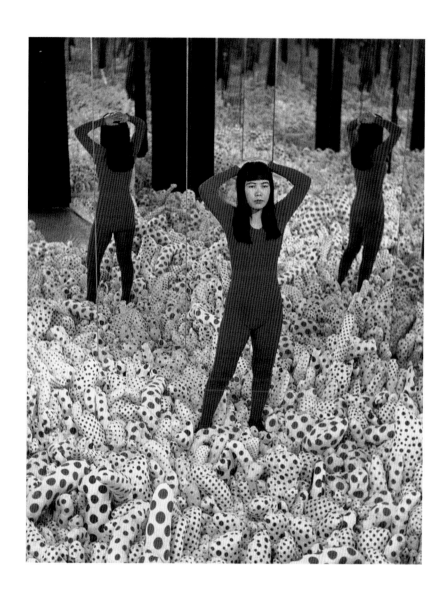

Infinity Mirror Room (Phalli's Field)
1965
Sewn, stuffed fabric, mirrors
360 × 360 × 324 cm each
Installation, 'Floor Show', Castellane
Gallery, New York

Robert Mangold

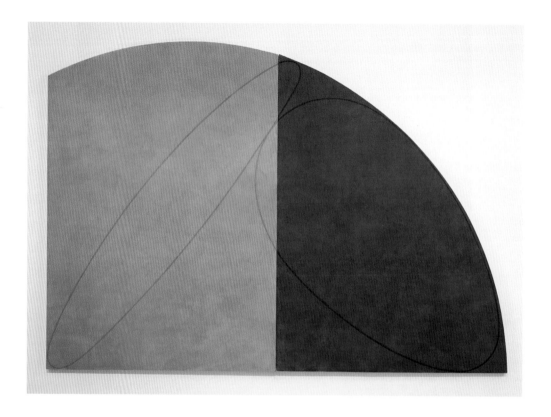

Curved Plane / Figure IV 1995
Acrylic and black pencil on canvas
248.9 × 362.6 cm

Robert Mangold

Red Wall 1965
Oil on masonite
244 × 244 cm

Paul McCarthy

**Pinocchio Pipenose
Householddilemma** 1994
Performance video still
Wood, paint, table, plastic dishes,
assorted food, stuffed toys,
Pinocchio costume, latex mask

Bossy Burger 1991
Performance video, installation,
Rosamund Felsen Gallery, Los Angeles
and Luhring Augustine, New York
Barbecued turkey leg, television stage
set, bowls, cooking utensils, chair,
counter, milk, flour, ketchup,
mayonnaise, dolls, chef costume, mask

Paul McCarthy *Kristine Stiles*

in phone conversation
February 1996

Paul McCarthy I started making videotapes in the early 1970s. The first ones were around perception and illusion. The camera was upside down, or I'd use mirrors, things like that. But I also started making pieces that were performances in the sense that I would be in front of the camera. I would work in the studio primarily by myself with the camera. There was not much in the room. I would do some things and record them. They were often repetitious and intuitive. *Ma Bell* (1971) was one of the first actions that I did which involved liquids, in this case, motor oil. I had not planned to make the piece. It was spontaneous. It was the first tape where there was a persona.

Kristine Stiles *This aspect of performance is illusive. For although the actions are experiential and being produced for sensations, they are also part of the object being made. What does it mean that an action is equally an object? You arrive at 'something' that you've been waiting and looking for – but also not waiting for (because you have also just been doing actions for the sake of the action itself) – and you then try to recover it by recording it.*

Paul McCarthy In those situations, I would most likely work in the studio alone. There wasn't much else in the room, maybe a few objects that would become props for a tape. I would begin the actions. I would try a number of things and it might take a minute to recognize something in it. All of a sudden I would key in on what it was, or I would recognize something in it. I was pretty aware that I was actively trying to find something, to put something on the videotape machine.

I was experimenting – experimenting with the camera in the room, with the mind, with the props and the actions. I was experimentative when something seemed to happen. Then I would repeat it, refine it. The refining usually meant heightening the experience. I was interested in spinning, and I would often spin in front of the camera. I got to a point where I could spin for 30-40 minutes. I would bang my outstretched hands against the wall, which helped me from getting disoriented and dizzy. The intuitive action that I kept returning to became an involvement. I still make actions and sculpture that relate to spinning.

Kristine Stiles *The action I found most interesting in the* Basement Tapes *was* Whipping a Wall with Paint (1974). *Some quality in that is present in all of your work and comes through in that particular tape. It is a lurking violence, a presence just on the verge of being unleashed, some kind of horrific terror or force.*

Paul McCarthy There were actually two tapes, one which you call *Whipping a Wall with Paint* and a second version which was *Whipping a Wall and a Window with Paint*. Passers-by viewed the action from the street, on the other side of the window. I splattered paint against the window for about an hour and in the end the windows were covered. There's paint everywhere – on me, on the floor. I would dip a big blanket into a large bucket of a mixture of paint and motor oil, pull the blanket out and slap it against the wall and the window. It was

exhausting. The splattering of the paint or the residue of ketchup as in *Bossy Burger* or other pieces seem to suggest that an act of violence has happened.

Kristine Stiles *Well in fact an act of violence has happened.*

Paul McCarthy Even the ketchup in Bossy Burger (1991)– the motor oil and the ketchup – both refer to the splatter of blood splatter, and also to paint.

Kristine Stiles *It's not the direct, obvious, accessible metaphors that interest me so much in your work. What's more compelling to me has to do with what isn't there, this latent violence the manifestation of which is unclear as to what it will become. It may not become violent at all. It could become whimpering or sobbing, or laughing. But it never quite gets expressed. I identified it in early and late work: in* Whipping a Wall with Paint, *in* Bossy Burger *and in* Painter (1995). *This latent quality occurs most strongly when you are going in and out of doors, and around tables, and in between architectural settings. At these moments you seem to be meditative, almost performing a mantra–like action, latent with explosive material which may or may not be violent. So the metaphors of blood and all that are not so interesting to me. It's what is just on the verge of being expressed, but never is expressed. This is why I wanted to think about the question of beauty in your work, to move from the manifest to the latent centre of your work.*

Paul McCarthy There is a kind of self-hypnosis involved in going from space to space or from menial action/task to menial action/task. I think that this word 'latency' implies that something is not resolved, but I do think that there are moments of resolution in my actions. Maybe symbolic resolution. They could relate to forgotten memories – my traumas or possibly someone else's traumas. I seem to have a strong interest in placing the action in architecture and in using furniture: rooms connected to rooms, doors, windows and hallways. The house itself and the action of going in and out of its rooms. I always use tables; tables being a pedestal, something for me to stand on where I become figurative sculpture. The table is also a kind of altar, or a place for food preparation. I think it has to do with the search for a very basic kind of activity.

Kristine Stiles *The world is ordered by those actions and those objects, and when I say 'latent' I don't mean to imply a lack of resolve but a potential still dormant in the action that is compelling, in some ways terribly frightening, but also absurd, humorous and something that asks for empathy but is never overtly expressed.*

Paul McCarthy It reflects a kind of order, or cultural order. The action of the altar is primal; it involves the body. The altar becomes the place where the sack is cut open – the human sack is cut open – the body sack or the animal sack, the sack meaning the skin. We search for what can't be gotten at in the interior of the body, cutting open the body to peer inside. In my work there's a kind of theatre of that, and by theatre I mean the use of representation. The object becomes the body – it doesn't need to be me, or even another human.

I operate in a kind of theatre. I use objects to represent things, to represent thoughts and feelings. The objects don't necessarily have to relate to themselves, they can be a symbol for something else. Ketchup can represent blood, it's not necessary that it be blood. There were pieces that I made in the early 1970s where there was a sort of emphasis on concrete performance. Performance as a concrete reality, where you don't *represent* getting shot, you actually *get* shot. That definition of performance as reality – as concrete – became less interesting to me. I became more interested in mimicking, appropriation, fiction, representation and questioning meaning.

Kristine Stiles *I'd like to go back to the role of architecture in your work because your actions within certain kinds of architectural settings suggest some personal memory of an actual experience that is no longer recoverable but which comes through most powerfully in architectural spaces.*

Paul McCarthy I think that in part my work does refer to my own private, forgotten or repressed memories and that I seem to play them out unconsciously in my actions. It is from those repetitions that I recognize them as existing, but I am not sure how they relate to me. Are they specifically my traumas, or someone else's that I have witnessed either directly or through the media? But the definition of performance as only being real or performance as reality is limiting; psychologically or perceptually I found myself giving it a new reality. At one point I said that 'my face on the floor is my face on your stomach'. It has to do with the view of performance as a reality. I'm proposing that reality itself can fluctuate. The bottle of mayonnaise within the action is no longer a bottle of mayonnaise; it is now a woman's genitals. Or it is now a phallus. I suspect that that suspension of belief does exist within viewers, even though they cling to the conscious interpretation that ketchup is ketchup. I suspect that they're disturbed when ketchup is blood.

Kristine Stiles *I don't think so. I never lose sight of the names and functions of the objects that you use. I'm not disturbed in your work; I'm touched. You're suggesting that there's a suspension of belief, that it works metonymically: ketchup is red and viscous, and therefore it has a phenomenological continuity with blood.*

Paul McCarthy Yes.

Kristine Stiles *I have no argument with this. But the effect of your action hasn't so much to do with the symbolic meaning (or transference of meaning) as with a connection to the fact that you actually* do *the action. The question then is: what does it mean for Paul to make an action that transforms a bottle of ketchup into a vagina?*

Paul McCarthy For me the actions go in and out of affecting me differently. It is this quality that I feel again and again when I watch the tapes, even from the beginning up until now, for 25 years of tapes. There's this aspect of getting into something repetitive, going with that repetition to the point of discovery, and then sort of letting go in that space. I never get involved specifically with

the actual materials or making those kind of metaphorical or metonymical connections. Or transformations or representations of materials.

Kristine Stiles *But you use the same materials repeatedly, so clearly the repetition in the performances is significant. But it's not where the content of your work lies for me. I think the repetition, the objects, the characters, the bodily fluids are all a kind of camouflage, a mask, but more than a mask. They function as a smoke screen that detracts the viewer from the latent content in your work.*

Paul McCarthy The repetition lets you know that they are specific to the actions. I've often thought that the actions between 1972 and 1993 were dependent on liquids. I've often thought that particular types of objects – holes, bottles – appear all the time in my work. Architectural references are all obsessive in the same way. And the masks. The mask in the sense of it being an environment, almost an architectural environment. When my head is inside the mask, I'm peering out of these holes which are an inch or so away from my face. My voice changes inside the mask; it's hard to breathe. I also make this connection of the mask to a camera. The eye hole of the mask is similar to the lens hole of the camera or the frame of the picture. You can't see beyond the frame of the hole. I've made this hole metaphor as a metaphor of cultural control, what you can see and what you can't see. That wasn't something that I recognized at the beginning but which grew out of performing. I started doing those performances and constructing pieces around the eye, the idea of a hole, of looking through something. This was both a cultural metaphor and a personal or private metaphor. And that was one of the things that was interesting to me about Duchamp's *Etants Donné* … , that you look through the two holes and you can see only what he wants you to see. You can't see anything beyond the frame of the hole. You can't see what the object looks like above or below the frame of the hole. You can only see what the hole allows you to see. My early black paintings, from 1967, were done as doors. I understood all Western art in relationship to mirrors, windows and doors. Painting has always had a reference to architecture.

Kristine Stiles *A lot of your activity goes on in between architectonic space. This discourse is one of framed space, but a frame (unlike the hole) that is certain. Curiously, it is also a space where you do a lot of talking. For example in* Painter, *you say things repetitively: 'I can't do it'; 'I think I will', and so forth. At the same time it seems to be a space of contemplation for you.*

Paul McCarthy It may have to do not only with my conscious and unconscious memories but also with my difficulty in accepting something versus nothing, existence versus the void. They may be related, they *are* related. The use of architecture is associated with constructing a place, framing, objectivity and existence, ordering, substitutes, necessity and absurdity.

Kristine Stiles *You've told me in other conversations that Beckett is really important for you. There are many similarities between* Waiting for Godot *and aspects of your work.*

Paul McCarthy In *Waiting for Godot* and in *Bossy Burger* there is a sense of being trapped, having no way out. When I did *Bossy Burger*, I did drawings during the actual performance and during the taping session. I made aerial views of the set – pathways through the set going into one room, down the hall, through the door into another room. I am making a sculpture now of three buildings – a saloon, a bunkhouse and a teepee – with animate characters in each building. Before I placed the inanimate figures in the saloon, I made a film inside with actors. The film has no precise narrative; it is a series of shots, repeated scenes.

In *Bossy Burger*, the Alfred E. Neuman character never leaves the architecture. I envisioned him as an entrapped person, trapped within the architecture. And the house represents a trap; the earth is a trap. He may stick his head out but he immediately pulls it back in. He uses the door to spank himself. When I was doing that piece I was really aware that he would not leave the architecture, and that the architecture existed in a void. And in *Pinocchio Pipenose Householddilemma* (1994), Pinocchio never leaves the house. The house is the dilemma: the dilemma of our inability to understand. The dilemma is so alien that it smells of insanity. Paranoia and psychosis breed in this sort of pool of milk, a pool of milk as a metaphor for this existential dilemma. It becomes very much associated with the reality within a house as absurdity. The construct of reality as absurdity.

Kristine Stiles *I think you told me that Alfred E. Neuman, for example, in* Bossy Burger, *was the image of how you saw yourself as a child.* Sailor's Meat *referred to your dad …*

Paul McCarthy Not only references to Alfred E. Neuman but to Howdy Doody and Charlie McCarthy. I shared similar characteristics with them. I identified with puppets and cartoon characters. The Alfred E. Neuman mask was bought the day of the performance. I went to the store and out of twenty masks, I just picked that one. And the same with the chef's outfit: I went to buy pots and pans and just bought a chef's outfit too. The character/persona of Alfred E. Neuman as a chef was unexpected and is related to chance and coincidence. Most store masks are in one way or another a personality, a stereotype of a film character or a politician.

Kristine Stiles *There's clearly a parody and a critique going on (through all your work) of culture, popular culture in particular. I always laugh because of the farce. In* Bossy Burger *it's of the Galloping Gourmet; in* Painter *it's of de Kooning. When I thought of asking you about your notions of beauty, or where that concept figures in your identity as an artist, it was because of the very critical position that you take in your art* vis-à-vis *Hollywood, Disney, television sitcoms, do-it-yourself entertainments. Something really cynical and angry becomes funny and ironic in your work. Your analysis of mass culture has to have a corollary with some quality you imagine that might be different from the corruption you ridicule. In order to understand something as abused, one has to be able to imagine how it would be if it weren't abused. Your work is about corruption, a discourse on everything that corruption is not. That's why I'm trying to find a way to talk about – to talk*

through – your smoke screen. We both acknowledge that we understand that the words we use for beauty have no value. That's why you create another language, a language of abuse used to discredit the language which has been abused.

Paul McCarthy I mistrust a lot of what has been conjured up in this culture. At one point I mistrusted reality completely. It occurred in 1971-72, when suddenly the experience of being confronted with my existence was overwhelming. And that experience lasted for over a year. I was confronted with nothingness, why was there anything, why was there something, an object, an inanimate or animate object?

Kristine Stiles *Why is it that performance seemed to be the best medium through which to engage yourself in those questions?*

Paul McCarthy It is a physical process, making an object while in character, in persona. It is related to everyday life, the passing of time. The mediums of action/ performance and object/sculpture get confused. I am interested in images produced during the performance. My photographs of performances are more about painting than performance; they are images in rectangles to be placed on the wall or in a book. They are not the performance.

Kristine Stiles *But why does performance engage you more directly in the question of nothingness than object-making? Even as you speak about painting, you're suggesting it was performative for you anyway. I think performance revitalized bodily discourse (corrupted by nineteenth-century academic representation and twentieth-century social realism) as one of the only authentic ways to address human experiences.*

Paul McCarthy It allows me intuitively to act out unconscious and conscious dilemmas in a character. In some cases the character reverts to a kind of dumbness, a sort of numbness. Also, my concerns are not always in relation to the viewer. I was also involved with auto-actions, semi-private actions, the camera being the primary channel to the audience. I think it has to do with self-absorption, the self in the room, in the hallway.

Kristine Stiles *Still, I think every action you make is an act of recuperation. The elements of your performance – masks, objects, foodstuffs – are tools to get you there. Those spaces in-between in which I'm so interested are sites of beauty – for want of another word – for you.*

Paul McCarthy You mean beauty in terms of recuperation. It has to do with what I cling to, something that points to the figure. Within the figure also exists the character which reverts to a kind of repetition that only points to some notion of survival. In *Pinocchio Pipenose Householddilemma*, within the architecture of our surroundings exists the dilemma. For me there is no solution except for a kind of numbness, or to live with the acceptance. The undulating and convoluted repetition. The character is trapped: trapped in its surroundings.

Kristine Stiles *In the sense that the character was trapped spinning or the character was trapped whipping the wall, now the dilemma is expanded into these very complex environments with character development, masking, and all of that.*

Paul McCarthy Yes, but the character within these just goes from dilemma to dilemma.

Kristine Stiles *But that's exactly why I focus on this in-between area. There's a kind of knowing cognition going on in those spaces. The character is reflecting but he is also marking time. He loses his character quality because we're not involved in who he is but in what he is doing instead. There's a kind of purity in those in-between spaces, in such actions, outside of the vile dilemmas into which you cast your characters. The substance in your work isn't in the blood, gore and holes.*

Paul McCarthy I would agree with what you just said, but I believe that substance also exists in a frantic expression. I don't know whether I would recognize the architecture or these spaces which you are describing as any more critical than the character/persona or the utensils.

Kristine Stiles *I'm not saying that there's no substance in all of that. What I'm suggesting is that in those spaces the action is a negation. It's a negation of all the things that the action deplores. The action itself is negation. So there's a double negation going on. Then there are these interim spaces. They may have some of the same qualities as frenetic or repetitive action. But the in-between spaces represent a sort of halcyon moment where an alternative condition of Being takes place. There the mask somehow doesn't matter, what you say somehow doesn't matter. There's some kind of recuperation in that space. It's different, and it interests me because it's there that I think you recuperate the corruption of beauty.*

Paul McCarthy A kind of beauty? How would you define beauty then?

Kristine Stiles *Well, certainly not in any of the ways to which we've been acculturated. I would define it in terms of a constant hunger that human beings have for some kind of truth, a non-specific meaning. That's what I was referring to as a latency that's present in your work. It's not a sign with signification that you can chart. It's a floating kind of non-specific, relational – but felt – meaning.*

Paul McCarthy I don't know whether I associate beauty with truth. I mistrust the notion of truth – maybe beauty is recuperation, satisfied acceptance, as opposed to a fractured sensation and alienation. The notion of beauty is associated, I think, with the sublime – the sublime being tranquil. Do you think of beauty as associated with tranquillity?

Kristine Stiles *No, with some value.*

Paul McCarthy That somehow it's possible for humans to find value?

Kristine Stiles *That is truth, and we've called it beauty. It's not truth with a capital T, because who knows what truth will be for any experience. It's relative. But you seem to enter that space of reordering things in those transits in-between the acts of negation.*

Paul McCarthy I don't know what you mean; I don't know whether I agree or disagree with you.

Kristine Stiles *Gratuitous violence – which is what I think you do in your actions – is compelling to see, especially when it's symbolic. Because we live amidst so much violence, we are compelled to watch ourselves watching ourselves. But gratuitous violence will never sustain us.*

Paul McCarthy I don't agree with you regarding gratuitous violence. What might appear as violence in my work I understand not only to be a cultural-media mockery of film and television but also some kind of symbolic expression of my own fears and memories which are both unconscious and conscious. Mocked violence can be used as humour as well as something pathetic or tragic.

Performance deals with issues that I am concerned with but it can not deal with all issues. There are issues that exist within objects, where the discussion of inanimate and animate objects – inanimate objects being the other – occur. I do not believe that all of my concerns can be played out in performance.

Kristine Stiles *I don't want to say* only *in performance, but it happens differently there, and the reception is definitely different from the response one has to a static or kinetic object. To view another human being – another consciousness – is a dramatic act of recognizing another presence, another subject. This never happens with viewing an object because performance has unique qualities of action and reception specific to the medium.*

Paul McCarthy Yeah, but the real ultimate difference for me between performance and the static object is not in perception, the point of view of another human. The real difference is the position of the performer, the person who acts. But I find hardly any difference in the observation of that act being made by another human or by a static object. I think that identification occurs with inanimate objects or projections and representations of animate objects, film for example.

Kristine Stiles *We can invest inanimate objects with presence. But we can never see an inanimate object, no matter how much presence it's invested with, as having subjectivity. The viewer/performer relationship is an exchange of subjectivities that can never occur with an object.*

Paul McCarthy But the major difference for me is that I am *in* it; that's the importance. It involves a separation from my personality, and the act of creativity in general has to do with the separation from personality. And that's what I find to be the engaging part of the act of art. The importance of performance for me lies within the fact that I'm the action itself. I think that within the creative action, and in the separation of personality, is a kind of beauty. But not in the sense of what we think of as beauty, but in a sense of substance or meaning.

Kristine Stiles *So you can find a space for beauty in your work! That quality does not reside in how your work looks, but in what it is.*

Paul McCarthy In *Pinocchio Pipenose Householddilemma*, the house inverts, the building actually turns upside down. I get turned upside down. It was videotaped to create an illusion of no gravity, almost like a space capsule. There are tunnels that I crawl through, and the tunnels resemble some sort of furnace vent or a hallway. The architecture of the body – or the body as architecture – is one thing that had struck me about Minimalism and late 1960s sculpture. They were often hollow, works by Tony Smith, Donald Judd, Robert Morris. I had done pieces that were made from furnace vents or ducts. One of them was an H-shape, like a capital H. It's open at the four ends of its legs, and the part that was really interesting or important to me was not only that it was hollow and you could see that, but that the centre section of the H, the cross section, was inaccessible. The H itself was small enough that the human body could not crawl into the legs. You couldn't experience the space of the cross member. Later I made a drawing of a piece that was about a two-foot cube; at the bottom corner of the cube was like a little arm or leg that extended out and then made a jut down. The cube was hollow, and this little leg was hollow. You could see the hollowness. That (visual) hollowness of the small leg indicated that the centre part was also hollow, but you couldn't be in that cube. You couldn't experience it physically or see it either. The title of that piece was *A Skull with a Tail* (1978), the cube being the skull and the little leg the tail. There was a reference in the title to the body. I made one that was a cube, but on two perpendicular sides there were arms that just stuck out, right in the middle of the plane of the cube. That one was called *A Skull with Ears*. Then I made *Pinocchio* – a house, a cube with a leg, a crooked leg just like *A Skull with a Tail*.

Kristine Stiles *Many, many years later.*

Paul McCarthy I didn't realize that the Pinocchio house was in the same shape. The house is a square, and then there is a hall that comes out of it. The furnace vent that Pinocchio crawled in comes out of the cube, or out of the house, and makes several bends. It was the same kind of shape, or the same kind of piece as *A Skull with a Tail*. Then I noticed that the H laid flat on the ground. The H was like a human being with two legs and two arms. I did the piece in San Francisco, *Inside Out Olive Oil* (1983) where I actually made a body, a room in the shape of a body. I'm inside the body, inside the human figure, although there is no head, no lower arms and hands and no lower legs and feet.

Kristine Stiles *When did you make* A Skull with a Tail *and* A Skull with Ears? *Did it have any reference to the historical moment in the late 1960s? I'm thinking of Vietnam especially.*

Paul McCarthy *A Skull with a Tail* was in the 1970s; *A Skull with Ears* was in the 1980s. I don't know how the whole situation of Vietnam affected my work. My early memories of Vietnam, from 1965 through 1969, were full of confusion, images from television, magazine and newspapers; images of death. I made black paintings in 1967 sometimes with images. I had referred to these paintings as doors and windows. Ad Reinhardt was in there somewhere, as was Wally

Hedrick, an artist in San Francisco. He painted all black paintings during the Vietnam War. I was really interested in the Beat Generation and poets especially in San Francisco. They were political and involved with political protest. I refused to register when I was eighteen, but they didn't catch me until 1969. My case was referred to the courts. Art was defining itself within the alternative culture in a number of ways. There is a reference of the H as being a piece of formal sculpture but also an image of a dead body and of corporate architecture, of hallways and rooms. The metal of the H is violent.

Kristine Stiles *I'm not saying that the work is associated with Vietnam. What I'm suggesting is that Vietnam was another site in which the body was threatened. That is clearly one of the principal metaphors in your work: the body as threatened and denigrated, unable to find its way into the knowledge of its condition. The black windows and the black doors that you made are an interesting visualization of that problem and paradoxical in that windows and doors are things one may see or go through into another area. To blacken those out suggests one has no access through the very things that should provide access. The same thing holds true about the description you gave of* A Skull with Ears *and* A Skull with a Tail. *They represent a place where one can't go. This inability to know – through the metaphorical vehicles of knowing (windows and doors) – and the death of the body (within an architectonics of death) are the basic substance of your work. Vietnam – as an historical manifestation of some of these ideas – would have been yet another kind of analogue (from the socio-political frame) that could have provided another layer to the aesthetic and experiential one in which you were already involved. The titles are also very significant.*

Paul McCarthy Yes, I agree. *A Skull with a Tail* suggests that there's something inaccessible, suggests that we can't know. I remember thinking of those works in terms of the soul that we couldn't access – the soul that occupies the head. At the same time it was a cube, a minimal cube, and they were painted black. They were almost direct references to Tony Smith's sculpture.

Kristine Stiles *Which he titled* Die!

Paul McCarthy I never thought of that, but the H was also titled *Dead H*.

Kristine Stiles *Many of these metaphors of spaces that exist but are inaccessible are classic signs of trauma.*

Paul McCarthy Maybe that doesn't surprise me. I think my work deals with trauma, my experience of trauma, physical/mental trauma/abuse. I act as a clown stuffing and feeding orifices, enacting body hallucination – size changes, weight changes. Reality is force-fed: eat this. My actions are visceral; I want it to be visceral. The props of ketchup and mayonnaise are the right consistency for the action to be visceral. They cover the objects in a kind of body lubricant. They are force fed into the mouth, the eye, the asshole. These images play themselves out in my work.

Kristine Stiles I was very fascinated with **Ma Bell** *because of my interest in artists whose performances include working with books. How did you come to do that particular piece? Why the phone book?*

Paul McCarthy In the studio there was a stack of telephone books, and I made a couple of pieces with them. The building was in the middle of L.A. It was empty and had previously been the induction centre for World War II and Vietnam. It still had lines on the floor – follow this line to the psychiatric testing area, you know ...

Kristine Stiles *So my question about Vietnam was not so empty.*

Paul McCarthy Yeah, I ended up on the top floor of this building. It became my studio. The building was in the shape of an H, which was a coincidence.

Kristine Stiles *You didn't remember that before now?! The building you were in, which was a former recruitment centre for the wars, including Vietnam, was in the shape of an H!*

Paul McCarthy It is very odd that the building was in the shape of an H. Yeah, I didn't remember.

Kristine Stiles *What was in the centre part?*

Paul McCarthy Elevator shafts! There were windows all the way around, looking out onto downtown L.A., the lights of L.A. and everything. The building had very few objects in it, but there were things around like stacks of telephone books. I started making pieces with the telephone books because they were there. I said to a friend of mine, 'I'm going to do something with the telephone book.' It all sort of clicked into this thing, pouring oil onto these pages of the telephone book in this crazy lab, you know, this insane lab. And being at the top of this building, kind of on top of L.A., almost like putting a curse on L.A. ... The book itself had everybody's name; everybody was in the book. I was pouring oil over them with this sort of primal goo. It was almost as if I was mixing a recipe: flour, or food, oil – like baking a cake or something.

Kristine Stiles *When I saw this tape, I associated it with Judeo-Christian traditions: Jews being the people of the word, or book, and Christians being the people of the body. I associated how the name in the book comes to stand for the body. You performed a kind of effacement. I saw that piece not only as performative in terms of your action, but also in terms especially of what the telephone book might represent as words for bodies, multiples of bodies. The telephone book has a kind of corporeal existence in* absentia, *that was redoubled in the performance itself. The telephone book itself was performative. So the action of defacing also obliterated the performance, a kind of self-obliteration in the obliteration of the book. The relationship between naming (or language) and the body seems to be very much in keeping with one of the central performative qualities in all your work, which is to destroy the performer in name and body. Or, perhaps it is the experience of the viewer who is submitted to watching the destruction of the performer again*

and again, either in his inability to speak, his self-abuse, his abuse of other things *(which is a kind of self-abuse) and so forth.*

Paul McCarthy One thing about that piece is that it was the first piece I did as a sort of persona, as a sort of character. I imagined myself as a kind of hysterical person.

Kristine Stiles What was it about the situation that compelled you to assume a persona?

Paul McCarthy Prior to that performance, most of the pieces had been very task-oriented. But that was the first piece where I felt I was actually assuming a character, a persona.

Kristine Stiles Why did you stop performing in 1983?

Paul McCarthy I don't know. The situation in performance art had changed a lot. I wasn't as interested in a lot of the dialogue of performance art. I went back to doing a lot more drawing. I wanted to make wax figures, wax sculptures, almost replacements of myself. It didn't really translate until years later, with *Bavarian Kick* in 1987 and *The Garden* in 1991–92.

Performance was really wearing me down psychologically. I wanted to get a real distance from it and think about it in another way. There was no money. It seemed as if I should back away. I wasn't sure it was so healthy for me. Performing for an audience did affect my actions, but I was also interested in what happens when you put a frame, a camera window, in front of the performance and the viewer watches it through this window. You change the situation that way. You hide parts of what they could see and you control it. It reflects on culture's use of control.

Kristine Stiles I'm very much aware of the camera's presence, especially its shadow, in certain aspects of Bossy Burger *where it is visible while showing the kitchen and some nebulous spaces that appear to be hallways, doorways and exteriors – interim spaces. Anthropologist Victor Turner theorized that certain kinds of interim spaces are liminal and operate as a site of recuperation, an escape valve wherein activities not permitted anywhere else in society may occur. Liminal space functions as a kind of exhaust for pent-up, taboo and impermissible acts. Rituals are performed within liminal spaces, on the margins of society, where all kinds of things were permitted that need to be addressed in the culture, but aren't addressed in any other way.*

Paul McCarthy Along with the H-shaped sculpture, *A Skull with a Tail*, and *A Skull with Ears*, there was a metal cube I wanted to make with louvres on four sides, like an air conditioning unit or a swamp cooler. It was a cube that vents air, and it was meant to look like it was venting interior air. I had referred to it as the act of venting. I wrote a poem in the 1970s called 'Vented' in which I described my actions as 'venting', that I was 'venting'. I was thinking about venting trauma, and that art could act as a vent.

Cildo Meireles *Gerardo Mosquera*

in conversation
October 1998, Rio de Janeiro

Gerardo Mosquera I'd like to ask you first about the development of Neo-Concretism in Rio de Janeiro and the way it relates to your work. In Brazil in the early 1960s there was a strong Concrete Art movement, derived from the traditions of Russian and European Constructivism, which developed in an orthodox manner in São Paulo. However, in Rio this tradition had evolved by the late 1960s into the more liberated, sensual and subversive movement known as Neo-Concretism which included Lygia Clark (1920–88), Hélio Oiticica (1937–80) and yourself. This is an interesting art-historical phenomenon: an art form with social implications that developed out of the formal and self-referential investigations of Brazilian Concretism. How do you place your work in relation to this movement?

Cildo Meireles Neo-Concretism was based on the introduction, by artists in Rio, of a 'multisensorial' approach to the art object. This is seen particularly in the work of Hélio Oiticica and Lygia Clark, at the point in the late 1960s when the body became central in their practice. As a result their art began to point in two directions. Clark investigated the interior of the body in works such as *A Casa é o Corpo* (*The House Is the Body*, 1968), a body-enveloping environment in which participants could experience a 'rebirth'; while Oiticica focused on the body's exterior, in works such as *Parangolés* (*Capes*, 1965–67), coloured garments which brought the wearer into a heightened awareness of his or her movement in social space.

 Although I was born in Rio, from the ages of ten to nineteen I lived in Brasilia. I was not that close to anyone in the Neo-Concretist group, although I came to know Oiticica in the early 1970s when we were both living in New York. I had already been aware of his work, however, in the early 1960s. While I was studying in Brasilia I tried to follow this group of artists through Brazilian art and architecture magazines such as *Habitat*. From 1964 I had access to the University of Brasilia's library collection of contemporary art books and magazines, which were generally hard to find in Brazil. I had already returned to Rio by the time Oiticica curated the landmark group exhibition at the city's Museum of Modern Art, in 1967, 'Nova objetividade brasileira' ('New Brazilian Objectivity') which set out a new agenda for Brazilian art.[1]

Gerardo Mosquera Your early works have a dual aspect. On one hand, drawings such as Cruzamen (Crossing, *1968*), belong to the tradition of new figuration prevalent in Latin American art of the late 1960s. This neo-expressionist style was linked to the representation of contemporary social conditions, which included guerrilla movements, student protests, violent repression and torture. On the other hand, there are totally different works, such as the drawings for Espaços Virtuais: Cantos *(*Virtual Spaces: Corners, 1967–68) in which your prime concern was an abstract investigation of space.

Cildo Meireles Drawing was the first medium I used – for various reasons, one of which was the availability of materials in Brazil at that time. My figurative drawings of the early 1960s were derived from the impact of an exhibition of West

African masks and sculptures from the collection of the University of Dakar, Senegal, which I saw at the University of Brasilia in 1963.

Another of my influences in the mid to late 1960s was animated film, particularly work from Eastern Europe; it had an energy and gestural quality that I wanted to consolidate with my interest in figurative drawing. However, at the same time I needed to formalize, also through drawing, certain conceptual ideas I was carrying around in my head. Drawing continued to be my main medium until 1968. I made a huge number of these conceptually based drawings, even filling my diaries with them. Through them I began to investigate what happens when you describe sections of three-dimensional solids or two-dimensional forms simply by indicating them, for example, with an interrupted line. More than just a drawing exercise, these works investigated the notion of transforming subjective ideas into objective forms.

In 1968 I began a series of works based on Euclidean principles of space, which included *Virtual Spaces: Corners, Volumes Virtuais* (*Virtual Volumes*, 1968–69) and *Ocupações* (*Occupations*, 1968–69). These works, which relate to Bruce Nauman's *Corridor* (1968–70), used three planes to define a figure in space. Looking for a way of making this abstract idea more concrete, I decided to show it through a model reconstruction of the corners in a typical domestic room. The *Virtual Spaces: Corners* evolved, first as a series of drawings, then as three-dimensional sculptural environments resembling corners of rooms. In *Virtual Volumes*, lines – constituting perimeters, areas or corners of solids – were projected onto walls. The *Occupations* series made spatial constructions from a minimum of elements, predominantly large canvases which filled the entire space of the gallery. This is what I was making when I discovered the work of Hélio Oiticica and Lygia Clark. I also admired their contemporary Lygia Pape, whose sense of the relationships between different scales has been of abiding interest to me. Orson Welles' radio broadcast of [H.G. Wells'] *The War of the Worlds* exerted a similar fascination.

Gerardo Mosquera *On one hand you were conducting experimental research into geometry; on the other you were making expressionist drawings that in some cases dealt with social violence. How could you reconcile these two concerns?*

Cildo Meireles There was a point in 1968 when I decided to abandon the expressionist style of drawing. I would only make drawings related to things I wanted to construct. These would be more like floor plans or technical drawings, directly related to the three-dimensional construction of the works. When I was living in New York at the beginning of the 1970s I worked as a bicycle messenger for a time, which I loved. When I returned to Rio in 1973 I wanted to do the same job, but realized that Rio was very different from New York – if I wasn't killed in the traffic by the end of the month, the low pay would kill me instead.

I went to Brasilia to visit my family. One day while I was there I had the

impulse to go to the same local stationery shop where I used to buy paper and ink. From that moment I decided to resume drawing and returned to Rio, where I survived financially by selling my drawings.

Gerardo Mosquera *You say that you separate your work into formal and social aspects. However, I don't think one can use the term 'formal' when referring to works which are not geometrical speculations, as in classical Concretism, but experiments with ideas and sensory perception within a conceptual framework.*

Cildo Meireles No, when I speak of the formal aspects I am speaking above all of an idea. By this I mean not only the materialization of the work but the formalization of the concept itself. I search for formal elegance in the concept of a work as much as in its physical manifestation.

Gerardo Mosquera *You called your expressionist style 'Afro-Brazilian', yet it could only be called so in formalist terms, as it did not actually engage with Afro-Brazilian culture.*

Cildo Meireles This was because of a need I felt to tackle every theme, whatever it might be, with that mixture of strength, delicacy and elegance which I found in African sculpture.

Gerardo Mosquera *In 1970 you made* Inserções em Circuitos Ideologicos: Projeto Coca-Cola *(*Insertions into Ideological Circuits: Coca-Cola Project*). Messages like 'Yankees Go Home' were transferred onto Coca-Cola bottles and placed back into circulation. In response, the art critic Federico Morais commented by making his own work. Morais asked Coca-Cola for two lorry-loads of bottles with which he covered the gallery floor, placing just one of your inscribed bottles on top. He was implying that it is impossible to infiltrate these circuits, as they will always devour you.*

You made the Insertions … *projects for a brief period and then abandoned them. Had you concluded that it was pointless to intervene in these circuits, or were these works more a political gesture than a real plan of action?*

Cildo Meireles My intention at the time was to arrive at a formula which could potentially have a political effect, and I think that the piece achieved this. Nonetheless, it is practically impossible to achieve anything on an individual scale through this work. The contribution of each individual insertion is minor in comparison with the potential scale of the work. At the time I felt great about the project, because it was at least feasible, even if it raised this issue of disproportion.

The *Coca-Cola Project* part of *Insertions* … was almost like a metaphor for what I consider the real work: the *Cédula Project*, which was contemporaneous. In this project, banknotes were stamped with political messages and re-inserted into circulation. The idea of the circuit was still there and of course it had a greater effect than the *Coca-Cola Project*. In the confrontation of the individual and the state in those circumstances, the state was clearly seen to be the problem. The *Coca-Cola Project* addressed more the issue of the individual in relation to capitalism. Like Pop Art, it

played with mass iconography in an ironic way.

Gerardo Mosquera *When you made works like this, were you making art or were you engaged in a more political type of action?*

Cildo Meireles What interested me was the double character of these works: one object could simultaneously engage on two levels, both within and outside an art-historical definition of the art object. Whenever we try to define art, we confront the divisions between what is and what is not considered the art object. In pre-classical times, art and religion were synonymous. In classical Greece, art and architecture were similarly connected. Later a distance was created between the artistic and the architectonic. Art was seen as the documentation or reproduction of the real, and so on. What attracted me to Neo-Concretism was the possibility of thinking about art in terms which were not limited to the visual.

Gerardo Mosquera *The* Insertions … *projects were not only a subversive intervention which attempted to use capitalism's own distribution mechanisms; they also addressed another vital issue, that of individuals versus mass-determined systems. Did you conceive of the work as a systematic project, a kind of public artistic 'guerrilla' action, or as your own personal gesture?*

Cildo Meireles It was both. The *Insertions into Ideological Circuits* consisted of information and instructions on how to repeat the process.

Gerardo Mosquera *Like the instructions in your next work,* Inserções em Circuitos Antropológicos *(Insertions into Anthropological Circuits, 1971), for making coin-style tokens out of clay compressed in handmade moulds. You made it seem as if they could then be used as 'counterfeit' in dispensing machines or on public transport.*

Cildo Meireles The *Insertions into Ideological Circuits* had concentrated on isolating and defining the concept of the circuit, by taking advantage of a pre-existing system of circulation. In this sense, the texts on the Coca-Cola bottles and on the banknotes functioned as a kind of mobile graffiti. By contrast, the basic model for the project *Insertions into Anthropological Circuits* consisted in the fabrication and circulation of a series of objects, such as these 'tokens' for transportation, telephone or dispensing machines, which could influence socio-political behaviour. They dealt with the circuit by utilizing features which existed as a pre-condition of the product.

Gerardo Mosquera *But was there some way of teaching people how to use these structures in a subversive manner?*

Cildo Meireles There was always the possibility. I was always coming back to normal means of diffusion. In the late 1960s and early 1970s, Brazilian art was still very marginalized.
 Nevertheless, in the international exhibition of Conceptual Art, 'Information' at The Museum of Modern Art, New York in 1970 (the first

time the *Insertions into Ideological Circuits* were displayed in an art context) four of the one hundred participating artists were Brazilian.

Gerardo Mosquera *Can you describe the cultural scene in Rio in the 1960s and 1970s? At this time in Rio there was a boom of experimental art which united formal, social and political concerns.*

Cildo Meireles The best thing was the many artist friends I made; we were all between eighteen and nineteen years old. The bar of the National School of Fine Arts, which was the former National Museum of Fine Arts, was a popular meeting point, as was the bar of the Museum of Modern Art. Poetry, experimental music, performance and cinema in particular were as important as visual art at the time and there was much exchange of ideas between visual artists and practitioners in other artforms.

It was during this period that I began to read the Argentinean writers Jorge Luis Borges, Julio Cortázar and Bioy Casares.

My political awakening came earlier, however, in 1964, when I was sixteen years old and living in Brasilia. I was beginning to get involved in student politics. In April there was a demonstration in the central bus station. There were tanks surrounding the Congress building. Someone suggested we go there. At one point, I suddenly found a flag in my hand. I thought, hold on, what am I doing with this flag? I have no reason to be here; I am not trained to do this. It was at this moment that I realized the political left lacked structure and organization. There was a feeling, perhaps an illusion, that we could resist, but it was inarticulate.

Gerardo Mosquera *In 1970 you made* Tiradentes: Totem-Monumento ao Preso Político *(*Tiradentes: Totem-Monument to the Political Prisoner*), to coincide with the inauguration of a new exhibition space, the Palacio das Artes, in Belo Horizonte. It was a controversial work. You tied hens to a post, at the top of which was a clinical thermometer, and then set them alight, burning them alive while a shocked audience watched from the gallery windows. This work was a powerful statement on the violence in Brazil under the dictatorship, and a homage to the famous Brazilian known as Tiradentes, who organized the* Inconfidência Mineira *in 1789, the first organized uprising against Portuguese rule, inspired by French Enlightenment ideals. In 1792, Tiradentes was hanged and his body dismembered for public display.*

Cildo Meireles The work was made during the week that commemorated the *Inconfidência* uprising. The figure of Tiradentes was being used by the military regime in a very cynical way. He represented the antithesis of what they stood for. The military regime had effectively moved the capital, symbolically, from Brasilia to Ouro Preto, near the site of the exhibition in Belo Horizonte. The exhibition was part of their programme commemorating Tiradentes (Joaquim José da Silva Xavier) as 'their' national hero. Of course, the hypocrisy of their symbolic manoeuvres was clear and I decided to make a work about this.

Some Brazilian artists felt obliged to make compromising political work at that time, even if their actual artistic and intellectual interests were apolitical, as mine were. I always tried to make it clear that this was a personal response. It expressed my beliefs and also responded to the demands of the artwork I was trying to produce. There were formal and conceptual aspects which were closely linked to the issue of the art object, and which had nothing to do with political discourse.

In *Tiradentes* ... I was interested in metaphor and in the dislocation of the theme. I wanted to use the subject, life and death, as the raw material of the work. This dislocation is what matters in the history of the art object. But this work also contains a more explicit, direct discourse, which is my own point of view. As a formal object, it evokes memories of self-immolation, or of victims of explosions or napalm attacks. There was all this imagery of war at that time, and I wanted to make reference to this in a way which would bring it attention. This action was staged in a dislocated scenario, resembling an exhibition opening held in a construction site.

Of course I would never repeat a work like *Tiradentes* ... I can still hear those poor hens in my emotional memory. But in 1970 I felt it had to be done.

Gerardo Mosquera *A utopian constant in your work is the attempt to move beyond metaphor to work with life itself, not as a subject but as artistic matter. In* Tiradentes ... *you were working with life as well as death.*

Cildo Meireles Precisely. As a professional artist, which is maybe a contradiction in terms, I see the market as an important horizon, but my work always searches for some kind of communion with this indefinable, broad entity called the public. At the same time, it has a completely independent aspect. The work has to stand on its own, in the sense that it has to have complete autonomy. If you deny this, the idea of the work disappears.

Returning to the *Insertions* series, although it has these elements of dialogue and neutrality, there is nothing to prevent a Neo-Nazi coming along and producing a fascistic version of this work. The project's neutrality is derived from its attitude, which is rooted in my own personal position.

In much of my work there is an interpenetration between the artwork and everyday life, and this affects the choice of material. I am interested in materials which are ambiguous, which can simultaneously be symbol and raw substance, achieving a status as paradigmatic objects. Materials which can carry this ambiguity range from matches to Coca-Cola bottles, from coins and banknotes to a broom, as in *La Bruja* (*The Witch*, 1979–81). They are in the everyday world, close to their origin, yet impregnated with meaning.

Gerardo Mosquera *These ideas are related to Neo-Concretism and its negation of art as pure symbolization. It proposes art as a new reality, as something which exists in a lived space. There is also the 'you see what you see' effect of Minimalism.*

Cildo Meireles Where is the origin of Minimalism's aesthetic position? Perhaps long before the 1960s, for example in Gertrude Stein's line, 'a rose is a rose is a rose' (1914) – a material is what it is and no more.

Gerardo Mosquera *In your work these formal concepts take on another dimension. You try to make something which goes beyond metaphor, and for this reason you use materials which have symbolic content. This is where we find the disruptive edge to your work, where Concrete, Minimal or self-referential work is attacked by referentiality, invaded by external meanings. You developed* Virtual Spaces: Corners *as a perceptual critique of Euclidean geometry, but you chose to represent this by recreating the modest corners of a domestic room.*

Cildo Meireles The *Virtual Spaces: Corners* are almost didactic, immediately identifiable. The issue is developed through abstraction but the physical and sensorial relationship emerges almost instantly. One of the qualities of artworks is that they permit extreme freedom with regard to time. If you want to relate to a book, you must read it from the first word to the last, although of course you have a general idea after reading a few pages. In literature there is a kind of slavery to time.

 As an exception to this rule I would mention a Brazilian concrete poem of the early 1960s by Ferreira Gullar: *Lembra* consists of a cube resting on a base; when you lift the cube, you read the word *lembra* (remember). Normally, however, time is the fundamental issue. This is also vital in film, where everything happens in time. Maybe time is the only reality. In the visual arts you have to be seduced and involved in a second; then maybe you will look longer and begin to understand. But in those same seconds you may move on to the next thing, or leave.

Gerardo Mosquera *Do you think there is a possibility of art transcending representation?*

Cildo Meireles I don't think it's a question of choosing between one or the other. Representation is always there and 'that which is not there' is always there; 'that which is not there' is always present in an artwork. This does not mean it cannot exist alongside manifestations of that representation. Sometimes certain objects acquire this 'something else'; they become impregnated, and transcend themselves as utilitarian objects, achieving a paradigmatic quality. They almost become symbolic.

 Although I am interested in these objects as materials, transcending representation is not really an issue for me. Some of my works suggest transcendence, others are far from it.

Gerardo Mosquera *Your interest in deconstructing space is related, in a broad sense, to your desire to subvert established structures, as in the* Insertions … *Is this an attempt to transgress space as the arena of human life?*

Cildo Meireles Much of my work is concerned with a discussion of the space of human life, which is so broad and vague. Space in its various manifestations covers

psychological, social, political, physical and historical arenas. In many works this is perfectly clear, as though I were working with the proverbial pea under the pile of mattresses. I don't think it really matters if an interaction between a utopian space and a real space is achieved or not. I think that there is an almost alchemical aspect: you are also being transformed by what you are doing. Many of these transformations occur at a hidden, subtle level.

Gerardo Mosquera *As in* Fio *(Thread, 1990/95) which consists of a needle and 100 metres of gold thread encircling bales of hay?*

Cildo Meireles In this piece there is also a discrepancy between use and exchange value, symbolic and real value. My works that use money all refer to this dichotomy between work and the artwork, between hay and gold. In *Fio* there is also an element of imperceptibility; the gold thread is concealed.

Gerardo Mosquera *These works all imply a critique of the aura surrounding art; of the work as a fetishized object which constructs its value in a field of relations.*

Cildo Meireles Most of my works can be reconstructed; they do not have to be unique. This debate was very common in Brazil in the late 1960s. We were concerned with how to make works freed of the author, the brushstroke, the corporeality which legitimates the original. In other words, we were more interested in making works which could be reproduced and re-made, like the *Virtual Spaces: Corners*; anyone who had access to the working drawings could make the constructions. We were concerned with the problem of how to structure the work so that it could always be re-made almost identically and escape from the aura of the original.

Gerardo Mosquera *There are works which deal specifically with this, like* Árvore do Dinheiro *(Tree of Money, 1969), in which a bundle of banknotes is placed on a traditional plinth for sculpture. The banknotes in this context seem to represent an abstract 'value' which is worth nothing in its material aspect.*

Cildo Meireles The contradiction is that it really is worth nothing, which is a paradox; money declares a value but in fact you have no way of knowing what it is really worth. Money depends on reserves, and today there is a great deal of money floating about without reserves.

Gerardo Mosquera *There is a constant sense of paradox in your work. It is there even in the title of* Malhas da Liberdade *(Meshes of Freedom, 1976), because meshes or nets are usually used to capture things, to deny freedom.*

Cildo Meireles In the 1960s I was always doodling, like anyone who is bored. First I'd draw a line, then another that intersects it, and so on, until I'd made a grid. In 1976 I decided to do the same with more rigid materials. Then it was no longer a matter of lines over lines; the second line was on an altogether different plane. This is the origin of *Malhas da Liberdade*, of which the grid is just one manifestation. The work consists of a module and a law of formation: how

the module intersects the previous one determines how it is then intersected by a third, and so on. The composition creates a grid which spreads over a plane, but it also starts to grow in space, to create a volume. Theoretically, this structural principle could be used to make an endless variety of forms, from cubical, to spherical, to random structures. It has no formal limitations, but consists rather in the passage from one part of a structure to another, at any point in time and space.

The first two versions of this work, made in 1976, were in fact fishing nets. I approached a fisherman who made nets, explaining that I wanted the nets made in this particular way; although he thought it was strange, he made them. The nets were totally soft and were not intended to be mounted on a structure. In 1977 I made a metal version for the Paris Biennial.

After making this version I tried to find information, especially in mathematical literature, about this principal of growth. I thought it was so obvious. Why had nobody done it before? If it had never been done, perhaps this was to be my greatest work! However, I suspected it had already been done, in network theory. At the time I asked some friends who were mathematics lecturers in the University of Brasilia for more information and background, but they couldn't help me. Later I learned of the work of Mitchell Feigenbaum, a North American physicist who published this theory, apparently for the first time, in 1977, the same year I sent the work to the Paris Biennial. He developed the theory of the universal coefficient, a number which appears many times in the most diverse circumstances. In transitional states, you always find this number, a mathematical constant, based on a concept of branching forms, known as 'cascades of bifurcations'. A similar concept appears in Borges' story 'The Garden of Forking Paths' (1944). For the Paris Biennial I wanted to make a cell-like space, the sides of which would be made of grids using this structural principle. You would enter, and once inside, you understood the module and how it worked. What I had wanted to send was strips of paper, with instructions for constructing this ambiguous and paradoxical space from paper strips.

Gerardo Mosquera *This is an interesting issue in your work; you undertake artistic investigations which are similar to scientific research in their approach. You are not a scientist but you do pursue a kind of 'artistic science'. You explore a poetic dimension of mathematics, geometry and physics.*

Cildo Meireles Mathematics and physics were my favourite subjects at school. I even considered becoming a mathematician or scientist. My knowledge is not sufficient for me to adopt a fully scientific approach, but I'm fascinated by certain aspects of physics. I'm interested in particular aspects of scientific rigour, which I then modify. In some works this is clear, for example in *Eureka/Blindhotland* (1970–75). My original idea for this work was that I insert a piece of metal into the centre of a young tree's trunk, wait several decades until the tree grew, then cut it and make an X-ray to see how the

metal had lodged itself inside. From this I would have made the wooden elements in the installation.

However, I ended up using a different process. *Eureka/Blindhotland* includes a wooden cross, placed on a weighing scale, and two identical bars of the same wood, placed on the other scale. They are both seen to weigh the same, although the perceiver would assume they had different weights.

Ouro e Paus (*Gold and Wood*, 1982/95) and *Fio* (*Thread*) are connected to *Blindhotland* as they both explore visibility. *Eureka/Blindhotland* works from a concept of density, or mass divided by volume, although in this case the volume remains the same. But it is not only about that; it also touches on the idea of synaesthesia: perceiving one sense through another. That interests me – the possibility of redefining space not through visual perception but through muscular contact, bodily awareness.

Gerardo Mosquera *This work is characteristic of your interest in transcending the visual in the visual arts. But in a way,* Eureka/Blindhotland *ends up as a defence of visuality because you include a pair of scales which allow the viewer to perceive immediately through sight, rather than through direct experience.*

Cildo Meireles Certainly the scales are an instrument to measure weight through vision, but before that process has taken place, the muscles have already identified this. When you put an object on the scale, it is your physiological memory which informs your brain that one object is heavier than another. My intention in these works is never to 'blind' the perceiver. I simply think that you can raise visual issues using other senses as well. Oiticica also examined this idea, referring to the 'multisensorial'.

Gerardo Mosquera *There is much talk now of virtuality, and this has been present in your work from the outset. In your installation* Marulho *(*The Surge of the Sea, 1991–97*), shown at the Johannesburg Biennial in 1997, the sea is evoked through a 'carpet' of books which reproduce colour photographs of the sea itself. As the spectator advances along the wooden deck, he or she hears the word 'water' repeated in many languages, by many different voices. You have referred to this work as a kind of low-tech virtual reality.*

Cildo Meireles I meant this in terms of seduction, which I maintain should always be present in the work. I don't consider myself a conceptual artist, although I have many works which tangentially border on conceptual issues and I have taken part in Conceptual Art exhibitions such as 'Information'. One of the reasons Conceptual Art is difficult for art history to deal with is its perceived excess of verbal rhetoric. People are generally not keen on going to galleries to read explanations.

Art can provide a systematic diversion, because it is not simply an expression of artistic thought. I believe that the artist must be open to this diversion, even within the production itself. I believe that every idea demands as singular a solution as possible. In almost every new project one is drawn

towards new techniques and materials. I am often disappointed when I see an exhibition by an artist whose work is strong but who is always making the same work, doing in 1998 what he or she was doing in 1968. I always try to follow the work of artists whose work surprises. I have great respect for artists whose work, even if it is not great, generates uncertainty.

Gerardo Mosquera *A problem in contemporary art is its cult of boredom. For many people, if what they see projected on a screen is boring, they assume it's video art; if it's entertaining, they decide it's probably a film. It is very refreshing that your work, and Brazilian art in general, maintains a minimal-conceptual perspective which expands to encompass a more sensual dimension. Seduction and pleasure are rarely debated elsewhere in contemporary art circles.*

Cildo Meireles In Brazilian Conceptual Art, so linked to sensuality, the limits of the body and pleasure, it is impossible not to think of seduction; there are also, however, political aspects which are rare in art from other parts of the world.

Gerardo Mosquera *Latin American culture has specialized in appropriating, digesting and re-signifying the production of other cultural centres of the world. This is the notion of 'anthropophagy' or cultural 'cannibalism' coined by the Brazilian poet Oswald de Andrade in 1928. In your work and that of other contemporary Brazilian artists this process is reversed. You are making 'international' art in a Brazilian way: your cultural identity is not represented by vernacular or local components, but it determines a different way of making the 'international'. It is an 'anti-samba' art which generates its difference not through representation – the common strategy among contemporary Mexican and Cuban artists – but through action.*

Cildo Meireles I think that this is the best tactic, but I don't want to be chauvinistic about it. I think the notion of 'anthropophagy' is a positive contribution that Brazilian culture can make to the possibility of co-existing with difference. This model of social harmony runs throughout Brazilian culture, despite its historical social and political upheaval.

Gerardo Mosquera *You once spoke of your interest in working with space as if it were a Japanese haiku, a highly condensed short poem. What did you mean by this?*

Cildo Meireles Although I come from a culture which is seeped in the Baroque, I have always been interested in the poetics of synthesis, of condensation. My work aspires to a condition of density, great simplicity, directness, openness of language and interaction. I am not very interested in overly analytical work, because the end result is always murky. I tend to identify and empathize more with works that have a concentrated and simple end result, even if this simplicity is mere appearance. That is how I relate to haiku.

Gerardo Mosquera *Perhaps the clearest example of this simplicity is* Cruzeiro do Sul *(The Southern Cross, 1969–70), a tiny 9mm cube, half of which is pine wood, the other half oak. It is intended to be displayed alone in a large space, demonstrating a kind*

of hyper-minimalism which reduces the work to the extreme of barely being perceptible, yet it simultaneously carries an extraordinary condensation of meanings.

Cildo Meireles For the Tupi people of Brazil, the oak and the pine are sacred trees. The Jesuits translated the divinities they worshipped, the 'Tupã', into a single deity, 'the King of Thunder', when in fact the Tupi meaning was more complex. The trees were sacred because of the friction between them: by rubbing a branch of oak against one of pine, the pine would burn. What was sacred was the knowledge that fire could be produced in this way, as fire was a divine manifestation. Their concept was far more sophisticated than the Jesuit interpretation.

 With *The Southern Cross* there is a symbolic representation, but it can also be read as a political work. My primary approach in this work is poetic. As well as dealing with symbolism, it addresses issues of scale in the art object. By simply being there, it introduces an inevitable comparison with the space in which it is displayed. It will always work that way. Its 'insignificance' opens a dialogue with the cultural hierarchies which position art in the world.

Gerardo Mosquera *These issues are also present in your series of works* Arte Física *(Physical Art, 1969),* Mutações Geográficas *(Geographical Mutations, 1969) and* Condensados *(Condensations, 1970). These projects constitute a kind of conceptual Land Art.*

Cildo Meireles In these works I could never escape from the two strata – one historical and the other extremely physical – that one finds in Land Art. However, I always tried to introduce another aspect, external to the work itself. I dealt with information which was more contextual than Land Art works in which, for example, a straight line is demarcated in a landscape. These projects always related that straight line to a specific location and cultural context, such as Tordesillas, the Brazilian frontier, in *Geographical Mutations.*

Gerardo Mosquera *Tell me about your works with sound.*

Cildo Meireles Sound appeared as a way of working with ideas of sculptural or social space, outside the restrictions of the visual. As a 'sculptural' medium, sound's structure is perceived within the dimension of time. The record *Mebs-Caraxia* (*Möbius strip/spiral galaxy*, 1970–71) was recorded with a frequency synthesizer which translated two graphs into sound. The record *Sal sem Carne* (*Salt without Meat*, 1975) was like a radio 'soap-opera' set in the ghetto. At particular historical moments, part of the population segregates another part into a particular space. When you concentrate anything you increase the internal activity; you increase not only the numbers but also the information flow, which is greater inside than outside, where everything is less compressed. When people are put under pressure, they produce more, think more; ideas appear and circulate and, after a while, the situation of those inside and outside the perceived 'ghetto' tends to get reversed. For example, when I lived in Manhattan, in the early 1970s, I observed how most white,

middle-class New Yorkers could not enter many parts of the city, while black residents could circulate more freely. The whites lived in 'high security' apartments. They were subject to restrictions which mirrored those they had originally imposed on the other group. From this real situation I began to develop the more abstract notion that when you compress something, you provoke an explosion. *Sal sem Carne* looked at this process in Brazil, in terms of relations between various cultures. The record has eight tracks: four for the Indigenous cultures and four for the Portuguese.

Gerardo Mosquera *Another aspect of your work is danger. There are works which are in fact dangerous, such as the 'Fiat Lux' matchboxes in* O Sermão da Montanha: Fiat Lux *(The Sermon on the Mount: Let There Be Light, 1973/79).*

Cildo Meireles Yes, I think that human beings in general are simultaneously attracted and repelled by danger. Children often play with danger. I remember a game from my childhood in which two groups of children sit on different sides of a road and take turns to run in front of passing cars; whoever passes closest to the car wins. No one considers the speed of the car, which could be 10 or 100 km per hour; the only criterion is space. When you survive this kind of game, you see danger as something which is always present. There are other, less immediate, types of danger, when people live in particular circumstances. In *Volátil* (*Volatile*, 1980/94) and *The Sermon on the Mount: Let There Be Light*, the danger exists in potential, in the materials themselves. In the enclosed space of *Volatile*, the floor is covered with a thick layer of ash; the only illumination is from a single domestic candle, and there is a pervasive smell of natural gas. The accumulated 'Fiat Lux' matchboxes used in *The Sermon on the Mount: Let There Be Light* had the potential to create a huge explosion. Danger is a constitutive element in these works. Psychologically, when you come into contact with danger, your senses become more alert: you not only see but feel with greater intensity.

Translated from Portuguese and Spanish by Gabriel Perez-Barreiro

1 Oiticica's notion of New Brazilian Objectivity included: 'spectator participation: corporal, tactile, visual and semantic; … addressing and taking a stance on all political, social and aesthetic issues; a tendency towards collective art; … the re-emergence of new formulations of the concept of anti-art'. Federico Morais, *Panorama das Artes Plásticas, Séculos XIX e XX*, São Paulo, 1991, p. 118

Lucy Orta *Nicolas Bourriaud*

in conversation
July 2002, Paris

Nicolas Bourriaud We met at the beginning of the 1990s, a time when artists were beginning to question art's social usefulness in new terms. Artists such as Krisztof Wodiczko and Christine Hill made works for the homeless, for example. For artists including Rirkrit Tiravanija, Carsten Holler, Peter Fend or even Maurizio Cattelan – all artists who emerged around that time – art was about working well within social reality, not just about finding a means of representing that reality. A debate arose: how can art have a direct effect on reality when it is mediated solely through galleries and the art system? The ambiguity between the actual usage of the work and its aesthetics creates an interesting problem: what part is shaping and what part is operational in these works that 'function'? Let's take for example your work Refuge Wear (1993–96). Is the usage of this work integral to its form? In other words, can we speak of your work as a 'functioning aesthetic'?

Lucy Orta The context for my first work in the 1990s was the economic recession, resulting from the repercussions of the first Gulf War and the stock market crash. There was rampant unemployment, and you could feel the effects of such instability sweeping the streets. I was working as a design consultant for several fashion houses and having some financial difficulties myself. Although I could have remedied them relatively easily by taking on more design contracts, I felt that I needed to become more socially active and work creatively in a new visual medium. I had been assisting my husband, Jorge Orta, with the production of his artwork, which was highly engaged with the social and political climate. Together we had been organizing protests, fabricating objects for his activist gallery shows and initiating the large-scale light projection works for Jorge's Machu Picchu expedition in 1992. Jorge had lived through the 1970s military dictatorships in Argentina and had dedicated his work to exposing the contradictions in society, challenging structures of power and giving new visual forums to suppressed issues.

Jorge was incredibly supportive of my desire to develop a critical and engaged art form that could respond to the growing problems in society. As a result of the research and projects that we worked on together, I created the *Refuge Wear* series. This was the first visual manifestation of my work, and you were one of the first people to see the drawings, as well as *Habitent* (1992–93), exhibited at Galerie Anne de Villepoix in Paris in 1993.

The very first objects I created were shown outside the art system in the form of 'interventions', such as the *Refuge Wear* and *Nexus Interventions* in the Cité La Noue housing estate in Montreuil, east of Paris, or in the streets and abandoned outskirts of the city during Paris Fashion Week. The *Identity + Refuge* workshop (1995) with the residents of the Salvation Army was actually initiated by the director of the Cité de Refuge Le Corbusier shelter in Paris' 13th district; he believed that art had an important role to play inside the social reality of the shelter and totally supported the exhibition, 'Art Fonction Sociale!' (Salvation Army Cité de Refuge, Paris, 1993).

These interventions and actions did not attract any real interest from

the art network in the beginning. I came to the conclusion that I would have to be active in two camps: both 'inside', in the museum and art centres – vitrines where I could confront and debate ideas – and 'outside', on the street. In this way I could engage with 'real life' situations and question the relationship between research and practice without making theoretical assumptions beforehand. My encounter with philosopher Paul Virilio in 1994 was also fundamental to where I chose to position my work. The social reality at the time was demoralizing; I realized that the street was the place to begin asking questions. It was here that the debate was heated and virulent.

Galleries and museums represent just a fraction of an active and complex system that I have put into place with Jorge, and the work functions differently in each scenario. I have initiated an artistic production and a communication medium primarily by fabricating objects, conscious that the forms cannot just represent reality. On the contrary, they should be active, reactive, and also function as catalysts.

To go back to your question about what part is modelling and what part is operational, I try to work on four levels:

1. The work acts as a warning, an alarm bell or distress whistle to signal aspects of reality that the media ignore or simplify, before evacuating it completely.

2. The design innovations and the new materials I employ give the impression that they are operational, or functional. *Refuge Wear*, *Survival Kits* (1993–95), transformable and polyfunctional objects such as *Citizen Platform* (1997) or *Processing Units* (1999) are just some examples. Many manufacturers have approached me to re-appropriate such works into their own production lines.

3. The forms I model are poetic, and they raise questions. They are surprising, dream-like; maybe 'science fiction'. I employ *détournements* and metaphors – after all, they are artworks!

4. Finally, and most importantly, each work or series acts as a release mechanism for a gradual transformation process. To become 'operational', each work triggers another work via a network system of 'acts'. Each object or project forms a link in the catalyst chain.

'Functioning aesthetic': the term seems right, and pertinent. Jorge and I are researching notions of 'operationalibility', and several projects could already be defined in these terms, the most successful being *Opera.tion Life Nexus* (2001). We are developing poetic actions closely linked to human, social and economic developments. We oppose a nihilistic vision of 'art for art's sake'. We are interested in an art form that crosses disciplines, integrating both the poetic and the functional. One of the most interesting consequences of this approach is my nomination, in 2002, as head of a new master's programme, 'Man and Humanity', at the Design Academy of Eindhoven. This is a direct outcome of the transversal projects and theories that we have been researching for several years.

Nicolas Bourriaud *You evoke the nihilism of 'art for art's sake'. Isn't this position similar to that of the Russian Constructivists after the October Revolution? At that time, for example,*

the critic Osip Brik denounced Modernism as a bourgeois and socially useless
art. Couldn't certain non-functional works today indirectly turn out to be more
'useful' than those that specifically aim at social efficiency? In other words, isn't
art always useful?

Lucy Orta Luckily, all points of view are permitted in art, leaving open multiple ways to
invent alternatives according to each and every person's own certitude. What
bothers me in certain artistic intentions is a nihilistic air that often becomes
a pose or a fashion, and the flippancy becomes a social reference. Cynicism
becomes cool. Look at the lack of Utopian vision and the general level of
apathy in youth culture today. Faced with manipulative globalization, how
can one not react? I don't want to respond with a complacent or compliant
work. Art-making is profoundly emotional, an expression of hope, a proposal
for alternative living. It's a life project; it's a commitment with yourself as well
as with society.

In my work I do not restrict myself to ideas of functionality or non-
functionality. Concepts such as 'utility' or 'social effectiveness' are too
complex to be answered in a few words without further debate and reference
to specific examples. I totally agree that non-functional art can be useful,
such as the work of Shirin Neshat, Mona Hatoum, Kendell Geers, Andrea
Zittel, Peter Fend, n55 or Rirkrit Tiravanija. An obvious example in my work
would be the *Nexus Architecture* where fabric tubes act as a metaphor for
creating a social alliance. I try to investigate many different art forms such
as pilot enterprises, object-making, public interventions, interactive websites,
workshops, museum installations, relational objects and educational
programmes; each of these functions in a different way, and can also
be potentially operational in another. The projects have varying levels
of effectiveness depending on the audience addressed.

Nicolas Bourriaud *Most artists seem to consider 'the street' as a metaphoric space, a symbol or*
a backdrop for their social or political preoccupations: the city as a decorative
element. Do you consider your practice to be a tentative move towards
producing a specific urban 'grammar'? How do you organize your work
between the street and the gallery?

Lucy Orta The city is not décor; it is a vital space for interaction and a hub for social
activity, a vector for exchange and an ever-changing scenario in which
I 'intervene', employing new formats. In early investigations, such as the
Refuge Wear and *Nexus Architecture* interventions, I utilized the street in
an investigative manner, questioning the individual's right to occupy public
space rather than becoming subsumed by the architecture. By reclaiming
public space, these projects sought to empower marginalized individuals
and render them more visible.

In more recent public works – such as the open-air fêtes, meals and picnics
– I use the urban geography as a powerful tool to mediate dialogues between
social groups. The buffet of surplus produce served up at the openings of *All*

in *One Basket* (1997) and *Hortirecycling Enterprise* (1999) are a result of my dismay during French agricultural demonstrations. Each year tons of fruit are dumped onto the highways to protest against imported goods. My reaction was to act locally, and direct my demonstration of empowerment towards the tons of edible leftover produce, utilizing the urban players in the Parisian street markets – vendors, clients, passers-by and cleaners – to create micro-community gatherings and discussion forums. The tasty dishes of surplus food prepared by a famous French chef in these public projects led quite naturally to large-scale public picnics and open-air dinners, such as the *70 x 7 The Meal* project in the French rural town of Dieuze (2001), with its 300 m-long table snaking down the main street. The whole town was involved in preparing this project. All demographic, social and religious groups then shared a meal, which assumed the role of social space.

I'm not sure what you mean by 'grammar'; this term would imply to me a controlled set of signs or codes, but I hope that it's more of a fluid language. Perhaps, however, it is a new discourse weaving in and out of different scenarios, moving from the public to the private, crossing over, raising questions, listening to different reactions and building from these responses into a nourishing experience.

Some of my recent concerns are less about the kinds of different spaces than about new methods of creating dialogue, such as the simultaneous workshops in Stroom Centre for the Visual Arts, The Hague, and The Dairy, my project space outside Paris. The workshops brought staff and students from the London Institute, the Design Academy in Eindhoven and the Decorative Arts School in Paris, together with professional artists in other countries. Here, the dialogue affects the actual work in progress, and this is made visible on the Internet (www.fluidarchitecture.net).

Nicolas Bourriaud *Usually, art in public spaces is perceived as the shaping of an intention for the public, more than a real relationship with a real public. Do you have examples of events that took place in the urban space that modified the content of a work, or how you look at it? What have been your strongest experiences with the non-art public?*

Lucy Orta In Florida I worked on a project during Art Basel Miami (2003), which strikes me as an interesting example of a symbiosis between the community, the street, the gallery and the art exhibition. In conjunction with a touring show at the Florida Atlantic University Gallery, we had the intention to develop the audience and education programme in a new direction, creating new links using the geography and the dynamics of an international art show. I installed *Nexus Architecture x 110* (2002) in a temporary gallery – situated in a central exhibition site in the Miami design district – 60 km south of the University Gallery and we orchestrated a series of projects for both the community and visiting art viewers. The installation is made up of 110 tiny overalls, suspended from the ceiling. Hundreds of children were contacted from different social and geographic zones around the county; with the help

of educational staff and volunteers from the museum we engaged the children in a series of workshops to discuss notions of dialogue and connection. The suspended installation – without the small fragile human bodies – is a powerful image for connection, but the work took on a whole new meaning when hundreds of children come together from all over the county to inhabit the work. The image and the power of the two concord projects – the installation and the workshops – has set in motion a process of forging new community links for parents, educational staff and art visitors, and these links can be built upon even after my work has gone.

When the work evolves beyond the initial parameters it is an incredibly moving experience. *Identity + Refuge*, which I mentioned earlier, was a pilot project to engage Salvation Army residents, first in Paris and then in New York, in a series of creative workshops that would assist them in coming to terms with one of the many problems they face, that of identity. My brief was to deconstruct, transform and reconstruct the surplus clothes from the Salvation Army thrift store into more personalized garments without discarding anything. This process of revealing new forms, without changing the content, nurtured the confidence of the participants in a sustainable manner. These were the initial theoretical assumptions underlying the project, but only when working alongside the residents did *Identity + Refuge* really take form, and the results reached way beyond our expectations.

In *Identity + Refuge*, after a very difficult start coming to terms with the despair and lack of self-confidence of some members, I changed direction and brought in fashion magazines and young fashion design students. This unleashed a new set of dynamics between the individuals and the groups; the laundry where we were working became a dynamic hub that resonated throughout the hostel. The project transformed some of the participants' self-perceptions, it redefined my practice, and after our experimental catwalk show, which received major media coverage, hopefully altered the general public's misconceptions about the Salvation Army hostel itself.

The initial intentions of the enterprise were never realized and the project is, effectively, unfinished. It will be completed, perhaps, when this kind of pilot enterprise becomes a functioning business proposition and can really contribute to assisting marginalized people to re-engage with society. A discussion I held with an art critic after the event perturbed me greatly; he simply refused to believe that the Salvation Army residents had the capacity to project beyond their present state and achieve results. The video, the photographs and the twenty-four outfits produced have been re-interpreted by many fashion designers since then and still remain a pertinent legacy to 'functioning aesthetics'.

I recently edited the sound recordings of the *Nexus Architecture* workshop held during the 2nd Johannesburg Biennale (1997). Even though the discussions are in Zulu, Xhosa or Africaans, the verbal gestures are so emotional that they transcend the premise of the workshop. That work

resulted from a site visit I made to Johannesburg prior to the Biennale. I visited the Usindiso women's hostel, located on the opposite side of the city to the exhibition venue. Between these two poles, thousands of micro communities live on and from streets – streets that no white person dares to walk. My initial instinct was to link the city symbolically, as well as physically, by drawing the women living in the hostel into the exhibition space with the work *Nexus Architecture*. A couple of weeks before the event I recruited women to form the core of the workshop, which was to be installed in a worker's library adjacent to the main exhibition hall. They were supposed to be skilled labourers, but the community was so desperate to work that I took on unskilled women as well and trained them to be totally autonomous. Each woman was able to cut, sew and assemble an entire suit, rather than being a segment in a production line, dependant on the non-existent factories and rampant all-male unions. By the end of the workshop each participant could produce beautiful *Nexus* suits, and the women kept the templates complete with the social link, the tube that joins the suits together. I had insisted that the garment could be manufactured for sale on the street without this umbilical element, but the women were adamant, claiming it was the most important part of the design. The proof was the public intervention that we staged for the opening of the Biennale, which formed a defiant chain linking the city and exhibition venues, with passers-by, children, men and teenagers tagging on shoulder to shoulder. The women began spontaneously singing an improvised chorus version of *Nkosi Sikelel' iAfrica* (*God Bless Africa*), which stopped everybody in their tracks and resonated so powerfully. This song had been outlawed under apartheid. The songs, hymns and rhythms chanted by the women were extremely poignant and epitomized the social and political climate in the new South Africa.

Nicolas Bourriaud *Let's talk about experiences you have had with cultures other than your own. In my opinion there is no absolute beauty, rather there are situations that generate different ratios of activity and thought. A work of art in a certain context could be insignificant, dull or repetitive; in the same situation another work could raise a whole new set of questions.*

All aesthetics are circumstantial. We shouldn't look for a global aesthetics in a false universalism or a patchwork of specifics, but rather in the study and the discussion of circumstances, what could be called 'jurisprudences'. If I condemn political repression in a given country, I start from a set of universal values. I believe that the rights to democracy and freedom of expression apply to all the human beings, whatever their cultural tradition. Do you think on the contrary that absolute values exist?

Lucy Orta I totally agree that we should not globalize aesthetics, nor look for absolute beauty. Each person and culture has individual values, beliefs and knowledge. Unfortunately even though absolute beauty does not exist, a universal aesthetic has already been imposed by more dominant cultures and, for the

most part, has been assimilated by others resulting in a severe loss of their traditional cultures. A small example is my experience in Johannesburg. The yellow and purple 'raincoat' *Nexus Architecture*, which travelled to South Africa, was at first far more appealing to the Zulu and Xhosa women than the West African Dutch wax print Kangas that I bought in the local market. Initially I regretted that I had not brought the 'white man's raincoat' fabric with me. It was only when we began experimenting with printed fabric associations that the women were able to personalize their expression and rediscover an aesthetic that, although it was not all their own, they could identify with.

The loss of cultural identity and a dominant aesthetic are things I oppose, and this stance is fundamental to my postgraduate programme Man & Humanity at the Design Academy in Eindhoven. The first assignment for our students is the development of a new 'global' awareness devised around an eight-week design period in a developing country. Here we coach our students through the experience of working together with the local population – artists and artisans – before we even consider what aesthetic could be 'exported' for Western consumption. The students gradually re-define their notion of beauty by living alongside the people they are working with, and discovering their skills, images, textures, gestures, smells and tastes; most importantly there is an exchange of emotions. As with all new experiences, the difficulty is in discovering how to transform these sensations into ideas that can be brought back to the West. When re-situating or re-enacting that special experience in a totally different context, the viewer – or in the case of my students, the customer – is not attuned with a capacity to project themselves into the original situation and often does not even have the time, or the will, to do so. So yes, there is a great need to discuss, and also to act, in a way which opens windows to other cultures, increases awareness of the poverty of spirit in our own lives, and educates us through the beauty of experiencing others.

Connector Mobile Village (2000–03) and *Collective Dwelling* (1998–2003) are examples of 'templates' that I use as a basis for initiating dialogues and stimulating awareness on a small and intimate scale with very diverse cultures and age groups. Over the past three years well over twenty groups have participated in the *Connector Mobile Village* project. The participants have come from far afield and from culturally diverse locations. They have included young children from the Metropolitan Ministries Care Center in Tampa, Florida, and art and design graduates at Mushashino Art University in Tokyo. The *Dwelling* workshops have been running for five years and ten groups have been involved world-wide, including teenagers in Sydney, unemployed adults in Glasgow's notorious Gorbals estate, and young design students at a Design Camp at Minnesota University. The participants can investigate the idea of a collective membrane that envelops each person's body, yet forms the walls of a larger enclosure. Although the workshop briefs

in both of these projects are common to all the participating groups and the methodology for the investigations conducted are the same in each location, each person is encouraged to express their individual identity and culture through various mediums. The children with whom I worked on the Lower East side in New York, for example, live in an amazing multi-ethnic community and in their responses this is expressed through colour associations, use of bold patriotic cultural signifiers and a fascination with branding and logos. In the same way the Glaswegian adult groups could transpose opinions and ideas inspired from their social and cultural heritage, such as a coat of arms, or designs related to their daily activities. In Freidrikstad, Norway, the response from the teenagers differed: an Iraqi refugee depicted a helicopter bombing a city and a local Norwegian talked about mythical emblems and symbols of cultural importance. Many of these signifiers are perhaps not obvious at first glance and the unusual compositions are fully understood only when explained. I merely give groups a framework for their ideas to become visible.

Beauty is circumstantial; an example would be the *70 x 7 The Meal* project for the rural town of Dieuze in the northeast of France in 2001. Jorge and I took up the proposal of the director of the local Maison de Jeunesse et Culture (Youth Club) to unite the all inhabitants of the sleepy town. We believed that the *70 x 7* picnic meal could succeed in bringing disparate communities together, and that Royal Limoges Plates would be worth the costs of production despite resistance from a local association. We were not sure if the artichoke design on the plates would 'please' the inhabitants. However, the hard work of contacting each and every citizen, along with their personal contributions to the design of the plates, resulted in the successful sale of over 750 plates on the day of the picnic. I can imagine these plates now hanging above fireplaces in Dieuze and that they probably do not resemble any other design motif in the house. The circumstance of the meal evidently moved the inhabitants, and the memory and emotion of the event is conveyed through the object.

A more personal experience would be the unforgettable expedition to Peru in 1992 with Jorge, to realize his project to paint the Andes Mountain range with light for the 500th anniversary of the discovery of the Americas. Before leaving we filled the projector fly-cases with pens, pencils and exercise books for Peruvian school children. A sponsor had donated shirts to the team and hanging from each shirt was a tag filled with confetti. I instinctively kept for the children the tags that Jorge had discarded so as not to be too encumbered during the arduous trip. On the journey from Cuzco to Aguas Calientes local children clambered on and off the train. As well as the school books, we gave out the tags to as many children as possible. I have never seen such awe before. Confetti, which is used during ritual offerings, is a rare commodity in the rural villages. These insignificant minuscule, multi-coloured paper discs were an offering from Heaven. More transfiguring experiences followed

throughout our expedition and culminated in the light projections in Cuzco for the Intiraymi festival. We had already inscribed many Inca monuments with Jorge's light symbols over the weeks of the expedition. A statue of Christ nests in the valley about 1 km from Cuzco, the colonial citadel. As the light projectors panned the city, one of the technicians accidentally changed their light to a stroboscope effect; what happened next was beyond anything we had imagined. The beams struck the statue and that immediately began an incredible ascent to heaven. The thousands of Peruvian Indians assembled in the main square were witnessing a miracle. No project since has moved an audience to such an extent or left me as incredulous. These are rare moments that are lived in a personal and divine way.

You cited universal values in a political context, values that save human lives and strive for liberty; these are dominant values, we should be sharing them and striving to implement them. It is too difficult to define absolute values, because values correspond to the human condition and are represented by current thinking. Each era has values, and we should continue to elaborate and re-define them. The more we progress, the more values should evolve. These values should transcend our beliefs, our thoughts and what we have built, like human rights. Values should be universal, respect life and combat repression.

Raymond Pettibon *Dennis Cooper*

in conversation
May 2000, Los Angeles

Dennis Cooper *As a writer myself, I'm curious about your relationship to literature. Since language and visual imagery seem equally important in your work, I'm wondering if one interest preceded the other?*

Raymond Pettibon Literature was originally and probably still is just as important to me as art.

Dennis Cooper *Do you read a lot of fiction and poetry?*

Raymond Pettibon Mostly fiction, some poetry. But I haven't read much poetry in the last ten years.

Dennis Cooper *Did you ever want to be a writer in the traditional sense?*

Raymond Pettibon I was never really much of a writer. The first things I ever wrote to any extent were related to my artwork, and I still don't write narrative fiction *per se*. My longer, non-art pieces are usually screenplays related to my videos.

Dennis Cooper *Do you think of your work as a response to literature?*

Raymond Pettibon In the beginning, yeah, it was. To trace it back distinctly, I guess my first artworks were cartoons, and were a response to cartoons, also. It's kind of a subtle line between that and what I do today, but, in another way, it's quite a dramatic line to have crossed. From a distance, the average work of mine might resemble a cartoon. But there was a specific point where I think I crossed over into something else.

Dennis Cooper *Were the associations you made between language and imagery always poetic, even when you were making more traditional kinds of cartoons?*

Raymond Pettibon No. The ideas always came out of reading, and they were kind of between the lines, or suggested. It's kind of like swimming in words and letters. I place myself in this state of consciousness where I'm receptive to associations and stuff. Rather than quoting, as I have in the past ten years, they originally were more like responses than quotations. But they always had to do with reading things from the world at large – media, television, music, books – rather than being personal or anecdotal.

Dennis Cooper *Were image and writing always associated for you?*

Raymond Pettibon Yeah. Sometimes I wonder about the possibility of aspiring to the image alone. I've done that before, but not really successfully. Even when I do, it usually has some kind of narrative drive to it. Sometimes I can dispense with the image and use only language. I probably do that more often. But even that's fairly rare, I suppose.

Dennis Cooper *What about illustrated literature? You know, children's books – the Dr Seuss series, for example – or adventure novels that use illustrations selectively? I'm sure you read them, like every kid does, but did they have anything to do with the development of your work?*

Raymond Pettibon No, no. I think there's a big difference between illustration and what I do. I just don't have either the aptitude or the interest. There are illustrators

whose art is reliant on draughtsmanship, drawing what the writing describes. That kind of thing doesn't really do it for me. I think it's just a way to break up the page. I don't think it's really ever done successfully. I'm talking about the kind of illustrations you find in a Mark Twain or Robert Louis Stevenson novel, where there are half a dozen illustrations interspersed. Children's literature, comic books, books where it's clear that image and language were born in combination, those are different.

Dennis Cooper *Comic books can be such a beautiful wedding of the two.*

Raymond Pettibon I never read comic books until I was in my late teens, and they were a way to learn to draw. I saw them as an extension of film; cartoons basically meant Disney at the time. I've done comic book type stories, and they're something I'd like to do more. There's no reason why you can't deliver as good a work in that medium as in any other. Comics are just kind of debased by the nature of their audience.

Dennis Cooper *Did you come to the comic book clean, the way most kids do, or were you already familiar with Pop Art's recontextualization of the comic?*

Raymond Pettibon Yeah, I was. But I think I had an opposite view of comics than most of the Pop artists did. Lichtenstein might treat the comic as this Americana type of detritus, and see art as a kind of archenemy of the comic book. I think the medium itself is as legitimate as any other. That's not to say there's much that's ever been done in the comic book form that's that great.

Dennis Cooper *How do you rate underground comic artists like Robert Crumb or Spain, who some see as fine artists working within that form?*

Raymond Pettibon I don't know. I'm not comfortable about drawing a line and making a distinction. I guess it's just a personal thing, more of a matter of taste than empirical study. I think there are people who've done comics whose work doesn't have to be treated with indifference. Crumb is not my line, but I don't think the underground comic has to be justified by its closeness to fine art.

Dennis Cooper *I'm harping on the comic book not because I think that point of comparison is an interesting way to enter your work.*

Raymond Pettibon I don't think so either.

Dennis Cooper *But it's not an uncommon point of comparison in the writings on your work. I don't necessarily think literature is the best way to think about your work either. But those two angles seem to spring to critics' minds most frequently.*

Raymond Pettibon If my work is judged based on how it stands up next to comics, then it's pretty thin. My skills as a video artist or as a draughtsman aren't things I need to brag about. To have my work discussed in those terms, well, that's kind of ridiculous. And in terms of literature, it's not just the quality of the language

I use either. My work's not literature. It may be a combination, but it's something completely different than either comics or literature.

Dennis Cooper *One of the things I really love about your work is how you get images and language to collude and collide. It just astonishes me how you do that: they cancel each other out and complement one another simultaneously. Their relationship is so strange. I know that you probably can't isolate exactly how or why that happens, but can you give it a shot?*

Raymond Pettibon I've been doing it so much and for so long now that it's starting to become a formula, or could be if I let it, which is something I hope I escape most of the time. But, you remember, I did like half a dozen works based on your fiction and poetry. So maybe you could trace that back, because that's almost a demonstration of my process.

Dennis Cooper *I'm not sure I can. All I can say is that you created associations that felt as though they were abstracted off decisions that I'd made. They seemed completely connected with decisions I had originally made when writing those sentences and phrases you chose, but they were associations I would never have been able to realize in language alone; they were kind of stillborn in my subconscious. In my writing I'm interested in the ways language can transcend the fundaments of language and function musically – syllabically, rhythmically – as well as conveying content. I felt like you were responding to that duality, and maybe felt an association with that aspect of my work, which of course excited me.*

Raymond Pettibon Yeah, my work is about making associations. You could probably write a computer program to do that. I mean, that's actually been done. But there is an original sense of perspective lacking there. I think when my work is successful … well, one of the only standards I use is to look at the image and consider that this is something no one else in the world could have come up with. There are great *New Yorker* cartoons I'll see and wish I would have thought of first, but, really, it's the work that makes you say, this is something I couldn't have done in a million years. That's the work I try to talk about and do.

Dennis Cooper *Do you ever feel uncomfortable or restricted by the art world, the gallery and museum context? Because you came into art by a really unusual route. Growing up in LA, and being part of the punk scene in the late 1970s, I first saw your work in zines, on flyers for concerts, and on album covers by bands like Black Flag and Minutemen. Those are pretty much oppositional contexts.*

Raymond Pettibon Showing in galleries doesn't bother me for a number of reasons. For one thing, it's more about social conditions and economic relationships. The minute I was working in what I consider to be my mature style, which is from 1977 on, I considered my work as art, as much as any artist showing in galleries at that time. There's nothing I had to apologize for. My work never had anything to do with illustration, or commercial art, or advertising. The

fact that some of my drawings were used for record covers or advertisements doesn't matter. They were never done with that context in mind.

Where my art is shown is pretty irrelevant to me. It's nice to have an audience, but it could be just one or two people. That's a cliché, but there is a lot of truth to that. I'd love to do more artwork that's pasted up on telephone poles, that sort of thing. I've planned on doing that for years and years, but I just haven't gotten around to it. I still do books sometimes. In some ways, I did prefer those ways of showing my art to showing it in galleries. It's not because of the nature of the work that I say that, it's just, like I said, more about my attitudes in general. At this point, it would just mean more to me to go outside this frenetic gallery system where you're preaching to the converted. It's a very small world.

Dennis Cooper *The books are obviously a way to get around that.*

Raymond Pettibon Yeah, and my work lends itself well to reproduction, usually. But it's true that my case is not recommended for anyone going into the art racket *(laughter)* because I think it's very unlikely for anyone to make it without going through the university mill. And it's not something I would recommend to art students, to get themselves out of there. In a way it's kind of unfortunate that the gallery system is so defined. It does affect the ways I think about making art. When I was first making art, the gallery system wasa lot different than it is now, this kind of blue chip thing it's become. And you know, I don't want to take too much credit for it, but I think my work has helped open things up. You see a lot more drawing shows now, and there's more of a mentality in the galleries that it's possible to sell a number of smaller works by an artist, rather than expecting collectors to buy a single blue chip painting or sculpture.

Dennis Cooper *Nevertheless, you're a rather unique case. You're somewhere between an artist like Mike Kelley, who works exclusively in galleries and museums at this point, and someone like Mark Gonzalez, who shows in galleries, but is essentially a street or populist artist.*

Raymond Pettibon Yeah, well, for every artist like Mark Gonzalez, there are a trillion bad museum artists, and for every Mike Kelley, there are a trillion bad street artists. So I don't want to necessarily encourage anyone to think that there's this big reservoir of great undiscovered street artists out there, because unfortunately that's just not the case. Mark Gonzalez is an exception, and I was too, I guess.

Dennis Cooper *I want to ask you a little more about the art you made that wound up adorning those punk flyers and record covers. You're saying that the artwork was not in any way inspired by the music?*

Raymond Pettibon No, except for one or two cases where some knucklehead would come to me and say he had this great idea: 'Oh, you've got to do this!' And sometimes, just

because of friendships with the people involved, I'd use the idea. But if I did a record cover, I preferred to do the whole thing without any strings attached, and it still wouldn't necessarily be an illustration project, even in that case.

Dennis Cooper *Is your early association with punk rock a red herring? I mean in terms of reading that period of your work? At least in shared attitudes, I feel like there was an unusual compatibility. But then your work's ubiquitous appearance on flyers and album covers in the late 1970s did a lot to define punk's image.*

Raymond Pettibon Well, I've never been a musician, so I never felt restricted by the association with punk. I don't know if my art was really affected by punk. I never thought much about it. But in a way there was the quality of the music that came out of punk – and I think there's some pretty big stuff, especially considering the times. Just in that way it might have affected me, like it affected a lot of people. But it's like what we were saying about the gallery scene. Punk had the same kind of institutional framework, in a more slothful way. Still, the art world doesn't have that do-it-yourself kind of thing that punk had at its best.

Dennis Cooper *There's certainly some relationship there. As an artist, you're the embodiment of the do-it-yourself ethic.*

Raymond Pettibon Yeah. But back in the punk days I pointedly avoided contemporary references. My depictions of the nuclear bombs or hippies or whatever were references from the 1960s and 1950s. The first time I ever did a drawing about punk was after the fact, in the late 1980s. But that's really beside the point, because I'm not a topical artist, and I usually maintain a historical distance from my subjects. It's just a kind of a guilt by association thing, but it's not about guilt. It's like the same thing with comic books, or illustration, cartoons, rock album covers. It's a knee jerk response to the company I happen to keep. That's what 99 per cent of people are reacting to. That's not a battle I want to get into. I couldn't care less, it's just such a waste of time. Whenever I'm asked to talk, everyone wants to talk about rock 'n' roll. I'll do that if I don't have to bring my art into it. It just shows the obsession that society has with rock music and rock culture, nowhere more so than in art.

Dennis Cooper *Change of subject, then. Do you have any particular interest in other contemporary artists who use language in a meaningful way in their work? Say, Lawrence Weiner or Jenny Holzer or even Sean Landers?*

Raymond Pettibon I like all three of those artists, but I think more has been made of the association between artists like that and myself than is really worthwhile. Over the years, there's been kind of a bias, a kind of anti-literary bent to a lot of contemporary art. At times, it can be almost scandalous. That's wishful thinking more than anything else – to write directly on to the canvas. But purely abstract art can have titles that are very poetic, and sometimes that interests me a lot. There's always been a literary element in art, but it's not necessarily at play in the work of artists who use language in an obvious way.

Dennis Cooper *I guess what I'm getting at is whether you feel any kinship with visual artists who work with language in an overt way?*

Raymond Pettibon A kinship? That's not easy to answer, because you're talking about an emotional response. And I can honestly say that when I look at their work, I don't feel an association. I see a lot of art using language as just a way of playing with the public, using language as a way to stick in little clues. That's not something I do or care about.

Dennis Cooper *Obviously, emotion is a determinate in your work. Or, I imagine that because I often have a strong emotional response to your work. Are there emotions that you find more inspirational or easier to translate than others?*

Raymond Pettibon Actually, I really want to disagree with the idea that there is much of an emotional spring to my work. I'm sure there are further and more distant artists than myself, but I think, for better or worse, that I'm on the outside in a way. My art just doesn't come out of emotion. It doesn't really draw up that much heat, personally. Partly that's a reflection of my personality, I guess.

Dennis Cooper *But when you use language, it seems quite clear to me that you're often addressing or redressing an emotion, whether it's your emotion or not. I'd go so far as to say that the majority of the phrases and sentences in the work I've seen of yours delineate emotional states – sadness, hope, fear, the ecstatic. You're saying that is a purely formal decision?*

Raymond Pettibon Yeah, I've always considered it more a formal thing. I think this goes back to one of your earlier questions. If my work was coming out of an emotional source, then you should be able to read it as autobiography, and it's not. It's an extension of my art that it lets people read into the feelings it talks about. The fact that I'm not and never was a raving punk rocker is a case in point. In some ways, I've consciously been thinking of engaging more politically in my art, and going beyond just the formal exercise in that way, but that's a different thing.

Dennis Cooper *Politically, in what sense?*

Raymond Pettibon Well, I don't mean that my goal is to influence people. I don't mean propaganda in that sense, because I don't think that kind of influence is possible. I don't really know. It's just something I'm thinking about.

Dennis Cooper *So if I have a largely emotional response to your work, is that an incorrect response?*

Raymond Pettibon No, of course not. I'm just saying that the intentions of the artist are irrelevant. I mean no one, to this day, knows who Shakespeare was. But that doesn't really matter.

Dennis Cooper *This might be a difficult question to answer, but when you appropriate lines and phrases from literature, what is it about a particular writer's work that*

causes you to want to borrow and transform his or her words? If it's easier to speak about a specific example, how about Henry James, whom you've quoted quite a lot.

Raymond Pettibon I don't know how successfully I could answer that. To take a writer like James, he writes these really meandering sentences that are part of the novels' narratives, but when you do a kind of dissection of his writing, and take it out of context, there's something going on in the sentences on their own. Sometimes these fragments appear that are not just parts of his sentences to me, and seem to tell me something else, something specific.

Dennis Cooper *So when you read, say, a Henry James novel, I assume you don't read it in a way a person on a plane reads it. I assume you're always thinking about the language and how it works.*

Raymond Pettibon Yeah, I don't get lost in a novel in the sense of getting lost in the narrative flow. That's something that you lose. Like when a filmmaker watches a film, he's always thinking about how it was put together, edited and framed, and the same with musicians. I've known a lot of musician friends who've lost their ability simply to listen to music. They become very hypercritical about the quality of the recording, and the parts are dissected as they listen. So, yes, I've lost that ability. I guess that's a reason why narrative *per se* doesn't really interest me any more. I can't just read an adventure story or whatever. Like reading the newspaper, I used to read the whole paper, and it would take me a few hours. Now I read it looking for things for my art – not that I read it in the same way I would read literature that affects my art. Journalism is something I just shut off from my creative mind. But I guess my mind and my eye were trained over the years, so even now it becomes a kind of mechanical thing, where the eye just goes at this slow pace. But I think maybe it's not some particular stylistic or formal thing that decides why a certain writer becomes a part of my art. It's probably just that there are some writers I like to read, and who engage me to be a part of their life. That's probably what it comes down to more than anything. You know I put together that anthology of writers I like,[1] but it wasn't a definitive collection.

Dennis Cooper *It wasn't your canon?*

Raymond Pettibon It wasn't a hierarchy, yeah, it wasn't my canon. It was a collaborative thing. Actually, it was a real down. The end result really didn't have much gel, inner coherence, as a record. It's just an anthology.

Dennis Cooper *I think some people view that anthology as a kind of instruction manual to understanding your work.*

Raymond Pettibon Yeah. There are a number of works in that book that do describe what I'm doing, some more than others. It's kind of self-referential, in that sense. But I put that book together more out of a sense of humility than anything else, probably. You know, as a tribute.

Dennis Cooper *My sense is that people in Europe generally read more, and are just generally better read and more well-educated than Americans. Do you find that there tends to be a better or more accurate response to your work in Europe?*

Raymond Pettibon Actually, well, yeah. It used to be pretty glaringly obvious, or at least I thought so. But then 90 per cent of the Europeans who I've had any detailed discussion with about my work spoke English as a second language, so … I think if there's more interest in my work in Europe, it's because there's just been a shift in the art world at large towards Europe in the last ten years or so. Especially towards Germany, I think.

Dennis Cooper *But you don't find that people bring up literature in relationship to your work more often in Europe and that, as a consequence, the understanding of what you're doing is more thorough?*

Raymond Pettibon Well, it's true, they do. But I'm kind of hesitant about getting into that kind of psychology of bashing your home town and feeling unappreciated, because it's really not like that.

Dennis Cooper *But you read a lot of literature, and literature is deeply involved in your process, so it's natural to assume that the discourse around your work might interest you more when it's coming from people whose reference points are similar to yours.*

Raymond Pettibon Well, yeah, you're right, although it's not something that I've dealt with directly that much. It's not like I'm going to be sitting over a conference table at some literary art café society talking about the fine points of art and literature. But there definitely is a kind of bias in Europe that interests me. On the other hand, I'm not a prophet of doom saying that America is on its way to illiteracy. There's probably more good writing now in America than ever before, but maybe there's just not as much of an audience for it.

Dennis Cooper *What would be the ideal response to your work? I mean if a kid says, 'Oh my God, I love these drawings. They're so fucking cool. They're the best art in the world!' Or someone has a very erudite analysis of your work based on an informed idea of its relationship to art history. Is one or the other of those responses more pleasing to you?*

Raymond Pettibon It's not something I dwell on. There's not so much of this common response feedback relationship in the first place. But, yeah, of course there is an ideal response, but I don't know if I can nail it down exactly.

Dennis Cooper *It seems to me that it would be entirely possible for someone who knows nothing about contemporary art to have a really profound response to your work that would not be an inaccurate response. Say someone who might respond to it viscerally, as a kind of poetry.*

Raymond Pettibon Yeah. But I think if someone is completely illiterate, then obviously he's going to be missing something. An absolute moron is going to be getting a little bit more out of it maybe. I'm not above making what I guess we'd call in-jokes or allusions to art or literature in my work, and knowing those references might

add something. There are a lot of things going on in one drawing, at times. Obviously, everyone is not going to get everything. I don't expect them to, and sometimes there might be a personal allusion that I'm not expecting anyone to understand. A lot of times I think my work's getting across when I know someone's laughing. That's something that's nice. Maybe that's my ideal response.

Dennis Cooper *Certain images and motifs return again and again in your work. There are obvious examples, like Superman or Vavoom or Charles Manson, who appear frequently for a few years, and then disappear. Then there are more general themes, say surfing and baseball, that seem to run throughout your body of work.*

Raymond Pettibon Yeah. Well, I think any particular image that I've used over and over again was born for the first time every time I used it. It's not connected to the earlier usage. There wasn't some grand scheme of things. For whatever reason, I just started from there again, and had plenty more to say on the subject, I guess. There's a thing that happens. I guess you could use the term snowball. There's a snowball effect. But I'd have to speak to each individual image I've drawn to speculate on reasons why some of them repeat.

Dennis Cooper *Okay, then let's say surfing. On the one hand, you're a Californian who grew up and lives near the beach, so the association is a natural one. But at the same time, there's an almost utopian quality to your surfing and ocean imagery, as though the idea of surfing was more of a dream than something readily available to you.*

Raymond Pettibon I don't surf much any more, but I grew up with it. I was never a card-carrying surfer. But yeah, some of the motifs I use, like surfing or baseball or drag racing, I do have more of a passive relationship with them. But that doesn't mean there's a longing. There really isn't a personal relationship there that explains it.

Dennis Cooper *So the fact that you live near the beach, and have surfed, is completely unhelpful in explaining the recurrence of this imagery in your work?*

Raymond Pettibon Yeah, these really aren't obsessions of mine. I could do a thousand drawings of a certain thing, and that doesn't mean it's more important to me. On the other hand, there are things that interest me about surfing or baseball, more so than other sports, and that's a factor. But that really doesn't come back to me so much. It's not personal.

Dennis Cooper *So, in the case of surfing, it's that you find the motif multiplicitous on a formal level, essentially?*

Raymond Pettibon Sometimes it is a visual interest, but it can also be the way something like surfing describes a society, and the people in it. I've done a lot of large drawings and prints of that imagery. It has that epic nature, that sublime nature, that almost asks you to reproduce it full sized on the wall. So there are some images where I have reasons like that to do them again and again.

But with something like Batman and Superman, for instance, they represent a lot more to me than Operaman, for instance. There's a reason why I'm going to use them a lot. It's what they represent to me.

Dennis Cooper *Do you see them as a way to critique American values?*

Raymond Pettibon A lot of times, yeah. Or I draw the train a lot, for instance, because it's a metaphor for a frontier, I guess. I mean not always, but there are some images that are useful in that way, to represent something general and pervasive.

Dennis Cooper *Images of Charles Manson function in that way too, I imagine.*

Raymond Pettibon Yeah, I mean I'm not a disciple of Charlie! But that's usually just assumed. Charles Manson is not a personal obsession.

Dennis Cooper *Charles Manson has a general meaning as the ultimate evil, insane criminal who also helped destroy hippie culture. He also has a hipster meaning as the ultimate, anti-society, amoral hero/philosopher. There's a lot to play with in him, and a lot of predetermined opinions about him to play off of.*

Raymond Pettibon Sure. Manson is a kind of shorthand. I guess if you had a whole book, a whole series of images to work with, then you could create your own character like Manson, invent your own cult leader, and invent activities and stuff around him. But Manson already comes with all that baggage, so he's really useful.

Dennis Cooper *Do you think there's a comprehensive linear narrative running through your work? If one were to take all your work, and display it together chronologically, would there be a revelation, a larger meaning revealed?*

Raymond Pettibon I've thought about it. There wouldn't be any direct line. I'm not a stick figure, a cartoon figure, and my work doesn't reflect that. I don't think that kind of display would really reflect back on me. But sometimes I think you could look at my work and learn a great deal about American society. That's not really what I'm attempting to do, and that's verbal psycho-storming a work. But that has its own interest, too. So I think you could line up all my drawings in order, and think about them that way, but it would still be a tortuous, meandering line.

Dennis Cooper *What about taking all of the drawings you've done about, say, Batman, and lining them up?*

Raymond Pettibon In order, from when they were drawn?

Dennis Cooper *Or not. Just isolating that work, either in a display format or in a book. What do you think would happen, if anything, to the work, or to our understanding of that work?*

Raymond Pettibon No, I don't think anything would happen. If I wanted to do that, I would do new work as either a comic book type narrative, or I would do it as a sequence, or as a film or video, which I've already done. I have written a Batman screenplay.

Dennis Cooper Has it been filmed?

Raymond Pettibon No. I don't have a lot of spare time. It's been a long time since I made a video.

Dennis Cooper Are you still interested in making videos?

Raymond Pettibon Yeah. It's just whenever I get around to it. The directing part of it, I don't mind. The writing part of it is fine. But I guess what you'd call the producing angle, the people working together, that's hard. There are just so many asses. That's not something I'd look forward to doing again. I'd almost just as soon write a script, let it exist as a script, and leave it at that.

Dennis Cooper Have you considered publishing a collection of the scripts?

Raymond Pettibon No. Because there's really no good reason not to shoot them. Publishing them would be kind of like giving up. It's either meant to happen, or it isn't, but it's not something I'm going to force.

Dennis Cooper To my knowledge, the last video you made was The Holes You Feel *back in 1994, about John Lennon and Yoko Ono. It was never completed, right?*

Raymond Pettibon I did an edit, and it was shown once in that form.

Dennis Cooper I was at that screening, at Brian Butler's old project space in Santa Monica. My sense was that what you showed was a very rough edit, and in no way finished.*

Raymond Pettibon Yeah. Well, OK, that's a perfect illustration. It was such a disaster making that video. The dick who was supposed to play John Lennon just purposefully disappeared half way through, and the video was already set to screen on a certain date. It used to be I'd make videos in a couple of days, no problem. But under those circumstances it was ridiculous. But I'm going to do something with it, and finish it.

Dennis Cooper You definitely should. It had some fantastic things in it.*

Raymond Pettibon Yeah, that's a problem. It had some of the best performances I've ever got. Frances Stark was so amazing as Yoko, and everyone else involved in it was really great. The best thing would be to get those people back again and do it over, but I don't know. I probably should just release it as it is. I'm not a perfectionist anyway when it comes to those kinds of boring attitudes, and I think the blanks and mistakes have a way of reaching the audience, and doing something interesting.

Dennis Cooper Do you have any thoughts about the difference between the way language works in your drawings, as opposed to the way language works in your videos? Do you see the way you use language in the videos and in the drawings as different processes?*

Raymond Pettibon Not consciously. In some ways, the drawings can have a lot in common with something like the video format, because, in a way, they both imply at least sort of a beginning and maybe a past and a future in a way. But on the other hand, for whatever reason, some subjects seem to assume that I need to write

497

a script. I do like to write dialogue, although there's a lot of dialogue in my drawings also. Some drawings start with maybe one line and grow. It's not as if that if that one line doesn't work, it's a loss. It doesn't mean it might never be a perfectly realized, finished work, potentially. Sometimes I'll just end up covering the whole drawing with finely inscribed words. In that case, there are a lot of similarities between the two forms, sort of in the same way that comics have so much in common with jokes and storyboards, and how comics can be fairly indistinguishable from each other.

Dennis Cooper *You've never worked in photography, right? Off the top of my head, that seems like the one medium you haven't worked in.*

Raymond Pettibon No. I have considered doing that. It's just that I'm technically into other things. There's no real reason why I haven't. A lot of my work could function just as well if it was photography. Maybe it's like the problem with the videos. It's just that working the way I do, doing the drawings, just seems to be right most of the time, because it's just me. It's not to do with anyone else. I'm really so, so undemanding as far as control goes, in that way. But there's a kind of psychology that a lot of people have. The more freedom they get, the worse they can handle freedom. It's just easier, so much easier to do things on my own. That's what's great about being able to work in this manner. I'm not responsible to anyone else. You know I write songs too, and it's so hard to get them recorded, because there are so many people involved in doing that. As I said, I'm not a perfectionist. I don't care about technique, practice, production. But it just doesn't get done. Things just don't get done. So those are really the reasons I find to do my work, and keep doing it the way I do it, and do whatever I do. It's just that. It's been a while since I've done videos or music or anything beside drawing. But, you know, when I get around to it ...

1 *Raymond Pettibon: A Reader*, Philadelphia Museum of Art and The Renaissance Society at the University of Chicago, 1998

Richard Prince *Jeff Rian*

in conversation
April 2001

Jeff Rian *Where are you from?*

Richard Prince From the Panama Canal Zone. Place isn't even there anymore. I grew up outside of Boston. In a suburb. Moved there in 1954. It was part of a development. About thirty houses right next to each other. Put together by one contractor. I remember the contractor's name … Campenelli. Our house burned down three months after we moved in. Bad fireplace. Cheap. Plywood. Lawns wouldn't take. Everybody had a new car. Halloween was great. Ice cream truck in the summer. Honeydip donuts on Sunday mornings.

Jeff Rian *I wrote somewhere that artists of your (our) generation learned about images, TV, music, magazines by themselves – after school. Those things were the basis of our informal education – the exciting one, the one outside school, which was square. We were all self-taught. We were the first naturalized citizens of an electronically programmed world. In art school we learned about the School of Paris (Picasso, Matisse, etc.), the School of New York (Abstract Expressionism) and Pop Art. You once said (in our 1987 interview in* Art in America*) that everyone is a Pop artist.[1] Clearly a step had been made. Was it rock and roll? Was it an album cover made to go around the thoughts and sounds and jokes in our heads?*

Richard Prince It was certainly rock 'n' roll. I remember first hearing Little Richard. Immediate connection … immediate. Don't know why. Just did it for me. Elvis' 'Hound Dog'. Fantastic. I'm like six years old when I hear it. I remember my parents letting me play it in a diner, on one of those little juke boxes they had at the end of the table. Incredible. And yeah, we were the first generation actually to grow up on TV. I mean you're five years old and you're grooving on 'Zorro'.

Jeff Rian *You were an artist as a five-year old?*

Richard Prince Five years old. Yeah, I was an artist. I stayed in my room all day. I rearranged my furniture ten times a day. I used to vacuum the carpet like a baseball infield, crisscrossing with diamond shapes. Everyone is an artist when they're five. Then they take it away from you. They make you tie your shoes. Eat your vegetables. Go to school. Clean up the yard. Get on the bus. I was in love with 'Zorro'. The TV show. Once a week, seven o'clock at night, on a little black and white. It actually comes into your living room. And it's what matters. It's what's important. The whole concept. Like Superman. During the day a regular guy … but the other side, something like a hero. I made drawings of Zorro. I think that's all I did for two years – make drawings of Zorro.

Jeff Rian *You were a Pop artist already?*

Richard Prince All kids are Pop artists. A little later it got a bit more sophisticated … It's 'Twilight Zone'. Totally real. Real scary. Under-the-covers real. You didn't have to leave your house for this stuff. It was free. And it wasn't in school. It wasn't part of the programme. There was no homework to do. You got to

choose from a whole lot of shows. The choice became the act. This is what I like. This is what I chose. It was available. It was there if you wanted it. The show, the magazine, the movie, the records were all there. Not like before. Everybody had a radio. Everybody had a TV. Everybody had subscriptions. Everybody went to the movies. Or at least that's what I thought. Because that's what I did.

And album covers. John Hammond covers. I remember wondering where he got those clothes. Kind of the same reaction to Bernado in *West Side Story*. I saw it when I was twelve. I mean, I grew up in the suburbs ... no one wore cool clothes. I had never seen a white Levi's jacket or a small trim black suit with a purple shirt before. These things became important, for me. They were signs, signals, things that didn't need to be explained. I knew what they meant right away. What they looked like, what they sounded like ... I knew they were cool, and what was great. A lot of other people were feeling the same way. It was incredible how important hair became to a teenager. Some teenagers died for a 'do'. I remember this kid in my eleventh-grade class, who used to sit in front of me in homeroom. He was told to cut his hair. This was 1966. A 'not yet' year for personal expression among the younger set. Anyway, he got so pissed he came in the next day and had completely shaved it off. Bald. It freaked everybody out. He was in a band. He had a great voice. He knew about the Yardbirds. He knew about the movie *Blow-Up*. He should have dropped out, because he was already tuned in. But instead he killed himself. Two days after the shave. He was serious about his hair. I never bought that shit about his 'imbalance'. These things are out there. The way a pair of boots were pointed, man that's what was important. I would have died for a pair of Beatle boots.

Jeff Rian *Did you go to an art school?*

Richard Prince No. I applied to San Francisco Art Institute in 1972. I proposed that I would drive the teachers around the city in a 1968 Dodge Charger, the same one that was in the movie *Bullitt*. The school would have to buy me the car. Basically I'd be a high-octane chauffeur. I guess they thought I was trying to hustle them. I didn't get accepted.

Jeff Rian *How did you get to the New York art world?*

Richard Prince I first went to New York in 1973. I went there because of what I had seen in a photograph. It was of Franz Kline staring out the window of his 14th Street studio – foot up on the sill, cigarette in hand, his face a mask, intent on what he was thinking about, looking out over that scene, what was outside the photograph. Whatever was in that photograph was what I wanted to be. That kind of desire and the way of seeing the world started for me around 1963. I stopped thinking that way in 1977.

Jeff Rian *What happened?*

Richard Prince The photograph of Kline was a life that I wanted but didn't have. I wanted to be alone in a studio surrounded by the world, instead of being alone in a room surrounded by a family, a dog, wall-to-wall carpet, a driveway, a lawn, a small two-way street, and a backyard where the grass grew, and another house just like the one I was living in. In 1973 I came to that world. I got a loft on Renwick St., just west of Hudson, just north of Canal, just south of Spring and just outside of SoHo. Finally I wasn't outside looking in. I was in. I was alive. Moving to New York was hard. I didn't have any money. I didn't have any friends. I didn't know anybody. What would it have been like? I didn't want to ask that question. I needed to be in the picture. IN THE PICTURE.

Jeff Rian *Art students in the early 1970s learned about the New York School, Jasper Johns and Robert Rauschenberg, Minimal and Conceptual Art. Your early photographs combine Pop Art imagery with a Johnsian matter-of-factness: what you see is what you get. Illusion is all but gone. Were you thinking at all about Johns?*

Richard Prince Yeah, I was thinking of Johns' target with the plaster moulds on top. Johns' stuff was about the subject matter. Subject matter first, the medium second. Flags, targets … If you think about it, they were pretty close to folk art. He made them. He didn't paint them. He made them beautiful. I think the beauty was subversive. That's pretty much like folk art. I remember him saying in the movie *Painters Painting* that he'd never really heard of Marcel Duchamp. Me neither.

Jeff Rian *Isn't advertising also a kind of folk art; a big, expensive version of Pop Art? It's like jungle art, with big noisy drums, semi-nude chicks, barking voices, voodoo, enticement and allure, all the way to the fire or the rack – folk artists with accounts at Dean & DeLucca. Johns was an upstate antique hunter, hanging out with the art elite and power poets. His flags were totems. He jumped right into the taboo with the flag – without being soiled or working up a sweat. A few artistic generations later, you played a similar kind of shaman game by showing us masks of fate and destiny. Models, porn actors, rock stars, celebrities, biker girls, waves, cars, all wanting to be in a picture, all wanting to live forever. You've mentioned that you thought of your works as objects. Was this also a move away from single objects, maybe even the Johnsian object?*

Richard Prince I started to think of a photograph as an object and not a repetitive multiple. I mean, for me the frame around the photograph was important: how it was presented and hung on the wall. The edition was important. I started making editions of two. Not quite unique but almost. Up to then most photographers didn't care about editions. Most of them made editions of fifty or open-ended editions. Making an edition of two was really shooting the sheriff. To this day I've never had one of my photographs bought by The Museum of Modern Art or reproduced in a straight photography magazine.

Jeff Rian *In the late 1970s the big attraction was New Image Painting. Holly Solomon opened her gallery in SoHo with Pattern and Decoration paintings, like Kim*

MacConnell's. Canal Street artists were still unknown. Photography was something altogether different. Was there something in the air that gave you permission to do a kind of picture that no one, then, could really figure out? And how did you come to figure it out – what you did?

Richard Prince Yeah, you're right, there wasn't a lot of photography around. Pattern painting. New Image painting. I remember I wanted to make something seamless, no telltale signs about how it was put together … no cut-up paper, no pasting, no pencil. I wanted it to look as if it had been sent away for. I was working at the Time-Life building in this department called Tear Sheets, where I would cut up all their magazines and send the editorial parts up to the people who called down for them – to the authors. By the end of the day I was left with the advertising sections and nobody called down for those. They were like these authorless pictures, too good to be true, art-directed and over-determined and pretty much like film stills, psychologically hyped-up and having nothing to do with the way art pictures were traditionally 'put' together.

 I mean they were so off the map, so hard to look at, and rather than tear them out of the magazines and paste them up on a board, I thought why not re-photograph them with a camera and then put them in a real frame with a mat board around the picture just like a real photograph and call them mine. I mean 'pirate' them, 'steal' them, 'sample' them. I figured no one was going to like them … not the subject matter, much less the way they were produced … forget the way they were produced … 're-photographed' … But I thought this was it. This was the break. This was what I was hoping for … the dive into the empty pool, the dive off the empty wall, the can of shit, the nude descending the staircase, the African mask, the dripped paint, the huge canvas … I don't know. What I put out wasn't a collage, it was a real photograph, with everything a photograph has in it.

Jeff Rian Photographs can take us to the very edge of possibility, to our most reckless fantasies. A memory elicits a ring. Often they remind us of things we know, and show us things we don't know. They might be about a subgroup, but they hit a larger group right in the crotch and between the eyes. But why photography?

Richard Prince Why did I use photography? I didn't know anything about photography. So it was a way to put together a picture that I didn't have any history with. I didn't have to care about the medium because I didn't expect to get anything out of it. I had no mentor. I had no method. I had no ideas. I had no technique, no training, no experience. For me, it was all brand new.

Jeff Rian At the time photography was barely considered an art form. It was usually put off to the side with artefacts and crafts.

Richard Prince There was the John Gibson Gallery where the artists were using photography to back up a narrative, using it with words to present a pseudo document. People like Peter Hutchinson, Bill Beckley, Vito Acconci, Bill Lunberg, James Collins. They used photography as an ingredient. It was supplemental.

It wasn't editioned. It wasn't matted or framed. I think what I got from them was that even though my photographs were presented or looked like normal photographs, I still treated photographs as 'objects'. I made editions of two. I put them in traditional frames. Normality was the next special effect. I had no 'expertise' with the camera. I didn't use a dark room, I took them to a lab. I was like the guy who would pick up a guitar, never having played one, and one week later would be on stage at a downtown club fronting a band, maybe with a new sound. Only I used a camera.

Jeff Rian *From the beginning, your photographs contained the tricks and traits of avant-garde art: pushing margins, working with a hot but not-yet-accredited medium, photography. Then you added what you call the 'sent-away for' element. You photographed a really well-made photograph, and got it without the sweat and the hassles. But you still had to go through the motions of cutting up pictures, making selections, re-framing them, buying slide film and making a choice. More than that, you had to recognize the possibility that you could redo an existing picture, and that there was a different kind of product available for the so-called taking. Then, you still had to go out there and schmooze and show them to people. How did you allow yourself (give yourself the permission) to retake a picture that was unlike what was then hot in art, and how did you feel doing them? Did you know what you wanted the pictures to look like? Did you have an aesthetic look in mind? Or was it really the look of a photograph of a photograph?*

Richard Prince I don't know … there was definitely an 'attitude' involved in standing behind the camera looking at a tear sheet from a magazine and re-framing the image, then clicking and depressing the shutter, knowing that what would come out was pretty much what was 'almost there'. And I think ALMOST is the thing here. I mean the picture I was taking wasn't going to change. It would look the same today as tomorrow. And it was 'almost' the picture it came from – pretty much what I could wrap my 35mm lens around.

Jeff Rian *Were you at all aware of or involved in the 'Pictures' show that Douglas Crimp and Helene Winer had organized at Artists Space in 1977?*

Richard Prince There was no connection with Crimp or Helene Winer. That was later. I did the deed in 1976, the break so to speak. Yeah, I was thinking today about what it was like working without a net. You know, taking a chance, placing a bet. I mean there was no model, no instructions, no one to ask for advice.

Jeff Rian *The 'pictures' generation – Cindy Sherman, Sherrie Levine, Troy Brauntuch, Jack Goldstein, yourself – based art on a kind of resonance principle: shared associations were drawn from audiences by giving them pictures and styles they were familiar with. The 'photograph' was essentially the impetus for a mind game of illusion based on memory. The photographs could have been made by someone else. In your case they were. This made them like ready-made souvenirs – like tokens and cards that drew on the memories of those looking at them. This is like participating in someone else's dream (which is how advertisers try to manipulate us to get our attention).*

If artists like you began to 'use' photography, was it because pictures had become an ingredient in our mind games and part of the palette in our forms of representation?

Richard Prince I'm not sure I want to be in someone else's dream and I don't think I want them to be in mine. Or is it: I'll let you be in my dream if I can be in yours?

Jeff Rian In your early works, like Untitled (three women looking in the same direction) *(1980), or even* Untitled (three hands with watches) *(1980), people are looking into space, like they could be waiting for a phone call or a bus. Then suddenly with the* Sunsets *(1980), an apocalypse is going on behind them while they frolic. The picture has got much hotter. What were you thinking about when you made the* Sunsets? *How did you make them?*

Richard Prince I wanted to make an image that looked as if it had been made by someone else. These images were before Photoshop. Before digital. Before computers. But they had that 'impossible' look. Purple Haze. They were in and out of focus at the same time. The rear-screen projection look. They were over-determined. Psychologically hyped up. Artificially defined. Japanese fake. Times Square cut-up. They had that production quality, like they were art-directed. They were like primitive storyboards, splashes ...

Jeff Rian What about the Entertainers (1982-83)?

Richard Prince Technically they were the same as the sunsets, except that they were portraits of people in the entertainment business. Not successful people. In-between success. The Sweet Smell of Success seekers. Really colourful with non-art graphics ... Times Square graphics in a big Plexiglas box container, the frame leaning against a wall. These people would appear in gossip columns in the *New York Post*. They all had names, made up ones, spelled differently.

Jeff Rian How did people respond to your work? Who were the members of your first audience?

Richard Prince I wasn't really aware of any audience or response. The first audience I think was mostly other artists and people exactly like me.

Jeff Rian What other artists?

Richard Prince Artists like Jenny Holzer and Cindy Sherman. I was playing in bands with Glenn Branca and Frank Schroder. Going to clubs like Tier and the Mudd club. I remember going to galleries like René Block and seeing Joseph Beuys' coyote piece (*I Like America and America Likes Me*, 1974). A lot of Artist's Space openings.

Jeff Rian When – or how – did you start thinking in clusters, in series, in 'gangs' as you called them?

Richard Prince The gangs were a photo-lab thing. There was a term used at the lab about 'ganging' pictures together on one negative, putting nine or twelve 35mm negatives onto one big 8 × 10-inch negative. It was a way to organize your work. When I realized you could do this gang thing and blow up the one

negative on a huge piece of photo paper and have the nine different pictures come out next to each other, seamlessly, it changed the type of image and the type of magazine I looked at. I realized I could have a whole show on one piece of paper, instead of nine or twelve pictures in a room, on different walls. I could have the nine or twelve pictures in one frame, on one piece of photo paper. It meant I could start using pictures from different magazines. Not just the advertising sections but the editorial sections. I could push nine or twelve slides. (I still continue to use, and have always used, 35mm colour slides.) I could 'arrange' those slides on a light box, tape them together – gang them together – send them to the lab, and they'd take the taped slides and transfer them to an 8 × 10-inch inter-negative. That was it. Anyone could have done it. It was easy. Any nine or twelve slides taped together. The slides could be of anything. Taken from anything. From surfing mags, motorcycle mags, porn mags, pet mags, joke or treasure-hunting magazines. Everyone out there has their own magazine. And the slides didn't even have to be that good. They could be out of focus, overexposed, black and white or colour. You just gang them together and gave them to the lab. The lab would give you back this big 50 × 80-inch photograph with all those pictures on it – each one about 8 × 10 inches or about as big as it was when I first saw it. The space between each picture was just the slide mount. It's not what I made up. It was what was made up for me. Made up. I made up what was made up.

Jeff Rian *A lot of the 'gangs' are of subjects who know they're going to be in a picture, who want to be in the picture, who might die for it, like the eleventh-grader did over his hair. You talked about your pictures being 'almost' all of the picture. Those folks knew they were going to be in a photograph. You cut out part of the frame, maybe bringing them in closer. Your pictures, because of what they are – pictures about being photographed – draw us inside a feeling that is 'almost' the real thing, the put-on we have in our heads, the person we want to be in a photograph, even the person or the self we put on in the morning or at night or on weekends. Is it an alter ego? Is it the image the kid died for?*

Richard Prince To die in the picture. You can certainly die outside the picture. I think you're alive in the picture. You're more alive in the picture than outside the picture. At least you go on living in the picture after you've died outside it.

 That's the way we look. That's the way we want to look. To be pictured. A portrait. The *Girlfriends* were portraits. They were pictures of the way I wished I could be. Maybe it's a kind of stupid desire. Passion. Is passion what we are? Is that what we are in pictures? Is what we are in pictures almost real? Maybe it's become the 'most' real thing. I mean, the picture I take has already been taken. I take it again. My picture is seamless. No cuts. No scissors. The camera as electronic scissors. It makes the magazine picture a photograph. The photograph is 'close'. It's real close. Close to the real thing. Yeah, self-consciously real. When you're taking a picture you're conscious. You're woken up. You're up. You're up yours.

Jeff Rian *I woke up at 3 a.m. thinking about this interview, and imagining the comedian Milton Berle in his suit telling jokes we'd heard a thousand times. They were funny. They weren't funny. It didn't matter, they were jokes. They were written on 3 × 5-inch cards. Jokes set up situation possibilities. Then I imagined your works – the pictures, gangs, jokes, hoods and paintings – as being haunted by a world of TV watchers and magazine mavens looking for a life and dreaming about their own. The watchers are the kids who grew up on Borscht–belt comics like Berle. They are noisy bikers and their reckless girlfriends. The guys who live next to the girls next door (all of them), the folks on both sides of the bar, the saps at the gambling table, the loners and longing lovers. Everyone of those TV watchers and magazine mavens is implicated in ads showing beautiful girls and handsome, indifferent guys (but maybe not so 'easy to handle' as the word 'handsome' implies) showing off their watches, looking like they have a different kind of access to a different kind of dream world. The TV watchers and audience members dream of fame, access, money, a good lay, a whore dressed like Lois Lane, a man in glasses, 'Real Big Surf', or simply a safe suburban house or an apartment uptown. They make up their own visions, which someone eventually makes a magazine about, showing them dunking their heads in buckets of beer, lapping their girlfriend's tits, sticking their tongues out, dressing up like satyrs and cross-dressers, wearing dark glasses, telling jokes fraught with humiliation and indifference. Some of them have turned away from the formality of the silent suburbs and live in an informal underworld of anger and abandonment. This is a world of endless jokes – the best refuge for a person with a grudge.*

Then there are your pictures. The pictures are silent. All photographs are silent. What they seem to be about is an experience of desire and the hope that turns so many of us into comics, bikers, actors, artists and crooks. Who are they? What are they? Where do they come from?

Richard Prince *Criminals and Celebrities … Bitches and Bastards. The Velvet Beach … Live Free or Die … Girlfriends* and *Untitled (parties).* You forget what you did. Sub-pop pictures. Mainstream cults. Off the road, not on it. They weren't exactly obscure pictures. I mean they all had their own magazines. You could find them at any newsstand. Today they're all over fashion mags and MTV … in music videos, in TV ads. What was out is now in. Out and in. Like fucking. Fucking the picture. Yeah, maybe re-photographing a picture is like fucking a picture. There is something sexual about standing behind a camera and staring at another picture. It's hard to explain. It's like you've captured it. Even before you've taken it. Before you press the shutter. You can stare at it all day. The picture will never change. You don't need the right light to re-photograph a picture. You don't need the right moment … You don't need to be lucky.

Criminals and celebrities were perfect for a 'gang' photo. It was so perfect. You could even turn the photographs upside down and sideways. It was definitely a mix. Making that 'gang' was like dee-jaying … Spinning the records. Dancing the picture. I wonder if I own one of the *Criminal and Celebrities* editions. If I don't … fuck it.

Jeff Rian There is almost no artist's 'veil' in your pictures, no sleight-of-hand illusion. You show things as you find them. But in the selection, in the framing, in the choice of words like 'gang' or 'girlfriend', a vision is conveyed. A lot of works are also untitled, with a kind of description in parentheses, such as Untitled (three women looking in the same direction). *That's where you set up a kind of question. Something else is going on. That's when viewers start thinking and wondering about themselves. As you've said, you just 'put it back out there'. This is also making the familiar strange. Is this 'the night of the living dead', where the picture comes back as Casper the ghostly picture? Is the girl next door a shared memory? Does the guy get a job, but NOT the girl? Is our apocalypse a hangover? Does anyone ever get laid the way they'd like? Are both the guys and the chicks putting on an act because they don't have a clue about how to deal with life in relation to the dream experience? Is the only hope the joke at the end of the day? Is God Milton Berle – a bad joke writer, but a joker just the same?*

Richard Prince I don't know, the untitled and the parentheses thing is a way to title and not title … to have it both ways I guess … a way to change my mind, a way to describe the piece specifically, a way to make the familiar strange. Yes. The more one sees the same thing, the better the chances for the thing to be true. The *three women looking in the same direction* … that has to be true because it looks true. Again, it's just a feeling. It's twilight. It's in between. Just out of reach. I'm always falling out of planes and landing on top of buildings that don't have any windows or stairwells, only tightropes that are so loose you can only hang onto them with your hands. And then there's the clowns begging you to let go.

Jeff Rian *You use just about every medium used by artists working in a studio: photography, silkscreen, painting, sculpture. You also hook them all into the entertainment age – where hunger and desire stream out of still and moving pictures. You mix photographic realism and a style of abstraction. Are you comfortable with all those media?*

Richard Prince Realistic or abstract: those were what I thought my choices were. I always thought I'd be an abstract artist. I don't know why. I've never thought much about the different mediums I work in. Whatever fits the subject. The subject comes first. Then the medium I guess. Like the jokes. They needed a traditional medium. Stretchers, canvas, paint. The most traditional. Nothing fancy or clever or loud. The subject was already that. So the medium had to cut into the craziness. Make it more normal. Normalize the subject. Normality as the next special effect. It's also a question of restlessness. Not wanting to be bored. You know, surprise yourself. One day it's a photograph, the next it's a painting, the next day I'm working on a book, the next day I'm casting something. I don't know. People like Bruce Nauman, Sigmar Polke, Andy Warhol, they did the same thing. Worked the same way. Collecting has become more a part of the work. You know with these publicity pictures I'm doing now, I don't really think about 'how' as much as 'what'. What comes first. What's not on second. What's on first.

508

Jeff Rian *Two artists from America's golden decade – the 1950s – seem to be likely precursors: Warhol and Rauschenberg. Both involved big media, both used silkscreen. Were they important to you?*

Richard Prince De Kooning was important to me. And Rod Serling's 'Twilight Zone' TV series. And 'Spy vs. Spy' in *Mad* magazine. And, yeah, I've always loved the way Warhol would shoot a film and just let the film run out of the can and that would be the end of the film.

Jeff Rian *Are there photographers who also caught your attention?*

Richard Prince Just the obvious ones. Man Ray. I like photographs of naked people.

Jeff Rian *In 1939, Clement Greenberg wrote his well-known essay 'Avant-garde and Kitsch'.[2] He said that kitsch was not art. He didn't like De Kooning, Warhol or any of that. As an American living in Europe now, I've come to learn, kitsch is something different from bad taste. It has a 'kind of' taste. There's an aesthetic. It's sentimental, but it's not Las Vegas, Liberace or Milton Berle. It's someone turning a log into a teddy-bear or painting a ceramic pitcher to look like wood. It's a custom car and a tyre planter. Greenberg would have hated this stuff – maybe your stuff, too. But he lived when he lived, and ultimately went down in flames. The world disagreed with his brand of art-school formalism – even though the guy had really brilliant moments. Pop Art put Greenberg's formalist diatribe to bed. OK, he had a grudge, an axe to grind. Earlier you talked about images you chose as being 'sub-pop' – the biker chicks, the cheap cartoon jokes, the bad jokes, the basketball nets, the car hoods. Are these subcultures? Are they the pioneers of bad taste? Are they the soul of America? Was* Spiritual America *a disguised version of Edvard Munch's* The Scream *(1893)? Are the emotions a cross between Nietzsche and Elvis and Evel Knievel?*

Richard Prince Bad taste? Yeah … I don't know. The way people dress and look. When people don't care. Taste … What's beautiful, what's ugly? It's kind of a silly question. I mean maybe that's why Greenberg burnt out. He cared too much. The paramount thing is not to care. It's like a dog chasing its tail. The chicken or the egg. Who knows if it's popular? More than 50 per cent? If it becomes a fashion, a trend? As for kitsch: the answer is a revolving door. The answer is blowing in the wind. There's no such thing. It's what makes you feel good. It's what makes you feel bad. It's feel. You feel. Laughing and screaming. It used to be bad. Now it's good. But it's still bad. It turns. I turn it. I turned it. Maybe it had already turned. Turns out … Turns out it was always there. Always there. That sounds like soul.

Jeff Rian *You gave the biker chicks a second look. You turned them into artworks. When you put your pictures in front of a different audience, are they like slice-of-life striptease for connoisseurs? Were you putting them out there like Velázquez did with those dwarfs?*

Richard Prince Velázquez? Dwarfs? No, I always thought the *Girlfriends* were just portraits. Like Diane Arbus. They were normal pictures. They had their own

magazines. They were Snow White. The seven dwarfs were outside the picture. What's in a photograph is real. What it looks like is what it is. You look at a photograph in your lap. Sitting down. It's usually in a book or a magazine. You usually turn a page. The best photographs are sexual. Photographs are sexy. I guess that's also a way of answering the Pictures generation question.

Jeff Rian *Photographs are real, but when we start looking for similarities, say between ourselves and a celebrity, reality starts turning to jelly. I mean the photograph may be what it is, but the people looking at, say, really hot sex pictures, start thinking about themselves. That's when the picture takes on a different dimension. That's when people start thinking and fantasizing. Icons are anonymous images that look like something familiar, but take us out of the present by reminding us of something else. Photographs function as 'reminders', too. They are the cheapest, most highly evolved form of self-expression ever devised. They are our anonymous artefacts. Everyone has them. Everyone makes them. They fit everyone's perspective. But the religious fervour has been traded in for an orgiastic barbecue or some great head.*
 The giggly kids in your apocalyptic vacation Sunsets, *the* Bitches *and* Bastards, *the losers stuck on an island, a girl with her pants at half mast: these watchers and dreamers share an experience we've all had in pictures. Still pictures, moving pictures, dirty pictures, the pictures of themselves where they think they look like the people in the magazines. The experience is a memory that did or didn't or might happen … if only some kind of wish were fulfilled or some accident or magic could intervene. This is where the soul comes in, where rock 'n' roll and Sam and Dave and Nietzsche's Dionysus and St. Augustine's 'dark night of the soul' is a 3 a.m. nightmare vision. And somehow this is where your works seem to get their synergy. This is where soul and attitude meet.*

Richard Prince What about rubber soul? Is that the kind you can bounce off? I'm staring at my Beatles gold album of Abbey Road – I bought it at an auction a while ago. Lennon looks so fucking great crossing the road. In his white suit. White sneakers. He must have been a really fucked up guy to do what he did.

Jeff Rian *For some years now you've also started taking pictures of basketball hoops, neighbourhood girls, car meets, garages, tyre planters (which later became cast sculptures) and so on. What was the impetus?*

Richard Prince Living in New York for twenty-five years. I was living inside. Inside buildings, inside apartments, inside magazines. I was taking pictures of things 'inside'. Then I moved to upstate New York, where I was outside. So I started to take pictures of things that were outside.

Jeff Rian *You've also published them in magazines like* Purple, *where I'm an editor. Is this a way of sneaking back into the world you've been usurping all these years? How do you feel about them? Are they really about the girl next door, the guy in the garage?*

Richard Prince The *Girlfriends* first began when I re-photographed biker girls that had their pictures in biker magazines. Then, when I moved upstate, I actually met some real biker girls, at biker parties. I started to take their pictures, but it wasn't the same. I liked it better when I'd buy the magazine and look at their pictures that were already there. Anyway I'm getting used to seeing things outside of magazines.

Jeff Rian *You are also a collector of books, art, a few cars. Are your latest photographs also a kind of collector's art? Are you the conservator of a museum of lost souls?*

Richard Prince Am I the conservator of my own museum of lost souls? Dylan went electric in 1965. I went electric in 1977.

Jeff Rian *What's the difference between your generation and those who came before – between then and now?*

Richard Prince You know the biggest difference between us and the people who went before 'us' is the auctions. I mean 'they' … Pollock, Rothko, Newman, Picasso, Duchamp, Klein – yeah, Yves – they didn't have to live with people fucking speculating on what they put out. I mean it happens twice a year. October and May. These auctions. It's unbelievable. Unbelievable. I guess that's the word. Anyway … just a what? … A reaction? An episode? A knee 'jerk' … I don't know … How do I know? Am I suppose to like it? Feel flattered? I'm at the end of a dead-end dirt road reading skin magazines. Tits. That's what I like. Tits.

 I just finished a piece I've been working on for ten years. It usually doesn't happen like that. It's a 'hood' piece. Anyway I'm sure the usual references to Rothko will apply. Maybe he was painting hoods, car hoods … fuzzy cloudy car hoods. I don't know – that's the trouble with his work: I don't know what he was painting. Anyway, I just finished this car hood. Finally. Now it makes me want to paint more hoods. That's the trouble with finishing something. You know somebody is gonna take it away and you're left with what? Money. Yeah money. But you don't have the hood anymore. This is the only 'hood' I have. It was the perfect thing to paint. Great size. Great subtext. Great reality. Great thing that actually got painted out there, out there in real life. I mean I didn't have to make this shit up. It was there. Teenagers knew it. It got 'teen-aged'. Primed. Flaked. Stripped. Bondo-ed. Lacquered. Nine coats. Sprayed. Numbered. Advertised on. Raced. Fucking Steve McQueened.

Jeff Rian *So do you hate to let a picture go? Do you want it to stick around?*

Richard Prince Letting things go … Once in a while I hold on to something I've done, but not much. I've been trying to hold on to a couple of new *Cowboys*. They're done differently now. They're done digitally … meaning I can re-photograph the entire ad. I don't have to shoot around the copy because we can get rid of the copy with the computer and Photoshop. So now I get the whole picture. They're the shape of the magazine page. Sometimes a two- or three-page spread. Anyway, I've tried to hold on to some of these. I do about two a year.

They're pretty cinematic. Maybe if I made less work I would be less inclined to let things go. But I make – or at least I think I make – a lot of work. It's just the way it is. Letting it go is easy. Of course with the early stuff … in the beginning it wasn't even a question. Nobody wanted it, so I just kept it.

Jeff Rian *The other day I asked Elein Fleiss, the publisher of* Purple *magazine, what she would like to ask you. She wondered how you managed to continue to be such a vital artist and not just a member of a generation of artists?*

Richard Prince I don't know … Maybe thinking I never had an audience. Never thinking anyone was ever looking. Never thinking anyone ever expected anything. Maybe being half-successful. The paramount concern was never to care. I remember what Lawrence of Arabia said when asked why he crossed that impossible desert, so that he could attack the Turks from behind – he said, 'because it was fun'.

1 Jeff Rian, 'An Interview with Richard Prince', *Art in America*, New York, March 1987
2 Clement Greenberg, 'Avant-garde and Kitsch', *Parisian Review*, 1939

Richard Prince

Protest Painting 1993
Acrylic and silkscreen on canvas
102.6 × 52.4 × 7.6 cm

Cildo Meireles

Eureka / Blindhotland 1970–75
Eureka, 2 pieces of identical wood,
1 wood cross, weighing scales
Blindhotland, 200 black rubber
balls, varying in weight between
150-1,500 grams
Dimensions variable

Cildo Meireles

Inserções em Circuitos Ideologicos:
Projecto Cédula (Insertions into
Ideological Circuits: Cédula Project)
1970
Rubber stamp on banknotes
Dimensions variable
Collection New Museum of
Contemporary Art, New York

Lucy Orta

Nexus Architecture x 50 – Nexus
Intervention Köln 2001
Original colour photograph
150 × 120 cm

Refuge Wear – Intervention London
East End 1998 2001
Original colour photograph
150 × 120 cm

Raymond Pettibon

Where the water flows down indeed.

The artist is not far behind (upstream)
with his watercolors, muddying
the stream.

Untitled (Where the water) 1992
Ink on paper
56 × 35.5 cm

Raymond Pettibon

Untitled (Meet the band.) 1987
Ink on paper
35.5 × 28 cm

Richard Prince

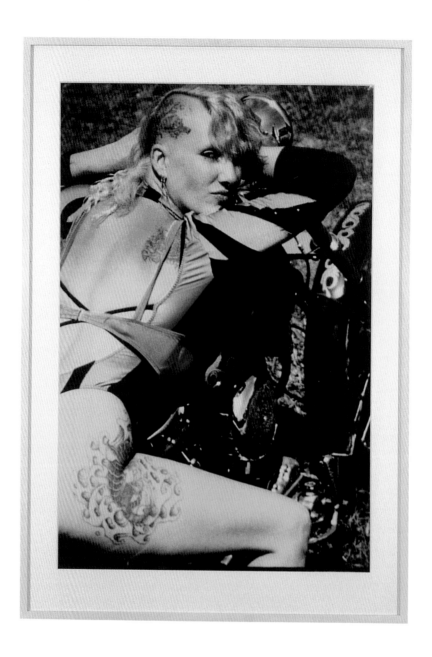

Untitled (girlfriend) 1993
Ektacolor photograph
152 × 102 cm

Pipilotti Rist *Hans Ulrich Obrist*

in phone conversation
February 2000

Hans Ulrich Obrist *In architecture, it is customary to publish and discuss unrealized projects; architects can make a whole career out of such work. But in art, unrealized artworks strangely remain almost totally unknown.*

I wonder if you could tell me about an unrealized 'dream' project that you would like to see in the future? Do you have any projects which are too big or too expensive to make, or which would not fit into the existing structures for exhibiting work?

Pipilotti Rist I'm not really that interested in unrealized work. I want people to take part in my creation, and if they can't, I feel I have failed. I try not to feel sorry for myself because of the impossibility of my unrealized projects; I don't want to mythologize them. Unrealized projects can be infinitely big, but it's hard to estimate their worth: would they even work, if they could be made? Of course you are right to say that the existing structures for exhibiting art often stand in the way of ideas. There are always obstacles presented by the building conditions, laws and permits, restrictions, power struggles, budgets, intrigues, incomprehension, laziness and divergent ideas of what a project is meant to be. These days artists must devote their imagination not only to the art itself, but to negotiating the given structures, which are often very rigid. They can do this on their own or with the help of a curator, who passionately and carefully arranges conditions on the artist's behalf. We need art managers!

Going back to your question, some projects remain unrealized for personal reasons, or because the time isn't yet ripe – and maybe it never will be. In many cases unrealized projects are not lost, but return in different guises.

Hans Ulrich Obrist *You made a proposal for a project with an airline, on board an aeroplane, that was not realized.*

Pipilotti Rist I was invited by Swissair to propose an art intervention. Most of the entertainment offered in the air reproduces the usual, TV-based idea of the banality of everyday life, or – even worse – represents an institutionalized, infant stage in an incomplete womb. We proposed videos that, alongside the existing information-oriented videos shown before landing, would also give information about the approaching city but from the super-subjective point of view of the artist. Private interviews with flight personnel about their experiences in the city of destination would also be included. The flight attendants and pilots would document their stop-overs in various cities with a camera, and passengers would watch this uncut material.

We wanted to organize mini workshops on contemporary art during the flight. Short animated films inspired by the aesthetics of the security information videos would be screened to instruct the workshop participants. Passengers could hear short 'radio plays' on an audio channel; for example they could listen to the couple sitting in front, discussing their relationship, or the flight attendants making fun of a passenger, or they could listen to the pilot's latest dream, or even the internal monologue of a passenger suffering from fear of flying. Meanwhile the flight attendants would recite poems.

We proposed to install a corner for yoga and meditation in first class, accessible to all passengers. We wanted to stick prisms on the windows that would break the sun's rays into spectral colours. There were to be outboard cameras with telephoto lenses towards the landscape; the resulting images would be shown on the floor of the plane.

Swissair didn't want our proposals in the end. They got cold feet.

I must mention that one of the best projects with aeroplanes I have ever seen was by Nedko Solakov with Luxair in collaboration with Casino Luxembourg. He wrote short poems on the aeroplane wings, so that when you looked out at the wings, you could read poetry.

Hans Ulrich Obrist *What are some of your other 'roads not taken'? And, what is your idea of a Utopian space where such unrealized works could exist?*

Pipilotti Rist I would like to build a huge leisure park full of art, in collaboration with architects, musicians, designers and writers. I have already designed it in my mind on long forest walks with my friend, artist Käthe Walser, and with Iwan Wirth (who is more than just a gallerist) and with my staff.

Another project would be to establish a worldwide kindergarten chain. Also, I would like to create a skyscraper full of studios for Eastern European artists.

Another idea would be for people to sew labels into their clothes; on the labels they would write where the clothes had been worn, what happened when they wore them and so on. Every piece of clothing would carry with it the full record of everything it had experienced. I would also like to make an installation that would cure visitors of the pains of love.

My Utopia is working with the people with whom I already work. Utopia, I expect, is not an easy place to live, however.

One ideal place which really does exist is the Centraal Museum Utrecht in the Netherlands, not far from Amsterdam. It's set among a number of other buildings – a monastery, a psychiatric clinic, a church and a residential building. The museum has 45,000 pieces in its collection: works of fashion, painting, ceramics and more. You look the item up in a catalogue; each has a reference number, like the call number in a lending library. You can request the item and it's brought to you within an hour, so you can have a good look at any object in the collection. That's what I call service! The entry tickets are issued by machine, but each of the 100 employees, from the cleaning staff to the director, takes their place at the entrance for three days a year, offering their help to you. They wear uniforms, which consist of jeans and a denim jacket, with a green band around the torso with their name written on it.

Anyway, going back to your question, unrealized projects are created every day in billions of conversations and humorous dialogues. I would like to live in your nose.

Another unrealized project was my unsuccessful attempt to rob the Feldkirch stadium (in Feldkirch, Austria) during an ice hockey game.

Hans Ulrich Obrist You've mentioned in the past that one of your aims is to create unexpected partnerships between science, art, literature and physical recreation.

Pipilotti Rist That's exactly what I attempted in my one-and-a-half-year tenure as the artistic director of the Swiss National Exposition, in the three-lake area in western Switzerland in 2002. The project is a six-month event that draws together the cultural, economic and social forces of our small country. My team and I launched many interdisciplinary projects, such as a collaboration among scientists, insurance companies and artists who together explored the phenomenon of pain. Other ideas we had included: building recycling machines as translucent sculptures; creating an institution where you could get married for twenty-four hours. A few of our projects are now actually being put into practice.

Appointing an artist as the Expo director was a sign. My way of working as director – as an art theorist who considers her acceptance of the job as a conceptual choice[1] – is pretty rare. But beware of being overly enthusiastic about the potential for contemporary art to filter into 'the real world'. The fact is that most people are not interested in art as an interdisciplinary field. Art has repeatedly opened itself to other disciplines, but most of these other disciplines have not responded by being open to art. Art's task is to contribute to evolution, to encourage the mind, to guarantee a detached view of social changes, to conjure up positive energies, to create sensuousness, to reconcile reason and instinct, to research possibilities, to destroy clichés and prejudices. Most people don't see it that way.

Hans Ulrich Obrist One of the problems of the cross-disciplinary approach is the 'territorial anxiety' it can induce. How can we go beyond this anxiety of breaching the boundaries between disciplines?

Pipilotti Rist Art still offers a protected field in which to experiment and work. But it becomes more and more essential for artists to have an unequivocal attitude about their usefulness to society. Artists' great wealth lies in their distance from the ways of the world and in the 'time out' that they can take. Artists are abandoning the notion of a creative vision, becoming more like great inventors in their specialized fields. Artists are importing, changing, interpreting and positioning everything they find. The danger is that artists, kept busy learning and digging up information, can no longer get around to developing new media, raising funds, forming artists' groups and so on. If they want to improve the substance of their techniques, they lose the time and money necessary to go deeper into their subject matter.

Also, I think technicians and scientists should make art too.

Hans Ulrich Obrist Have you always worked with video or did you begin with other practices, like painting, drawing or design? What was your first contact with video?

Pipilotti Rist I studied graphic design in Vienna at the Hochschule für Angewandte Kunst (Institute of Applied Arts, 1982–86). I made Super-8 animation films, created

stage sets for bands and did a lot of drawing there. When I finished school and returned to Switzerland I knew I wanted to work with moving images. I took the entrance exams for video classes – although really all I wanted was to use their equipment for free. I didn't care whether I worked on celluloid or analogue tape, I just wanted to learn and experiment in the audio-visual field. Film is a good, high-resolution medium, but production is too cumbersome and the division of labour absolutely necessary. I opted for video because I can perform all the steps myself, from the camera work to online editing, and that suits me. I can work all by myself or in a small team.

Hans Ulrich Obrist *Could you tell me more about the differences between video-making and film directing?*

Pipilotti Rist If you're the director of a big feature film you know a little about everything, but you're not a specialist in anything in particular, so your knowledge is general. A low-budget video director still needs a filmmaker's general knowledge, but also has to be practical – you really have to know every single technical and artistic step. I often say that video is like a painting on glass that moves, because video also has a rough, imperfect quality that looks like painting. I do not want to copy reality in my work; 'reality' is always much sharper and more contrasted than anything that can ever be created with video. Video has its own particular qualities, its own lousy, nervous, inner world quality, and I work with that.

Hans Ulrich Obrist *What were your influences at the beginning? Were pop music and culture as important to you as art?*

Pipilotti Rist Like everyone else I've seen a lot of movies, especially on TV. I don't necessarily know the titles or the directors' names but they still influenced me. I started making Super-8 films in Vienna following the example of the girls in my animation film class, Bady Mink and Mara Matuschka. I began working with video and music in Basel around the same time MTV was developing in the mid 1980s and people later saw a connection there. At that time I was more influenced by experimental films, such as *Parallels* (1960) by Norman McLaren, or *Plötzlich diese Übersicht* (*Suddenly This Overview*, 1981) by Peter Fischli and David Weiss, and feature films, for instance the Czech film *Daisies* (1966) by Vera Chytilová, or *Pink Flamingos* (1972) by John Waters. There is a long history of films inspired by music and other experimental filmmaking that predates MTV. People saw my first video, *I'm Not the Girl Who Misses Much* (1986), as a critical reflection of MTV, but I hadn't even seen MTV at that point. That work was a reflection of contemporary pop culture in general.

In video class our teacher, René Pulfer, showed us a whole range of video art from the 1960s to the 1980s, from Ulrike Rosenbach to Joan Jonas to Peter Callas, and I admired that work a lot.

Hans Ulrich Obrist *It's interesting that one of your first texts was a homage to Nam June Paik.[2] Was he another early influence?*

Pipilotti Rist Yes. Paik really set out to occupy the space that television had opened up, exploring the possibilities of the machine-cable-space connection. I like the way he treated technology, simply as another ingredient, without much respect for it. He arranged electronic cables so they'd seem like organic elements, like flower stems or veins. For Paik, technology could be adapted to any context.

Hans Ulrich Obrist *Paik was a pioneer: he was using video when it was a new medium, which is very different from now, when it's so widely available it's as common as drawing with a pencil.*

Pipilotti Rist We can no longer look at technology innocently and see it as miraculous; it's become too ordinary. Video art has been outdone – in both form and content – by music clips, TV advertising and film. The important thing in art is the quality behind the artist's basic motivation. Artists must be uncompromising. When they want to make trash, they must do it consciously. The 'I'm-doing-this-badly-so-that-I-can-distance-myself-from-commerce' style can't survive much longer. It's bad and it's kind of impertinent. It steals the viewers' time, in the sense that with a painting you can decide more quickly whether to stay and look, or walk away. With video you have to watch for at least a minute before you can decide, and that's too much time to give a bad video. Creative expression is a 'summing up of time' (*Zeitschöpfung*). With video you give the viewer fifty hours' work in one minute, so video is like concentrated time. Video-making must be precise; Paik, for example, was very precise in his work. It's not surprising that he was also a musician, working with sound and synchronization.

Hans Ulrich Obrist *What connection do you see between your work and Paik's?*

Pipilotti Rist Paik's work and mine have in common that we both try to draw the viewer inside it. At first you look at the box, at the screen or projection, but when you concentrate on the sequences you feel as if you're inside the box, behind the glass, within the wall. You forget everything around you and concentrate completely on the box: you're swallowed. This can be achieved in many different ways, for example, through the number of monitors or the size of the display, through the installation and its choreography. Paik managed to rid himself of this suspicious box in many different ways: he'd transform the TV monitor into a lamp or place it inside an aquarium. Reconquering the space inside the TV set: that's one of my aims as well.

Hans Ulrich Obrist *What about Yoko Ono? She was among those artists who, from the 1960s onwards, promoted a strong idea of art for everyone, not confining her work only to the art audience but addressing a wider public.*

Pipilotti Rist I was very interested in John Lennon when I was growing up, although I was born ten years too late to be a real fan. Through his music I became aware of Yoko Ono; I discovered that she made films and I started to learn about her

marvellous work. Together with my first boyfriend, designer Thomas Rhyner (with whom I still collaborate), I collected everything I could about Ono. By the way, why is Yoko Ono always treated so badly?

Hans Ulrich Obrist *She made amazingly pioneering work, such as her 'do-it-yourself' art pieces, like Do It Yourself Dance Piece, 1966, artworks created by viewers who follow her set of conceptual instructions.*

Pipilotti Rist In my village in Switzerland I had a small window on the art world through the mass media; through John Lennon/Yoko Ono I moved from pop music to contemporary art. It was through my interest in mass media that I became involved in art. In return, I will always be grateful to popular culture. I've never had a snobbish attitude towards pop music or the applied arts. I've always had a great deal of respect for my colleagues who are doing great things in these different contexts.

Hans Ulrich Obrist *Could you tell me about the importance of collaboration in your practice?*

Pipilotti Rist My working structures have changed in the last fifteen years. They've become more professional, but the atmosphere has remained private.

I used to work at the editing suite of my school in Basel. Later I was a member of small film collectives (VIA, Basel; Dig it, Zurich), and now I have my own editing suite. At first, among friends, we used to pay each other with working time. Gradually, I began working with freelancers who have become regular collaborators, whose salaries are part of the production costs of a work. Cornelia Providoli, an art historian, handles the planning with curators and is responsible for the budget. You could say she's my manager; I'm her boss and her child at the same time. Pius Tschumi is responsible for development, production and installing shows.

Most of my working relationships are or turn into friendships. My gallery acts as more than my producer: gallerists Manuela and Iwan Wirth have become very dear friends. In the studio, in addition to Cornelia and Pius (with whom I've been working for eight years) are Davide Ciresa (interior decorator), Sushma Banz (video archives and technical files) and Remo Weber (workshop and storage). Working with and for Cornelia are Claudia Friedli and Rahel Sprecher, who are in charge of photo archives and documentation. This group of close collaborators also includes artist and musician Anders Guggisberg, with whom I've developed the sound for my works for more than five years, since my band Les Reines Prochaines; Aufdi Aufdermauer and Karin Wegmüller, who service all the technical equipment, help install shows and produce the DVDs; designer Tamara Rist, who collaborates on all the installations and also installs individual works on her own; my mother, Anna Rist, as driver and best girl; and Dimitri Westermann, who develops and produces special equipment (like the redirecting mirrors of *Extremitäten (weich, weich)* (*Extremities [Smooth, Smooth]*, 1999) or the smoke bubble machine of *Nichts* (*Nothing*, 1999). Apart from my team, Käthe

Walser, a video artist like me and my best friend, is an important person with whom I discuss my work. She taught me how to solder metal, and so many other things.

The actors are often people from my team – for example, Cornelia plays the woman in the snow in *Himalaya's Sister's Living Room* (2000) – or from my circle of friends – for instance, architect Gabrielle Hächler is the policewoman in *Ever Is Over All* (1997). In that same piece my mother Anna and my brother Tom are passers-by. Journalist and documentary filmmaker Silvana Ceschi, who plays the hit woman in that piece, turns up again in the forest of *I Couldn't Agree with You More* (1999), as does my co-musician Anders Guggisberg. Singer Saadet Türkös also turns up in several works. When I'm not acting myself, I'm behind the camera; sometimes I do both.

Hans Ulrich Obrist *You have many roles: you shoot your own videos, produce them and often perform the central role, and for a long time you were responsible for their distribution. Then there's your work with your band Les Reines Prochaines, and the Rist Sisters Corporation, which functions a bit like a 'factory'.*

Pipilotti Rist Rist Sisters Corporation is a small, serious company, with development and production units for unique works in many disciplines. We are trying to blend the innocent mood of the 1960s with the ambivalence and differentiated perspectives of the 1990s. As I said earlier, at first we – my friends and sisters and I – just paid each other with our time. Now I work with a permanent, professional team. I run a small enterprise, like the carpentry shop around the corner – although perhaps with better, self-invented jobs. Artists plan big exhibitions the way directors must organize a large-scale film production. Rist Sisters Corp. functions like a self-sufficient spaceship: my team and I arrive at the exhibition space with all the necessary equipment, with the installation process organized in great detail in terms of logistics and personnel. We have already tested the installation process using models in the studio and can work quickly.

Hans Ulrich Obrist *The staff includes your sisters, like the traditional family enterprise, only all-female.*

Pipilotti Rist The name 'Rist Sisters Corp' was simply a nod to names like 'Warner Brothers'. My sisters, twins Tamara (designer) and Andrea (photography student), often work with me. My older sister Ursula sometimes handles my private photos and brother Tom was the model for our T-shirts from 'Slept In, Had a Bath, Highly Motivated' (Chisenhale Gallery, London, 1996). I never want to sideline the basic operational aspect of art-making, it's really part of being an artist. A huge part of art-making is administrative and technical work, which involves hammering away and tinkering with everything, travelling, examining samples, changing, improving and making decisions. We often work closely with manufacturers and specialized technicians. These are very pragmatic, technical negotiations, and we

try to create a positive atmosphere. We cook and have lunch together, so if tensions arise we can resolve them. I feel that if the process of creating hasn't been positive, then that negativity will come out in the final work.

Hans Ulrich Obrist *What is the role of improvisation and self-organization?*

Pipilotti Rist One of my goals is to avoid as many of the architectural, financial and structural constraints of the institutions where I show my work as possible, or to use the constraints in such a way that they become normal conditions of creation. My small team is phenomenal in this. In terms of software and modes of film production, we work on a low-budget level which leaves room for plenty of experimentation. I can afford to make a lot of mistakes in my laboratory. The result is a lot of unpublished material that ends up in my huge archives, and which I may come back to years later.

Hans Ulrich Obrist *Has the Internet changed the way you work?*

Pipilotti Rist It's become less complicated to foster long-distance friendships, as with my friend Liliane Lerch, a web designer in Los Angeles. *'Dear Lilchen, I'm wearing the red and red-pink plastic lace dress that we bought on our walk to the sea, the one you photographed me wearing, the one in the picture of me that you have hanging behind your desk. I'm wearing a pink long-sleeved shirt underneath and a 100 per cent acrylic cashmere-like orange cardigan, but that's lying beside me now.*

'A lot has happened; I don't get those bottomless lows anymore. I'm calmer; I've gotten to know my mother, my nephews and my sisters a lot better, and the family is a bed of roses again. Officially I'm still in that half-year sabbatical I began when I was with you, and which was nice.

'Don't worry, Sophia Coppola's Virgin Suicides *hasn't weighed me down too much; I thought it was quite atmospheric. I didn't really understand the need for the wild turn at the end. I saw the suicides more as an emotional metaphor, an image of the power of feelings in teenage years.*

'After a few weeks in supermagnificent nature in an almost magical house near Basel, I'm now back in Zurich. A great plus is my new, larger studio. We have almost 100 m² more on the mezzanine now, and I have my own editing suite. From the kitchen we can go out and sit on the loading platform. Downstairs we're having a hardwood floor put in so we can take yoga lessons before meetings.'

Hans Ulrich Obrist *How do you choose the subject matter of your films, inductively or deductively?*

Pipilotti Rist The term 'subject matter' in relation to works of art is something I've never understood. People often ask me about subject matter and expect a one-word answer. Such questions miss the point. My subjects are amorphous and overlapping. It's the subjects that choose me, not the other way round. We marry, the subject and I, and every now and then I'm being hurled out of the whirl of time and catapulted to my editing suite. This sponge made up of so many subjects from life comes over me and covers me up.

Subject matter can develop through conversations and desires. For example, the work *Closet Circuit* (2000) came out of a discussion after lunch, when I expressed my desire to visualize what, where and how my body produces every day. I made a joke that we set a camera in the toilet and play the real time images back to the seated person on a screen in front of them. Pius took my idea seriously, and *Closet Circuit* is the result.

In other instances a work can come about by chance, or can manifest itself during the development of another body of work. With *Nichts (Nothing)*, for example, we had been testing whether it was possible to project images on smoke. The resulting 'smoke bubble machine' worked surprisingly and wonderfully well as an independent work.

Blood, sweat and tears are usually required to create the subject/matter connection. I think I can arrive at something that's socially relevant with honesty and Protestant diligence.

I'm interested in universal feelings. However, there are certain images that never or hardly ever appear in my work: cigarette-smoking, urban architecture (at least not until I visited Kitakyushu, Japan), intrigues, hatred, weapons, carved wood, teacher-pupil situations, masks, moving cars shot from the outside and sports.

Hans Ulrich Obrist *At the first show of yours that I saw, at the Kunsthalle St. Gallen in 1989 (with Muda Mathis), you made your famous statement comparing video installations to a handbag, because 'there is room in them for everything: painting, technology, language, music, movement, lousy flowing pictures, poetry, commotion, premonitions of death, sex and friendliness'. One could almost say that the handbag opens and spreads its contents out into the city in quite a subversive way.*

Pipilotti Rist Yes, the holy, holy handbag. Video has all these different levels in form and content, as well as in its technical possibilities and its potential to combine visual and audio media. What has really changed in the last decade is that video equipment has become much cheaper and smaller. Mass-market cameras now are as good as professional ones were just a few years ago. Cameras have become much lighter, so I can move them around easily, even with my thin, rather weak body. For example, in my work *I Couldn't Agree with You More* (1999), a woman is filming herself, the camera rotated 90 degrees, as she walks around a supermarket and an apartment in a skyscraper. Her gaze is hypnotic. The image has been enlarged to fill the entire wall, so it's grainy. Another image is projected at closer range on her forehead and it's clearer, brighter. It looks like a tiara, or like liquid thoughts shining through her mind, onto her forehead. In this 'tiara' image, naked people in a forest are disturbed by car headlights. The people are shy, yet curious, like wild animals. The atmosphere is one of both fear and fascination – which is exactly how I feel when I'm in a city. We are like wild animals in the city. We watch each other; we are interested in those around us, yet we don't want them to come too close.

Hans Ulrich Obrist *The handbag is also a kind of urban survival kit, isn't it? A survival kit for urban street guerrillas.*

Pipilotti Rist It contains the basics, but its contents are always a portrait of the owner. I love looking into other people's handbags; they reveal their secrets and tell me a lot about their owners' characters, about their wishes and fears. Exhibiting my art is like letting people take a look into my bag.

Hans Ulrich Obrist *I wanted to ask you about a non-video work, your tramway project in Zurich* Achterbahn/das Tram ist noch nicht voll *(Tram Route 8/The Tram Is Not Crowded Yet, with Thomas Rhyner and Jan Krohn, 1998) where you inserted your art into the urban flux.*

Pipilotti Rist In *Achterbahn* we changed the list of regulations on the Zurich trams to read:
Count all light blue cars.
Push the button so my heart will explode.
See luck lying in the road.
Remain on tram for one week.
Whisper to somebody through the window.
We also changed the names of all the stops of the map inside the tram, so Paradeplatz became Paradoxplatz, for example. Through the speakers the passengers heard sounds which varied according to the context – when the tram went by a bank you could hear the sound of jangling coins, when it passed the lion's cage at the zoo you'd hear a roar. One seat was marked as reserved for fare dodgers. On the front, tram number eight (*Achter*) was named *Achterbahn* ('helter-skelter' in German); on the rear was a sign which read 'You wanted to finish first, didn't you?'

Hans Ulrich Obrist *Was* Achterbahn *a performative space?*

Pipilotti Rist Yes, but the performer was the passenger. The basic idea was to change the information in the tram only slightly – using the same font, same size, same colour as the original – so that if you jumped on in the morning, at first you didn't notice any difference. This piece was influenced by the Living Theatre in Brazil in the 1960s, who used to intervene in ordinary, everyday social situations without anyone knowing they were performers. It was also influenced by the work of Yoko Ono, of course.

Hans Ulrich Obrist *There is an ever-increasing proliferation of video work. Writer Siegfried Zielinski, in his important reflections on 'advanced audiovision', discusses how the hegemonic role of cinema and television, both of which can be considered as interludes in the history of the moving image, are coming to an end due to their sheer ubiquity. Now that film has broken free of the specialized viewing space of a cinema or television, it has become a part of the network of moving images within the visual environment.*
You used a large electronic billboard for Open My Glade *(2000) in Times Square in New York; this was a way of injecting video into the urban flux.*

Pipilotti Rist I see Times Square as an overwhelming space full of electric blossoms and electronic twinkle that hit visitors like a slap in the face. I use the energy of this 'slap' to fuel my video segments. The video was broadcast for 60 seconds every hour, sixteen times each day. Viewers saw a woman flattening her face against the screen as if she wanted to break out and come down into the Square. The flattened face looks very deformed and needy. You want to set her free, and with her all the ghosts on the surrounding screens.

Hans Ulrich Obrist *These large-scale electronic billboards do not seem to be conceived as public space, but as private (rental) space for the advertising industry, and they are therefore normally used in a very homogeneous way.*

When artist Felix Gonzalez-Torres (1957–96) produced his billboard projects in the early 1990s (such as the unmade bed in Untitled, *1991) he spoke of infiltration rather than confrontation: 'I want to ... look like something else in order to infiltrate, in order to function as a virus. The virus is our worst enemy but should also be our model in terms of not being the opposition anymore.'*[3]

Pipilotti Rist Yes. I think that 'trying to be different' is exactly the system already at work in Times Square, where thousands of advertisers are all trying to attract your attention at once. Advertising exists to grab our attention, and teams of advertising executives sit around tables asking, how can we be different? And of course they end up neutralizing each other. So, how can we really break with the resulting homogeneity?

The screens on Times Square blink and flash and have their own unco-ordinated rhythm. The only genuinely 'different' image would be one in which the viewer can see and feel that there is no commercial intention behind it: this would truly be a shock. I don't pretend you can really knock TV out of its habitual hectic rhythm or provoke much reflection among viewers, even if this, of course, is what most artists would like to provoke – a distanced reflection on society, to shift the viewers just outside themselves and experience a flash of identification.

Pure subversion is no longer possible because our reality is too complex and disparate: it is already subversive in itself. I think mass media production, without the pressure of gaining a large audience (although I usually aim for that as well) is probably where the rupture occurs. The fact that an artist – who has nothing to sell but ideas, who has no direct commercial impetus, and no powerful company behind her – is given precious advertising time on Times Square is quite good. Art protects me even in this deeply commercialized site; it is my bodyguard.

Times Square, with all the big corporations, networks and advertising companies in the neighbourhood, is the symbol of the pseudo-democratic idea that your message can be heard by the whole world, all at once. New media does have some real democratic possibilities, but for the moment this idea still seems an illusion to me. In Times Square physical space melts into virtual space. Remember the New Year's Eve 2000 celebrations there, where

you could watch 100,000 people watch themselves watching themselves on huge screens? It was wild.

I want people to pay attention to technology, to register its limits and its potential for deceit. Technology is so important in our lives! In the spirit of Paik, people should be more aware of the distinction between technological devices themselves and their virtual content. They should be aware of technology as a simple 'object', as the furniture of everyday life.

Hans Ulrich Obrist *An interesting example of a use of technique in connection with subject matter can be seen on Colombian television. There, whenever there's news of another victim of terrorism, the image changes from colour to black and white.*

Pipilotti Rist Black and white pretends to represent documentary-like truth and credibility, which is what's most wanted and needed today. But the meaning of black and white is always changing. If you look at TV adverts now, a lot of them are reverting to black and white precisely because they want to be different. In 1991 black and white made an impact, but perhaps Gonzalez-Torres would have chosen a different strategy today. I made some technical tests in both colour and black and white on the screens in Times Square, and the black and white looked too fashionable. This opens up a whole issue for me: is it always necessary to react to trends or a current mood, or can I find an genuinely independent language?

Hans Ulrich Obrist *Often your videos and installations lead us into rooms within rooms, which reminds me of the writings of Georges Perec (1936–82). In* Espèces d'éspaces *(Species of Spaces, 1974), Perec describes how we never really know 'where a room stops, where it bends, where it separates and where it joins up again'. He wrote of rooms within rooms, and the magic charm of smaller and smaller repetitions of space, a complexity of convoluted spaces and images.*

Pipilotti Rist This kind of non-hierarchical space also acts as a remedy; it helps to open up your principal space: your mind and body. You may wish to imagine as many 'real' spaces as you can, but you can also open up your own primary space and expand it, so that you no longer return to a closed personal space. This is the main reason why I'm interested in these spaces within spaces.

Hans Ulrich Obrist *This view into a room 'behind the screen' transforms so-called public space into a more private space, creating as it were a room within a room. This idea often appears in your work: one space always hides another.*

Pipilotti Rist The moving picture itself is always a room within another room. When you project an image, the wall dissolves and the image becomes the architecture. I've been collecting pictures of rooms from interior decoration magazines for twenty years now. Once, in 1997, I wallpapered my living room with all these pictures of other living rooms. I never really had a theory about it; it was just a way to survive, a mind-opener, a way of enlarging horizons. Afterwards, for the installation *Himalaya Goldsteins Stube* (*Himalaya Goldstein's Living*

Room, 1999), I made digital scans of these living-room images, printed them out in different sizes and made computer collages from them.

The artist Thomas Huber has said that today, now that we have explored the whole geographical world, pictures or films are the new, unexplored spaces into which we can escape. They are the new rooms in our physical reality. I'm interested in the way levels of memory affect our view of the present moment. What happened yesterday, and how does that change my view of this moment, sitting at this table, overlooking the river Thames, talking to you?

Hans Ulrich Obrist *This leads to the ideas of Israel Rosenfield, mathematician, doctor and philosopher, who writes of memory as something dynamic.*

Pipilotti Rist Yes, but now I must go; my husband Maurizio calls me every evening at the same time, after his spaghetti, and I must be home.

German parts of this interview translated by Simon Lenz.

1 See also 'Hans Ulrich Obrist Talks with Pipilotti Rist', *Artforum*, New York, April 1998, p. 45
2 Preface to *Nam June Paik: Jardin Illuminé*, Galerie Hauser & Wirth, Zurich, 1993
3 Felix Gonzalez-Torres interviewed by Hans Ulrich Obrist, Museum in Progress, Vienna, 1994

Doris Salcedo *Carlos Basualdo*

in conversation
November 1999, Bogotá

Carlos Basualdo I'd like to ask you about your work both as a student and lecturer. You studied art at the local university in Bogotá, Colombia, at the end of the 1970s. What did your training consist of? Was it specifically geared towards the visual arts, or did it develop through a dialogue with other disciplines?

Doris Salcedo No, it was exclusively in the visual arts and I started earlier, when very young. My art education in Colombia was interesting in that it took place on the fringes; in a Third World country one suffers from lack of information. Colombia is largely cut off from the rest of the world and this arouses anxiety, which leads us to concentrate on study, making connections with the world outside. So, paradoxically, one can end up gaining access to information and achieving quite a sophisticated education. I feel that I had a very interesting training in art history. My art school didn't have a good sculpture workshop, so I never made any sculpture there. I knew I wanted to make sculpture, however the sculpture being produced during that period in Colombia represented a strain of Modernism that seemed boring to me in comparison with other artistic languages which were being explored in painting, performance and other disciplines.

Carlos Basualdo So you were interested in performance even though this was not an integral part of your training?

Doris Salcedo I had an extremely thorough training in painting – which I think comes through clearly when you see the surfaces of my works – but I was also interested in theatre. I worked for a short time designing stage sets. It was in the Colombian theatre of that time, with its political overtones, that my interests in art and politics came together. However, this engagement with theatre was just a brief interlude.

Carlos Basualdo At art school, did you have any mentors who played a special part in your training?

Doris Salcedo Among my teachers was the Colombian painter Beatriz González, a highly complex artist who, amidst the clamour of the Colombian art scene, nevertheless managed to devote her time to theoretical study. She now regards herself as half art historian, half painter.
As a painter she did things we hadn't seen before, such as using photographic documentation and real events as important elements in her work. You could see how she went about developing a piece of work, superimposing layers of information that she would bring in from different fields of knowledge, not only from the pictorial. I feel that this model of working was essential for my development as an artist.

Carlos Basualdo You've described your interest in theatre and painting, and the way in which your painterly training comes through clearly in the surfaces of your work. Would you say that, from the beginning, your sculptural production has been based on a principle of hybridism?

Doris Salcedo I hope so. I consciously try to achieve this. I cannot say whether this hybrid quality is always clear in the work, but it is intended.

Carlos Basualdo *In the early 1980s you left Colombia for New York and gained a Master's degree in sculpture at New York University in 1984. During your stay there, did you have any memorable experiences or access to artworks that decisively influenced the way you were to approach your own production?*

Doris Salcedo In New York I was able to see the work of Joseph Beuys, and I chose it as a point of departure. I devoted much of my time there to the study of his work. Another important experience was coming to terms with being a foreigner. What does it mean to be a foreigner? What does it mean to be displaced? When I returned to Colombia, I continued to live like an outsider because this gave me the distance that one needs to be critical of the society to which one belongs.

Carlos Basualdo *Did the way you viewed your own work change as a result of your New York experience?*

Doris Salcedo It did change, because I hadn't had the chance to make sculpture until I reached New York. I already had a theoretical framework for what I wanted, or didn't want, prior to sculpting in practice. That in itself made things difficult at the beginning. I wasn't at all interested in the Modernist sculptural tradition. Before going to New York, I'd spent a year travelling around the world looking at all kinds of sculpture, from Modernist and contemporary Western sculpture to monumental works from other cultures. The latter I found far more interesting than anything else.

Carlos Basualdo *What exactly was your relationship to the work of Beuys? Were you taken by his methods of establishing a dialogue with the post-war sculptural tradition, or were you more interested in his social thinking?*

Doris Salcedo I was enthusiastic about both. Encountering his work revealed to me the concept of 'social sculpture', the possibility of giving form to society through art. I became passionately drawn to creating that form, which led me to find sculpture meaningful, because merely handling material was meaningless to me. Placing a small object on a base seemed completely vacuous. That is why Beuys was so important to me. I found the possibility of integrating my political awareness with sculpture. I discovered how materials have the capacity to convey specific meanings.

Carlos Basualdo *In Beuys' sculpture there is an attempt to re-think monumentality in terms of the social sphere. Would you say that the very idea of monumentality is one of the conceptual foundations of your work?*

Doris Salcedo I wouldn't regard my work as monumental, but now that you mention it, that link could be established. The only thing that was important to me was space. In that sense, the influence of Beuys might have been a way to approach the

monumental, but my interest in the space of sculpture was in the way it can represent a crossroad, a meeting point.

Carlos Basualdo *Would this phenomenological perception of sculpture as a meeting point stand in opposition to the Modernist idea of sculpture as autonomous and self-contained?*

Doris Salcedo Of course. What also fascinated me was a type of knowledge that is greater than oneself; which is so broad spatially, and in terms of its volume and comprehensiveness, that one cannot even grasp its meaning. The task of making such an object exceeds my capacity as a person. Whenever art enters this field of the 'uncanny', or what is beyond the human sphere, it arouses my interest.

Carlos Basualdo *What you're describing reminds me of the way you have installed some of the earlier works in the series* La Casa Viuda *(Widowed House, 1992–95). By placing a work, for example, in a gallery entrance or passageway, at an angle to the main wall of the exhibition space, it was as if you used the installation to draw viewers' attention first of all to the very nature of the space, by almost causing them to avert their habitual gaze, momentarily delayed from focusing on the object and its detail.*

Doris Salcedo That's exactly what I set out to achieve. That was what prompted me to construct those works and why they were arranged in that way. I myself feel displaced. I believe that contemporary artists are displaced people. There are some beautiful images suggesting this – like Bruce Nauman's photographs and short films of the mid 1960s, where he's circulating around his studio. They convey a disquieting feeling, an anxiety over not being able to do anything or achieve anything in that space. I'm also reminded of a photograph of Robert Smithson walking along the surface of his *Spiral Jetty* (1970). It's as if the centre of the spiral, which suggests the feeling of vertigo, represents his position as a displaced person.

Carlos Basualdo *During your time in New York did you come into contact with the work of Gordon Matta-Clark (1943–78)?*

Doris Salcedo Unfortunately I didn't see Matta-Clark's work at that time, only later. It's powerful work; it makes us aware of space, specifically of spaces that are negated, that we can no longer inhabit. Contemporary sculpture can address this issue of uninhabitable space, which is absolutely pivotal to our time. For several decades now we have witnessed in many parts of the world human masses on the move, fleeing from horror, going into exile.

Carlos Basualdo *It's interesting that although we've been discussing primarily aesthetic concerns of sculpture, you've made constant references of a political or ethical nature, as if a space could never be conceived of as neutral or depoliticized.*

Doris Salcedo I don't believe that space can be neutral. The history of wars, and perhaps even history in general, is but an endless struggle to conquer space. Space

is not simply a setting, it is what makes life possible. It is space that makes encounters possible. It is the site of proximity, where everything crosses over. I feel I am scattered in many different places. As a woman and a sculptor from a country like Colombia (regarded by outsiders as having a pariah status), working with victims of violence and showing my work in different places around the world, I find myself encountering extreme and contradictory positions, both on a large and small scale. This is why I think I am in a privileged position, always at a junction.

Carlos Basualdo *Do you think that this position you occupy as an individual influences the aesthetic structure of your artworks?*

Doris Salcedo Yes, it's essential.

Carlos Basualdo *To return to your early years, after receiving your MA in New York, you returned to Bogotá and became a lecturer in sculpture and art theory at Colombia's national university during the mid to late 1980s, for a time also serving as Director of the school of plastic arts at the Instituto de Bellas Artes in Cali. By 1992 your work had become well known internationally. Were these two developments related, in the sense that the period of teaching which preceded your appearance in the international arena might have enabled you to reflect on your production and your positioning?*

Doris Salcedo To some extent they are related. When I'm working it's not only my own experience that counts; the experience of the victims of violence I have interviewed is an essential part of my work. Dialogue is crucial in this process; it is what allows me to know the experience of the Other, to the point at which an encounter with otherness in the field of sculpture is possible. Thus my work is the product of many people's experiences. A parallel can be traced between my working process as an artist and teaching, which is usually at least as positive for the teacher as it is for the students, because it's a dialogue, and learning is the product of this encounter. Like sculpture, it's a meeting point.

Carlos Basualdo *It's interesting that when talking about teaching you stress the fact that it implies, through dialogue, a confrontation with the Other. In a way, this is a structuring leitmotif in your discourse on the artwork. Do you feel that teaching is the ground that enables you to formulate this relationship with the Other more clearly?*

Doris Salcedo No, it's the other way round. My awareness came first, and that gave shape to my teaching. In a country like Colombia, life is constantly interrupted by acts of violence. There is a reality which is intrusive, that disrupts the way you wish to live. In other words, life imposes upon you this awareness of the other. Violence, horror, forces you to notice the Other, to see others' suffering. When pain is extreme there is no way to avoid it. In the First World you can walk past a homeless person on the street and either give him or her a coin or do nothing and expect the State to take care of this person,

without losing any sleep over it. But in the Third World, when you encounter five hundred homeless people and there is no 'paternal' State, you have to notice them. This presence becomes part of the environment, part of the air you breathe. It is always with you. You can't get it out of your mind; there is no way to avoid it. So, having been born in Colombia is what makes me look at the Other. I have no choice.

Carlos Basualdo *This must affect your relationship to the artwork: you mentioned how you experience your work through its 'otherness' – the feeling that it never quite belongs to you.*

Doris Salcedo All the works I've made so far contain first-hand evidence from a real victim of war in Colombia. I have sought out such victims, interviewed them and attempted to be as close to them as possible. I try to learn absolutely everything about their lives, their trajectories, as if I were a detective piecing together the scene of a crime. I become aware of all the details in their lives. I can't really describe what happens to me because it's not rational: in a way, I become that person, there is a process of substitution. Their suffering becomes mine; the centre of that person becomes my centre and I can no longer determine where my centre actually is. The work develops from that experience. So the elements I work with are those which would be available to that person. From this point of view, the piece forms itself.

Carlos Basualdo *The methods you're describing must have given rise to the first series of Atrabiliarios (1991–96) in 1991. Was that the point of departure in your working method?*

Doris Salcedo No, there were two previous untitled works made in 1987 and 1989. A few months after I returned to Colombia in 1985, having spent a year in Europe and two years in New York, the Palace of Justice in Bogotá was occupied by guerilla forces. The violence that ensued ended in a horrific tragedy. It was something I witnessed for myself. It is not just a visual memory, but a terrible recollection of the smell of the torched building with human beings inside … it left its mark on me. I began to conceive of works based on nothing, in the sense of having nothing and of there being nothing. But how was I going to make a material object from nothing? So I began to look for source material, rummaging through waste, and Third World waste is extreme like our reality. I retrieved a number of discarded objects from a hospital in Bogotá and began to produce works from them. These were the works that preceded *Atrabiliarios*.

Carlos Basualdo *So you were first prompted to make a work out of nothing: Atrabiliarios, with its wall cavities into which shoes are placed, then half-concealed by a sewn-on screen of animal fibre, involves activating negative space, and the gesture of excavation. It's interesting to see how this element in the work relates to other post-war sculptural experiences, like Matta-Clark's.*

Doris Salcedo *Atrabiliarios* was based upon the experience of people who went missing. When a beloved person disappears, everything becomes impregnated with that person's presence. Every single object but also every space is a reminder of his or her absence, as if absence were stronger than presence. Not a single space is left untouched, and there isn't a single area of one's life left untainted by sorrow. This mark of pain is so deeply inscribed in the expectancies of victims' families that what I did was almost a literal transposition of their feelings to a real space. Furthermore, it was vital to construct the work in spatial terms, to act as a meeting point for those of us who had lived through such ordeals. The experience had to be taken to a collective space, away from the anonymity of private experience.

Carlos Basualdo *You seem to be pointing to a social dimension of space that is inseparable from space's strictly aesthetic dimension, as if they were inextricably linked.*

Doris Salcedo Yes, to me they are one and the same thing. Of course, everything happens to us in spatial terms. To place the invisible experience of marginal people in space is to find a place for them in our mind. I think of space in terms of place, a place to eat or a place to write, a place to develop life. So there is no way of isolating living experience from spatial experience: it's exactly the same thing. Certain types of contemporary work underscore this aspect of sculpture as a topography of life.

Carlos Basualdo *You mention 'underscoring' as if alluding to a form of reiteration. Your use of reiteration is quite different from the way it is used in Minimalist sculpture. In your work, for example, reiteration seems related, in the activity of recovering negative space, to the act of digging, with all the associations this evokes. This is paralleled by other recurring features in your work, such as absences, created by the marks and traces of that which is no longer present. This seems to connect with the marginalization that you described as the bedrock of your gaze.*
 Another type of displacement comes into play in your use of the readymade, which is different from the Duchampian model. Duchamp claimed that the readymade has to be aesthetically neutral, but your found objects are far from neutral. What specifically prompted the choice of the shoes in Atrabiliarios?

Doris Salcedo In this case, the choice of the objects had nothing to do with an artistic decision. While researching specific cases of disappearance I discovered that the only feature common to all cases, which enabled the identity of the missing people discovered in a common grave to be determined, was each person's shoes. The shoes also represent traces of the trajectory that led the victim to such a tragic death. I worked with facts and with the experience of the families. As I said before, I do not believe in artistic freedom. I do what I have to do or what I can possibly do.

Carlos Basualdo *Another aspect of the artwork is its relationship to the public and private spheres. You have described space as a point of intersection. If I understand this correctly, it is perhaps less a space for communication than for community, for sharing*

something akin to a secret, and therefore to silence, not something on the level of verbal communication. Would you say that, for you, the spectator is never an isolated person but always already a member of a continuum, a possible community?

Doris Salcedo Yes, undoubtedly. I envisage different moments of communication in the development of the work. At first, as I investigate the various acts of violence, a form of communication – or more precisely, a form of communion – is established with the victim. This endures throughout the whole process of making the work. I make the piece for the victim who makes him- or herself present in my work. This process involves a dynamic of its own. Once the piece is finished, it becomes completely autonomous from me. It is this autonomous creation that establishes a dialogue with the spectator who is open to it. The viewer may find something in the work that triggers his or her own memories of sorrow, or some personal recollection. It is during this unique moment of beholding that the viewer may enter, as I did, into communion with the victim's experience. The artwork fully manifests itself at that moment.

Carlos Basualdo Not only in Atrabiliarios *but also in the series* La Casa Viuda *there is a strong phenomenological aspect to the encounter with the work. The sense of anthropomorphization is heightened in, for example, the piece of clothing that is attached to the underside of the chair in* La Casa Viuda I *(1992–94). This has parallels with the work of certain Surrealist artists such as Meret Oppenheim. Were they an influence on your work?*

Doris Salcedo No, surprisingly enough. I have only recently made approaches towards Surrealism, which to some degree I had rejected. I was far more interested in Minimalist aesthetics and in the work of Duchamp. I found the openly narrative aspect of Surrealism separated it from reality, from real time and space. Obviously a relation could be established; there is the fact that I'm rather old-fashioned in that I like telling stories, and in *La Casa Viuda*, each of the pieces tells its own story, articulated by images relating to real events. They rely heavily on words the victim used while telling his or her experiences, in some instances, and on objects given to me in others. That is what endowed them with their peculiar form. If there are any marked formal differences between *Atrabiliarios* and *La Casa Viuda*, it's because each of the pieces is based on a specific testimony. So the work is defined by the nature of the victim's ordeal.

Carlos Basualdo I mentioned Surrealism because historically it has worked with ideas relating to the unconscious. I felt that the marks alluding to the presence of the body, and that movement towards the work's anthropomorphization, always seem to be pointing to an absence. In the context of your work, we could refer to what is missing as 'the body', but we might just as well refer to it as 'the Other', or 'the unconscious'. There is an affective dimension that apparently comes into play in the very fabric of the work, and I assume that is what you are referring to when you mention the

'communion' between the victim and yourself and ultimately between the viewing public and the victim, through the artwork. I'm fascinated by this paradoxical placing of the body as the unconscious element, which enables an affective connection with the audience.

Doris Salcedo My answer to the last question was perhaps misleading because I was thinking of Surrealism in painting and sculpture, to which I had no links. However, at that time I was reading George Bataille, whom I consider to be the most interesting Surrealist thinker. So, there was indeed a connection through Bataille and it was a very important one when it came to conceptual-izing a new work. I was only able to confront the horror because Bataille led me by the hand. When you come up against horror, reason seizes up – only the unconscious and affect remain. There's no way you can think. You can plan things a thousand times over, you can be well prepared, but when it comes to the crunch, everything vanishes and you are put to the test, on the fringes of the raw unconscious.

Carlos Basualdo Structurally, your works appear to be articulated by what Freud described as the two organizing principles in dreams: condensation and displacement. I wonder if on a material level too there's a connection to the unconscious of the type you've just described. I'm referring specifically to the combination of materials in your sculptures and the way in which no material seems to be what it is, but appears to turn into, or point to, something else.

Doris Salcedo The way that an artwork brings materials together is incredibly powerful. Sculpture is its materiality. I work with materials that are already charged with significance, with a meaning they have acquired in the practice of everyday life. Used materials are profoundly human; they all bespeak the presence of a human being. Therefore metaphor becomes unnecessary. I work matter to the point where it becomes something else, where metamorphosis is reached.

The handling of materials in each piece is the result of a specific act, related to the event I am working on. It is an act of everyday life that gives shape to the piece. In some cases it is a hopeless act of mourning.

The image is the result of what has happened to the material as a result of this action. I work with gestures *ad absurdum*, until they acquire an inhuman character. The processes go beyond me, beyond my very limited capacity, whether because one single person couldn't possibly have made the work (*Unland*, 1995–98), or because of the brutality and massiveness of the act (untitled furniture sculptures, 1995–98), or because it is inhuman to handle certain materials (*La Casa Viuda*).

Carlos Basualdo Your work reveals an intense and intimate dialogue between the use of the Duchampian readymade and a certain type of craft fabrication. I would say that craft, in the context of our semi-developed countries, appears exactly as that which industrial production represses or marginalizes. This is a further way in which

your sculpture occupies a position fluctuating between the aesthetic and the political. How do you reconcile the appearance of elements belonging to industrial aesthetics with those relating more to craft?

Doris Salcedo It reflects the situation in which I live – it's a mixture, a juxtaposition of diverse epochs. Parts of Colombian society remain feudal, other sections are industrial; you can see advanced technology existing side by side with extreme forms of underdevelopment. Oppositions of this kind are part of my life. Reality cannot be viewed on a single level, it always occurs on multiple levels. It is diachronic in spite of the fact that everything happens at the same time. But reality is always disrupted, always severed. In other words, it is not simply a mixture but a cruel juxtaposition of things striving violently to manifest themselves simultaneously. This propels me to construct the artwork in a parallel way: these uncanny images are a result of the mixture of materials that come from opposite realities.

Carlos Basualdo The kind of hybridism you're describing is usually attributed to Postmodern art and philosophy. Yet in your description it appears rather as an alternative form of Modernism, as if it were an integral part of the way you postulate modernity.

Doris Salcedo I do see this aspect of the work in terms of an alternative, marginalized form of modernity. It engages with the way we construct reality on the basis of our own day to day experience: a half-hearted, wavering reality, which lacks the solid rational reality of industrialized societies. The handmade element of the work marks not merely an absence of industrial values, but also a wholehearted rejection of rationalism. Paradoxically, war is the maximum expression both of industrialism and of its destruction. European thinkers who lived through the Second World War teach us how to think in the aftermath of Auschwitz. They provide us with a completely different angle on humanity and lead us to question the values that we're taught to regard as important. I'm interested in the notion of the artist as a thinker attuned to every change in society but at the same time producing art that is irreducible to psychological or sociological explanations.

Carlos Basualdo Matta-Clark's work operates on an archaeological level in relation to the architectural and urban status quo; your work evokes archaeology in terms of the layers of its various constituent parts. The individual elements that constitute your works never become fully integrated in a totality but remain autonomous; each part is separate from the other, retaining its individual character. Thus the way you piece a work together seems to respond to a desire to maintain the differences between these constituent parts. The sculptures cannot be apprehended as a self-contained unity; rather there is a sequence of superimposed stages, a montage in which the various elements assert their presence simultaneously. I wonder whether there isn't also a sense of precariousness written into the materiality of these objects. How do you regard the idea of precariousness and fleetingness in relation to your work?

Doris Salcedo　Precariousness is essential. As I said earlier, I work with what I can. In some cases, situations are so precarious that one is reduced to working with materials from the body itself – hair, bone – there is nothing else. Extreme precariousness produces a paradoxical image, one that is not defined; an image in which the nature of the work is never entirely present. It is indeterminate, so silence is all there is.

When you are caught up in a conflict, in precarious conditions, you can't even remember things, never mind produce history. History summarizes, sanitizes and smooths out differences, so that everything appears to have been perfectly synchronized as a unified stance. This is not available to us. We not only have to deal with economic precariousness but with the precariousness of thought: an inability to articulate history and therefore to form a community.

Carlos Basualdo　*You've touched on something vital when you say that one is unable even to remember the traumatic incident; thus in effect one bears witness to nothing. This means that instead of monumentalizing a tragic event the artwork is merely a means of coming into contact with nothing. As I see it, that is what is inscribed in the materiality of the work.*

Some critics interpret your work in terms of commemoration, as if it involved the recollection of a tragic event in the traditional sense of a monument. I think you operate on a far more complex level.

Doris Salcedo　Yes, I think this came out clearly in *Unland*, where there is nothing, where nothing happens – absolutely nothing – and viewers desperately try to come to terms with the fact that vision gives them no answers. A surface reverberating with no specific character allows the communion we discussed earlier to arise. Otherwise, there would be an imposition on the viewers of whatever occurred to me to tell them, and I never harbour such intentions, because I'm incapable of holding a clear grip on reality. As Maurice Blanchot has said, one cannot experience death.

Carlos Basualdo　*In psychoanalytical terms, this 'communion' would perhaps be described as remembering myself as if I were someone else?*

Doris Salcedo　Yes.

Carlos Basualdo　*The title* Unland *alludes to a work by the German Jewish poet Paul Celan (1920–70). Celan is a key figure not merely for the position he occupies in Western poetry of the post-war period but because of his stance in relation to the Holocaust. He translated the experience of absence, the horror of the Holocaust, precisely through the disintegration of language and its structures. Do you think that there are equivalences between the way Celan treated language and your approach to the material of your work?*

Doris Salcedo　I think that is exactly what we were saying earlier. You mentioned that the pieces are never wholly integrated, that they remain dismantled; that to some

extent they occupy the same space and are part of the same object, but each one remains individual. Celan's poetry involves piecing together from ruptures and dissociations, rather than association and union. This is the way I approach sculpture. I concern myself with the disassembled and the diachronic.

Carlos Basualdo *Celan's contemporary, the Frankfurt school philosopher Theodor Adorno, felt that it was no longer possible to write lyric poetry after Auschwitz. There is an affirmative attitude in Celan's decision not to remain silent but to convert silence into some other form of expression. I think that attempt is a key aspect of your work. In the context of countries like Colombia one also recalls the argument between Brazilian filmmaker Glauber Rocha and French director Jean-Luc Godard in the late 1960s. For Rocha, social and political critique in Godard's films had reached a point of utter sterility. Rocha maintained that Godard failed to understand the sheer need for cinema in Brazil, for a constructive and affirmative critical practice, even if its conditions may sound at times paradoxical. Does Rocha's experience resonate in your work?*

Doris Salcedo Yes, what motivates the sculpture is necessity. We are living in a highly complex reality which wipes everything out very quickly. There is vertigo in violence: if one violent element wipes out another, and so on, time gathers momentum and complete chaos ensues. The only way of attempting to check this speed, this chaos, is through the process of the artwork.

Carlos Basualdo *You have stressed that* Unland *operates on the basis of invisibility. It is a work in which connections are clear and the constituent pieces retain their individuality, but there are also some highly subtle transformations. These require one to stare fixedly at the work and to forfeit the visibility of its context, so that one's gaze fluctuates between a view of a detail and a view of the whole. That fluctuation might be reminiscent of blindness, an inability to comprehend an artwork visually in its entirety. Invisibility of this kind appears to be inscribed in your work and becomes increasingly more explicit. Do you feel that this counteracts the materiality of the work? Does your sculpture involve an opposition between presence and invisibility?*

Doris Salcedo I'm not interested in the visual. I have constructed the work as invisibility, because I regard the non-visual as representing a lack of power. To see is to have power; it's a way of possessing. At least from where I stand, I cannot conceive of human beings as all-powerful and knowledgeable. We are just human beings, without memory.

Carlos Basualdo *Does this resistance to visuality in the artwork reveal an aversion to materiality itself, to the possibility of transforming the work into a monument in the classical sense?*

Doris Salcedo Yes, it does, because what I'm addressing in the work is something which is actually in the process of vanishing. As I stated earlier, it is a half-present

reality. You never manage to perceive it as something concrete; you never manage to grasp it. I'm most concerned about what goes beyond my understanding. I myself fail to apprehend it.

Carlos Basualdo *I'm interested in such allusions to excess: that which is beyond one's reach, which one cannot hope to recall, and which overshadows the very presence of the artwork. Through excess, the work seems to convey the presence of otherness.*

Doris Salcedo Of course. Everything that is beyond me, that I fail to grasp, that I cannot remedy or deal with, is the Other, or in the philosopher Emmanuel Levinas' description, 'the face of the neighbour'. In addition to what I have already described, there is a sense of delay: the Other needs me urgently, but I arrive late. I always work on the premise of that delay in arrival, which marks my work with a lack of hope. It is not a question of the impossibility or immensity of the task but of my being incapable of acting effectively. I am disabled. My work is too.

Carlos Basualdo *What do you feel has happened in the last few years, during which your work has earned international acclaim and made inroads into what we could describe as the circuit of capitalization? How do you think this affects your work, if at all, and what is your reaction to this process?*

Doris Salcedo That's a complicated question; when works leave my studio they no longer have anything to do with me; they become completely alien. I acquire a distant view of my works once they have reached completion. Each work has to find its proper place in the world. They will never become real objects that someone could wholly possess, because of their intimate character, their material fragility, and in some cases because of the very nature of the material. There's also the fact that they've become dissociated from the installation in which they were originally presented.

Carlos Basualdo *It's interesting to note that the very presentation of the works constitutes a manifestation in itself. I wonder what happens when the show's over and the works are dispersed – when they become discrete 'works' in the traditional sense. That seems to go very much against the way you conceive the presentation of your work.*

Doris Salcedo Yes, dismantling the structure of an installation is a painful process but there's nothing I can do – I'm not building temples where sculptures can remain intact forever. Time moves on, and that is a challenge because once the installations have been dismantled, as far as I'm concerned the initial work vanishes and a new one appears. But for me there is a void, which is enormous and lasts for many years. I'm not very prolific; there are intervals of up to three years between my works.

Carlos Basualdo *Should one accept the wear and tear of the materials as intrinsic to the work?*

Doris Salcedo Yes, the work involves a process of deterioration. I've always liked using the word 'creatures' to describe the sculptures – I learned that from Paul Celan.

As creatures we all deteriorate and go into decline. I'm not building bronze or marble monuments but producing works that refer to something extremely private, that challenge us constantly by virtue of their fragility. This fragility is an essential aspect of the sculptures. They can even be affected by someone coming too close to them; they show us how fragile another human being can be. I am talking of the fragility of a passing caress. We are even exercising an influence on the world by delicately touching the surface of an object, because the object changes. If we were capable of understanding this fragility implicit in life, we would be better human beings.

Carlos Basualdo *When I arrived in Bogotá, I mentioned to someone that I was visiting you, and I was told about your involvement in a recent public action in a street of the city. Can you describe how this came about?*

Doris Salcedo In August 1999 the humourist Jaime Garzón, who had played an important role in giving Colombians some sense of identity, was killed. Most Colombians were in mourning; I was in mourning too. When things of this nature happen one is overwhelmed by a feeling of extreme impotence. This painful event led me to make a public appearance. It was difficult for me, because I've always considered it important to remain private. Privacy allows me to be an outsider in my own city in order to have the critical distance required to make my work. This action was a response to what most Colombians, including myself, were feeling. Such public action was direct; the fact that we felt so strongly had a real effect.

A group of Colombian artists, in which I was included, decided to manifest their pain, in the most respectful way. We made a ritual act of mourning. A wall was chosen, where people had already expressed their pain and profound indignation by placing all kinds of messages on it. This wall was in front of the house where the assassinated humourist had lived. We decided to place 5,000 roses along a 150 metre stretch of the wall. The roses slowly withered and declined, becoming an ephemeral site of memory.

The importance of this act of mourning lay beyond this particular action. A month later another intellectual and professor at the national university was killed on campus. The students spontaneously covered the walls of the university with flowers.

Carlos Basualdo *It's remarkable how that action, which bordered on the anonymous, prompted the production of other works. The way it operated in the social sphere, and took on a sculptural dimension, seems closely related to the rest of your work.*

Doris Salcedo I didn't think of it that way. I never thought of it as an artwork. When someone dies, one brings flowers. I was paying homage. It was never an artwork, and much less a piece attributable to a particular artist. The idea was to bring together a group of artists, viewing our own tragedy and responding to such a terrible event. Well, unfortunately this action was attributed to me; in that respect it half failed.

Carlos Basualdo *But it was a successful failure in the sense that it provided the incentive for something similar.*

Doris Salcedo Yes, it did provide the incentive, but to paraphrase Samuel Beckett, 'What does it matter who's talking?' If one knows who's doing the talking, it rather detracts from the image. You are imposing an image, handing something down. The idea was basically to provide a gesture in the prevailing climate of grief that forced us to articulate our mourning.

Carlos Basualdo *Can your deliberate anonymity in Colombia be reconciled with your acclaimed position in the international scene? Does this anonymity respond to a strategy or to a premeditated intention?*

Doris Salcedo It's absolutely deliberate. Being a foreigner or an outsider in a parochial setting is absolutely essential. I would like to add that every setting is parochial. It's a basic survival strategy. Otherwise, it would be very difficult to have the privacy I need to work and research with mobility and complete discretion. While anonymity gives me freedom, showing abroad gives me hope, because in the midst of war, art can be made. It's not only horror that is produced in this country; there is also sophistication in a complex reality like the one we live in Colombia. My work can be exhibited abroad, because the Colombian situation is a capsule of condensed experience that is valuable to the rest of the world. Our horror is, in a way, a paradigmatic one. That is why knowing that these works come from Colombia, and that a woman from Colombia produced them, is important. Both are premeditated strategies, and I think my artworks have a journey to make, and they will return when the time is right. A civil war obviously doesn't provide the right timing.

Carlos Basualdo *Your response to this predicament is a highly active form of anonymity.*

Doris Salcedo Very active, because I'm producing artworks. I'm only active in the field that interests me. Socially I'm not active but artistically I am.

Carlos Basualdo *I've noticed that, instead of the word 'marginalized', you prefer the term 'displaced', which has many connotations, and that the displacement in question affects all spheres: the aesthetic, the phenomenological, the political and the social.*

Doris Salcedo Displaced is the most precise word to describe the position of the contemporary artist. Displacement allows us to see the other side of the coin: indifference and war. It is obviously a position that generates tension and conflict, but I believe that from the position of displacement art derives its most powerful expression.

Translated from the Spanish by Dominic Currin

Thomas Schütte *James Lingwood*

in conversation
July 1997, Düsseldorf/London

Introductory Note: The day before James Lingwood interviewed Thomas Schütte in Düsseldorf, he had travelled to Neuengamme, a labour camp established by the Nazis in 1938 outside of Hamburg. Until the liberation of the camp at the end of World War II, over 100,000 people, mainly Russian, Polish, Dutch, French and German, had died in the camp. In 1995, Schütte had been asked to make a small room of remembrance within a modern documentation centre on the site of the labour camp. They agreed to begin the interview by considering this project.

James Lingwood What was your brief in working at the Neuengamme labour camp?

Thomas Schütte The context was the fiftieth anniversary of the liberation of the camps in May 1945, which also marked the German surrender and the end of World War II. People who had done nothing for the past fifty years suddenly decided to do something.

I was invited in early 1995 to do a work for a small room of remembrance. But the proposed space was just a low-ceilinged little office room inside a 'documentation centre', and this made me very angry. I recognized immediately how complicated the situation was, and the lack of will on the part of the people involved and the lack of a political concept.

So in one meeting I improvised a plan for the entire building to make a decent event for that one day of the anniversary, without my doing any sculpture.

James Lingwood What was there before?

Thomas Schütte A very shabby installation of left-overs, didactic photos and panels, a bureaucratic way of trying to touch people, lots of text and some barbed wire. It was such a muddle that it became a duty for me to be involved.

James Lingwood Did you remove a lot of visual material?

Thomas Schütte Almost everything, all the vitrines, partitions, the entire lighting system, the sound system, everything except a very large model of the site made in the 1940s. The documentation centre moved to a new site down the road for the occasion of the anniversary. The main idea was to get a decent space by kicking everything unnecessary out – even sandblasting the plaster and paint off the walls and returning to some kind of shell which could breathe again. At the end, most of the walls were painted blood red and a new model of the whole site was commissioned and placed opposite the old one.

Because time was short – only about three months – the city had to agree, without getting into long, fruitless discussions over power and money. I told them I could work as a kind of advisor or director, but not as an artist. It wasn't about works of mine being fabricated or presented. I more or less just developed the concepts and tried to convince others to help create a strong experience of the place. Not in a normal way by bringing things in, but by stepping back and rebuilding very carefully using only the models and

the record books and the names.

So my job was somehow a service – a public service.

James Lingwood *They agreed not to have something monumental?*

Thomas Schütte Yes. At the same time in Berlin there was a big discussion about a proposal
for a national monument to the victims of the Nazis. More than 500
artists and architects participated in the competition, mainly designing
minimalistic structures and speaking with heavy forms and heavy materials
about heavy human problems. The competition was cancelled; just now
the whole issue has been resurrected – it's a very problematic situation
once more.

James Lingwood *Which memorials do you think are most effective in terms of confronting people
with their historical responsibility or awakening a memory in a sort of
unmanipulative way?*

Thomas Schütte The Vietnam Memorial in Washington I found very, very fascinating because
it's so discreet and not imperialistic at all. In the case of the Neuengamme
project, the architect of the building from the 1980s was very happy to be
involved again and to return the building to a clear structure. It has a strong
echo and inside you are very much aware of yourself. He had worked a lot
with sacred architecture and paid particular attention to the acoustics, the
ears of the visitors.

James Lingwood *Was it important to include the individual names?*

Thomas Schütte The names were the only remains of thousands of people, and many died
even without their names being recorded. Actually, the banners were by Arne
Petersen – it was a project that was planned before I had been invited. It was
not an issue for me to include them within my overall concept. The situation
was very, very complicated, with the prisons around and the old factories and
so on, but I think we were all fortunate to achieve this in such a short time.
I hope the city will take good care of it and keep it open to the public.

When the day of the anniversary came, the focus of the discussion in
this country was that it wasn't only the concentration camps which were freed
by the allied troops: the Germans were liberated, too. So in their hearts the
Germans were not responsible for those twelve years, they were the victims
too. It was a big relief when the anniversary passed, with its cynical
misunderstandings and bad conscience.

James Lingwood *How does your sculpture* Die Fremden *(The Strangers, 1992) relate to this
problem of a sculptural means of remembering? And what kind of historical
situation did that come out of?*

Thomas Schütte At a certain moment in Germany, after the unification in 1989 when housing
problems and unemployment became more severe, the foreigners – the ones
who had come from the East or from Yugoslavia or Africa – became

the scapegoats. They were held responsible for everything. A number of refugee hostels were burnt down, and the State did nothing. And by letting it continue, the State actually promoted it. Still today a lot of foreigners' houses or hostels are set on fire; racist prejudices do not just go away.

James Lingwood *You made the work specifically for the 1992 Documenta; was that a public stage which you wanted to use to engage with a particular political moment?*

Thomas Schütte It was actually a public commission from the department store in Kassel next to the Fridericianum. It is a very old *palais*, partly rebuilt in the 1950s and now a big, modern, clothes store. It was being renovated then.

James Lingwood *They wanted figurative sculpture?*

Thomas Schütte No, they wanted something like the 'cherry column' which I had done in Münster, placed on the street in front of the building. They wanted sculpture as a logo or a traffic sign, but I immediately had this idea of putting figures on the roof.

James Lingwood *Figures of foreigners?*

Thomas Schütte No. The first idea was just of figures with luggage; the title came later. I knew the context well, particularly from my visit to Documenta V in 1972, and still remember that performance by James Lee Byars, standing in a blue suit among the muses on the roof of the Fridericianum, holding a megaphone and shouting names to the crowd on the square. These allegorical figures on top of the building had stayed in my mind.

James Lingwood *At what point did it change from a project about placing figures on a roof into something with an explicitly political dimension?*

Thomas Schütte This was not clear; we had more technical considerations than political ones. For me it was first of all a very interesting site overlooking this place, and I immediately had this image in mind of placing some colourful, static figures on top of the building as a permanent installation. The only way to get bright colour is to use either plastic or ceramic, and with ceramic the colour is better.

Basically, in 1992 the political dimension was changing every week – and all these issues are still unresolved. What defines a German, the passport, the blood, the country of birth, the language or the mentality? The parliament even changed the constitution, but it did not help much.

James Lingwood *I'm still keen to know at what point the figures become refugees.*

Thomas Schütte After its installation the piece was reproduced a lot in the press, and there it was given its definitive title, its political dimension, in the sense of the way in which it was read. For many people, *Die Fremden* worked as an excuse, a kind of relief in a terrible situation.

James Lingwood *Were they related to Oskar Schlemmer's figurative forms?*

Thomas Schütte No, I wasn't thinking about Schlemmer, but certainly I was impressed by the Chinese terracotta figures which are so amazing on a technical level. My figures are built up in clay and fired in one piece, so they cannot have a steel armature inside them. Basically they were geometric vases up to the hip, and then the upper part of the body was worked in a more abstract way. The face is quite realistic but then the hair is more expressionistic. So there was this idea of a synthesis of different figurative styles blending into something new.

James Lingwood *Why are the eyes closed?*

Thomas Schütte Limitations of time and technique. I did not want them to be blind, I just wanted something simple and convincing. The question was, are they arriving or departing, are they bringing something or taking something, and why are they here at all? What culture or attitudes or ideas do they carry with them? There is always the feeling that people who come from elsewhere are taking things away; that they are thieves. The eyes are cast down so that the figures have this shameful expression. This solved a lot of problems and gave us more time to work on a richer variety of bodies and of luggage. I think the luggage defines them as strangers.

At the end of the exhibition, I divided the whole work into three families, each with one man, one woman, one child and some luggage. One part stayed in Kassel, hopefully for ever.

James Lingwood *Do you like the idea that some of the families are still on the move?*

Thomas Schütte It is like real life, some stay, some go, some keep moving. One family found quite a good place in Lübeck, on the roof of an oversized conference centre. Lübeck is one of the places at the centre of this racist problem, a beautiful German humanist city where the houses are still being torched.

James Lingwood *The sculptures have to be in a public situation?*

Thomas Schütte Yes, they have to be exhibited as a group, they have to be outside, and they have to be in a place where they catch the sunlight, otherwise the ceramic makes no sense. The public shouldn't get too close to them, no closer than ten metres.

James Lingwood *Did the figurative tradition become devalued because of the way the figure had become used in totalitarian statuary?*

Thomas Schütte In my eyes the figurative tradition failed at the point when the artist had to create heroes in a democratic system, which nowadays is something television networks can do much more effectively.

The power is no longer represented by a king or a single figure, it operates through a system or many, many different, overlapping nets which tend not to be visible and to hide away. So the power structure is basically anonymous and it's impossible to give it a face or even a body. My figures in Kassel are victims, basically lifesize vases, precious containers with modest faces. I hope

everybody feels that the figures have an interior.

James Lingwood *You mentioned the importance of being useful. Do you see that use primarily in terms of creating symbols, images or experiences which raise consciousness about such issues, or do you also mean in a more directly functional way? Your architectural models play with this dilemma, with the promise of a public role.*

Thomas Schütte As an artist you have these ego problems, and feeling useful fills the hole. If I have a commission or a show, I always ask myself, what could be necessary? I don't ask myself what I want to do; I ask myself, what really is the problem? What could be necessary, what could be useful, what is missing?

James Lingwood *It's unusual for an artist to have this idealism …*

Thomas Schütte I am not an idealist. I would be happy if I was, but I am not. I'm strictly a pragmatist.

James Lingwood *At what point did you lose your idealism?*

Thomas Schütte I never had it.

James Lingwood *Not even at the art academy?*

Thomas Schütte No. I was always busy and enthusiastic, but never idealistic. I never read any idealistic philosophy. The only thing I read was Nietzsche when I was about eighteen, and most of the anarchist writers, but after that it was impossible for me to follow big theoretical constructions or all-embracing ideological views of the world.

James Lingwood *What did you get from Nietzsche?*

Thomas Schütte Doubts …

James Lingwood *There was a strong sense of social responsibility when you were a student at the Düsseldorf Academy. How did you relate to an older generation with their utopian models or ideas?*

Thomas Schütte Basically we all grew up together in the 1970s and it was more or less a period of research for everyone. It wasn't like the big consumption period of the 1980s – the funfair. There wasn't a powerful market, and actually there weren't any big media heroes except Warhol. Everyone was very approachable. Perhaps an idea of responsibility comes from that situation; there was space for a lot of different attitudes, even for the terrorists. Documenta V was very important – a very influential experience for me even today.

James Lingwood *What particularly impressed you there ?*

Thomas Schütte A sense of incredible freedom, with ideas and materials.

James Lingwood *How strong was the aura of Beuys for you ? He was more concerned with an idea of direct action.*

Thomas Schütte I didn't speak with him, but he was a fantastic showman. His discussion basically revolved around his mythology and social ideas. He was pretty much hated at the Academy, especially by the conceptual and minimal artists.

James Lingwood *So after Documenta in 1972, you decided you wanted to go to the Düsseldorf Academy?*

Thomas Schütte In 1973, I sent my drawings there and they accepted me. It was just fantastic because there was so much energy. Carl Andre, Bruce Nauman, Sol LeWitt, On Kawara, Richard Serra showed at the galleries like Konrad Fischer and Schmela, as did the professors, Gerhard Richter, Bernd and Hilla Becher, Klaus Rinke. All these people were in the Academy or in the bar or in the city. It wasn't about studying but just being a part of it, breathing it in all the time, inside the academy but also outside. Beuys was kicked out by the State shortly before, but he still had a strong presence in the city.

James Lingwood *So what was the real motivation for you and your fellow students?*

Thomas Schütte To keep up with ideas, to keep on pushing the research. To be a colleague rather than a student. And to try and work out your own position amongst all this discussion, and to learn the grammar and the semantics. And certain tricks. Benjamin Buchloh was teaching for a short time and his position was discussed a lot.

James Lingwood *Your decision as to the work you could make seems to have derived from certain conceptual models. In 1975 you couldn't have considered making a figurative sculpture, for example.*

Thomas Schütte That's right.

James Lingwood *What were you doing at the Academy?*

Thomas Schütte At the beginning I was painting after photographs. I stopped and then for a couple of years I was interested in working with decoration, like Daniel Buren and Niele Toroni.

James Lingwood *Did that mean decoration as a kind of deconstruction of classical pictorial space or as a way of looking at ideas of beauty or utility? Was the idea of beauty of any interest?*

Thomas Schütte Nobody was talking about deconstruction at the time. The key questions were an awareness of context and the framework of the museum. The idea of the fake and artifice was interesting to me, the idea of playing a role. Mimic and mimicry, or even camouflage.

James Lingwood *So what were you mimicking?*

Thomas Schütte The idea of being positive. I made a lot of decorative work, works that you could live with. I made several installations in private homes – not to shock people, but to express an idea of permanence and an ambition for a better life.

Beauty was a subject, too. But I think more ironically than the older generation do: they really could believe in themselves.

James Lingwood *Yesterday I saw your early work* Lager *(Storage, 1978) reinstalled in the Hamburger Kunsthalle. It seemed to suggest that there were all these possibilities that might once have been available to a painter but which couldn't be used any more. It seemed quite melancholic to me, a colour-chart waiting to be formed but not being formed.*

Thomas Schütte I found it very optimistic at that time. Somehow the idea came from the Russian productivist movement after Constructivism, when artists worked with real life objects for mass production, like in the Bauhaus.

In *Lager*, there were fifty sets of three varnished boards of wood with holes in them for hanging. It could be shown or extended in many different states. It was a colour-chart in the form of storage, with unlimited possibilities of use.

James Lingwood *So the work was in a state of waiting to be, of not being fully made, like the models are in a state of waiting.*

Thomas Schütte It was better to keep things in the air rather than close them down, and storage is a more potential state. The models came from a similar way of thinking – if I could afford a better studio, what might it possibly look like? The if-questions are always essential.

James Lingwood *You wanted to keep a series of options open?*

Thomas Schütte Options are what everyone has on computers, but I don't think they are the same as possibilities. It was important for me to keep a lot of possibilities in play. 'Repertoire' was an important word for us at the time. We played roles, imagining offers or commissions for a particular kind of applied art. This happened a bit later on, but not at that time. Nobody wanted their house painted or designed by us, except the postcard shop of the König brothers which I designed and painted with Ludger Gerdes.

It is important to have a repertoire of tools and tricks and solutions for the different and even contradictory jobs you do. It was playful and it was totally serious at the same time.

James Lingwood *Most of the modes in which you work are for your temporary use, to be taken up and then put down again?*

Thomas Schütte Yes, because I get bored very easily and when things get to a certain level of production, I lose interest. It's difficult for me to repeat one idea over and over again. But on the other hand there are themes that recur over the last fifteen years, like the models for buildings on tables.

James Lingwood *Would you have been interested in being an architect?*

Thomas Schütte This architectural debate, the postmodern debate at the end of the 1970s, was really important, and clarified how unsatisfying modern dogmas had become.

It was very refreshing that there were suddenly many more ways, citations, and games possible. Nowadays I'm very happy that I am not an architect; postmodern architecture has become totally obsolete. Basically I continued playing around and I found out along the way that it was not possible to work in such an open way in the film industry or in architecture. Art is still the only place where you can do work this way.

James Lingwood *What about theatre? The idea of staging has seemed to concern you since the 1970s?*

Thomas Schütte I was quite close friends with the set designer people in the Academy and actually this model-building comes from them. I took their scale of 1:20: it's a very unusual scale but one which works for me. But the theatre itself is not very convincing for me, either on or behind the stage.

James Lingwood *In some of your first maquettes for the exhibition 'Westkunst' in Cologne (1981), there were figurines. Where did they come from?*

Thomas Schütte I used figures from *Star Wars*, because they had the right scale and they were flexible. I just had a man and a woman, nothing else.

James Lingwood *Did the large aluminium figures relate to similar kinds of toys? They look like blown-up sci-fi figures or melted-down monuments ...*

Thomas Schütte No, the form mostly comes from dealing with technical problems, and from the material. For example the first figurative sculpture was *Mann im Matsch* (Man in Mud, 1982-83). It was a little wax figure and it was always falling off its feet. I didn't want to put it on a plinth or a base, so I cast it in a plastic box up to its knees. It was a simple technical solution but it was also an effective image, a kind of miniature sculpture and a large-scale model at the same time – the man in mud, the embodiment of being stuck.

So far as meanings are concerned, I would rather talk with my hands and through forms and let these creatures live their own lives and tell their own stories. Avoiding certain fixed positions is important to me, avoiding being too classical or too predictable ... I always hope that in the end the work will be physically present. That the works lead to essential questions is important.

James Lingwood *Could you say what the essential questions are?*

Thomas Schütte The things you cannot talk about – these are essential. Some answers can't be spoken. I believe that material, form and colour have their own language that cannot be translated. Direct experience is much more touching than media, photographs and so on. The body and soul thing, space and light ...

James Lingwood *Had you thought about Rodin's or Degas' sculptures of dancers?*

Thomas Schütte I cannot draw these art historical connections by myself. For instance I've never forgotten the early Greek sculptures, the Kouros figures. I found them much more impressive than the famous classical Greek sculptures.

James Lingwood *These earlier, more archaic ones are totally statuesque.*

Thomas Schütte Yes, but they have a fantastic presence.

James Lingwood *Even if you don't want to draw the connections yourself, nonetheless you know that you are increasingly working within a figurative tradition. The figures aren't models, or ciphers, or even actors now. You're taking on the weight of a tradition which stretches back thousands of years.*

Thomas Schütte I don't feel the weight because when I do them, I'm not thinking about the history, I'm thinking about the future. And in any case some traditional forms are still very present, they are right here with us, and not just in books.

There are some ideas I'm working on at the moment – for instance to have a whole figure, not distorted but contained within itself. Sometimes I have the need to look at history, I am very interested in looking again at the heavy figures of Maillol, or these brutal sculptures of Matisse, they are really brutal, and there is a lot to learn from them.

James Lingwood *Matisse's backs?*

Thomas Schütte The backs and the small figures and heads. If you made them today, people would think they were completely eccentric. It's an interesting challenge for me to handle these heavy subjects. Doing my work is like hiking through the Alps and getting lost every ten minutes. It's important to have different perspectives opening up all the time. I don't know where the path leads to and there is nowhere to sit down. Sometimes there are companions on the journey, which is very nice.

James Lingwood *Are there other artists working with whom you have a dialogue – with your colleagues from the Düsseldorf Academy ?*

Thomas Schütte In Düsseldorf, there are a lot of artists and there are many different scenes and everybody's known each other for a long time and there's a continuing conversation, with Harald Klingelhöller, for example. But there's an increasing tendency towards isolation. I do believe this, that forms and colours and light constitute a language, and this is the conversation you have in the studio, with material. I still think today that artists should have dirty fingers. You don't have a real discussion in the museum any more, the museum doesn't offer those conditions, it hasn't been a moral place for a long time. But the studio can still be a moral place.

James Lingwood *What about your relationship with other artists working with the figure now, like Juan Muñoz for example?*

Thomas Schütte Muñoz was here last week actually, and I showed him everything in the studio, and the casting workshop. Artists communicate with each other, but through their works and not so much with their words. There is a dialogue, and actually a real discussion going on, but it is through the works. We learn from each other, from the things that work and the things that don't. It's better to have this dialogue without the scaffolding of too much theory or

too much philosophy. That makes it too heavy, you can't stay afloat for long.
But we talked a lot anyway, about the feet of the figures for example.

James Lingwood *All the figures before the aluminium ones seemed static, waiting or stuck in mud, or bound together. Even the aluminium ones seem frozen, like the victims of Mr Freeze in the last* Batman *movie.*

Thomas Schütte For me they don't seem frozen. Unlike the ceramic figures, with this technique using wax, you can play with movement. In fact the starting point for all of the aluminium figures was a collaboration with Richard Deacon, which ended up as an exhibition called 'Them and Us' at the Lisson Gallery in London in 1995.

James Lingwood *There was a sense in which this exhibition was almost like a sequence of scenes from a tale by Swift.*

Thomas Schütte Yes … Richard and I had a fantastic discussion, perhaps no more than ten words in an hour. We developed our things separately, and we brought them together and then had a discussion about scale, monuments, man and animal, man and man, man and light, space and colour and so on … all of these basic problems. We made twelve pieces – you could call them model situations. The gallery was our playground.
 I like the small scale of the model because you have the whole world inside a room or on a table top. And then I can see some way forward. Or perhaps I can see that this is a dead-end, and I should turn around and go in the opposite direction. I still don't know what these figures are. I don't want to explain them, to cast them in words or philosophy, because very soon I am going to lose interest in them.

James Lingwood *You called* United Enemies *(1993) 'a play in ten scenes'. These were photographs which could have come from the staging of some characters in a violent puppet show or pantomime. The figures seem quite cruel.*

Thomas Schütte I did not find them cruel, I just found them funny. The photographs helped the figures a lot – without the large images behind, I think the sculptures would not have been seen. Later on somebody told me they were about the German unification but I couldn't really follow that.

James Lingwood *But you had developed an interest in physiognomy, in ideas of deforming or defacing – like caricature.*

Thomas Schütte After 1992, after making *Die Fremden in Kassel*, I had a grant to stay in Rome and I started looking at the great classical sculpture. I didn't look whilst I was making *Die Fremden* because it would have been a distraction. If you don't know what to do, history is really a dangerous field to go digging around in. But when you do have an idea, then it's very useful – to get information or to revise your work, or to revitalize you. If you look at the hundreds of heads in the Capitoline Museum, or some of the Bernini fountains, they are

incredible. Just to look with fresh eyes, as if they were done today, not with the tunnel vision of art history.

I was there in 1992, the year there was this peaceful revolution in Italy where the heads of State and a lot of prominent people were being exposed and discredited and sent to jail. So the caricature and the satire was a reality.

James Lingwood *So the classical sculpture in Rome helped you, even if your own figures could hardly be said to be classical?*

Thomas Schütte For the little figures called *United Enemies*, yes. Actually the first big set of them was made in Rome.

James Lingwood *The clothes they are wearing parody the folds of classical sculpture?*

Thomas Schütte They are just sticks with a head on top and another stick that builds the shoulders. I used my own clothes to wrap them in and form the body. For me they were puppets and not related to classical art.

James Lingwood *The repertoire of expressions is very broad. At what point did you decide that a certain expression was right?*

Thomas Schütte I disciplined myself to modelling each head for one hour only. They have no hair, so the face is more concentrated, more general, because hair always suggests a particular period. Many Roman heads have this fantastic curly hair, but that would have limited me too much – and it's twice the work!

James Lingwood *The figures had first materialized in your work quite a while before. I'm thinking of* Teppichmann *(Carpet Man, 1988) or* Mohr's Life *(1988).*

Thomas Schütte Yes, I used them for scale and for photos, to tell stories or to play around with. A lot of projects and ambitions remain latent for a while. It's good to have a couple of ideas in storage ...

James Lingwood *The faces of the* United Enemies *are grotesque or deformed. Do you see a possibility of working within a more naturalistic mode?*

Thomas Schütte Yes, but not without drawing. I am not very interested in naturalism but drawing from life is fascinating, if the mood is right.

James Lingwood *So the drawings are about mood?*

Thomas Schütte Sure, looking and inventing one line and then the next. I would play the piano if I could – each time you play a piece, it's slightly different. Everyone's interested in fantasy, or surrealism, nobody wants to see real things, to see the lines in the faces of their contemporaries. Maybe it's important for me, because the real things or the essentials are disappearing, into phantasms or networks or global policies. But perhaps this is sounding a little nostalgic and I'm not very nostalgic.

James Lingwood *It's hard to reconcile this interest in life drawing with some of the other forms in your repertoire.*

Thomas Schütte All work off each other – in a kind of balance of contradictions. I would not have made these *Große Geister* (Big Spirits, 1996) without the counterpoint of this extended sequence of life drawings of a woman called Luise. So the large aluminium figures in Münster and the portrait drawings of Luise and the *Love Nest* model in Documenta X are talking to each other. I really like to keep these different possibilities in play.

James Lingwood *So to make drawings based on observation is specifically a kind of opposition to a world where you feel that real, physical things are evaporating?*

Thomas Schütte Yes – an attempt to see and to feel something and to express this. Basically, I want to be different, or on my own, or opposite. I think I'm in opposition to anything you can mention, even if I know it's wrong.

James Lingwood *That includes taking positions that you know could be seen as reactionary?*

Thomas Schütte Yes, or let's say childish or unclear. I need this contradiction between trying to make things easy and being utterly difficult. But I don't know what reactionary or progressive means today. Certainly the situation is completely different to the beginning of this century. Perhaps the idea of endless progress is as repressive and meaningless as the false promise of eternity of the salon artists at the end of the last century.

James Lingwood *You can't live without contradiction.*

Thomas Schütte I am contrary all the time, yes. It's a pity that I cannot feel comfortable. This tension seems to be some kind of motor in my work and my life.

James Lingwood *You find the culture of art in general very conformist?*

Thomas Schütte Yes – but hasn't this always been the case?

James Lingwood *Alongside your occasional optimism there's a strong sense of scepticism?*

Thomas Schütte I still believe in enlightenment and inspiration, of that moment of sudden awareness of yourself. I believe it's more possible with physical materials and real spaces than with immaterial things, all these virtual promises with their elegant, prefabricated experiences, these edited-down readymades.

James Lingwood *You said earlier that the studio was still a moral place. But the studio is also a paradoxical place in your work – a place where you are able to confront or draw from this physical world, but also a place where you can withdraw from it. The idea of the studio as a kind of retreat runs through your work from the early 1980s; perhaps it's a counterpoint to the idea of being public. There are recurrent images of isolation – bunkers, for example, first as models, then as an actual concrete sculpture, the* Schutzraum *at Sonsbeek in 1986 or later the maquettes of basements. Or the lonely room with furniture and blue watercolours called* Belgian Blues *(1990).*

Thomas Schütte In my experience it is better to be lonely than to be destroyed in this industry. You have to have a place that can give you inspiration. And the mood can be set better in your own place than in these new art spaces. They have no respect, they treat you like a passenger at the airport. The sooner you leave the better it is. I don't want to complain too much, but the soul has to be protected most of the time. It makes no sense to hang around there, so it is better to be away from that situation and back in the studio. I've been working on the road for a long time, making things on site, in factories and so on, and now I feel that period is over. It's very relaxing to be rooted somehow.

James Lingwood *You made this very powerful image of withdrawal at Sonsbeek in 1986, and then the next year in Documenta you built a functioning pavilion, Eis (Ice Cream, 1987). Two opposites being held in balance again ...*

Thomas Schütte The floor plan of the pavilion in Kassel was much more complex than the piece in Arnhem. It was a pity that they never opened the toilet, that was important. The bartenders misused it as their storage place.

James Lingwood *It wasn't clear whether the* Schutzraum *was also meant to be useful. There was just the idea that something or someone was entombed in a way – art, or the artist?*

Thomas Schütte I was inside briefly before the door was welded, locked.

James Lingwood *It seems you are oscillating between two extremes. On the one hand a powerful pessimism and on the other hand, one of playful optimism, selling something which everybody likes and tastes good.*

Thomas Schütte Yes, I see the limits of something, and then I go in another direction. It's true that I switch back and forth, between different positions and oppositions, and sometimes it gets all twisted up. But at the same time, I see this whole work as a therapy too.

James Lingwood *A personal therapy?*

Thomas Schütte As a personal therapy. And even more so as a public address system. Conflicts are formulated and sometimes solved over years. It's important to live it through, to grasp the problem and somehow deal with it.

James Lingwood *There is a kind of storytelling dimension within your work, and the stories are quite often about the condition and the status of the artist and the artwork. I'm thinking of* Mohr's Life *with its image of a painter with canvases of landscapes and money and a collection of old socks, or* Schrott *(Rubbish, 1986) where the artist's work is incinerated, or* The Laundry *(1989). You're quite disenchanted with the condition of the artist today?*

Thomas Schütte I certainly don't believe in the heroic idea of the artist. This Van Gogh model I don't find interesting at all.

James Lingwood *But your role as an artist is still an unresolved dilemma?*

Thomas Schütte Yes, perhaps this is my life, this dilemma. I don't have a fixed position. Being apart, being useful, being successful, which is more or less being used by some people, being exhausted and being lost sometimes.

James Lingwood *This is a speculative question. But is there a period, a time or a culture in which you imagine the role of the artist might have been more fulfilling?*

Thomas Schütte The beginning of the twentieth century, yes. Actually, I'm right now reading the autobiography of Henry van de Velde. First he developed the Art Nouveau idea and then the Deutsche Werkbund and he prepared the ground for the Bauhaus in Weimar. He went from being an artist to an applied artist to being an architect – and without any architectural training. These people really moved something.

James Lingwood *So you were more interested in this moment than in the actual Bauhaus.*

Thomas Schütte He prepared all the ground. The Bauhaus got all the credit and made all the mistakes. I mean their disciples made a lot of cities ugly; nobody wants to live in them. But it's always a problem when the footnotes become the main story. Like the jokes of Duchamp, they became the mainstream, an unavoidable, autocratic ideology which you get sick of.

James Lingwood *So there's a disappointment at not being able to have a project which could be applied socially in the way the Werkbund did, for example?*

Thomas Schütte Perhaps the awareness of limits, of the limits of my ability, is what frustrates me. Also my talent for being social is disappearing.

James Lingwood *I mentioned idealism at the beginning of our conversation. You said you were absolutely pragmatic. But with these movements there was great idealism as well as pragmatism.*

Thomas Schütte Well, I am still searching for the right thing to concentrate on, which could have some impact on the structures of the world. For the moment I just have formulations, confusions and preoccupations, like these aluminium figures. How far they go, I'm not sure. But the journey goes on …

Lorna Simpson *Thelma Golden*

in conversation
December 2001, New York

Thelma Golden *Can you talk a little bit about your artistic influences? What was the first work of art you ever saw?*

Lorna Simpson My parents had an appreciation of Modernism and Minimalism, particularly abstract painting, so therefore I had an appreciation of this too. They had these reliefs on the wall: 1960s ceramic plaques with jazz musicians. They were black and white – a black ground with the relief area, the contours, in white. And stylistically they were near-abstract.

I remember looking at them for years, and recall the moment when I suddenly realized, 'Ah, it's a jazz musician!' I was a little disturbed by that. Whenever I discovered realism within something that I'd thought was abstract, it was a little unnerving to me. I also remember deciphering in a little reproduction of Picasso's *Three Musicians* the dog under the table, and that completely changed it for me, and made it less interesting. Those are the first things I remember.

Thelma Golden *You then went to the High School of Art and Design and the School of Visual Arts in New York. In those formative years, or later when you went off to graduate school, were there artistic influences?*

Lorna Simpson On a certain level I led a very privileged life, with access to all sorts of things. But I don't think that I can characterize them as 'artistic influences'. I was very interested in music, in playing the violin, and in ballet – to the point of thinking about being a dancer or a choreographer when I grew up. But since I was so immersed in the arts, it doesn't really even matter, the genre or the particular pieces of art or particular activities that I was involved in. In terms of dance, at the moment I stood on stage in about 1972, aged about twelve, at the Lincoln Center with my gold bodysuit and gold toeshoes, I knew I'd prefer to be in the audience. I loved performing, but the moment that was most significant was the realization that I'd rather watch. It was like performing from a black hole, I immediately knew this was not for me.

Thelma Golden *So when did you know it was visual art that you wanted to pursue?*

Lorna Simpson When I got sick one time, as a kid. I'd saved up all these coupons from tissue boxes just out of boredom, and I sent them in to get a Polaroid camera of my very own. Then I'd take my camera and photograph my dog, or people in my neighbourhood. I didn't feel I had any great proficiency at it but I enjoyed taking pictures. And it was something with which I had a much more relaxed relationship than performing. Photography is something that kept coming up while I was growing up.

It's funny, being in college and going to the school of Visual Arts in the late 1970s, which at that time seemed to be somewhat segregated in terms of the discussion of artists and photographers. There was a particularly white environment at the School of Visual Arts, with its own peculiar politics, but on my part there was a strong desire to see what black contemporary artists who lived in New York were doing. So I got an internship at the Studio

Museum, Harlem, in the Education Department. And that was a significant moment: being, I don't know, seventeen or eighteen years old and meeting David Hammons and Charles Abramson, who were artists in residence. And to have the opportunity to be immersed in the work of Conceptual artists and others who were working at that time, collaboratively, doing installations and all sorts of things, was very awakening and interesting for me. I think it did inform my sense of my own agency as an artist, returning from the Studio Museum uptown to the School of Visual Arts downtown, another sort of environment. It gave me some perspective on the education that I was getting – not in terms of being an artist, but in terms of art history, in terms of perspective, and who's teaching what. A kind of revisionist history was at the core of the Studio Museum's project and it showed me what was happening, understanding not just about living artists, but about the past.

Thelma Golden *In graduate school you were at University of California in San Diego at a moment when the programming department was known not just for producing a generation of artists who went on to create groundbreaking conceptual photography, but for being taught by some of the people who were pioneers in an experimental approach to photography. And that group of people was creating a sort of third way that was not the photo world at the Museum of Modern Art's Photography department in New York, and also not the fine art world, but something in between. How did that inform the way in which your work developed?*

Lorna Simpson At that time there was a marked contrast between the schools of thought on the East Coast and the West Coast. The West Coast was completely conceptual and the East Coast was very traditional in terms of painting, sculpture and photography. When I was at UCSD it was very much about performance art. It was interesting to be immersed in an environment that was completely different from the one I'd been in, in New York, and it was important in terms of thinking about film as well – thinking about my perspective on photography and about the viewer. I'm not convinced that I would, within the environment in New York at that time, have come to the same conclusion. It brought a more Conceptual bearing on what I was doing.

Thelma Golden *Who were your teachers there?*

Lorna Simpson Allan Kaprow, David Antin, Eleanor Antin, Phil Steinmetz, Patricia Patterson, Babette Mangolte, Jean-Pierre Gorin.

Thelma Golden *Who were your fellow students?*

Lorna Simpson I'd gotten out of college about six months earlier, doing graphic design, and I'd met Carrie Mae Weems in New York. We both went to UCSD, so I hung out a lot with Carrie, although she was a year ahead of me. It was a very interesting place to have met her, because although our work is different, and she was working from a completely different perspective, it was nice in a very simple way, within these environments that are monolithically white, to have

another black woman there. The funny thing about that though is that Carrie – who is very statuesque, much taller than I am and completely different looking – and I and another black woman who was shorter than I am, a completely different body type and appearance, were always being mistaken for each other. So it was like these three separate women, differently graduated in height and body size, were all interchangeable. This acted constantly as a reminder that our presence was as interchangeable as it was invisible. The isolation of that place provided a time for reflection, and I think that was one of its great assets.

Thelma Golden *Your work has always engaged a range of subjects that take you both inside an artistic dialogue – about form, the image of the body, the figure, space, objects in space, narrative – and outside of it, to talk about many other things. Can you say something about the influence of ideas outside of art that have played a role in the formation of the works you make? For example, it seems to me that the texts, both the texts of the photographic works and the spoken text, or even the soundtracks of your film work, take a lot from fiction in the ways in which you use language. You never use reportage in any way. I've often talked to the playwright Suzan-Lori Parks about your work. We discussed this notion of the way language is used: there's standard English, the generic news-speak, and then there are regional dialects, but there's also this kind of personalized language. She often uses the language that her grandmother spoke, which she takes as a very distinct black way of speaking. Instead of her grandmother saying something like, 'The ink is black', she'd say 'That ink is sure black!', 'That sure is some black ink!' And when you look at your phototext works or the texts with the felt pieces and read them aloud, or you hear the text of the films, there's this approach to language that owes a lot to spoken language.*

Lorna Simpson That's true.

Thelma Golden *It owes a lot not just to spoken language, but to people who speak their language with a certain love of it; people who use language as a way of dramatizing. In your photoworks, the way the words string together have a certain rhythm like speech.*

Lorna Simpson I think that exactly pinpoints my love of language and my love of using texts. You're right to mention Suzan-Lori Parks, whose plays I saw in New York from when she began in the late 1980s, and we're good friends. There's this thing in her work of alliteration and the use of words: in the repetition sometimes they lose their meaning, or their meaning becomes enhanced, or shifts completely to something else, and that's something that I really love working with. It's a very difficult thing on a certain level to work with, because one must really have that ear – an ear beyond the words simply being something visual on the page. So, yes, Suzan-Lori Parks or Toni Morrison are influences. Certainly a lot of the prose narratives that I've read have characters with a sense of language, or whose agency in terms of trying to describe their predicament is framed by using language in a certain way.

Lorna Simpson

Still 1997
Serigraph of photograph
with text on 36 felt panels
78 × 61 cm overall
305 × 731.5 cm overall
Collection, The Miami Art Museum

Pipilotti Rist

Open My Glade 2000
Video installation still
9 -one-min. videos for Panasonic
Screen, running every quarter part the
hour from 6 April to 20 May 2000
Panasonic Screen, Times Square,
New York
Commissioned by the Public Art
Fund, New York

Pipilotti Rist

I Couldn't Agree with You More
1999
Audio/video installation,
still of 2 overlapping video installation
tapes, audio system
Sound: Pipilotti Rist and Anders
Guggisberg
Collection, Museum of Contemporary
Art, Los Angeles

Thomas Schütte

Die Fremden (The Strangers) 1992
Glazed ceramic
Lifesize
Installation, Documenta IX, Kassel,
1992

Thomas Schütte

United Enemies,
A Play in Ten Scenes (detail) 1993
2 of 10 offset lithographs
69 × 99 cm each

Doris Salcedo

La Casa Viuda I 1992-94
Wood, fabric
258 × 39 × 60 cm
Collection, Worcester Art Museum,
Worcester, Massachussets

Doris Salcedo

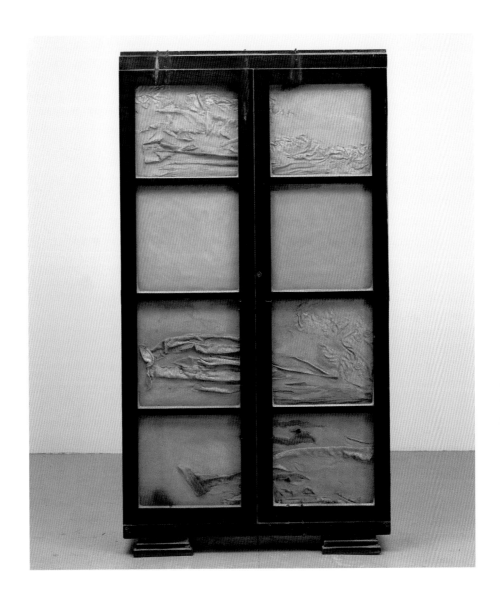

Untitled 1995
Wood, concrete, steel, glass, fabric
217 × 114.5 × 39.5 cm
Collection, Museum of Contemporary
Art, San Diego

Lorna Simpson

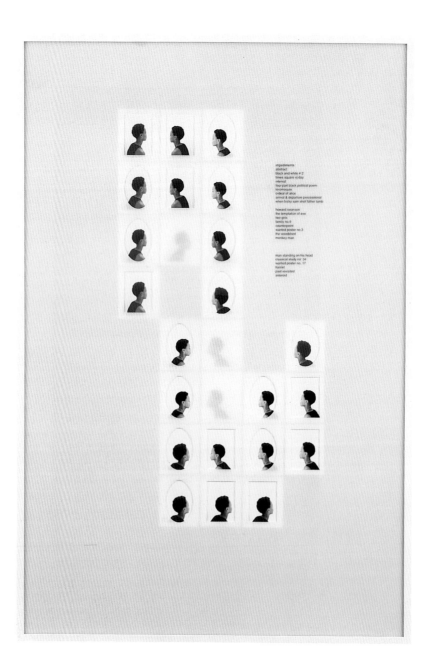

Untitled (impedimenta) 2001
Archival gelatin prints under
semi-transparent Plexiglas with black
vinyl lettering in wooden frame
104 × 155 × 2.5 cm framed

And I find that an interesting way to write. Not that I'm a writer, but in the way that I play with text and think about the way the viewer comes to the work, it certainly is what brings the texts alive.

In terms of the way language operates with the film, it's a little bit different. I have yet to use that format directly in film; it all has to do with the context in which the films are put together. I use stories and have actors retell them. The stories are about repetition, or there's a repeated element that goes through them. Sometimes there's a phrase that I use in a piece and the actress that I'm working with just can't say it. But there's something about that that I really love. I leave the door open for a lot of improvisation, so that the actors bring in a sense of their own media and intuition with the work as well. That's the space between the photographic pieces and the film pieces where the textual components operate. I'm gradually coming to more of a meld of the two in terms of process.

Thelma Golden *How else would you characterize the similarities or differences between your current work and that at the beginning of your career? Obviously it has been a trajectory that has moved through different media and also through a variety of thematics. But is there a common thread that you see as the impetus taking it from the beginning and into the future?*

Lorna Simpson The subject that I reach towards most often is memory. But beyond the subject matter the common thread is my relationship to text and to ideas around representation. The work has changed in terms of medium, format and approach, even in terms of genres.

Thelma Golden *You've certainly shifted media throughout your career. In the early 1980s you began working with photography, and then the photographic work became almost sculptural. And then you moved into making installational works that incorporated film and video, and you subsequently went from there into film installations while all the time periodically returning to these other media. Can you talk about this move between media, and the relationships between them, as they play off in your work around these ideas about memory?*

Lorna Simpson Much of my investigation is an interest in photography. The phototext-based work came from looking at experimental and underground political filmmaking of the late 1950s and 1960s, like Maya Deren, Jean-Luc Godard, Jean-Pierre Gorin, Chantal Akerman. In college I studied film history and how to deconstruct film as a reader, as a viewer. That's really what informed the way I approached photography. I was able to try out my own ideas and explorations in a medium that I was very familiar with intellectually but had never worked with artistically myself.

Thelma Golden *Your work has always dealt with a sequential narrative, and some of that comes from this early approach to film. Some of it plays out in literal, purely formal ways, from the early phototext works and their use of a multi-panel or multi-text format, to the installation works, which again often divide the plane of whatever space in*

which you're working into separate spaces, to the film works which move through a narrative that makes sense in a linear way but also has a sequential, scenic quality. Can you talk a little about why you use sequential narrative in your work?

Lorna Simpson From the beginning it came from a desire to work in film. It was connected with trying to work with a medium that's very flat and two-dimensional, trying to talk about thought processes over a period of time, or interpretations of how certain words are spoken and the multiple meanings behind them, and a slight shifting of context to affect the meaning of a particular set of words. I'm thinking of *Memory Knots* (1989) for instance. One way to get the viewer into the way my brain may be processing something is to make it sequential. It's this slow process of the shift, the subtle changes and differences that are made, either in the depiction of the person who's portrayed on the wall photographically, or the way that the text moves subtly from one group of words or phrases, or a more poetic text or story, to the next. An audience can experience this thought process if the images are sequential and look at something over the course of time. Not that my pieces have to be read in a linear form; it's more about time, about comparing one thing to the next as you move along.

Thelma Golden Similarly, the sequential notion in your work also plays out in terms of how the works exist in a space. Can you talk about both the early use of installation as you moved from two-dimensional work into pieces like Hypothetical? *(1992) and* Standing in the Water *(1994) to the film installations, and how physical space now plays a role in bringing the viewer into a narrative?*

Lorna Simpson I think this is the aspect of the work that I'm the least comfortable with, because I'm not much of a sculptural artist really. I like objects but I'm not very confident about my investigation of them within a space. Maybe the first exploration of space was the *Screen* piece of 1986. I used screen devices and the metaphors of screens and how they divide up a room as a way of making a three-dimensional piece that was photographic. I think now I've maybe come more to terms, within the context of the film pieces, with the way that narrative can be delivered in a non-linear form in spatial works. Space, interior or exterior, is developed in a way that technically, in order for it to function, is very literally linear. But the experience of it is one where it seems arbitrary as to what comes up first, what comes up second, what narratives pop up. And that piece for me functioned very well in terms of thinking about space, since a lot of the work that I've done is about narratives. A film reflects a desire for a more structural way of putting things together that insists upon a linear narrative, regardless of what comes first, what comes second, what comes third, what's at the end. But with projections on the wall, when someone walks into that space they become attracted to a narrative that pops up here and there, without any real order or reason, so the sequence becomes arbitrary.

Thelma Golden In some ways Still *(1997) also has a relationship to the film work in the way in which it exists in the space as an installation, which is similar to what you do*

with the projection: really claiming the space of the wall, physically. It's about how the viewer encounters the work.

Lorna Simpson That's true. Because of the way *Still* is printed using a silkscreen onto the felt, there are two levels of engagement. From a distance you can't quite see the text that's embedded into the image, while the image has great clarity. As you come closer to it, the image becomes less distinct while the text becomes more succinct. You engage with the piece in this very subtle way. With a lot of those works that claim a large space – it's on a 17-foot (520-cm) wall – I always seem to insert some kind of disruption. The felt pieces, for example, are cut into panels; there's never a seamless, panoramic work. With the figures they're never completely developed and constructed as huge, real-life photographs.

Thelma Golden Why?

Lorna Simpson Because in the reality of the politics that I was referring to, the images should be very compartmentalized in terms of the body and one's identity. One compartmentalizes different aspects of one's life and the world around one, so it seems false to provide any other structure. In some ways the text also fragments and divides the image.

Thelma Golden One of the things that I think is interesting is that your work hovers around a larger issue: the notion of negative and positive images. While that argument has very little to do with the intentions of your work, what I do think is interesting is that you pay consistent attention to the notion of negative space; it physically exists in your work as a significant aesthetic component, both in the early black and white work, and in the films. I'm interested to know if there's any way in which there was a conscious approach to this notion of the negative?

Lorna Simpson There was a was a really interesting comment in a review of one of the film pieces a few years ago that kind of clued me in to why I do that. The comment was something like, 'they're interesting but nothing happens'. That way of formulating the space probably comes from the short course in film I took when I was in graduate school, and this is when I met Babette Mangolte, who shot Chantal Akerman's *Jeanne Dielman, 23 Quai du Commerce, 1080 Bruxelles* (1975) and *News from Home* (1976). Babette was really rigid in terms of fixed camera positions, and not doing close-ups or not doing a lot of work to engage the viewer. In some ways it was about selective simplicity – suggestions of what is going on outside the frame have strong implications for what you're centring on. I'm not speaking on any huge, ideological level, but there's a simplicity to that idea in terms of shooting that I appreciate, as a kind of formalistic tool. For the viewer it brings up the question, where is the subject in all of this? Without framing the subject so centrally there's either a little too much space inside the frame, or there's a whole lot squeezed into the frame that has nothing to do with what's actually going on.

Thelma Golden And in many cases if you brought in those things outside of the frame, it would change your work significantly and enter into a conversation that your work stays out of, because of the fact that you really force the viewer into less literal readings.

Lorna Simpson Yes.

Thelma Golden What made you make the shift from the phototext works to the more sculptural photographs and the tactile works printed on felt?

Lorna Simpson In the late 1980s, early 1990s, I made a decision not to use the figure with the text in the way that I had before. I decided to investigate the surface, and started working with felt. That decision was also prompted by wanting to expand, because after seeing a survey show at the Museum of Contemporary Art, Chicago, of ten years of my work, I really felt the necessity to change. My works had become so familiar to me in terms of process that there was no more joy or surprise left in making them. It was just to free up my relationship to materials and then see what ideas would come, which I think yielded some interesting work and some not so interesting work. But in terms of process it was really important that I was not in a comfortable, familiar relationship to the work that I was doing.

Thelma Golden It seems to me that your move away from the body had something to do with the way in which your work was in many ways responsible for a whole dialogue opening up around issues of representation, around the body, around the figure, around gender, around race. What else informed your decision to move away from the body, which was so much a part of your work?

Lorna Simpson There was a feeling of discomfort that the audience immediately recognizes the way that the work operates and has a particular expectation of what they're going to see. The whole premise of the work was to engage with the audience in a way they wouldn't be used to – to put them off balance. It comes to the point when the audience, if they've seen it enough and heard or read enough about it, already know the dynamic you've set up and then they don't so much figure out but assume how particular pieces operate. And that for me is not an interesting relationship between my artwork and the viewer.

 Another reason that's much more personal is that during that time my mother died, many friends had died of AIDS, and there seemed to be an overwhelming feeling of absence. Even emotionally it seemed appropriate that the figure was absent. The death of a parent or friend also transforms you in a way that makes it difficult to return to the things you did before. That's why there was an abrupt switch away from it – not because I'm uninterested in terms of the subject, and not because I thought that I didn't have anything more to say, or that there was no audience for what I was saying, but purely in terms of process and my own personal feelings.

Thelma Golden But in the way that you used the body, specifically a black woman's body, there was an absenting as well, because you never revealed the faces of your models. In some

ways you already have absence, which is the stark difference from the film
work, where you engage these models, actresses, the people in your films
as presences, and you allow them to exist with their own faces, bodies and
personalities. There was a lot of conversation about your work at that time
about this denial, which some people never quite understood. Or they misread
it, because without a face it assumed a certain autobiographical quality that
made it always a picture of you.

Lorna Simpson I don't think it is me!

Thelma Golden And so that body seems problematic on so many levels: absented, confused,
misidentified, misread … Now, your work embraces bodies. How would you
categorize that transition?

Lorna Simpson I see both areas as working with artifice. If I have a model, or a surrogate,
a performative individual in front of the camera for a still photo, I'm trying
to question the viewer's engagement with portraiture. When they experience
a representation of a particular individual, what information do they think
they're getting? I see working with actors in the films in the same way, because
what they're giving is artifice; this is not them as individuals. The older works
were photographed in a studio that was set up; I requested them to perform
stories and to be particular characters, or they could form the characters
themselves. Both types of works are about artifice – no one is who they actually
appear to be. There is no autobiographical subjecthood or biographical
subjecthood in terms of the people who are performing in the films.

Thelma Golden But what's interesting is that in the early photographs, the subjects with their
faces obscured were read simply through gender and race. They were read totally
generically either as you, or as some kind of prototypical, hypothetical, archetypal
black woman. The characters in your films now, though of all races, are read
outside of that. They're not performing as an archetype.

Lorna Simpson No they're not. But because I still use black-haired, Latin American, Indian
or Eastern people – they're Brazilian or Chinese, or Korean, or African-
American or African – a lot of attention is still paid to race. If you look at the
works from the 1980s and early 1990s of black women, and then at the film
projects, there's an equal level of response, in that these characters aren't seen
as a kind of stepping-off point towards a universalism. They're generically
seen as black characters or as people of ethnic groups. Whatever the subject
of my work, it will always first be categorized in those terms. I have my own
utopian sense that at a certain point people's relationship to this work will
change, that it will not come to the forefront as 'Oh, they're black!'

Thelma Golden It's not a racialized reading that you're bringing to your own narratives?

Lorna Simpson No. But the way that they're interpreted out in the world – they're racialized
first. Regardless of whether I'd shown the face or not in those photographs
from the 1980s, or if an actor performed a particular character in a film piece

fifteen years later, all this baggage about race becomes an interpreter by which your work gets read.

Thelma Golden *But don't you think that if there's a theoretical, ideological conundrum that surrounds your work, that would be it? It seems to be something that your work very effectively points out. Not that it's your work's purpose to do so, but in a sense the trajectory of your career points to the way in which on the one hand critical, theoretical thinking and writing have increasingly embraced some of these issues and ideas about gender and the racialized body over the last twenty years, but at the same time if we look at the response to the work of the late 1990s, it still comes down to a simple inability to see beyond colour. And your work provides an interesting test case illustrating an uneasy rubbing together between the theory and the practice, which doesn't reflect the changes that should have happened and that would allow for other readings and other possibilities.*

Lorna Simpson Yes.

Thelma Golden *Your next shift was into full-scale installations in 1998, where you were working in spaces. There was* Standing in the Water *(1994), which was also interested in space,* Still, *which had a certain quality about it in which it consumed space, and* Hypothetical?, *which also worked as an installation. Was that shift just an extension of what you were saying earlier, this idea of working in different materials and media, and moving outside of the frame?*

Lorna Simpson Eliminating the idea of working with the figure and moving into the text pieces in that way opened up a whole arena for me in terms of thinking about working three-dimensionally. And then there was working with sound, which I'd never done before *Hypothetical?*.

Thelma Golden *Let's say a little bit about your newest work,* Untitled (impedimenta) *(2001). There's always been a subtle rebuke, through the insistent presence of bodies of colour in your work, of their absence in art history. And this last body of work takes this to another level.*

Lorna Simpson This body of work contains oval and square images, and they're all of a woman's head, slightly out of focus. There's a little bit of her revealed, but not much; we kind of see her face, but the photographs lie just beneath a translucent material and become silhouettes or are clouded or glossed, so you can only just make her out. The references within the work are titles of paintings from the 1790s to about 1970, and of films from about 1910 to the 1970s. Formally, the ovals point to turn-of-the-century photographs and daguerreotypes – photographs that people would carry around, images of their loved ones. The four-by-five, rectangular images represent modern photography and art. I mix those up in a kind of incomplete grid, so that it's somewhat fallen apart and not completely filled in, but the grid structures each individual piece.

 My first idea was to create a piece in which I had a character who goes

through the same motions over a 100-year period. I was looking for a narrative that could be repeated every thirty years by a different character, and would shift and change over the course of decades, given the nature of the address of that period, and the context of the time in which the narrative was spoken. That became a little too complicated and I didn't like the way it worked out. I realized that the titles of paintings revealed their context over the course of time, and also defined a particular historical moment – like a portrait of a slave in the nineteenth century. But even the images from the late 1970s, which have a completely different political position in terms of representation, are revealing in the way they describe themselves. In all the paintings and all the films there is no consistent ethnic group or person in terms of authorship. What is depicted within those paintings or films is the presence of Africans or African-Americans who are either in the background or at the forefront. What interested me about the titles that I chose was that they seemed highly loaded and spoke very much about time in terms of their language and their address, and also the way they saw their subject, or the invisibility of their subject. To use two different areas, film and painting, as comparative sets of texts – and certainly photography in its beginnings was very influenced by painting – seemed interesting to me. In terms of the pleasure that they give the viewer, both painting and photography operate in the same way.

Thelma Golden *Each of the works that you selected has a black figure in it. You look at this as an expansive scan across history, recording the presence or absence of the black figure – it's sort of a personal look at that presence-absence. How do you feel about making work in which the presence of the black body is consistently foregrounded?*

Lorna Simpson Given the generation that I was brought up in, and given the way in which that affects how I see things now, I cannot take that presence for granted. The moment I take that presence for granted the dominant image will quickly return to a kind of monolithic, non-ethnic depiction. That irritates me on a day-to-day level. This is not to say there aren't any black images in circulation, particularly in film and painting; fields have opened up and there's a lot more black work to see. I just don't take any of it for granted.

Thelma Golden *The way in which you position these works is not necessarily about the past, but about the constant fight for visibility either in art or in film in the present.*

Lorna Simpson It's an off-shoot that is forgotten or put aside or that is still struggling to bear a sense of importance and place within the canon.

Thelma Golden *Where do you see your work existing in the lineage of feminist-inspired contemporary art?*

Lorna Simpson The work was embraced by feminist writers and academics, and is to this day.

Thelma Golden *Was that something that was comfortable or uncomfortable for you?*

Lorna Simpson Part of my inability to answer these sorts of questions is because there was a fracture within feminism in the late 1970s in terms of the involvement of women of colour. In the past ten or fifteen years there's also been a kind of revisionist take on feminism by young women about what exactly it means as a political tool or position, which has further complicated the debate. Women's reproductive lives, their autonomy, are probably the central most important aspects of feminism to me, personally, but over the past few years it's kind of shifted. While in a certain sense my work operates within a feminist critique, it's about negotiating and taking aspects from it that I feel are valuable. But I am not at the centre of a feminist argument.

Thelma Golden But your work has been critically positioned within the feminist dialogue as resolving the issues around women and women of colour and women's bodies in the lineage that includes work by Carolee Schneeman or Eleanor Antin. A whole realm of women created work that performed on, in and around women's bodies and critiqued a notion of artmaking as an exclusive, masculine-dominated, patriarchal arena. It's impossible now to enter into any course on women's art and not get to 1985 and have Lorna Simpson's work put forward as this almost religious pairing of race and gender. I'm asking you how you feel about that; I see that there could be a certain ambivalence for you about that positioning.

Lorna Simpson When you make a work and that work becomes embraced, regardless of who it's embraced by, and it's used intellectually to support a particular agenda, it provokes a level of discomfort. I'm never in one place consistently; there isn't a clear ideology that I'm trying to present, that's monolithic or that's so consistent it speaks to a particular gender. I guess what's at issue is, in terms of art criticism, careers are made by investigating work that's consistent in its production. And I can't really say I use that model very well.

Thelma Golden Your work has consistently used women's bodies, almost exclusively. Did feminist work influence you in this choice?

Lorna Simpson I think maybe that choice was made more from reading literature. What came out of feminism originally was a kind of a gay or lesbian agenda. Notions of feminism do run through my work in terms of the body and control, but a lot comes from literature.

Thelma Golden In looking back and thinking about the work and how it's developed, where do you see it going now?

Lorna Simpson I see my work now as revisiting photography. It's a difficult relationship to return to; I haven't worked with photography for so long, yet it's still very familiar.

Thelma Golden And thematically?

Lorna Simpson After the pieces with titles from paintings and films, such as *Untitled (guess who's coming to dinner)* (2001), I'm now thinking of a film where the dialogue

is constructed from titles, which are twisted to seem like conversation, but what the actors are doing is speaking only titles.

Thelma Golden *Has this process provided any revelations like those you had when you saw your survey show and understood that you had to look at your work in a larger way?*

Lorna Simpson Certainly, in terms of working with film, I see that there's lots of room for experimentation. I haven't done that many films – about five or six to date. The photography is a little bit more difficult, only because I've investigated it so much. I'm trying to bring some of film's more playful process into making the photographs with text.

Thelma Golden *It's like you're starting over in a way? You're re-establishing your sense of how you work with both media?*

Lorna Simpson Yes, correct. I'm not boxing myself in, and not being so constrictive.

Nancy Spero *Jo Anna Isaak*

in conversation
December 1994, Geneva, New York

In the winter of 1994 Nancy Spero and Jo Anna Isaak met and taped these conversations. They projected a selection of slides of the artist's work on the wall and discussed issues the works addressed, the art world and Spero's life when she was making the work.

Jo Anna Isaak *This first image is called* Dancing Figure. *I have never seen this work before.*

Nancy Spero Oh, it's student work, a lithograph with writing on it. I used a lot of language in those days. It is some frenzied, fiery, apocalyptic kind of dance. I did that at the Art Institute in Chicago. I graduated in 1949 so it must have been in 1948 or so.

Jo Anna Isaak *This is a great work to begin with because it introduces the theme of dance which runs throughout all of your work.*
 Let me go to another dance piece called Smoke Lick.

Nancy Spero *Smoke Lick* was 1974. We had this terrible fire in our apartment when we were on 71st Street and Broadway and a lot of my work was smoke-damaged. I collaged smoke-damaged paper onto *Hours of the Night*. I called this piece *Smoke Lick* because the smoke was almost like a strange animal with a lot of tongues coming into my studio.

Jo Anna Isaak *For me this looked like a Vaudevillian dance routine, a cakewalk with exaggerated steps, or a slinky – you know, the kid's toy.*

Nancy Spero They are cartoonish. Actually, I was influenced by medieval animal imagery.

Jo Anna Isaak *Why medieval?*

Nancy Spero I was interested in making a connection with medieval art, to tie my art to art history (*laughter*); I still considered myself an underground artist and, at the time, so angry and disconnected from activities in the contemporary art scene. I had been thinking back to medieval images of the apocalypse that showed the sinners and all the horrendous things that were done to them – bodies drowning in rivers, animals with their tongues coming out. That imagery was my rationale for allowing myself to make those grotesque, fantastic, imaginary things.

Jo Anna Isaak *Was that the first time you used tongues?*

Nancy Spero No, I had used tongues early in Bloomington, Indiana, in 1958, in a work called *Homage to New York*. *Art News* was the big art magazine at the time and it primarily featured New York artists and Abstract Expressionists. I did this painting with a tombstone right in the middle and then on each side are two heads with dunce caps and rabbit-like ears and their tongues are sticking out. And on this phallic-like tombstone in the middle of their tongues are the initials of all the artists who were prevalent then. Some of the initials you can recognize very easily. On top I wrote, 'I do not challenge' and then 'Homage to New York' below.

New York was the centre of the art world and Abstract Expressionism was so powerful then. In Chicago we were always aware of New York. There was a theatre group at the time called Second City: if you were in Chicago, you knew you were in the Second City.

Jo Anna Isaak *Oh right. Second city, second class, second sex – it adds up.*

Nancy Spero Also, I was very resistant to New York because I was a figurative artist. At the Art Institute I really found my milieu. I was a very unhappy girl before that but I loved it there with the other alienated beings, so to speak, the other misfits in society.

Jo Anna Isaak *This next work is* Great Mother and Child.

Nancy Spero These are unstretched – you can see how ragged the edges are; this was a real change. I used to work so long on these paintings. You saw that early dancer; then I was working fast and they were much more expressionistic. This is more controlled. I only did a few paintings a year. Leon Golub and I were sharing the studio in Chicago; we have always had a commonality of interests and have always discussed our art. At this phase I think we were looking at a lot of classical and ancient art.

Jo Anna Isaak *The painting looks as if it is lit from within. How do you get that effect?*

Nancy Spero Underneath is a sized canvas. The paint is gold oil and then to make it ancient-looking I painted it over with black. These Black Paintings got darker as I worked and reworked them.

 The paint is pre-mixed, then put on. I don't scrape it. I did rub off a lot which made kind of a dull grey surface. Sometimes the surface would go rough where the grey paint got greyer and then I would rub out a certain area with turpentine and then redraw it and repaint it. And it got greyer and greyer and muddier. It was very discouraging. That's why I quit oil painting.

 Now this is *Hanged Man*. You can't really tell who is the hanged man and who is the executioner. They both look like they have hoods over their faces. This was the beginning of these double images. This was '58. They aren't literally mirror images, but the figures are always attached to each other.

Jo Anna Isaak *Well, the Hanged Man is a tarot figure.*

Nancy Spero Yes, exactly. This is the beginning of my interest in the mirror image. With *Mother and Child* I was exploring an idea of destiny, and the individual and characters were tied together but with separate fates. I felt that way with the 'couples' paintings also, that the figures are elegiac and lyrical but existential; together, but in this ambiguous space. All of these works are in a non-specific background and the figures melt into it or they come forth or they just exist in space without explanation. A lot of my work seems to have a narrative but there is no narrative, there are only inferences.

Jo Anna Isaak *The ambiguity of these figures reminds me of Picasso's Blue Period, the circus family, or the boy with the horse where everyone is bound to each other but the ropes are not visible. This whole series, the scenes from the Mediterranean, the Lovers, Mother and Child paintings, all the Black Paintings, seem to be a happy period. Was the time you spent in Paris a good time?*

Nancy Spero Yeah, we were there from '59 to '64, although there was a brief interruption in 1960 with the Fuck You series of works on paper, which were very angry. I have these strange creatures, saying '*merde*' and 'fuck you'. These worm-like or snake-like figures are a precursor of the *War Series*; they are screaming and their tongues are sticking out.

Jo Anna Isaak *Just like Caliban, the first thing you do when you start to speak is to curse. It is an appropriate response to being forced to speak in a language not your own. But also I was thinking lately that you are not such an angry young woman anymore (laughter).*

Nancy Spero Yes, I shifted and changed. I think that the anger in the *War Series* and the Artaud Paintings came from feeling that I didn't have a voice, an arena in which to conduct a dialogue; that I didn't have an identity. I felt like a non-artist, a non-person. I was furious, furious that my voice as an artist wasn't recognized. That is what Artaud is all about. That's exactly why I chose to use Artaud's writings, because he screams and yells and rants and raves about his tongue being cut off, castrated. He has no voice, he's silenced in a bourgeois society.

　　Then, when we came back from Paris, I really reacted to the Vietnam War and to the media coverage of it. I wanted to do something immediately, I was so enraged. Coming back from Europe, I was shocked that our country – which had this wonderful idea of democracy – was doing this terrible thing in Vietnam. I wanted to make images to express the obscenity of war.

Jo Anna Isaak *This is the motive for the sexual, scatological series of bombs.*

Nancy Spero Yes, exactly, and all this craziness in '66. The *Sperm Bomb* has to do with male power but the image is rather elegant. I think it resembles testicles.

Jo Anna Isaak *It does. There is the whole sexual metaphor underlying war, so why not reveal it?*

Nancy Spero Most relevant to the Vietnam War was the helicopter. So I started thinking about the Vietnamese peasants, what they would think about when they saw a helicopter and how to visualize this.

Jo Anna Isaak *This* Helicopter and Victims *(1967) looks like a kind of a prehistoric dinosaur figure.*

Nancy Spero There are bloody bodies, skulls and remains. The helicopter is eating and shitting people, just like an efficient war machine.

　　Now this is *S.U.P.E.R.P.A.C.I.F.I.C.A.T.I.O.N.* This is what I consider the obscenity of the war. I thought the terminology and slogans like 'pacification'

coming out of the Pentagon were really an obscene use of language. They would firebomb whole villages and then the peasants would be relocated into refugee camps. This was called 'Pacification and Re-education'. So in this image the helicopter has breasts hanging down and people are hanging on with their teeth, like in a circus act.

Jo Anna Isaak *I see, sucking on the tit of the Great American War Machine.*

Nancy Spero Yes, exactly. Now this is *Crematorium, Chimney and Victims*. These creatures are the victims coming around and licking the chimney. I think this had to do with the idea of the oppressor and the victim and the terrible symbiosis of that relationship. This was pre-feminist. Now this is *Eagle, Victim and Medusa Head*; it is slightly larger. At this point I was using Sekishu, a Japanese handmade rice paper. It is very strong and fragile at the same time. I couldn't work on it the way I did the others. So this is when I really started collaging, in the late 1960s, for the *War Series*. I print a lot of images on it now and collage them to the Bodleian paper. The double-headed eagle is a man's head with a tongue and then an eagle's head. There are dismembered bloody victims below.

Jo Anna Isaak *Dismemberment is another motif that keeps coming up in your work. Your next work was the Artaud Paintings; how did you first become interested in Artaud? Were you reading him in French or English?*

Nancy Spero A friend of ours, Jack Hirschman at Indiana University, did an anthology of Artaud's writings in translation. He became an Artaud freak. He was tall and dark and he became even more gaunt and more Artaud-like as he worked on the book. He got these other American poets in Paris to do translations of Artaud. They were brilliant, and so the first year of the Artaud Paintings, I used English. Then I decided that, as beautifully done as it was, it wasn't right, that the original French was right. I went to Artaud because I wanted a vehicle to show my anger and he was the angriest poet there was.

Jo Anna Isaak *I can't think of a woman writer at that time expressing so much anger, yet it is interesting that Artaud so often speaks in a woman's voice, he even invents imaginary daughters in order to express a woman's pain, or the marginalized, all those outside of language. Julia Kristeva describes Artaud's writing as an 'underwater, undermaterial dive where the black, mortal violence of "the feminine" is simultaneously exalted and stigmatized'. She says that if a solution exists to what we call today 'the feminine problematic', 'it must pass over this ground'. Freedom of speech, freedom of movement, freedom of the spirit involve coming to grips with one's body by going* through *language, going through 'an infinite, repeated, multipliable dissolution, until you recover possibilities of symbolic restoration: having a position that allows your voice to be heard in real social matters – but a voice fragmented by increasing, infinitizing breaks'. I think this is a good description of Artaud's writing as well as the trajectory of your development.*

Nancy Spero In 1969, in the first series of the paintings, I wrote a letter to Artaud in blood-red ink, 'Artaud I couldn't have borne to know you alive your despair – Spero'

In this work, *Pederastically in the Beginning …* , I am quoting Artaud, 'In the beginning, Father, Son and Holy Ghost. That's a family, father, mother, and Baby Wee … I say grotesquely'. He was very hateful about the family. In between his description of the family I collaged my images: there on top are the pederasts; Mother and Baby Wee are in the middle. The Mother is very ferocious, like the fierce protective mothers in the Black Paintings. Artaud was mentally and physically ill but so brilliant. He lashed out at everything; that it is just what appealed to me.

Jo Anna Isaak *The next work is called* But the sleeper that I am …

Nancy Spero 'But the sleeper that I am will not fail to awaken and I believe this may be very soon', and then the nonsense words begin where he is speaking in tongues. He did that a lot in his writing.

The first *Codex Artaud* was made in 1971, after two years of the Artaud Paintings. After the Artaud Paintings, I wanted to move into space, so I used these archival art papers that were around the studio and glued them together. They are all different types of paper. The first and the fourth piece are the same, the second is French vellum, a tracing paper.

Jo Anna Isaak *Is the vellum coloured silver and orange?*

Nancy Spero That is the painting. It is like a Rorschach blot, by that I mean I painted the paper and then folded it in two. The typing is on vellum and all those figures are collaged onto it. The left is a mummified figure, one of those strange Egyptian figures, and I added the tongue sticking out. Then there are some Greek classical figures, and then in the last the quotes are about 'before I commit suicide'. It is very ambiguous: 'I want to know if there is another form of being'. I guess he wants to know if there is an afterlife or if a spirit exists after his death …

Jo Anna Isaak *In* Codex Artaud III *there is a figure holding a banner with a head on it …*

Nancy Spero The whole thing is about gesture. This image is heraldic, holding a shield up proudly. Those arms come from the poses of Roman bronze statues in Pompeii. The other one is holding a sign like the Chinese had for victims who are going to be executed or tortured with the crimes they have committed hanging from their necks. I got everything from any old source. But it all relates to death. In the *War Series* I have a female figure with four breasts leaning over and a nursing child. I was thinking of Romulus and Remus and the Egyptian goddess. In *Codex Artaud VI* the figure has four breasts and a penis. Now this turned out to be androgynous because I was responding to the ambiguity of Artaud's sexuality.

Jo Anna Isaak *What is going on in the patterned type?*

Nancy Spero That is what I call the Artaud rug. I just used Artaud's name and I repeated it in certain ways. There was a lot of pattern painting going on at the time, pattern painting and Op Art ...

Jo Anna Isaak *When he talks about the obscene phallic weight of the praying tongue, do you think he is talking about religion or language in general?*

Nancy Spero I thought it was about language, sex and religion.
 Another thing enters into the Artaud work. There is a quotation in one of the last pages in his notebook on pain. I was suffering a great deal from arthritis, and I thought, that is what he talks about, mental and physical pain, I can use this.

Jo Anna Isaak *What made you move away from the mythopoeic recording of unrightable wrongs that you were engaged with in the* Codex Artaud *to recording real case histories of torture?*

Nancy Spero In '72 I had had enough of Artaud. I thought there is real pain and real torture going on, never mind Artaud. His pain is real, but it is the expression of an internal state. So this was an important step, to disengage myself from Artaud and to externalize this anger. I decided to address the issues I was actively involved in – women's issues. I wanted to investigate the more palpable realities of torture and pain.
 The change had to do with my activities within the women's movement and more immediate concerns in my own life. I had been going to AWC (Art Workers Coalition) meetings. AWC staged all kinds of protests. The men were very outspoken in their complaints, but the women artists were getting an even rawer deal. I felt, you know, I had three kids at home still. Then I heard of something that really rang a bell: WAR (Women Artists in Revolution). WAR was a radical group of women artists who split off from AWC to address the concerns of women artists. It was a very lively time, we wrote manifestoes and engaged in actions and protests. Once we went over to the Museum of Modern Art, eight of us, one woman even had a child of about six or so, dragging along. We marched into the office of John Hightower *[then Director]* and we demanded parity for women artists. He asked us to sit down and we wouldn't sit down. We demanded parity and then we left. Later, I joined the Ad Hoc Committee of Women Artists. We did all kinds of actions, sit-ins and picketing. A whole bunch of us invaded an opening at the Whitney. We went inside and sat down, plop, right in the middle of the museum. It was good fun. I was really restless at that time, so angry and frustrated with my career. Then Barbara Zucker got the idea that we could form a gallery. There were so many unaffiliated strong women artists floating around. Six of us met: Barbara Zucker, Dotty Attie, Susan Williams, Mary Grigoriadis and Maude Boltz. We discussed the idea of an all women's gallery. We all thought it was a great idea. *[AIR, the first women's gallery in New York City, opened in September 1972 with a group show of its founding members.]*

Jo Anna Isaak *The next large work is* The Hours of the Night.

Nancy Spero The title is Egyptian and refers to the passage of the Sun God into the underworld for twelve hours, but I made it eleven hours. This had to do with the terrors of the night and the war. I put all kinds of stuff I'd used previously, really cannibalizing my own work. 'Body Count' was printed directly on the paper, as was 'The Hours of the Night'. All the rest are collaged inserts. So that is 1974, when I was doing all sorts of crazy things with language and text – experimenting.

Jo Anna Isaak *Is the panel that begins with the huge yellow letters 'Explicit Explanation' the first panel of* Torture of Women?

Nancy Spero Yes it is. This is an explicit explanation of hell, the real hell of these women's lives. Now on panel nine I started printing figures, not just letters. This was the first printed figure I used. When I was buying all these alphabets, the guy said to me, 'If ever you want to make a drawing, I can make you a plate and you can print it.' That was the beginning …

Jo Anna Isaak *Ah, so this is the beginning of your alphabet of women, your fundamental female lexicon.*

Nancy Spero Absolutely. So I printed her over and over inside this grid. Her hands and feet are cut off, she is really cramped; it is like a metaphor for women in jail cells, in prison. Actually, I make these prints from metal plates, and I inked up some dowel sticks and made those lines. The metal plates are for paper only. Now, when I print directly on the wall, I use polymer plates because they are flexible.

My next work, *Notes in Time on Women*, took three years to do – 1976 to 1979. If we include *Torture of Women*, which was originally planned as part one of *Notes*, then it took five years, but the information gathering had begun long before that. It was like working on a book, a solitary activity. I had to sequester myself. Rarely was anybody interested enough to ask to see my work in those days and I had nothing to show for years. I was stockpiling images and quotations, handprinting them and collaging them directly on the paper. Then, in the last few months of work, I put everything together.

Jo Anna Isaak *Your account of the process reminds me of Wyndham Lewis' description of how James Joyce made* Ulysses: *'He collected the last stagnant pumpings of Victorian Anglo-Irish life … for fifteen years or more – then when he was ripe, as it were, he discharged it, in a dense mass, to his eternal glory. That was* Ulysses.*'*

Perhaps this is the stuff modern epics are made of. The stories are not taken from the front pages of the newspaper. What you document in the panels on contemporary history are just incidents in the lives of ordinary women. For example, there is the story of a young woman medical student, top of her class, who was denied readmittance to medical school in her final year because she was Jewish, female, and, as her report noted, 'had a much higher I.Q. than

her male colleagues'. Her case, filed in 1972, dragged through the courts for five years, like a suit in Chancery.

You begin with a dance: ancient, mythological and contemporary images of women running in celebration. The celebration seems to be about the freedom of movement, the ability to dance, to leap athletically, unfettered.

Nancy Spero The women are all dancing after a panel with the words 'Certainly childbirth is our mortality, we who are women, for it is our battle'. The passage is from an ancient Aztec book. It could be read as 'Certainly childbirth is our *im*mortality' as well; both are true. Artemis interrupts this celebratory dance, her fist raised. She is Artemis/Apollousa, the destroyer, the goddess of childbirth. Artemis, 'who heals women's pain', is a frequent figure in my work. So I have these figures running by. It is the same pose but the ink is unevenly applied, the handprinting varies, the different colours and pressures of the ink give the effect of multitudes in motion.

Working on this piece was depressing; the history of women was so horrific, so negative, so oppressive, that I thought, how can I counteract this? That is how all these depictions of athletic women got started. Gathering all this information about women, being madder than hell, realizing further my status as a woman, I decided to make Woman the protagonist, to depict her as liberated, even if I know this isn't really the case.

Jo Anna Isaak That makes sense, an image of agency, an image of physical autonomy that could stand up against the weight of these accounts that spoke only of women's victimage. Throughout the text, women – ancient, mythological, modern – run, leap, dance, do somersaults, splits, cartwheels, anything they can to break up the 'heavy phallic weight' of the language.

Nancy Spero Once you and I were talking about the printing process I use in which the same figure appears and reappears in an extended narrative format. You mentioned Gertrude Stein's use of repetition and her term, the 'continuous present'. That is a good term for what I'm doing. The history of women I envision is neither linear nor sequential. I try, in everything I do – from using the ancient texts, to the mythological goddesses, to H.D.'s poems on *Helen of Egypt* – to show that it all has reverberations for us today. And then it makes sense.

Jo Anna Isaak The story of women recorded here is that of women striving for the very bodily freedom you depict.

Nancy Spero I was thinking of documenting images and stories of women through time. I first envisioned *Notes* as a continuation of *Torture of Women* but with other subjects, accounts of women from historical or even pre-historical times, but including the celebratory: dance, power and buoyancy as well. When it says *Part 2: Women, Appraisals, Dance and Active Histories* it meant that *Torture of Women* had been planned as Part I, but I had to separate the two parts because it was too long, there was too much material. There are twenty-four

panels in *Notes*. It is huge. By calling it 'notes' I meant jottings and selections, and that made it arbitrary. Totally arbitrary.

Jo Anna Isaak *Actually, it is not arbitrary at all. It is epic. It is organized, like most epics, by the so-called accretion theory of epic formulation in which the author gathers together all kinds of fragments and bits of stories, stories that are already well-known to the community. It is epic in another sense. The epic re-presents the dominant values of the time – the values, that is, of the rulers of the time. While your subject may be women, you are not pretending that women have any greater purchase on language, power, or the law than they actually do. Most of the language is written or spoken by men; if women speak they often marvel at being allowed to speak and usually they speak of their disenfranchisement. Abigail Adams may write to John Adams in 1776 to ask him to 'Remember the Ladies' as he is making 'a new Code of Law for an independency', but he promptly responds to her letter by saying, 'Depend upon it, We know better than to repeal our Masculine systems'. In the section devoted to black women, Sojourner Truth speaks before the Fourth National Women's Rights Convention, held in New York City in 1853, and says to the crowd – in turmoil because a black woman had been given the podium – 'I know that it feels kind o' hissin' and ticklin' like to see a coloured woman get up and tell you about things, and Woman's Rights.'*

Nancy Spero This section is devoted to black women. Throughout these printed stories I collage painted heads of black women onto the paper. Some are of recognizable individuals and some are not. In the centre is a large figure of a young black woman, regal and unmistakably black. When you look closely, you see that she is slightly pregnant.

Jo Anna Isaak *It is a hopeful section. Sojourner Truth's desire to go the polls and vote before she dies leads directly to convictions of Dr. Mamphela Ramphele. Even after her friend and father of her child Stephen Biko, founder of the Black Consciousness Movement, has been murdered, and she herself has been sent into exile for five years, she is confident that her son will not grow to adulthood in a white-ruled society. But the hope and conviction of these black women seems to be blotted out in the next section, in which accounts from Amnesty International,* Matchbox *and the* USLA Reporter *document the torture, rape, murder or disappearance of hundreds of women, many of whom live in countries with American-backed governments.*

 At this point the scroll seems to haemorrhage; it is the way you have typed it. The individual case histories are printed crowded against each other. Each one is the story of a woman: her name, her age, her job, her family, the town where she lived and the community who knows her fate are all documented there, but it all so dense and intense.

Nancy Spero Someone called this a wailing wall, like the Vietnam Memorial in Washington with the names of all those who died in the war. There are so many of them, and their imprisonment, torture and murder takes place in so many countries.

They are unknown women, but we cannot pretend we have never heard of them or of the fate of women like them.

Jo Anna Isaak *It seems to be possible to read the dramatic action in the type itself. Text compounds upon text, the print grows in size as if to increase the volume of the message; at its loudest pitch, it blacks out. Afterwards there is a hiatus ... long stretches of blank white spaces speak of the silence, loneliness, emptiness and estrangement that must have followed such trauma. And the next section is about the violence towards women that is in language itself. It seems to function as a coda to the preceding section, as if offering some rationale for the hideousness of the torture of women.*

Nancy Spero Yes, exactly. I quote passages from the *Malleus Maleficarum* that compare woman to the Chimera, a beast with a lion's head, a viper's tail, and the filthy belly of a goat. This was a commonplace adage during a severe wave of persecution of women in the sixteenth century. One says a woman was *'une beste imparfaite, sans foy, sans loy, sans crainte, sans constance'*. Nietzsche claims torture itself is female, 'the extraction of the tooth, the plucking of the eye. They are the violence of the Christian idea, of the idea become female.' Then there is the contemporary theoretician Leo Bersani, who compares the penetration of art by criticism to the sexual penetration of two still-warm female corpses who are offering a choice of orifices.

Jo Anna Isaak *You quote Derrida saying 'there is no essence of woman ... there is no truth about woman ... the feminist women are men ... feminism, indeed, is the operation by which woman wants to come to resemble man', but that whole virile illusion is disrupted by a very buoyant gold and black figure of a woman who is able to do splits while leaping over his words. Your signature head sticking out its tongue runs throughout. In panel IXX, rows of painted heads of women are collaged onto the paper forming a kind of anonymous women's Hall of Fame.*

Nancy Spero In panel XXI a sign appears saying 'défense d'uriner': it is forbidden to urinate. That was the feminist Françoise Parurier, working in the 1940s or 1950s, who asks, 'And who pees against the wall?' The answer is, men and dogs pollute the city. It ends with an Indian song from a young girl's puberty ceremony: 'I am on my way running/I am on my way running/ Looking towards me is the edge of the world/I am trying to reach it/The edge of the world does not look far away/To that I am on my way running.' I printed it so that it seems to be raining down upon the dancers. It is an orgiastic dance. Pregnant women, women with their babies cradled in their arms, women waving dildos, women masturbating, women embracing each other dance, leap, kiss, copulate and do acrobatic acts.

Jo Anna Isaak *In the work which follows* Notes in Time on Women *there is no text at all, yet ironically you call it* The First Language.

Nancy Spero I finished *Notes in Time* in '79. I had used so much text, I decided at this point, no text. It is about body gesture; the language is composed entirely

of the female body set in motion. I decided the figures themselves were like hieroglyphics. I worked on *The First Language* for two years. It starts with images I cannibalized from my earlier work. There is war and rape, brutality, but also Dionysiac sexuality, athletic women running, young African women ritualistically dancing, a contemporary woman roller-skating, the whole thing just rolls along.

I printed all these figures and then had studio assistants cut them out. The assistants also handprint the plates and I then choose the images and compose the work. I feel very free with this collage technique and the linear format. I have a theme and I can orchestrate it, add stops and then have them running again.

Jo Anna Isaak *Yes, you do get a sense of narrative timing, or choreography. The next work is* Let the Priests Tremble. *This I remember very well.*

Nancy Spero This is the work you exhibited in *The Revolutionary Power of Women's Laughter* show in January of 1983. You also included *To the Revolution* in that show. You recognized the humour and the defiance in the work. That was a very exciting moment. That exhibition provided another context for my work, another insight into what I was doing. Just about that time I had my first commercial show at Willard Gallery; that was in 1983 as well. And I did this mini-retrospective at AIR. I have a lot of shows now and it is not that I am blasé about it, but the importance of these first things – particularly the women's movement in the arts – can't be denied.

This next one is *Black and the Red*, 1983. This image was taken from an erotic Greek vase. In the Greek version she had two dildos in her hand. They are in the panel on sexuality in *Notes in Time*. When I first started to make these printing plates, I took out the dildos.

Jo Anna Isaak *But later on, you put them back in, for example, in* Rebirth of Venus.

Nancy Spero Yes, but the provenance is entirely different: it was a drinking cup.

Jo Anna Isaak *Where did the image of the athlete in the second panel of the* Rebirth of Venus *come from?*

Nancy Spero I did a drawing from a media photo of a black athlete who won a medal at the Olympics a few years ago. She is triumphal. And she is way out of whack proportionally; the back leg is just enormous, even though I worked for days, trying to get her into proportion.

Jo Anna Isaak *Well, it serves another purpose in terms of giving her a sense of power and forward thrust. Your work at this point is no longer so angry; it is much more colourful and filled with buoyant dancers and the idea of rebirth.*

Nancy Spero I had been fighting a sense of victimage, my own and that of other women in *Notes in Time* and *Torture of Women*. But I was thinking, I cannot stay with victimage; there is humour too. That was when you came along and we talked about humour as a revolutionary strategy.

Also at this time I was gaining a certain recognition as an artist. My goal of having a dialogue with the art world was beginning to be realized to a certain extent.

Another thing at this point was that my physical condition was becoming more apparent. You know I often felt very rotten with this arthritis, but now I acknowledged it.

Jo Anna Isaak *The* Monsters *diptych (1984) isn't at all up-beat. Are all the monsters women? Are those monstrous breasts?*

Nancy Spero Yes, she's a monster, she has this terrible head and teeth. And then that woman on the right waving a club is a monster. I got that photo from some sort of riot. There is an image of women's monstrous sexuality. I got that image of the woman with her hands near her crotch from a pornographic magazine, and these monstrous headless torsos are from some book on ancient civilizations. Dr Klaus Vierneisel, Director of Antiquities in the Glyptothek in Munich, gave me a show in the Antiquities Museum and he took it upon himself to look up some of these sources, for which I was very grateful.

This, for example, is the irradiated woman from the *War Series*. I call her 'irradiated' because this imprint was all that was left of a woman's body after the bombing of Nagasaki.

Jo Anna Isaak *She is an image that endures, something of her remains. She is not erased.*

Nancy Spero *Mourning Women/Irradiated* (1985) is an image of endurance: an old woman walking over the corpses has escaped and she still keeps going with this cigarette in her mouth. She is with three of these strong athletic figures of women and they are like spirits. In the diptych *Vietnamese Woman* she walks away from the victims; she's a survivor.

Jo Anna Isaak *The next is* Sky Goddess, *done in 1985. Her body forms a canopy over the other figures ...*

Nancy Spero The inspiration for that was the ceilings of Egyptian tombs. And there is an aboriginal figure and an African woman reaching up with her baby strapped around her back. There is the dildo dancer, and a group of aboriginal figures below. In the lower panels I am starting to play with the Sky Goddess. She is starting to move stiffly like a machine, almost reiterating the pose of that woman with the baby strapped on her back. She is actually looking for food, there is a famine.

Jo Anna Isaak *This wonderful blue figure at the top must be a fertility figure with a foetus in her belly and a long curling umbilical cord. Now we have* Chorus Line I.

Nancy Spero When the American curator Robert Storr curated 'Devil on the Stairs', in 1993, at the ICA in Philadelphia, thirty-five artists represented different categories. I was in the 'Body Room' with Louise Bourgeois, Ana Mendieta

and Francesco Clemente. Clemente had a painting depicting male figures, with huge penises. The room was small, so on a beam above Clemente's paintings I did the *Chorus Line I*.

Jo Anna Isaak *It is as if you have a complete cast of women characters and now all you need to do is play with the many combinations. For example, in* Sky Goddess/ Egyptian Acrobat, *when you print vertically you get narratives reading vertically and horizontally, then the whole thing seems to pivot around the acrobat in the centre. She seems to spin the whole thing around.*

Nancy Spero Yes. The handprinting and collaging technique is very freeing. This was for a show in Germany; I wanted to do a contemporary piece with eleven bands, like *The Hours of the Night* .With this next group of works, Leon had found this image in a magazine of a woman about to be hanged captioned 'Document trouvé sur un membre de La Gestapo' and I took it and had it made into a printing plate. She is bound and gagged; a rope is around her neck and her whole body is bound very tightly and most brutally. One breast is forced up. She is naked apart from half stockings and shoes. Her head is bowed and averted, which means that probably the guy who took this photo watched this hanging. I had this image and I didn't know how to use it. A year or so later I heard a programme on Bertolt Brecht on National Public Radio. One of the things that was read was the 'Ballad of Marie Sanders'; it was fantastic! I tracked it down in a book of Brecht's poetry and that is the translation there, 'The Ballad of Marie Sanders, The Jews Whore'. It is a story of a woman who slept with a Jew; she was arrested by the Nazi SS, who cropped off her hair and walked her down the street to her disgrace. In the poem, she is just in her slip, and the drums roll, coming to her death. It says, 'In Nuremburg they made a law at which many a woman wept, who'd lain in bed with the wrong man.' And then there is the stanza: 'The price is rising for butcher's meat, the drumming is now at its height. God alive, they are coming down our street, it'll be tonight.'

 I did this as a wall installation in Amsterdam and I met a young Dutch artist there, and he said this is not a poem; this is really a ballad and it has to be shouted. Then he made a loud stamping with his feet and I thought, that is how that poem should be.

Jo Anna Isaak *Yes, I remember you printed this directly on the wall at Smith College, it was '90 or '91. I see you have used the Gestapo photograph again in this work called* Frieze II.

Nancy Spero Yes, I juxtaposed it with an image from a French comic book. It is about glamorizing torture, making it sexy. Then on the other side are those mourning women patterned abstractly. In this next work, *Running Totem*, there's a change of style to solid colour. I print the background areas very heavily with a Brayer roller. This technique really comes together in the work I created for the Malmö Konsthall, *Black and the Red III*. I was challenged by the large and airy exhibition space and its simplicity. The

Director, Sune Nordgren, wanted to show *The First Language*, possibly because of its pace and tones. I decided to respond to this by creating a new work which had the same dimensions but would explode with intense and vibrant colours and forms. This was an ecstatic and extremely ritualistic work that continued the linear format of *The First Language* around the museum space – the figures continued dancing on the walls.

Jo Anna Isaak *Now this last work is called* The Audience II. *This is pretty amusing.*

Nancy Spero They are all those 1930s women. And she is sitting there smoking and enjoying the show.

Jo Anna Isaak *I like the panel where the head goes around the edges as if she is looking down on you. It really suggests intense surveillance. It is also a good work to end on. So much of your work is about the formation of a female protagonist as the universal; in this piece it seems you are now refiguring the audience as female, as if women too can assume the controlling gaze.*

Nancy Spero Well, yes. Why not?

Jessica Stockholder *Lynne Tillman*

in conversation
July–September 1994, Brooklyn

Location 1
Stockholder's apartment in Brooklyn. Stockholder and Tillman are talking
and looking at slides.

Jessica Stockholder I started painting on unstretched canvas.

Lynne Tillman *Did you paint when you were a kid?*

Jessica Stockholder Yes. I remember getting into a mood where I just wanted to make something.
It was always a frustrating experience. I felt that I lacked facility, that
I was inept.

Lynne Tillman *How did you know what to measure against?*

Jessica Stockholder My mother painted. For a while, I painted next to her. I remember making
one painting that was a sort of stage with figures on it. It was an orange and
black painting.

Lynne Tillman *You still make stages – platforms, ramps.*

Jessica Stockholder In a journal I have from when I was a kid, I have a dream written down about
yellow newspaper. I've used a lot of yellow newspaper in my work. This is
unstretched canvas, with little bits of pieces of stuff stuck on it. Actually it's
cloth, not canvas. There are different pieces of cloth stuck together, painted,
then there are bits of acrylic paint – this was in 1980.

Lynne Tillman *Do you have a name for it?*

Jessica Stockholder I didn't title pieces until much later … These are made with pieces of cloth
and stuff stuck together.

Lynne Tillman *Did you go to art school?*

Jessica Stockholder No, I went to university. Earlier I studied with Mowry Baden, who's a
sculptor. This is a very early one – a watercolour of me.

Lynne Tillman *Looks more like a wolf man or a farmer –*

Jessica Stockholder Overalls were in style then. Here's one I like very much.

Lynne Tillman *That's beautiful. Like a Matisse.*

Jessica Stockholder He's one of my favourite painters … These are all close to square or
rectangular painting.

Lynne Tillman *Was this while you were studying with Baden?*

Jessica Stockholder Yes. He's a friend of my father's. When I was fourteen, I had private lessons.
He taught me to draw – line drawings of objects that became quite abstract.
He taught me to appreciate the surprise of making something unexpected.
He would talk about the drawing in terms of how it addressed the page.
It wasn't about representing the thing that was on the table.

Lynne Tillman Most artists, writers too, recapitulate a number of different styles. It's about working with a language. You have to figure out what's already there, then see what you can do with it.

Jessica Stockholder Here's my Larry Poons. And this is one of the first paintings where I started to break up the pieces, so that there'd be space between the things on the wall.

Lynne Tillman How did that come to you: to begin using cloth and …

Jessica Stockholder Mowry spoke about the unstretched pieces not having integrity as objects.

Lynne Tillman Why was that?

Jessica Stockholder The cloth hanging on the wall was flimsy. He talked about the easel painting as a small replica of the wall it hangs on. He pointed to architecture giving meaning to the historical structure of painting. This way of thinking made a lot of sense to me. I later found similar ideas discussed by Brian O'Doherty in *The White Cube*. Though his view of painting's history is more cynical.

 An unstretched canvas hanging on the wall doesn't provide a place to take off from the material and forget it's there.

Lynne Tillman Is it a neither here nor there state?

Jessica Stockholder For me painting is wonderful because it provides a place to forget the material, even while your attention is drawn to it.

Lynne Tillman How do you mean? – forget the material –

Jessica Stockholder I use material as a place to make fiction, fantasy and illusion. When this happens, attention is drawn to something abstract and separate from the material – the physical paint and canvas.

Lynne Tillman Do you use a material in order to forget it?

Jessica Stockholder I like there to be places where the material is forgotten; but I also love to force a meeting of abstraction with material or stuff. Colour is very good at this, always very ready to assert itself as independent of material.

Lynne Tillman Particularly when its use is idiosyncratic. In Recording Forever Pickled (1990), in front of a kind of skeletal wall, a wooden structure, there's a wrapped armchair. What seems a coffee table is in front of the chair, but it's made of concrete. I think about the impossible living room. The space one can't talk in. The spaces or things one can't talk about. I think that piece is, again, a kind of stage, with an element of the absurd in it. And the yellow on the floor could be any other colour. One's attention is called to the yellow just as a colour. It's bright, challenging, odd.

Jessica Stockholder It couldn't be any other colour, because the colours are keyed to each other. There's plywood holding the crosses or Xs up. The back is painted violet, and this violet reflects onto the wall. Then the red –

Lynne Tillman The wall seems to disappear. I can't tell if there's space behind.

Jessica Stockholder I often use white to do that, because visually white sinks back into the wall of the gallery. When the viewer moves around to the edge of this piece, the reflected purple or violet between the wall I made and the wall of the gallery is seen as a volume of colour. The violet complements the yellow-orange on the floor. The colours are keyed to carry the eye around; they read across space. In this way the colour is very specific.

Lynne Tillman *You could have set up a different set of colour combinations. But you call attention to colour by what seems to be an arbitrariness in the decision, since it's not linked to a 'natural' concern.*

Jessica Stockholder That's right. The colour is not descriptive of something else in the world.

Lynne Tillman *It has its own life as colour. You use it idiosyncratically, calling attention to it, which is painterly …*

Jessica Stockholder I weave the fiction that the colour makes together with what the objects are and suggest, along with a structure that I make.

Lynne Tillman *You moved from painting on paper, to unstretched canvas, then to bits of cloth, things stuck on cloth, to something that begins to fill a whole space.*

Jessica Stockholder I can show and tell you how that happened. In this work, I found painted boards and stuck them to the wall. The little pink wiry thing comes out from the wall onto the floor, and a piece on the edge goes up through the ceiling. So, though this piece is still very rectangular and framed by the wall, it pokes out a little bit, up through the ceiling and onto the floor.

Lynne Tillman *When was this?*

Jessica Stockholder 1980.

Lynne Tillman *When you became more interested in the space between things, objects started coming off the wall. You became interested in the space between two objects – and the wall itself. Did you feel that you were involved in a critique of painting and a critique of the institution of the gallery?*

Jessica Stockholder I don't think I work from a space of critique. My work isn't, in the end, a critique of anything. It's more of an exploration. I work against the kind of polarization that's implied by the word critique. I could critique the institution, and I certainly have feelings of criticism about institutions, but it's undeniable that my work depends on the institution that is art.

Lynne Tillman *That's a contradiction that everybody lives with – whatever system one's in. The scientific, academic or literary community. You work within it.*

Jessica Stockholder I have always felt uncomfortable in museums and galleries. There's a kind of a deadening in those places that I work in response to. I try to bring the work closer instead of having it all framed off and removed from me. Even so, I love what the art institution makes possible; there's a kind of intensity and

it's a place where you can express anything, and explore anything without hurting your neighbour. Art is elevated – presented as special. This makes it possible to pay close attention to very wonderful mundane things.

Lynne Tillman *Without that distinction, between art and something else –*

Jessica Stockholder It just runs into brushing your teeth.

Lynne Tillman *Warhol confounded that, problematized it. If you make a picture of a soup can, you will think about what's outside the frame of that picture, and maybe you will think differently about that ordinary can. Representing it takes it out of the realm of the so-called ordinary.*

Jessica Stockholder I try to bring some of that specialness, or heightened quality, from art-making to the ordinary. This work was outside at the University of Victoria. The little pieces of wood are painted and hinged. There's a figurative element too. This piece never was finished; it was just rearranged. I was thinking about the colour being thrown around, an idea I'm still interested in. The planes of wood were throwing colour back and forth or reading across to each other. The colours bridge the space at a speed that's much quicker than walking. So the interaction of the colour starts to feel abstract, as though it's not material. And me moving, I'm another kind of material.

Lynne Tillman *The way you think about art relates to science, geometry, physics. Speed, light, volume. As a viewer, I'll use my frames of reference. The concrete wall has an object jutting out. It raises – projects – certain questions. My eye might be moving, because of the colour play, but I don't think I would be thinking that. There are different moments in it. It's arresting in terms of your process.*

Jessica Stockholder I begin in a very physical place, without a lot of words. When you were speaking about the colour in *Recording Forever Pickled* – how it doesn't refer to anything, that it is its own matter-of-fact thing. I thought, there's a kind of muteness in that. When I'm asked what my plans are for the future I look inside and find a mute feeling. There's a quiet – there are no words for what I'm going to do.

Lynne Tillman *In* Recording Forever Pickled, *what would a conversation be in an impossible living room? The spaces are what one can't talk about. Using the yellow you might also be signifying something that can't be spoken about.*

Jessica Stockholder It's interesting to consider that as a meaning of yellow. Manipulating material is a way to speak.

Lynne Tillman *How did you move into installation?*

Jessica Stockholder Installation is a very poorly defined word. The earlier work started to elbow the space of the wall. It doesn't seem like such a huge jump to dealing with the space of the room. In 1982 Barbara Fisher invited me to put drawings in a show at Open Space Gallery in Victoria. I didn't want to put drawings in the show.

Lynne Tillman And then she said: You can have this space to do anything you want?

Jessica Stockholder Yes. This was the first time I consciously addressed the space rather than just the wall. I've kept doing it. It certainly doesn't make life easy! And installation has become so prevalent a part of art-making. People don't buy it for their homes, to be cute about it. You set up a challenge for yourself. There's not much of an art market in Canada. As an art student I wasn't thinking about selling work, and I had no place to store it, so I didn't think about keeping it.

Lynne Tillman It's almost impossible for me to imagine – not keeping one's work.

Jessica Stockholder I keep the slides. The process is what matters to me – making the work, how one work leads to another, and how showing the work and having people look at it and talk about it feeds it.

Lynne Tillman That fits in with some of the art movements of the 60s and 70s which were responding to the object-oriented nature of art.

Jessica Stockholder It was in the air. Mowry was very much involved with thinking about how art objects function politically within an economy; this was all part of the discussion around me.

Lynne Tillman A curator says: Here are these walls. Instead you want to use the whole space. To do something that fills that space or speaks about space. Takes it up or shows some sort of relationship to it. That's intriguing not only formally, but also psychologically.

Jessica Stockholder It's an attempt to make things immediate.

Lynne Tillman I don't know that writing functions in that immediate way. Maybe it does. But the process of reception –

Jessica Stockholder The way I read is probably more immediate than you would like!

Lynne Tillman Maybe the way I perceive art is less immediate than you would like. I don't think about tactility, a word that crops up about your work. Some artists want the sense that this could be something you'd want to touch. In some way I guess I don't feel myself in the world physically. Although you push that. In the piece with a ramp, The Lion, the Witch and the Wardrobe, I understand it as something that goes nowhere.

Jessica Stockholder How do you see that?

Lynne Tillman Usually a ramp leads somewhere. Again you take something that has a function and use it in a way that calls attention to it as other than its function – ramps take you from one place to another. Now, it does take me from one part of your artwork to another. But it's in such an absurd way that it speaks to me of a certain futility – about going anywhere. I'm a pessimist, but it did confront me, made a physical impression on me. I don't know if that means 'tactility'. I think of it as this object in the room –

Jessica Stockholder – calling attention to itself as a thing, yes. That's what I like it to do.

Lynne Tillman *Your later work pushes that, off the wall. You even make your own walls. Architecture's 'the art or science of building'. Not one or the other – both. In a sense you can take your choice. Science and art relate to your work.*

Jessica Stockholder I once proposed a work for the San Francisco Exploratorium, a science museum with an artist in residence programme. I proposed that it was a matter of scientific interest to what degree we brought information with us that coloured our vision when faced with art. They didn't go for it.

 I began making art without much sense of the physical world and discovered how much it mattered to me through the process of working. It was a part of the world I was able to encounter entirely on my own terms.

Lynne Tillman *It's also about making a place for itself, for oneself. In the world. If you enter a space, as you did at Open Space Gallery in 1982, and decide: no, I won't hang on the wall, I'll be this space. It's like making yourself, constructing yourself also.*

Jessica Stockholder The work has always functioned as a place to affirm my subjectivity. That we have intense subjective response to objects is curious. It can't be denied.

Lynne Tillman *The way you treat that subjectivity resorts to, employs, a certain level of abstraction to handle your own psychological needs. I don't feel, when I walk into a room of yours, that I'm dealing with Jessica Stockholder's psyche. I feel that it's all been mediated, thought through, worked through, so that your use of colour may indeed go back to some psychological meaning to you about colour. But it informs the work and has a resonance within the work that's not specific to you.*

Jessica Stockholder That makes perfect sense to me. I'm trying to think about why that's so, and why that happens. To turn something that's intensely personal into something that's publicly available.

Lynne Tillman *It's one of the fascinations about making art, writing. In my writing I'll use 'I', and it's usually not me. Yet there is the desire to write it, or just to write, which is from oneself. You became engaged in the space between two objects. That wall – maybe the wall was you, between you and the world.*

Jessica Stockholder When I began I experienced architecture as a kind of given. Buildings were the world. A building was as much a given as the fact that the ground is made of earth. Through my work, I've come to understand that buildings are invented by other people, as was our history, civilization and society – it's all made by people, it's not a given.

Lynne Tillman *Buildings don't have to look like this.*

Jessica Stockholder Exactly. They all carry meaning. Galleries aren't neutral. They signify a kind of neutrality that we gave them.

Lynne Tillman *You explode into that so-called neutral space with work that is sometimes very theatrical. In* Edge of Hot House Glass *(1993), there's a raised platform. Had you ever done that before? Raised the floor?*

Jessica Stockholder It's not unlike *The Lion, the Witch and the Wardrobe*. But it's not a ramp, it's a platform.

Lynne Tillman *There was no entry onto that floor?*

Jessica Stockholder No.

Lynne Tillman *You literally raised the stakes on your own practice, as if saying: Here's a new floor, new ground. It's a huge piece, isn't it?*

Jessica Stockholder It's not one of the biggest pieces I've made, but it's big – the platform's probably 20 by 20. The space was difficult – dark, almost a basement in feeling with little lighting, dark, shadowy. Generally, I don't like my work to be atmospheric. Theatrical was a bad word when I was in school.

Lynne Tillman *It's hard to avoid when there's what looks like a stage or a ramp.*

Jessica Stockholder But I like the work to be immediate. I don't like the work to be lit differently from the space you're standing in. It's not theatrical in that its audience isn't in a different space from the work. I struggle very hard to keep the work in the same place as the viewer. This particular space was hard for that reason.

Lynne Tillman *Is that opposed to some notion of illusion in a way?*

Jessica Stockholder No. It's that I want the illusion to coexist with my experience of the table next to my piece, or the staircase next to the work. I don't want there to be a divide. Many people like their experience of work to be heightened, separate from one's experience of having walked into the gallery. Gallery windows are often covered, galleries are often dark. I like the windows to be open, to have no drapes on them. I like to walk in and be aware of where I came from, to have that experience of having just entered into the gallery next to the experience of looking at the work. This space in Nîmes was hard for that reason. You didn't see the daylight that you'd just left behind.

Lynne Tillman *Is that why you moved the floor up?*

Jessica Stockholder I moved the floor up to try and counter the feeling of being sunk into this room. I contemplated having a place where the viewer could stand and not be able to move around. But I like the viewer to be able to move, so that there's choice. I like there to be pathways.

Lynne Tillman *You want a continuous experience between what's art and what's so-called everyday?*

Jessica Stockholder Fredric Jameson gave a wonderful lecture at Bard College this past summer (1994). The lecture was outside – we were all sitting on the steps outside a building because there was a power outage; behind Jameson was a backdrop of trees and birds; the sun was slowly setting, and the moon was coming up. And he delivered his very abstract, formal and organized lecture just as he would inside, only in this new context it was a completely other thing. The contrast between the formed, abstract thing that he was delivering, and how

independent it was of wherever he was, and the birds, and his lectern being messed with while he was talking – for me that was beautiful. That this abstraction that he's in the business of making coexisted with the trees, and the birds, and these things that are so easily romantic, was beautiful.

Lynne Tillman *We have all sorts of feelings about trees that have nothing to do with trees.*

Jessica Stockholder They have to do with us.

Lynne Tillman *We think about nature, place it in relation to our human lives. It has significance for us because we make it, or don't make it, significant.*

Jessica Stockholder But I also think that it does exist separately from us, as distinct from Jameson's lecture, which doesn't. Jameson's lecture exists only in so far as he made it. He manufactured his lecture, which can exist next to a tree or inside a university building. In my work I manufacture something like that, like his lecture, that's very abstract and ordered, by me, and by the culture that houses me. But all that I make is meshed with, and sits on top of, stuff that is incontrovertibly there. I understand that we could talk – and philosophers do talk, ad infinitum, about whether in fact it's there if you don't see it. But I – and I imagine most people – have an experience of some things as really there, and other things as not quite there. I'm interested in how those two experiences mesh.

Lynne Tillman *Your concern almost from the beginning was to deal with a structure that was already there. You didn't choose to ignore it.*

Jessica Stockholder That's true both of the physical structure and the social structure that contains my process.

Lynne Tillman *It didn't happen in a vacuum. You're not alone in that concern. The way in which you handle it has its own particularity, the way you try to encounter a space – it's fun even to use the word encounter when you use a structure like a counter. To me your work is filled with words, with metaphors, that I as a writer can immediately, and not the way you want me to, probably, translate. I'm beginning to be more aware of the physical world, of the built environment, let's say, than I was. I'm even more aware of birds. But it's taken me a long time.*

Jessica Stockholder Me too. I start from a place that's not unlike what you're describing. Only I don't have the words. I don't trust the words.

Lynne Tillman *I don't trust them exactly. I use them. I don't believe they say everything, but, obviously, I want to be working with them. Maybe I'm interested in visual material as much as I am because there may be some similar sources to making it, but it's translated into something I could never accomplish. Especially in three-dimensional forms. To me that's one of the strangest, hardest things to do.*

Jessica Stockholder It's funny, in some ways, that's also true of me. I started on flat surfaces, with planar images. To make them three-dimensional was a challenge. I could

conceptualize, and had a real facility with things on a page, graphically, but I couldn't, and still have difficulty, conceptualizing in three dimensions.

I don't begin installations knowing what they're going to be in the space. Part of the interest for me is to see what happens. As my work grows, part of the challenge is to continue putting myself in a place where I am in the dark and required to respond immediately, where I can't predict the outcome.

Lynne Tillman *Maybe that's why I find jokes in your work. One's a play on the truism that art is organized out of chaos. There's chaos in your art. There's clearly a mind at work organizing, with a system, responding to the space, but it's discomforting. Your work asks: where do I look first? It's not organized so that there's a front, or a frontal perspective. You don't have a vanishing point. At least I can't find it.*

Jessica Stockholder There isn't one.

Lynne Tillman *In Western art, the vanishing point, frontality, and other devices, organize it, so as to organize vision, the world – but there's another sense of organization in your work.*

Jessica Stockholder Part of the work is highly ordered and organized, and part of it just lays where it falls. To use a visual metaphor for this idea – objects in the place of ideas – if I use five different objects, parts of them will fit together in a very tight, formal way, and the rest will just hang out chaotically. Another way to visualize my order in chaos is to imagine a bunch of threads overlapping in one place. Where they overlap, things are tight and ordered. But the ends fly off in a million different directions, often having nothing more to do with each other.

Lynne Tillman *That's a scary way of working. There's not a contradiction but odd consequences. On the one hand you want the viewer's experience to be of the same order as the experience of walking down the stairs and going to a place. On the other hand – this may be what your experience of the world is – you make a disorderly organization. A disquieting, sometimes demented –*

Jessica Stockholder Yes!

Lynne Tillman *... bunch of things.*

Jessica Stockholder Yes, it's amazing that things work as well as they do. I am not interested in making work that pretends the world is not like that. But I do appreciate the work of Richard Long. He'll place a bunch of stones in a circle, or a path. He works out in the landscape. His work is very cohesive, and ordered – round things, or square things – very unified. I think his work functions as meditation.

Lynne Tillman *Your art doesn't leave room for rest. It's not a resting place. In the way you were describing the Long work, one could, as in Noguchi's, imagine standing, looking, and feeling a sense of quiet.*

Jessica Stockholder I miss that in life!

Lynne Tillman Maybe that's why he does what he does. He wants …

Jessica Stockholder – to make it.

Lynne Tillman Maybe it represents what's missing in his life. Or what he thinks life –

Jessica Stockholder – needs.

*Lynne Tillman You might want that, but insist instead: I don't find it anywhere. I don't know
that I can make that, in order to say this is as it should be.*

Jessica Stockholder Though I agree there's no quiet place in my work that compares with the
quiet of Noguchi or Long, there are places in most of my pieces where you
as viewer are definitely outside, looking at a quieter, static whole.

Lynne Tillman You said you allow pathways. There are exits.

Jessica Stockholder And points of detachment. In *Where It Happened?* (1990) and in *Mixing Food
with the Bed* (1989), you enter and just at the gallery door the piece is in front
of you as if it were a stage set or a painting. Then you walk through it, and it's
chaotic and formally difficult to get a handle on. Having walked through and
turned around, you are definitely not in that piece anymore.

Lynne Tillman How do you know for sure?

Jessica Stockholder You're standing on the normal gallery floor. White walls are around you. You
can, from this point of view, make a distinction between the elements of the
piece and the gallery. So you have detachment.

*Lynne Tillman But then what is the shape of it? That's often what I wonder about your work:
What is its shape? One walks into a space in which you've installed an artwork,
where the viewer's given a place somewhere in the room to feel distance from it.
I don't know if it's detachment.*

Jessica Stockholder I don't make environments that you walk into in which the space or place has
been disguised. My work isn't like wallpaper. You always know there are two
elements – the building and the work. But just where the building begins or
ends, and where the work begins or ends, isn't clear.

Lynne Tillman There's an issue about boundaries.

Jessica Stockholder Absolutely.

*Lynne Tillman What are the boundaries? On the other hand, you do leave some breathing room
within that questionable symbiosis between thing and person or between art and
so-called life.*

Jessica Stockholder That matters to me tremendously.

Lynne Tillman In Installation in My Father's Backyard *(1983) you hung a red mattress on the
side of a barn –*

Jessica Stockholder Garage.

Lynne Tillman *Garage, sorry. The garage wall, part of it is grey and there's some blue. You've painted the grass and flowers, or shrubs, in front of that wall. It's a real mattress?*

Jessica Stockholder It's a double or a queen-size mattress spraypainted with fluorescent paint – a little bit transparent so the markings of the mattress show through. There is a blue, or purple, cupboard door that's mounted on top of the garage with a roll of chicken wire.

Lynne Tillman *It's compelling and weird for many different reasons.*

Jessica Stockholder Let's hear.

Lynne Tillman *You make a mattress red which underscores sex and sexuality. Then you confound the built, the garage, with the object itself; and the ground is grass which you paint. You put something on the grass that makes it unnatural. That seems to have some reference to a family structure, to the idea that the family is considered a natural unit, though each unit is different – has its own colour. But it has a basic structure we recognize: father, mother – or lack of – and children. Then your use of the blue on the roof and door are in relation, reflecting each other: blue grass, blue door. A door opens and shuts and could be an obstacle. Also an entrance or exit. Many meanings. Then there's wire, which is an aggressive element. If you landed on it, if it touched you it wouldn't –*

Jessica Stockholder It would not feel good.

Lynne Tillman *The piece is also deeply site-specific.*

Jessica Stockholder I enjoy your reading, but I can't say whether I agree or disagree. The way I came to making this piece has none of that conscious information in it.

Lynne Tillman *Tell me how you did it.*

Jessica Stockholder I found this mattress in the garage and painted it red as the complement to the grass. The backyard is more or less rectangular, so it's similar in shape to the mattress and garage. The lawn is brought into a dialogue with the mattress, and with the history of painting, because paintings are rectangular too. Here I'm making a painting – only it's also a back yard. The red of the mattress called to the colour of the berries in the tree, heightening colour that's already there. I painted the grass with a hard-edged form, kind of rectangular so it has a formal relationship to the door, and to the mattress. I never know exactly why I choose materials. Your analysis makes sense, but part of my interest is to work with materials that are in some way randomly selected – to put them together so that they speak for me. I have some faith that I will be able to speak through what is at hand.

Lynne Tillman *A mattress is so redolent. One couldn't go to one's father's house, take a queen-size mattress out of the garage and hang it without having some awareness that it referred to a father-daughter relationship, the Oedipal, the family.*

Jessica Stockholder I can see why you might say that, but I don't think about that stuff when I'm working. In order to avoid having my personal history, which drives the work, making the work clichéd or diminished, I don't spend a lot of time thinking about it. I think about the form that the work takes. I make sure that in the end the experience is right – that the work is active.

Lynne Tillman *The formal elements are first what one's conscious of: you've used two rectangles – all of that is there. But I think what makes the work have resonance is that the formal is logged into this narrative, through its metaphors ...*

Jessica Stockholder I don't mean to say that I'm not aware of the psychological. But I don't feel as if I can control it or the narrative.

Lynne Tillman *I don't think one can – not control one's being drawn to, driven to, taking up the material. Why one's driven to tackle a particular formal problem, why write it in this way – there are psychological issues involved that formal concerns don't conceal.*

Jessica Stockholder And formal concerns are not interesting unless they carry this other information.

Lynne Tillman *In some way, for me.*

Jessica Stockholder For me also.

Lynne Tillman *It seems that you use two kinds of titles; one kind seems to refer more to narrative.*

Jessica Stockholder Narrative is something I'm trying to find a way to talk about now, though I'm not sure 'narrative' is the right word. There is a kind of building or layering of meaning that results from the literary content of the objects I use, but the structure is not linear. There is no beginning, middle or end. My aim is to throw the net as wide as possible, even while there are focused areas of literary meaning that develop here and there.

Lynne Tillman *Some of your titles are long and specific, about the thing itself, about naming itself. For example,* Yellow sponges, Plexiglas, small piece of furniture, newspaper maché, plastic, oil and acrylic paint, cloth, small blue light and fixture, glass on the wall *(1990). All the elements are named, yet the piece is not merely an aggregate of those elements. The pieces with the long titles are more, it seems to me, object oriented and can be taken in by standing in front of them. They seem to be more about painting, the limits and possibilities of painting.*

Jessica Stockholder The titles consisting of a long list of objects are titles by default. My intention was to leave these pieces untitled. I always request that there be no title – and that the word 'untitled' not be used. In many cases the list of materials is used instead of a title. People just can't get their heads around the space being blank where they're used to seeing a title. But I'm not unhappy about the conversation this has given rise to. When I do use titles, I often work with the words in a way that feels parallel to the way I work with objects. I like the title to work alongside the piece rather than lead you down a path.

Lynne Tillman My interpretation's by default then, too, I guess. Some of the titles signal that the piece will be more narrative, about time and space, like The Lion, the Witch and the Wardrobe. That long ramp seems to be about space as well as about the time it might take to walk on it, if you were to walk on it.

Jessica Stockholder Even walking alongside of it, that takes time.

Lynne Tillman Even if it's immediate in feeling, it also requires duration, which is about narrative, so that if you want the viewer to be physically in that space with that piece, the viewer must be active. To go from point A to point B.

Jessica Stockholder And in the process of going from point A to point B, there are places where the work becomes very ordered and static, as a painting is static and separate from you. In that process, the memory of one side, or one view, of the work informs the viewing of the next side. If I'm looking at something that's red, and I know the other side of it's black, my memory of the black part functions in my forming of the composition, as if that black were visible. Do you understand?

Lynne Tillman I think so. It relates to issues about narrative and psychology. If black is the memory, the unseen colour in back of the memory, it's present no matter if it's in the past or if it's visually present in the moment.

Jessica Stockholder That your memory is equal to what you're viewing in the present is fascinating.

Lynne Tillman It's another kind of dialectic in your work. On the one hand you want the experience to be in the present – you want the viewer to come in and have this experience. On the other hand, you're very aware that no one comes into a space without memory.

Jessica Stockholder How those two things merge is most exciting. It's a struggle. It's not a modern struggle; it's an ancient struggle, actually to be present for the moment and what that means. I'm sure that's part of Richard Long's struggle too.

Lynne Tillman I could imagine he might think, or someone making work that allowed for contemplation in one place might say: you are present, I am.

Jessica Stockholder Or he would hope to be providing the opportunity to be present.

Lynne Tillman Now, what is that desire about?

Jessica Stockholder I think it has something to do with providing a place to experience will. If you can actually be aware of a moment and aware of yourself existing immediately, separate from, or in addition to, your history or memory, and culture, and all that makes you you, then there's room for choice.

Lynne Tillman To give one some sense of agency – that you are somehow able in that moment to recognize yourself and another object's being there. But your work doesn't make presence in the world easy. It's not about a unity or a unified presence.

Jessica Stockholder Well, I think it is and it isn't. But this takes us to the next stage – in the next location.

Lynne Tillman Which you're choosing.

Jessica Stockholder Right. *(Laughs)*

Location 2
Stockholder's studio is located in the Williamsburg section of Brooklyn.
Stockholder and Tillman are looking at photographs.

Jessica Stockholder These photos are of a piece I made in the spring (1994), *House Beautiful*.
The white is the wall of the gallery; the work spans three rooms. The carpets
are stretched with cables to the walls, floor and ceiling.

Lynne Tillman *You couldn't take one photograph of the piece?*

Jessica Stockholder No.

Lynne Tillman *Craig Owens once said that the history of art was the history of slides of art.
This piece would need at least two to represent it. I don't know immediately
where the work begins or ends, or if, in the photograph, it is right side up or
upside down. It returns me to the place we left, or left off, last week. Even though
you use brightly coloured materials, which are often supposed to mean 'happy',
you very contradictorily propose to this happiness a discomforting sense of
disorientation and dislocation. You're not using the ramp in this one, but you are
taking the viewer on an excursion. And there isn't a single, unified form.*

Jessica Stockholder Spatially, this isn't one of the most difficult pieces I've made. There is a green
carpet on the floor; it is similar to the ground; you can walk over it or along it.
The rectangular volume of yarn is a literal volume of colour; we know that the
colour goes right through; it's not like a painted surface, or an object that has
been painted. The yarn is a solid volume of colour contrasted to the flat areas
of colour; we know the flat areas of colour are flat skins of paint on top of the
carpets but they have an illusion of volume. Colour seems to project into the
air in front of it. The fan which I painted green – like this green on the carpet
– blows the air filled with colour.

Lynne Tillman House Beautiful *contains puns. Carpet/ground, a household fan/audience.
Hanging the carpet so that it refers to background/foreground, craft, laundry.
To women's work and again to a stage set. Is it a Persian carpet?*

Jessica Stockholder It is a 100 per cent polypropylene Persian carpet. I used it because it was easily
available and inexpensive. I would love to use real Persian carpets.

Lynne Tillman *What would be the difference for you?*

Jessica Stockholder A real Persian carpet is truly a rich experience.

Lynne Tillman *If it were a real Persian carpet, you'd be aware of that. You hang it now like
laundry. Persian carpets are a form of art, people hang them on their walls. If
you had a real Persian carpet, it would have a different valance, wouldn't it?*

599

Jessica Stockholder The other day Jay (Gorney) asked me, 'If you had a lot of money, would you use expensive things instead of cheap things?' We were talking about the fact that my work isn't about junk. This is an issue because critics have often written about my work that way. It's about things – some of them are junky, some of them are new and some of them are old.

Lynne Tillman *Why isn't it about junk? It's not that I thought of it as junk. Why do you think people see it that way?*

Jessica Stockholder Because I take objects out of their normal context, and there's a dishevelled, jumbled quality to the way I use them. Things are jumbled when they are thrown out. Perhaps that's how people arrive at that.

Lynne Tillman *Is it because you take everyday, ordinary material, and then don't use it in its expected way? In other words, because you make things no longer have their necessity, their function?*

Jessica Stockholder Perhaps that combines with the fact that the way in which I put things together doesn't adhere to a standard craft. When I use wood and nails and glue, the craft doesn't match the craft that one uses making cabinets. When I sew, the craft isn't the same as when you put together a garment. The work isn't about being well crafted, but the way the thing is made is important. Ways of making are meaningful – as significant as the meaning we attach to objects.

Lynne Tillman *That's different from the issue of junk. When John Chamberlain, in the sixties, took a car and crumpled it up, was it about junk or disaster?*

Jessica Stockholder People have discussed his work in terms of disaster and also more formally. In contrast to my work, his is formally very consistent; he lays out a formal language using one material. It's easy to forget that he is using crushed cars and see his work in terms of volume and shape. In my work the formal language is much more varied, and there is a question as to whether or not one should look at what the objects are. They are much more in your face than in his work. I don't think he invites you to think very much about cars.

Lynne Tillman *If those carpets had been ancient Persian carpets, would you have done the same thing? Ancient Persian carpets are valuable in and of themselves.*

Jessica Stockholder They have two kinds of value, a value in terms of the pleasure they give and a monetary value. If I were to use them instead of polypropylene we would be very aware of how I had taken away their previous value. This brings up all kinds of questions that I haven't had to deal with.

Lynne Tillman *Hard questions, whether one would take something rare and ruin it – but you're not doing that.*

Jessica Stockholder I feel curious about what you said a while back about the colours all being upbeat and happy in contrast to this structure that leaves you in a place of discomfort.

Lynne Tillman That's one of the most peculiar aspects of your work – you construct a controlled situation that recreates the discomfort of being disoriented within and by the familiar stuff of our lives.

Jessica Stockholder I've being reading Anthony Vidler's book on the architectural uncanny; I think that is what he would call uncanny, to take these familiar objects and make something unfamiliar with them.

Lynne Tillman 'Uncanny', from unheimlich, 'unhomed by' – great word. One could also say your work is about de-familiarizing ordinary objects or feeling unfamiliar in familiar circumstances. I don't see junk in relation to your work. The word 'junket', going on a junket, comes up. Or junking certain notions about familiar objects, loosening them from the familiar grip. Many of your materials are 'traditional' women's materials: cloth, bright colours, wool. You use objects from a domestic space, couches, for example.

Jessica Stockholder Things from a domestic space are associated with women, that's perfectly standard but it's a little odd. Men inhabit domestic spaces too.

Lynne Tillman Too often the divide is women/domestic or private space, men/public space. Your work isn't traditional 'women's work'; but you take risks by using what some might consider benighted materials – junk to some, maybe because it's from the home. You do it in such an aggressive, peculiar, uncanny way, it's not about protecting the home or simply valorizing that space. It allows the domestic other interpretations. Your use of ramps, rooms, carpets, raised floors – things spill over and out. It's not a contained or containable world. In your play with the domestic, the so-called private sphere is always either threatened by or merging with the public, and the distinctions between public and private are blurred.

Jessica Stockholder And between femininity and masculinity.

Lynne Tillman When one walks into House Beautiful, will she or he feel that the carpet is masking or covering anything?

Jessica Stockholder No, since what you first see as you enter the room is the structure around which the carpet is wrapped. There's nothing hidden. There are many things or actions that build on each other and inform each other, but I don't like to create mystery about what is actually there.

Lynne Tillman It seems to say that something doesn't have to be hidden or covered in order for it not be apprehended. This work is hard to apprehend: it builds, it moves, you have to walk with it, there are many elements. How do you apprehend this? It's not that you're hiding anything, not that a mystery is something hidden, but a complexity that can't be understood even when seen. The turquoise – what did you think when you were doing that? Is that paint?

Jessica Stockholder Yes. Why do you ask?

Lynne Tillman It's like a swimming pool. It suggests many allusions, from Narcissus, to ideas
about thought, art and reflection – the green chandelier in it is a light, after all –
to an art reference, David Hockney's swimming pool.

Jessica Stockholder Hockney's pools.

Lynne Tillman The turquoise appears to be an exit, a moment of escape.

Jessica Stockholder It's more abstract, lighter than anything else.

Lynne Tillman Your work's often concerned with exits and entrances, giving the viewer a number
of them. It's a relief here in several senses – a rectangular relief that's on the floor, a
painting on the floor, a relief from the piece and its insistence to move on. One can
stop at the turquoise. Would you call it a moment?

Jessica Stockholder A pause.

Lynne Tillman A pause that refreshes. Why did you title it House Beautiful?

Jessica Stockholder *House Beautiful* the magazine is about controlling the structure and
surface quality of one's environment. This work is about that too, but
from a very different point of view. The materials I use here could be
from a house – in a sort of turned upside-down manner. The title refers
to taste and structure.

Lynne Tillman It also challenges the idea of taste.

Jessica Stockholder I think about taste a lot. *House Beautiful* the magazine reinforces and puffs
up the notion of good taste, as if there's a right way to do it. My work opens
that up to question and proposes that there is no right way to do it, that
there's a lot of meaning apparent in the decisions that people make.

[Stockholder and Tillman are walking around the studio and look at a piece.]

Jessica Stockholder In 1987 I made my first piece at this furniture-like scale. It had a light pointed
at the wall, so there was a circle of light on the wall, seen in relationship to
the object in front of the wall. These smaller works activate the space between
the wall and the thing in front of it, creating an event but in a more limited or
proscribed way than the installations do. I titled the first six *Kissing the Wall*.
Since then, almost all of the smaller pieces have had a relationship to the wall.

Lynne Tillman An immediate, probably off the wall response to it: because the green rope is tied
to the wall, what comes to mind is 'the tie that binds'. A relationship, about art
to the gallery wall, and an interaction between two things – tense because the
green rope is taut. The green rope ties what looks like a lounge chair and a kind
of picket fence, to the wall. One side of this stuffed chair is very brightly coloured,
a patchwork pastiche. A crazy quilt, and it's painted. What is the material?

Jessica Stockholder The red is fabric, there is a white shirt glued to the sofa with paint on top of
it; there's plastic, and the rest of it is painted colour.

Lynne Tillman *The couch or sectional's sort of grotesque. You've built an armature around it, indicating a fence to me. Sectional plays on 'sexual'. Your work takes 'real' things and makes a mockery of that reality. Is Mother the sectional/couch? Is the art / wall Mother? It's the green rope – I can't help thinking of ties, dependency, the umbilical cord. Then the gap between wall and chair could represent a formal relationship of art viewer to gallery wall. The strangely painted couch could stand for the spectator and the spectator's relationship to seeing paintings and drawings on a wall. One formative relationship – mother/child – leads into other relationships, like what is a viewer's relationship to a piece of art?*

Jessica Stockholder And what is the relationship of the piece of art to context? Does a particular context support art, like an umbilical cord from the mother supports the child? What do buildings mean to us? What about independence? All of these are questions in the work.

[Stockholder and Tillman move to another work.]

Jessica Stockholder In this smaller piece, one part is a cast concrete inflatable ball; the ball served as the form for the concrete.

Lynne Tillman *It's attached to the wall under a bird cage, but not attached to the bird cage. Birds, flight, imprisonment … Being imprisoned would be pretty weighty. But the cage is open, so again, there's an exit. It reminds me of Buñuel's film* The Exterminating Angel. *The characters can't leave a room when there's nothing physical stopping them.*

Jessica Stockholder And there is a shower curtain and a piece of flowered clothing attached to the bird cage; there is also paint, silicone caulking and yarn.

Lynne Tillman *Oranges …*

Jessica Stockholder … apples, plums, lemons and peaches.

Lynne Tillman *Because there are so many, it's like a growth.*

Jessica Stockholder This yarn piece is very much like a growth. It's quite beautiful and sort of hideous. An accumulation of things in a cancerous sort of a way.

Lynne Tillman *Cancer is what I thought of immediately, a wild cell division.*

Jessica Stockholder There's bias tape hanging down the back with a few threads and a few wires. For me that implies frivolity – it might be ribbon – and also leftovers, bits and pieces from something just finished or not quite done.

Lynne Tillman *It's funny to use concrete as a 'concrete' object in the midst of this fantasy, this phantasm.*

Jessica Stockholder Exactly, a phantasm, all these things coming together produce something quite fantastic; and then the concrete is a real heavy, simple, known quantity that weighs it down to the floor.

Lynne Tillman *Some of your pieces are human scale, and some are much bigger.*

Jessica Stockholder I love shifts in scale – shifts in point of view.

Location 3
The Nether Mead in Prospect Park. Stockholder and Tillman are sitting on portable chairs which they carried from Stockholder's apartment.

Lynne Tillman *We're looking at scenery – trees and grass, a park, a baseball diamond.*

Jessica Stockholder I thought this would be a good place to come because it provides a vantage point that's unusual in a city. The vistas are so long here. How my relation to things changes here has something to do with my work. This place is more reminiscent of the landscape in Vancouver than any place else in NYC.

Lynne Tillman *How does this intersect with your interest in architecture, and how your work is architectonic? How does your interest in landscape turn into a built environment?*

Jessica Stockholder Architecture is a landscape we make. I often experience architecture and landscape as if they weren't made, as if they just happen to be there framing my life process. The landscape we're looking at is made. But in general, there is more about landscape that exists before us and without us than in architecture.

Lynne Tillman *Most landscapes we see are built.*

Jessica Stockholder There is a difference between the Vancouver of my childhood and this part of the world. In Vancouver there were, and there still are, more places where you can view a landscape which hasn't been manipulated by us. It has been less touched.

Lynne Tillman *An idea of wilderness, something untouched by human beings. But you want to touch things, you want to move the environment around.*

Jessica Stockholder The landscape in Vancouver provides a particular spatial experience which is wedded to my work. The way the water meets an island, or another piece of land, and forms a horizon line below the one made by the tops of the mountings meeting the sky – that particular horizon line has something to do with the kind of space that I am interested in. I'm also very interested in the difference between what we make and what is.

Lynne Tillman *When you see things in terms of art, you're thinking how nature is like art. Of course, things confirm our beliefs, most of the time, since we look for that.*

Jessica Stockholder Are you less comfortable at this angle, looking at nature instead of at art?

Lynne Tillman *I have some agoraphobia, some fear of open spaces, empty, six-lane highways – not crowded cities. There's something strange about the distance between us, this long space between us, and the trees. In that space there could be an incredible amount of horrible things happening.*

Jessica Stockholder The work you called 'raising the stakes' – *Edge of Hot House Glass* – had a second title, *The Body Repeats the Landscape*, a quotation from Jane Smiley. In that work I became aware of something that carries through my work. I saw it as a very large body. There was velvet, there were beads; but things didn't cohere. They did at moments but always threatening to come apart at the seams. It was as if you, the viewer, were very small, looking at a giant body. The body as a landscape. I think this has something to do with having been a child, very small and growing.

Lynne Tillman *Some more than others – physically, mentally, emotionally.*

Jessica Stockholder That physical experience, that shift in point of view, happens to everyone. In a way, the landscape changes on us. Perhaps our first experience of landscape is of the big bodies holding us.

Lynne Tillman *I don't know that, as a viewer, I would have thought of the landscape as a body, although I might have thought of a body of land, an island jutting into the space. I don't know if I can reverse my position. I would become the thing that a body would normally be looking at. A sort of reversal of positions.*

Jessica Stockholder It's not that the work is a body. It's about the experience of the body as landscape. I'm interested in conveying an experience having to do with the difficulty of having things cohere – the feeling that sometimes things are too close so you can't see the edges; or things are so large that you can't see the edges – a lack of definition, or a possibility for expansion lurking in the background of everything we make.

Lynne Tillman *Maybe that's from having grown up in surroundings that were majestic, the physical situation in which you lived in Vancouver. I was in Vancouver once and remember looking up suddenly, and seeing towering mountains around the city. It did draw off the city itself; it surrounded it, giving it this odd feeling of temporariness. I felt very much aware that the city was something that had been built in the middle of something that had been around much longer.*

Jessica Stockholder Vancouver is located – there is a sense of place that's missing here in New York.

Lynne Tillman *Though Manhattan is bordered on both sides by rivers. When I was a kid, it was very hard for me to understand how all the big buildings could be on a little island. Obviously rivers are flat. They're not towering over Manhattan; Manhattan towers over the rivers.*

Jessica Stockholder New York hasn't been constructed to call attention to the rivers and not much is made of the waterfront. I miss that. Growing up in Vancouver with American parents involved feeling confused about my place culturally and nationally. Perhaps the particularity of the landscape became more important for that reason.

Lynne Tillman *You're very much in a place when looking at your work, it's about positioning you there. I guess that's the physical sensation of it – it's not as if you are just looking at*

an object which lets you think only in the abstract. You have to do both, you look and think abstractly and are aware that you are standing somewhere.

Jessica Stockholder It's nice to hear you say that. That's why I wanted to come here.

Wolfgang Tillmans *Peter Halley*

in conversation
February 2002, London

Peter Halley *Let me ask you about the very beginnings of your work. Were you taking photographs from an early age?*

Wolfgang Tillmans No, I was never particularly interested in my own photography until I was twenty. I never had the idea that I needed to record anything as a souvenir, and never dreamed of being a photographer. I always felt that the intention to record something, to remember something, stood in the way of experiencing the thing in the first place. When I was growing up my parents would avidly photograph and film on Super-8 all our family events and holidays. Maybe because of that family thing, I never needed it; for me it was just an experimental tool. Nobody told me it could be a valid art medium. I always had a thing for newspaper photos though. As a teenager I had a scrapbook into which I collected news photos, like the hijacked plane in Mogadishu or the suicide cult in Jonestown, Guyana. I felt drawn to how so much drama can be condensed into a cheap, grainy picture.

Peter Halley *You didn't take any photographs at all as a teenager?*

Wolfgang Tillmans None, except for some home sessions of my best school friends Lutz and Alex and myself dressing up as New Romantics, pretending to be at London's Heaven nightclub, whilst actually being in my parents' living room. Then I took a couple of rolls on holiday in 1985 and 1986 when I was sixteen or seventeen. I borrowed my mother's simple viewfinder camera, and on both trips I took a few pictures that are still relevant to me today.

There's a photo that's sort of my picture number one (*Lacanau [self]*, 1986). It's a self-portrait on the beach in France, photographing down on myself. It's a pink shape, which is my T-shirt, and then a bit of black, which is my shorts, and then a bit of skin, which is my knee, and then a big space of sand. It's also my first abstract picture: you can't make out what it is, but it's actually totally concrete at the same time. And it was about this moment of reaffirmation, or self-affirmation – I *am*. It was like coming out to myself as an artist. It's a record of an experience I had. Once I'd experienced something, recognized something, I could take a picture of it.

Peter Halley *Did other people think of you as an artist?*

Wolfgang Tillmans No, not at that point. I didn't have that image at all, because I couldn't draw and I was bad at art in school. I was never brought up with the idea that I could be an artist, that I should be an artist, or that it's a good job. The funny thing was that, even though I acted like an artist, it took me a long time ... I don't know when I really, fully adopted the idea that I was an artist. There was this weird schism in me: I thought and acted and behaved like an artist and yet when I was asked: 'What do you do? What do you want to be?', I couldn't say it. Even in Hamburg, after school, when I did community service, I was writing applications to do an apprenticeship in business administration or in an advertising agency because that was what I thought I should do.

Peter Halley *Be sensible?*

Wolfgang Tillmans Sensible, yes. I never actually mailed them, however.

Peter Halley *You finished high school in 1987?*

Wolfgang Tillmans Yes, that was in Remscheid where I was born and grew up, a manufacturing town specializing in hardware – hammers and pliers and so on. Everybody there was involved in making tools. My parents ran a small business exporting tools to South America. I couldn't wait to leave after school to live in a bigger city, so I moved to Hamburg to do community service instead of military service, because there's still the draft in Germany.

Peter Halley *Before you went to art school?*

Wolfgang Tillmans Yes. You usually go into the army straight after school to get it out of the way.

Peter Halley *So you chose community service. Did you have to be a pacifist?*

Wolfgang Tillmans Yes, you have to be a conscientious objector, and then you have to do twenty months of community service, but you can choose where, and what you want to do. So the logic for me was that it would be in the biggest German city where I could do it – which was Hamburg, because Berlin was not yet part of West Germany. For the first ten months I worked for a mobile social health service, helping nurses wash patients, doing cleaning for old or disabled people living at home, doing light medical and social work in old people's homes.

Peter Halley *What about the last ten months?*

Wolfgang Tillmans Then I had a bad back, and was also tired of my boss and the whole situation. So I claimed that I couldn't do it any more and got transferred to operate the switchboard of another help organization in the centre of Hamburg. From there I organized my first exhibition. Being on the switchboard, I could use the phone all day, and the photocopier in my office.

Peter Halley *What kind of things were you making?*

Wolfgang Tillmans In my last year in high school I discovered a Canon laser photocopier in my local copy shop, which was the first digital black and white photocopier that could really reproduce quality photographs at that time. You could enlarge them up to 400 per cent. Then, when I lived in Hamburg, I approached this nice gay café to see if I could do an exhibition of these photocopies there.

Peter Halley *None of them were your photographs?*

Wolfgang Tillmans A few of them were, but others were taken from newspapers. I didn't even own a camera then. I was zooming into photographs, destroying, dissolving their surfaces. They were displayed as triptychs of three A3-sized photocopies. I felt very strongly that was what I wanted to do, so I put on this exhibition, which even got a couple of sales and the attention of a curator,

Denis Brudna, who gave me a bigger exhibition in 1988. I was totally driven, without categorizing what I was doing.

Peter Halley *You were driven to try to find venues so you could show it to other people?*

Wolfgang Tillmans Yes, exactly. These photocopies, these triptychs made sense to me in my bedroom, in my flat in Hamburg, and I felt they should be seen.

Peter Halley *But you felt they should be seen in a 'zine that you'd produced or in a café rather than a Kunsthalle or a gallery?*

Wolfgang Tillmans That was primarily because I wouldn't have dared at that point – even though I sent everybody invitations!

Peter Halley *What art were you looking at during this period?*

Wolfgang Tillmans There was one exhibition in Hamburg at the time that left a lasting impression on me: the 'D&S' exhibition. It had people like General Idea, David Robbins, his *Talent* portraits of artists (1986), and also Alan Belcher and Jeff Koons, that whole generation.

Peter Halley *Basically that's my generation.* Talent *is such a great piece, and people still remember it. And Alan Belcher is really interesting. Do you know him?*

Wolfgang Tillmans Yes, because he lived in Cologne in the early 1990s, so I met him there a few years later. He showed with Daniel Buchholz then.

Peter Halley *He was the other partner at Nature Morte with Peter Nagy. What else were you looking at?*

Wolfgang Tillmans I also very much liked Jenny Holzer. I bought a complete set of prints of the *Truisms* for 120 DM with money saved from my community service. I really loved that piece, and I also liked Barbara Kruger and Laurie Anderson. They all touched me in terms of how it's possible to pursue your work and at the same time aim to reach a broad audience. Unfortunately they're not the coolest people to mention now.

Peter Halley *I think that's only temporary.*

Wolfgang Tillmans Yeah. A lot of that work really moved me on a very direct level, but at the same time it was conceptual, some of it. It still had the power to touch me; that's also what I always liked about Andy Warhol's work. It didn't come with an explanation as to why a grainy picture of a flower should affect you the way that it did.

Peter Halley *What about Richard Prince?*

Wolfgang Tillmans I was aware of him. There was a great cover of *Wolkenkratzer* magazine with his appropriation of the picture of that child actress, Brooke Shields. That really spoke to me. After that I subscribed to that magazine; suddenly I felt I wasn't alone. At the time I didn't know any artists or anything.

Peter Halley Did you look at any well-known historical photography?

Wolfgang Tillmans No. Classic photography seemed so remote, so irrelevant to me. It just didn't touch me. Now I'm glad I never knew the history of photography until after I found my stylistic footing. However, photos on record sleeves – Peter Saville's New Order covers and the photography in *i-D* magazine – touched me in the most profound way.

Peter Halley Can you tell me what *i-D* meant to you? What was *i-D* culturally? Why was it such an attraction?

Wolfgang Tillmans I think the main attraction was that it showed you that you can create your own identity, or rely on your own identity without having to subscribe to any official rules of how to behave and how to look in order to be right or to be cool. In particular, it was always beyond the commercial. It was all about being free, in terms of money. The sorts of lifestyles that were endorsed in *i-D* were all about their accessibility. And things were labelled with their prices, to show just how cheap things were, like second-hand coats for £5 and sunglasses for 99p. And so there was this liberty: you could actually be having a great time, be sort of glamorous, and at the same time not buy into any commercialism.

Peter Halley I'm older and I missed that, but I can understand that pretty well.

Wolfgang Tillmans With magazines and the whole club culture it just seemed so relevant, so tangible. In 1988 I started to go out tons and take ecstasy and that became this all-encompassing experience that I wanted to communicate to *i-D* – how exciting Hamburg was at the time. I bought a flash for $15 and took my camera and went to the clubs, and sent them to *i-D*. Those were the first pictures I ever took for a magazine, and they got published. That was the magazine I wanted to be in; there was no other magazine I wanted to move 'up' to, as most photographers do. I never had any interest in pursuing a career in fashion or advertising. After that, a local magazine called *Prinz* commissioned me to take club pictures. So it was this very immediate thing: I wanted to capture how amazing the scene was.

Peter Halley It's different in the US, but as I understand it, European club culture in the late 1980s had a kind of ethos. If you take it as a whole – your experiences, the people you're with and the things you're doing – do you see the whole thing as having a positive ethos, almost a purpose?

Wolfgang Tillmans Absolutely. It definitely seemed to be for a better society, a better understanding. It was a utopian ideal of togetherness. That's how living together could be: being peaceful together and enjoying the senses. It seemed a very tangible and inherently political thing to me. But that wasn't fully accepted at first. Then in Europe it became common culture through acid house and techno music, and suddenly everybody felt that there was this utopia that was very real, and you could actually live this utopian dream. As usual, of course, it didn't last.

Peter Halley *Do you think it had any relationship to the 1960s equivalent? Or did you feel it was a new thing?*

Wolfgang Tillmans No, that was the incredible thing. In 1988 when it started for me, for the first time in my life I felt part of something first hand that I wasn't distant from, that wasn't retro, that was just completely in the here and now. And there was absolutely no sense of yesterday because everything about it was completely new. That sound, the music of the time, was absolutely unheard of.

Peter Halley *The acid house scene and the humanitarian feeling and the communion with people whom you barely know, was that, coupled with group sexuality, an ideal that even went beyond hedonism?*

Wolfgang Tillmans It can be spiritual. I think that's one of the strongest points of it: this idea of melting into one. Paradise is maybe when you dissolve your ego – a loss of self, being in a bundle of other bodies. It's really the most regressive state you can be in on earth. The other way to it is sex. Neither of the two are ideal for permanent models for living. Clubbing and sex have great potential to go stale and become boring and repetitive.

Peter Halley *A number of your photographs lead to the melting and blending of bodies. It's a big theme in your work.*

Wolfgang Tillmans Yes, definitely. That idea of being together, of fusion.

Peter Halley *What was the first gallery exhibition or relationship that moved your work into the right context, when your work began to be seen?*

Wolfgang Tillmans That was in January 1993 at Daniel Buchholz in Cologne. I'd been exhibiting since I was nineteen, and started publishing in magazines a couple of years after that, but somehow I consider that exhibition to be my first.

Peter Halley *How did you meet Daniel Buchholz? Was his your first major gallery?*

Wolfgang Tillmans Yes, it was. I had a loose contact with Maureen Paley in London, whom I saw when I was a student now and then. Then in the autumn of 1992 she decided to take a picture of mine to the Cologne unofficial art fair, the Unfair – a large inkjet print of *Lutz & Alex, sitting in the trees*. I decided to go to Cologne for that only because there was also an *i-D* party there the night before. I decided I might as well install the picture at the Unfair myself. The night before the art fair, at the *i-D* night, Michael Hengsberg (Daniel's assistant at the time) told me they'd really like to do a show with me. They invited me on the strength of the work they'd seen in *i-D*.

Peter Halley *At the time of that first show, who was encouraging you and talking about your work? How did people first interpret the work? What happened after that first show? Clearly it didn't go unnoticed.*

Wolfgang Tillmans No. The main thing was that I found my signature in terms of showing my pictures in a non-hierarchical way. It was a very radical thing at the time, to

show magazine pages alongside original photographs and to leave the photographs unframed; not to make a distinction in terms of value – you know, what belongs on the wall, what doesn't. For me, the printed page had been a sort of unlimited multiple from the start. I always loved magazines and newspapers, as actual compositions and objects; since I was designing some of my spreads in *i-D* at that time (1992–93), they were as close to an original work by me as the print that I was making in the dark room. I think that was one key aspect that I got across. It came naturally at the time; I wasn't calculating it in a cold way. I guess you're never aware at the time that it might be something important; you only ever have a presentiment of it.

Peter Halley *So people didn't just see it as a show of photographs, but also as an installation about information, or images of the world?*

Wolfgang Tillmans Yes, it was very much an installation. It was a tiny space: 3 × 3 m, literally a white cube. One wall was very sparse, with a series of pictures in one straight line, the *Chemistry Squares* (1992). Then, as it went around the room, it got denser, from floor to ceiling; there were structures of grids and lines involved. For some reason, already at the opening there was a special buzz, and there were lots and lots of people. It's funny how later you hear who saw it, like Kasper König. I sold my first picture to the artist Isa Genzken, which was hugely exciting for me. At that time we immediately struck up a special relationship; that was a great encouragement; soon after that we started working together on the portfolio 'Atelier'. Also Daniel told me a week later that Sigmar Polke had spent a while looking at my show.

Peter Halley *Yes, this is what I'm trying to get at: that early moment when people who form opinion, whom you might value personally, begin to come into contact with your work.*

Wolfgang Tillmans Another important thing that greatly enriched my life was that after having lived in England for more than two years, I was able to come to my own culture in Germany as a semi-outsider, to participate as both part of and not part of the local situation. Cologne was then the centre of the German art world. I was part of that scene but at the same time living in London, where I was more connected to the music, magazine and nightlife of the early 1990s. For a while I was also connected to Paris, where I was in a number of exhibitions, most prominently 'L'hiver de l'amour' (1994) at the ARC Musée d'Art Moderne de la Ville de Paris. It was a very open period – the bottom of the art market after the crash. It's surprising how fluid things are during these 'difficult' periods. Also through an exhibition in Paris I got in touch with a Swiss workwear manufacturer, who invited me to photograph their clothes in actual working environments (*Operation theatre II-I*, 1994).

Peter Halley *Can you elaborate on what the artistic situation in Europe was like then?*

Wolfgang Tillmans In continental Europe there was this emerging scene of artists questioning the art object and the whole practice of exhibiting, and I think that's why

I was so well received there. They'd gone through the object-driven 1980s, and young artists were really not interested in that any more; they were questioning why or how we exhibit at all and how objects can still be meaningful. My taking magazines seriously as a platform for my work as an artist came from that sense of urgency. The British scene hadn't really had that wipe-out after the 1980s and was, with people like Damien Hirst, celebrating the object and production values. So there were different agendas in Britain and the rest of the art world. I remember in the summer of 1993 gallerists Gregorio Magnani and Daniel Buchholz invited a dozen artists and friends to a house in Tuscany with this idea that we would all spend time together to sit down and think about how things could progress, what art could look like in the future. It really was completely open, up for grabs. Nobody was selling anything, and there was a similar situation in New York and in Paris, where there were three independently published small art magazines, three circles of people at the magazines *Documents*, *Bloc Notes* and *Purple Prose*, all asking the same question: how can meaningful art be made now? They all emerged in Paris at almost exactly the same time.

Peter Halley *Who were you in contact with at the time, in Cologne and in Paris?*

Wolfgang Tillmans People like Justus Köhncke, Isa Genzken, Lothar Hempel, Marcel Odenbach, Carsten Höller, Philip Parreno, Dominique Gonzalez-Forster, Angela Bulloch, Maurizio Cattelan, Lily van der Stokker and a little later Kai Althoff, Cosima von Bonin, Michael Krebber and Christopher Müller.

Peter Halley *How would you describe your reception in the States?*

Wolfgang Tillmans In late 1993 I made a trip to New York and three different galleries were concretely interested in showing me, which at the time seemed extremely exciting. But on the other hand I was just ... well, dealing with it. I wasn't sitting there saying, 'Incredible, three New York galleries want to show me!'

Peter Halley *It's so anxiety-producing.*

Wolfgang Tillmans At the time it was like ...

Peter Halley *'What if I choose the wrong one?'*

Wolfgang Tillmans Yes, but I was also quite confident in a way. Whatever happened to me, I never felt out of place, like, 'I shouldn't be here, this is vertigo-inducing.'

Peter Halley *I think every artist who manages to reach the goal of success has to have a sense that they're entitled to it; they have to internally believe that this is where they belong. Inside, we think we're saying something important and in a way the recognition is more of an affirmation than a surprise. Do you agree?*

Wolfgang Tillmans Yes. It's dangerous to say because it's easily misunderstood as arrogance.

Peter Halley *It could be, but frankly I think being an artist and having something to say and being confident about it isn't arrogant. It's a relatively modest goal.*

Wolfgang Tillmans Yes. Anyway, I joined Andrea Rosen's gallery and after another visit decided to leave London and move to New York, where I arrived in September 1994, coinciding with my first one-man show there. Andrea's gallery was an exciting place, with artists like Felix Gonzalez-Torres, Julia Scher, John Currin and Sean Landers showing there, and it was impressive to experience the density of artists of all generations in downtown New York. Already during my first month there I met dozens of great people. I generally felt appreciated in a way that maybe only Americans can make you feel. And on a personal level I met the love of my life there, Jochen Klein, another German artist who had moved there around the same time as I did. He collaborated with artist Thomas Eggerer and was a member of Group Material; we had dramatically different practices yet similar overall concerns and interests, which was great.

Peter Halley *At its best, New York can be just like that: bringing people together like no other place. To move on to themes in your work, for the most part the universe in your photographs seems luminous and joyous. But I'm wondering, if you were to identify any darker or more pessimistic emotions that might be in the photographs, what would they be?*

Wolfgang Tillmans All my work has been made with the knowledge of possible death, because since 1983 I've had an acute awareness that this disease, AIDS, affects me. In 1985, after my first few sexual encounters, when I was seventeen, I had this big AIDS fear. That's actually crazy, when you think of a seventeen-year-old schoolboy lying in bed thinking he's going to die.

Peter Halley *I don't think it's that crazy. It happened. It was real and a lot of people did get sick and die.*

Wolfgang Tillmans The threat of AIDS has been with me for all my active sexual life, and so all the celebration and the joy and the lightness in my work has always taken place with that reality on board.

Peter Halley *In other words, if life is fragile one needs to celebrate and appreciate it more?*

Wolfgang Tillmans Yes – well maybe that's too much of a statement. You could take away the 'if', because life is fragile, and you have to celebrate it and enjoy it and not despair over the fact that it's fragile because it just is. And that's why I don't despair; that's why I'm optimistic, because it doesn't only affect me – it affects us all. It just brings us all together again in the sense that that's part of the deal. We're all equally mortal.

Peter Halley *You had your very own experience of tragedy in your life. How did that affect your work?*

Wolfgang Tillmans That's the darkest period in my life, when Jochen died in the summer of 1997, practically out of the blue with one month's warning. The pictures from that time, I never explicitly said what they were about.

Peter Halley Pictures of him?

Wolfgang Tillmans No, for example *untitled (La Gomera)* (1997) or pictures in Munich, some still lifes, our hands clutching on the day he died. There's a self portrait, when I'm starting to ask, 'Why am I here?' There's a still life of the food that we took on the plane from the last hotel night back to hospital. I've never explained this to anybody before, because I never want to bring my personal life into my work in a direct way. It should never be read as, 'I'm telling you about my personal life, these are my friends, this is what happened', and so forth. I've never wanted to create this inclusion/exclusion as regards my private life.

Peter Halley It's nearly five years since Jochen died. How many years were you together?

Wolfgang Tillmans Almost three. Which always sounds so brief, but it was the perfect match. We met in early '95 when we both lived in New York. In '96 we moved to London to live together. That's where Jochen started painting again, and in that short period he created a group of paintings that posthumously got a lot of attention. We didn't actually know he was sick until a month before he died. The work from that time, autumn 1996 to summer 1997, when I was working among other things on *Concorde*, was fuelled by a profound sense of happiness. We had, for example, a great time when we worked together in staging and preparing the Kate Moss pictures. I helped him find source material for his paintings. He introduced me to Spanish and Italian Baroque painting, and we discussed each other's work almost daily. It all ended the day after the opening of 'I didn't inhale' at the Chisenhale Gallery in London, for which we'd had a huge opening party at our place. Jochen came down with AIDS-related pneumonia from which he never recovered.

Peter Halley That's an enormous tragedy and burden. I remember when it happened, I thought you were able to go on in a very dignified way. I don't want to pry into personal matters, but besides the enormity of him being gone, to go through that kind of mourning and loss is not something that typically happens when you're only twenty-eight. How else did this relate to your photography? How did you manage to continue?

Wolfgang Tillmans It completely took the steam out of me. I cancelled everything and I wasn't really functioning.

Peter Halley Were you able to take pictures?

Wolfgang Tillmans I did carry on taking pictures. Not a great deal; a self-portrait, when I cleared out his studio.

Peter Halley Those pictures are so beautiful. There's a sense of peace, rather than anger.

Wolfgang Tillmans I was very much overcome by the power of it all. I felt crushed, of course, but it felt so powerful that I couldn't really rebel or complain. It was the biggest thing that ever happened to me and so I never felt anger because when something is so powerful, what can a little bit of anger do against it?

Peter Halley If you don't mind my saying so, I'm glad I asked you because now I clearly understand the ethical dimension of your life and work. Certainly death is one of the big ethical issues, and for you to speak about the nature of your mourning I think ties very much into your thoughts about how to form a photograph or an installation.

Wolfgang Tillmans I can't control everything in my life and the installations are a reflection of this underlying sentiment that's been with me from an early age: this dichotomy between wanting to control everything and the humble acceptance of what actually is. I think this is, for example, reflected in the use of materials in my work, showing that there is no definite or permanent answer in photography. A photograph can never be stable and perfect and protected and I like the way it's constantly in flux. I position the different angles that go on in the materiality of a photo and I point them against each other. Some pictures I have framed, and others I hang directly on the wall as inkjet prints, and then with others I take away the whole uniqueness and limited-edition-ness thing and give a magazine page or a postcard an equal presence on the wall.

Peter Halley You've given a great deal of thought over time to your exhibition practice, and the installations have continued to evolve dramatically. The way you hang pictures and the technical considerations given to the photograph as an object have all been important. Can you give an idea of how that has evolved over the last ten years?

Wolfgang Tillmans What intrigues me is the tension of the two key qualities of a photograph: the promise of it being a perfect, controlled object, and the reality of a photographic image being mechanically quite unsophisticated. It creases or buckles when it's too dry, curls in humidity, becomes rigid and vulnerable when it's mounted, and for that reason loses its flexibility. I choose to reconcile all this and don't try to pretend that it isn't happening. I've made all of that part of the beauty of the visual experience. The fact that photographs aren't permanent is like a reminder of our condition; showing their vulnerability protects one from the disappointment of seeing them fade. The inkjet prints have this built in as a concept: their impermanence is clearly imaginable yet the owner also has the original master print and can reprint the inkjet print when they feel it's necessary.

Peter Halley How do you decide which images are framed under glass and which are pinned?

Wolfgang Tillmans I'd never pin a photograph, because when you pin it you pierce the corner. So I found this tape with which I can tape a picture to the wall without it even touching the surface of the emulsion, and I can remove the tape afterwards and the print is totally untouched. I pin the magazine pages with steel needles, because if you tape a magazine page, you can never safely remove the tape, it always tears. I use this made-up logic in terms of how I present the stuff, how I fix it to the walls. Somehow, however minuscule these technical decisions probably are in the larger picture, they're crucial to the meaning of

my project and what's important to me – to really understanding the nature of the object that I put up. Each thing needs a different treatment. At the same time, of course, they use a language of personal associations and 'thought-maps'. Then again I also use grids and linear installations, hanging the works all around the gallery at the same height.

Peter Halley *I like your description of the various methods of caretaking, or hanging your images. Basic themes in your work are spontaneity, being in the moment, and enjoyment. Combined with that, however, is a tremendous sense of concentration, and a strong impulse to take care of things in a very … you could almost use the word 'loving' way that doesn't abuse this poor photograph. Often, really good art combines contradictory sides of the artist's psychology or ethos. Your description in this case brings that out for me. It might be that what you do is synthesize impulses that we may typically see as contradictory – make oil and water mix.*

Wolfgang Tillmans That's a great way of putting it.

Peter Halley *What are you thinking about as you place photographs on the wall?*

Wolfgang Tillmans It comes largely from a very personal approach – things that are meaningful to me at this point, in that room or in that month. I usually spend about a week on an installation, which includes day and night shifts. I'll work on it, then leave, then come back fresh, have a new angle on it, change the whole thing, and so on, until the installation settles into a shape that gives me the sense that I can't add to it or change it; only then do I feel it's finished. Underlying decisions regarding content are, of course, formal decisions about colours, shapes, sizes and textures.

Peter Halley *It all seems very multi-determinal: various vectors of intuition about your own interests, your perception of the audience, how you feel the photographs will form the space at any given time.*

Wolfgang Tillmans Exactly. 'Multi-vectored' is the word I like to use. This way of hanging allows for each of these different vectors to have a voice, so that things are not exclusive. It's an inclusive practice, which allows me to have a little joke in one corner and some sort of personal wink to somebody else in another corner. And also to say something very deliberate in terms of formal considerations related to, say, portraiture or landscape. It's not all personal, although that is one level. The viewer should be encouraged to feel close to their own experiences of situations similar to those that I've presented to them in my work. They should enter my work through their own eyes, and their own lives – not through trying to piece together mine.

Luc Tuymans *Juan Vicente Aliaga*

in conversation
December 1995, London

Juan Vicente Aliaga *Very little is known about the inception of your work and I think beginnings are always meaningful. Can you tell me how you started out?*

Luc Tuymans I made my first oil painting when I was sixteen or seventeen years old. The idea of becoming a painter, of doing something within a certain type of visuality, was always there from the start, ever since I was five or six years old. A lot of my earlier work has been destroyed. From the beginning I had this idea about painting as sort of antique. There's one painting that is significant: my first self-portrait which won me a prize in a contest among several Belgian academies. Along with the prize money I was also given a book on James Ensor in which there was a self-portrait he had done at my same age, eighteen. Although the paintings were formally different, there was a similarity in meaning. I had worked on my painting for more than three months; I thought I had made something original, and then discovered that it was impossible. The idea of the original faded away and after a short crisis that gave me a new idea: all you can do is make an authentic forgery. I wanted the paintings to look old from the start, which is important because they are about memory. My best painting from that period is the portrait of my mother's brother, who got killed in the war. It was made from an old painting.

Juan Vicente Aliaga *Is that G. Dam?*

Luc Tuymans Yes. My grandparents' house burned down and all the photographs were burnt. Strangely enough an old painting of my uncle was saved in which he was seen not the way I would have painted him but with his face turned to the side. In this painting I turned him to face front. That was my first 'important' painting, from 1975, when I was still studying at the academy. At that time I was very interested in the work of August Sander.

Juan Vicente Aliaga *Some of your paintings recall the use of cinematic and photographic procedures: enlargements, blow-ups, croppings, close-ups. You in fact worked with a cameraman in 1982 and have made some experimental films on Super 8, 16 and 35 mm film which you call 'stories with no end'. Could you explain your connection with the cinema?*

Luc Tuymans In 1982 I didn't see any point in going on with painting, I had a sort of crisis. Coincidentally I got a Super 8 camera with which I could shoot in black and white without much light. Strangely enough, although I could never take a photograph, I could make films. There's something similar about filming and painting. In order to approach the image you have to go through the process of creating it. The first films were not about anything; they were just everyday images which struck me. I had an enormous amount of material. I cut and cut until the cutting became even more important than the film itself. It gave me a lot of ideas about framing. My first painting after two years was *The Correspondence* (1985): my first conceptual painting with a story behind it. This is the first painting in which you can see lines cropping up. Other

paintings derived directly from the idea of filming are *Antichamber* (1985) and *Encounter* (1985).

Juan Vicente Aliaga *There is always a grid in these paintings.*

Luc Tuymans Yes. But there's also the framing and the drawing. First I painted the background and then I worked toward the front. Film is about projecting images, and I wanted to 'project' that onto the painting also. I needed to have a background colour to start from.

Juan Vicente Aliaga *Were you aware at the time of Eisenstein's ideas about montage and editing?*

Luc Tuymans Yes, I had read some books about montage, especially Eisenstein's. I had read that in the course he taught in Moscow, he would explain framing using a painting, a portrait that he cut up into little parts, like framings, to get different meanings from them.

Juan Vicente Aliaga *There is a recent painting,* Resentment *(1995), which is also inspired by cinema, particularly the fade-out.*

Luc Tuymans Yes, it is based on photography. In the 1970s there was this trend to combine nature and human faces, it was a sort of romantic thing. In this painting I just show the eyes, not the whole face. It's very cinematic because it looks as if it is fading away.

Juan Vicente Aliaga *It gives you the feeling of someone appearing and disappearing …*

Luc Tuymans For my generation, television is very important. There's a huge amount of visual information which can never be experienced but which can be seen, and its impact is enormous. I think it's almost impossible to make a universal image. One can only make bits of images. Existence looks edited. For an artist like Gerhard Richter, the fight of true painting against photography was very important; for me it's much more interesting to think in terms of films, because on a psychological level, films are more decisive. After seeing a film I try to figure out which single image is the one with which I can remember all the moving images of the movie. Painting does the opposite; a good painting to me denounces its own ties so that you are unable to remember it correctly. Thus it generates other images. One shouldn't be able to remember the real size of a painting because that's the very core of its power. Before I paint, the image already exists; sometimes it's an image which is memorized and so there's a mimetic element, which could also be very filmic.

Juan Vicente Aliaga *Which contemporary artists were relevant to you when you started out?*

Luc Tuymans Among contemporary artists, no one interested me. I started out in extreme isolation, for instance I only got to know Gerhard Richter's work much later. The most important experience was seeing the work of El Greco in the flesh. I was sixteen or seventeen, and for the first time I realized what painting really meant. El Greco showed me that painting should appear, confront the

viewer and then disappear, like a kind of retraction. In El Greco there was a sort of deconstruction going on within the imagery; he left out the middle part of the painting. I couldn't remember the whole image.

Juan Vicente Aliaga *In El Greco's paintings there is a sort of artificial light, something unreal. I thought your work was more linked to Velázquez and other seventeenth-century Spanish still life painters, like Zurbarán, or even Ribera, because of the roughness and dryness in their work. El Greco to me is completely different, kind of theatrical, artificial due to the light effects and the colours – those pale blues and yellowish hues making figures look like cadavers ...*

Luc Tuymans What really shook me up was that the light was always cool; the warmth is removed from the imagery, which makes it more powerful. The first time I saw El Greco's paintings in a book, I disliked his mannerism, but when I saw it in the flesh, I realized that what I had taken for mannerism was actually very rigorous rationality. There was a structure; the whole thing was carefully constructed. There are all these misunderstandings within the image, so that when you look at it on an intellectual level it becomes very interesting.

Juan Vicente Aliaga *Maybe there is something else in El Greco that you were attracted to. There's a lack of flesh, a lack of solidity. Bodies look as though they're disappearing; they have no consistency somehow.*

Luc Tuymans No, I think there is a consistency. El Greco, it is assumed, was a very tall man, he was a thin character with a long head. There is a resemblance between his paintings and his being. You always project your own physicality upon the image. But then I also saw in El Greco a sort of detachment.

Juan Vicente Aliaga *I think that even today most contemporary Belgian art is considered to be somehow related to the Surrealist tradition, the absurdity in Magritte, Marcel Mariën and Marcel Broodthaers. The materialistic aspect of Belgian surreal art is also linked to the use of puns and the derision of moral and patriotic values. This art accentuates irony, sarcasm, and is flippant, nasty. Do you feel you are a part of that tradition?*

Luc Tuymans You must remember that the first documentary ever made was done in Belgium in 1913. The idea of reality is very important for Belgians. If you go back to Jan van Eyck you find this same sense of realism, which is very Belgian. It's also in Magritte, who didn't regard himself as a Surrealist. Most of the elements I paint exist in a sort of vacuum. Most of my pictures depict rooms; everything has been taken out of the image. I am fed up with associating Belgian art with Surrealism and the grotesque. I feel much closer to Spilliaert, who was a loner and a greater intellectual than Ensor. So was Magritte in comparison to Broodthaers. But I am opposed to the idea of tradition. One should never mix the idea of tradition with that of one's origins; they are two different things. The only thing you can say about Belgian art is that groups were never possible. The Belgian art world has only ever provided individuals.

Juan Vicente Aliaga *One thing that struck me in your oeuvre is the unpretentious side of it, the modesty of the sizes, the sheer simplicity of it all. Do you think that this austere restraint, this kind of monastic approach to painting, connects you to Spilliaert?*

Luc Tuymans I think so, yes. I feel a link with him but also with Caspar David Friedrich, who was the first artist who turned the landscape into a mental image. He applied the first restrictions, in terms of the imagery, and then kept reducing. Spilliaert did it, de Chirico did it too. The work has to be painted in a very pragmatic way. Everything tends to go towards a sort of extreme image. You have to reduce in order to be clear, but it doesn't have to be obvious. My work is born from isolation, although compared to someone like Spilliaert, it's less tormented. My work is much more rationalized, it revolves around the notion of indifference. This could, however, be connected to Spilliaert, since he too, in my view, had a very detached view of reality.

Juan Vicente Aliaga *I have the impression that you paint in a half-hearted way, as though you do not want to make it precious. Some of your paintings can even look shoddy, like* The Nape *(1987).*

Luc Tuymans *The Nape* comes from the idea that if somebody turns his back on you it's offensive. It's like a shield, a shield for the personality. The individual is blinded; there is no possible contact. It's a very austere image, and violent too. *The Nape* was a painting about intensity. What you actually see is a framing within the image. I outlined the figure and gradually the grease of the paint entered the image. Because it's a very violent image I deliberately stigmatized it by punching holes into it …

Juan Vicente Aliaga *In your work there's a kind of reluctance to portray human images. It's not that they don't exist; they do, but they are defaced, erased, as if deprived of identity. Take* Heillicht *(1991), which shows a doctor's face covered by a mask, or* The Conversation *(1987), in which two men are portrayed as two monsters, their faces smeared. In* DDR *(1990) the left panel also shows someone's face daubed or smeared. The seated figure in* Hands, *the piece you have lost from 1978, has no face, or at least not a distinguishable face. Another work I like very much,* Nr. 3 *(1978), shows four half-naked figures, their faces kind of covered.* Angel *(1992) depicts a faceless angel playing the harp. All these works seem to speak of camouflage – you've even painted a piece entitled* Camouflage. *And finally* Nr. 6 *(1978) depicts a sort of hooded, masked man. Why this insistence on a blurred or hidden identity?*

Luc Tuymans *Nr. 6* and *Hands* are very old pieces, about the idea of isolation. I still work in isolation, in a very small room with a big mirror. If you look very intensely at your face your traits disappear and you see only a black hole, leaving only the background. I had the idea of surrounding myself with fake figures or, worse, fake personalities that you can only see as different self-portraits. I destroyed a lot of those portraits. In *Nr. 6* the face was painted afterwards on paper and glued with paint on top where the face should be. These are very existential

images, and from a very existential level they grew into something very rationalized. I don't want to make portraits on a psychological level. I take all the ideas out of individuality and just leave the shell, the body. To make a portrait of someone on a psychological level, for me, is an impossibility; I am much more interested in the idea of masks, of creating a blindfolded space of mirrors.

Juan Vicente Aliaga *Not only do you erase the faces, but sometimes you cast off the heads as well.*

Luc Tuymans It's again the idea of blocking out identity. Take *Body* (1990); there is no head, no genitals either. A Spanish guy was looking at it at Documenta and he said it reminded him of the *Infanta Margherita* by Velázquez. In *Las Meninas*, Velázquez got a kick out of painting the clothes instead of the infantas' faces, as if the faces had been added later.

Juan Vicente Aliaga *They don't look real; they look like dolls, or dead bodies.*

Luc Tuymans Right.

Juan Vicente Aliaga *And your piece* Body *is like a puppet, somehow.*

Luc Tuymans Yes, it's stuffed. In *Body*, the two lines create the impression that the body is opening up. One painting which does the opposite is *Silence* (1991). It's a sick child, but the body has faded away. Only the head is left.

Juan Vicente Aliaga *Some of your paintings focus on the representation of childhood. This period of human life is not conjured up in your work by the presence of children's games or by a sense of laughter or happiness, or even by innocence. On the contrary, some details induce the viewer to think about childhood as fraught with horror, with unease, open to torment, abuse, ailment.* Silence *is a very significant piece. The baby's face – he or she, we don't know – shows a closed mouth; the eyes too are closed and covered by a kind of sickly orange and green brushstroke. The rest of the body, as you said, is not even drawn.*

Luc Tuymans The idea of fear is pretty much embedded in my personality. Constant fear and constant uneasiness. A constant restlessness. My childhood memories are not happy ones, although I wouldn't go so far as to call them traumatic. *The Nape* (1987) and *Geese* relate to that: fear of the dark, of physical mutilation, which were instilled very early on in me.

Juan Vicente Aliaga Child Abuse *(1989) is a puzzling work. Different objects are displayed: a bed (or something similar), dots … It's hard to work it out.*

Luc Tuymans That painting was made in a single afternoon and stems from my fascination with advertising. I get all these magazines in my letter box with advertisements. What you actually see is a stylized head, which reminds you of a cat or a toy, or a sort of stylized tulip with a price on top. The box in the painting is like a cat box. The two little blocks are images of a lawn and the dots are there just to keep the attention going. When my wife saw

Luc Tuymans

Body 1990
Oil on canvas
49 × 35 cm
Collection Museum of
Contemporary Art, Ghent

Nancy Spero

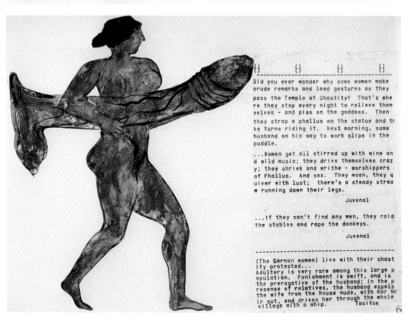

Notes in Time on Women
(panels VIII, XXI) 1979
Handprinting, gouache,
typewriting, collage on paper
2 of 24 panels
51 × 6398 cm overall

Nancy Spero

Codex Artaud I (detail) 1971
Typewriting, gouache, collage on paper
56 × 218 cm

Jessica Stockholder

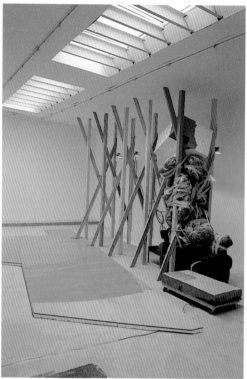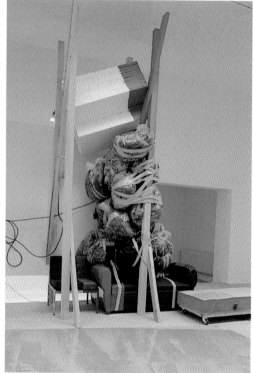

Recording Forever Pickled 1990
Wood, styrofoam, paint, halogen lights,
electric cords, concrete embedded with
plastic resin-coated cookies and a red
ball on wheels, one couch, one metal
framed chair, about 12 clear plastic
garbage bags filled with leaves, sticks,
and twigs, 2 black garbage bags filled
with the same, yellow green duct tape
Approx. 400 × 580 cm
Room, 1120 × 580 cm
Installation, Le Consortium, Dijon,
France
Collection, Le Consortium, Dijon

Jessica Stockholder

Edge of Hot House Glass 1993
Plants, grolites, aerated concrete block,
halogen lights, paint, black velvet,
newspaper maché, cable, beads, balls,
concrete, building
Approx. 11 × 12 m
Installation, Galerie des Arennes,
Nimes, France

Wolfgang Tillmans

Lutz & Alex, sitting in the trees 1992
Colour photograph

Wolfgang Tillmans

untitled (La Gomera) 1997
Colour photograph

Luc Tuymans

Silence 1991
Oil on canvas
86 × 78.5 cm
Collection Kunstmuseum, Bern

this painting she was struck by its violence. It was a painting about consumerism but it made her think of child abuse, that's why I gave it that title.

Juan Vicente Aliaga *There's another piece dealing with childhood called* Silent Music *(1992). It's a fairly large picture showing an interior packed with furniture. There is a sense of* malaise, *maybe due to the pastel colours, and the stifling atmosphere. The space is too crowded.*

Luc Tuymans But at the same time it is empty. The bed is unmade; the chair empty; the cupboard closed. The light source is unclear. You have the sense that you're peering in through an open door. And pink and blue are typically children's colours, for a child's room that someone else has prepared for you. In that sense it's horrific. If you look carefully at the image you realize that the chair is bigger than life-size; it couldn't be for a child. It is not my room but a sort of universal kid's room, turned into a prison, a cell. The objects are things you need to survive: a bed, a table, a chair, a cupboard. The colours are meant to be friendly and yet there's a sense of claustrophobia. A lot of my imagery has a sense of coziness which is turned into something terrifying. Anything banal can be transformed into horror. Violence is the only structure underlying my work. It's both physical and detached at the same time.

The title is correct because the painting reminded me of silent music. The title itself is the heart of the image and can never be depicted: the missing image. *Gas Chamber* is another work that might look warm, but when you read the title it becomes threatening, the whole image changes. And *Silent Music* is similar on a poetic level. The title is too big for the picture. You can read my pieces as ironic if you want.

Juan Vicente Aliaga *In* Geese *(1987), one of the pair is headless, cut off by the right edge of the painting. I read that a similar picture used to hang in your room as a child and that it frightened you. You also mentioned that when you were seven years old, you experienced the film* Snow White *as something terrifying.*

Luc Tuymans It's the idea of animation which is terrifying. When I first saw *Snow White* I was shocked to see an animated image move in an almost human way. Illusion became reality; it was very scary. In *Geese* I was frightened by the black hole in the goose's eye. It's not really an eye, it's more like a black dot. It's an element through which you can disappear, through which you could be displaced or swallowed. In a painting there is always a weak spot; a painting should always have an entrance or hole through which you can enter. Even if it is not visible to the spectator, it is always visible to me.

Juan Vicente Aliaga *Considering that much fin-de-siècle art deals with the representation of the body, often focusing on the body's innards, it is interesting that on the contrary you work on the body's lack of corporeality or materiality. In America, for example, the body is often represented in a very crude and direct way, while in your work, the body is there and not there. In* Body, *despite its title, what we see is a nobody. We see only the garments that cover it, which become more*

significant than the body itself, which is amputated, almost lifeless. In Torso *the central image is more an armour than a real body.*

Luc Tuymans For me it's to do with the idea of a form that has turned into something soft, which is why clothes are more emphasized than the body itself. When I thought about trying to paint the sexual act, for example, I came to the conclusion that it was impossible to depict, because it is timeless. It is a timeless repetition.

Juan Vicente Aliaga In a series of works entitled Der diagnostische Blick *(1992) the body is present by means of the gaze. It's the largest series (ten works) you've ever made. In it you depict all kinds of people, mostly men, middle-aged. But the common denominator lies in the way they look, their vacant eyes, the sickness in their eyes.*

Luc Tuymans No, the sickness is in the spectator. I was interested in showing medical photographs because the people portrayed in them are real people who later died. It was like using people. These paintings were the most physical point I have ever reached, and they are my hardest paintings. All the works were painted in the same manner, at the same speed. Most eyes in medical books look straight into the lens; I changed that. There was a sort of compassion, and I took that out by making the eyes look askance. The ultimate idea of reality is to be confronted with hardness and the impossibility of psychological penetration. I wanted to depict sickness not in its obviousness. Sickness should appear in the way the painting is made, and have it throw that sickness back at the viewer.

 The title is very important because it's about diagnosing an image. This reminds me of my earlier paintings showing toys and little figurines. I have always liked Edward Hopper because he didn't paint real figures. To me they are like puppets. I regard Hopper's work as though it were a toy, not a painting. As for the people in *Der diagnostische Blick*, for me they are more objects than people; these individuals are portrayed as elements. They are monumental and confrontational images.

Juan Vicente Aliaga Heillicht (1991) is another work dealing with the ailing body. In this case there is a figure, an erect male figure, whose features are partially erased or blurred, examining a half-naked patient. Despite the colour, which is brighter than other works, I wouldn't say it's a warm painting.

Luc Tuymans No, it isn't. It's an illustration of a picture. There is a white vertical line on the left-hand side next to the painted image. It reduces the whole thing to the idea of illustration and gives you the impression that the image came out of a book.

Juan Vicente Aliaga It is hard not to think of Bloodstains *(1993) in terms of AIDS. Today there is a sort of awareness about medical details which we were not familiar with years ago.*

Luc Tuymans I wasn't thinking of AIDS. It was a microscopic image which actually multiplied the image of blood into stains. It is not something I thought about, although I acknowledge that, given the idea of decomposition and the

reddish colour, there might have been some subconscious relationship. This image is more a pure abstraction, but at the same time there's an enormous amount of physicality in it. The drops are isolated and are constantly moving. When you hang this painting on the wall it grows …

Juan Vicente Aliaga *You mean it's animated somehow.*

Luc Tuymans Yes, it has an animated element to it. Because it is so close-up it produces an unreal effect. It is understandable that the viewer relates it to the body, to blood in the veins …

Juan Vicente Aliaga *From sickness let's move towards death. Some of your paintings allude in an indirect or vicarious way to the scene of death, although death itself is never enacted.* Gas Chamber *(1986) is one of your more harrowing paintings. It presents a room spattered with dark blotches, and there is a sort of drain in the floor which conjures up the notion of a residue produced by the body.*

Luc Tuymans There seems to be a kind of logic in what you are asking me. First we have the bloodstains and the virus. The idea of stains in the body relate to what I was saying before about the entrance to the painting. In *Bloodstains*, because the frame is crooked the image is distorted. There is no real depth or perspective. These stains or blots are similar to the drains in *Gas Chamber*. Also the stains in the ceiling describe showers. If you didn't know about the gas chamber you would think this was a normal bathroom or just a basement. But I wanted to make a warm painting about something horrific. The title sometimes is more important than the image itself. Once a German collector wanted to buy the painting because he was moved by it. He asked me what it was, and when I told him he was blocked and petrified. He had felt the warmth in it but the title put him off. The space had to be depicted like a skin because human beings were killed there. It is a space that never ends, a space that goes beyond the image itself. There is another picture similar to this called *The Green Room*, from 1994. It's a room with no ceiling, so it seems to expand upwards in space. In *Gas Chamber* the narrowness of the ceiling and the floor stress the depth of it all. The edges of the picture look filthy, or dark, and that gives the viewer the idea of sweat, even steam, something physical. *Our New Quarters* (1986) was more important than *Gas Chamber*. It is more a statement than a painting, a reminder of the idea of war. It's a sort of metaphor of violence. Western culture, I think, is one of the few cultures that, in order to progress, has incorporated destruction. There is a link between annihilation, hygiene, consumerism, production and propaganda. When you think about hygiene, sometimes it can be connected to ethnic cleansing. This can appear as an economical and rational perspective. The final solution is something hidden, and I want to integrate that into the cultural discourse. It could be seen as a metaphor for the culture we live in. I see it as something that might happen again, as a possibility. I don't want to take a moral stance, but I want to oppose the taboo aspect of it. The biggest reaction against the war in former

Yugoslavia came when people saw prisoners behind barbed wire fences. The perversity of the image made people react, triggered our collective memory of the Nazi camps.

Juan Vicente Aliaga *One cannot take your paintings on face value. For instance,* Apple *(1993), which was shown in 'Indelible Evidence'. What we see is a close up of a partially bitten apple. What the painting hides is that the image was inspired by a police archive photograph of an apple left by the killer at the scene of a murder. The teeth marks eventually identified the murderer. When I first saw it I thought it was a skull standing on its base, but this actually is the horizon line.*

Luc Tuymans I was amazed when I saw the apple for the first time on British TV. They have a TV show called 'Indelible Evidence', like my show. It was mainly about forensic science and what they find through stupid, banal things. The banality of elements can be very meaningful.

Juan Vicente Aliaga *The combination of banality and* humour noir *recurs in your work. In* Candycontainer *(1992) we see a pear containing a roundish, childlike face that is screaming. Inside a trivial object – a fruit, in this case – lies horror.*

Luc Tuymans The candy container depicted is of a reusable type used in the United States at Christmas time. I wanted to show the effect of something bottled up that cannot get out. The pear from the States usually smiles; mine screams. Christmas for me has something horrific about it.

Juan Vicente Aliaga *You paint in a very uniform way and treat serious topics or banal things in the same way. It's like you're equating everyday objects with, say, the memory of war.*

Luc Tuymans There is a sort of indifference in my paintings which makes them more violent, because any objects in them are as if erased, cancelled. I am not a material painter, I mean I don't use a lot of paint.

 Most of my paintings are not painted on a stretcher. They are painted on a piece of canvas or on a piece of board. When the image is finished I just paint a white ribbon around it to focus it. That's the last thing I do when the painting is finished. It gives me the chance to alter the size of the image. None of my paintings are the same size. Every painting differs, even if only by a millimetre. When the painting is framed it evens itself out. The visibility drops and a kind of gloominess appears on the painting, a sort of second skin. That gives people the impression that the paintings are similar.

 There is a continuity in the way I approach painting. The notion of contrast, of outline and shadow, is very significant in my work. I have made a group of pieces about shadows and mirrors because they create immaterial spaces. It's hard to depict them, it's challenging especially for someone like me who thinks that painting is only about precision. It has nothing to do with virtuosity; it's a necessity. Most of my work could at first look clumsy, deprived of aesthetic elements. I am not into aesthetics; I am into meaning and necessity. Folk art works in a similar way. It's about anonymous elements,

something that is not owned by anybody in particular. It's a collective thing, it's precise, it may look banal at first but it isn't. Take for instance my piece *Superstition*. It's about poltergeists. It comes towards you and at the same time sucks you in. The insect depicted is dark and is placed in front of the body, in front of the genitals. The body is just an outline. You do not know for sure whether this dark form is coming towards you or is receding. The notion of danger, of a threat, is there. It's a small painting but it takes up a lot of space. It works on an enormous scale. *Superstition* could be a *nom de plume* for art. Art that transgresses, that transmits. The insect in *Superstition* sucks you in; it's almost shamanistic.

Juan Vicente Aliaga *I see your work as deprived of sex. I have been looking for traces of sexual activity in your work and have been unable to find many.*

Luc Tuymans When something is not depicted it makes it more meaningful, more sexually loaded not in terms of the figures but in the physicality of the painting itself. Caressing the painting, flattening it out. Painting wet on wet. I wouldn't say that every act derives from sexuality but a lot is triggered by it.

Juan Vicente Aliaga *Is sexuality based upon the structure of violence?*

Luc Tuymans I would say that if you look carefully at my paintings there is also pleasure, which may not be apparent but is there in the making of the painting.

Juan Vicente Aliaga *It's hard to think of your paintings in terms of pleasure.*

Luc Tuymans I know. But there's pleasure when I paint. The act of painting itself is so concentrated. There is a sort of ease when I work, a directness. Every painting is made in one day, never more than that. In long or short sessions, it depends. Four hours, eight hours … it can go up to thirteen hours or more but it has to be finished in one day.

Juan Vicente Aliaga *Why?*

Luc Tuymans I cannot work otherwise. It's about truly focusing, and that is sexually loaded. It's true concentration, true intensity. When I fail to reach that breaking point it is not accurate and it never will be. That's why it is very sexual. It's another type of arousal.

Juan Vicente Aliaga *I would like to ask you whether the notions of tedium or boredom are in your work. It sometimes reminds me of Walter Sickert's painting* Ennui, *with a woman and a man in a room, both with vacant expressions and paying no attention to each other. The objects are more communicative than the people. I think of the array of objects you have painted: lamps, curtains, flowers, bathroom tiles …*

Luc Tuymans It could be anything. It's just that there's the element of someone using the object in its portrayal. The physicality of the painting as an object is important, whereas I don't think the depiction of psychological states

can give the same impact, the same strangeness, the same directness – or indirectness. It's more photographic this way. Objects enable me to create a message not on a moral level but on an instantaneous level. Paintings have a long life span, which turns them into very abstract elements. Paintings were the first transmitters. No matter how long they are hung in a museum, three years or 400 years, they still give you something. Every image has this disconcerting element of going further in time, into magical time. Some may think it is naive to think that by depicting something you capture its soul or that you have control over things. But it really does have something to do with that.

Juan Vicente Aliaga *I am interested to know more about your recent series* Heimat, *shown in Nantes in La Salle Blanche at the Musée des Beaux-Arts. This is a difficult word to translate from German. Homeland? Fatherland? Motherland? Native land? In some way these eight paintings try to deconstruct and analyse the rise and the strength of neo-Fascism in Europe and the danger it represents, especially in Antwerp, where you live and where it's really on the rise. I was struck to see the evenness, the uniformity of the images, like your early pieces on concentration camps.*

Luc Tuymans I have tried to rebel against a certain identity which is pretty strong in my country, this Flemish idea of a mythical, fixed identity. It is not only political but cultural as well. Fascism also has a cultural basis. It goes beyond politics, because politics is about compromises, about life. Nationalism is uncompromising. All forms of nationalism remove the qualities of real life and create a uniformity out of individual differences. I wanted to show the relics of the Flemish movement, for instance the *Yzer-tower* (1995), built after the First World War as a homage to the fallen Flemish soldiers. Or the portrait of the regional writer, Ernest Claes, in *A Flemish Intellectual*, who had been recently commemorated on a postage stamp. I have depicted him as though he is lacking in identity. The face is not really a face; it is more like a masked image. Nationalism for me is like a mask: unmovable, and quite hollow.

Take the idea of *The Flag* (1995), for instance. I depicted it in such a way that the colours are denied and it looks like a pile of white dust, hanging on the wall – not waving in the sky. The whole thing was about emphasizing the hollowness of their symbols. The Flemish movement wants to enhance the idea of 'art for everybody', so I made this series very typical and popular, but there is also something nauseating about it, even violent.

Juan Vicente Aliaga *So there is a clear critique of Fascism in this series. And neo-Fascism is spreading all over the world, not just in Belgium. I know you have started a new series of paintings entitled* The Heritage, *which you will be showing in the States, and that you will be using American symbols. Is there a link between* Heimat *and* The Heritage?

Luc Tuymans Well, it's going to be a completely different show. I have finished five
paintings up to now. It would be interesting to see both series of works
together, because there is a new velocity in this new series. The works for
Heimat are much more stable and motionless. They are almost fading away.
It's a backward velocity, it goes back in time, whereas in *The Heritage* I
depicted symbols like the American flag as if it were a neon sign, or I painted
baseball caps that take the place of faces, one on top of the other. I don't
want to show a single face, something individualistic. I am showing symbols
deprived of any personal attachment. I want something icy, but at the same
time a type of abstraction and monumentality. They will produce a constant
uneasiness, like a constant noise. My first show in the States was about
superstition, so *The Heritage* is the logical follow-up. The titles of my
shows are really relevant. If you list them you can see a sort of guiding line
across my work.

Juan Vicente Aliaga 'Disenchantment', 'Indelible Evidence', 'Heimat'…

Luc Tuymans Also 'Embitterment'. Different elements, with images which as a matter
of fact were never really painted.

Jeff Wall *Arielle Pélenc*

in e-mail correspondence
October 1994

Arielle Pélenc *I thought we could start with the idea of conversation and talk. A lot of your pictures involve verbal communication:* Diatribe *(1985),* The Storyteller *(1986),* Pleading *(1988),* Dead Troops Talk *(1986). You once told me that the film* La Maman et La Putain *by Jean Eustache was very influential, and this film is mostly based on talking. How does talking, or voice, participate in the construction of your pictures?*

Jeff Wall One of the problems I have with my pictures is that, since they are constructed, since they are what I call 'cinematographic', you can get the feeling that the construction contains everything, that there is no 'outside' to it the way there is with photography in general. In the aesthetic of art photography as it was inspired by photojournalism, the image is clearly a fragment of a greater whole which itself can never be experienced directly. The fragment then, somehow, makes that whole visible or comprehensible, maybe through a complex typology of gestures, objects, moods and so on. But, there is an 'outside' to the picture, and that outside weighs down on the picture, demanding significance from it. The rest of the world remains unseen, but present, with its demand to be expressed or signified in, or as, a fragment of itself. With cinematography or construction, we have the illusion that the picture is complete in itself, a symbolic microcosm which does not depict the world in the photographic way, but more in the way of symbolic images, or allegories. For example, Giotto's paintings, although often part of narrative cycles, seem to evoke a whole universe just by the nature of the depiction and composition. Italian Catholic art as a whole has this totalizing quality, in which the design of the picture implies a complete and profound statement about the subject, and we do not have the feeling that there is anything left outside the frame. This condition is always at odds with the nature of pictorial construction based on perspective and the rectangle, which necessarily implies a boundary to the picture and not to the subject. This conflict is one of the essential sources of energy for Western pictorial art. It reached its first absolutely decisive formulation in the 'naturalistic Baroque' of Caravaggio and Velázquez, in which meanings seem to be totalized while the pictorial form is recognized as being inherently bounded. In their work, there is simultaneously no outside and an outside, and I think we've been in this borderland ever since.

Making pictures of people talking was for me a way to recognize this condition. I have always been interested in the nature of the pictorial, its indwelling structure, its transcendental conditions, if you like. Journalistic photography developed by emphasizing the fragmentary nature of the image, and in doing so reflected on the special new conditions created by the advent of the camera. So, this kind of photography emphasized and ven exaggerated the sense of the 'outside' through its insistence on itself as fragment. I accept the fact that a photographic image must be a fragment in a way that a painting by Raphael never is, but at the same time I don't think that therefore photography's aesthetic identity is simply rooted in this fragmentary quality.

In the history of photography itself there has obviously been a continuous treatment of the picture as a whole construction. This has often been criticized as the influence of painting on photography, an influence that photography has to throw off in order to realize its own unique properties. But in my view, photography's unique properties are contradictory. Imitation of the problematic completeness of the 'naturalistic Baroque' is one of them.

A picture of someone talking is to me an elemental example of the problem of the outside and the threshold. I can construct the gestures and appearance of the speaker and listener, and so can suggest that I also control the words being spoken and heard. But, at the same time, it is obvious that I cannot, and that every viewer of the picture can 'hear' something different. Talking escapes, and so it is itself an image of what is both included and never included in a picture, especially in a picture which seems to wish to imitate the 'naturalistic Baroque' invented by painting.

Arielle Pélenc *The child in* In the Public Garden *(1993) looks like an automaton – in the garden but cut off from the outside world. There is a lot of automatic gesturing in your pictures, maybe because of their 'cinematographic' character. This automatism of the image is different from the distancing produced by theatre or painting. In classical cinema, the* hors-champs, *the outside, is open and endless. But with modern cinema the* hors-champs *is transformed by the jump cut (*faux raccord*). It becomes like an irrational number not belonging to one or the other class or group it is separating. Your work presents these irrational cuts where the rupture with the outside world is visible inside the image, like in* Dead Troops Talk, *for example.*

Jeff Wall My work has been criticized for lacking interruption, for not displaying the fragmentation and 'suturing' which had become *de rigueur* for serious art, critical art since the 1960s. In your terms, it didn't seem to have any jump cuts which let in the outside, and break up the seamlessness of the illusionism. But, already by the middle of the 1970s, I felt that the 'Godardian' look of this art had become so formulaic and institutionalized that it had completed its revolution, the plus was becoming a minus, and something new was emerging. I preferred *Mouchette* to *Weekend*, and was interested in the preservation of the classical codes of cinema as was being done by Buñuel, Rohmer, Pasolini, Bergman, Fassbinder and Eustache, all of whom achieved very new things in what I would call a non-Godardian or even counter-Godardian way. Eustache's *La Maman et La Putain* had a tremendous effect on me. I wish he hadn't died.

What I think these people were doing was transferring the energy of radical thinking away from any direct interrogation of the medium and towards increasing the pressure or intensity they could bring to bear on the more or less normative, existing forms which seemed to epitomize the medium. They accepted, but in a radical way, what the art form had become during its history. They accepted technique, generic structure, narrative codes, problematics of performance and so on, but they broke away from

the decorum of the dominant institutions, like the production companies or, in Europe, the state filming agencies. In that process, they brought new stories and therefore new characters into the picture. Think of the couple in Fassbinder's *Ali: Fear Eats the Soul*, or Mouchette herself, or the people in *Persona* or *Winter Light*.

There's a lot that could be said about a kind of internalized radicalism in the work of these filmmakers and others working between, say, 1955 and about 1980, an almost 'invisibilized' intensity as far as any disruption of the classical codes is concerned. What happened was that the 'outside', as you call it, did get inside, but in doing so it refused to appear directly as an outside, disruptive element. It dissembled. It appeared to be conventional, appeared to be the same as (or almost) the conventionalized 'signs for the real' that make up ordinary cinema. Buñuel was of course a master at this. So, the new form of the threshold was not a drastically broken-up surface like in Godard, but a self-consciously, even ironically, even manneristically normalized surface. This is – or seems to be – a more ambivalent approach to the idea of critique and auto-critique than an openly contestatory one. This apparent ambivalence, this technique of mimesis and dissembling, this 'inhabitation' didn't satisfy anyone who demanded avant-gardist criteria of overt, antagonistic confrontation. I agree that there are these 'jump cuts' or irrational cuts in my work. But they appear as their opposites, as adherence to a norm, the unity of the image or picture. I accept the picture in that sense, and want it to make visible the discontinuities and continuities – the contradictions – of my subject matter. The picture is a relation of unlike things, montage is hidden, masked, but present, essentially. I feel that my digital montages make this explicit, but that they're not essentially different from my 'integral' photographs.

Arielle Pélenc *Representation of the human body, depending on the construction of micro-gestures, is kind of programmatic in your work. Recently some unrealistic, improbable bodies have appeared such as those in* The Vampires' Picnic *(1991),* The Stumbling Block *(1991),* The Giant *(1992) and the zombies in* Dead Troops Talk. *What are these bodies?*

Jeff Wall I feel that there has always been a grain of the 'improbable' in my pictures and in my characters. For example, I thought of the woman in *Woman and Her Doctor (1980-81)* as a sort of porcelain figurine, and tried to make her look a bit like one, very glossy, so that the 'clinical gaze' of the doctor would have something to work on. I made a 'double' in 1979 (*Double Self-Portrait*). The man in *No* seems to have only one leg – how is he moving along the street? The woman in *Abundance (1985)* always seemed sort of hallucinatory to me. *The Thinker (1986)* is an impossible being, too. I have always thought of my 'realistic' work as populated with spectral characters whose state of being was not that fixed. That, too, is an inherent aspect, or effect, of what I call 'cinematography': things don't have to really exist, or to have existed, to

appear in the picture. So, I see my more recent 'fantasy' pictures as just extensions of elements that have always been present. Being able to use computer technology released certain possibilities, certain energies, and made new approaches viable. But a recent work like *Restoration (1993)*, for example, used the computer and the process of digital montage to create a very realistic, very everyday, very 'probable' scene; so this technique does not just imply overtly fantastic images. It makes a spectrum of things possible, and helps to soften the boundary line between the probable and the improbable. But it did not create that threshold – that was already there, both in my own proclivities, and in the nature of cinematography. 'What are these bodies?' – that question requires an interpretation of the picture in which they appear, and I'm not the best person to do that.

Arielle Pélenc *In an interview with T.J. Clark you emphasized the notion of the representative generic constructions of your pictures. By using generic constructions, figures, stories or gestures, your work seems to underline the inadequacy of representation to its referent. Would your 'spectral characters' be an indication that the world and its representation do not match?*

Jeff Wall The claim that there is a necessary relationship (a relationship of 'adequacy') between a depiction and its referent implies that the referent has precedence over the depiction. This 'adequacy' is what is presumed in any imputed legitimation of what you're referring to as Representation. A critique of Representation claims that Representation happens when someone believes that a depiction is adequate to its referent, but is deceived in that belief, or deceives others about it, or both. Representation occurs in that process of self-deception, and so it becomes the object of a deconstruction. I don't think depictions, or images, can be judged that way, and I don't think they're made in those terms, or at least not primarily. Depiction is an act of construction; it brings the referent into being. All the fine arts share this characteristic, regardless of their other differences. Depictions are generic because, over time, themes, motifs and forms bear repetition and re-working, and new aspects of them emerge in that process. Genres are forms of practice moulded slowly over time, like boulders shaped by water, except that these formations are partially deliberate, reflexive and self-conscious. 'Generic' constructions are old by nature, maybe that is why they play such an important part in the expression of the 'new' and the 'modern', as Baudelaire observed.

In that sense, there is always something spectral – ghostly – in the generic, since any new version or variant has in it all the past variants, somehow. This quality is a sort of resonance, or shimmering feeling, which to me is an essential aspect of beauty and aesthetic pleasure. But none of this is concerned with the adequacy of the depiction to its referent. This notion of such a relation is not artistic; it seems to have more to do with other ways of thinking, other images, other depictions. The 'match' between the world and depictions is organized or regulated differently in different practices. Art

might refer to, borrow from or even imitate other things, the way many artist-photographers have imitated photojournalists, for example. But it does not accept the totality of regulations covering or defining that from which it borrows – the principle or condition of the autonomy of art ensures that. I think our awareness of this is the outcome of the years – or even decades – of deconstruction.

Arielle Pélenc *In his essay 'Analytic Iconology', the art historian Hubert Damisch looks into the question of beauty in relation to the Freudian theory of desire, revisiting the myth of Paris through European painting from Raphael to Seurat. It is clear that the female nude from the Renaissance to Manet and Picasso has been the site for aesthetic and libidinal gaming with tradition, a site of transgression of its rules and laws.* The Destroyed Room *(1978) is a kind of allegory of the nude, and you have made male nudes –* Stereo *(1980) and* The Vampires' Picnic. The Giant *is your first female nude. What importance do you give to this subject?*

Jeff Wall I'm not convinced that the nude is such a 'site' on which such transgression is acted out. That's not to deny the historical and even psychological truth of this acting out, but only to place oneself in relation to it. Being 'in relation to it' is not to be outside it or free of it, but not to be simply subjected to it as an inevitable and necessary condition. I don't think it is any longer necessary to make nudes, which might be a way of saying it is no longer necessary to enact transgressions in order to make significant works of art, even modernist art. This is, again, not to suggest that the cultural and social antagonisms which provoke the whole process of art as transgression, from Romanticism on, have been cured or calmed. But the 'culture of transgressions' involves a sort of romantic binarism. Law exists, and the soul is crushed by it. To obey the law is to live in bad faith. Transgression is the beginning of authentic existence, the origin of art's truth and freedom. But modern societies are constitutional; they have written, deliberately, their own foundations, and are continually rewriting them. Maybe it is a sense that it is the writing of laws, and not the breaking of them, that is the most significant and characteristic artistic act in modernity. Avant-garde art certainly operated this way, writing new laws as quickly as it broke any old ones, thereby imitating the constitutional state. The maturation and aging of modernist art maybe brings this aspect more into focus. In any case, the gesture, or act, of transgression seems far more ambiguous in form and content than it has seemed in concepts of art simply based upon it. I feel that art develops through experimentally positing possible laws or law-like forms of behaviour, and then attempting to obey them. I admit this is a completely reversed view, but it interests me more than any other. So I guess the nudes I've done are not intended to be sites for any such gaming with authority. I see them as 'mild' statements, marking a distance from any Philosophy of Desire. Except for the vampires, of course.

Arielle Pélenc *I think you're dismissing the idea too easily. I was thinking about transgression in a more symbolic sense, not simply in terms of 'shocking the bourgeoisie'. If you say*

that modern society is constitutional, are you saying that it is like all societies in the sense that they are constructed in terms of the main law – the interdiction against incest, which allows language as the symbolic function? Any significant work of art touches on or crosses that interdiction, that borderline, which is also the border between nature and culture. When that border is not approached you have academic art, art made by the application of laws. The production of meaning in poetic language, because it reactivates what Julia Kristeva called the 'archaic body', is equivalent to incest. That is, by means of rhythm, intonation, everything that introduces the heterogeneous law is challenged. It seems to me that the economy of meaning in your work acknowledges this territory.

Jeff Wall OK, I agree that in that sense, my work must involve what you want to call transgression. When I talk about law-making, I see that in the light of the origins of constitutional states, that is, regicide. So there is no question of the application of laws, of academic conformism, except in the sense that we can never simply oppose conformism without in some way internalizing it, participating in it, becoming part of it. The image of pure law-breaking activity, pure violation, pure incestuousness (if you want to call it that), seems to me to be a rhetorical construction, a kind of romantic fiction of the radical avant-garde.

To my mind, the violator is hypothesizing a new or antithetical code, to which he or she conforms often very strictly. I recognize what Kristeva is referring to – the heterogeneity and productivity of the poetic. I identify that with the pleasure created over and over again by the picture itself. But I don't think of it as essential, or as more productive than the 'linear' or impulses towards institutionalization, reiteration, enforcement and mimesis. This is part of not accepting that art is primarily or directly a gesture of liberation, as all avant-garde concepts insist it is.

They are still quarrelling with their own 'Ancients'. In my opinion, the triumph of the avant-garde is so complete that it has liberated what previously had to be seen as the anti-liberating elements in art, or in the process of making art. There are transgressions against the institution of transgression. I think the pictorial has come to occupy this position to a certain extent.

Arielle Pélenc *I can follow you on that, but to be a little more specific, your pictures are full of 'micro-transgressions', many of which are involved with themes of violence, particularly male violence. I think of* No (1983), Milk (1984), Dead Troops Talk *or* The Vampires' Picnic. *If we think of representation in terms of a symbolic function equivalent to the Name of the Father, it seems your work has something to say about it but not in terms of 'deconstruction' or 'seduction'.*

Jeff Wall The problem is that the rhetorics of critique have had to make an 'other' out of the pictorial. This is the form the history of art has taken, from the beginning of Modernism. This is our 'Quarrel of the Ancients and Moderns'. The pictorial itself is identified with the Name of the Father, with control

and domination, and, finally with violence. I think I understand why this has happened, but, as I said, I see that as a necessity imposed by the polemical character of artistic discourse, by the 'quarrel'. So there is truth in the identification. But, rhetorically, this truth has been totalized, and transformed into what Adorno called 'identity'. I'm struggling with this identity.

The violence you see in my pictures is social violence. *Milk* or *No* derived from things I had seen on the street. My practice has been to reject the role of witness or journalist, of 'photographer', which in my view objectifies the subject of the picture by masking the impulses and feelings of the picture-maker. The poetics or the 'productivity' of my work has been in the stagecraft and pictorial composition – what I call the 'cinematography'. This I hope makes it evident that the theme has been subjectivized, has been depicted, reconfigured according to my feelings and my literacy. That is why I think there is no 'referent' for these images, as such. They do not refer to a condition or moment that needs to have existed historically or socially; they make visible something peculiar to me. That is why I refer to my pictures as prose poems.

Arielle Pélenc The Vampires' Picnic *is certainly a prose poem. I saw it as a kind of reversed and dark version of the Paris myth, a kind of disintegration of the aesthetic judgement, and this interiorized violence, this emotional and pictorial discord seems to have something to do with the symbolic function.*

Jeff Wall The feelings of violence in my pictures should be identified with me personally, not with the pictorial form. These images seem necessary to me; the violence is not idiosyncratic but systemic. It is repetitive and institutionalized. For that reason I feel it can become the subject of something so stable and enduring as a picture. The symbolic function we call the Name of the Father appears in a process of masking and unmasking, and perhaps of re-masking. The work of art is a site for this process, and so the work potentially is involved in masking. But, from that it is difficult to move to an essential identification of any artistic form with masking alone. This would be to single out that form as so different that it would have to have a category all of its own. Any image of a male has to include in some way the identity with the Father, and so all the problems involved with that are evoked just in the process of depiction. Rather than dominating and organizing that experience, the picture sets it in motion in an experimental universe, in a 'play', including a play with tropes of depiction, a play of styles. For example, I think that the nude in *The Vampires' Picnic* signifies the Father function. I wanted to make a complicated, intricate composition, full of sharp details, highlights and shadows in the style of German or Flemish mannerist painting. This style, with its hard lighting and dissonant colour, is also typical of horror films. I thought of the picture as a depiction of a large, troubled family. Vampires don't procreate sexually; they create new vampires by a peculiar act of vampirism. It's a process of pure selection, rather like adoption; it's based

in desire alone. A vampire creates another vampire directly, in a moment of intense emotion, a combination of attraction and repulsion, or of rivalry. Pure eroticism. So a 'family' of vampires is a phantasmagoric construction of various and intersecting, competing, desires. It's a mimesis of a family, an enactment of one. I thought of my vampire family as a grotesque parody of the group photos of the creepy and glamorous families on TV shows like 'Dynasty'. The patriarch of this family is the nude who is behaving oddly. In this behaviour he occupies the position of Father, and the discordancy implies something about the vacancy of the symbolic position itself, which can be occupied adequately by a figure who does not perform in a conventional or law-governed way. I wanted to get a lawless feeling, a feeling that things are amiss and at the same time normal – that 'father feeling'.

Arielle Pélenc *In your* Galeries *interview with Jean-François Chevrier you discussed the 'black humour' and suppressed laughter you thought were in your work. But I see, or hear, another laughter, softer, gentler and maybe more humanistic. This is maybe most evident in* The Stumbling Block, *maybe in* The Giant, *where I sense it to be a nourishing, maternal feeling.*

Jeff Wall When I started to work with the computer, I had the idea that I could use the otherworldly 'special effects' to develop a kind of philosophical comedy. *The Giant, The Stumbling Block* as well as *The Vampires' Picnic* and *Dead Troops Talk* are in this genre, as are older pictures like *The Thinker* or *Abundance*. This makes me think of Diderot, of the idea that a certain light shone on behaviour, costume and discourse creates an amusement which helps to detach you from the immediate surroundings and project you into a field of reflection in which humanity appears as infinitely imperfectible. This imperfection implies gentleness and forgiveness, and the artistic challenge is to express that without sentimentality. I guess the key metaphor in these works is 'learning'. We learn; we never complete the process of learning, and so learning is a kind of image of incompletion and limitation but a hopeful image as well. I've tried to express this feeling, and this love of learning, in pictures on the subject of discourse and talk, like *The Storyteller* or *A Ventriloquist at a Birthday Party in October, 1947 (1990)*. In *The Stumbling Block*, I thought I could imagine a further extrapolation of society in which therapy had evolved to a new, maybe higher stage than it has up to now. In my fantasy, *The Stumbling Block* helps people change. He is there so that ambivalent people can express their ambivalence by interrupting themselves in their habitual activities. He is an employee of the city, as you can tell from the badges on his uniform. Maybe there are many stumbling blocks deployed on the streets of the city, wherever surveys have shown the need for one. He is passive, gentle and indifferent: that was my image of the perfect 'bureaucrat of therapy'. He does not give lessons or make demands; he is simply available for anyone who somehow feels the need to demonstrate – either to themselves or to the public at large – the fact that they are not sure

they want to go where they seem to be headed. The interruption is a curative, maybe cathartic gesture, the beginning, the inauguration of change, healing, improvement, resolution, wholeness or wellness. It's my version of New Age; it's homeopathic. The ills of bureaucratic society are cured by the installation of a new bureaucracy, one which recognizes itself as the problem, the obstacle. I think there's a sort of comedy there. It's not really black comedy, though; there's still a little black in it. It's a sort of 'green comedy' maybe – dark green.

I had a phone call from a critic yesterday; she was preparing a talk involving *The Giant* and had connected it to the figure of the 'Alma Mater', a monumental symbol of learning which personifies the university. I hadn't thought of that, although I had heard the term 'Alma Mater' ever since I had been a student. *The Giant* is a sort of imaginary monument, and that genre itself is connected with various branches of humour or comedy, for example, the Surrealists' proposals for reconfiguring some of the familiar monuments of Paris. Theirs were usually done in a spirit of *humour noir*. Mine is maybe post-*humour noir*. I associate *The Giant* with two other pictures: *Abundance*, in which the older women personify something intangible – freedom – and *The Thinker*, which was also a sort of hypothesis for a monument after the model of Dürer's *Peasant's Column*. I think both of those works involve some *humour noir*, but *The Giant* is different.

Arielle Pélenc *Earlier, when you were discussing the role of 'talk', of 'voice' in your pictures, you concentrated on speech in terms of the characters in the picture, that is in terms of the narrative. There is another kind of voice in your pictures that signifies but not in terms of the narrative. There is something 'ventriloquial' in the pictures.*

Jeff Wall That sounds like what I would call 'style', keeping to the old-fashioned way of describing things. Maybe it has something to do with the elemental illusion of photography; the illusion that something was there in the world and the photograph is a trace of it. In photography, the unattributed, anonymous poetry of the world itself appears, probably for the first time. The beauty of photography is rooted in the great collage which everyday life is, a combination of absolutely concrete and specific things created by no one and everyone, all of which becomes available once it is unified into a picture. There is a 'voice' there, but it cannot be attributed to an author or a speaker, not even to the photographer. Cinematography takes this over from photography, but makes it a question of authorship again. Someone is now responsible for the *mise en scène*, and that someone is pretending to be everyone, or to be anonymous, in so far as the scene is 'lifelike', and in so far as the picture resembles a photograph. Cinematography is something very like ventriloquism.

Gillian Wearing *Donna De Salvo*

in conversation
June 1998, London

Donna De Salvo *I've read that you see your work as interrupting the logic of photo-documentary through your subjects' apparent collusion in their own representation. What do you see as the relationship of your work to documentary?*

Gillian Wearing In terms of the models that existed at the time when I began working, the only thing I saw around me was documentary photography. I'd become very interested in working with people, but I didn't want to follow what had already been done. For me, one of the biggest problems with pure documentary photography is how the photographer, like the artist, engineers something to look like a certain kind of social statement – for instance, you can make someone look miserable, when this is just one side, a nuance of their personality. They might just be looking away at something, but their expression could be read as showing a kind of depression in their overall behaviour. I couldn't bear the idea of taking photographs of people without their knowing.

Donna De Salvo *Without the individuals knowing they were being photographed?*

Gillian Wearing I didn't want that. I definitely wanted something that involved collusion. Firstly they would have to agree, and on top of that they would have to think and say something that they felt. For me this worked so much better because, when they returned with something they had written, it challenged my own perception of them. We all start making up our minds when we see someone; we all get ideas based on how people look, even though we know these ideas can be knocked out of us as soon as we get close to them or start talking to them.

Donna De Salvo *It's true, you can see a photograph of someone's face and read what might appear as disgust, or fear, or anger, yet it could just be the result of the camera framing the face in a certain way. It's a pictorial fiction. I think of photographers such as Garry Winogrand or Lee Friedlander, or even August Sander, and the way that a visual typology emerges as expressions become codified. How do you approach the people you want to participate in your projects, such as* Signs that say what you want them to say and not Signs that say what someone else wants you to say *(1992–93)?*

Gillian Wearing I was quite shy when I first started that project and I couldn't approach anyone – or I thought I couldn't anyway. I originally started off by writing things myself, handing them to people I knew and asking them to hold them up. I set it up indoors and there was no real aesthetic or structure to it. It wasn't working. Then one day I happened to go into Regent's Park, and I realized that I just had to do it: I had to pluck up my courage and approach strangers. The first person who came along was this older woman. I asked her to write something down and she wrote, 'I really love Regent's Park'. From that moment I just knew it would work. It's hard to stop people in a busy street, but once I actually got the sentence out and explained that I was an artist, and this was what I was doing, I'd say 85 per cent of the people said 'yes', because they seemed to understand what I was trying to do.

Donna De Salvo *Do you think it made them feel empowered?*

Gillian Wearing I think so, actually. This was in 1992. At the moment we're totally saturated with TV chat shows, or fly-on-the-wall style programmes, and this has made people think that we can all be famous for fifteen minutes, but in 1992 it was somewhat different. I think people just felt, 'I *can* say something', and that it was a nice idea that they'd been approached. Some people even thought that they had to pay me, that maybe I was going to produce a portrait of them.

Donna De Salvo *How did you decide whom to approach?*

Gillian Wearing One thing I didn't do was choose people from the way they looked, although I think that was connected with my shyness at that time. I'd stand on a street corner, anywhere. I'd probably be there for about ten or fifteen minutes. I didn't want to stay there for too long, as people would begin to see me as part of the scenery or as that odd girl, and I didn't want them to come back. I stopped people and just said, 'I'm an artist, and I'm doing a project where I ask people to write something on a piece of paper.' Some of them got really bashful when I asked them to do something like that; for others it was just fine. Some wanted to get into a long conversation – there was one person I talked to for about two hours, and he actually went through the whole history of his sex life.

Donna De Salvo *What did his sign say?*

Gillian Wearing It was the sign that said, 'I've thought about being a gigolo but I'm worried about the health risks'. When I looked at these photographs of what people had said, I kept thinking, 'God, you said that!' For weeks and weeks there were these people saying the most amazing things.

Donna De Salvo *So life and reality continually surprise you. I mean, you couldn't write those lines.*

Gillian Wearing If you were to write them yourself you couldn't help creating stereotypes.

Donna De Salvo *So, not scripting, having those things come on their own …*

Gillian Wearing A lot goes back to my feeling of being totally illiterate. I always used to feel like a foreigner in my own country, because I didn't receive a very good education. I'm more interested in how other people put things together, how people can say something far more interesting than I can.

Donna De Salvo *Do you think that also led you to pursue things on a visual level?*

Gillian Wearing Definitely, yes. I don't think I would have become an artist otherwise. When I was at art school, on the foundation course, I started off by making paintings, attempting to express what I couldn't verbalize. I was aware that there was something missing, something that could only be expressed visually.

Donna De Salvo *Yet it's interesting how critical language is in your work: its effect derives from the relationship between the visual image and the spoken word, especially as you*

explore human stories and the inadequacies of language in relation to really telling that story. Do you see the Signs ... *series as portraits?*

Gillian Wearing I do now. At the time I just saw them as documents. When I first started doing the *Signs* ..., the most important aspect was approaching strangers on the street and the interaction between us: that a sign and an image came out of it. I didn't think it was something in itself at the time. I didn't print them for an entire year. I didn't know if or how I could show these things. The only thing I did know was that they would work best when shown en masse, because it involved that kind of democracy. You have someone from one background next to someone from a very different background, and what they have in common is this white sheet of paper. In a certain way it breaks down all those differences, and then all of a sudden you have to start re-appraising people. In this instance, the photographic form was more democratic because, unlike in a video sequence, you could concentrate on all the images at once, if they were installed in a gallery.

Donna De Salvo *So you could perceive the totality, you could be surrounded by the photographs, whereas with a single-channel video or multiple monitors, you could not take everything in as one image?*

Gillian Wearing Yes, exactly, and the white paper of the signs became like a uniform.

Donna De Salvo *The photographs have, as it were, a built-in caption. Do you think you're also capturing whatever the participants' true thoughts are at that moment? An hour later, as you say, or even ten minutes later, they could write something completely different, so it's almost like getting people to externalize the actual process of thought. But what about that which remains unsaid?*

Gillian Wearing It's like, who needs a three-course meal when it's enough just to have the entrée? Also I don't believe in patronizing viewers. If you give people everything, you're doubting their ability to make up their own minds.

Donna De Salvo *What about the project that followed* Signs ... *?*

Gillian Wearing I made *Take Your Top Off* (1993), a series of three photographs of me lying in bed with transsexuals. I wanted to do something with transsexuals because of the way in which they represent the most overt form of sexuality. They experience both genders; in their minds they're starting afresh. They have to be more open all of a sudden.

Donna De Salvo *You went from a very public space, out there on the street, to a deeply private one: the bedroom, with its connotations of privacy. Why?*

Gillian Wearing What was missing in the *Signs* ... was my physical presence. When I first decided to do something with transsexuals, I wasn't thinking about my own presence.

Donna De Salvo *It's as if you came onto the stage in that series. Was it a way of exposing your own collusion in the whole process? Once you cross that line, you're there in a very different way.*

Gillian Wearing I wanted to do something that made me feel vulnerable. For *Take Your Top Off*, I phoned people without meeting them first, and then went to their place and got into bed. I wouldn't go through a rehearsal beforehand. I just wanted to know what would happen, so it was all done on the same day.

Donna De Salvo *Did it feel as if it was a test for you as much as for the other person?*

Gillian Wearing I didn't think about it as a test, but it probably was. I was trying to find a structure that felt pure, or something like that. I'm not an exhibitionist. I think it was slightly easier for the other three people, because they'd just had, or were going through, a sex change. They were being reborn, so they actually quite liked showing off their bodies. I didn't. I felt like a bit of an impostor in that piece, and still do to an extent. I didn't even know, when I put it on the walls, whether it felt completely right. I didn't really like seeing myself in such a vulnerable position, but I did it. I thought, I have to do it.

Donna De Salvo *It would have been hard enough for you as an artist to have critical distance from your work, but the stakes would have been even higher when you became a visible part of it. Also, if the timespan between making the work and exhibiting it was very fast, it wouldn't have given you much time to absorb it.*

Gillian Wearing I think that's good. I showed the piece within a month of making it. I couldn't talk to anyone about it. When I first showed it I didn't tell anyone that the people in the work were transsexuals, even though in one of the photos there are all these pills and prescriptions next to me. People started working it out from that. I didn't want to make that point. I don't want to get into breaking down barriers all the time, but I wanted them just to be seen as people who looked like women.

Donna De Salvo *But what about your choice of people? There exists a perception that you deliberately choose people regarded by much of society as freaks or outsiders. Are you attempting to normalize these people, or to project your own identity through them?*

Gillian Wearing That's a hard one to answer, because obviously on one level it's true. I try to incorporate as wide a variety of people as possible and hopefully, through my choices, I can cast my net much wider. I do see a continuity in the way things start to come across as representing my interests. Sometimes it feels like painting: I build up a picture, a portrait, through time, and then I can move things around. Through building up these narratives, I probably do reflect how I see the world or what I've experienced.

Donna De Salvo *But in painting, even though chance plays a role, control manifests itself in a different way. How do you feel about the idea of giving up control?*

Gillian Wearing When you have a work that's just one take, like *Sixty Minute Silence* (1996), then obviously I couldn't edit it. *Sixty Minute Silence* felt like I was taking a chance, because I didn't know if people could actually stand or sit for that long. It actually came out perfectly the first time.

Donna De Salvo *What made it perfect?*

Gillian Wearing The person who just screamed really loudly at the end, because of the whole frustration of the thing. That was not planned, but it put a nice full-stop to it.

Donna De Salvo *The participants were conscious of playing a role, so it becomes a portrait of people pretending they're police officers. Suppose it had been actual police officers?*

Gillian Wearing Initially I did try to use real police officers, but due to their different shifts it was impossible to co-ordinate one time for all of them. More important for me was the metaphor of control that the uniforms represented.

Donna De Salvo *You've also mentioned daguerreotypes in connection with this piece.*

Gillian Wearing I was interested in doing something with duration. This reminded me of daguerreotypes, for which subjects often had their heads held in place by clamps; this gave them a kind of presence and seriousness. I wanted that controlled look, and of course you think of the control of the police in this country. I wanted to combine the sensibility of painting and sculpture with the sensibility of photography, but nothing tricksy, just something very simple.

Donna De Salvo *Do you think it's the most painterly of your works?*

Gillian Wearing Sculptural. I see it as slightly three-dimensional. You have these three rows …

Donna De Salvo *But the viewing format, when enlarged to wall size, is that of painting. Did you see yourself as quoting the history of painting?*

Gillian Wearing The majority of people who saw it when it was shown at the Tate Gallery compared it to painting, but because to me these people were standing like statues, I saw it as sculpture. I first showed it, at the Henry Moore Studio (Dean Clough, Yorkshire, 1996), as a back-projection. It looked like a slide coming back at you, so it reminded you of a photograph. When people first saw it they probably thought, what's the point of showing a back-projected slide of a bunch of policemen? Most of them walked straight past it; then they'd pass it again and notice this very subtle movement, and get slightly freaked that there might even be someone behind the screen.

Donna De Salvo *You forced them really to look?*

Gillian Wearing If there's a thread that runs through all my work, it's that slight double-take.

Donna De Salvo *Your work meshes together different histories … Which artists were most influential for you?*

Gillian Wearing References for me only came in later, when people started saying I should look at this or that artist's work, but when I started the *Signs ...* series there was no one I was aware of as an influence. That's why I didn't frame work up for a long time, because I didn't realize it was something I could actually show.

Donna De Salvo I see your work within the context of certain traditions of realism, documentary and also 1970s Conceptualism, particularly its legacy of video and photography and the focus on subjectivity. Do you see yourself as a video artist?

Gillian Wearing No, I hate that term. I don't see myself in that tradition at all. I got into video because a friend had a camcorder, so it was more about things that had become accessible to everyone. I'm interested in process, I'm interested in people, but I can't bear the idea of the technology being something that represents me. The thing that goes through my head is not the technology but what I want to do, with whom, and when, and what inspires me. People talk in general terms about artists using video but I consider these things on their individual merits, not because they share the same technology. Its format does not give it any more credence. I think there is also a weakness in shows that group artists together because they all use video, when in fact they are actually totally different in their approaches.

Donna De Salvo How much has the culture of television influenced you?

Gillian Wearing It was only when I started to try video as well as photography, early on, that it pricked my consciousness and jogged a memory of things I had really enjoyed in the past that I'd seen on television. It was definitely a 1970s thing that I picked up on – those earnest, serious documentaries about everyday people, like *Seven Up* (Michael Apted, 1964) and *The Family* (Franc Roddam, Paul Watson, 1974), which was the British equivalent of the US documentary *An American Family*. I was interested in remembering how I was affected by them at the time – the realization that people who were not that dissimilar from you or your friends were being represented. This was at a time when, if you were on television, it was for a very special reason.

Donna De Salvo With documentaries such as An American Family *we became conscious of the camera as a causative element in the action. The members of that family couldn't just live their lives any more, they were performing their lives. So your early influences came from popular culture rather than art?*

Gillian Wearing That's what jump-started me, say, in 1990–91. Those were the things that I had to fall back on, because I didn't really know what I was going into. I had no role-models, so I was going into a very unsafe area. Although I had nothing to lose, because I'd just come out of college, it was worrying that I had nothing, no money. I just had to experiment. It was exciting because I had no one on my shoulder, but at the same time there was no one to guide me. Since then, people have referred to Diane Arbus in relation to my work. One person used that as an insult, saying my work was dehumanizing.

I hadn't really followed Arbus' work, but I do remember seeing her famous twins portrait and thinking, God, that's an amazing image, so Arbus had been in the back of my mind somewhere. However, it was only when that comparison was made that I really looked at her work, and then I decided not to take the comment as an insult, because I recognized something there, in the way she worked with people, that was to do with her own presence.

Donna De Salvo *This historic moment is very different from the time when Arbus was making that work. Aren't you working with a greater awareness of the ways in which the maker influences the image and assumes a position of power?*

Gillian Wearing I learned that early on. I'd already seen controversies going on with documentary photography and news reporting, so I was aware that photography was a weapon and that you could say anything with that one very static image. But I have to work with what is here. Although it seems as if everything has been done already, I don't necessarily believe that. Even if an image just ends up affecting someone on a personal level, something will come out of that. We are still individuals.

Donna De Salvo *You once said, 'It's more intimidating being watched by someone in person than by someone behind a security camera, whom you can't see.' For me, it's quite the opposite.*

Gillian Wearing It doesn't bother me at all, because I think most of these people aren't looking anyway. I'm more conscious of walking past a policeman or someone of authority in the street, because I think I have to put my head up. Normally, I have my head cast down.

Donna De Salvo *What gave you the idea to use the voices of children, in 10–16 (1997)?*

Gillian Wearing I wanted to do something that had children coming up with things, talking about all sorts of things. I didn't know exactly what I was going to get when I set out. For *Confess all* ... I had used masks, and I was thinking of using them again, because children can't know if in the future they're going to want themselves portrayed at ten or eleven years old. They have no say in that. They also tend to say more interesting things when there's just a microphone, rather than a camera pointing at them. If I just made a documentary of children talking, that would be throwing you back into the camp of television, or traditional documentary, and that's not what I wanted to do. It wouldn't be about transforming what's out there into a new language, another language.

Donna De Salvo *Can you go on a little more about that idea of transformation?*

Gillian Wearing I just think art allows you to fit something into a structure that's your own, and not someone else's. You have no one telling you what you can and can't do, so you can be open. For me, transformation means, for example, how Turner's paintings made people look at the sky in a different way. We know children have interesting things to say and use language in a rich way, but when you channel this through an older body, then all of a sudden there's

a pathos and you're transforming how people look at that. Especially as you get older, you realize there's something else there, screaming to come out. It offers something fresh and it's better than something straightforward, which can't make you come out of the complacency of what you already know. If we look at our existence in this way, it is pretty disturbing.

Donna De Salvo *Some aspects of that piece are almost terrifying. There's a kind of terror that comes across in the people's voices, and it isn't always about the extreme things; there's also a terror in normality.*

Gillian Wearing There's more, because people have kept themselves in this very tight strait-jacket for so long. How long can you last before you crumple up inside, before your body crumples?

Donna De Salvo *It's curious how that plays out culturally. In America it would follow different routes; in Britain it seems one is expected to repress things more.*

Gillian Wearing Yes, and this has totally fed my work from the beginning. I understand that reserve. I see myself as being unable to get beyond my own reservations, and a lot of my work obviously deals with me trying to go out there myself. I found that there's something quite intense about a person's reserve. In every culture, once you're dealing with that one aspect, you become more aware of what's been negated. For the *Signs ...* series, people were quite eager to be involved, even though they often didn't really know why they were doing it.

Donna De Salvo *When I watched* Confess all *..., that desire to confess, the need to unburden, to feel understood, reminded me of the darkened rooms of Catholic confessionals. One could say that asking people to confess on video is sick or weird, and yet when you think about the way confession exists within that religious context, it seems even stranger.*

Gillian Wearing *Confess all ...* was different from the religious context because people felt they just had to confess anything, so they could have made it up. They all wanted to wear a mask, none of them wanted to be revealed. People wanted to exhibit some emotion, but not to be identified, and that's where the odd thing comes in. The last person, who talked about his problems with his sexuality when he was sixteen, was a middle-management type. He had money, he didn't need to be an exhibitionist. He was seeing a psychiatrist at the time, but he came to me, as he says himself in the video, as part of the therapeutic process. He particularly wanted it to be seen in an art gallery and not on television, because he thought that no one he knew would ever see it in an art gallery. He wouldn't see it, but he would know it was somewhere out there, somewhere where it would just disappear. It was definitely a form of exorcism. Therapists know your identity because they see your face, whereas he and I were never going to set eyes on each other again, so that was better for him.

Donna De Salvo *There's such a performative quality to it all. How did you get the idea for* Confess all *...?*

Gillian Wearing Originally I was almost going to use an idea which I then discovered the artist Tony Oursler was already working with. It would have involved members of my family confessing, with small projections of their faces onto something like rag dolls. Then I happened to read a preview feature in a newspaper on Tony Oursler's next show, and realized that my piece would be too similar. So I had to change things. It would have something to do with a kind of mask, but how wasn't quite clear. It doesn't make much sense where it all comes from; I don't start with some kind of great insight, I can tell you that. I decided to use the masks and have all these confessions, and make it much more straightforward. I'd just place an advert in the paper asking people to come and confess. I'd used adverts before, so I went back to using them. I was fascinated by the added element of which mask they would choose, and how this might end up influencing how the whole story was perceived. They could hide behind it and that would enable them to say things they wouldn't normally say.

Donna De Salvo *There's a degree of acting-out in your work, even a pathology at times.*

Gillian Wearing Because we're aware of the camera, some parts of the work are very narcissistic, so, again, there's good and bad aspects of the video camera. However, even though it involves acting-out, it is cathartic. The people are trying to be as honest as possible, within the context of an alien environment, which is obviously very difficult for them. That was the good thing about having the mask, because they already felt protected. They didn't have to wait for me to go and use a computer to pixelate the image of their face and promise I would protect them. Also, since they'd read the advert I placed, some came knowing what they were going to say. They had already taken control.

Donna De Salvo *Are there any works that you feel are like self-portraits, or that you strongly identify with?*

Gillian Wearing I think *2 into 1* (1997) – the mother with her two sons. That strikes home a bit uneasily – the criticism of the children, and also the male-female thing, where the boys are being critical about her looks. It's very hard-hitting and quite painful, I think, in the way the children view adults and the family. It's not just about children and parenting. The piece is about familiarity, closeness, breeding and contempt.

Donna De Salvo *It seemed especially about the male-female relationship. It seemed to embody so many aspects of the way women are regarded in the culture, and how roles are formed so early on.*

Gillian Wearing Even an eleven year-old can totally undermine someone, very acutely, in a very sophisticated way. The boys use humour, and they have a wonderful way with language – I always think humour and vitriol work so wonderfully together. When you have that in two eleven year-olds you have a winning formula for attack.

Donna De Salvo *How did that piece evolve?*

Gillian Wearing I didn't meet the people before making the work, I met them and taped them at the same time. I'd already had the idea that I wanted to exchange parents and children and it didn't matter to me whether it was girls, boys, mothers, fathers – it wasn't intended to be about gender difference. It was hard to find an interesting relationship, so discovering those two boys and their mother was a godsend because they were honest and bright enough to give you everything in one full blow.

Donna De Salvo *Throughout your work, there is a focus on power relationships: your power in the situation, and the participants' power. In this piece, the mother was presumably in the position of authority, and yet these boys were amazingly disrespectful. How you do think being female plays out in the work you make?*

Gillian Wearing It's quite funny, because when my work was on the cover of *Artforum* in 1994, a lot of American readers thought I was a man because the name Gillian isn't familiar there. They read it as slightly genderless, but also immediately presumed it to be a male name. But I see myself as an individual with my individual approach. I have been quietly saying things such as, 'I think it's easier to do some of the work that I do as a woman talking to men,' because I think women are used to talking to women and to men, whereas male to male relationships still always seem uneasy to me. I think that in the culture of male bonding there's something missing, as if there's an openness on the surface but the more emotional side never really surfaces. If you look at the difference between Diane Arbus and August Sander: Sander captured people in a very formal way, whereas for Arbus it seems more about an emotional agenda. I think about Cindy Sherman – any woman can relate to her because of the many different masks women wear. It's incredibly perceptive work. When I was younger, I used to dress up with my friends, wear different clothes all the time and pretend to put on different stances. You realize she's tapped into something that's been going on for years.

Donna De Salvo *There's a degree of what could be termed social experiment in your work, like the idea of bringing together people who don't know one another, and seeing what will happen. It reminds me of Andy Warhol's early films, except that Warhol had these loosely based narratives. How do you approach that idea of narrative? His early films also used low production values. If you were to get involved with special lighting and sets, how would that change the work?*

Gillian Wearing If something ends up looking visually good, that certainly wasn't the important thing I worried about, because I can't always control what happens. I have to be quite simple about situations. I think there is a kind of narrative that flows through the work in many cases. With *The Unholy Three* (1995–96), I brought three unconnected people together, which was definitely my doing, and I threw them into meeting each other. Because they also had very extreme views of life, they were willing to work off each other, and create

some debate. I was creating something that had a plot-line, I suppose, but some people bring their own story and plot along. It's just by chance that it becomes a kind of fully formed story. Other things I do, through the editing process, also build up a narrative.

Donna De Salvo *What about the editing process?*

Gillian Wearing I really like the editing process. It's the closest thing that you get to the old-fashioned way of making art. I can get quite obsessive about it. It's one of the things I got out of painting: all of a sudden I get totally into it and no one can tear me away.

Donna De Salvo *You become a kind of story-teller, except that in telling the story you end up adding your bias, so you also become a part of that story. We don't know where you begin and they end.*

Gillian Wearing I was thinking about the problems with that. People could ask, where does Gillian Wearing come into this? We want to know the full facts. And then I was thinking, you don't, because you're never going to get the full facts anyway, whether you want them or not. It's like that whole idea of photography and truth: however simple you make your process, there's still a lot missing anyway. In *Sacha and Mum* (1996) there were actors, who were used to someone changing and controlling the camera angles. You can't do that with 'real' people, because it would seem completely illogical to them to make something aesthetic out of it. Sometimes you see documentaries that go for crazy camera angles and it doesn't really work, because real people can't perform that way.

Donna De Salvo Sacha and Mum *seems to be the one piece where you most reveal the manipulative aspects of the medium by running it in reverse, and this becomes part of its subject matter. Would you agree with that?*

Gillian Wearing Yes, it's totally contrived from beginning to end, it was heavily story-boarded. The volume is turned up far more to start off with. That aggression is something that people would never normally reveal to me. The woman pulls the girl's hair five or six times on many shots, so all in all she must have pulled her hair about thirty-odd times. It had to be far more aesthetically aggressive because the camera had to record it all in one go.

Donna De Salvo *At times you use real people and at others actors, but the audience doesn't always know the difference. Do you want people to know?*

Gillian Wearing I didn't try to pass that piece off as involving real people. I've always said they were actors and actresses, but when it was exhibited for the Turner Prize (Tate Gallery, London, 1997), people were saying how terrible it was that I was encouraging violence in children. It's so ridiculous. I can't even take those arguments seriously. I just can't be bothered discussing them.

Donna De Salvo *When we know it's a real person, I think it becomes more disturbing. There seems to be a progression in your work towards taking these complex ambiguities even further and weaving them together in different ways.*

Gillian Wearing I didn't choose to be much more complex. When I chanced on the idea of the mask for *Confess all …*, I began to see the power of working with internal states through external channels. Obviously a lot of my work is about that, but I wanted to stretch that point.

Donna De Salvo *There's an anthropological aspect to your pursuit; clearly people are your subject matter – is that what really interests you?*

Gillian Wearing Yes, and I'm moving towards more narrowed-down formats – which are in fact more open. I'm now focusing more on things that are slightly more problematic and uncomfortable for some people. When I narrow down the possibilities, I also try to open things up every time I do a new piece.

Donna De Salvo *When you mentioned the internal and the external, it suggested to me how much you are working with certain conceptual notions about the construction of space – political and social space in particular – especially the ways in which being looked at is so important in contemporary cultures.*

Gillian Wearing I sometimes think of this in relation to the quiet way I live in my own flat. In England our flats are small, so you're quite aware of what's around you. I often think that people are not very relaxed; it's as if the only time they're really relaxed is when they're asleep. For the rest of the time they're very aware of the four corners of their room or the street. It often seems that there's hardly any disparity between the interior of their homes and the street.

Donna De Salvo *In* Dancing in Peckham *(1994) you're very much in your own world. Some people really stare at you, yet then they casually look away.*

Gillian Wearing I had to make a conscious decision to do that piece. It didn't come easily. It was actually because I had seen someone else dance crazily – she was someone whom I instantly liked, or was interested in, someone who could do that without feeling totally self-conscious. It was about taking that kind of fantasy and being able to do something in a public space, where you do end up looking like a nutter, ultimately, because it's not acceptable behaviour. But when someone saw it at the Royal Festival Hall, there was a bunch of South London girls standing around it, going 'Wow! It's South London, it's Peckham!' So people could enjoy that piece on different levels.

Donna De Salvo *There's a strong focus on isolation in your work, which is greatly emphasized in* My Favourite Track *(1994).*

Gillian Wearing *My Favourite Track* uses five monitors showing five or six people singing the tunes playing on their Walkmans, but their Walkmans are turned up so that they can't hear themselves. Listening to it is like being in a kind of tower of Babel, where everyone is talking at once but no one is listening to anyone

else. The piece is about isolation, and the Walkman is a kind of isolating factor to escape the reality of street life, to have both things going on at once, bringing you some other element to enable you not to bother about the others around you. Maybe that goes back to subjectivity and objectivity. People want escapism somehow, and if you've got something that can make you feel good, like music, you can escape from the banality of any situation, be it shopping or having to post a letter. We want access to things that can make us temporarily escape into the spaces in our heads.

Donna De Salvo How important to your work is the viewing context?

Gillian Wearing The one thing I have no problem with is the art gallery. I've always preferred a simple smart space to any kind of rough space. I actually like a neutral space that doesn't interfere with the work. And there's something quite sympathetic about the gallery space. People might not feel that when they walk into a gallery, because it can feel slightly intimidating. It's this clean white space, where people are very quiet. It can be like going into a chic dress shop, where you might expect the staff to be more intimidating than what's on show. But I think there isn't a better space to show, because you can control the whole environment, and even some cinemas can be very unsympathetic spaces for certain films.

Donna De Salvo In what way?

Gillian Wearing Well, the seating, and also you're sitting with people who might be ten times taller than you, or people are eating, which I hate. I hate food in the cinema. I think it's a disgusting idea, because you can always hear crunching. People have weird habits. The only thing that puts me off going to the cinema is the habits of some of the other people watching. People don't eat in a gallery, that's one good thing.

Donna De Salvo What strikes me about a lot of video installations in galleries is that seating is often not provided, even when the work has a long duration.

Gillian Wearing It helps sometimes if there are seats, but not if they're tiered in any way. It's nice to experience work when there's just three people in the room. Galleries and museums don't want this, but in this way you can have a very personal experience with the work, which is different from seeing a film.
 We haven't yet talked about *Homage to the woman with the bandaged face* … (1995).

Donna De Salvo When I asked you earlier which piece you thought was most like a self-portrait, I was thinking about that one.

Gillian Wearing In *Homage to the woman with the bandaged face* … I was answering a lot of my own questions about how I perceive people, and the perception of someone looking at me. Even though I was still holding the camera and I was a total voyeur, I really stood out somewhat maniacally from everyone

else. They still looked at me, en masse, as the one, the freak, the odd person out. It was a real choice. I had seen someone with a bandaged face like that, and I just knew that this wasn't one of the times that I could approach the person. So she remained a mystery; I couldn't work out who she was or why her face was bandaged. That was fascinating, and quite exotic, in a way.

Donna De Salvo *So you just saw her on the street?*

Gillian Wearing Yes, I was in a friend's car, and I told my friend to circle round a couple of times, it was just so fascinating.

Donna De Salvo *So first you saw the woman, and then that inspired …*

Gillian Wearing Inspired me to pay homage, so I became that person, in black and white.

Donna De Salvo *It's as if you assumed her identity, like a role you took on, except that for her it's not a role, it's whatever happened to her. It could even have been a face-lift, we just don't know.*

Gillian Wearing Yes, it could have been absolutely anything. And so that mystery was never resolved.

Donna De Salvo *You are certainly very mysterious in it. That line between fact and fiction is very blurred. If viewers were to see it without the subtitles, they wouldn't really know. What was it like having someone else film you?*

Gillian Wearing Two parts of it are me filming from my perspective and there's one part of me being filmed, but I didn't really enjoy that. I find it highly embarrassing. But when I was filming, it was far more horrific, because I went out by myself. I had the camera, but I had to keep it quite low. When I first walked out on the street I was laughing because I felt such a mess – not laughing because it was funny but because it was embarrassing, like I hope no one sees me. I had to have a few drinks before I went out. Also, I didn't want anyone I knew to see me. In a way I was much more vulnerable than in *Take Your Top Off*, because I could easily have been attacked. People do find it quite offensive sometimes when you look so odd. I haven't got it on video, but one person did tell me to fuck off very blatantly and straight to my face. Also, because your vision is slightly cut off because of the mask, you don't feel so aware.

Donna De Salvo *Throughout your work, there's a way in which you present things in seemingly normal contexts, either domestic settings or very simple settings, that heightens the normal.*

Gillian Wearing I remember from my years at college, when I was still making sculpture, seeing Robert Gober's and Jeff Koons' work for the first time. It left me feeling that I, as the viewer, could think creatively of all the possibilities inherent in the idea.

Donna De Salvo *There's an ambiguity in that work, especially Gober's. It's familiar in some ways, and then again it isn't. It's like Magritte's work on that level.*

Gillian Wearing Magritte was fantastic in the way that he could express something abstract, but through images of familiar-looking objects and people. I remember, years ago when I didn't know much about art, coming across his work and thinking how it reminded me of something, but I didn't know what it was. It's that kind of unknowability of everyday things you encounter, like the back of someone's head, that's frightening.

Donna De Salvo *Was he one of the first artists that you remember being attracted to, even before you started making art?*

Gillian Wearing Yes, I also liked the aspect of Pop Art where a banal object would be blown up and exaggerated. That makes you more aware of it: all of a sudden it feels like something you do know, but which hasn't been pointed out to you. Sometimes it can only be pointed out to you by going around it. Someone has to draw it out in a way that's different, pull it apart, because from an early age we've learned to blank so many things we've seen.

Donna De Salvo *This seems to be precisely what you do: you take things apart, put them back together with a different structure, and make us go round them in a way that makes us look again.*

Lawrence Weiner *Benjamin H. D. Buchloh*

in conversation
May 1997, New York

B.H.D. Buchloh *I was always puzzled by your insistence that you executed* Cratering Piece *as early as 1960. Thinking in terms of historical context and frameworks, of models and paradigms, it seems almost impossible to imagine that anybody in 1960 could have gone out in the desert and would have set off a series of small TNT explosions declaring them to be a sculpture as you did in that work.*

Lawrence Weiner It was not in the desert; it was a national park. I wish I were as radical and revolutionary as historians would like to make out, but I was an eighteen-year-old kid. I found myself in San Francisco around the City Lights bookshop and the Discovery bookshop and I was working around people like John Altoon, Bruce Connor and others. Here I was, reasonably intelligent, with an enormous knowledge of what was going on, I must say. There were artists performing all over the place, doing happenings, performances, other things. My deciding to make sculpture by blowing holes in the ground, yes, in the light of my history, it is a big deal. In the light of what the hell was going on, it was just another artist out there, doing another sculpture park thing, using explosives, using performances, using tons of steel. This was all normal.

I had got to California by hitchhiking my way across the country, building structures and constructing things everywhere I went, leaving them on the sides of the road. The Johnnie Appleseed idea of art was perfect for me: Johnnie Appleseed spread apple seeds across the United States by just going out on the road and spreading apple seeds. I do not know if this is true, but I would love it to be.

B.H.D. Buchloh *The next phase of your work was the early paintings, particularly the series of* Propeller Paintings *(1960–65)?*

Lawrence Weiner I was making the strangest kind of paintings. I was in a very distressed state about the political relation of the artist to society and I knew that the artist's lifestyle was something that I was determinedly going to hold on to because in fact it was a better lifestyle than that of the lower middle class from which I had come. It left me a little bit more freedom to function as I wanted to. I had gone to Europe in 1963, trying to collate where I was going to stand, whether I was going to do this or do that. A lot of things led up to these paintings. I began to understand things that were being discussed in the context of the painting of emblems. I had an old television set which only had one channel, with signals that I watched all night. That became my modus operandi. I began to make these paintings, all in different sizes and all in different shapes and all at the same price. As if that really mattered, but I thought it did at the time.

B.H.D. Buchloh *And you used commercial enamel paint for all of them, like Frank Stella did at the time?*

Lawrence Weiner Whatever. Silver paint, aluminium paint, sculpmetal, commercial enamels, crap I found out on the street, paint that I invented myself. Anything. Impasto. I was using all the things that people use to make paintings. You

can spray it, stripe it. Name me all the painting conventions you can think of. All the things your parents ever taught you. These paintings then led to the cut-out sculptures from 1966 and they led to this other stuff, the notched paintings. They are paintings that can lie on the table. Some of them are made out of wood.

B.H.D. Buchloh *So these paintings were really reliefs and objects and that is where the traditional categories break down?*

Lawrence Weiner Those categories just completely collapsed on me. I wanted them to collapse but I was not going to hasten their collapse. I was going to follow it through and I followed it through to where it collapsed. The bridge no longer supported me. Great. Got me across the water to here. I am a happy immigrant.

B.H.D. Buchloh *Did you know Stella's 'black paintings' at that time?*

Lawrence Weiner I remember seeing them when Frank Stella had his first one-person show at the Museum of Modern Art. I thought they were absolutely fabulous. I remember a PBS broadcast of Henry Geldzahler interviewing Frank Stella in the early 1960s. Stella looked plaintively at the camera and said, 'My god, if you think these are boring to look at, can you imagine how boring they are to paint?' I was very impressed. I mean it. Extremely impressed.

B.H.D. Buchloh *What about Robert Ryman; were you aware of him? He appears to have been such an isolated figure. People seem to dismiss Ryman as somebody who was inarticulate and not reading the same books as everybody else.*

Lawrence Weiner Bob Ryman had a studio on the Bowery. He was a great person for me to go to talk to. I dropped by every once in a while and he was a very friendly man.

B.H.D. Buchloh *But unlike Stella's, his work was not well-received in New York throughout the early and mid 1960s. Did you not think of Ryman as somebody who was important in deconstructing the conventions of painting?*

Lawrence Weiner No. In adding to painting: making it a viable thing that had something to do with our own sense of ourselves. I thought Ryman's work was really, I don't know about important, but absolutely marvellous. But at that time he did not have that kind of success. It took me a long time to be able to make a living as well. Those things happen.

B.H.D. Buchloh *Obviously there are many trajectories in your work, but one of them is painting, and the dialogue with Jackson Pollock. But it is a dialogue mediated through looking at Jasper Johns and Cy Twombly and these two positions had already transformed painting when you started. I would like to talk about the relationship of language to painting. Language re-emerges in the painting of the 1950s in the work of two very different but closely related artists – Johns and Twombly – and I think they were both important in that sense for you. Their emphasis on language within the conception of painting itself seems to criticize Modernism's*

foundational definition of an exclusive visuality. Formally organized visuality is of course still an element of your work but it is no longer the work's primary foundation. This critique of modernist visuality and the simultaneous critique of representation and narrative become two central strategies of your work.

Lawrence Weiner The Leo Steinberg article¹ probably made me realize where Johns stood in my existence: this idea of how he placed the studio, not as a metaphor for the outside world but as an arena outside of the personal angst of other people whom I respected like Pollock or Kline or especially de Kooning. He was perhaps the coolest of all of them. He figured out that his life had more value than his place within society. Kline was not interested in that. Pollock – God knows what he was interested in.

I have always considered Twombly a beautiful painter. I thought that his work was absolutely exquisite: this was the life of a human being. This was class, without placing it within the context of modern art, without making it look important, but making it the way it was supposed to look. That is what made Ryman also such a fabulous painter for me: he was able to make it look the way it was supposed to look. Jasper Johns was doing that too. He did not ask me to be transcendental … he did not have to tell me that his found objects were a bridge.

I think that Rauschenberg in the end will turn out to be a far more important artist, because Rauschenberg did prat-falls, he took chances; Johns never took a risk in his life. What if we step aside for one second and then substitute one word, 'lifestyle', public placement within society, for 'narrative'. You are talking about 1955 and narrative was not the problem, the problem was lifestyle.

I did not have that advantage of a middle-class perspective. Art was something else; art was the notations on the wall, or art was the messages left by other people. I grew up in a city where I had read the walls; I still read the walls. I love to put work of mine out on the walls and let people read it. Some will remember it and then somebody else comes along and puts something else over it. It becomes archaeology rather than history.

B.H.D. Buchloh *After you moved away from painting, you made work that looked as though it was closely related to minimal sculpture.*

Lawrence Weiner I worked damn hard on this too. I mean, we are of our times as we are trying to find out who we are.

B.H.D. Buchloh *So, between 1966 and 1968 you redefine the painterly or sculptural object, its material structure and its production process. You move on to a textual proposition that seems to be either the 'mere' description or the theoretical definition of a material process, rather than its actual execution. From that moment onwards, you introduce a totally different set of terms for thinking about sculpture and I think its ramifications are hardly understood up to this very day. Rather than considering the conflicting genres of sculptural production (e.g., artisanal or*

construction sculpture versus the ready made object), you seem to address the processes of sculptural conception and reception in contemporary audiences.

Lawrence Weiner The audience is a hairy problem, but I must say I disagree. This has more to do with my politics than my aesthetics.

B.H.D. Buchloh *There seems to be a peculiar contradiction: on the one hand, you insist that sculpture is the primary field within which your work should be read, yet at the same time you have also substituted language as a model for sculpture. Thus you have dismantled the traditional preoccupation with sculpture as an artisanal practice and a material production, as a process of modelling, carving, cutting and producing objects in the world.*

Lawrence Weiner If you can just walk away from Aristotelian thinking, my introduction of language as another sculptural material does not in fact require the negational displacement of other practices within the use of sculpture.

B.H.D. Buchloh *But why would it even have to be discussed in terms of sculpture, rather than in terms of a qualitatively different project altogether?*

Lawrence Weiner What would I call it? I call them 'works', I call them 'pieces', I called them whatever anybody else was coming up with that sounded like it was not sculpture. Then I realized that I was working with the materials that people called 'sculptors' work with. I was working with mass, I was working with all of the processes of taking out and putting in. This is all a problem of designation. I also realized that I was dealing with very generalized structures in an extremely formalized one. These structures seemed to be of interest not only to me but to other artists at the time. I do not think that they were taken with the idea that it was language, but we were all talking about the ideas generated by placing a sculpture in the world. Therefore I did not think I was doing anything different from somebody putting fourteen tons of steel out. I said it was possible that I would build it if they wanted, I said it was possible to have somebody else build it, and then I finally realized that it was possible just to leave it in language. There was not a skill; art is not about skill.

B.H.D. Buchloh *In the post-war American context, the strategy of de-skilling responds first of all to the cult of gesture and of the artist's hand in Abstract Expressionism. That is in fact one of the most crucial strategy changes within artistic practices, re-emerging in the 1950s with Jasper Johns.*

Lawrence Weiner But I am questioning whether the skill of making the spoon is the point of being an artist, or whether the spoon that holds water is the point of being an artist. I am still vying for the fact that it is the thing itself that makes you an artist, not your acquired skills, not your special insight into the world or anything else.

B.H.D. Buchloh *So what defines the functional quality of the work if it is not its dimension to communicate most adequately with a certain type of audience?*

Lawrence Weiner For me, the making of sculpture, the placing of sculpture within cultural environments and in the public, is about allowing people to deal with the idea of mass, of other materials, the dignity of other materials, and to be able to figure out how to get around them if they are dangerous, get over them if they are easy and lie on them if they are sensual. My use of language is not in any way designed and it has never been. I think that I am really just a materialist. In fact I am just one of those people who is building structures out in the world for other people to figure out how to get around. I am trying to revolutionize society, not building a new department in the same continuum of art history.

B.H.D. Buchloh *I want to spend a moment discussing the question of materials, from* STATEMENTS *to now. I think there is both continuity and change. If one looks at* STATEMENTS *and the work that you did around that time, you selected a rather circumscribed number of materials that are very diverse and yet have a strange homogeneity – materials that are not manifestly industrial such as steel or lead (i.e., in works by Carl Andre and Richard Serra), but that are not manifestly pop-cultural like formica or vinyl (i.e., Claes Oldenburg, Donald Judd or Richard Artschwager). You, by contrast, use materials that share a certain subtle commonality, such as nails, pieces of string, cardboard, brown wrapping paper or plywood. And then there is yet another type, strangely suspended between function and object, as for example the dyemarkers or a flare or firecrackers, which are rather peculiar objects, relating to both the elements of water and fire and to the functions of signalling and sending signs. That is the first group of materials listed in* STATEMENTS. *Your works at that time approach the limits of ephemerality; they push the definition of sculpture away from its mythical involvement with industrial production, away from the spectacular deployment of industrial materials and processes.*

Lawrence Weiner With *STATEMENTS* I attempted to pull together a body of work that concerned itself with traditional 1960s art processes and materials. It was not anti-minimal sculpture; I was trying to take non-heroic materials – just pieces of plywood (nobody thinks about plywood), industrial sanders (everybody has one) – trying to take everyday materials, and give them their place within my world of art, with the same strength and the same vigour, but without the heroics. These works are decidedly non-macho, but they turn out to be the tough guy in the bar.

I wanted people to accept the value of these sculptures because they were functioning as sculptures, not because they were associated with the factory, the foundry, the quarry, the man-things that in those days seemed to mean something. Then I got to *TERMINAL BOUNDARIES* (1969), which was the next book, the one that did not get published. It is a body of work that has been published in different places that had to do with my being a traveller, that I was a wandering sort of person since I had been a kid. The works in *TERMINAL BOUNDARIES* were all about materials like quicksilver and

lead and all of these other materials that I could use without being heroic, because they were the normal things that people on a road trip would come across.

B.H.D. Buchloh *At the same time, the materials that you chose seemed strangely suspended between an aesthetic of the readymade and that of production. One would certainly not refer to your materials as descending from a readymade tradition; quite the opposite, they emphasize process and production.*

Lawrence Weiner But you had to do something with materials. For me it was my approach to dialectical materialism: it was things that you had control over in terms of their production, therefore you would have a sense of their value outside of their monetary value. My work is not Duchampian or anti-Duchampian. I had other concerns at that moment and I still probably do. Duchamp continues to stand as a very important, interesting artist.

B.H.D. Buchloh *If one looks at works such as* A SQUARE REMOVAL FROM A RUG IN USE *(1969) or* A 2 "WIDE 1" DEEP TRENCH CUT ACROSS A STANDARD ONE-CAR DRIVEWAY *(1968), one sees how the issue of place, another and equally important aspect of your definition of materials, enters the work at a very early moment. Some works are clearly independent of place: very important works of that moment are operating in an undefined place and yet others reflect very specifically on site and context. So did site, context and location become central concerns that led to more complex reflections later on?*

Lawrence Weiner Well, a wall is not really that site-specific.

B.H.D. Buchloh *But the driveway work is an interesting piece in that it selects a very peculiar detail of functional, vernacular, domestic architecture.*

Lawrence Weiner The driveway, again, is not a specific driveway: a driveway is a material.

B.H.D. Buchloh *Yes, but it is a space that is pointing to private property, it points to the home, it points to a location outside of the museum. There is another dialectic that emerged at that time, which is the one of removal and addition: some pieces in* STATEMENTS *are works that proposed the adding of a sheet of plywood to the floor, for example, or the emptying of a spray-can of paint on the floor, which seems to conclude the eternal dialogue with Pollock. Other works define themselves by the removal of material from existing structures, functional structures. They not only interfere in the visual surface and continuity, but also address another question: to what degree is an object not only defined by language conventions but also by property relations? For the first time they bring the socio-economic factor into the production of the work of art.*

Lawrence Weiner That is just what it was: the attempt to reconcile my politics internally – my emotional politics as well as my real politics – with what was becoming my lexicon or my aesthetics, my means of communicating with the world. The funny point is that there was one piece that had to do with Jackson Pollock

and it was not that one. It was the piece that was up in Nova Scotia – it was the piece where five gallons of tempera paint were just poured on the floor ...

B.H.D. Buchloh *There is something about your usage of the spray-can as both a tool and as a material that makes it rather peculiar and at the same time it refers to a whole range of vernacular and daily usages.*

Lawrence Weiner The spray-can is an object that contains a whole range of chemical and physical compounds and vernacular and daily usages. It was the looked-down-upon thing, it is about the not-skilled.

B.H.D. Buchloh *Do these strategies and materials not add up to an internal criticism of the false heroicization of even the last layer of industrial materials that was still dominating the aesthetics of minimal and post-minimal sculpture?*

Lawrence Weiner Exactly, but that was my role, my own chosen role. I had come from a situation where in order to survive I had to practise, though not necessarily accept, a heroic scale of misunderstanding of the place of the male artist within our society. I then looked at artists whom I really respected, like Pollock, Kline and Mondrian, who had doubts about this and at the same time did not let that come into their work. They let it into their private life – they had doubts whether they really were David Smith ... whether they were still the he-men that they started to be, even though they were making art about their soul, even though they were trying to save their soul by making art. I realized that you did not have anything to prove to them any more, that by making art you fulfilled whatever your gender role was, indeterminate or otherwise within the society.

B.H.D. Buchloh *It seems that by the late 1960s you had recognized that the usage of sculptural forms and materials (e.g., the steel cube or the metal plate) even in their most rigorously serialized form as in Minimalism, or even in their most scientistic-industrial presentation as in Andre or Serra, represented a model of sculpture that was largely based on traditional spatial definitions of communicative and perceptual experience. You detached sculpture from its mythical promises of providing access to pure phenomenological space and primary matter by insisting on the universal common availability of language as the truly contemporary medium of simultaneous collective reception.*

Lawrence Weiner A universal common possibility of availability. The whole problem is that we accepted a long time ago that bricks can constitute a sculpture, we accepted a long time ago that fluorescent light could constitute a painting. We have accepted all of this; we accept a gesture as constituting a sculpture. The minute you suggest that language itself is a component in the making of a sculpture, the shit hits the fan. Language, when it's used for literature, when it's used for poetry, when it's used for journalism, constitutes an assumed communicative pattern. That implies a belief in God. Without that implication there's no way that words like love and hate and beauty would have any significance.

B.H.D. Buchloh *If I understand at least aspects of what you say, I would interpret it as a statement about a model of language that precludes both transcendentality and representation, a model of language that insists on its condition of self-referentiality. You seem to be suggesting the deployment of a particular type of language game that has its origins in the pictorial models of Modernism. I still think, however, that early sound poetry in the context of Dada and Russian Futurism approached an equally critical stance, an equally radical anti-narrative, anti-transcendental and anti-representational conception of language.*

Lawrence Weiner I am not arguing that language is not representational. It represents something. I am interested in what the words mean. I am not interested in the fact that they are words. I am capable of using words for their meaning, presenting them to other people. I hope that the vast majority will read the words for their meaning and that they will place that meaning within the sculptural context of their parameters and how they get through the world. I cannot seem to find the historical precedent for this. Maybe the reason that I spend so much time trying to explain that art does not require a historical precedent in order to function as art, is because for many of the things that I've found myself doing I cannot find the historical justification.

B.H.D. Buchloh *Let us look at the second phase of your work – even though I am aware that it is problematic to divide it up into phases – announced by the publication of* STATEMENTS, *a work which not only suggests the possibility of abandoning materials altogether, but also the inevitable resulting reflections on site and placement. With* STATEMENTS *a new set of presentational problems emerge that you resolve quickly by designing books. The book becomes for a while one of the key carriers of the work, both in terms of its presentation and its distribution.*

Lawrence Weiner I still prefer books and catalogues.

B.H.D. Buchloh *Initially at least, it seems there was relatively little design work implied in the presentation of the books. The books seem to emphasize neutrality and conceptualist purity, but there is an explicit denial of traditional artistic book design (e.g., typography and other design choices).*

Lawrence Weiner I disagree with that absolutely, totally down the line. Those early manifestations – they are not early, but from the late 1960s, when I had the opportunity to make posters and books and things – are so highly designed you cannot believe it. I mean, take *STATEMENTS*: there is a design factor to make it look like a $1.95 book that you would buy. The typeface and the decision to use a typewriter and everything else was a design choice.

B.H.D. Buchloh *But still, your arrangement of design features opposed the design culture of the 1920s and 1930s, since the design that you developed in the context of 1960s Conceptual Art is distinctly different from the heroic moment of avant-garde design. Your book design positions itself in an almost utilitarian context: the book*

is small, the book can be carried anywhere, the book is totally unpretentious, it does not have graphic intricacies, it is the most functional object imaginable.

Lawrence Weiner I found El Lissitzky's work fascinating when I was a kid, and then Piet Zwart was the next logical thing. My tendencies are towards people who sold themselves on the left rather than people who sold themselves on an authoritative right. But those are my tendencies, those are my politics.

B.H.D. Buchloh So you define design as a communication that inserts itself within public life, without imposing itself?

Lawrence Weiner It presents itself, it cargo-cults itself, it attempts to entice people to understand that you could talk about universal ideas using simple basic concepts.

B.H.D. Buchloh But that approach to design among the 1920s avant-garde artists was one thing, whereas in the meantime something had happened to design culture, specifically in America after the Chicago Bauhaus. Here design had been increasingly aligned with ever more rigorous commercial interests and design …

Lawrence Weiner … and power …

B.H.D. Buchloh Exactly. Design became a power system of the first order, where no modernist benevolence was appropriate any more. So it is in the witholding of a manifest design in the 1960s work that you stage an opposition to commercial graphic design.

Lawrence Weiner It was in opposition to what was considered chic design: that you could have a class association with design when design essentially was supposed to cut across class.

B.H.D. Buchloh I think it is important to recognize that you work on both tracks. For example, graffito and tattoo seem to be two graphic forms to which you refer quite often as the opposite extreme of design culture, which is as far removed from the immediacy of bodily experience as one can possibly get. On the other hand, designers have assimilated your presentation of language and sometimes you are are explicitly sought after as a designer.

Lawrence Weiner I seem to have a place within the design community.

B.H.D. Buchloh But a minute ago we agreed that design in certain ways is also the manifestation of power and interest.

Lawrence Weiner So is art.

B.H.D. Buchloh Both the tattoo and the graffito are for you fundamentally related to a primary relationship to the body?

Lawrence Weiner I am a sensual artist, I am involved with the the sensual relationships of materials. That seems to be the nature of art and I don't think curtailing that nature is going to make it any more rigorous per se, because essentially it is still about the communication of one human being's observations to another

667

human being with the intent of bringing about a change of state. At the same time I see myself as working in terms of graffito and in terms of drawing, as if it were a tattoo on whatever part of the body it fits. This is what it should look like; it is an emblem.

B.H.D. Buchloh *Do you remember what you thought when you saw Ed Ruscha's early books such as* Every Building on the Sunset Strip *or* Twenty Six Gasoline Stations?

Lawrence Weiner Oh that was fabulous, because this was somebody who understood America. This was American art. This was about America.

B.H.D. Buchloh *What was American about it? The focus on vernacular architecture?*

Lawrence Weiner No, it had to do with the way Americans saw the world. You had reference points – Mondrian, Pollock, Picasso, anything you want, and they can also be gas stations on route 66. That is how you knew where you were in the world. I walked into Documenta in 1972 with the intention of making a book and there was my colleague and good acquaintance Ed Ruscha building this structure with Konrad Fischer and it looked fabulous. He just took his books and he hung them up: they want art, they can have their art.

B.H.D. Buchloh *Looking at your book* STATEMENTS, *one realizes that there are several language games taking place simultaneously. I think that it is only the beginning of an increasingly complex diversity of language operations that you eventually employed in your work. Some of them appear to be purely 'descriptive'; they are explicitly directed against the inherently metaphorical potential of language. But there are already indications – and these will become much more obvious later – where the purely process-oriented description of a sculptural project is displaced by an explicit acceptance of a found idiom, i.e., language as a proverb or as a cliché. Is your deployment of the analytic proposition or the performative directed against both visual representation in painting and narrative and metaphor in literature?*

Lawrence Weiner I think what I am doing is reasonably pure, even though it might not fit into a language system. Just because I use language, it does not give me the inherent responsibility to be a grammarian, or a linguist.

B.H.D. Buchloh *Could one compare your introduction of language into the field of representation to a situation in the late 1970s, when photography was introduced as a strategy to displace the mythical and fetishistic residue inextricably inherent in painting and sculpture? Photography at that time was an infinitely more communicative medium, as we recognize now that it is within language that ideology and identity are constructed and that it is within language (rather than in volumes) that public communication is possible. I am obviously speaking of your conception of language as one that operates outside of literature and outside of poetry.*

Lawrence Weiner This may leave me with egg on my face, but I would say that the introduction of language as a sculptural material has had the effect of incorporating a larger audience into the same questions and the same world as photography

did. However, I would also venture that the people who brought in photography were bringing it in for the same reasons that I brought in language. They had no other way to question the answers that had been presented to them but to use this other material. They brought about a revolution. If I was part of this process of bringing about a revolution in comprehension, in making art and a rational occupation within society, then I will take the credit for it. It is a barricade that I would like to be on and I feel quite comfortable with it, but let us not think that I sat down and figured it all out. Everyone wants to make sense out of the body of an artist's work but in fact it's not supposed to make sense, it is supposed to have meaning.

B.H.D. Buchloh The most evident case of an artist criticizing narrative and metaphor in the early 1960s was Andy Warhol, specifically in his films. Looking at your own filmic work, I always thought that Warhol must have been an important figure for you. Did you think that his critique of narrativity in film and language should be radicalized and extended into other practices, such as painting and sculpture?

Lawrence Weiner Warhol. That is a real question. Warhol was a real artist. I always had great respect for him, which everybody seems to have always attacked me for. I got a great deal of pleasure from his work.

B.H.D. Buchloh From the films or from the paintings?

Lawrence Weiner From the work, as I saw it as an oeuvre. If I learnt anything from Andy Warhol, it was how to use a structure to bring about what you wanted, rather than having to use a heavy hand to bring it about. He knew exactly what he was doing, and he knew how to do it, but he was not that big of an influence. Historically, yes, people accepted artists making films after Warhol, but they accepted artists making films before – Kenneth Anger, Joseph Cornell. Warhol was just another person in that line and I think he just stepped into it because he saw that people he admired, like Cornell, were making movies. Maybe I stepped into it because I finally saw people whom I admired, like Godard, like Warhol, making movies, so I just stepped in and made my movie.

B.H.D. Buchloh You discovered Godard at the same time as Warhol, in the early 1960s?

Lawrence Weiner I saw *À Bout de Souffle* (1960) when it came out. It influenced me very much.

B.H.D. Buchloh I saw it recently again and it struck me as the first real work of French Pop Art.

Lawrence Weiner Yes, that's what it is; the first real work of Pop art in film.

B.H.D. Buchloh I always thought that your work was critical towards Pop Art, specifically with regard to the affirmative dimension in Warhol's work. There is an implicit political radicality in your work that Warhol never had because he is ultimately a profoundly apolitical artist. In that sense you have in fact a much closer affinity to Godard's project of a critical political film.

Lawrence Weiner I don't see Andy Warhol as an apolitical artist. I don't see a conservative
acceptance of historical precedent as apolitical: it is extremely political.
Warhol's idols were people like Yves Klein and as such he would have been
forced to acknowledge and support things that I would not choose to support
and endorse, then or now. That is what a capitalist system is about. They
forget to talk about 'each to their needs and each to their abilities'. They
forget to talk about how much is enough. It seems to be endemic in all
classes. But they leave the other part out. I would like not to leave the other
part out. That's the difference. Godard would have liked not to leave the
other part out. Fassbinder would have liked not to leave the other part out.

B.H.D. Buchloh What about the usage of language in your first film, A FIRST QUARTER *(1973)?*

Lawrence Weiner It is a pretty movie; it is my Godard movie.

*B.H.D. Buchloh What would you say is happening in this film, in terms of my question concerning
the traditional narrative framework? The actors are placed in various social and
erotic situations and – rather than speaking dialogues – they suddenly pronounce
your statements. The radicality of that approach – while indebted to him – exceeds
Godard.*

Lawrence Weiner That sounds sexy. What if we now take it out of an aggressive stance to
radicalize cinema? My major dialogue was existential: I decided to make
a *mise-en-scène* that was closer to where my work could exist, and, in fact,
cheapen its value within the society. I was making sculpture to cheapen
it to the point that it would infiltrate society and its children's lives. It had
to become a norm within children's lives. That is all that art is, it is a point
of observation for other human beings to notice.

B.H.D. Buchloh You might not agree, but could one say that A FIRST QUARTER *is as distant
from Warhol as it is from Godard?*

Lawrence Weiner I would absolutely agree. The only thing I learnt from Warhol was that if
you wanted do something, you just pulled it together.

*B.H.D. Buchloh The first difference is that Warhol's conception of dialogue insists on language
in its most common condition, whereas your dialogue is totally scripted and
artificially staged. The actors in your films perform very complicated linguistic
statements, whereas Warhol prides himself on constructing this endless flow
of mundanity.*
 *It seems that in some of the subsequent films and tapes, you criticize your
original emphasis on the exclusivity of the linguistic in the work of the late 1960s
and early 1970s. Your early work had systematically excluded matter and
materials (except for their naming) and the whole plenitude of bodily experience,
or the non-linguistic dimensions of subjectivity, narrative and the representation
of historical experience had been excluded from your work and from Conceptual
Art at large. Suddenly, in works such as* DO YOU BELIEVE IN WATER?
(1976) there is a repositioning of subjectivity between the linguistic and the

psycho-sexual. Here again there is a tension between the erotic performances and the linguistic performance that seems almost programmatic.

Lawrence Weiner It is very programmatic; it is a very structured tape. It is about playing games, about the basis of games. I put in an actor, a homosexual performer, who was nervous around lesbian women for some reason, together with two lesbian women who had never said publicly that they were lovers until then. And that set up tension. What can I say? Nice tape, a little long, but a nice tape. I will be dammed if I ever wanted to exclude any sensual function from art. I am just an artist, you know, I do not have to be right all the time. I am not giving out medical prescriptions to people and I am not flying an airplane, I am just this person putting things in the culture, with a responsible thing that can change the culture.

B.H.D. Buchloh *Another important example in that context would be the so-called pornographic videotape from 1976, entitled* A BIT OF MATTER AND A LITTLE BIT MORE *where you confront the viewer with actors who pronounce your work and at the same time perform sex acts – what might be perceived as the opposite of a linguistic operation.*

Lawrence Weiner It is not grammatic but it's not anti-linguistic. The porn tapes were done for political reasons. They were done because the United States government was putting people who made pornography in jail. Now I do not get off on pornography, but I do not like them putting people in jail just for making pornographic films.

B.H.D. Buchloh *We talked about the various language models that are already evident in* STATEMENTS. *But there is another language model entering your work later, where you insert statements that explicitly refer to specific historical conditions. I am thinking of the installation in Vienna for example,* SMASHED TO PIECES (IN THE STILL OF THE NIGHT) *(1991), where the statement itself seems inextricably bound up with the historical context of the city and the site where you installed the work – even though one can read the statement in a variety of other ways.*

Lawrence Weiner It found an immediate metaphor when it was placed within that structure. If they have been objectified culturally, then historical references are usable as materials, because that is an objectified cultural entity the same as time and sound and remembrance.

B.H.D. Buchloh *Would you really say that all the resonances of these works with their sites are as uncalculated as you claim now?*

Lawrence Weiner When I was invited to Vienna, I was involved with the sound of things in the night and the sound of things in the day because I had been working through projects where I had been awake all day and all night. Things sound different at night from in the day, especially in cities ...

B.H.D. Buchloh *Can one really read the work, when installed on the Vienna Flakturm, outside of the Holocaust history of the city?*

Lawrence Weiner I am interested in the difference in sounds between night and day. They offered me this Flakturm, this anti-aircraft defence tower; I chose that piece to put on it. I knew damn well it had a metaphor. It was the work that was coming out at the time, maybe at that moment I was thinking about those things. Art is fabulous because it starts off as one thing and becomes something else for somebody. That is its whole function. In fact this is not the metaphor of this particular work. If I put it in another context, which I often do as you know, it has a totally different metaphor. You put that piece in the South Pacific and all night you will hear coconuts falling, all day you hear coconuts falling.

B.H.D. Buchloh *Your work for Skulptur Projekte in Münster in 1997, DRY EARTH & SCATTERED ASHES …, could be another example. It is by no means the only piece that focuses on those questions concerning the relationship between text and material and between text and placement. Would you want to differentiate the function of writing from the function of the object in your work, since the writing does not in all instances take on a material, sculptural form of presentation; it can also take on a merely typographic, scriptural form. Are there specific criteria according to which you decide that one work should appear solely in writing and another work appear in a material structure?*

Lawrence Weiner The criteria are totally non-hierarchical. The work gains its sculptural qualities by being read, not by being written. Each work itself is the result of material experimentation, material building, translation – translation into language and then the presentation is whatever affords itself. In Münster, I was in a dilemma, I was confronted by a social paradigm that required that I question what is public sculpture, because in fact the carnival atmosphere of these shows does not necessarily have anything to do with public sculpture. So I used the steel plates that they put over holes in the ground. But there is no real hierarchy about how a work is presented. If somebody wants a tattoo they get a tattoo – it all has to be basically the same to me.

B.H.D. Buchloh *Does this mean that the same statement that was shown in Münster could theoretically be shown somewhere else?*

Lawrence Weiner It was initially shown in Munich and there is a little book of prints that were also made into posters to be given away in Munich.

B.H.D. Buchloh *So the work was neither specific to its context nor specific to its presentational and distributional support system?*

Lawrence Weiner It was not specific to Münster, the work is never specific to any place. I have a feeling about work that one does, because it is the dance to the music of your time. That is the problem for me with work that is specific and journalistic: it serves its function in its first performance, but it is never allowed to live a full

Lawrence Weiner

A sheet of brown paper of arbitrary
width and length of twice that width
with a removal of the same proportio
ns glued to the floor

A 2" wide 1" deep trench cut across
a standard one car driveway

STATEMENTS 1968
Sample pages from catalogue
17.5 × 21 cm
for exhibition/catalogue 'January 5–31,
1969', Seth Siegelaub at McLendon
Building, New York

Jeff Wall

**A Ventriloquist at a Birthday
Party in October, 1947** 1990
Transparency in lightbox
229 × 335 cm

Jeff Wall

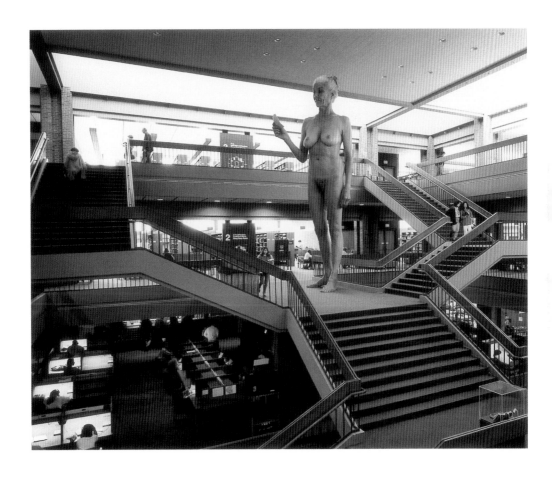

The Giant 1992
Transparency in lightbox
39 × 48 cm

Gillian Wearing

**Confess all on video. Don't worry,
you will be in disguise. Intrigued?
Call Gillian** 1994
Video
30 mins., colour, sound
Video still
Collections, Arts Council, London;
Tate Gallery, London; Kunsthaus,
Zurich

Gillian Wearing

From **Signs that say what you want
them to say and not Signs that say what
someone else wants you to say** 1992–93
C-type colour photograph, mounted
on aluminium
40.5 × 30.5 cm
Series of approx. 600 photographs

Franz West

Chou-Chou 1998
4 chairs: metal, wood, carpet
45 × 54 × 84 cm
Collection Kunstmuseum, Bern
Fake 1997
Lacquer, wood, plastic
82 × 155 × 5 cm
2 loudspeakers, 2 CDs,
amplifier, wood, dispersion
Wall: 82 × 155 × 5 cm
Installation view MAK, Museum
of Applied Arts, Vienna 2001

Franz West

The First Passstück 1978–94
Plastic, metal, plaster, paint, text, video
23 × 25.4 × 9 cm
Pedestal: 75 × 40 ×35 cm

Lawrence Weiner

SMASHED TO PIECES (IN THE STILL OF THE NIGHT) 1991
Paint on wall
Letter h. approx. 60 cm
Installation in German and English,
Flakturm, World War II anti-aircraft
defense tower, Esterházypark, Vienna

complete life as a work of art, which is to find its own metaphor. I mean, the Giacometti stage-set *The Palace at Four a.m.* (1932–33) found its metaphor in the Museum of Modern Art – that made more sense to emerging New York City kids than it did when it was shown for the first time – it had no metaphor there. It was very important for me as a young person. It was not about alienation, it was about survival, very much like my youth. Forty-second Street and places like that at four o'clock in the morning. Coming out of the movies having seen *Général de la Royère*, I began to understand what people were trying to do – they were trying to build a *mise-en-scène*.

B.H.D. Buchloh *Let me put the question in a different way, or expand on it: what language model underlies your critique of metaphor as a pre-established fixed meaning, as a pre-established belief system? Are you establishing with your own means a critique of language that would have parallels in poststructuralist deconstruction, from Lacan to Derrida?*

Lawrence Weiner It is pre-Derridian and it is certainly non-Freudian. The argument between Piaget and Chomsky provided me with my definition of the language model. My discovery of the original Chomsky in the Mouton edition as a kid helped me comprehend that there was a whole understanding of generative grammar and a kind of genetic imperative. Piaget was dealing with shell-shocked children; his realization was that children are in need of 'nomering' something, and in 'nomering' it, they do not always have to accept why it is called *pomme de l'air* or *pomme de terre* – an apple is called an apple because the name apple is written down inside it. All children determine that, so why do artists have to be made into romantic souls because they bring the soul out of the material and make the material acquire its real name?

B.H.D. Buchloh *I was wondering whether we could establish a certain continuity between the film work and your recent music. There is a similar juxtaposition between your statements and the given system, in this case the peculiar lyrics and the specific musical conventions, ranging from reggae to country western. Are they, like Pop Art, addressing pre-existing systems of representation? Could one say that you use musical structures in the way that Roy Lichtenstein used a comic book structure as the point of departure for a painting?*

Lawrence Weiner The entire concept for me of using a musical structure as a means to present work is not new. I made my first record, *SEVEN*, with Pierre-Yves Artaud and Beatrice Conrad Eybesfeld around 1972. Later I worked on the soundtrack for my film *A FIRST QUARTER* with Dickie Landrie and on soundtracks with other musicians like Peter Gordon. Putting the work in the context of the music cheapens it and at the same time heightens the fact that it has a relevance to our society. It is not just that it can fly that makes it interesting, it is the fact that it can walk as well, and that is why I use the songs. I have retained the privilege of being an artist who makes films, an artist who makes music. I do some arrangements, but essentially I am

a lyricist for musicians. You have to write lyrics that place the work within the context in which you would like it placed. Again, without a metaphor.

B.H.D. Buchloh *What happens, however, is a radical transformation of the musical structure. One model that comes to my mind would be the Situationists' détournement. That really seems the closest comparison that I know: using an existing structure of signification within the culture and overturning its reading.*

Lawrence Weiner No, I don't turn it upside down. I take it out of its context. I don't say this is in the lines of Chuck Berry but that this is something using what he would use, but with an artist collaging something in. It is not done in a Situationist manner, it is not the détournement.

B.H.D. Buchloh *What about the CD you did with Ned Sublette,* MONSTERS FROM THE DEEP *(1997)?*

Lawrence Weiner I wanted to deal with a spectrum of music, a reconstructive aspect that I had been interested in from early techno, but at the same time I did not want to find myself doing retro things. So we went and found Kim Weston – who really sings like that to make a living – J.Otis Washington, Red Fox, Lenny Pickett. This is the music they play every day of their life. We gave them a slightly different rhythm and different words.

B.H.D. Buchloh *What interests me here is the relationship between your writing as work and your writing of the songs. Can we talk about the content of the lyrics versus the commonality of the music? Why do you inscribe these rather esoteric lyrics into popular forms of music and how are these songs different from your other writing, if at all?*

Lawrence Weiner You mean the work? They have nothing to do with the work even though often the songs will incorporate works.

B.H.D. Buchloh *How does that relation function then?*

Lawrence Weiner They are shown within the context. Look at it as a *mise en scène* – they set the *mise en scène* for the previous collection of work.

B.H.D. Buchloh *You keep using the term* mise-en-scène *and I do not think that it is as clear as you imagine it to be.*

Lawrence Weiner It is the stage set. I made a small-scale sculpture edition in Japan, *STAGE SET FOR THE KYOGEN OF THE NOH PLAY OF OUR LIVES* (1995). It is a stage set for the Kyogen that has Madame Butterfly talking about contemporary problems at this particular moment that never existed before. They do that in the middle of the Noh plays – they have little political things that they hit the drum for and then they make these jokes.

B.H.D. Buchloh *The work as language is then inscribed into the song as a given, pre-existing language structure?*

Lawrence Weiner As a given language structure that relates to something else. The piece from Münster appears in a song in *MONSTERS FROM THE DEEP* – it is just presented within that other context. Everything has a double context, you know – a Carl Andre brick sculpture can also be used to stop the levee from going over the side. A brick remains a brick. There is no question of transcendence. I don't see any reason why if they can take a work of art and put it on a record cover, you cannot put it inside the song.

B.H.D. Buchloh *But when you say that the songwriting has nothing to do with the work, I still think that this distinction between statements as sculpture and 'mere' lyrics for the songs is not as easily made, at least not from the outside, because the transitions between the two seem very fluid.*

Lawrence Weiner It is collaged.

B.H.D. Buchloh *So you would argue that the texts of your works inserted into the lyrics function as sculptures?*

Lawrence Weiner The works are always sculptures, so what everybody calls texts and sentences and wall-tattoos and this and that – it is not for me to give them a name, it is art – are functioning as art. That was my job as an artist, to say that that was art.

B.H.D. Buchloh *So when Kim Weston or Red Fox now sing your famous STATEMENT OF INTENT from 1969, when they now sing it in their different intonations and one flashes back to 1969, when the STATEMENT was presented as a radical promise, does it not sound as though the contemporary musical presentation had acquired a certain farcical dimension and that you cannot take that original revolutionary aspiration of the STATEMENT OF INTENT quite as seriously any more?*

Lawrence Weiner Yes, but then if you go from being a revolutionary who will only fight in causes they believe in to being a soldier, you cannot really consider yourself a revolutionary any more, can you? You may as well do it with some aplomb. Why, in heaven's name, when something is taken off its pedestal, why does it have to be less important than it was before?

1 Leo Steinberg, 'Jasper Johns. The First Seven Years', *Metro*, no. 4–5, 1962; revised 1963

Franz West *Bice Curiger*

in conversation
August 1998, Stockholm

Bice Curiger *We're sitting here in* Chou-Chou *(1998), a new work of yours for 'Pink Fluid', an exhibition I have curated at the Maritime Museum in Stockholm. It's a bit like being on stage. We are sitting on a row of chairs as though we were facing an audience. Why is your work slightly stagey? Would you ever describe it that way yourself?*

Franz West I came to the arts through the surroundings I was sitting in. Broadly speaking, that meant artists and students in the Viennese coffee houses that you used to find in the 1960s and 1970s. I came to art via the places where artists meet, places where you would go and sit. My brother, Otto Kobalek, was an actor, and maybe there's a connection; it's never occurred to me before …

Bice Curiger *A stage raises things up, like a plinth. You raise something up out of its normal surroundings, as though you were somehow drawing an abstract field, a slightly more neutral area in a way, where the thing can be reborn.*

Franz West Of course I consider myself a visual artist. I studied sculpture, which I hadn't necessarily planned to do. Sculpture is more about three-dimensionality than painting, and gets you away from the picture surface. In my case that went even further, almost as far as the stage. My pictures were mainly collages. The unambiguous reproduction you have in a collage becomes less clear in meaning precisely because it is a reproduction – unless you are part of it yourself. It's the same with us, sitting in *Chou-Chou* right now. If someone were to come into this space we would be collaged into the work.

　　Maybe that's not quite correct. As a body, you stand or walk around the sculpture. It's almost equivalent to your own corporeality, to taking up space in one's own three-dimensionality in a defined artspace. As far as sculpture in the normal sense is concerned, the viewer is more or less obliged to engage in movement. There is something standing here that you walk around, and perhaps the impression you have of what is being presented also determines whether the movement is quick or especially slow, depending on whether you are really concentrating. So here we are. Fortunately we don't have to move like that just now, but even with the *Passstücke* (Adaptives, 1974–), those sculptures that you are supposed to move about with, there is a limit.

Bice Curiger *About your objects: a chair in your work is not just a chair – it is a meta-chair. I remember you once said about a couch, 'The perception of art takes place through the pressure points that develop when you lie on it', so that the couch is like a tool for perceiving art. You become aware of the art in the friction between the couch and …*

Franz West Yes. When I thought about the word *Stuhl* [chair] it struck me that *Stuhl* and *Stuhlgang* [bowel movements] sound a bit like each other. And I came to the chairs through art critic Denys Zacharopoulos, who taught for a while at the Academy in Vienna, in the Institute for Contemporary Art. There were chairs there that you could stack, so they could be grouped; the rooms could also be used as studios. These chairs were rather shabby, and he asked me if I would design new chairs for the rooms. When I heard the word *Stuhl* my

first thoughts were of discharging faecal matter. It must have been the same for Dieter Roth, with the 'stools' in his own work and in art in general.

Bice Curiger *His so-called 'Shit–books' in the 1970s?*

Franz West In his pictures too. I once heard Roth talking about one of his own exhibitions, and he said, 'It's full of shit.' In some symbols or metaphors, chairs and stools and shit might be regarded as having been produced by the artist.

As far as the groups of seats go, it was like this. When I was first asked to make new chairs for the student rooms in the Institute, I thought, no, I'm not doing that. It was in fact a major shift from the way things were, from the 1970s to the mid or late 1980s. In the past, as I understood it, it would have been unthinkable for an artist to make furniture. People would have thought it far too profane, until the Italian furniture firm Meta-Memphis approached artists to design furniture for them. And some Conceptual artists, like Lawrence Weiner and Joseph Kosuth for instance, made chairs for this company. Since the late 1980s I have made special chairs and designs. Whether or not they get approved, however …

Bice Curiger *So, Meta-Memphis, 'meta-chair'; there must be 'meta-people' sitting on them? It has already been said that, along with the things you exhibit, you include ideas with them, or use these ideas as material. Materials are not just what we can grasp with our hands; while we are sitting in the piece* Chou-Chou *we also hear, or in a sense 'see', music. Music in this work is actually material, it is taken up and becomes an integral part of the object standing there.*

Franz West Actually that takes us back to the beginning: to the fact that it's like a collage. When I was invited to take part in 'Pink Fluid', I felt a bit odd about the title. For the last fifteen years I've had to listen to Pink Floyd and that kind of music in public places. Then I heard two records by Schubert and Schumann being played and noticed they were in pink sleeves. These were a kind of equivalent, the same kind of imposition, and these two are just as long gone as the – now doubtless denture-wearing – members of Pink Floyd.

The musical element in *Chou-Chou* is like walk-in collage. This is the function of the music, like the photographs in my collages. I made my first collages out of advertisements from magazines. I didn't cut them up, I just re-arranged them, and you could understand them as pieces of collage, in the sense of reproductions of parts of reality which are then put together differently, not in the same way as normally in other configurations of daily life. In this situation the difference is spatial, because you sit in it. As far as the effect it has on one's own artistic intentions is concerned, the individual has to regulate that effect him or herself. You can sit down and ask yourself, 'So where's the difference?' That would be my reaction. The other possible reaction would be to sit here like us; that could be the purpose of the piece. And is that interesting to anyone else? You find the same thing in the work of some philosophers: Berkeley said *Esse est percipi*, i.e., 'To be is to be

perceived.' At worst you could always cling to that. I think he meant that materials do not really exist; this is called Idealism. In any case a collage is a two-dimensional, or in this case three-dimensional, materiality. I once read an interview with Marcel Duchamp done at the time he made the *Large Glass* (1915–23). In those days the fourth dimension was a topic in philosophy, and the point was to find this fourth dimension. It could be the same thing here.

Bice Curiger *I also think of the function and use of colour in collage. In your case there are many works that might almost be described as colourless. The materials – papier mâché, plaster, newspapers – have their own colourlessness, but then you apply extremely bright colours to them. The colours often have something very material about them.*

Franz West I have had some very unfortunate experiences with colour. The thing is, when I started with colour, I used it according to my taste at the time and then, after a short time, when I saw it again I was always appalled. If you later decide that your own work is bad, then the more colourful it is, the worse it seems. Colourlessness is not so noticeable, so sometimes you can even just ignore it. I have always had more certainty about the forms I use; at least the shapes seem more unchanging, so to speak. With colours you're much more dependent on the mood of the moment than with forms, which are more static. A form is the same at night as by day, while you can't even see colours at night; at least you can bump into shapes in the dark. And also with the constancy of a form I can be unambiguous much more easily than with colour. Colours always refer to something else, I feel. If you use them for any length of time, you become used to them.

Bice Curiger *But this pink picture in* Chou-Chou *is a 'fake', as it says in the title, a replica of another work.*

Franz West Yes, it's an exact copy.

Bice Curiger *... of a work titled* Fake *that you made in the 1970s?*

Franz West Yes. In those days I used a lot of brown. Ochre and pink seemed primary colours to me. I used to associate pink with intimate things. When I was a child, ladies generally had a pink *combinaison* [undergarment]. If you looked under their skirts, you saw pink. And the ochre, that's perhaps the colour of their stockings.

Bice Curiger *And the yellow?*

Franz West I became interested in yellow later on. Yellow can be compared to urine or gold. In Freud I read of urination as confirmation ...

Bice Curiger Freude *(joy)?*

Franz West Yes. I've asked a few psychologists about it but none of them have known what I meant. Whatever the case, for me yellow was a symbol for saying yes to life. That's also very important, because when I started, my things were

saying no to all the dictates from above. Now that's changed. I had a horror of my early collages with all their references. My response to these references was to oppose them with high spirits and humour, yet without necessarily prettifying or trivializing them. This humorous element, a kind of softening-agent, saps their claims to being serious, and softens things. Maybe I've put this into practice.

Bice Curiger *Last time we saw each other you had just read Malaparte's* The Skin *(1949). I was wondering why you were interested in it?*

Franz West He describes a raw reality that remains supple by being lubricated or oiled with a kind of sarcasm. This reality does not exist at the moment.

Bice Curiger *One might associate that idea with thoughts of creases and wrinkles in a person's skin. A lot of your sculptures seem, by the look of them, to have a raw, mobile surface.*

Franz West I had an apartment, and I didn't have any money, and didn't like the hierarchical way firms work, so I painted the walls and doors myself for a few hours, here and there. When you paint a room, while it's still wet it looks grey, and then the grey begins to dry; gradually it becomes white. It is a lovely process. In Vienna the architraves above the doors are curved. The shapes of older architraves are semi-circular, which for me signifies movement and change. I think that's where the *Adaptives* came from. I made them white, despite Malaparte's descriptions of skin as being alive. The skin on milk was something that as a child I especially disliked. We used to be given warm milk and if there was a skin on it, it was really horrible. I had an old aunt, who always said that this was the best bit, and she just swallowed it right down. There's supposed to be something especially healthful about it.

Bice Curiger *Your works seem to have such potential for change, something positively physical, as if something liquid has turned into something solid, crystalline.*

Franz West Well, the status quo of the viewer, of the recipient, should be a different form of perception. When I started making these things I had different needs, when I went into a museum, to those I have now. My needs have changed in the twenty-five or thirty years since I started, and now they are being realized. At first it wasn't possible to exhibit the *Adaptives*. My only chance was with private galleries, where no one was allowed to touch anything. Things might get broken (Malaparte again). They could never be shown publicly like that. In some ways when you're fifty you feel that the ideas you had when you were twenty-five are too far away, but as a motif they seem interesting to me. Otherwise when I am pushed into something, I really don't know what to make.

Bice Curiger *In recent years you have made large-scale spatial installations; the 'Proforma' exhibition (Museum Moderner Kunst, Vienna, 1996), for instance, was very architectural, and so was* Clamp *(Carnegie International, Pittsburgh, 1995). In* Clamp, *the installation included seven working telephones and the walls were*

papered with pages from the telephone book. So that wasn't about the Adaptives *that you can get hold of, but about a telephone that you can use, and which vastly extends the immediate effect of the work.*

Franz West Yes, only now you don't need that any more. At the time I didn't take into account that we already had mobile phones, but *Clamp* was just another of my experiments, a situation with a viewer. Actually all I really wanted to do was install my studio in the museum. I had just moved out of my studio, so I wanted to put that studio in there. In the studio where I now make sculptures, sometimes I get a phone call, and I get caught up in the call. I read during the day, and then in my sculptures I recapitulate what I have read. Then the phone rings, and while I'm taking the call, talking to someone else, I see it, I *see* the sculpture. If I were alone I would go on working and wouldn't know when to stop. But then I see it while I'm talking on the phone, and it is at this point that I know I can leave it.

That is another question: to what extent can the impression – not the message but the impression – satisfy our notion of perceiving art? If I see a sculpture or hear music that I find beautiful or interesting, it does not necessarily have to be beautiful. Is that enough? That is the problem in my works. I proceed with a concept, and that concept gets realized. With the smaller things that I make with my own hands, or when I choose the colour, the auditory, visual or sensual parts of the object come together. But some of the time, when I make sculptures, I repeat what I've read, and that is my repertoire. The movements, the ideas, the changes, go hand in hand with each other, and that goes into the title, the accompanying text, or the style, something like that.

Bice Curiger *When people look at your catalogues and books, they see lots of bright sparks near you. Who are you talking to and who is writing about you? It seems that you are exchanging ideas with people like Reinhard Preissnitz, Ferdinand Schmatz, Otto Kobalek, Hermann Schürrer, Johannes and Elisabeth Schlebrügge, Bernhard Riff, Robert Fleck and others. Has it been like this for you ever since your beginnings in the Viennese coffee houses?*

Franz West No, that's had to change because I don't live like that any more. It's the same with music. I used to hate the classical music being played here in *Chou–Chou*. Although I listen to a lot of music, especially piano music, in the past it was jazz, and then jazz got swept away by the Beat vogue. This Beat wave was really a physical onslaught, almost like an operation, slow but meticulous. People got heavily involved in it, we took special notice of what the leading lights used to say. I never used to like reading, but then it became necessary, when I was in the middle of all of that noise. If you don't happen to be studying philosophy or whatever, then it can have an intensely stultifying effect. Or rather, people don't become stultified, that's how they already are, but it can bring on a stubbornly resilient form of stultification.

As if to free me from this, one day Lacan dropped into my hands. The

book was called *Schriften I* [Jacques Lacan, *Writings*, vol. I] and on the back cover was a sentence which I used to know by heart, but now I'd have to rack my brains to remember it. It said something like, 'The "I" of modern humanity is in a cul-de-sac, a state of delirium. The only reliable way out of this cul-de-sac is through our engagement with the sciences.' So I thought to myself, I'll read something scientific, but it was very difficult to understand scientific texts for someone like me who doesn't know his way around linguistics (a bit like engineering) and Heidegger. It's really hard. Then I read Karl Kraus, and he was satirical and cynical. I didn't like Nietzsche very much. I thought the word *Wissenschaft* [science] sounded a bit like Wittgenstein ('Wi-Wi', *oui-oui* in French, that'd be a double confirmation), so I immediately read Wittgenstein. When at last I met a Lacanian, it hit me that they don't like Wittgenstein at all, and I discovered the debate between the Positivists and the Idealists.

Bice Curiger *About the cul-de-sac?*

Franz West Well, I managed to squeeze my subject into Positivism. What interested me about Lacan was that he said that some powers have their own resonance. If someone rings up, then there is some kind of resonance. And in fact, without deliberately looking for them, I managed to get to know some Lacanians, two even. After all, they are fairly rare. It was stunning that I found two; that already had some resonance. That's what you were just asking about, my surrounding myself with people who are interested in philosophy and psychology.

Getting back to the bebop music I used to listen to, I have to declare my hand there too. I didn't want to listen to bebop any more, but I always need to listen to some music or other. So I've got closer to classical music, although it really used to repel me, especially the kind of music playing here in *Chou-Chou*. There's also a personal connection to this piece: my mother was a dentist; she used to leave dentures lying around, lots of them, and they were this pink colour. My mother would listen to music, and we had a waiting room where patients could sit. On the walls there were art reproductions. For a while I slept in that waiting room, so for me it's autobiographical. When it comes to looking at the work, then that's another matter. I have got off the subject, and anyway in art you don't need verification; that's why it's art after all. My private life shouldn't be of the slightest interest to the viewer.

Bice Curiger *Yes, but isn't a prosthesis rather close to your* Adaptives?

Franz West Freud says (I think in *Totem and Taboo*) that man is a prosthesis-god. That is to say, a car is a prosthesis for getting around in, a radio is a prosthesis for information, and art is a prosthesis for culture, the non-technological. Mind you, now that we have so many virtual images, we use virtuoso know-how to make an absolutely uninteresting virtuality, the supposed infiltration of the arts by technology … But I'm not really interested in that any more. No doubt some up-to-date person could do something with it, or at least appear to. I am more interested in …

Bice Curiger *Human beings probably, a human scale, perhaps?*

Franz West The skin, the skin on our hands.

Bice Curiger *You mentioned Lacan a moment ago, and I know that in your work you have highlighted the notion of intersubjectivity, which derives from his work.*

Franz West I haven't come across that in Lacan. I only poked around in Lacan's first volume. It seemed too much and too difficult for me really to devote myself to philosophy or psychology. So then I turned to art history and art theory, what philosophers think about art: what Kant said about art, what Hegel said about art, how Plato saw art. That's pretty exhausting. Really getting to grips with it would take a great deal of time and concentration. Of course the works use a lot of ideas from Structuralism. You really have to know a bit about that first. But, like I said, I didn't start getting interested in that until quite late, when I was twenty-five. I autodidactically arranged philosophy into blocks for myself, and it really does seem to take a lifetime before you even begin to get anywhere with it.

Bice Curiger *Earlier on you were saying to me that you chose a text on prostitution by Professor Kathryn Norberg, for the 'Artist's Choice' section of this book. While we are on the subject of reading texts, what interested you about that?*

Franz West Well, in the first place it was pretty off-beat, because you are not just dealing with grisly details. When it all becomes too tame, the arts I mean, then it just becomes too dull. And Kathryn Norberg has put together a minute, very dry account of prostitution in the eighteenth and nineteenth centuries. In my romantic younger days I was much taken by Baudelaire, who compared art to prostitution. Baudelaire's thinking impressed me very much at the time. It was so unusual, his way of thinking, for someone from a normal background like mine. When you get to know Baudelaire, it's unlike the world that you always knew at school; it's not the world of football and television. The ability to grasp the world like Baudelaire, that was enough to get away from those petit-bourgeois schooldays, from art, from the game. But one shouldn't cling to all these Bohemian things too readily, as Marx pointed out long ago and as Hitler seems to have proven. Napoleon III was also from a Bohemian background. Some people even claim that, among other things, Bohemia produced fascism. That is the more disturbing side of Bohemianism. But if it were to disappear, what would be left of our cities? Car showrooms and car parks. There is not much else beyond our own four walls – except for these raves, where young people have a pretty ecstatic time. When I was between fourteen and sixteen years old the cinemas showed unbelievably stupid films, Heimat-obsessed films. You could still show them in nursery school, but they certainly wouldn't do even for twelve-year-olds any more. In those days this was normal enter-tainment for a cultural evening. The new generation who take drugs and go to raves have it made. So really, there's a lot going on. But when you grow out of your own background, or if it dies off, then there's not much left.

Bice Curiger *Since we have come round to more individual matters, perhaps we could find a link here with the psychoanalytic notion of the intersubjective. In your work there is a certain tension between the intimate, individual experience and the public. After all, you also make works for the outdoors, for the public at large. The seventy-two couches you installed at Documenta IX (Auditorium, Kassel, Germany, 1992) for example. What is your approach to public art?*

Franz West Initially, public spaces seemed to me the most natural places to show art. However, over the years I must have become a little less other-worldly: now they just won't do, public spaces, the only spaces that don't cost anything. You don't even need to go far to find them. And you don't even need particularly to perceive 'public' work; it's simply there. There are enough bad artists out there, as anyone can see. What is presented as art-in-architecture, at least in Austria, is pathetically obvious, but at least it's not shut away in museums and totally uninteresting. Best of all I like art in the streets; it doesn't demand that you make a special journey to see it, it's simply there. You don't even have to look at it – that is probably the ideal art. Horkheimer said that he would prefer it if life were more intense and art less interesting – not that there were no art, just that art were less meaningful, and that's what I like about public art. Art that people have hanging around, that stands about in spaces with other people – that's the kind of art I want to do.

Bice Curiger *Not long ago you made a piece in connection to James Lee Byars?*

Franz West Yes, but it was a coincidence. I don't want to joke about an artist who has passed away. In 1997 Byars had the show before me at the Serralves Foundation, Porto. So I was in the museum, having a look at the space, and there was a piece by James Lee Byars. I had never seen it before, and yet I had made almost the identical sculpture to his! It was basically a column a few metres high and I had done exactly the same thing; only the material was different. I didn't put my work in the same place, but Byars wanted to reciprocate by making exactly the same thing, a square column, and setting it in exactly the same place as my work. In the end I put it in front of the museum. It just sort of crept round there. It's partly in memory of James Lee Byars, whom I got to know personally. His exhibits touched me deeply in their unusualness. It's always a bit difficult, because a lot of people I knew have died, a lot of friends from the art world. Reverence is not the be-all and end-all of the *Adaptives*; rather, they should be used to oppose the notion of reverence. But when it comes to friends and acquaintances passing away, and there is a lack of reverence, then it becomes problematic. But I called that work after James Lee Byars and put it in front of the museum. I wish I could do it again.

Translated from German by Fiona Elliott

Biographies

Artists

Vito Acconci is an American artist. One of the most important pioneers of performance and video art, he investigates the boundaries between the body and public space, enlisting sculpture, installation and experimental architecture. Acconci's solo shows include 'Seedbed' at the Sonnabeningd Gallery, New York (1972); he has been included in many significant group shows, among them Documentas 5 and 7 (1972/1982). The work of Acconci Studio, set up in 1988, was featured at the Venice Architecture Biennale (2001).

Doug Aitken is known for his innovative film and video installations. The Los Angeles-based artist utilizes diverse artistic approaches towards an idea of pure communication. His exhibitions include the 1999 Venice Biennale, where he won the International Prize. Solo shows include the Vienna Secession, Kunst-Werke Berlin and Kunstmuseum Wolfsburg (all 2000). He has been included in numerous group shows, including the Whitney Biennial (1997/2000) and the National Gallery of Victoria (2003).

Uta Barth is a Los Angeles-based German artist who explores the possibility of a subject-less photography, producing unexpected background images rich in their subtle explorations of composition, light and space. Her work has featured in such group exhibitions as 'Ten Artists, Ten Images', Tate Modern, London (2001), 'New photography 11', The Museum of Modern Art, New York (1995) and 'Visions of America', Whitney Museum of American Art, New York (2002). Her solo retrospective, 'Inbetween Places', was at the Henry Art gallery (and touring), 2000.

Christian Boltanski is one of France's most significant contemporary artists. Often referring to his own semi-fictionalized autobiography, the Paris-based artist gathers old photos, clothes or found objects that are presented as archival artefacts tracing individual lives. His art has been presented in museums and public sites worldwide, including a solo show at the Jewish Museum, San Francisco (2001) and such group surveys as the Lyon Bienniale and 'The Last Picture Show', Walker Art Center, Minneapolis (both 2004).

Louise Bourgeois, who moved to New York from France in 1938, has worked closely to many of the twentieth-century's key artist movements, from Surrealism to Abstract Expressionism to feminist-inspired art. As sculptor, painter and printmaker, she is recognized as one of the pre-eminent artists of her generation. Exhibitions at The Museum of Modern Art, New York (1982) and the Guggenheim Bilbao (2001-02) are among her many solo shows. Bourgeois represented the United States at the Venice Biennale in 1993, and was awarded a Golden Lion in 1999. Her installation *I Do, I Undo, I Redo* inaugurated London's Tate Modern's Unilever Series in 2000.

Cai Guo-Qiang is a Chinese-born artist based in New York City. Cai has developed a reputation for his ambitious, often explosive, projects throughout the world. His major solo shows include 'Inopportune', Massachusetts Museum of Contemporary Art (2004) and '18 Solo Exhibitions', Bunker Museum of Contemporary Art, Taiwan (2004). His 'Project to Extend the Great Wall of China by 10,000 Meters: Project for Extraterrestials No. 10' (1993) was designed to be viewed from outer space by aliens. Cai was awarded a Golden Lion at the 48th Venice Biennale (1999); he curated the Chinese Pavilion at the Venice Biennale in 2005.

Maurizio Cattelan is one of the best-known Italian artists to achieve a global profile since the 1990s. In the spirit of 'anti-artist' Piero Manzoni, Cattelan produces unorthodox sculptures, performances and photoworks that are as varied as they are unnerving. His art has featured in four Venice Biennales (1993/1997/1999/2001), the 1st Seville International Biennial and the Whitney Biennial, Whitney Museum of American Art, New York (both 2004). The Museum of Contemporary Art, Los Angeles, hosted a solo show in 2003. He is based in New York.

Vija Celmins left Latvia as a child in 1944, and has lived most of her life in the US. Celmins has updated the genres of landscape and still life through her technically impeccable paintings, prints and drawings of vast spaces. Her 1996 retrospective travelled to the Whitney Museum of American Art, New York, the Museum of Contemporary Art, Los Angeles and the ICA, London. Celmins' work has also featured in two Whitney Biennales, New York (1997/2002). She lives and works in New York.

Richard Deacon has occupied the foreground of British sculpture since the 1980s. His constructions range in scale from the domestic to the monumental, their structures referencing mechanical and anatomical worlds. His work is held in collections at the Tate Gallery, London, Centre Georges Pompidou, Paris and The Museum of Modern Art, New York. Shows include a solo exhibition at the DCA, Dundee, Scotland (2001) and the group survey 'Between Fiction and Fact', Musée d'Art Moderne, Villeneuve d'Ascq, France (1992). He won the Turner Prize in 1987. Deacon lives and works in London.

Mark Dion is an American artist who investigates the visual representation of nature and the history of the natural sciences. He often works with scientists, archaeologists and naturalists to realize his installations, films and performances as he constructs laboratories and *Wunderkammern*. Fascinated with the classification of objects, Dion is interested in what he calls 'rescue archaeology'. In 2005, Dion excavated the site of New York's new Museum of Modern Art. A retrospective of his work was held at American Fine Art Co., New York in 2003; his group shows include the Venice Biennale (1997).

Stan Douglas is a Canadian artist whose work combines traditional cinematic techniques with new technologies to produce images that are suggestive of repressed memories and forgotten histories. He has shown in group surveys such as the Venice Biennale (2001, 2005) and Houston Contemporary Art Museum (2004). Solo shows include the Serpentine Gallery, London (2002).

Marlene Dumas was born in South Africa and now lives in Amsterdam. The painter's intimate and disturbing work recalls the gestures of Expressionism, combining the critical distance of Conceptual Art with the pleasures of eroticism. Dumas represented the Netherlands at the 46th Venice Biennale (1995). Solo shows include the Fondazione Bevilacqua la Masa, Venice (2003). She has also participated in such survey shows as 'Stop Press: beautiful productions', Whitechapel Art Gallery, London (2001) and the 51st Venice Biennale (2005).

Jimmie Durham is an artist, writer and poet of Cherokee descent whose sculptures, drawings and installations mimic the attributes of humans and animals, and how they are then incorporated into history. His collages of found objects and fake ethnographic displays deliver an assault on the colonizing procedures of the Western world. His work has been featured at Documenta 9 (1992) and the Venice Biennale (2003, 2005). His solo show 'Crossings' was held at the National Gallery of Canada, Ottawa (1998).

Olafur Eliasson is an installation artist and photographer who recreates the extremes of landscape and climate of his native Denmark in new terrains. Eliasson's works have been seen at many of the most important surveys of international art, among them the 2nd Johannesburg Biennial (1997), the Sydney Biennial (1998) and the Venice Biennale (1999/2005). His solo installations include Tate Modern, London (2004). He lives and works in Berlin.

Peter Fischli and David Weiss are a Swiss duo who first began working together in the late 1970s. Their sculpture, video and photographic works look at everyday life and its conceptions of beauty and pleasure, so forming an innocent, unpredictable art. Their work has been seen at such key international exhibitions as Documenta (1987/1997) and the Biennales of Sydney (1997/1998) and Venice (1988, 1995, 2003 Golden Lion Award). The Centre Georges Pompidou, Paris, held a solo show in 1992.

Tom Friedman is an American artist who reinvents sculpture for an ephemeral age. His use of humble materials – pencil shavings, spaghetti, Styrofoam – may be reminiscent of an Arte Povera-type approach, but Friedman's work also connects to 1960s Conceptualism. Solo exhibitions of his work have been held at The Museum of Modern Art, New York (1995) and the Art Institute of Chicago (1996); in 2000-02, a touring exhibition took in five major American contemporary art museums. His group shows include 'Young Americans II', Saatchi Gallery, London (1998) and 'Retrospectacle', the Denver Art Museum, Denver (2002). Friedman works in a windowless studio in rural Massachusetts.

Isa Genzken is a German sculptor whose architectural works expose expand on Minimal art, objet trouvé, collage and public sculpture. Genzken's visual language, developed over the last twenty-five years, is as intensely political as it is personal. Shows at Galerie Daniel Buchholz, Cologne (2001), Hauser & Wirth, London (2004) and David Zwirner, New York (2005) number among her solo exhibits; her group shows include Documenta (1982/1992/2002) Carnegie International, Pittsburgh (2004). Genzken, who was awarded the Munich International Art Prize in 2004, lives and works in Berlin.

Antony Gormley is an internationally acclaimed artist who has revitalized the human figure in sculpture. His sculptures raise key issues about the relationship between art, society and the environment as both social and political realms; his works can be seen in many public places, including Gateshead, England, where his giant *Angel of the North* (1998) towers above the town. He was the recipient of the 1994 Turner Prize. Large-scale surveys of his work have been held at the Malmö Konsthalle, Sweden (1993), the Tate Gallery, Liverpool and the Irish Museum of Modern Art, Dublin (both 1994). He has also shown at the Venice Biennale (1982) and Documenta 8 (1987).

Dan Graham is recognized as one of the most influential Conceptual artists to emerge in 1960s New York. He was a pioneer of performance-related video art in the 1970s, while his subsequent architecturally based projects have led to commissions around the world. His work has featured in four Documentas (1972/1977/1982/1992); solo exhibitions include the Stedelijk Museum, Amsterdam (1993) and the Whitney Museum of American Art, New York (1995). A two-city Japanese retrospective was dedicated to him at the Chiba City Museum of Art, Chiba and Kitakyushu Municipal Museum of Art, Fukuoka in 2004. He lives and works in New York.

Paul Graham is a British artist who uses photography to map a cultural and geopolitical topography. Always on the verge of photojournalism, his series such as 'American Night' (2003) present a fractured landscape. Graham's work has been included in surveys at The Museum of Modern Art, New York, the Fotomuseum, Winterthur, Switzerland and the Tate Gallery, London. He lives and works in New York.

Hans Haacke is a key figure in post-war art. Originally a painter, in the 1960s Haacke moved towards sculpture and installation art, often with a strong performative aspect. He is admired for his research into the art world's hidden economies and politics. He has shown at the New Museum, New York (1987), four Documentas (1972/1982/1987/1970) and three Venice Biennales (1976/1978/1993), winning (with Nam June Paik) the Golden Lion in 1993. Born in Cologne, Haacke has lived and worked in New York since 1965.

Mona Hatoum is a Palestinian artist who has lived in London since 1975. Using performance, video, sculpture and installation she creates architectonic spaces that relate to the body, language and the condition of exile. Her many group exhibitions include 'féminimasculin – le sexe de l'art' at Centre Georges Pompidou, Paris (1995) and 'Artistes Palestiniens Contemporains' the Institut du Monde Arabe, Paris (1997) and the Venice Biennale, 2005. Her work toured extensively throughout the United States in 1997.

Thomas Hirschhorn is a Swiss-born artist who emerged in the 1990s. He is noted for his vast, labour-intensive assemblages of low-grade materials. Moving beyond the status of the readymade, Hirschhorn's work comments on the proliferation of consumables, raising questions as to how his fragile, and sometimes temporary, work is to be ingested. His latter-day *Wunderkammern* won Hirschhorn the Prix Marcel Duchamp in 2000. He took part in Tate Modern's 'Common Wealth' (2003, London) show and at Documenta XI, London in 2004. Hirschhorn lives and works in Paris.

Jenny Holzer is among America's best-known artists. Using billboards, posters and LED displays, Holzer's disembodied texts analyse the power of language and authority. Awarded a Golden Lion for the American Pavilion at the 1990 Venice Biennale, Holzer's work has been seen at the Solomon R. Guggenheim Museum, at Times Square (1985) and the Venice Biennale (2005). One of the most recognizable artists of her generation, Holzer continues to exhibit worldwide. She lives and works in upstate New York.

Roni Horn is an American artist whose work takes the visual language of movements such as Minimalism to a new level. Horn's work ranges from sculptural objects to books and photographic installations. Her recent shows include a retrospective at the Musée d'Art Moderne de la Ville de Paris (1999), and a solo exhibit at the Art Institute of Chicago (2004). She featured in the Whitney Biennial, Whitney Museum of American Art, in 2004. Horn lives and works in New York and Reykjavik.

Ilya Kabakov, who spent thirty years in the USSR as an 'unofficial' artist, first came to Western attention in the 1980s; he is recognized as one of the most important Russian artists of the late twentieth century. His installations speak as much about conditions in post-Stalinist Russia as they do about a universal human condition. He has featured in major survey shows such as Documenta 9 (1992), the Whitney Biennial (1997) and the Venice Biennale (1993). The Museum of Fine Art, Columbus, Ohio staged a solo show in 2001. He lives and works in New York.

Alex Katz has been a key artist since the early 1960s. He first emerged on the New York art scene during the heyday of Abstract Expressionism and before the birth of Pop Art, but always worked independently of these movements. A major touring retrospective originating at New York's Whitney Museum of American Art was held in 1986. His paintings are in the collections of The Museum of Modern Art, New York, Tate Modern, London, the Centre Georges Pompidou, Paris, and the Nationalgalerie, Berlin, among others.

Mike Kelley is a Los Angeles-based sculptor, performance and installation artist. Kelley's art has been recognized for its ability to reveal the social and moral fabric of contemporary culture. He has shown at Museum Moderner Kunst Stiftung Ludwig, Vienna and Tate Liverpool (all 2004). He also particpated, with Paul McCarthy, in the Lyon Biennale (2003). Kelley is the author of *Foul Perfection: Essays and Criticism* (2003) and *Minor Histories: Statements, Conversations, Proposals* (2004).

Mary Kelly is an American artist and theorist. Kelly came to prominence with *Post Partum Document* (1973-79), an epic series that explored her relationship with her baby. Its combination of found objects, images and texts was pivotal to both Conceptual Art and feminist discussion. Solo shows include the Santa Monica Museum of Art, California (2002). Her *Circa 68*, was shown at the Whitney Biennial, Whitney Museum of American Art, New York (2004). Kelly is based in Los Angeles where she is also Professor of the Interdisciplinary Studio in UCLA's Department of Art.

William Kentridge is a South African artist whose work since the 1970s has navigated between the personal and political through the innovative use of animation in drawings, film and theatre. He first attracted international attention when his work was shown at the Johannesburg and Havana Biennials (both 1997). A major touring exhibition was presented by the Museum of Contemporary Art, Chicago, the New Museum, New York and the Hirshhorn Museum and Sculpture Garden, Washington, DC in 2001. His work was included in the 51st Venice Biennale, 2005.

Yayoi Kusama is one of Japan's most respected contemporary artists. Since the early 1960s, she has pursued her themes of infinity, sexuality and obsessive-compulsive actions in paintings with flat, net-like patterns, or rooms where surfaces are covered in repetitive markings and structures. In 1993, she represented Japan at the Venice Biennale. Her retrospective, 'Love Forever: Yayoi Kusama 1958-1968', toured major spaces in the US and Japan in 1998-99. In 2000, the Serpentine Gallery, London presented a significant solo show. After spending many years in New York, she now lives and works in Tokyo.

Robert Mangold paints large-scale, geometrically inspired images which take in Abstraction and Minimalism. Mangold has featured in many prestigious survey shows, including three Whitney Biennials (1979/1983/1985) and three Documentas (1972/1977/1982); his influential touring retrospective, 'Painting As Wall: Work from 1964-1993', visited several galleries in Europe in 1993-96. 'Paintings, 1990-2002', at Aspen Art Museum, Aspen, Colorado (2003), is among his most recent shows. Mangold lives in Washingtonville, New York.

Christian Marclay works across numerous visual media – sculpture, installation, performance, found object and collage – alongside music and its artefacts, to create a unique, multidisciplinary art. A respected musician who has collaborated with John Zorn, Elliot Sharp and others, Marclay has presented his unique sound-and-vision at the Whitney Biennial, New York (1991/2002) and the Venice Biennale (1995/1999). A major retrospective originated at the Hammer Museum, UCLA (2003), travelling to the Barbican Art Gallery, London, (2005). He lives in New York.

Paul McCarthy creates Grand Guignol performances and installations featuring animal, vegetable and human hybrids in an uncanny evocation of a national American subconscious. His work parallels the utopian impulse of much European live art with a postmodern, dystopic twist. He has featured in the Whitney Biennial, Whitney Museum of American Art, New York (1995). His retrospective visited the Museum of Modern Art, Los Angeles (2000), the New Museum, New York and Tate Liverpool (2001). McCarthy lives and works in Los Angeles.

Cildo Meireles is one of Brazil's best-known post-war artists and, since the 1960s, a pioneer of installation art. His dramatically and politically charged works have often involved walk-in environments that engage the full range of sensory experience. He featured in the São Paulo Biennial (1998) and the Venice Biennale (2005), among the group exhibitions. A major retrospective of his work was held at the New Museum of Contemporary Art, New York (1999), before traveling to museums in Rio de Janeiro and São Paulo. He lives and works in Rio de Janeiro.

Lucy Orta makes wearable habitats and emergency shelters. Part architectural, part clothing, her Refuge Wear and Collective Wear prototypes examine human boundaries with social activism. The London-based artist has staged solo shows and public interventions at the Cartier Foundation for Contemporary Art, Paris (1996) and the Victoria and Albert Museum, London (2004). Her group shows include 'Strike'. Wolverhampton Art Gallery, Wolverhampton (2002). As part of her research activities, Orta currently holds the first Rootstein Hopkins Chair of Fashion at the London College of Fashion, and she also leads the 'Man + Humanity' Master in Industrial Design at the Design Academy, Eindhoven.

Raymond Pettibon is recognized as one of America's foremost representational artists. Emerging on the international art scene in the 1980s, he is best known for his ink-wash drawings and their short, enigmatic texts. His comic-book style subject matter is a snapshot of an American subculture that takes in cult punk bands, film noir and surfing. A major retrospective at the Kunsthalle Bern (1995), 'Heaven', a group group show aat P. S.1, Long island City, New York and a US touring show (1998-2000) are among Pettibon's many exhibitions. He lives and works in Los Angeles.

Richard Prince emerged in the 1980s as part of a generation of influential and innovative New York-based artists who worked with the margins of American sub-culture and visual debris. Using photography, readymades and painting, Prince extracts images from the world of advertising, gang culture and comic books to create his own, strangely recognizable, reality. He has been exhibited in major museums and galleries around the world; in 1992, the Whitney Museum of American Art, New York, held a Prince retrospective. He was included inthe Whitney's 'The American Century – Part II' (1999).

Pipilotti Rist is a Swiss artist whose work since the 1980s incorporates the art forms of film, video, music, sculpture and performance. Her work invents new possibilities for self-portraiture. It has been shown at the Kunsthalle, Zurich and the Musée d'Art Moderne de la Ville de Paris (both 1998) and presented on a giant video-display in Times Square, New York (2000). She participated in the 51st Venice Biennale (2005). She lives and works in Zurich and Los Angeles.

Doris Salcedo is a Columbian sculptor, a key South American artist since her emergence in the 1990s. Often using domestic interiors and objects, Salcedo transforms her materials into ghostly settings that hint at loss and memory. Her work has featured inthe Sydney Biennial (1992), the Carnegie International, Pittsburgh (1995) and the Liverpool Biennial (1999). In 1998, major solo shows were presented at the New Museum, New York and at SITE, Sante Fe. She is based in Bogotá.

Thomas Schütte is one of the most important German artists to emerge in the post-war era. His installations, models, drawings and watercolours may seem utilitarian, but in fact offer a world of contradictory sensations. Notable among the many solos shows which have been held at museums across Europe is the 1998 survey presented by Whitechapel Art Gallery, London, De Pont Foundation,Tilburg and Fundação de Serralves, Porto. He won a Golden Lion at the Venice Biennale (2005). Schütte's permanent public commissions can be found in Antwerp, Münster, Kassel and Neuengamme. He lives and works in Düsseldorf.

Lorna Simpson was the first African-American woman ever to show at the Venice Biennale and to have a 'Projects Exhibition' at The Museum of Modern Art, New York (both 1993). The photo-based artist and filmmaker juxtaposes elegant and haunting images of black women with fragmented texts, raising questions about the construction of the self. Her recent solo exhibitions include the Studio Museum, Harlem, New York (2002) and the Irish Museum of Modern Art (2003). Simpson has also featured in such group shows as Documenta 11 and the Whitney Biennial, Whitney Museum of American Art, New York (2002).

Nancy Spero is an American artist whose imagery concentrates on the depiction of women. Inspired by classical and modern sources, she collages and imprints her contemporary goddesses onto friezes that scroll around museum walls. Her work has attracted much acclaim, and given form to new feminist issues and critical discourses. Spero's major exhibitions include a retrospective at the ICA in London (1987) and the American Center, Paris, with Leon Golub (1994).

Jessica Stockholder sprang to international attention in the late 1980s. Her multi-media installations use sculpture, painting and architecture to create a new kind of pictorial space. Her work has been promoted by institutions including the Sprengel Museum, Hanover, the Dia Center for the Arts, New York, and the Blaffer Gallery at the University of Houston, which, together with the Weatherspoon Gallery in North Carolina, presented a major travelling exhibition of her work. 'Unbound: Possibilities in Painting', at the Hayward Gallery, London (1994), is among her many survey shows. Born in Seattle, Stockholder was raised in Vancouver and is now based in Connecticut.

Wolfgang Tillmans began his career working for fashion and music magazines. His photographs of young people in their social environment marked him as the chronicler of his 1990s generation. Tillmans' work has an unusual breadth of subject matter, ranging from the particular to the highly abstract. In 2000, he was the first non-British artist to win the Turner Prize. The West German-born artist has exhibited internationally, presenting installations at Portikus, Frankfurt (1995) and The Museum of Modern Art, New York (1996), among others. He particpated in 'Moving Pictures' survey at the Solomon R. Guggenheim Museum, New York in 2002. He lives and works in London.

Luc Tuymans is a Belgian artist who has been exhibiting internationally since the 1990s. His work fuses Old Master Flemish and Spanish genre paintings with a source of his imagery – atrocities in the Belgian Congo or Nazi exterminations – that is resolutely modern. Solo shows have included K21 Kunstsammlung Nordrhein-Westfalen, Düsseldorf (2004-05) and Tate Modern, London (2004). Tuymans also has a considerable international presence, via group shows such as 'Dear Painter, Paint Me', Schirn Kunsthalle, Frankfurt (2003). Tuymans represented Belgium at the Venice Biennale (2001). He lives in Antwerp.

Jeff Wall is an artist working in photography. He has exhibited his pictures internationally for the past twenty-five years. His solo shows include ones at the Museum Moderner Kunst, Vienna, Manchester City Art Gallery (both 2002) and Tate Modern, London (2005). He has also featured at Documenta 11 in Kassel. In 2003, Jeff Wall was awarded the Roswitha Haftmann Prize for the Visual Arts in Zurich and in 2002, the Hasselblad Prize for Photography. He lives and works in Vancouver.

Gillian Wearing uses photography and video to explore the intimacies and complex dynamics of quotidian life. Her work consciously borrows from familiar forms of popular culture to present an art that can be both confessional and disturbing. She was included in the 'Sensation' survey at the Royal Academy, London (1997, and touring), and has presented solo exhibitions at the Frans Hals Museum, Haarlem (2004) and 'Mass Observation', Museum of Contemporary Art, Chicago (2002, and touring). Her writing has also appeared in *Artforum*, *frieze* and *Purple Prose*. London-based, Wearing won the 1997 Turner Prize.

Lawrence Weiner is among the foremost of America's Conceptual artists. Long interested also in the potential for language as a visual art form, his wall-based art has been exhibited worldwide. Recent solo exhibitions of Weiner's work have been mounted at the Hirshhorn Museum and Sculpture Garden, Washington, DC (1990), the Musée d'Art Contemporain, Bordeaux (1991/1992) and 'PRIMARY SECONDARY TERTIARY', Kunstverein Ruhr, Essen, (2003). Weiner has produced numerous films and videos, including *Beached* (1970) and *Drift* (2004), with John Baldessari and Juliao Sarmento. Weiner lives and works in New York.

Franz West is an internationally renowned Austrian artist who often incorporates the bodies of his spectators into his sculpture. Emerging out of Vienna's Aktionism generation of the 1960s, West's work questions the viewer's involvement with art, as well as his artist's duty to them. He has exhibited widely, at spaces including The Museum of Modern Art, New York (1997) and regularly shown in such international art surveys as Documenta X (1997) and Skulptur Projekte in Münster.

Authors

Juan Vicente Aliaga lectures at the Faculty of Fine Arts, Valencia, where he lives and works. He is the author of several books, most recently *Bajo vientre: Representaciones de la sexualidad en la cultura y el arte contemporàneos* (*Lower Abdomen: Representations of Sexuality in Contemporary Art and Culture*, 1997) and *Arte y cuestiones de género* (*Art and Gender Matters*), 2004. A curator and art critic, Aliaga writes regularly for *Artforum*.

Michael Archer teaches art history and theory at the Ruskin School of Drawing and Fine Art, University of Oxford. He is an art critic and regular contributor to *Art Monthly* and *Artforum* magazines. He contributed to *Installation Art* (with Michael Petry, Nicholas D'Oliveira and Nicola Oxley, 1994) and is the author of *Art Since 1960* (1997).

Carlos Basualdo is an independent critic and curator is Adjunct Professor at the IUAV in Venice, Italy. Among his curatorial projects are Documenta 11, Kassel, Venice Bienniale (both 2003), and 'Tropicália: 1967-1972' at the Museum of Contemporary Art in Chicago (2005).

Daniel Birnbaum is the contributing editor of *Artforum* and the author of several books on art and philosophy, including *The Hospitality of Presence: Problems of Otherness in Husserl's Phenomenology* (1998) and, with the artist Carsten Höller, *Production* (2000). Since 2001, he has been the Director of Portikus and the Rector of the Städelschule Art Academy, Frankfurt. He was co-curator of the 50th Venice Biennale and also of the first Moscow Biennale. He is a regular contributor to such art journals as *frieze* and *Parkett*.

Barbara Bloom is a New York-based artist whose many international museum exhibitions include the Venice Biennale (1988) and the Museum of Contemporary Art, Los Angeles (1989/1998). Her artist's books include *Ghost Writer* (1988), *The Reign of Narcissism* (1990), *Never Odd or Even* (1992), *Broken* (2001), and the upcoming *The Collections of Barbara Bloom* (2006).

Nicolas Bourriaud is a curator, critic and writer based in Paris. He is co-director of the Palais

de Tokyo, Paris. His writings include *Relational Aesthetics* (1998) and numerous critical writings, including *Postproduction* (2002). Bourriaud was the founder of the magazine *Documents sur l'art* and the cultural review *Perpendiculaire*. He is co-curator of the 1st Moscow Biennale (2005).

Benjamin H. D. Buchloh has written extensively on European and American contemporary art since 1945. His books include *Neo-Avantgarde and Culture Industry: Essays on European and American Art from 1955 to 1975* (2001), *Photography and Painting in the Art of Gerhard Richter: Four Essays on Atlas* (2000) and *Formalism and Historicity: Essays on American and European Art Since 1945* (1999). The editor of *October* magazine, he is the Virginia Bloedel Wright '51 Professor of Art History at Barnard College, New York.

Carolyn Christov-Bakargiev is the Chief Curator at the Castello di Rivoli Museo d'Arte Contemporanea, Turin. She has recently co-curated 'Faces in the Crowd: Picturing Modern Life from Manet to Today' at the Whitechapel Art Gallery, London (2004-05). Her publications on contemporary art include books on Arte Povera (Phaidon, 1998) and on Franz Kline and Pierre Huyghe (both 2004).

Lynne Cooke has been Curator at the Dia Art Foundation, New York, since 1991. Co-curator of the 1991 Carnegie International, and Artistic Director of the 1996 Sydney Biennale, she has also curated numerous exhibitions in North America, Europe and elsewhere. In addition to teaching at Columbia University in the Fine Arts and Art History Departments, she is on the faculty for Curatorial Studies at Bard College. Among her publications are essays on the works of Rodney Graham, Jorge Pardo, Diana Thater and Agnes Martin.

Dennis Cooper is a novelist, poet, and cultural critic based in Los Angeles. His most recent novels are *God Jr.* and *The Sluts* (both 2005). He is best known for the *George Myles Cycle*, an interconnected sequence of five novels that comprises *Closer* (1989), *Frisk* (1991), *Try* (1994), *Guide* (1997) and *Period* (2000). His novels have been translated into seventeen languages. He is a contributing editor to *Artforum*.

Douglas Crimp is Fanny Knapp Allen Professor of Art History and Acting Director of the Program in Visual and Cultural Studies at the University of Rochester. He is the author of *On the Museum's Ruins* (1993) and *Melancholia and Moralism: Essays on AIDS and Queer Politics* (2002). Recently published essays on Andy Warhol's *Blow Job* and *Screen Test #2* will be included on a short book he is writing on Warhol's films.

Bice Curiger is a founding editor of *Parkett*, one of Europe's leading contemporary art magazines, and also the editorial director of *Tate, Etc.* An art critic based in Zurich, Curiger is a curator at the city's Kunsthaus. Her books include the monograph *Meret Oppenheim, Defiance in the Face of Freedom* (1989).

Diedrich Diederichsen writes on art, music, theatre, film and politics; he lives in Berlin and teaches in Stuttgart. His most recent publications are *Sexbeat: 1972 bis Heute* (2002), *2000 Schallplatten* (2000) and *Der lange Weg nach Mitte* (1999). He also edited *Golden Years: Queer Subculture between 1959 and 1974* (2005) and *Loving the Alien* (1998). He is currently working on a theoretical book on pop music and a monograph on Martin Kippenberger.

Mark Francis is a curator and writer, based in London. In 2000 he was director of the fig-1 project in London. Formerly the founding director and chief curator of the Andy Warhol Museum in Pittsburgh, he has also been a curator at the Carnegie Museum of Art, Pittsburgh, the Centre Georges Pompidou, Paris and the Whitechapel Art Gallery, London. He is the author of numerous publications on artists including Andy Warhol, Richard Hamilton and Douglas Gordon. He is a director of Gagosian Gallery, London.

Tamar Garb is Professor of the History of Art at University College, London. She is the author of *Sisters of the Brush: Women's Artistic Culture in Late Nineteenth-Century Paris* (1994), *Bodies of Modernity: Figure and Flesh in Fin de Siècle France* (1998) and *The Painted Face: Portraits of Women in France, 1814-1914* (forthcoming 2006). She also co-edited (with Linda Nochlin) *The Jew in the Text: Modernity and the Construction of Identity* (1995).

Alison M. Gingeras is an independent curator and writer. When she was curator at the Centre Georges Pompidou in Paris (1999-2004), she organized Thomas Hirschhorn's 'Skulptur-Sortier-Station' (2001), Daniel Buren's major solo exhibition 'Le Musée qui n'existait pas' and the group show 'Dear Painter, Paint Me' (2002). Her writing appears regularly in *Parkett*, *Artforum*, *Purple Fashion* and *Tate, Etc.*

Robert Gober is among the most important American artists to have emerged since the 1980s. Primarily a sculptor and installation artist, Gober's handcrafted works are often based on homely objects; they have been in major solo exhibitions at the Museum of Contemporary Art, Los Angeles (1997), the Galerie Nationale de Jeu de Paume, Paris (1991) and the Art Institute of Chicago (1988). In 2001, Gober represented the United States at the Venice Biennale.

Thelma Golden is a New York-based critic and Director and Chief Curator of the Studio Museum in Harlem, New York. Previously, Golden was a curator at the Whitney Museum of American Art, New York, and Special Projects Curator for the Peter Norton Foundation in Santa Monica, California.

E.H. Gombrich has a standing in the world of art that remains unrivalled by any other art historian. Gombrich's books have been translated into nearly thirty languages and many titles – including *The Story of Art* (1950), now in its 16th edition – have become classics. Ernst Gombrich was born in Vienna in 1909 and came to England in 1936. He spent most of his working life at the University of London's Warburg Institute, where he was Director. His retirement saw the publication of numerous books and the conferring of many international honours, including a knighthood and the Order of Merit. In 1994 the city of Frankfurt awarded him the Goethe Prize. He died in 2001.

Kim Gordon is the bass player and vocalist for the punk band Sonic Youth, which she founded in New York with Thurston Moore and Lee Ranaldo. Originally an installation artist and critic, she now writes the lyrics for the band, which deal with feminist issues such as rape, sexual harassment, anorexia and the beauty culture. She is credited with inspiring the Riot Grrl movement in the late 1980s and produced Hole's first album *Pretty on the Inside* (1991). She continues to work as an artist, most recently showing at Kenny Schachter, New York (2003) and Reena Spaulings Fine Art , New York (2004).

Isabelle Graw is founder (with Stefan Germer) and editor of *Texte zur Kunst*. She also writes for *Artforum, Wolkenkratzer Art Journal* and *Artis*. The Berlin-based critic is also Professor of Art Theory at the Städelschule, Frankfurt.

Peter Halley is a New York artist and the publisher of *index* magazine. Exhibiting since the 1980s, Halley has presented surveys of his work at The Museum of Modern Art, New York (1997) and the Folkwang Museum, Essen, Germany (1998). Halley has also written extensively on art and culture. His writings have been published in *Collected Essays 1981-87* (1988) and *Recent Essays 1990-96* (1997). In 2001 he received the Frank Jewett Mather Award for art criticism from the College Art Association. Since 2002, he has served as Director of Graduate Studies in painting at the Yale University School of Art.

Paulo Herkenhoff is the Director of the Museu Nacional de Belas Artes in Rio de Janeiro. He is a former curator at The Museum of Modern Art, New York and was artistic director of the 24th Bienal de São Paulo (1998). He has curated exhibitions of Lygia Clark (São Paulo), Guillermo Kuitca (Madrid) and Lucio Fontana and Cildo Meireles (Rio de Janeiro). He has written on Louise Bourgeois, Roni Horn, Ernesto Neto and Helio Oiticica, among others.

Matthew Higgs is a British artist, writer and curator based in New York where he is the Director and Chief Curator of White Columns, the city's oldest alternative art space. His curatorial projects include 'Protest & Survive', Whitechapel Art Gallery, London (2000), 'To Whom It May Concern' at the CCA Wattis Institute for Contemporary Art, San Francisco (2002) and 'Trade', White Columns, New York (2005).

Jo Anna Isaak is a critic and curator and the author of *The Ruin of Representation in Modernist Art and Texts* (1986) and *Feminism & Contemporary Art: the Revolutionary Power of Women's Laughter* (1996), and *H₂O* (2002), in addition to numerous articles on art and critical theory. Born in British Columbia, Isaak lives in New York City. She is Professor of Art History at Hobart and William Smith Colleges.

Miwon Kwon is Associate Professor in the Department of Art History at University of California Los Angeles. She is a founding editor of *Documents*, and sits on the advisory board for the journal *October*. She is the author of *One Place After Another: Site-Specific Art and Locational Identity* (2002).

James Lingwood has been, with Michael Morris, Co-Director of Artangel since the early 1990s. Based in London, Artangel has commissioned a sequence of ground-breaking projects over the past decade including Rachel Whiteread's *House* (1993) and Gregor Schneider's *Die Familie Schneider* (2004). Lingwood has curated numerous exhibitions for museums across Europe, including surveys of the work of Vija Celmins, Susan Hiller, Juan Muñoz and Thomas Schütte.

Sylvia Plimack Mangold was born in New York in 1938 and studied at Cooper Union and Yale University. She began exhibiting her paintings in the late 1960s and her work has been the subject of more than thirty solo exhibitions, including three museum surveys each accompanied by a monograph: Madison Art Center (1982), Wesleyan University and University of Michigan (1992) and Albright-Knox Art Gallery (1994). She lives and works in Washingtonville, New York.

Gerardo Mosquera is Adjunct Curator at the New Museum of Contemporary Art, New York. Author of several works on contemporary art and art theory, in 1996 Mosquera edited *Beyond the Fantastic: Contemporary Art Criticism from Latin America*. He was also a co-founder of the Havana Biennale in his native Cuba.

Molly Nesbit is Professor of Art History at Vassar College and a contributing editor of *Artforum* and *October*. She is the author of *Atget's Seven Albums* (1992) and *Their Common Sense* (2000). With Hans Ulrich Obrist and Rirkrit Tiravanija she curates 'Utopia Station', an ongoing project.

Hans Ulrich Obrist is the curator of ARC / Musée d'Art Moderne de la Ville de Paris and art editor of *Domus* magazine in Milan. The first volume of Obrist's ongoing interview project has been collected in *Hans Ulrich Obrist Interviews* (2003).

Arielle Pélenc has been the director of Rochechouart Contemporary Art Museum in Limousin, France since 2002. Previously, she was contemporary art curator at the Musée des Beaux-Arts, Nantes, where she curated the photographic show 'Remix' (1998), and 'Vision Machine' (2002), a show with a set by architect Lars Spuybroek.

Jeff Rian is a writer and musician who teaches at the École des Beaux-Arts, Paris-Cergy. He is an editor of *Purple* magazine, a contributor to *Artforum,* and the author of *The Buckshot Lexicon* (2000) and *Lewis Baltz* (2001). He was composer, co-producer and guitarist on the Alexandra Roos' *Everglade* album (2000) and, with Palix, on *Fanfares* (2004).

David A. Ross is President of the Artist Pension Trust, a financial service company working exclusively for visual artists. Ross has been involved in the arts community for more than thirty years, serving nearly twenty years as a director at the San Francisco Museum of Modern Art, the Whitney Museum of American Art and the Institute of Contemporary Art, Boston. A trustee of the Studio Museum in Harlem and Chairman of the Anaphiel Foundation, he is also on the Board of the American Anti-Slavery Group, Rhizome, and the Committee Scientifico of the *Fondazione CRT* in Turin, Italy.

Donna De Salvo has curated exhibitions of, and published on, a wide array of artists, including Andy Warhol, Roni Horn and Gerhard Richter. Her thematic exhibitions include 'Hand-Painted Pop: American Art in Transition 1955-1962', the Museum of Contemporary Art, Los Angeles, 'Century City: Art and Culture in the Modern Metropolis', and 'Open Sewers: Rethinking Art circa 1970' (both Tate Modern, London). She has held curatorial posts at Tate Modern, Dia Art Foundation, the Andy Warhol Foundation and Wexner Center for the Arts. She is Associate Director for Programs and Curator at the Whitney Museum of American Art in New York.

Amanda Sharp is the publisher and co-founder of *frieze*, the contemporary art and culture magazine. She is also a director and co-founder of the annual frieze art fair. She is based in New York.

Joan Simon is Curator-at-Large at the Whitney Museum of American Art, New York. A former managing editor of *Art in America*, Simon has published extensively on contemporary art and is the author of *Ann Hamilton* (2002), as well as monographs on Susan Rothenberg, Gordon Matta-Clark and Jenny Holzer. She was the general editor of the exhibition catalogue and catalogue raisonné on Bruce Nauman. A writer, curator, editor and arts administrator based in Paris, her articles have also appeared in *Art Press, Beaux Arts, Parkett* and other international journals.

Dirk Snauwaert is the Artistic Director of Wiels, a contemporary art centre in Brussels. Previously, he was joint artistic director of the IAC Institut d'Art Contemporain in Villeurbanne/Lyon. He has also worked as director of the Munich Kunstverein and curator at the Société des Expositions du Palais des Beaux-Arts de Bruxelles.

Beate Söntgen is Professor of Art History at the Ruhr University of Bochum, Germany. Previously, she was Laurenz Professor of Contemporary Art at the University of Basel. She has published books and essays on modern and contemporary art and art theory and contributed to many catalogues and publications, including *Texte zur Kunst* and the *Frankfurter Allgemeine Zeitung*. She has also worked in such exhibition spaces as the Städel Museum, Frankfurt and at K20, Düsseldorf.

Nancy Spector is a Curator of Contemporary Art at the Solomon R. Guggenheim Museum in New York, where exhibitions she has organized have included Felix Gonzalez-Torres (1995), 'Postmedia: Conceptual Photography' (2000), 'Moving Pictures' (2002), 'Matthew Barney: The Cremaster Cycle' (2002-03), and 'Singular Forms (Sometimes Repeated)' (2004). At the Deutsche Guggenheim Berlin, she has overseen commissions by Andreas Slominski, Hiroshi Sugimoto and Lawrence Weiner.

Kristine Stiles is an artist and Associate Professor of Art and Art History at Duke University, North Carolina. She has been writing on art since the late 1980s with an emphasis on destruction and trauma in the post-1945 period, particularly in the field of live art. She is co-author (with Peter Selz) of *Theories and Documents of Contemporary Art* (1996).

Robert Storr is the Rosalee Solow Professor of Modern Art at the Institute of Fine Art, New York University and a former senior curator in the Department of Painting and Sculpture at The Museum of Modern Art, New York. He has published widely in his field, including books on Gerhard Richter (2002), Philip Guston (1986) and the survey *Modern Art Despite Modernism* (2000). Storr is a Contributing Editor to *Art in America* and *Grand Street*. His curatorial shows for MoMA include 'Gerhard Richter: Forty Years of Painting' (2002) and 'Chuck Close' (1998). He curated of SITE Santa Fe's 5th International Biennial (2004-05).

Akira Tatehata is a professor in the department of Art and Design at Tama Art University in Tokyo. He was Curator of the National Museum of Art, Osaka (1976-91) and the Japanese Commissioner for the Venice Biennale (1990/93). An acclaimed poet, in 1991 Tatehata received the Rekitei Prize for New Poets for his collection of poems *Runners in the Margins*. He is also the recipient of the Takami Jun Prize for Poetry for *The Dog of Zero Degree* (2005).

Mark C. Taylor is the Cluett Professor of Humanities at Williams College and Visiting Professor of Architecture and Religion at Columbia University. His books include *Disfiguring: Art, Architecture and Religion* (1992), *The Moment of Complexity: Emerging Network Culture* (2001) and *Confidence Games: Money and Markets in a World without Redemption* (2004). He contributes regularly to journals and books on philosophy, religion, art, architecture and technology.

Pier Luigi Tazzi is a critic, columnist, teacher and curator, currently based in Capalle, Tuscany. Among others, he was a curator at the 1988 Venice Biennale, co-director of Documenta 9 in Kassel (1992), co-curator of 'Wounds', the inaugural exhibition of the new Moderna Museet in Stockholm in 1998, and of 'Happiness', the inaugural exhibition of Mori Art Museum in Tokyo (2003). Tazzi has written widely on many artists, including Mark Wallinger, Max Neuhaus and Jan de Vries.

Diana Thater is a Los Angeles-based artist who works in video installation. Her work has been featured in major exhibitions at the Walker Arts Center, Minneapolis (1997) and The Museum of Modern Art, New York (1998). Featured in international art journals such as *Artforum* and *Flash Art*, her work has been included in surveys such as the Whitney Biennial (1995/97) and Carnegie International, Pittsburgh (1999-2000).

Lynne Tillman is a novelist and critic based in New York. Her last novel, *No Lease on Life* (1999), was a finalist for the National Book Critics Circle Award in Fiction. Tillman's story collection *This Is Not It* (2002) includes twenty-three stories written in response to the work of twenty-two contemporary artists. Her fiction appeared in the Whitney Biennial catalogue of 1993, representing American writing. She is the fiction editor of *Fence Magazine* and a contributing editor to *Bomb*.

Octavio Zaya is a New York-based critic and curator, born in the Canary Islands, Spain. He is the Co-Director of the magazine *Atlantica* (CAAM) and Editor-at-Large of the Madrid-based quarterly *A-42*. He is also an Advisor of MUSAC, Leon, Spain. Zaya was co-curator of Documenta 11 (2002), 'In/Sight: African Photographers, 1940-Present' (Solomon R. Guggenheim Museum, New York, 1996) and 'Alternating Currents', 2nd Johannesburg Biennale (1997). Zaya is also a regular contributor to *Art Nexus*, *Flash Art* and *NKA: Journal of Contemporary African Art*.

List of Illustrated Works

cm. Collections, British Council, London; Det Kongelige Bibliotek, Copenhagen; Wolverhampton Museum and Art Gallery; Victoria and Albert Museum, London

Genzken, Isa *Wasserspeier and Angels*, 2004. 18 parts and 42 aluminium panels. Various materials, dimensions variable. Installation view. Hauser & Wirth, London 2004

Genzken, Isa *Empire/Vampire, who kills death*, 2003. 1 of 22 parts, various materials, 98 × 62 × 45 cm. Installation view. Hauser & Wirth, London 2004

Gormley, Antony *Land, Sea and Air II*, 1982. Lead, fibreglass.
Land (crouching)
45 × 103 × 53 cm.
Sea (standing) 191 × 50 × 32 cm.
Air (kneeling) 118 × 69 × 52 cm

Gormley, Antony *Field for the British Isles* (detail), 1992. Terracotta, approx. 35,000 figures. Variable size, 8-26 cm each. Collection, British Council, London

Graham, Dan *Star of David Pavilion for Schloß Buchberg, Austria*, 1991–96. Two-way mirror, aluminium, Plexiglas, 261 × 420 × 238 cm. Permanent installation, Schloß Buchberg, Vienna

Graham, Dan *Homes for America*, 1966–67, 1 of 2 panels, colour and black and white photographs, texts, 101.5 × 84.5 cm each. Revised version produced in 1970 of the artist's original paste-up for *Arts Magazine*, New York. The version published in the magazine's December, 1966–January, 1967, issue substituted a photograph by Walker Evans for the artist's images

Graham, Paul *Television, Portrait, Cathy, London*, 1989. Colour photograph, 110 × 90 cm. Collection, Tate, London

Plate section VI, after page 320

Horn, Roni *Piece for Two Rooms* from *Things That Happen Again*, 1986–91. (Room 1). A suite of four sets of paired, solid copper forms, each forged and machined to duplicate mechanical identity, L. 89 cm each ⌀ 43-31cm each. Installation, Galerie Lelong, New York. Collections, The Detroit Institute of Arts, Detroit; Donald Judd Foundation, Marfa, Texas; Städtisches Museum Abteiberg, Mönchengladbach

Hatoum, Mona *Measures of Distance*, 1988. 15-min. video. A Western Front Video Production, Vancouver. Collection, Art Gallery of Ontario, Toronto; Musée national d'art moderne, Paris; Museum of Contemporary Art, Chicago; Museum of Modern Art, Toyama; National Gallery of Canada, Ottawa

Hatoum, Mona *The Light at the End*, 1989. Angle iron frame, six electric heating elements, 116 × 162.5 × 5 cm. Installation, the Showroom, London. Collection, Arts Council, London

Hirschhorn, Thomas *Deleuze Monument*, 2000. 'La Beauté', Avignon. Collection Fonds Régional d'Art Contemporain Provence-Aples-Côte d'Azur, Marseille, France

Hirschhorn, Thomas *VDP – Very Derivated Products*, 1998. Wood, cardboard, prints, photocopies, marker pen, aluminium foil, gold foil, transparent plastic foil, adhesive tape, stickers, Plexiglas, umbrellas, toys, gadgets, books, plastic cover, neon lights, electrical fans, integrated video 'Premises', Guggenheim SoHo, New York

Holzer, Jenny *Under a Rock*, 1986. 5 misty black granite benches, LED signs, Benches, 44 × 122 × 53.5 cm each, Signs, 25.5 × 286 × 115 cm each. Installation, Rhona Hoffman Gallery, Chicago, 1987. Collections, Art Gallery of Ontario; The Museum of Modern Art, New York; Museum of Contemporary Art, Chicago

Holzer, Jenny from *Truisms, Inflammatory Essays, Living, Survival, Under a Rock, Laments, Mother and Child* (detail) Floor, Rosso Magnaboschi marble tile in diamond pattern with Biancone marble border, Right wall, five 3-colour LED signs, 14 × 609 × 10 cm each, Left wall, five 3-colour LED signs, 14 × 609 × 10 cm each. Far wall, eleven 3-colour LED signs, 24 × 447 × 11 cm each. Installation, Gallery E, United States Pavilion, 44th Venice Biennale, 1990

Horn, Roni *Pi*, 1998. Photo installation, 45 Iris printed colour and black and white photographs installed on 4 walls. Various dimensions 51.5 × 69 cm; 51.5 × 51.5 cm; 51.5 × 46 cm. Collection, Staatsgalerie Moderner Kunst, Munich

Plate section VII, after page 400

Kelly, Mary *Post-Partum Document: Documentation I, Analysed faecal stains and feeding charts (prototype)*, 1974. Perspex units, white card, diaper lining, plastic sheeting, paper, ink, 1 of 7 units, 28 × 35.5 cm. Collection Generali Foundation, Vienna

Kabakov, Ilya *The Red Pavilion*, with musical arrangement by Vladimir Tarasov, 1993. Wood, board, paint construction, pavilion, wood fences, flags, builders' materials, loudspeakers, sound installation. Dimensions variable. Installation, Russian Pavilion, 45th Venice Biennale. Collection, Museum Ludwig, Cologne

Kabakov, Ilya *School No. 6*, 1993. Constructed and found school objects. Dimensions variable. Installed, disused barracks building, Chinati Foundation, Marfa, Texas

Katz, Alex *Edwin and Rudy*, 1968. Oil on aluminium, 122 × 110 cm

Katz, Alex *Red Coat*, 1982. Oil on canvas, 244 × 122 cm. Collection, Whitney Museum of American Art, New York

Kelley, Mike *The Trajectory of Light in Plato's Cave*, 1985/1997. Acrylic and acrylic latex on canvas, cotton, wood, electric lights, fake fireplaces, paint chips, felt. Dimensions variable. Installation, Rooseum, Malmö, Sweden, 1997

Kelley, Mike *Sod and Sodie Sock Camp O.S.O.* in collaboration with Paul McCarthy, 1998. Mixed media. Dimensions variable. Installation view

Kelly, Mary *Gloria Patri* (detail), 1992. Etched and polished aluminium, 1 of the 5 shields, 73.5 × 61 × 6 cm each. Installation, Rosamund Felsen Gallery, Santa Monica, 2001

Plate section VIII, after page 448

Marclay, Christian *Record Without a Cover*, 1985. Vinyl record ⌀ 30.5 cm

Kentridge, William Drawing for *Johannesburg, 2nd Greatest City after Paris*, 1989. 16mm animated film, transferred to video and laser disc, 8 mins., 2 secs., colour. Soundtrack: Duke Ellington; choral music,

Collections, Chicago Institute of Art; Johannesburg Art Gallery; Tate Gallery, London; Art Gallery of Western Australia, Perth; Carnegie Art Museum, Pittsburgh; National Museum of African Art, Smithsonian Institution, Washington, DC

Kentridge, William *Stereoscope*, 1999. 35mm animated film, transferred to video and laser disc, 8 mins., 22 secs., colour. Soundtrack: Score, Philip Miller; sound design, Wilbert Schübel

Kusama, Yayoi *Narcissus Garden,* 1966. 1,500 balls, ⌀ 20cm each. Installation, 33rd Venice Biennale

Kusama, Yayoi *Infinity Mirror Room (Phalli's Field)*, 1965. Sewn, stuffed fabric, mirrors, 360 × 360 × 324 cm each. Installation, 'Floor Show', Castellane Gallery, New York

Mangold, Robert *Curved Plane, Figure IV*, 1995. Acrylic and black pencil on canvas, 248.9 × 362.6 cm. Collection, Robert and Sylvia Plimack Mangold, Washingtonville, NY

Mangold, Robert *Red Wall*, 1965. Oil on masonite, 244 × 244 cm. Collection, Robert and Sylvia Plimack Mangold, Washingtonville, NY

McCarthy, Paul *Pinocchio Pipenose Householddilemma*, 1994. Performance video still. Wood, paint, table, plastic dishes, assorted food, stuffed toys, Pinocchio costume, latex mask

McCarthy, Paul *Bossy Burger*, 1991. Performance video, installation, Rosamund Felsen Gallery, Los Angeles, and Luhring Augustine, New York. Barbecued turkey leg, television stage set, bowls, cooking utensils, chair, counter, milk, flour, ketchup, mayonnaise, dolls, chef costume, mask

Plate section IX, after page 512

Prince, Richard *Protest Painting*, 1933. Acrylic and silkscreen on canvas, 102.6 × 52.4 × 7.6 cm

Meireles, Cildo *Eureka / Blindhotland*, 1970–75. *Eureka* , 2 pieces of identical wood, 1 wood cross, weighing scales. *Blindhotland*, 200 black rubber balls, varying in weight between, 150–1,500 grams. Dimensions variable

Meireles, Cildo *Inserções em Circuitos Ideologicos: Projecto Cédula* (Insertions into Ideological Circuits: Cédula Project), 1970. Rubber stamp on banknotes. Dimensions variable. Collection New Museum of Contemporary Art, New York

Orta, Lucy *Nexus Architecture x 50 – Nexus Intervention Köln*, 2001. Original colour photograph, 150 × 120 cm

Orta, Lucy *Refuge Wear Intervention London East End 1998*, 2001. Original Colour photograph, 150 × 120 cm

Pettibon, Raymond *Untitled (Where the water)*, 1992. Ink on paper, 56 × 35.5 cm

Pettibon, Raymond *Untitled (Meet the band.)*, 1987. Ink on paper, 35.5 × 28 cm

Prince, Richard *Untitled (girlfriend)*, 1993. Ektacolor photograph, 152 × 102 cm

Plate section X, after page 560

Simpson, Lorna *Still*, 1997. Serigraph of photograph with text on 36 felt panels. 78 × 61 cm overall, 305 × 731.5 cm overall. Collection, The Miami Art Museum

Rist, Pipilotti *Open My Glade*, 2000. Video installation, still of video-installation tape, 9 one-min. videos for Panasonic Screen, running every quarter hour from 6 April to 20 May 2000. Panasonic Screen, Times Square, New York. Commissioned by the Public Art Fund, New York

Rist, Pipilotti *I Couldn't Agree with You More*, 1999. Audio/video installation, still of 2 overlapping video installation tapes, audio system. Sound: Pipilotti Rist and Anders Guggisberg. Collection, Museum of Contemporary Art, Los Angeles

Schütte, Thomas *Die Fremden* (The Strangers), 1992. Glazed ceramic, lifesize. Installation, Documenta IX, Kassel, 1992

Schütte, Thomas *United Enemies, A Play in Ten Scenes* (detail), 1993. 2 of 10 offset lithographs, 69 × 99 cm each

Simpson, Lorna *Untitled (impedimenta)*, 2001. Archival gelatin prints under semi-transparent Plexiglas with black vinyl lettering in wooden frame, 104 × 155 × 2.5 cm framed

Salcedo, Doris *La Casa Viuda I*, 1992–94. Wood, fabric, 258 × 39 × 60 cm. Collection, Worcester Art Museum, Worcester, MA

Salcedo, Doris *Untitled* 1995. Wood, concrete, steel, glass, fabric, 217 × 114.5 × 39.5 cm

Plate section XI, after page 624

Tuymans, Luc *Body*, 1990. Oil on canvas, 49 × 35 cm. Collection, Museum of Contemporary Art, Ghent

Spero, Nancy *Notes in Time on Women* (panels VIII, XXI), 1979. Handprinting, gouache, typewriting, collage on paper, 24 panels, 51 × 6398 cm overall

Spero, Nancy *Codex Artaud I* (detail), 1971, Typewriting, gouache, collage on paper, 56 × 218 cm

Stockholder, Jessica *Recording Forever Pickled*, 1990. Wood, styrofoam, paint, halogen lights, electric cords, concrete embedded with plastic resin-coated cookies and a red ball on wheels, one couch, one metal framed chair, about 12 clear plastic garbage bags filled with leaves, sticks and twigs, 2 black garbage bags filled with the same, yellow green duct tape. Approx. 400 × 580 cm, room, 1120 × 580 cm. Installation, Le Consortium, Dijon, France. Collection, Le Consortium, Dijon

Stockholder, Jessica *Edge of Hot House Glass*, 1993. Plants, grolites, aerated concrete block, halogen lights, paint, black velvet, newspaper maché, cable, beads, balls, concrete, building. Approx. 11 × 12 m. Installation, Galerie des Arennes, Nîmes, France

Tillmans, Wolfgang *Lutz & Alex, sitting in the trees*, 1992. Colour photograph

Tillmans, Wolfgang *untitled (La Gomera)*, 1997. Colour photograph

Tuymans, Luc *Silence*, 1991. Oil on canvas, 86 × 78.5 cm. Collection, Kunstmuseum, Bern

Plate section XII, after page 672

Weiner, Lawrence *STATEMENTS*, 1968.
Sample pages from catalogue, 17.5 × 21 cm
for exhibition/catalogue 'January 5–31, 1969',
Seth Siegelaub at McLendon Building,
New York

Wall, Jeff *A Ventriloquist at a Birthday Party
in October, 1947*, 1990. Transparency in
lightbox, 229 × 335 cm

Wall, Jeff *The Giant*, 1992. Transparency in
lightbox, 39 × 48 cm

Wearing, Gillian *Confess all on video. Don't
worry, you will be in disguise. Intrigued?
Call Gillian,* 1994. Video, 30 mins., colour,
sound. Video still, Collections, Arts
Council, London; Tate, London;
Kunsthaus, Zurich

Wearing, Gillian From *Signs that say what
you want them to say and not Signs that say
what someone else wants you to say,* 1992–93.
C-type colour photograph, mounted on
aluminium, 40.5 × 30.5 cm. Series of approx.
600 photographs

West, Franz *Chou-Chou*, 1998. 4 chairs:
metal, wood, carpet, 45 × 54 × 84 cm.
Collection Kunstmuseum, Bern

West, Franz *The First Passstück,* 1978–94.
Plastic, metal, plaster, paint, text, video,
23 × 25.4 × 9 cm, pedestal: 75 × 40 ×35 cm

Weiner, Lawrence *SMASHED TO PIECES
(IN THE STILL OF THE NIGHT)*, 1991.
Paint on wall, Letter h. approx. 60 cm.
Installation in German and English,
Flakturm, World War II anti-aircraft
defense tower, Esterházypark, Vienna

Index